Hendrik Neubauer

D1507508

Curious Moments

KÖNEMANN

An expedition lays on a concert of canned music for these East African Masai in 1929.

»Ein Konzert mit Musik aus der Konserve« gibt eine Expeditionsgruppe 1929 für diese ostafrikanischen Massai.

« Un concert de musique en conserve » fascine ces Massaï, une ethnie d'Afrique de l'Est, lors d'une rencontre avec un groupe d'explorateurs en 1929.

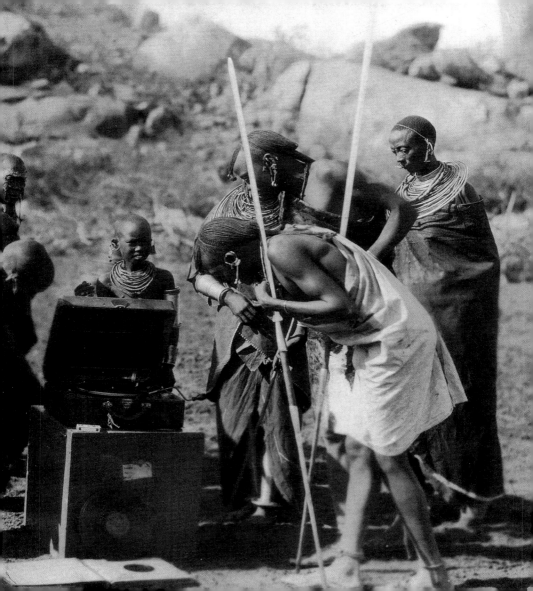

© 2006 Tandem Verlag GmbH
KÖNEMANN is a trademark
and an imprint of
Tandem Verlag GmbH

© for the photographs: SVT Bild/Das Fotoarchiv
Concept and text: Hendrik Neubauer/Das Fotoarchiv

Art direction: Peter Feierabend
Project manager: Sally Bald
Assistant: Lucile Bas
Layout and typography: Agentur Roman, Bold & Black
Editing: Stefanie Becker, Susanne Kassung, Angela Ritter
Translation into English: Michael Scuffil
Translation into French: Jean-Luc Lesouëf

Cover design: Simone Sticker

Printed in Germany

ISBN 3-8331-2192-0

X IX VIII VII VI V IV III II I
10 9 8 7 6 5 4 3 2 1

Curtain up!

Curious Moments provides a public stage for private individuals from the first half of the 20th century. *Curious Moments* tracks down the ideas and inventions, desires and fantasies, fears and prejudices, visions and delusions of earlier generations. *Curious Moments* is an historical treasure trove of a somewhat different kind. The reader will not find the great figures of modern history, but may well recognize old friends or distant relatives.

The pictures all come from the archive of the Stockholm agency Text och Bilder, which was taken over by Swedish television in the late 1960s. This photographic collection provides a cornucopia of history as reflected in the press photographer's camera lens in the period from 1900 to 1967. We owe it to the Swedish television archivists that almost seven million pictures with their accompanying texts have been preserved in their original condition. Now this archive, known for short as SVT Bild, has opened up its treasure chest for this book.

Curious Moments stages a comedy with tragic interludes in 19 acts. I wish you all a great deal of enjoyment and a happy ending.

Hendrik Neubauer

Vorhang auf!

Kuriose Momente stellt unbekannte Menschen aus der ersten Hälfte des 20. Jahrhunderts vor. *Kuriose Momente* spürt den Ideen und Erfindungen, Wünschen und Phantasien, Ängsten und Vorurteilen, Visionen und Abwegen früherer Generationen nach. *Kuriose Momente* ist eine historische Fundgrube der etwas anderen Art. In diesem Buch findet der Leser nicht die Größen der Zeitgeschichte, aber vielleicht alte Bekannte oder entfernte Verwandte wieder.

Die Bilder stammen allesamt aus den Beständen der Stockholmer Agentur Text och Bilder, die Ende der sechziger Jahre in den Besitz des schwedischen Fernsehens übergegangen sind. Dieses Fotoarchiv bietet ein Füllhorn der Historie im Spiegel der Pressefotografie für den Zeitraum von 1900 bis 1967. Den Archivaren des schwedischen Fernsehens ist es zu verdanken, daß fast sieben Millionen Bilder mit den dazugehörigen Texten im Originalzustand erhalten geblieben sind. Nun hat dieses Archiv, kurz SVT Bild, seine Schatzkiste für diesen Bildband geöffnet.

Kuriose Momente inszeniert eine Komödie mit tragischen Augenblicken in 19 Akten. Ich wünsche Ihnen vor allem viel Spaß und ein Happy-End mit diesem Buch,

Hendrik Neubauer

Le rideau se lève !

Moments bizarres offre une scène à des inconnus de la première moitié du XXᵉ siècle. *Moments bizarres* dévoile, les idées et inventions, désirs et fantaisies, craintes et préjugés, visions et errements des générations passées. *Moments bizarres* est un panorama historique d'un genre un peu particulier. Ici, le lecteur ne retrouvera pas les grands de l'histoire contemporaine, mais, peut-être, de vieilles connaissances ou des parents éloignés.

Les photos proviennent toutes des archives de l'agence de presse Text och Bilder, de Stockholm, qui, à la fin des années 60, est devenue la propriété de la télévision suédoise. Ces archives photographiques nous restituent les clins d'œil de la vie de tous les jours entre 1900 et 1967. Les archivistes de la télévision suédoise ont le grand mérite d'avoir préservé dans leur état original près de sept millions de clichés avec leurs textes respectifs. Et maintenant, ces archives surnommées SVT Bild font découvrir leurs trésors à travers cet ouvrage photographique. *Moments bizarres* met en scène une comédie à 19 actes qui tourne parfois au tragique. J'espère que vous aurez plaisir à découvrir ce livre dans lequel tout est bien qui finit bien.

Hendrik Neubauer

A posed episode from the everyday life of the Text och Bilder agency in Stockholm in the 1950s. The boss is getting worked up about a story which has just been sent in by a freelance contributor. Since 1967, the agency's entire stock has been in the possession of SVT Bild.

Eine gestellte Episode aus dem Arbeitsalltag der Agentur Text och Bilder in Stockholm in den fünfziger Jahren: Der Chef erregt sich über eine gerade abgelieferte Geschichte eines freien Mitarbeiters. Seit 1967 befindet sich das gesamte Material der Agentur im Besitz von SVT Bild.

Une scène reconstituée pour montrer le quotidien de l'agence de presse Text och Bilder, à Stockholm, dans les années 50 : le chef est en colère au sujet d'un reportage que vient de lui livrer un collaborateur freelance. Depuis 1967, tout le matériel de l'agence appartient à SVT Bild.

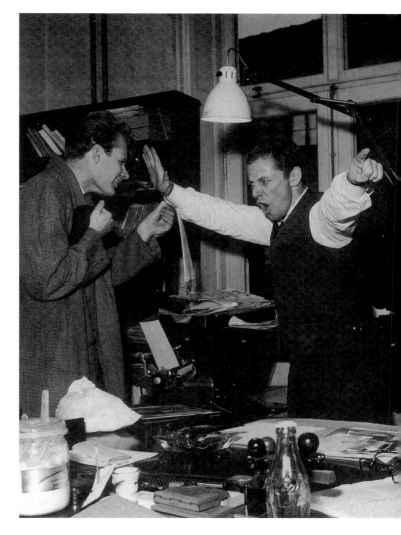

Life goes on

"2 August 1914. Germany has declared war on Russia. Swimming lesson in the afternoon."[1] This laconic entry is taken from the diary of Prague author Franz Kafka. In historical retrospect, Kafka's attitude can only be seen as extraordinary. The Great War breaks out, and the writer, who more than any other dealt in his works with the absurd and the minatory in modern life, simply goes about his daily business.

The gap between everyday life and world affairs is the underlying theme of *Curious Moments*. While events generally implant photographic icons into our historical consciousness, this book goes along untrodden paths. 700 press photographs report on local happenings from all over the world and tell the stories of ordinary people between 1920 and the 1960s. Compared with the better-known pictures of this crisis-ridden period, the perspective of the press story often comes across as curious. But the fact is that precisely in times of crisis, daily newspapers and illustrated periodicals devote more space to entertaining topics. They distract their readers' attention away from the shadow which world events are casting across their everyday lives. The watchword is "Life goes on."

Das Leben geht weiter

»2. August 1914. Deutschland hat Rußland den Krieg erklärt. – Nachmittag Schwimmschule.«[1] Dieser Eintrag findet sich in den Tagebuchaufzeichnungen des Prager Dichters Franz Kafka. In der historischen Rückschau kann Kafkas Haltung nur erstaunen: Der Erste Weltkrieg bricht aus, und der Dichter, der wie kein anderer das Absurde und Bedrohliche der Moderne in seinen Werken verarbeitet hat, geht seinen alltäglichen Gewohnheiten nach.

Diese Schere zwischen Alltag und Weltgeschichte ist der Kammerton der *Kuriosen Momente*. Während die Bildbände der Ereignisgeschichte fotografische Ikonen in unser Geschichtsbewußtsein einschreiben, geht dieser Band abseitige Wege. 700 Pressefotografien berichten von lokalen Geschehnissen aus aller Welt und erzählen die Geschichten der kleinen Leute aus dem Zeitraum von 1920 bis in die sechziger Jahre. Im Vergleich zu den bekannten Bildern aus dieser krisenbehafteten Zeit wirkt diese Perspektive oftmals kurios. Tatsache ist, daß sich gerade in Krisenzeiten Tageszeitungen und Illustrierte verstärkt unterhaltsamen Themen widmen. Sie lenken ihre Leser von den Schatten ab, die die Weltgeschichte auf ihren Alltag wirft, denn für alle gilt: »Das Leben geht weiter«.

La vie continue

« 2 août 1914. L'Allemagne déclare la guerre à la Russie. – Cet après-midi, cours de natation. »[1] Cette remarque a été notée par l'écrivain Franz Kafka, de Prague, dans son journal. Quand on se remémore l'histoire, on ne peut qu'être surpris par l'attitude de Kafka : la Première Guerre mondiale vient d'éclater et le poète qui, plus que tout autre, a traité dans ses œuvres de l'absurdité des temps modernes et de l'angoisse qu'elle lui inspire vaque immédiatement de nouveau à ses occupations quotidiennes. Le décalage entre la vie quotidienne et l'histoire mondiale donne le ton de *Moments bizarres*. Alors que les événements historiques se gravent habituellement dans notre mémoire sous forme d'icônes photographiques, cet ouvrage sort des sentiers battus.

700 photographies de presse restituent des événements locaux et nous racontent les histoires des petites gens de 1920 aux années 60. Par rapport aux clichés bien connus de cette époque ébranlée par les crises, cette perspective nous paraîtra souvent bizarre. Le fait est que, précisément en période de crise, quotidiens et illustrés attachent plus d'importance à des thèmes divertissants pour faire oublier à leurs lecteurs les ombres que l'histoire mondiale jette sur leur vie quotidienne. En effet, la devise est la même pour tous : « La vie continue. »

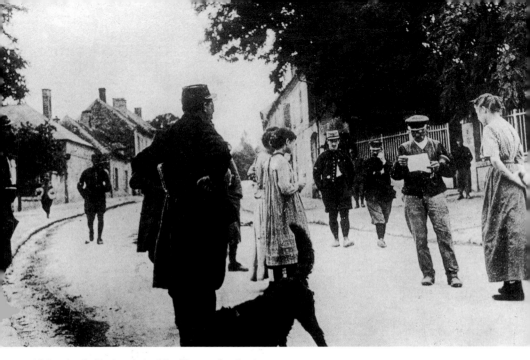

History books like to speak of the "frenzy of enthusiasm for war" which gripped almost all the belligerent nations of Europe in August 1914. Here, everyday life in a French village is interrupted when a local official reads out the proclamation of the state of general mobilization.

Geschichtsbücher sprechen gerne vom »Rausch der Kriegs-begeisterung«, der fast alle beteiligten Staaten in Europa bei Ausbruch des Ersten Weltkriegs erfaßt. Hier unterbricht die Verlesung der Generalmobilmachung durch einen Gemeindediener den Alltag in einem französischen Dorf.

Les livres d'histoire parlent volontiers de l'ivresse qui, à l'idée de se battre, s'est emparée de presque tous les Etats d'Europe lorsqu'a éclaté la Première Guerre mondiale. Ici, la lecture de la mobilisation générale par un garde-champêtre interrompt des villageois français dans leurs occupations quotidiennes.

Press and photography

In the Western world of the 20th century, reading the daily newspaper has become a part of social culture for broad sections of the population. The number of printed photographs was exceedingly small at first. On 21 January 1897, the first autotype appeared on the front page of the *New York Times*, while three years later, the *Chicago Tribune* printed a photographic series on New York's suburbs across a number of pages. Photography won a place for itself in the press, but lagged behind the daily events. While textual items could be transmitted by telephone or telegraph from the remotest corners of the earth, photographs and illustrations still reached the editorial offices by ship and train. Topical news stories were illustrated with archive material.[2]

The First World War was a setback for the development of the European press, but it quickly recovered from the shock. From then on, photographs had a decisive effect on the image of the publications. The working-class press and liberal periodicals of the German Weimar Republic period (1918–1933), above all, created a pictorial language of their own in the late 1920s, experimenting with graphic design. It was then that the term "photojournalism" was coined, underlining the new appreciation of photography.

Presse und Fotografie

Die Lektüre der Tageszeitung wird in der westlichen Welt des 20. Jahrhunderts innerhalb breiter Bevölkerungsschichten zu einem Stück Gesellschaftskultur. Die Zahl der abgedruckten Fotografien ist zunächst verschwindend gering. Am 21. Januar 1897 erscheint auf Seite eins der *New York Times* die erste Autotypie auf Zeitungspapier, drei Jahre später druckt die *Chicago Tribune* auf mehreren Seiten eine Fotoserie über die Vorstädte New Yorks. Die Fotografie erobert sich langsam ihren Platz in der Presse, aber sie hinkt den Tagesereignissen hinterher. Während Textnachrichten über Telefon und Telegrafie von den entlegensten Punkten der Erde übermittelt werden können, erreichen Fotografien und Illustrationen die Redaktionen immer noch per Eisenbahn und Schiff. Aktuelle Nachrichten werden mit Archivmaterial illustriert.[2]

Der Erste Weltkrieg wirft die Entwicklung der europäischen Presse zurück, doch sie erholt sich schnell von diesem Schlag. Fotografien bestimmen von nun an das Erscheinungsbild der Publikationen. Vor allem die Arbeiterpresse und die liberalen Illustrierten der Weimarer Republik kreieren Ende der zwanziger Jahre eine eigene Bildsprache und experimentieren bei der grafischen Gestaltung. Der Terminus »Fotojournalismus« wird geprägt und unterstreicht

Presse et photographie

Dans le monde occidental du XXe siècle, la lecture du journal quotidien s'inscrit dans les mœurs de larges couches de la population. Le nombre de photographies reproduites est tout d'abord extrêmement réduit. La première similigravure sur papier journal paraît, le 21 janvier 1897, en première page du *New York Times*. Trois ans plus tard, le *Chicago Tribune* imprime sur plusieurs pages une série de photos consacrée aux banlieues new-yorkaise. La photographie fait son « trou » dans la presse, mais elle a toujours un certain retard sur les événements quotidiens. Alors que le téléphone et le télégraphe permettent de transmettre des informations depuis les endroits les plus reculés de la terre, photographies et illustrations continuent d'atteindre toujours les rédactions par train ou par bateau. Du matériel d'archives sert donc d'illustration.[2]

La Première Guerre mondiale empêche la presse européenne d'aller de l'avant, mais ce handicap sera vite surmonté. Désormais, les photographies déterminent l'image d'ensemble des publications sous la République de Weimar; la presse ouvrière et celle de tendance libérale notamment, créent leur propre langue visuelle et se livrent à des expériences en matière de conception graphique. C'est alors qu'apparaît le terme de « photo-journalisme », qui met en exergue l'importance accor-

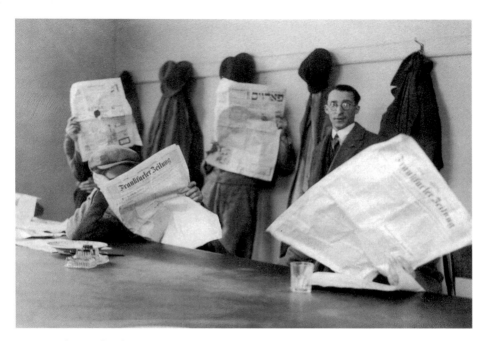

Paris, 6 April 1933: After the Nazis had taken power in Germany in January, the persecution of Jewish citizens began, as did the arrests of political opponents. The Jewish exiles are hiding their faces behind newspapers, since they feared for the lives of the relatives they had left behind.

Paris, 6. April 1933: Nach der Machtübernahme der Nationalsozialisten in Deutschland im Januar beginnt die Verfolgung jüdischer Bürger und die Inhaftierung politischer Gegner. Diese jüdischen Emigranten verstecken sich hinter Zeitungen vor dem Fotografen, weil sie um Leib und Leben ihrer in Deutschland verbliebenen Angehörigen fürchten müssen.

Paris, 6 avril 1933 : Après la prise du pouvoir par les nazis en Allemagne, au mois de janvier, commencent les persécutions des citoyens juifs et les arrestations d'opposants politiques. Les émigrants juifs cachent leur visage derrière des journaux parce qu'ils craignent pour la vie des membres de leur famille restés en Allemagne.

The next milestone was the pilot issue of the American illustrated magazine *Life* in 1936. Appearing weekly, it soon became the international flagship of photojournalism, with a circulation running into millions.[3] But the newspapers kept up with developments. By 1960, there were some 45,000 daily and weekly papers worldwide, with America and Europe (including the USSR) accounting for a third each.[4] Once the pictorial magazines had set new visual standards, the newspapers extended their own picture coverage. During the 20th century, the photograph became the proof that something had really happened. This applies equally to the classical daily newspaper section with entertaining news and pictures "From Around the World." Internationally active news agencies supplied short items with the "human touch." These so-called features became a daily reading experience from the 1920s on.

die neue Wertschätzung der Fotografie. Den nächsten Meilenstein setzt die Erstausgabe der amerikanischen Illustrierten *Life* im Jahr 1936. Das Wochenmagazin avanciert innerhalb kürzester Zeit zum internationalen Flaggschiff des Fotojournalismus mit Millionenauflage.[3] Die Zeitungspresse hält mit dieser Entwicklung durchaus Schritt. Bis 1960 werden weltweit 45 000 Tages- und Wochenzeitungen gezählt, jeweils ein Drittel erscheinen in Amerika und in Europa (einschließlich der UdSSR).[4] Nachdem die Illustrierten neue visuelle Zeichen gesetzt haben, weiten auch die Zeitungen ihre Bildberichterstattung aus. Das Foto wird im 20. Jahrhundert zum Beweis dafür, daß ein Ereignis wirklich stattgefunden hat.

Dies gilt auch für die derzeit schon klassische Tageszeitungsrubrik »Aus aller Welt« mit unterhaltsamen Bildern und Nachrichten. International operierende Nachrichtenagenturen liefern kurze Geschichten mit einem Hauch Menschlichkeit. Diese sogenannten Features werden ab den zwanziger Jahren zum tagtäglichen Leseereignis.

dée à la photographie. Le numéro zéro de l'illustré américain *Life*, en 1936, marque le franchissement d'une nouvelle étape dans l'histoire du photojournalisme. L'hebdomadaire devient presque instantanément le porte-drapeau international du photo-journalisme et tire à des millions d'exemplaires.[3] La presse quotidienne, elle aussi, s'adapte à cette évolution. En 1960, on compte dans le monde entier 45 000 quotidiens et hebdomadaires qui paraissent respectivement pour un tiers en Amérique, en Europe (URSS y inclue).[4] Les illustrés ayant imposé une façon de voir, les quotidiens publient eux aussi de plus en plus de photos. Au XXe siècle, la photo devient la preuve qu'un événement a réellement eu lieu.

Il en est de même de la rubrique quotidienne, alors déjà traditionnelle, qui privilégient les illustrations divertissantes et les informations « du monde entier ». Des agences de presse qui opèrent à l'échelle internationale livrent des historiettes « avec une touche d'humanité ». A partir des années 20, ces anecdotes appelées « features » sont lues en premier dans les quotidiens.

On Orchard Street in New York's Lower East Side, street traders sold female customers practically everything from pins to nylons. This picture, dating from 4 March 1946, shows the unconventional sales practices employed by Mr I. Knox, who is commending a girdle to Mrs J. Schaeger.

In der Orchard Street im New Yorker Stadtteil Lower East Side verkaufen die Straßenhändler ihren weiblichen Kunden von der Stecknadel bis hin zu Nylon-Strümpfen fast alles. Das Bild vom 4. März 1946 zeigt die unkonventionellen Verkaufspraktiken von Mr I. Knox, der seiner Kundin Mrs J. Schaeger einen Hüftgürtel anpreist.

Dans l'Orchard Street, du Lower East Side, un quartier de New York, les vendeurs ambulants proposent de tout à leur clientèle féminine, de l'épingle à cheveux aux bas en nylon. Cette photo du 4 mars 1946 donne une idée des pratiques commerciales peu conventionnelles de M. I. Knox, qui vante à sa clientèle Mme J. Schaeger les mérites d'un corset.

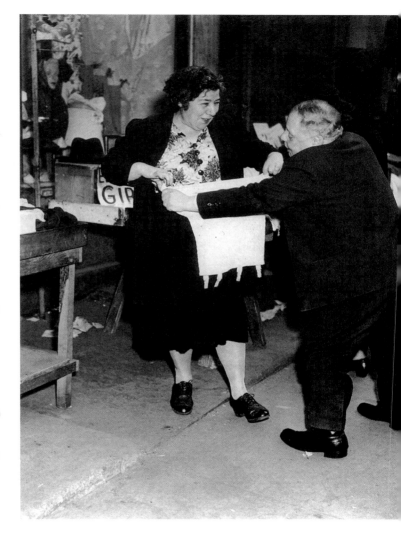

From around the world

Around the turn of the century, America saw the appearance of agencies which acted as intermediaries between the press, the photographers, and the journalists. The picture inflation of the 1920s and 1930s created an international network of agents and freelance photographers, whose works could be sent round the world in the bat of an eyelid thanks to the invention of picture telegraphy in 1926.

This global reporting was not restricted to current news events. Editors were also increasingly interested in foreign people and faraway places. The golden rule of this kind of photography was formulated by American editor A. J. Ezickson in 1950. "The magazine or newspaper may want a good single feature picture with universal appeal. Listed in that category are the animal, the baby, the pretty girl, the sparkling scenic... Don't get the mistaken idea that your immediate neighborhood is barren of material.

It's all around you, so long as people move and the fields and streams are stirring with life."[5] Agencies and photographers thus opened up a window on the world to the readers of local newspapers and regional magazines.

Aus aller Welt

Um 1900 entstehen in Amerika Agenturen, die als Mittler zwischen der Presse, Fotografen und schreibenden Reportern fungieren. Mit der Inflation der Bilder in den zwanziger und dreißiger Jahren spinnt sich ein internationales Netz von Agenten und freien Fotografen, die seit 1926 mittels der Bildtelegrafie in Windeseile aus allen Ecken der Welt berichten. Diese globale Berichterstattung beschränkt sich aber nicht nur auf die aktuellen Nachrichten. Redaktionen interessieren sich zunehmend auch für ferne Länder und fremde Menschen. Die goldene Regel dieser Art von Fotografie formuliert der amerikanische Redakteur A. J. Ezickson 1950: »The magazine or newspaper may want a good single feature picture with universal appeal. Listed in that category, are the animal, the baby, the pretty girl, the sparkling scenic... Don't get the mistaken idea that your immediate neighborhood is barren of material. It's all around you, so long as people move and the fields and streams are stirring with life.«[5] Agenten und Fotografen öffnen somit dem Leser lokaler Zeitungen und regionaler Illustrierten das Fenster zur Welt.

Nouvelles du monde entier

Les premières agences qui servent d'intermédiaires entre la presse, les photographes et les reporters apparaissent vers 1900 aux Etats-Unis. Avec l'inflation des illustrations dans les années 20 et 30 se tisse un réseau international d'agents et de photographes indépendants qui, à partir de 1926, transmettent des photos des quatre coins du monde grâce à la bélinographie.

Mais ces reportages à l'échelle planétaire ne se limitent pas exclusivement à ce qui est d'actualité ; les rédactions s'intéressent aussi de plus en plus aux pays lointains et aux peuples inconnus. Le rédacteur américain A. J. Ezickson dénonce, en 1950, la règle d'airain de ce genre de photographies : « Le magazine ou le journal désire une seule et unique photo, mais elle doit être bonne et avoir un intérêt universel. On peut classer dans cette catégorie les animaux, les bébés, les jolies filles, les anecdotes croustillantes... Ne commettez pas l'erreur de croire que votre voisinage immédiat est avare de motifs. Il y a des tas de choses qui se passent autour de vous, tant que les gens se déplacent et que les champs et les rivières regorgent de vie. »[5] A l'intention du lecteur de journaux locaux et d'illustrés régionaux, les agents et photographes ouvrent ainsi une fenêtre sur le monde.

A minor drama in New York in 1946. Joseph Dormant is returning from a mass measles immunization shot with his pants down, and to his chagrin, has to walk past the row of young ladies awaiting their turn in the "Children's Aid Society."

Ein kleines Alltagsdrama im Jahre 1946 in New York: Joseph Dormant kommt mit heruntergelassenen Hosen von der Masernimpfung und muß zu seinem Unglück die Reihe von kleinen Damen passieren, die in der »Children's Aid Society« noch auf ihre Spritze warten.

Un petit drame de la vie quotidienne en 1946 à New York. Joseph Dormant que l'on vient de vacciner contre la rougeole remontant son pantalon retourne à sa place. Pour son plus grand malheur, il doit passer devant le banc des fillettes qui, à la « Children's Aid Society », attendent leur tour.

Short history of a profession

The development of the profession of press photographer was described by Gisèle Freund in her book *Photography and Society*. She herself had begun a photographic career of her own while living in exile in Paris, did her first work for *Life* magazine in America in 1936, and in 1948 joined the photographer's co-operative Magnum. She writes: "Jacob A. Riis and Lewis W. Hine were still amateurs; for them, the photo was simply a means of giving their articles more conviction. But from the moment when photographs were regularly published in the press, their first press photographs appeared. Very soon, they got a very bad reputation. In order to take indoor pictures, they used magnesium powder. It created a dazzling light, and at the same time spread a cloud of pungent smoke and gave off a revolting stink. Cameras at that time were still extremely heavy. In consequence, the photographers needed more physical strength than talent. Dazzled by the sudden flash, the subject would often stand there open-mouthed, blinking, or else in an unflattering posture. The only important thing for the photographers was that their pictures should *come out*, which in those days meant they had to be sharp and thus capable of reproduction. The appearance was much less important for photographers and editors alike. High society and politi-

Kurze Historie eines Berufs

Die Entwicklung des Berufs des Pressefotografen beschreibt Gisèle Freund – die im Pariser Exil selbst eine Fotografenkarriere begann, 1936 erstmals für die amerikanische Illustrierte *Life* arbeitete und 1948 Mitglied der Fotografenkooperative Magnum wurde – in ihrem Buch *Photographie und Gesellschaft*: »Jacob A. Riis und Lewis W. Hine waren noch Amateure, für sie war das Photo nur ein Mittel, ihren Artikeln mehr Überzeugungskraft zu geben; doch von dem Augenblick an, wo Photographien regelmäßig in der Presse veröffentlicht werden, erscheinen die ersten Pressephotographen. Sie haben sehr bald einen äußerst schlechten Ruf. Um in Innenräumen Aufnahmen zu machen, benutzten sie Magnesiumpulver. Es erzeugt ein blendendes Licht, verbreitet gleichzeitig eine Wolke beißenden Rauchs und einen ekelhaften Gestank. Die Photoapparate waren zu jener Zeit noch äußerst schwer. Die Photographen mußten daher mehr physische Kraft als Talent besitzen. Geblendet vom plötzlichen Lichtschein standen die Photographierten häufig mit offenem Mund da, blinzelten mit den Augen oder nahmen eine ungünstige Haltung ein. Das einzig Wichtige war für die Photographen, daß ihr Bild *etwas wurde,* was damals bedeutete: Es mußte scharf sein und damit brauchbar für die Reproduktion. Das Aussehen

Histoire brève d'un métier

Gisèle Freund, qui a elle-même entamé sa carrière de photographe durant son exil parisien, a travaillé pour la première fois en 1936 pour l'illustré américain *Life* et a été admise, en 1948, comme membre de la fameuse coopérative de photographes Magnum. Dans son livre *Photographie et société,* elle décrit le développement du métier de photographe de presse : « ...Jacob A. Riis et Lewis W. Hine sont des amateurs qui utilisent la photo pour donner plus de crédibilité à leurs articles, mais à partir du moment où la photo est fréquemment utilisée dans la presse paraissent les premiers reporters photographes professionnels. Ils acquièrent bientôt une réputation déplorable. Pour faire des photos à l'intérieur, ils se servent de magnésium en poudre. Il produit une lumière aveuglante, répand en même temps un nuage de fumée acide et une odeur nauséabonde. Les appareils photographiques étaient encore extrêmement lourds à cette époque. Les photographes étaient choisis plutôt pour leur force physique que leur talent. Surpris par la lumière subite et aveuglante, les sujets avaient souvent la bouche ouverte ou clignaient de l'œil et apparaissaient dans des poses désavantageuses. Le but de ces photographes était avant tout de *réussir une photo,* ce qui voulait dire à l'époque que l'image devait être nette et

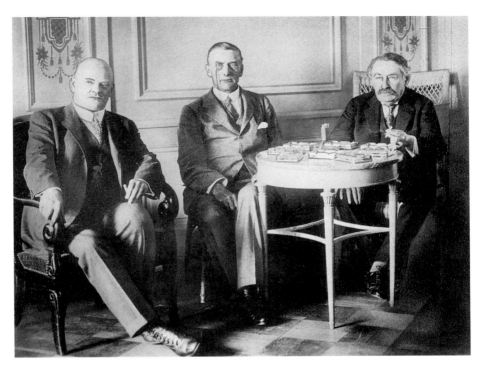

7 March 1932: on the occasion of the death of Aristide Briand (right), this 1925 news picture, whose formality is typical of its age, with the title "One of the most memorable moments in the life of the French Foreign Minister," recalls the Pact of Locarno. Briand together with his colleagues, Gustav Stresemann (left) and Sir Joseph Austen Chamberlain.

7. März 1932. Anläßlich des Todes von Aristide Briand (rechts im Bild) erinnert dieses zeittypische, da steife Nachrichtenbild aus dem Jahre 1925 mit dem Titel »Ein denkwürdiger Moment im Leben des französischen Außenministers« an den Pakt von Locarno. Briand im Kreis seiner Kollegen Gustav Stresemann (links) und Sir Joseph Austen Chamberlain.

7 mars 1932. A la mort d'Aristide Briand (à droite), cette photo de 1925, typique de l'époque par sa rigidité et intitulée « Un moment mémorable dans la vie du Ministre français des Affaires étrangères » rappelle le Pacte de Locarno. Briand entouré de son homologue allemand Gustav Stresemann (à gauche) et son homologue anglais Sir Joseph Austen Chamberlain.

cians, the first victims, held these press photographers in contempt and sought to keep them at a distance. The journalists charged with writing the article often found it hard to gain access. The name of the photographer was never mentioned. For almost half a century, the press photographer was regarded as a lackey, his status as comparable with that of a servant to whom one gave instructions, but from whom initiative was not expected. A totally new breed of photo-reporters was required to create respect for the profession."[6] Freund's less-than-objective tirade comes across as testimony to the deep divide which existed between press photographers and photo-journalists, who regarded themselves as authors. Equal status for photographers was what Freund and her colleagues, together with the Magnum agency, were fighting for. Daily newspaper and agency photographers, by contrast, had to be content at this period with having their photos distributed and published without attribution. When a press photo was printed, the photographer always remained anonymous – and unfortunately that goes for this book, too.

war für Photographen und Redakteure weit weniger wichtig. Die gute Gesellschaft und die Politiker, die ihre ersten Opfer waren, suchten sich diese Reporterphotographen bald vom Leibe zu halten und verachteten sie. Die Journalisten, die beauftragt waren, einen Artikel vorzubereiten, hatten es oft schwer, ihnen Zutritt zu verschaffen. Unter keinem dieser Photos stand der Name des Photographen. Fast ein halbes Jahrhundert lang wurde der Pressephotograph als ein Handlanger betrachtet, sein Status, dem eines Dieners vergleichbar, dem man Anweisungen erteilt, der jedoch über keinerlei Initiative verfügt. Es bedurfte einer völlig anders gearteten Rasse von Photoreportern, um diesem Beruf Achtung zu verschaffen.«[6] Freunds unsachliche Tirade erscheint als Zeugnis für den tiefen Graben, der zwischen den Pressefotografen und den Fotojournalisten, die sich als Autoren verstanden, bestand. Freund und ihre Kollegen, zusammen mit der Agentur Magnum, setzen sich vor allem für die Anerkennung aller Fotografen ein. Tageszeitungs- und Agenturfotografen hingegen müssen es sich zu dieser Zeit gefallen lassen, daß ihre Fotos ohne jeden Autorenhinweis vertrieben und veröffentlicht werden. Bei Abdruck seines Fotos bleibt der Pressefotograf immer anonym, leider auch in diesem Buch.

utilisable pour la reproduction. L'aspect de la personne portraiturée préoccupait beaucoup moins photographes et redacteurs. Les gens du monde et de la politique qui furent leurs premières victimes prenaient vite en grippe ces photographes et les méprisaient. Les journalistes, chargés de faire l'article, avaient des difficultés à les faire admettre. Aucune de ces photos n'était signée par leurs auteurs et le statut du photographe de presse fut considéré pendant presque un demi-siècle comme inférieur, comparable à celui d'un simple serviteur auquel on donne des ordres, mais qui n'a aucune initiative. Il fallait une tout autre race de reporters photographes pour donner à cette profession du prestige. »[6] Ce commentaire manquant d'objectivité de Gisèle Freund illustre bien le profond fossé qui séparait le photographe de presse du photographe-journaliste, lequel se concevait comme un auteur. C'est pour cela que Freund et ses collègues, notamment, se sont battus conjointement avec l'agence Magnum. A cette époque, les photographes qui travaillaient pour des quotidiens et des agences devaient, au contraire, accepter que leurs photos soient distribuées et publiées sans qu'on les mentionne. Lors de la reproduction de ces photos, le photographe de presse reste toujours anonyme – dans ce livre aussi, malheureusement.

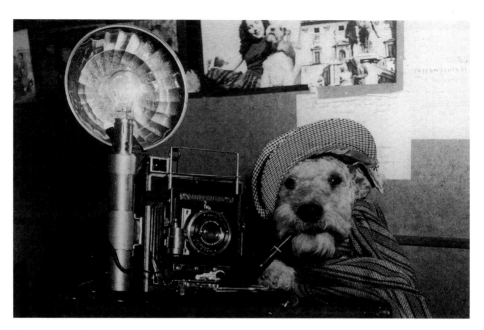

This photo was the occasion for the Italian sub-editor to make fun of his photographer colleagues in 1948: "This famous dog, nicknamed the 'Pride of Rome' for his many ventures and highly enterprising spirit, is embarking now on a new field of activity: press photography. Good luck, Lao Tze..."

Dieses Foto gibt dem italienischen Redakteur 1948 Anlaß, seine fotografierenden Kollegen zu bespötteln: »Dieser berühmte Hund, der aufgrund seiner zahlreichen Abenteuer und seines höchst unterhaltenden Wesens ›Der Stolz von Rom‹ gerufen wird, probiert sich nun auf einem neuen Aktivitätsfeld: der Pressefotografie. Viel Glück, Lao Tze...«

Cette photo est, pour le rédacteur italien, l'occasion, en 1948, de se moquer de ses collègues photographes : « Ce célèbre chien, que l'on surnomme la ‹ Fierté de Rome › en raison de ses nombreuses aventures et de son caractère extrêmement enjoué, fait maintenant ses débuts de photographe de presse. Bonne chance, Lao Tzé... »

The press photographer

Newspapers, magazines and agencies – they all depend on young talented photographers. In 1950, Joseph Costa summarized his teaching for the next generation in 11 points, which distilled his 30 years of active experience working as a New York press photographer.
"1. Know your story so all the facts are assembled in your mind.
2. Big images have impact – get in close and fill up the negative.
3. Know your camera so well that it almost works as an automatic part of you. This will leave your mind entirely free to concentrate on your subjects and your pictures, not the mechanics of shooting.
4. Heads and hands are dominantly important – don't overlook them.
5. In groups, get your people close together – it will result in larger faces and better features in the picture.
6. Get on the scene as early as possible – survey – think – find best locations – props – backgrounds. Eliminate clutter – simplify.
7. Get acquainted with your people fast – get them to like you and work *with* you, not *for* you. Ask for their suggestions, your subjects may know more about the story than you.
8. 'One more' makes good sense. In spite of all the ribbing cameramen take about the inevitable 'one more' – it is often that 'one more' exposure

Der Pressefotograf

Zeitungen, Magazine und Agenturen – alle sind sie auf junge talentierte Fotografen angewiesen. Joseph Costa faßt 1950 seine Lehren für den Nachwuchs aus 30 Jahren Arbeit als aktiver Pressefotograf in New York in 11 Punkten zusammen:
»1. Sorgen Sie dafür, daß Sie Ihre Story kennen, damit Sie alle Fakten im Kopf haben.
2. Große Bilder sind wirkungsvoll – gehen Sie dicht heran und füllen Sie das Negativ aus.
3. Lernen Sie Ihre Kamera so gut kennen, daß sie beinahe ein Teil von Ihnen wird. Das läßt Ihren Kopf frei, um sich auf Ihre Motive zu konzentrieren; Sie müssen nicht auf den mechanischen Vorgang des Fotografierens achten.
4. Köpfe und Hände haben überragende Bedeutung – übersehen Sie sie nicht.
5. Rücken Sie bei Gruppenbildern Ihre Personen eng zusammen; das bewirkt auf dem Bild größere Gesichter und klarere Gesichtszüge.
6. Treffen Sie so früh wie möglich auf der Szene ein – schauen Sie sich genau um – denken Sie nach – finden Sie die besten Standorte, Statisten, Hintergründe. Vermeiden Sie Durcheinander – vereinfachen Sie.
7. Lernen Sie Ihre Leute schnell kennen; sorgen Sie dafür, daß sie Sie mögen und *mit* Ihnen, nicht *für* Sie arbeiten. Bitten Sie um ihre Vorschläge. Ihre Modelle wissen möglicherweise mehr über die Story als Sie.

Le photographe de presse

Journaux, magazines et agences ont impérativement besoin de jeunes photographes de talent. En 1950, pour ceux qui prennent la relève, Joseph Costa fait, en 11 points, la synthèse de 30 ans de travail comme photographe de presse à New York :
« 1. Ayez tous les détails de l'histoire pour avoir les faits en tête.
2. Les grandes photos impressionnent – rapprochez-vous du motif et remplissez le négatif.
3. Vous devez parfaitement appendre votre appareil photo qu'il fasse presque partie de vous-même. Vous avez l'esprit libre pour vous concentrer sur vos motifs ; ne vous préoccupez pas de l'aspect mécanique du processus photographique.
4. La tête et les mains ont une signification exceptionnelle – ne les négligez pas.
5. Lorsque vous faites des photos de groupe, demandez aux gens de se rapprocher, les visages seront plus grands et les traits distincts sur la photo.
6. Arrivez tôt sur place – étudiez les environs – réfléchissez – repérez les meilleurs emplacements, les figurants, les arrière-plans. Evitez tout désordre – recherchez la simplicité.
7. Apprenez à connaître les autres rapidement, veillez à ce qu'ils vous trouvent sympathiques et travaillent *avec* vous, et non pas *pour* vous. Demandez de leur faire des propositions, vos modèles savent souvent beaucoup de choses sur l'histoire.

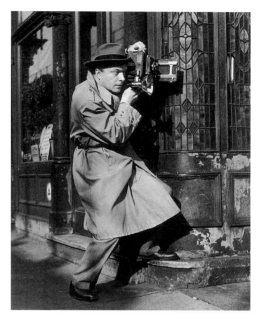

While the 35-mm camera has long been standard in photo-journalism, press photographers often worked with the Speed Graphic plate camera until well into the 1960s.

Während sich im Fotojournalismus die Kleinbildkamera längst durchgesetzt hat, arbeiten Pressefotografen bis in die sechziger Jahre hinein oftmals noch mit der Plattenkamera Speed Graphic.

Alors que les photographes-journalistes ont adopté depuis longtemps l'appareil photo de petit format, les photographes de presse travaillent encore souvent, jusque dans les années 60, avec la Speed Graphic.

which captures the best expression to better tell the story.
9. Consider your lighting. How can it be used to aid the picture.
10. Never make a picture with one flash bulb, if you have time to use two or more.
11. If you must use only one bulb – try to get it off the camera to achieve the greatest amount of modelling."[7]

8. ›Noch ein Bild‹ ist durchaus sinnvoll – trotz all der Neckereien unter Fotografen über das unvermeidliche ›Noch eins‹. Oft genug fängt gerade diese Aufnahme den besten Ausdruck ein und erzählt die Story noch besser.
9. Denken Sie an Ihr Licht. Wie kann es zur Unterstützung des Bildes eingesetzt werden.
10. Machen Sie nie ein Foto mit nur einem Blitzlicht, wenn Sie Zeit für zwei oder mehr haben.
11. Falls Sie mit einem Blitz auskommen müssen, versuchen Sie, ihn von der Kamera zu nehmen, um die bestmögliche Ausführung zu erzielen.«[7]

8. ‹ Encore une photo › a parfaitement un sens – malgré toutes les ironies entre photographes au sujet cet ‹ Encore une ›. Très souvent, c'est justement cette photo-là qui restitue la meilleure expression et raconte encore mieux l'histoire.
9. Pensez à votre éclairage. Comment peut-il être utilisé pour donner plus d'effet à la photo.
10. Ne faites jamais une photo avec un seul flash si vous avez le temps d'en utiliser deux ou davantage.
11. Si vous devez vous contenter d'un flash, essayez de l'éloigner de l'appareil photo pour obtenir le meilleur résultat possible. »[7]

Europe 1946

After the end of the Second World War, the war correspondents had to make their way back to civilian life. American agency photographer Walter Green reported in telegraphic style from Italy in 1946: "Rough and tough competition... mad scrambles to get your pictures to the papers first... restricted facilities for cameramen... club-swinging policemen who don't respect photographers' press card... demands from editors for exclusive pictures at fancy prices..."[8] In Germany, the Allies tried to put the press back on a democratic foundation once more. Werner Ebeler was working as a local photo-reporter in the devastated Ruhr area: "The problems started right from the beginning. What camera to use?... The black market – there was no alternative in 1945. At first, it was purely commission work, there was far too little space in the newspapers for photographs. So I set off, on foot, or by tram, and took my pictures. I had to make do with two or three shots for each subject."[9] The topics were dictated by the circumstances: "Immediately after the war, the themes were clearing rubble, finding food, the black market, with a little sport to liven things up, and that soon expanded. Later there were the first fashion shows in Essen's Saalbau. Mining was always a topic, too..."[10]

Europa 1946

Nach Ende des Zweiten Weltkriegs nehmen die Kriegsberichterstatter wieder ihre zivilen Berufe auf. Der amerikanische Agenturfotograf Walter Green berichtet 1946 im Telegrammstil aus Italien: »Rough and tough competition... mad scrambles to get your pictures to the papers first... club-swinging policemen who don't respect photographers' press card... demands from editors for exclusive pictures at fancy prices...«[8] In Deutschland versuchen die Alliierten, die Presse wieder in demokratische Bahnen zu lenken. Werner Ebeler arbeitet als lokaler Fotoreporter im zerstörten Ruhrgebiet: »Und da ging das Problem schon los: Mit welcher Kamera arbeiten... Schwarzer Markt – eine andere Möglichkeit gab es gar nicht 1945! Zu Anfang war es reine Auftragsfotografie, es gab ja viel zu wenig Platz für Fotos in der Zeitung. Da ging ich dann los, zu Fuß, oder fuhr mit der Straßenbahn und machte meine Aufnahmen, zwei, drei Schüsse für ein Motiv, das mußte reichen.«[9] Die Umstände diktieren ihm die Themen: »Direkt nach dem Krieg ging es ums Trümmerräumen, ums Essen, um den Schwarzmarkt, ein bißchen Sport als belebendes Element, das wurde sehr schnell mehr. Später gab es die ersten Modenschauen im Saalbau. Bergbau war auch immer ein Thema...«.[10]

Europe 1946

Après la Seconde Guerre mondiale, les correspondants de guerre exercent de nouveau leur métier dans le civil. Le photographe Walter Green écrit d'Italie, en 1946, en style télégraphique : « C'est une concurrence à couteaux tirés... On se bat pour placer ses photos dans les journaux... Conditions de travail déplorables pour les cameramen... Agents de police faisant tournoyer leurs matraques et qui ne respectent pas la carte de presse des photographes... Des éditeurs demandent des photos exclusives qu'ils vous payent une bouchée de pain... »[8] En Allemagne, les alliés s'efforcent de réapprendre à la presse la démocratie. Werner Ebeler travaille comme reporter-photographe local dans la Ruhr en ruines : « Et la question qui se posait était : avec quel appareil travailler... Marché noir – il n'y avait pas d'autre possibilité en 1945 ! On ne faisait que de la photographie sur commande, il y avait peu de place pour les photos dans le journal. Alors je partais, à pied, ou en tramway et je prenais mes photos, deux, trois prises de vue par motif, cela devait suffire. »[9] Les circonstances lui dictent des motifs : « Après la guerre, le travail de déblaiement, les problèmes de nourriture, le marché noir, le sport pour faire diversion, étaient les motifs favoris. Plus tard, il y eut les défilés de mode à la salle des fêtes. Les mines de charbon ont, aussi, été photographiées... ».[10]

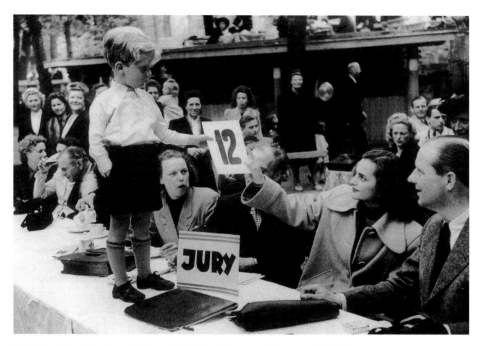

"A children's fashion show at the zoo!" This took place on 16 May 1949 in Berlin. Four days after the lifting of the Berlin Blockade everyday life returned to normal. The threat of the Soviet Union extending its occupation to the Western sectors of the city was past. Hundreds of children presented themselves to the jury, who were required to select Berlin's prettiest child.

»Kindermodenschau am Zoo!«, 16. Mai 1949 in Berlin. Vier Tage nach dem Ende der Berliner Blockade kehrt der Alltag wieder ein. Die Drohung der sowjetischen Besatzungsmacht, auch den Westteil der ehemaligen Reichshauptstadt unter ihre Kontrolle zu nehmen, besteht nicht mehr. Hunderte von Kindern stellen sich der Jury, die das hübscheste Berliner Kind prämiert.

« Défilé de mode enfantine au zoo », le 16 mai 1949 à Berlin. Quatre jours après la fin du blocus de Berlin, le quotidien reprend ses droits. La menace d'annexion et de contrôle par les occupants soviétiques de la partie occidentale de l'ancienne capitale du Reich s'est effacée. Des centaines d'enfants se présentent au jury chargé d'élire le plus joli petit Berlinois.

We'll meet again

Every local or regional newspaper contains a fair measure of local patriotism and self-praise. The lead roles are played by local dignitaries and placers of advertisements. Apart from this, the reporters and photographers decide who or what is important or interesting in the city or region. Many ordinary readers have a secret desire to have themselves photographed, and to appear in the papers with their names writ large. If only it were not for people's fear, as formulated by Susan Sontag in her essay *Heroism of Seeing:* "…and not because they – like members of primitive tribes – fear that violence will be perpetrated upon them, but because they fear that they could displease the camera. People want an idealized picture, a photo that shows them from their 'best side'."[11] Local reporting mostly pursues no other goal; it creates a stage for its fellow citizens and potential readers. Small victories are celebrated, and, no less emphatically, sympathy is expressed for failures and defeats. The photographer keeps up the "heroism of seeing" quoted above, because an ugly picture is a poor visiting-card for him. After all, in this social microcosm, he and his subject will meet again soon enough.

Stadtgespräche

Eine gehörige Portion Lokalpatriotismus und Selbstbeweihräucherung findet sich in jeder Stadtzeitung oder Regionalpresse. Die Hauptrollen spielen die Honoratioren und die Anzeigenkunden. Ansonsten entscheiden die Reporter und Fotografen darüber, wer oder was in der Stadt oder Region wichtig und interessant ist. Viele der gemeinen Leser hegen insgeheim den Wunsch, selbst einmal vor die Kamera zu treten und mit voller Namensnennung in der Zeitung zu stehen. Wäre da nicht die Angst der Leute, die Susan Sontag in dem Essay *Heroismus des Sehens* formuliert: »…und zwar nicht weil sie – wie Angehörige primitiver Stämme – fürchten, daß ihnen Gewalt angetan wird, sondern weil sie fürchten, sie könnten der Kamera mißfallen. Die Menschen wollen das idealisierte Bild: ein Foto, das sie von ihrer ›besten Seite‹ zeigt.«[11] Die lokale Berichterstattung verfolgt meist kein anderes Ziel, sie schafft eine Bühne für ihre Mitbürger und potentiellen Leser. Kleine Siege werden genauso emphatisch gefeiert, wie Mißerfolge und Niederlagen mit Anteilnahme begleitet werden. Der Fotograf pflegt den oben zitierten »Heroismus des Sehens«, denn ein häßliches Bild ist eine schlechte Visitenkarte für ihn – trifft man sich bekanntlich doch nicht nur einmal in diesem sozialen Mikrokosmos.

Petits potins

Les journaux locaux et la presse régionale profitent de l'esprit de clocher et de l'auto-encensement. Ce sont les notables et les clients acheteurs d'espaces publicitaires qui jouent le rôle le plus important. Pour le reste, ce sont les reporters et photographes qui décident qui ou quoi a de l'importance et présente de l'intérêt dans la région. Parmi le commun des lecteurs, beaucoup souhaitent en secret poser une fois devant les objectifs et voir leur photo dans le journal avec leur nom en toutes lettres. S'il n'y avait la crainte ressentie par les gens et que Susan Sontag décrit ainsi, dans son essai *L'héroïsme de la vue :* « …et contrairement aux membres d'ethnies primitives – ils redoutent non pas qu'on leur fasse violence, mais qu'il déplaise à l'appareil photo. Les hommes veulent d'eux une photo idéalisée : une photo qui les présente ‹ sous leur meilleur profil ›. »[11] Le plus souvent, les reportages locaux n'ont pas d'autre objectif. Ils s'emploient à créer une scène pour leurs concitoyens et lecteurs potentiels. De petites victoires sont célébrées avec autant d'emphase que les échecs, et les défaites suscitent toujours la compassion. Le photographe cultive l'« héroïsme de la vue », cité ci-dessus, car une photo laide est une mauvaise carte de visite pour lui. Il est notoire que, dans ce microcosme social, on ne se rencontre pas qu'une seule fois.

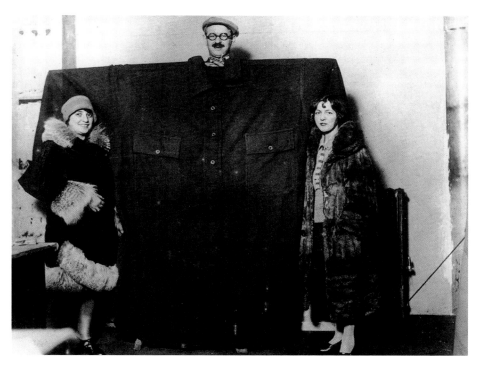

"It's yours if you can fill it." With this slogan, tailor Edward Cohen invited his Bostonian clientele to an unusual fitting in the 1920s. There was no reticence in the description of Cohen's special creations: "the largest ever made". He is flanked in this photo by Margaret Dugay and Helen Cohen.

»It's yours if you can fill it.« Unter diesem Motto lädt der Bostoner Schneider Edward Cohen seine Kunden in den zwanziger Jahren zu einer ungewöhnlichen Anprobe ein. In der Beschreibung von Cohens Sonderanfertigung wird nicht mit Superlativen gespart: »the largest ever made«. Für das Foto stehen ihm Margaret Dugay und Helen Cohen zur Seite.

« It's yours if you can fill it. » La devise du tailleur Edward Cohen, de Boston, qui invite ses clients à un essayage assez peu courant, dans les années 20. La création unique de Cohen est décrite avec le superlatif qu'elle mérite : « the largest ever made ». Pour la photo, Margaret Dugay et Helen Cohen se tiennent à ses côtés.

Urban myths

There is hardly a newspaper prepared to forgo "sex and crime" and "disasters." Statistics show that these stories are the most widely read.[12] But it is into these columns that cryptic tales tend to creep. Thus in a short notice in a German newspaper in 1927, a family tragedy in the Balkans was reported. "Belgrade, 1 December. In the village of Krushevica in Herzegovina a 5-year-old boy, who had been watching his father slaughtering sheep, stabbed his 6-month-old sister to death. The father was so horrified that he killed the boy with a blow and then committed suicide. When the mother saw what had happened, she plunged into the water and drowned."[13] The international variations of this tale follow the basic pattern of "accumulated disaster."[14] Modern legends and urban myths do not always end so tragically. But they encapsulate general fears, fantasies and breaches of taboo. Sometimes they seek to warn us, sometimes they discriminate against other people or tribes. But they always confirm the readers' place in their small world, damning all that is foreign wherever they can. When these stories are not just retold, but printed too, they really do come across as authentic and true.

Großstadt-mythen

Kaum eine Zeitung verzichtet auf die Rubriken »Sex and Crime« und »Katastrophen«, denn laut Statistik werden diese am meisten gelesen.[12] In jene Spalten schleichen sich mitunter Wandersagen. So wird in einer Kurznotiz in einer deutschen Zeitung 1927 von einer Familientragödie aus dem Ausland berichtet: »Belgrad, 1. Dezember. Im Dorf Kruschevica in der Herzegowina hat ein fünfjähriger Knabe, der seinem Vater beim Schlachten eines Schafes zugesehen hatte, sein sechs Monate altes Schwesterchen durch Messerstiche getötet. In der furchtbaren Erregung hierüber versetzte der Vater ihm einen tödlichen Schlag und verübte dann Selbstmord. Als die Mutter das Unglück sah, stürzte sie sich ins Wasser und ertrank.«[13] Die internationalen Varianten dieser Wandersage folgen dem Grundmuster des »akkumulierten Unglücks«.[14] Moderne Sagen und Großstadtmythen enden nicht immer so tragisch. Sie formulieren aber allgemeine Ängste, Phantasien sowie Tabuverletzungen. Manchmal wollen sie uns warnen, bisweilen diskriminieren sie andere Menschen oder Volksstämme. Doch immer bestätigen sie den Leser in seiner kleinen Welt und verdammen, wenn möglich, alles Fremde. Werden diese Geschichten nicht nur weitererzählt, sondern gedruckt, erscheinen sie erst recht authentisch und wahr.

Les mythes de la grande ville

Pratiquement aucun journal ne renonce aux rubriques « sex and crime » et « catastrophes », car, selon les statistiques, ce sont les plus lues.[12] Des légendes s'insinuent parfois dans ces colonnes. Ainsi, un bref article d'un journal allemand rapporte, en 1927, une tragédie familiale : « Belgrade, 1er décembre. Dans le village de Kruschevica, en Herzégovine, un bambin de cinq ans qui avait regardé son père saigner un mouton tua à coups de couteau sa petite sœur âgée de six mois. Dans un accès de fureur, le père lui porta un coup mortel et se suicida ensuite. Lorsque la mère vit ce carnage, elle se jeta à l'eau et se noya. »[13] Les variantes internationales de ce genre d'anecdotes suivent d'ailleurs toujours le schéma du « malheur accumulé ».[14] Les légendes modernes et les mythes de la grande ville ne se terminent pas toujours de façon aussi tragique. Mais ils véhiculent des craintes générales, des fantasmes ainsi que des violations de tabous. Ils veulent parfois nous mettre en garde, mais discriminent parfois d'autres gens ou peuples. Toujours, ils confirment le lecteur dans la bonne opinion qu'il a de son petit monde bien confortable. Si possible, ils fustigent tout ce qui est étranger. Quand l'on ne se contente pas de colporter de telles histoires, mais qu'on prend la peine de les imprimer aussi, elles paraissent alors d'autant plus authentiques et vraies.

Erdenheim, Philadelphia, 1927. "Walter McCorks, 13-year-old schoolboy, who impersonated a flapper and wrote love-letters to several men in the district was committed yesterday to the house of detention upon complaint of township authorities. Dressed as a modern girl, McCorks, police declared, has paraded suburban highways almost nightly for more than a month."

Erdenheim (Philadelphia), 1927. »Der 13jährige Schüler Walter McCorks, der sich als leichtlebige junge Frau ausgegeben und mehreren Männern im Bezirk Liebesbriefe geschrieben hatte, wurde gestern infolge einer Klage der städtischen Behörden festgenommen. Nach Polizeiangaben war McCorks bereits seit mehr als einem Monat fast jede Nacht in moderner Frauenkleidung durch die Straßen der Stadt stolziert.«

Erdenheim (Philadelphie), 1927. « Walter McCorks, un écolier de 13 ans qui avait coutume de se déguiser en jeune fille et d'écrire des lettres d'amour à plusieurs hommes du district a, hier, été incarcéré à la maison d'arrêt à la suite d'une plainte déposée par les autorités municipales. Dans des vêtements de jeune fille moderne, a déclaré la police, McCorks a, pendant plus d'un mois, déambulé, le plus souvent la nuit, le long des autoroutes suburbaines. »

Say cheese!

Bitte lächeln!

Souriez !

The list of media critics in the 20th century is long. But there has hardly been a better analysis of the almost pathological compulsion to smile into the press camera than that performed by Joseph Roth in a 1938 essay. "To all appearances, the cheerfulness of the world has not diminished, and it looks as if it would not know how to disparage all the things that happen to it every hour... Look at the still photographs in the illustrated newspapers and magazines, and the moving pictures in the cinema newsreels. Far and wide, for example, there is no European statesman to be seen who is not smiling happily in the face of diplomatic defeat; ... no seriously injured racing-driver, who on the tightrope between surgery and death is not contentedly smiling. These are not phenomena, but symptoms."[15] Roth is criticizing the ideological function of the mass media. Looked at objectively, in the sense of a geopolitical overview, there was in 1938 absolutely nothing to smile about. Subjectively, there may have been something to justify the radiant faces on the local pages of the newspapers. "A party, a ball, a beauty contest, a dog show, a race,...: their cheerfulness should not surprise anyone."[16] But what worried Roth, the Jewish author in Parisian exile, was the cheerful and relaxed mood in which the working class, to judge by press photographs, went on strike.

Die Liste der Medienkritiker im 20. Jahrhundert ist lang. Doch kaum einer hat den fast schon pathologischen Zwang der Fotografierten, in die Pressekameras zu lächeln, besser ins Visier genommen als Joseph Roth 1938 in einem Essay: »Dem Anschein nach ist die Heiterkeit dieser Welt nicht geringer geworden, und es sieht gerade so aus, als wüßte sie nicht abzuschätzen, was ihr alles jede Stunde zustößt... Man betrachte die stehenden photographischen Aufnahmen in den illustrierten Zeitungen und Zeitschriften und die beweglichen in den Wochenschauen. Weit und breit, zum Beispiel, ist kein europäischer Staatsmann zu erblicken, der nicht beglückt lächelte nach einer beispiellosen diplomatischen Niederlage;... kein schwerverletzter Rennfahrer, der auf dem Grat zwischen Chirurgie und dem Tod nicht noch gleichsam befriedigt lächelte. Es sind keine Phänomene, sondern Symptome.«[15] Roth kritisiert die ideologische Funktion der Massenmedien. Objektiv betrachtet, im Sinne einer weltpolitischen Gesamtschau, gibt es 1938 überhaupt nichts zu lachen. Subjektiv mag es Anlässe geben, die die strahlenden Gesichter auf den Lokalseiten der Zeitungen rechtfertigen: »Ein Fest, ein Ball, ein Schönheitswettbewerb, eine Hundeausstellung, ein Wettlauf,...: deren Heiterkeit dürfte eigentlich niemand wundernehmen.«[16] Angst macht dem jüdi-

Au XXᵉ siècle, la liste des détracteurs des médias est longue. Mais rares sont ceux qui ont mieux décrit que Joseph Roth, en 1938 dans un essai, l'obsession presque pathologique d'être photographié le sourire aux lèvres : « Il semblerait que ce monde est toujours aussi gai et qu'on ne se rend pas compte de ce qui arrive toutes les heures... Il suffit d'observer les photographies statiques dans les journaux, les illustrés et les images animées des actualités cinématographiques. Aucun homme d'État européen, par exemple, n'hésite à sourire béatement aux photographes après une défaite diplomatique sans précédent ; ... aucun pilote de course grièvement blessé qui, entre la vie et la mort, ne trouve encore le moyen de sourire d'un air satisfait. Ce ne sont pas des phénomènes, mais des symptômes. »[15] Roth critique la fonction idéologique des médias de masse. Objectivement, si l'on analyse la politique mondiale dans son ensemble, il n'y a vraiment pas de quoi en rire en 1938. Subjectivement, il peut y avoir des éléments qui justifient des visages rayonnants dans les pages locales des journaux : « Une fête, un bal, un concours de beauté, une exposition de chiens, une compétition, ... : la gaieté ne devrait à proprement parler surprendre personne. »[16] Mais ce qui effraie l'écrivain juif exilé à Paris, c'est la bonne humeur et la gaieté avec laquelle des ouvriers en grève

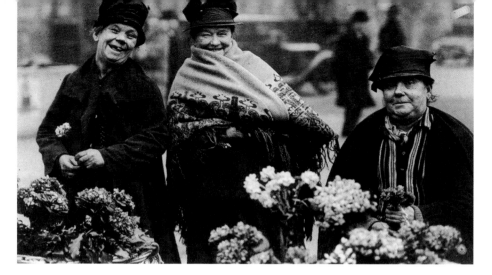

The local pages of the London newspapers were concerned with the distress of the "Piccadilly Flower Girls" in January 1931.

Die Lokalseiten der Londoner Gazetten beschäftigen sich im Januar 1931 mit den Existenznöten der »Piccadilly Flower Girls«.

Les difficultés existentielles des « Piccadilly Flower Girls » sont relatées en janvier 1931 dans les pages consacrées aux événements locaux.

"...to all appearances, in a world far removed from the seriousness of their situation and that which gave rise to the strike and also that which the strike was probably capable of causing."[17]

schen Schriftsteller im Pariser Exil jedoch, wie munter und ausgelassen die Arbeiterklasse vor den Objektiven der Pressefotografen in den Streik zieht: »... allem Anschein nach durch eine Welt entfernt von ihrem eigenen Ernst und von jenem, den Streik zur Ursache hat und auch von jenem, den er [der Streik] zu bereiten wahrscheinlich imstande wäre.«[17]

défilent devant les objectifs des photographes de presse : « ... apparemment séparés par des années-lumière de leur sérieux, de celui qui est à l'origine de la grève et de celui, qu'elle [la grève] serait probablement en mesure de générer. »[17]

Curious!
Curious?

The accusation of false ideological appearances hurled at the mass media – and indisputably the press is a mass medium – would seem to cast the *Curious Moments* in a somewhat dingy light. Is nothing in this book true? Are the pictures trying to distract attention from what is really important? Or does the author want to spoil our enjoyment of the many amusing pictures?

Not at all. These *Curious Moments* cut through the classical strands of contemporary history and tie them up in a new fashion. Historian Heidrun Friese describes it thus: these press photographs "destroy accustomed chronology, single out certain themes and significances, and like metaphors, their motifs and fragments form different, ever-changing and sometimes monstrous constellations. A picture... moves within other pictures and points to other pictures, everyday places, actions and experiences, the entanglements of everyday life and its dreams."[18] The historical tragedies of the period from 1920 until the 1960s are never entirely absent from the *Curious Moments*. They are however only indirectly palpable. Let us read these stories of press photography in their *Curious Moments* as social stories which are played out on a stage with its own laws. These include the cheerfulness so accurately described

Kurios!
Kurios?

Der Vorwurf des falschen ideologischen Scheins an die Massenmedien – und dazu gehört die Presse zweifelsohne – ließe *Kuriose Momente* in einem etwas fahlen Licht erscheinen. Ist denn in diesem Buch gar nichts wahr? Wollen diese Bilder von dem ablenken, was wirklich wichtig ist? Oder will uns der Autor vielleicht den Spaß an den vielen putzigen Bildern verderben?

Ganz und gar nicht. *Kuriose Momente* zerschneidet die klassischen Erzählstränge der Zeitgeschichte und verknüpft sie neu. Die Historikerin Heidrun Friese beschreibt das so: Diese Pressefotografien »sprengen die gewohnte Chronologie, sie kreisen bestimmte Themen und Bedeutungen ein, und wie Metaphern bilden ihre Motive und Fragmente unterschiedliche, stets wandelbare und manchmal ungeheuerliche Konstellationen. Ein Bild... bewegt sich in anderen Bildern und verweist auf andere Bilder, auf die alltäglichen Orte, Handlungen und Erfahrungen, die Verwicklungen des gewohnten Lebens und seiner Träume.«[18] Die weltgeschichtlichen Tragödien der Zeit von 1920 bis in die sechziger Jahre bleiben in *Kuriose Momente* nie ganz außen vor. Sie sind aber nur mittelbar spürbar. Lesen wir also die vorliegenden Geschichten der Pressefotografie in *Kuriose Momente* als gesellschaftliche Erzählungen, die auf

Bizarre!
Bizarre?

Reprocher aux médias de masse – dont la presse fait partie à n'en pas douter – affadirait les *Moments bizarres*. N'y a-t-il donc rien de véridique dans cet ouvrage ? Ces images veulent-elles nous détourner de ce qui est réellement important ? Ou l'auteur veut-il peut-être nous gâcher le plaisir que nous procurent ces nombreuses images amusantes ?

Pas le moins du monde. Ces *Moments bizarres* sectionnent les chapitres classiques de l'histoire contemporaine et les assemblent à nouveau, ce que l'historienne Heidrun Friese décrit en ces termes : « Ces photographies de presse bouleversent la chronologie habituelle, elles cernent des thèmes et des significations déterminés et, telles des métaphores, leurs motifs et fragments constituent des constellations différentes parfois incroyables, et toujours susceptibles de se modifier. Une image... se déplace en d'autres images et renvoie à d'autres images, à des endroits, des actions et des expériences du quotidien, aux événements de la vie de tous les jours et de ses rêves.»[18] Dans *Moments bizarres*, les tragédies de l'histoire du monde de 1920 aux années 60 ne sont pas passées sous silence. Mais on ne les ressent qu'indirectement. Lisez donc les histoires que relatent ces *Moments bizarres* et considérez-les comme des anecdotes sociales qui se dérou-

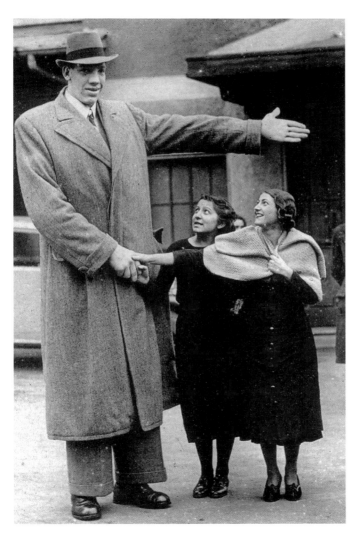

Ambivalent reactions were triggered by the juxtaposition of the world's tallest man with these two ladies in Milan on 18 January 1937. Vaimo Myllrynne from Finland, 8 foot 5 inches (2.51 meters) tall, was making the best of his unusual physique by touring Europe as an attraction for photographers and public alike.

Zwiespältige Reaktionen löst das Zusammentreffen mit dem größten Mann der Welt bei den beiden Damen in Mailand am 18. Januar 1937 aus. Der 2,51 m große Finne Vaimo Myllrynne macht das Beste aus seinem physischen Handicap und tourt in den dreißiger Jahren als Attraktion für Fotografen und Publikum quer durch Europa.

La rencontre de l'homme le plus grand du monde et de ces dames, à Milan, le 18 janvier 1937, provoque des réactions mitigées. Le Finlandais Vaimo Myllrynne, qui mesure 2,51 mètres, tire profit de sa grande taille et, dans les années 30, il pose dans toute l'Europe pour les photographes où se produit en public.

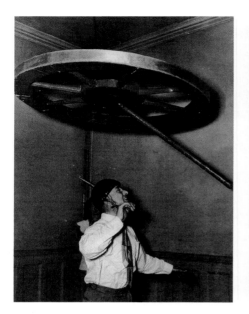 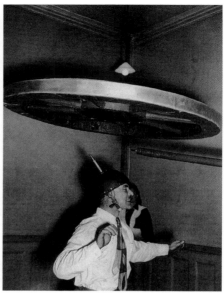

by Roth. They also include Western morality, within whose framework all world events are ordered and judged. Thus the comedy – with its tragic moments, as mentioned at the outset – can develop.
So, curtain up!

einer Bühne mit ganz eigenen Gesetzen spielen. Dazu gehört die von Roth so treffend beschriebene Heiterkeit. Dazu gehört ebenfalls die westliche Moral, unter der das gesamte Weltgeschehen geordnet und beurteilt wird. Dann kann sich die eingangs erwähnte Komödie mit tragischen Augenblicken entfalten.
Also, Vorhang auf!

lent sur une scène ayant ses propres lois. La gaieté décrite avec tant de pertinence par Roth en fait également partie, de même que la morale occidentale selon laquelle tout ce qui se passe dans le monde est ordonné et jugé. Place à la comédie mentionnée un peu plus haut avec ses instants tragiques.
Levons le rideau !

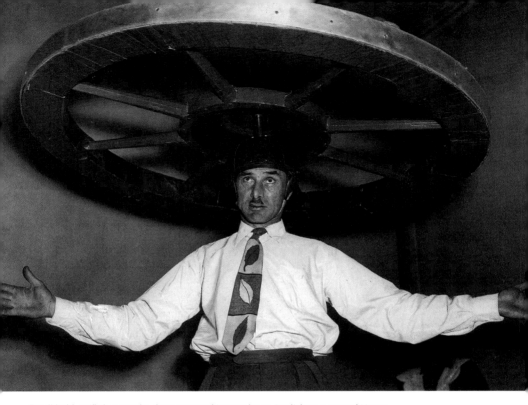

"Well held, sir!" These tricks, demonstrated in 1952 by an Englishman named Henry, required both great strength and enormous stamina. Here he is pictured catching a falling cartwheel on his helmet. The wheel then turned on his head. He was able to repeat this feat three times in succession.

»Gut gefangen, Sir!« Ganze Manneskraft und ein außerordentliches Stehvermögen erfordert dieses Kunststück, das der Engländer Henry 1952 zeigt. Mit seinem Helm fängt er ein herunterstürzendes Wagenrad, das sich dann auf seinem Kopf dreht. Er ist imstande, diesen Kraftakt bis zu dreimal in Folge zu wiederholen.

« Bien joué, Sir ! » Il faut une force et une résistance exceptionnelles pour faire ce que l'on voit sur cette photo datant de 1952. Casqué, l'Anglais Henry rattrape avec la tête une roue de charrette qu'il fait ensuite tourner. Il est capable de réitérer cette épreuve de force trois fois de suite.

Lookers-on

Zaungäste

Témoins de l'histoire

Is looking on a press event in itself, or does it point to something more? The looker-on looks on from afar, without an official invitation and without paying an entrance fee. He or she experiences the notable events of history in passing so-to-speak, without the chance of exercising any direct influence on them. But lookers-on and official spectators alike provide the resonance without which the voices of heroes and the noise of world political events of the 20th century would be mere whispers on an empty stage.

Ist das Zuschauen an sich bereits ein Presseereignis oder weist es über sich hinaus? Der Zaungast sieht aus der Ferne zu – ohne offizielle Einladung und ohne Eintritt zu zahlen. Große Ereignisse der Geschichte erlebt er gewissermaßen im Vorbeigehen und ohne direkt auf sie einwirken zu können. Aber der Zaungast und die übrigen Zuschauer bilden die Kulisse, die der Weltpolitik und den Heroen des 20. Jahrhunderts erst den Glanz und die notwendige Öffentlichkeit verleihen.

L'observation est-elle déjà un événement en soi pour la presse ou bien sa portée est-elle plus grande ? L'observateur se faufile entre les hôtes, regarde de loin, sans avoir été invité officiellement ou sans avoir payé sa place. Il est en quelque sorte le témoin indifférent des grands événements de l'histoire sur lesquels il n'a pas d'influence. Mais lui et les autres spectateurs sont les figurants dont la seule présence, assure le retentissement de la politique mondiale et donne aux héros du XXᵉ siècle la notoriété nécessaire.

During the dress rehearsal for *Roberta* on Thursday 4 February 1943, the Swedish photographer posed these wardrobe assistants for a picture for the next day's edition. The front-page headlines in New York, London, and in Stockholm, too, were, by contrast, dominated by the surrender of the German army at Stalingrad the previous Sunday, 31 January.

Während der Generalprobe für *Roberta* am Donnerstag, den 4. Februar 1943, stellt der schwedische Fotograf mit den Garderobieren in der Stockholmer Oper dieses Bild für die Freitagsausgabe. Die Schlagzeilen der Presse in London, New York und Stockholm werden hingegen von der Kapitulation der deutschen Armee in Stalingrad am Sonntag, den 31. Januar, bestimmt.

Durant la générale de *Roberta*, le jeudi 4 février 1943, le photographe suédois prend cet instantané des costumières, à l'opéra de Stockholm, pour le numéro du vendredi. Mais, à Londres, New York et Stockholm, c'est la capitulation de l'Armée allemande à Stalingrad, le dimanche 31 janvier, qui fait la une des journaux.

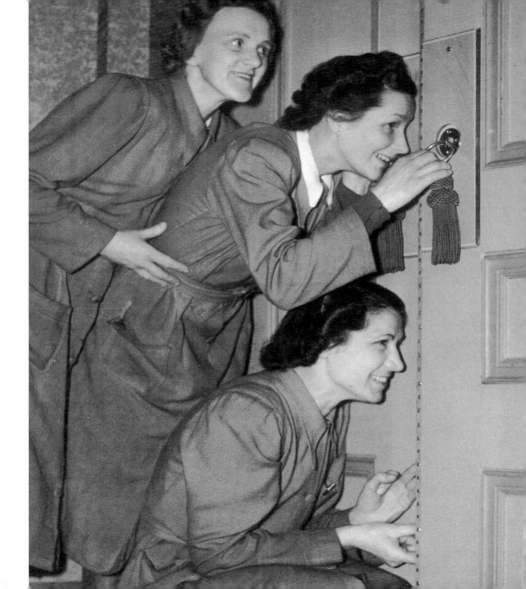

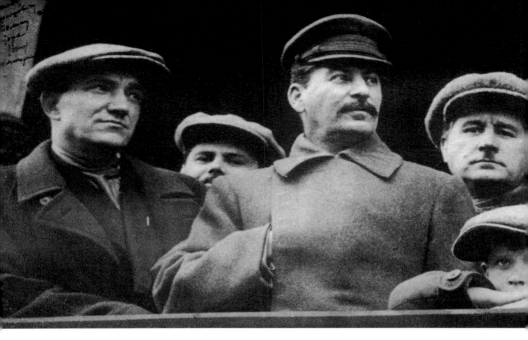

One small looker-on managed to smuggle himself on to the platform with Joseph Stalin (center l.) and his right-hand man Mikhail Kalinin (center r.) at this event in 1930. The following years saw Stalin extend his reign of terror ever further; even Kalinin's wife was not safe from imprisonment.

Ein kleiner Zaungast schleicht sich 1930 auf das Podium einer Veranstaltung mit Josef Stalin (Mitte l.) und seinem Vertrauten Michail Kalinin (Mitte r.). In den folgenden Jahren baut Stalin seine auf Terror gegründete Herrschaft kontinuierlich aus, und selbst Kalinins Frau bleibt von einer Haftstrafe nicht verschont.

Un petit curieux entre Joseph Staline, à sa droite, et Mikhaïl Kalinine, l'allié du dictateur, à sa gauche, réunis lors d'un défilé en 1930. Les années suivantes, la dicta-ture stalinienne fondée sur la terreur devient de plus en plus inéxorable et pas même l'épouse de Kalinine n'échappera à la prison.

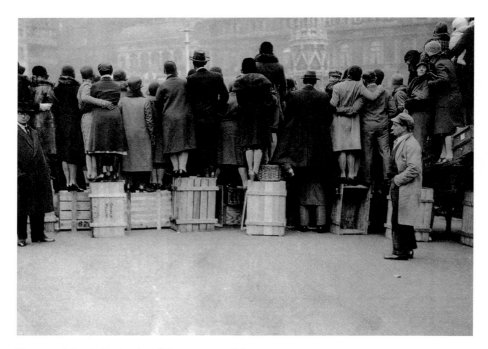

These spectators in the London of the 1920s use all the means at their disposal to catch a glimpse of the Lord Mayor's Show as it passes close by Charing Cross on 10 November. The boxes for this improvised grandstand were loaned by a helpful greengrocer – for ready cash.

Diese Zuschauer im London der zwanziger Jahre lassen nichts unversucht, um der Parade anläßlich des Lord Mayor's Day am 10. November in der Nähe von Charing Cross beizuwohnen. Die Kisten für die improvisierte Tribüne hat ein Gemüsehändler gegen bare Münze verliehen.

Ces spectateurs dans le Londres des années 20 ne reculent devant rien pour assister à la parade du Lord Mayor's Day, le 10 novembre, à proximité de Charing Cross. Un marchand de légumes a loué contre espèces sonnantes et trébuchantes les cageots qui leur servent de tribune improvisée.

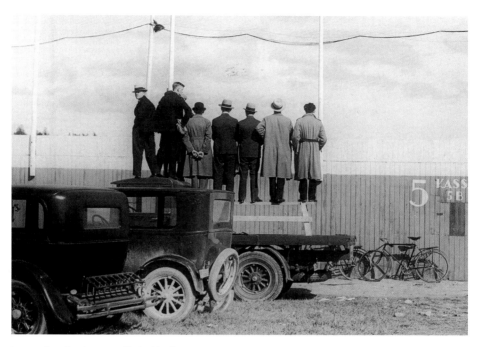

In 1932, Sweden too was affected by the Great Depression, but these boxing fans make the most of their opportunities, mounting a truck in order to follow the events in the ring – free of charge.

Die Weltwirtschaftskrise macht 1932 auch vor Schweden nicht halt. Diese Boxfans behelfen sich, indem sie einen Lastkraftwagen erklimmen, um gratis dem Geschehen im Ring zu folgen.

En 1932, la Suède n'est pas épargnée non plus par la crise économique mondiale. Ces amateurs de boxe se débrouillent comme ils peuvent et grimpent sur un camion pour suivre gratuitement le match.

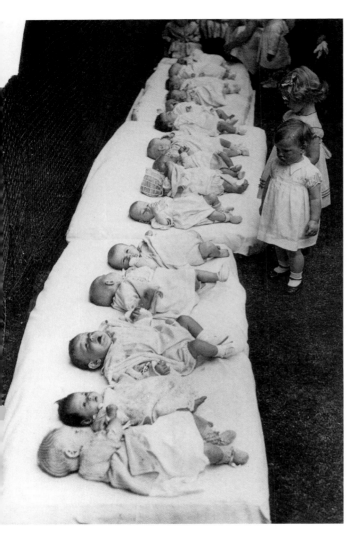

While the summer of 1938 sees British parents growing more and more worried by the day about Hitler's expansionist policy and the Sudetenland crisis, these two children cast a critical eye over some babies parked in the sunshine. The mothers were busy taking tea at a garden party being held at the Queen Mary Maternity Home in London.

Während sich die Sorgenfalten britischer Eltern im Sommer 1938 angesichts der Expansionspolitik Hitlers und der Sudetenkrise von Tag zu Tag vertiefen, beäugen diese beiden Kinder kritisch die im Sonnnenschein geparkten Babys. Die Mütter trinken derweil Tee auf einer Gartenparty des Queen-Mary-Entbindungsheims in London.

L'été 1938, alors que la politique expansionniste de Hitler et la crise des Sudètes préoccupent de plus en plus les Britanniques, ces deux fillettes posent un regard critique sur les bébés allongés au soleil, leurs mères prenant le thé à une garden-party de la maternité londonienne portant le nom de la reine Mary.

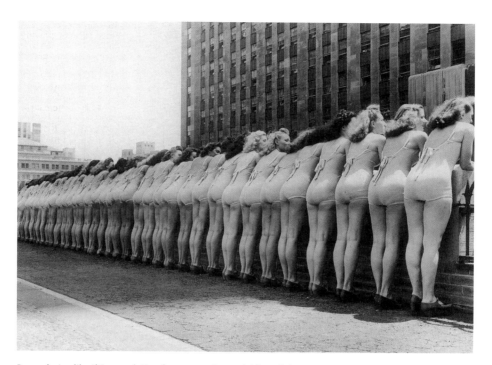

Press photos like this one, dating from 1942, give no inkling of the radical change in life in America since the Japanese attack on the U.S. Pacific fleet in Pearl Harbor on 7 December 1941. Since that day, American troops had been actively involved in the Second World War.

Pressefotos wie dieses aus dem Jahre 1942 lassen kaum erahnen, daß sich der amerikanische Alltag nach dem Angriff der Japaner auf die US-Flotte im pazifischen Pearl Harbor am 7. Dezember 1941 radikal veränderte. Amerikanische Truppen greifen seit jenem Tag aktiv in den Zweiten Weltkrieg ein.

A la vue de ce genre de photos de presse de 1942, qui pourrait croire que la vie quotidienne des Américains a changé radicalement après l'attaque par les Japonais de Pearl Harbor, la base navale des Etats-Unis dans le Pacifique, le 7 décembre 1941 ? Ce jour-là, les troupes américaines sont entrées dans la Seconde Guerre mondiale.

Youngsters improvise seating arrangements for a children's play in Berlin just a few weeks after the surrender of Germany on 8 May 1945. The German capital lay in ruins, and since 1 July had been carved up into four sectors by the victorious allies.

Wenige Wochen nach der Kapitulation am 8. Mai 1945 sitzen Berliner Jugendliche auf der improvisierten Tribüne eines Kinder-theaters. Die deutsche Hauptstadt liegt in Trümmern und ist seit dem 1. Juli in die vier Sektoren der alliierten Siegermächte aufgeteilt.

De jeunes Berlinois sur la « tribune » improvisée d'un théâtre pour enfants, quelques semaines après la capitulation de l'Allemagne, le 8 mai 1945. La capitale en ruine est divisée, depuis le 1ᵉʳ juillet, en quatre secteurs d'occupation administrés par les Alliés.

Whatever they are looking at, all these Berlin children had to think back on in 1947 was the hardship of the war years and the immediate postwar period. But from 5 June there was a glimmer of hope in the western zones of Germany: the United States had approved the Europe-wide Marshall Plan.

Zweifellos blicken diese Berliner Kinder 1947 auf harte und entbehrungsreiche Kriegs- und Nachkriegsjahre zurück. Doch ab dem 5. Juni ist in den Westzonen Deutschlands Hilfe in Sicht, denn die USA beschließen den europa-weit geltenden Marshall-Plan.

En 1947, ces enfants de Berlin, sans doute marqués par la guerre, souffrent encore des privations de l'après-guerre. Mais, à partir du 5 juillet, l'horizon s'éclaircit dans les zones occidentales de l'Allemagne. Les Etats-Unis vont, en effet, appliquer le plan Marshall à toute l'Europe.

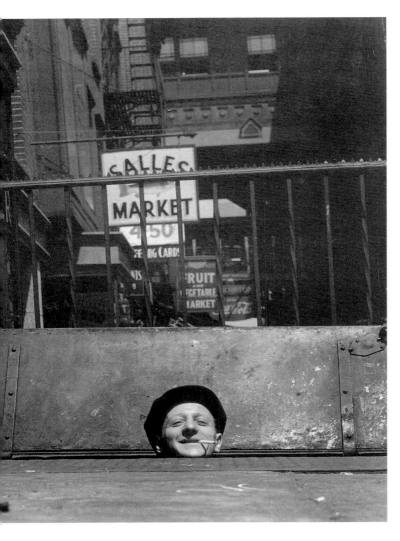

Strollers in Manhattan rarely notice these typical basement doors. The photographer here is directing our attention to the entrance to the "underworld" of New York business life in the 1940s.

Spaziergänger in Manhattan nehmen diese typischen Kellertüren kaum mehr wahr. Der Fotograf lenkt hier die Aufmerksamkeit auf den Eingang zur »Unterwelt« des New Yorker Geschäftslebens der vierziger Jahre.

Les piétons de Manhattan ne remarquent presque plus ces portes de cave pourtant typiques. Le photographe attire ici l'attention sur les bas-fonds du monde des affaires dans le New York des années 40.

New York school-
children in the 1940s,
on the platform of
the torch held aloft
by the Statue of
Liberty. The figure has
welcomed ships
entering New York
harbor since 1886, but
the French had sent
the torch across the
Atlantic for a short
exhibition, ten years
before the statue had
been completed.

New Yorker Schul-
kinder besteigen in
den vierziger Jahren
die Fackel der Frei-
heitsstatue, die seit
1886 die in New York
einlaufenden Schiffe
begrüßt. Bereits
10 Jahre vor der
Fertigstellung der
Statue schickten die
Franzosen die Fackel
für eine kurze
Ausstellung über
den Atlantik.

Dans les années 40,
des écoliers améri-
cains se trouvent sur
la plate-forme de la
torche tenue par la
statue de la Liberté,
qui depuis 1886, salue
les bateaux à leur
entrée dans le port
de New York. Les
Français avaient déjà
envoyé la torche
outre-Atlantique
pour une brève
exposition, dix ans
avant l'achèvement
de la statue.

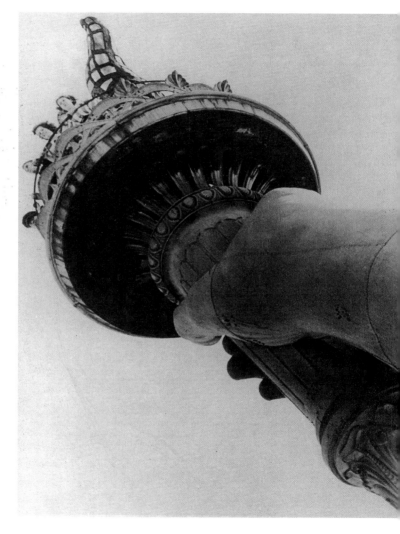

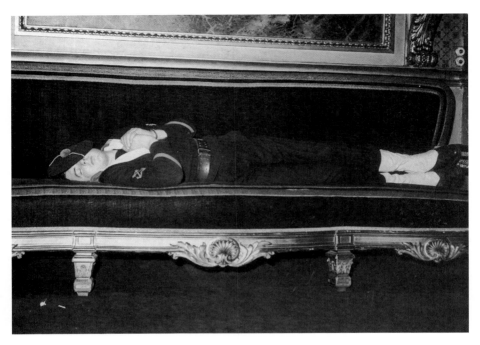

In April and June 1946, the U.S. Secretary of State, the British
Foreign Secretary and the Russian and French Foreign Ministers
conferred in Paris on the "German question" and future policy
toward Germany's war allies. The stagnation in the negotiations
had obviously rubbed off on the guards.

Im April und Juni 1946 konferieren die Außenminister der USA, der
Sowjetunion, Großbritanniens und Frankreichs in Paris, um über die
»Deutsche Frage« und die zukünftige Politik gegenüber den deut-
schen Kriegsverbündeten zu entscheiden. Der Stillstand der Ver-
handlungen überträgt sich scheinbar auch auf das Wachpersonal.

En avril et juin 1946, les ministres des Affaires étrangères des Etats-
Unis, de l'Union soviétique, de la Grande-Bretagne et de la France
étudient, à Paris, la question allemande et la politique à mener à
l'avenir vis-à-vis des pays de l'Axe. Les négociations qui s'enlisent
semblent avoir un effet soporifique sur les sentinelles.

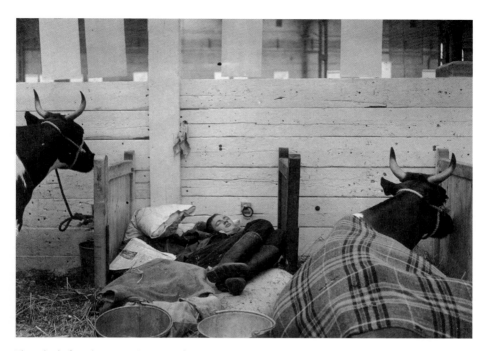

The calm before the storm. On 24 October
1949, everything was ready at Olympia in
Paris for the biggest ever show to be held by
the dairy industry. France was once more
demonstrating her agricultural strength.

Ruhe vor dem Sturm. Am 24. Oktober 1949 ist
das Pariser Olympia für die bis dahin größte
Ausstellung der Milchwirtschaft bestens
gerüstet. Frankreich demonstriert wieder
landwirtschaftliche Stärke.

Le calme avant la tempête. L'Olympia de Paris
est prêt, le 24 octobre 1949, à accueillir la plus
grande exposition de l'industrie laitière de
l'histoire. La France montre de nouveau ce
qui fait la force de son agriculture.

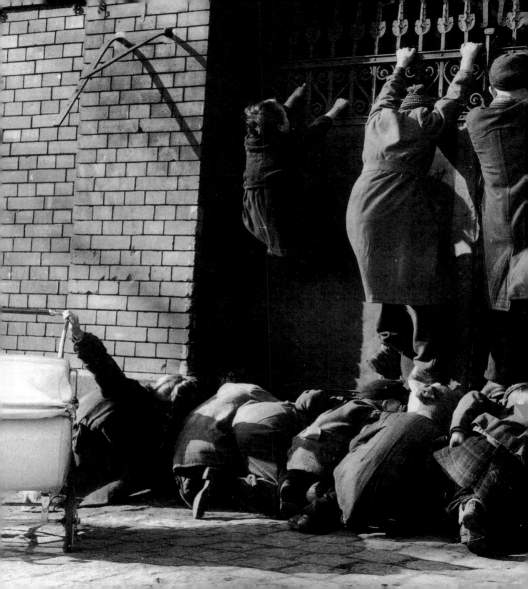

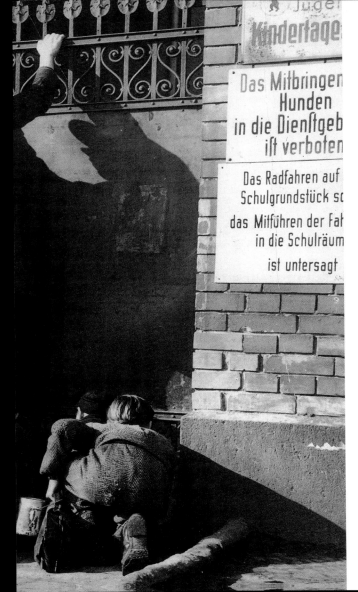

On 21 February 1951 these Berlin schoolboys were watching the aftermath of a fatal accident that had taken place in the yard of a children's day-nursery. The emergency services were trying to rescue six-year-old Dieter Bretall, who had fallen into an abandoned well 14 meters deep (over 45 feet).

Das Nachspiel eines Unfalls beobachten diese Berliner Schuljungen am 21. Februar 1951. Auf dem Hof einer Kindertagesstätte versuchen Rettungsmannschaften vergeblich, Dieter Bretall lebend zu bergen. Der Sechsjährige war in einen verschüttet geglaubten, 14 m tiefen Brunnen unter dem Schulhof gestürzt.

Le 21 février 1951, ces gamins berlinois épient les équipes de secours qui, dans la cour d'une école, tentent en vain de dégager Dieter Bretall, un petit garçon de six ans, tombé dans un puits de 14 mètres de profondeur, que l'on croyait comblé.

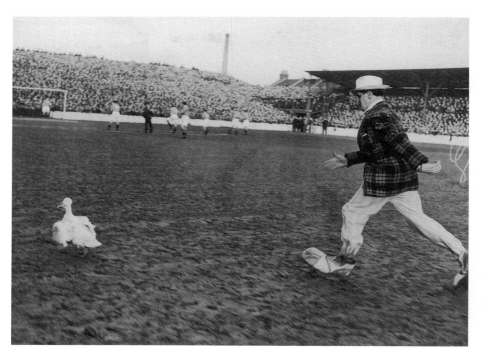

Two interlopers causing a pre-match stir at a cup-tie
between West Ham United and Blackpool on 12 January 1952.
Sid Bevers, a Blackpool supporter, is chasing his team's mascot
across West Ham's Upton Park pitch.

Diese beiden Zaungäste des Pokalspiels der heimischen
Mannschaft West Ham United gegen Blackpool am 12. Januar
1952 geben vor dem Spiel eine Sondereinlage im gegnerischen
Stadion. Sid Bevers, ein Blackpool-Anhänger, jagt das Vereins-
maskottchen über das Spielfeld des Upton-Park-Stadions.

Une diversion inattendue avant le coup d'envoi du match
de coupe de Blackpool contre West Ham United, qui joue à
domicile, le 12 janvier 1952. Sid Bevers, un fan de Blackpool,
court après la mascotte de son club sur la pelouse du stade
d'Upton Park.

The star of the
British Empire
and of the Royal
Navy faded
after the end of
the Second
World War. This
is the aircraft
carrier *Ark Royal*
returning to her
home port of
Plymouth on
1 March 1961.

Der Stern der
britischen Flotte
und des Empires
sinkt nach dem
Zweiten Welt-
krieg. Der briti-
sche Flugzeug-
träger *Ark Royal*
kehrt am 1. März
1961 in seinen
Heimathafen
Plymouth
zurück.

Après la
Seconde Guerre
mondiale,
l'étoile de la
flotte britan-
nique et de
l'Empire com-
mence à pâlir.
Le porte-avions
britannique
Ark Royal
regagne son
port d'attache,
Plymouth,
le 1ᵉʳ mars 1961.

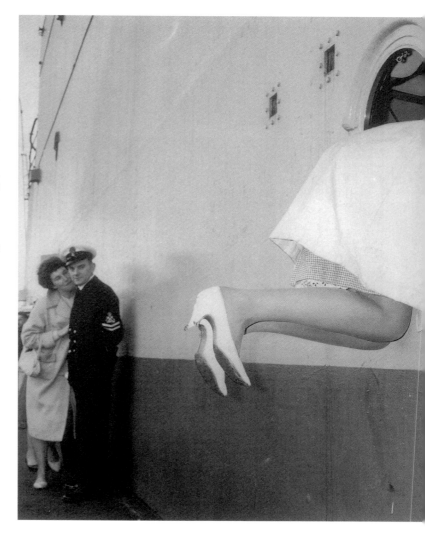

This snapshot taken in a Dutch zoo was distributed throughout Europe by a news agency in 1951. The headlines of the international press by contrast were concentrating on the establishment of the European Coal and Steel Community as the first major step toward European integration. The Treaty setting it up was signed by Belgium, France, Italy, Luxembourg, the Netherlands and West Germany on 18 April.

Dieser Schnappschuß aus einem holländischen Zoo wird 1951 von den Nachrichtenagenturen europaweit verbreitet. Die Schlagzeilen der internationalen Presse werden hingegen von der Gründung der Montanunion als erstem wichtigen Schritt zur europäischen Einigung beherrscht. Am 18. April des Jahres unterzeichnen Belgien, die Bundesrepublik Deutschland, Frankreich, Italien, Luxemburg und die Niederlande das Abkommen.

Les agences de presse de l'Europe entière diffusent cet instantané réalisé dans un zoo hollandais en 1951. Mais c'est la CECA, la première étape importante vers l'unification européenne, qui fait la une de la presse internationale. Le 18 avril, la Belgique, la République fédérale d'Allemagne, la France, l'Italie, le Luxembourg et les Pays-Bas signent le traité.

At the 1964 Brussels Inventors' Fair, Pierre Stoss from Switzerland presented these lightweight metal stilts "for spectators who do not wish to have others blocking their view at major events, street processions and other attractions."

Auf der Erfindermesse 1964 in Brüssel präsentiert der Schweizer Pierre Stoss diese Stelzen aus Leichtmetall »... für diejenigen Zuschauer, die bei großen Veranstaltungen, Festzügen und anderen Sehenswürdigkeiten niemand vor ihrem Blickfeld haben wollen«.

A la Foire des Inventeurs de 1964, à Bruxelles, le Suisse Pierre Stoss présente ces échasses en alliage léger « ... à l'intention des spectateurs qui ne veulent avoir la vue masquée par quiconque lors de grandes manifestations, de défilés et autres ».

He-men

A seemingly close-knit brotherhood: the photographer and the object of his designs, the he-man, and not least the sub-editor. They create scenarios far-removed from the international stage. On the title pages, the heroes of the age are anointed; on the local news pages, the parish-pump heroes ape the poses of the celebrities. They too seek to transcend the mass society of the 20th century. The camera gives them the chance of fame, if only for one click of the shutter or one event. The emancipation of women in the course of the century seems only to stimulate the male of the species even further in their desire to crystallize the idealization of their own sex in ever more pictures. And to set off their own virtues, they seek out deviant behavior or physical anomalies by way of contrast: alongside the transvestite and the midget, the plaster-of-Paris humdrum hero looks more like a Greek god in marble. Press photography provides these he-men – large or small, cultured or coarse, strong or skinny – with a vast playground for their fantasies and desires. The photos go their own, often labyrinthine, ways, and stumble into ever new interconnected significances.

Ganze Kerle

Eine scheinbar verschworene Gemeinschaft: der Fotograf und das Objekt seiner Begierde – der ganze Kerl – sowie der Redakteur. Sie schaffen die Szenarien fernab der Weltgeschichte. Auf den Titelseiten werden die Helden der Epoche gekürt, im Lokalteil eifern die Kleinen den Großen der Zeit in ihren Posen nach. Auch sie wollen aus der anonymen Gesellschaft des 20. Jahrhunderts hervortreten. Die Kamera gibt ihnen die Chance, für einen Tag berühmt zu werden, und sei es nur für einen Klick, für ein Ereignis. Die Emanzipation der Frau seit der Jahrhundertwende scheint die Männer zusätzlich zu reizen, die Idealisierung ihres Geschlechts in immer neuen Bildern festzuhalten. Um sich selbst zu erhöhen, suchen sie nach abweichendem Verhalten oder körperlichen Abnormitäten: Der Transvestit und der Zwerg lassen den gewöhnlichen Helden des Alltags noch größer erscheinen. Die Pressefotografie bietet diesen ganzen Kerlen – ob groß oder klein, wohlerzogen oder grobschlächtig, kräftig oder schmächtig – eine großartige Bühne für ihre Phantasien und Wünsche. Die Fotos gehen ihre eigenen, oftmals verschlungenen Wege und treten in immer neue Sinnzusammenhänge.

Le sexe dit fort

Tels des conjurés, le photographe et l'objet de ses désirs, l'homme que l'on dit fort, mais aussi et surtout le rédacteur semblent faire cause commune. Ils écrivent les scénarios en marge de l'histoire du monde. Sur les pages de couverture, on couronne les héros de l'époque ; dans les pages consacrées aux informations locales, Monsieur tout le monde singe les grands de l'époque et les imite jusque dans leurs poses. Lui aussi veut se démarquer de la société de masse du xxe siècle. Face à l'objectif, il a la chance, ne serait-ce que pour un instant, de devenir célèbre. L'émancipation de la femme depuis le début du siècle semble inciter d'autant plus fortement l'homme à idéaliser le sexe fort par le biais de clichés toujours plus inattendus. Pour se transcender lui-même, il recherche ce qui fait contraste, les comportements différents ou les malformations physiques : le travesti et le nain font paraître encore plus grands les protagonistes habituels de la vie quotidienne. La photographie de presse est pour des hommes dits forts, grands ou petits, bien éduqués ou frustes, forts ou fluets, comme un miroir où se reflètent leurs fantasmes et leurs désirs. Les photos ont leurs propres lois, souvent difficiles à discerner, et s'inscrivent dans des contextes émotionnels toujours renouvelés.

Social life was transformed by the Prohibition era in America in the 1920s. If the so-called stronger sex was not sitting in the back-rooms of murky dives drinking illegally distilled liquor and gambling, it took to the sober if unchaste pursuit of playing strip-poker in public.

Die Prohibition verändert in den zwanziger Jahren das gesellschaftliche Leben in den USA. Wenn das starke Geschlecht nicht in den Hinterzimmern dunkler Kaschemmen schwarz gebrannten Schnaps trinkt und Glücksspiele betreibt, gibt es sich öffentlich nüchtern und unkeusch beim Strip-Poker.

Dans les années 20, la prohibition modifie profondément la vie sociale aux Etats-Unis. Quand le sexe dit fort ne boit pas de l'alcool distillé clandestinement dans les arrière-salles de bouges ou ne s'adonne pas à des jeux de hasard, il reste sobre, mais perd toute inhibition quand il joue au strip-poker.

The French doctor and amateur aviator Jean Bouchon poses proudly in his consulting room with his "ground-breaking" invention. His mobile operating theater allowed surgeons to perform operations on airplanes without an assistant.

Der französische Arzt und Hobbyflieger Jean Bouchon posiert in seiner Praxis stolz vor seiner Erfindung, einer »Weltneuheit«. Seine mobile Operationsausrüstung ermöglicht es, an Bord eines Flugzeugs ohne Assistent zu operieren.

Le médecin français et pilote amateur Jean Bouchon pose fièrement, dans son cabinet, devant son invention, une « nouveauté mondiale ». Sa table d'opération mobile lui permet de pratiquer une intervention chirurgicale à bord d'un avion, même sans assistant.

The late 1920s was the period, Berlin's Thalia Theater was the place, Saturday night was the time: the "world's best" wrestlers would arrive to measure their strength against a Russian named Padubny, here seen training in the Palace of Sport.

Im Berliner Thalia-Theater finden sich an einem Sonnabend Ende der zwanziger Jahre die »welt-besten« Ringkämpfer ein, um sich der Herausforderung des Russen Padubny zu stellen. Der Fotograf erwischt ihn bei seinem Vorbereitungstraining im Sportpalast.

Au Théâtre Thalia de Berlin, les « meilleurs lutteurs du monde » veulent se rencontrer, un samedi de la fin des années 20, pour relever le défi du Russe Padubny. Le photographe a surpris celui-ci lors de son échauffement au Palais des Sports.

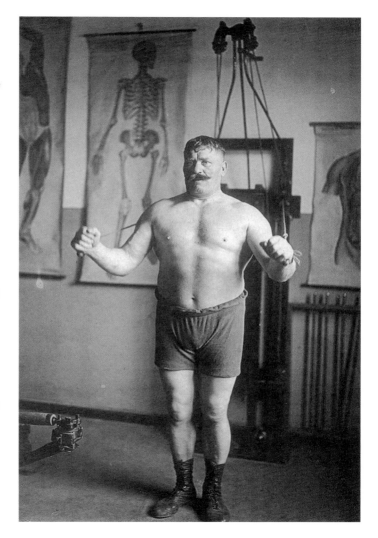

The press never goes in for understatement when it comes to the strength of the male sex. "The strongest young man in the world" was the description applied to 19-year-old Pole Adolph Holzmann, who in the 1920s amazed audiences at Berlin's Scala Theater by bending iron rods round his neck.

Die Pressetexte der Bilder sparen nie mit Superlativen, wenn es die Kraft des männlichen Geschlechts anzukündigen gilt. »Der stärkste junge Mann der Welt«, der 19 Jahre alte Adolph Holzmann aus Polen, tritt in den zwanziger Jahren im Berliner Scala-Theater auf und biegt Eisenstangen an seinem Nacken.

Les commentaires des photos de presse rivalisent de superlatifs quand il s'agit de vanter la force du sexe masculin. « Le jeune homme le plus fort du monde », le Polonais Adolph Holzmann, âgé de 19 ans, se produit, dans les années 20, au Théâtre Scala, à Berlin, où il tord des barres de fer contre sa nuque.

The German naturist film *Wege zu Kraft und Schönheit* (Paths to Strength and Beauty), premiered in 1925, bears witness to the popularity of the cult of the body in the Weimar Republic. Egyptian weightlifter Nusseir has been placed by the photographer in a classical Herculean pose.

Der deutsche Freikörperkulturfilm *Wege zu Kraft und Schönheit*, 1925 uraufgeführt, belegt die Popularität des Körperkults in der Weimarer Republik. Den ägyptischen Gewichtheber Nusseir lichtet der Berliner Fotograf in einer antiken Herkules-Pose ab.

Projeté pour la première fois en 1925, le film allemand *Wege zu Kraft und Schönheit* (Vers la force et la beauté) prouve la popularité du naturisme durant la République de Weimar. Le photographe berlinois fait poser l'haltérophile égyptien Nusseir à la manière de Hercule de l'Antiquité.

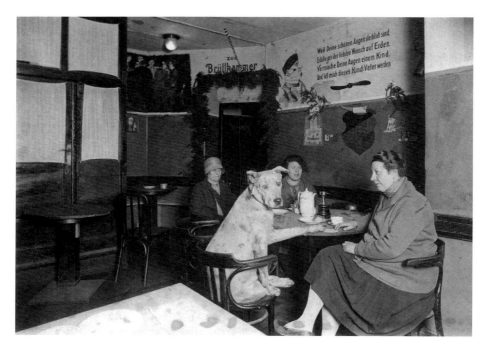

A coffee party, complete with "Strapping Dog", in the historic Berlin student tavern of that name. It is doubtful whether gatherings in the 100-year-old establishment were always so demure, as it was the haunt of student dueling fraternities. The doorway to the room where their meetings took place, the "Shouting Room", can be seen in the background.

Dieses Kaffeekränzchen tagt samt »strammem Hund« in Berlin an historischer Stätte. Es ist zu bezweifeln, daß es im 100 Jahre alten Studentenlokal »Zum Strammen Hund« immer so gesittet zugeht, wenn sich die schlagenden Corpsstudenten einfinden. Im Hintergrund der Eingang zur »Brüllkammer«.

Des femmes papotent au café du « Chien qui ne bronche pas » comme le leur. Ce café historique et centenaire de Berlin a sans doute connu des instants moins calmes lorsque les associations rivales d'étudiants s'y réunissaient. A l'arrière-plan, l'entrée de la « salle des cris ».

The hardened members of the Ken Wood Ladies' Swimming Club braving the gales and bitter cold for their 1929 Christmas swimming race. The photographer has caught the starter, Dr Potter, enjoying an "unrehearsed incident" just before the ladies take the plunge.

Die abgehärteten Damen des Ken-Wood-Damenschwimmclubs trotzen der stürmischen und bitterkalten Witterung beim Weihnachtswettschwimmen 1929. Der Fotograf fängt den Starter Dr. Potter und die Schwimmerinnen kurz vor dem Start bei einem »unvorhergesehenen Zwischenfall« ein.

Lors du concours de natation de Noël 1929, les membres du Club de natation féminine Ken Wood bravent, téméraires, les intempéries et le froid. Peu avant le départ, le photographe surprend le starter, le Dr Potter, avec quelques nageuses – un « incident inattendu ».

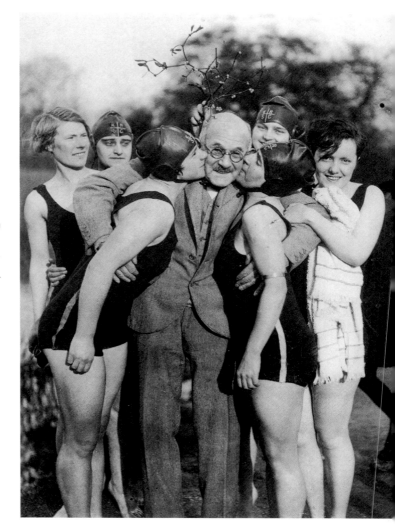

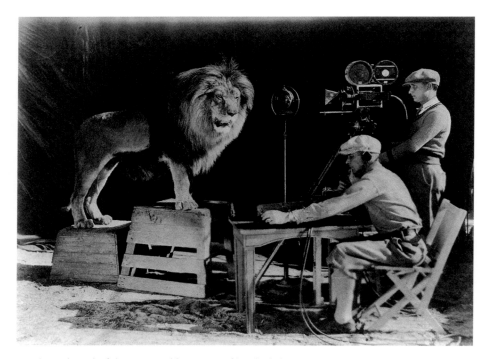

Leo, the trademark of the Metro-Goldwyn-Mayer films, looks less
than enthusiastic about his forthcoming leap into the age of
the talkies. 14 February 1929 was the date of the recording of his
unmistakable roar, which was to open countless millions of
evenings at the cinema.

Der Löwe Leo, Markenzeichen der Metro-Goldwyn-Mayer-Filme,
sieht seinem Sprung ins Zeitalter des Tonfilms noch recht unwillig
entgegen. Am 14. Februar 1929 wird sein unverkennbares Brüllen
aufgezeichnet, das in Zukunft Abermillionen von Filmnächten
eröffnen wird.

Leo le lion, figure emblématique de tous les films de Metro-
Goldwyn-Mayer. Que lui importe l'avénement du cinéma parlant.
Il n'empêche que son rugissement inimitable, enregistré le 14 février
1929, ouvrira à l'avenir des millions de séances cinématographiques.

"A new contender for the heavyweight title?" In the late 1920s, circus talent-spotter Joseph Eierling presented the "world's fattest man" in New York. John Webb was 19 years old and weighed 306 kilograms (675 lbs). He had previously earned his living on a farm in Alabama.

»Ein neuer Anwärter auf den Schwergewichts-Titel?« Ende der zwanziger Jahre präsentiert der Zirkus-Talentsucher Joseph Eierling in New York den »fettesten Mann der Welt«. John Webb ist 19 Jahre alt und wiegt 306 kg. Bisher verdiente er sein Geld auf einer Farm in Alabama.

« Un nouveau prétendant au titre des poids lourds ? » A la fin des années 20, Joseph Eierling, chasseur de talent de cirque, présente, à New York, « l'homme le plus gros du monde ». A 19 ans, John Webb pèse 306 kg. Il a jusqu'alors gagné son argent dans une ferme de l'Alabama.

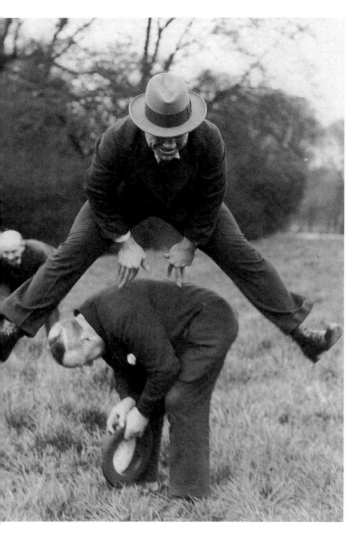

In the run-up to the fight between boxers Tom Heeney and Gene Tunney, the former demonstrates his unconventional training methods. But his optimism was to no avail. On 26 July 1928, New Zealander Heeney lost to reigning world champion Tunney from the United States by a technical knockout in the 11th round.

Im Vorfeld des Boxkampfs Tom Heeney gegen Gene Tunney präsentiert Heeney seine unkonventionellen Trainingsmethoden. Doch aller Optimismus ist vergebens. Der Neuseeländer verliert am 26. Juli 1928 in der 11. Runde durch technischen k.o. gegen den amtierenden Weltmeister Tunney aus den USA.

A l'occasion du match de boxe qui l'oppose à Gene Tunney, Tom Heeney présente ses méthodes d'entraînement peu conventionnelles. Mais, malgré son optimisme, le Néo-Zélandais perdra, sur K.-O. technique, le 26 juillet 1928, au cours du 11e round, contre le champion du monde en titre, l'Américain Gene Tunney.

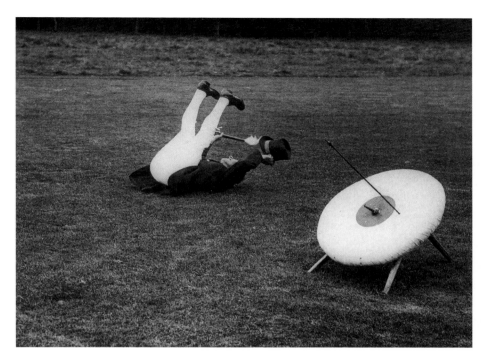

The Triennial March between the "Woodmen of Arden" and the "Royal Company of Archers" took place near Coventry in the English Midlands. In 1926 this judge was caught on his back waving his legs in the air, and commenting thus on the bull's eye which had just been scored.

In der Nähe von Coventry in England findet alle drei Jahre der Wettbewerb zwischen den »Holzfällern von Arden« und der »Königlichen Kompanie der Bogenschützen« statt. 1926 strampelt dieser Scheibenrichter auf dem Rücken liegend mit den Beinen und kommentiert auf diese Weise das hervorragende Ergebnis des letzten Schützen.

A proximité de Coventry, en Angleterre, a lieu tous les trois ans le challenge entre les « Bûcherons d'Arden » et la « Compagnie royale des Archers ». En 1926, ce juge-arbitre se laisse tomber à la renverse les jambes en l'air, indiquant à sa façon que le tireur a visé dans le mille.

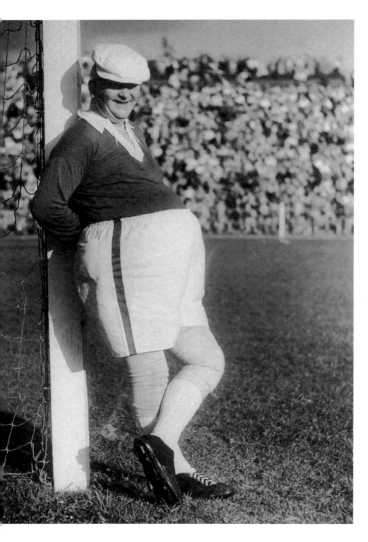

Soccer is traditionally a game closely associated with the working class, but in the well-heeled Berlin district of Wilmersdorf, the city fathers were not averse to the folksy touch. The mayor, Dr Batzel, is seen here keeping goal in the "precinct officials versus precinct councillors" match.

Das Fußballspiel ist zwar traditionell eher eine Sportart der Arbeiterschicht, doch im bürgerlichen Berliner Stadtteil Wilmersdorf zeigt sich der Magistrat des Bezirks gerne volksnah. Der Bürgermeister, Dr. Batzel, hütet hier das Tor beim Spiel des Bezirksamts gegen die Bezirksverordneten.

Si le football est traditionnellement lié au monde ouvrier, dans le quartier bourgeois de Wilmersdorf, à Berlin, le Dr Batzel, maire et magistrat de district aime se montrer proche du peuple. Ici, il est gardien de but lors du match qui oppose les services du district aux conseillers municipaux.

In the 1920s and '30s tall people captured popular attention in variety, in the circus, and at fairgrounds by virtue of their sheer height. To publicize his evening performance in the Olympia Circus, Jake Ehrlich from Texas introduced himself to the London press on 12 December 1930. He measured 8 feet 6 inches (2 meters 62 centimeters).

In den zwanziger und dreißiger Jahren erregen große Menschen im Zirkus, im Varieté und auf Jahrmärkten aufgrund ihrer Körperlänge Aufsehen. Als Werbung für seinen abendlichen Auftritt im Olympia Circus stellt sich am 12. Dezember 1930 der Texaner Jake Ehrlich den Kameras der Londoner Presse. Er mißt 2,62 m.

Dans les années 20 et 30, les géants font sensation dans les cirques, cabarets et fêtes foraines de par leur stature inhabituelle. Afin de faire de la publicité pour l'Olympia Circus où il se produit tous les soirs, le Texan Jake Ehrlich pose pour les photographes de la presse londonienne, le 12 décembre 1930. Il mesure 2,62 mètres.

Henry K. Ekizian, a
marine serving on
board the aircraft
carrier *Lexington*,
enjoyed the reputa-
tion of being one of
the strongest men in
the U.S. Navy. He is
pictured here on
1 March 1931 meas-
uring his strength
against 12 fellow
marines trying to
strangle him with
a rope.

Henry K. Ekizian,
Marinesoldat der
Besatzung des Flug-
zeugträgers *Lexington*,
genießt den Ruf, einer
der stärksten Männer
der US-Navy zu sein.
Am 1. März 1931 tritt er
gegen 12 Kameraden
an, die versuchen, ihn
mit einem Seil zu
strangulieren.

Henry K. Ekizian,
membre de l'équipage
du porte-avions
Lexington, a la répu-
tation d'être l'un des
hommes les plus forts
de la marine améri-
caine. Le 1er mars 1931,
il relève le défi lancé
par 12 de ses cama-
rades qui essaient de
l'étrangler à l'aide
d'un cordage.

On 23 January 1930, German newspapers reported the departure of Viennese figure skaters for New York. The fact that Melitta Brunner and Ludwig Wrede were sailing to the World Championship in New York on board the ocean liner *Bremen*, launched in 1928 as the symbol of the re-emergence of the German fleet, was not left unmentioned.

Am 23. Januar 1930 melden deutsche Zeitungen die Abfahrt von Wiener Eiskunstläufern nach New York. Nicht unerwähnt bleibt, daß Melitta Brunner und Ludwig Wrede auf dem Ozeanriesen *Bremen* – Symbol für das Wiedererstarken der deutschen Flotte –, der 1928 vom Stapel gelaufen ist, zu den Weltmeisterschaften reisen.

Le 23 janvier 1930, les journaux allemands annoncent le départ de patineurs artistiques viennois pour New York. Ils ne manquent pas de signaler que Melitta Brunner et Ludwig Wrede qui disputeront les championnats du monde, s'embarquent sur le *Bremen*, le paquebot mis à l'eau en 1928. C'est le symbole de la puissance retrouvée de la flotte allemande.

These three sportsmen are taking advantage of a reunion of former students in 1930 to recall the good old days when they played football for the University of Pennsylvania in Philadelphia. Sir Henry Thornton, President of the Canadian National Railways, who played for the team at center from 1890 to 1893, is preparing to pass the ball to his earlier teammate, quarterback Louis de P. Vail.

Der guten alten Zeit im Football-Team der University of Pennsylvania in Philadelphia gedenken diese drei Sportsmänner 1930 bei einem Treffen ehemaliger Studenten. Sir Henry Thornton, Präsident der Kanadischen Nationalen Eisenbahngesellschaft und ehemaliger Center-Spieler des Teams in den Jahren 1890 bis 1893, ist dabei, den Ball an seinen früheren Teamkameraden und Quarterback Louis de P. Vail abzugeben.

Lors d'une réunion d'anciens étudiants, ces trois sportifs évoquent le bon vieux temps de l'équipe de football américain de l'Université de Pennsylvanie, à Philadelphie en 1930. Sir Henry Thornton, président de la compagnie ferroviaire nationale canadienne et ancien centre de l'équipe de 1890 à 1893, est prêt à passer le ballon à son ancien coéquipier et quarterback Louis de P. Vail.

On 24 March 1931, Dr Hugo Eckener, commander of the airship *Graf Zeppelin*, visits Edward Deeds on the latter's yacht in Miami, Florida, in order to discuss with him future prospects for transatlantic airship services. However, the 1937 *Hindenburg* disaster at Lakehurst put an end to the airship as a commercial proposition.

Dr. Hugo Eckener, der Luftschiffkommandant der *Graf Zeppelin*, besucht am 24. März 1931 die Yacht von Edward Deeds in Miami (Florida), um mit ihm die Zukunft des transatlantischen Zeppelin-Verkehrs zu diskutieren. Mit dem Unglück der *Hindenburg* 1937 in Lakehurst kommt die Luftschiffahrt jedoch zum Erliegen.

Le 24 mars 1931, Hugo Eckener, commandant du dirigeable *Graf Zeppelin*, rencontre Edward Deeds sur son yacht, à Miami (Floride), pour évoquer avec lui les perspectives futures de traversée de l'Atlantique en dirigeable. Mais après la catastrophe du *Hindenburg*, en 1937 à Lakehurst, les dirigeables n'ont plus d'avenir.

The top of a skyscraper was the venue chosen by 6-year-old Don MacLaughlin on 17 October 1935 to demonstrate his lasso skills. Alongside this reminder of the Wild West, New York also had more highbrow culture on offer that month, for example the première of George Gershwin's *Porgy and Bess*.

Auf einem Wolkenkratzer demonstriert der sechsjährige Don MacLaughlin am 17. Oktober 1935 seine Lassokünste. Neben dieser Reminiszenz an den Wilden Westen bietet New York in diesem Monat auch hohe Kultur, u.a. die Uraufführung von George Gershwins *Porgy and Bess*.

Sur le toit d'un gratte-ciel, Don MacLaughlin, âgé de six ans, montre, le 17 octobre 1935, qu'il sait manier le lasso. Outre cette évocation du Far West, New York est aussi, ce mois-là, le théâtre de grandes manifestations culturelles dont la première présentation de *Porgy and Bess* de George Gershwin.

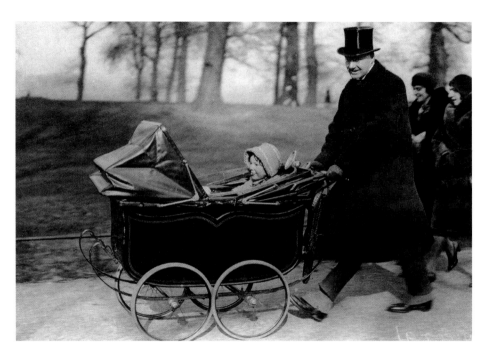

A fine Sunday morning in the 1930s entices Lord Gorell and his children out into London's Hyde Park. The original caption to this photograph, under the title "A noble nanny in the park", noted that Hyde Park continued to enjoy a reputation as the society children's playground.

Ein schöner Sonntagmorgen lockt Lord Gorell und seine Kinder in den dreißiger Jahren in den Hyde Park. Die ursprüngliche Bildunterschrift mit dem Titel »Ein adeliges Kindermädchen im Park« vermerkt, daß der Hyde Park weithin als Spielplatz der Kinder der gehobeneren Gesellschaft bekannt ist.

Par une belle matinée des années 30, Lord Gorell et ses enfants font leur promenade dominicale au Hyde Park. Le titre de la légende initiale « Une nurse aristocrate au parc » rappelle que Hyde Park est et reste le terrain de jeu des enfants de la haute société.

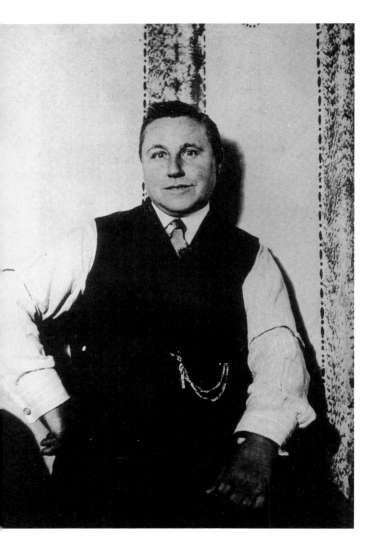

In 1931, after 12 years, Joseph Einsmann, a German from the city of Mainz, was exposed as a woman. Having separated from her husband, she acquired his identity papers shortly after the First World War in order to find work as a night-watchman during the period of economic hardship. Meanwhile she even managed to marry a woman with two children, and was regarded as "a good father".

Nach 12 Jahren wird der Deutsche Joseph Einsmann aus Mainz 1931 als Frau enttarnt. Sie lebte von ihrem Mann getrennt, eignete sich aber kurz nach Kriegsende seine Papiere an, um während dieser wirtschaftlich schweren Zeit Arbeit als Nachtwächter anzunehmen. In der Zwischenzeit hatte sie sogar eine Frau mit zwei Kindern geheiratet und galt »als guter Familienvater«.

Ce n'est qu'au bout de 12 ans que l'on découvre que l'Allemand Joseph Einsmann, de Mayence, est en réalité une femme. Séparée de son mari, elle avait décidé de vivre sous son identité peu après la fin de la guerre pour trouver du travail comme veilleur de nuit en plein marasme économique. Entre-temps, elle avait même épousé une femme qui avait deux enfants et jouissait d'une réputation « de bon père de famille ».

Paul Grappe, a Parisian, took the identity of a girl during the First World War in order to evade military service. Even when the War ended, he played the role to such perfection that the male society who frequented Montmartre were not averse to his charms. The photo shows Grappe in 1930, shortly before he was murdered by his jealous wife.

Der Pariser Paul Grappe verwandelt sich während des Ersten Weltkriegs in eine Frau, um dem Militärdienst zu entgehen, und spielt seine Rolle auch nach dem Krieg so perfekt, daß die Männerwelt des Montmartre ihm äußerst zugetan ist. Das Foto zeigt Grappe 1930, kurz vor der Ermordung durch seine eifersüchtige Ehefrau.

Pendant la Première Guerre mondiale, le Parisien Paul Grappe se fait passer pour une jeune femme afin d'échapper au service militaire et, même après la guerre, il joue son rôle avec une telle perfection qu'il s'attire les faveurs de la gent masculine de Montmartre. La photo montre Paul Grappe en 1930, peu avant qu'il ne soit assassiné par sa femme jalouse.

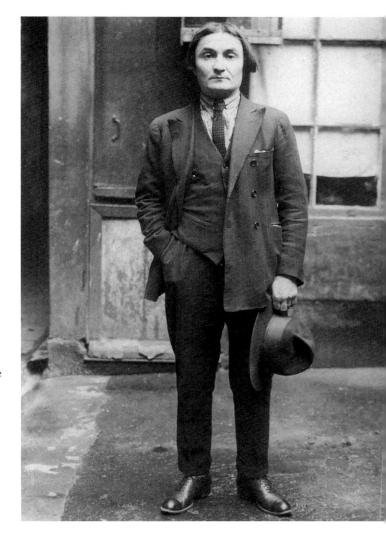

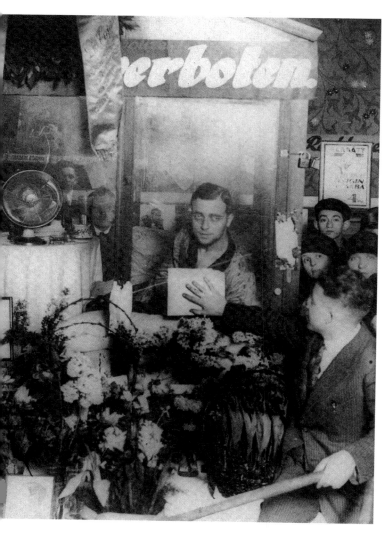

This German show-man, who went by the name of "Jolly the Hunger Artist", was fined 1000 reichs-marks by a Berlin court in the early 1930s for eating chocolate during a 44-day fasting stunt. It had been smuggled unnoticed into his sealed glass box.

Der deutsche »Hungerkünstler Jolly« wird Anfang der dreißiger Jahre von einem Berliner Gericht zu 1000 Reichsmark Strafe verurteilt. Er hatte während einer 44tägigen Fasten-aktion in einem abgeschlossenen Glaskasten Schoko-lade gegessen, die ihm unbemerkt zugesteckt worden war.

Cet Allemand surnommé « Jolly, le champion du jeûne », est condamné à une amende de 1000 reichsmarks par un tribunal de Berlin, au début des années 30, pour avoir, durant un jeûne de 44 jours dans une cabine en verre fermée, mangé du chocolat qui lui avait été glissé subrepticement.

English coal miner Jack Farnsworth from Clay Cross in Derbyshire was a local sporting hero in the 1930s. He attracted nationwide attention with this athletic number.

Der englische Bergarbeiter Jack Farnsworth aus Clay Cross ist in den dreißiger Jahren eine lokale Sportgröße in Derbyshire. Landesweit erregt er mit dieser athletischen Nummer Aufsehen.

Dans les années 30, le mineur anglais Jack Farnsworth, de Clay Cross, est une vedette locale, dans le Derbyshire, grâce à ses prouesses sportives. Il fait sensation dans toute l'Angleterre avec ce numéro très « musclé ».

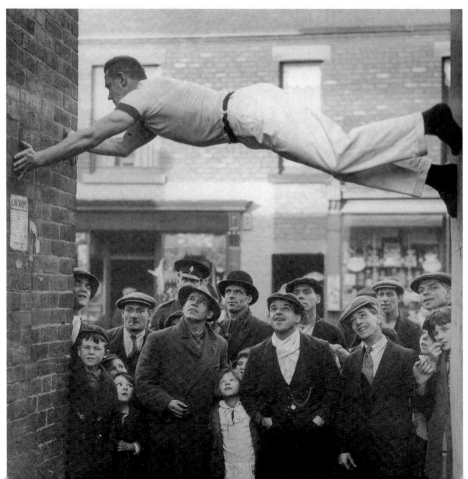

On 25 February 1935, Saiko Kojima from Osaka managed to pull this automobile along by his teeth, while at the same time crushing stones in his bare hands. The "miraculous physical and spiritual strength" of this karateist fitted well into a period during which Japan's government and military were hitting the headlines worldwide with their claims to be a great power in Asia.

Saiko Kojima aus Osaka zieht am 25. Februar 1935 dieses Automobil mit den Zähnen, während er obendrein mit seinen Händen Steine zermalmt. Die »wundervolle physische und spirituelle Kraft« dieses Karateka paßt sich ein in eine Zeit, in der Japans Regierung und Militär mit ihren Großmachtansprüchen in Asien weltweit Schlagzeilen machen.

Le 25 février 1935, Saiko Kojima, d'Osaka, déplace cette voiture en tirant sur la corde qu'il retient par les dents tout en brisant des pierres à mains nues. La « miraculeuse force physique et spirituelle » de ce karatéka est le reflet d'une époque où les visées hégémoniques du gouvernement japonais et de son armée défrayent la chronique dans le monde entier.

The National Socialists, voted into office in 1933, promised the German people "motorization for all". Even for this little lad, however, pictured gazing spellbound at this Reichspost vehicle, the real meaning of this propaganda slogan was exposed as "motorization for war" after 1939.

Die 1933 gewählte national-sozialistische Regierung verspricht dem deutschen Volk »Motorisierung für alle«. Diese Propaganda-formel entpuppt sich jedoch ab 1939 auch für diesen kleinen Steppke, der hier vor einem Lastkraftwagen der Reichspost in Ehrfurcht erstarrt, als »Mobilisierung für den Krieg«.

Le gouvernement national-socialiste élu en 1933 promet au peuple allemand la « motorisation pour tous ». A partir de 1939, cette formule de propagande se révèle en réalité être une « motorisation pour la guerre ». Ce qui n'empêche apparemment pas ce gamin d'être fasciné par la calandre de ce camion de la Poste du Reich.

Employees of Britain's Southern Railway steel themselves at a works fête near London on 25 August 1938. Mr "Cert" Villiers is anchorman for his tug-of-war team.

Angestellte der süd-englischen Eisenbahn-gesellschaft stählen sich auf dem Sommerfest ihres Arbeitgebers am 25. August 1938 in der Nähe von London. Mr »Cert« Villiers steht beim Tauziehen als letzter in der Reihe seines Teams seinen Mann.

Un cheminot de la compagnie de chemins de fer du Sud de l'Angleterre s'entraîne lors de la fête d'été de sa société, le 25 août 1938, près de Londres. « Tirera bien qui tirera le dernier », comme le fait Mister « Cert » Villier, lors d'un concours de tir à la corde en équipe.

A heatwave during the spring of 1934. At the Imperial Chemical Industries' works sports day in Bristol on 14 May, the organizers improvised a cooling shower for the exhausted athletes.

Hitzewelle im Frühling 1934. Am Rande des Betriebssportfests der Imperial Chemical Industries im englischen Bristol halten die Veranstalter am 14. Mai eine besondere Erfrischung für die erschöpften Sportler bereit.

Canicule au printemps 1934. Durant la fête sportive de l'entreprise Imperial Chemical Industries, le 14 mai à Bristol, en Angleterre, les organisateurs ont prévu un rafraîchissement spécial pour les sportifs épuisés.

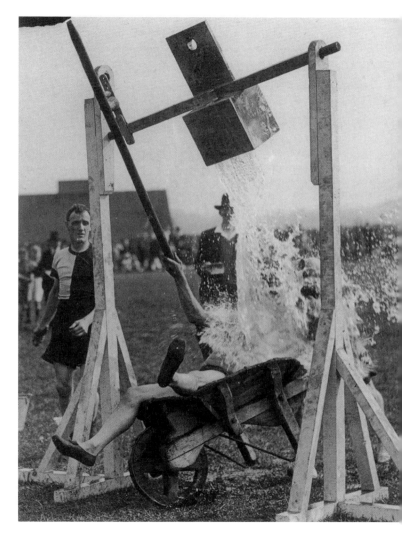

Technicians in San Francisco taking a breast impression of Tempest Storm in 1934. The local variety queen, who boasted of bra size 42c, wanted to have her bosom insured in London for 50,000 dollars.

Techniker in San Francisco nehmen 1934 einen Brustabdruck von Tempest Storm. Die lokale Varieté-Königin, die sich einer Oberweite der Körbchengröße 95c rühmt, möchte ihren Busen bei einer Londoner Versicherung mit 50 000 Dollar versichern lassen.

En 1934, des techniciens de San Francisco font un moulage des seins de Tempest Storm. La reine locale de la variété, qui se targue d'avoir un tour de poitrine de 110c, souhaite faire assurer son joli buste pour 50 000 dollars auprès d'une compagnie d'assurances londonienne.

Beneath the heading "Does it hurt badly?" Jackie, a chimpanzee from London Zoo, and its keeper Mr Slater play at air-raid precautions (with roles reversed) on 7 March 1939.

Unter der Überschrift »Tut es sehr weh?« spielen Jackie, ein Schimpanse des Londoner Zoos, und sein Wärter Slater für den Fotografen die Luftschutzübung am 7. März 1939 mit vertauschten Rollen.

Sous le titre « Cela fait vraiment mal ? », Jackie, un chimpanzé du zoo de Londres, et son gardien Slater jouent pour le photographe un exercice de protection contre les bombardements aériens, le 7 mars 1939, mais en inversant les rôles.

An unusual opening to a miniature show on 18 November 1930. Trick golf star Joe Kirkwood demonstrates one of his famous drives using baseball comic Nick Altrock as his tee.

Auf ungewöhnliche Weise wird am 18. November 1930 eine Miniaturen-Show eröffnet. Der Trick-Golf-Star Joe Kirkwood zeigt einen seiner berühmten Abschläge und verwendet dabei den Baseball-Komiker Nick Altrock als Tee.

Le 18 novembre 1930, une exposition de miniatures est inaugurée de manière inattendue : Joe Kirkwood, le magicien qui fait des tours avec son club de golf présente l'un de ses célèbres coups et utilise à cette occasion comme tee l'humoriste Nick Altrock.

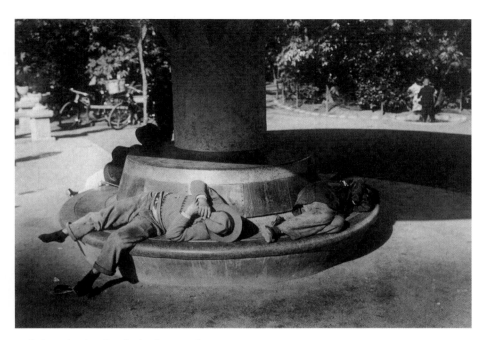

With the Italian heading "Dolce far niente",
sweet idleness, the German sub-editor makes
fun of the Japanese lifestyle of the 1930s. The
picture bore the caption: "Typical scene in a
Tokyo park".

Mit der italienischen Überschrift »Dolce far
niente«, das süße Nichtstun, mokiert sich der
deutsche Redakteur über den japanischen
Lebensstil der dreißiger Jahre und betitelt
dieses Bild mit: »Typische Szene aus einer
Tokioter Parkanlage.«

Avec le titre italien « Dolce far niente », la
douceur de l'oisiveté, un journaliste raille le
mode de vie japonais dans les années 30 et
accompagne cette photo de la légende :
« Scène typique dans un parc de Tokyo ».

A year after the American atomic bombs were dropped on Hiroshima and Nagasaki in 1945, this report on the start of the American football season was headlined: "Atomic Power". Tommy Pier from Philadelphia emulates the great football stars as he breaks through the opponents' line.

Ein Jahr nach den ameri-kanischen Atombomben-abwürfen über Hiroshima und Nagasaki 1945 kündigt diese Meldung den Beginn der Football-Saison in den USA mit der Schlagzeile »Atomkraft« an. Zweifels-ohne durchbricht Tommy Pier aus Philadelphia die Linie seiner Gegner im Stile großer Footballspieler.

Un an après le lancement par les Américains de bombes atomiques sur Hiroshima et Nagasaki, en 1945, cette photo annonce l'ouverture de la saison de football américain aux Etats-Unis avec comme légende « Energie nucléaire ». Tommy Pier, de Philadelphie, passe gaillardement la ligne de ses adversaires dans le plus pur style des grands de ce sport.

Darlene, daughter of the American weight lifter Dick Smith, knows all about strong men; here she is casting an expert eye on the newly chosen "Mr Washington 1948". The city's politicians were more concerned this spring with the future of post-war Germany and the sealing-off of the Soviet zone of occupation.

Darlene, die Tochter des amerikanischen Gewichthebers Dick Smith, kennt sich mit starken Männern aus und begutachtet den soeben gekürten »Mister Washington 1948«. Die Politiker in Washington D.C. beschäftigen sich in diesem Frühjahr mit der Zukunft Nachkriegsdeutschlands und der Isolierung der sowjetischen Besatzungszone.

Darlene, la fille de l'haltérophile américain Dick Smith, s'y connait en hommes forts et jauge celui qui vient d'être élu « Mister Washington 1948 ». Au printemps de la même année, les hommes politiques de Washington D.C. sont préoccupés par l'avenir de l'Allemagne de l'après-guerre et par l'isolement de la zone d'occupation soviétique.

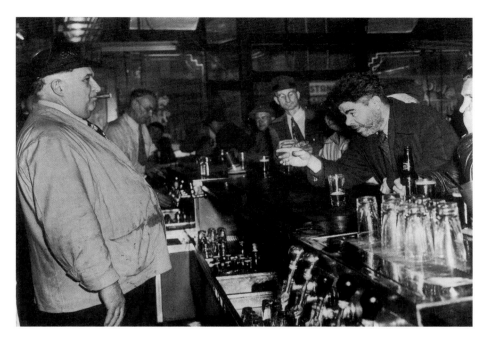

New Year's Eve 1946 allowed this photographer a profound insight into the bar life of New York's Bowery district. "They drink all right, but hardly in a merry fashion." And on this particular evening "there's little chance of wheedling a free drink out of this hard-faced bartender."

Der Silvesterabend 1946 erlaubt dem Fotografen tiefe Einblicke in das Kneipenleben des New Yorker Stadtteils Bowery: »Dort wird getrunken, aber kaum auf die fröhliche Weise.« Und auch an diesem besonderen Abend gibt es »kaum Aussichten, einen derart grimmig dreinschauenden Barkeeper dazu zu bewegen, einen Drink zu spendieren«.

La Saint-Sylvestre de 1946 permet au photographe d'apprécier l'ambiance dans les cafés du quartier new-yorkais de Bowery : « On y boit, mais pratiquement sans aucune gaieté. » Et, même en cette soirée si particulière, « inutile d'espérer que le cafetier, vu sa mine renfrognée, paie une tournée générale. »

There is a custom in Sweden of keeping a vigil by the fire on New Year's Eve. In 1946, though, Malmö's "Poseidon" swimming club ditched this custom and instead, to the delight of the onlookers, sent its members into battle with pillows on a 16-feet-high (5 meters) beam above the surface of the municipal swimming pool.

In Schweden ist es Sitte, den Silvesterabend mit einer Wache am Feuer zu verbringen. Diese sogenannte »Neujahrswacht« wirft der Malmöer Schwimmclub »Poseidon« 1946 über Bord und schickt seine Mitglieder vor begeistertem Publikum zur Kissenschlacht auf einen 5 m hohen Balken über der Wasserfläche der städtischen Schwimmhalle.

En Suède, on a coutume de passer le réveillon de la Saint-Sylvestre autour d'un feu de joie. En 1946, le club de natation « Poseidon », de Malmö, innove à cette occasion et, devant un public enthousiaste, ses membres se battent à coups de polochons sur une poutre placée à 5 mètres au-dessus du plan d'eau de la piscine municipale.

Public pillow-fights enjoyed great popularity in Sweden during the 1940s. Here, two warriors are battling it out on a soapy pole high above the grass of a Stockholm stadium.

Öffentliche Kissenschlachten ziehen in Schweden während der vierziger Jahre größere Kreise. Hier bekämpfen sich zwei Herren mit Kissen auf einer geseiften Stange hoch über dem Rasen eines Stockholmer Stadions.

Durant les années 40, les batailles de polochons en public font florès en Suède. Sur cette photo, deux hommes armés d'oreillers se livrent un combat acharné sur une poutre savonnée, à quelques mètres au-dessus du gazon d'un stade de Stockholm.

On New Year's Eve 1946, the newspapers entertained their readers with the story of 32-year-old James Bradley from Detroit. He'd bet an army buddy that his baby would be a boy; when it turned out otherwise, the new father had to push a walnut with his nose along the sidewalk round his block.

Silvester 1946 unterhalten die Zeitungen ihre Leser mit der Geschichte von James Bradley, 32, aus Detroit. Er hatte mit einem Armeefreund auf seinen Nachwuchs gewettet und auf einen Sohn gesetzt. Hier rollt der frisch-gebackene Vater eines Mädchen mit seiner Nase eine Walnuß über den Bürgersteig eines Häuserblocks.

Le jour de la Saint-Sylvestre 1946, les journaux divertis-sent leurs lecteurs avec l'histoire de James Bradley, 32 ans, de Detroit. Il a parié avec un copain d'armée qu'il aurait un fils. Ici, l'heureux papa d'une petite fille fait rouler avec son nez une noix sur le trottoir autour d'un pâté de maisons.

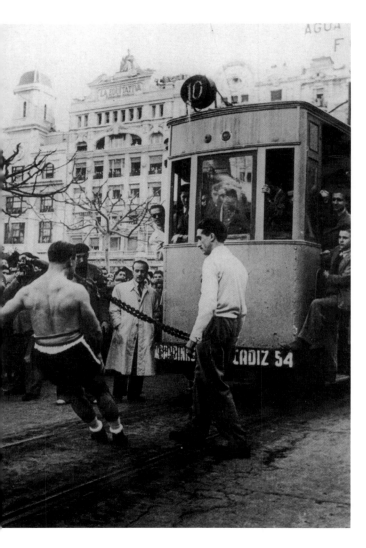

On the fringe of the week-long festivities in honor of St Joseph in the Spanish town of Valencia in 1948, Joe Fordson tried his hand, or his teeth, at replacing the motor of this streetcar. For the photographer, the fringe happening became a central event: "Another popular spectacle."

Am Rande der einwöchigen Feierlichkeiten zum Fest des Heiligen Josef im spanischen Valencia versucht sich Joe Fordson 1948 als Ersatz-motor einer Straßenbahn. Für den Fotografen wird das Randgeschehen zum Haupt-ereignis: »Hier ein weiteres Volksspektakel«.

En 1948, en marge des festivités en l'honneur de Saint Joseph, durant sept jours, dans la ville espagnole de Valence, Joe Fordson tente de tirer un tramway. Pour le photographe, cette anecdote est un véritable exploit : « Encore un spectacle populaire ».

In 1875, an Englishman became the first person to swim the English Channel between France and Britain. The following decades saw countless other swimmers from many nations emulate his feat. Here we see the first Greek channel swimmer, Major Jason Zirganos, starting out on 14 July 1951, in the hope of reaching the other side in 16 hours.

1875 durchschwimmt der erste Engländer den Kanal zwischen Frankreich und den britischen Inseln, und unzählige Schwimmer vieler Nationen folgen ihm in den kommenden Jahrzehnten. Hier startet der erste Grieche, Major Jason Zirganos, am 14. Juli 1951 seinen Versuch und hofft, in 16 Stunden sein Ziel zu erreichen.

En 1875, un Anglais effectue la première traversée de la Manche entre la France et les îles britanniques. Il sera imité par d'innombrables nageurs de tous les pays durant les décennies suivantes. Sur notre photo, le premier Grec, le major Jason Zirganos, se jette à l'eau, le 14 juillet 1951, et espère atteindre son but 16 heures plus tard.

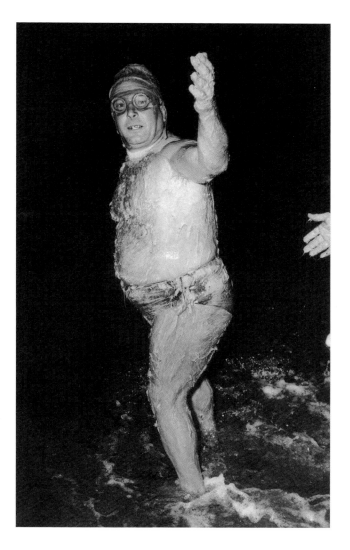

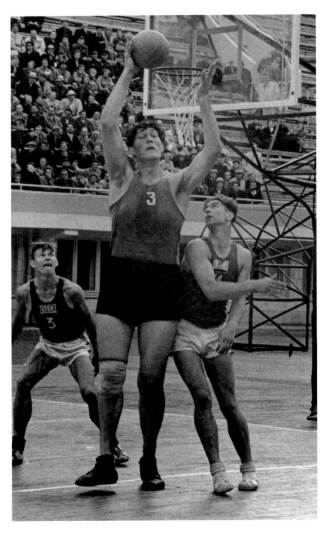

The Soviet news agency proudly reported in 1957 that this photo of a Russian basketball game had won the first prize at the 2nd International Photo Exhibition in Amsterdam. This claim to fame, however, pales beside the grisly pictures of the Soviet quashing of the Hungarian national uprising in 1956.

Stolz vermeldet 1957 die sowjetische Nachrichtenagentur, daß dieses Foto eines russischen Basketballspiels den ersten Preis der 2. Internationalen Fotoausstellung in Amsterdam gewonnen hat. Dieser kuriose Glanz verblaßt jedoch vor den grausamen Bildern der Niederschlagung des ungarischen Volksaufstands durch die Sowjetunion im November 1956.

En 1957, l'agence de presse soviétique déclare fièrement que cette photo d'un basketeur russe a remporté le premier prix du 2ᵉ Salon international de la Photo, à Amsterdam. Mais d'autres photos, terribles celles-là, de l'écrasement du soulèvement hongrois en 1956 par l'Union soviétique en ternissent l'éclat singulier.

In 1956 audiences at the Paris Variété were admiring Rolando, the Master of Balance. Political conditions in France, by contrast, were anything but balanced. The elections for the National Assembly had produced a swing to the left, depriving the conservative and center parties of their majority.

1956 bewundert man Rolando, den Meister des Gleichgewichts, in den Varietétheatern von Paris. Die politischen Verhältnisse in Frankreich sind dagegen alles andere als stabil. Bei den Wahlen zur Nationalversammlung gibt es einen Linksrutsch zu vermelden, und die bürgerlichen Parteien verlieren ihre Mehrheit.

En 1956, on admire Rolando, le champion de l'équilibre, dans les cabarets de Paris. La situation politique en France est, en revanche, loin d'être aussi stable. Une poussée de la gauche aux élections de l'Assemblée nationale fait perdre leur majorité aux partis de droite.

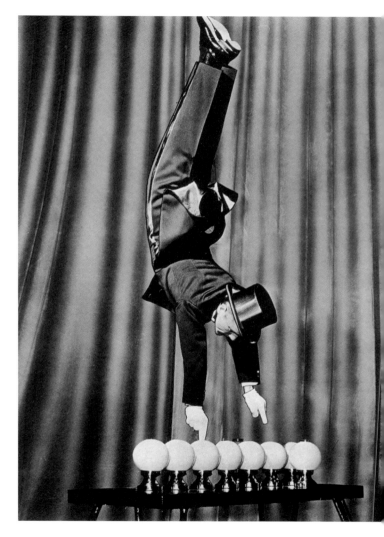

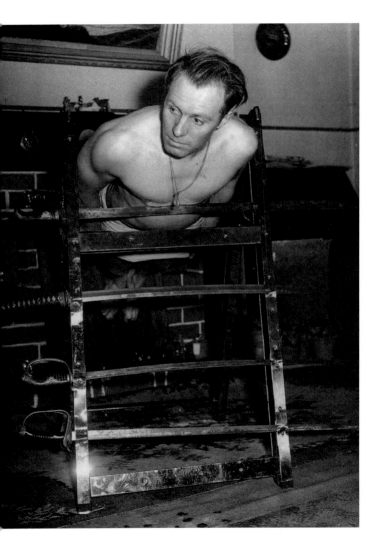

Albert Buxton from Middleton in England photographed on 27 November 1953 relaxing in his living room after a hard day's work. His favored form of relaxation was testing his skin on razor-sharp swords, to which 12 years of yoga had rendered him invulnerable.

In seinem Wohnzimmer entspannt sich Albert Buxton aus dem englischen Middleton von seiner Arbeit, fotografiert am 27. November 1953. Am liebsten erprobt er seine Kräfte an rasiermesserscharfen Schwertern, die ihm nach 12jähriger Yogapraxis nichts anhaben können.

Photographié le 27 novembre 1953, dans son salon, l'Anglais Albert Buxton, de Middleton, se repose d'une longue journée de travail. Il s'étend de préférence sur des lames d'épées tranchantes comme des rasoirs, mais qui ne le blessent pas, lui qui pratique le yoga depuis 12 ans.

29-year-old Danny Almond from India earned his living as a level-crossing keeper on the railway line from St Pancras to Barking in London. This picture shows him not on strike, but demonstrating the feats he had become capable of achieving after studying yoga in India.

Der 29jährige Inder Danny Almond arbeitet normalerweise als Schrankenwärter an der Londoner Eisenbahnlinie von St. Pancras nach Barking. Er tritt hier nicht etwa in den Streik, sondern demonstriert, zu welchen Kunststücken ihn sein Yogastudium in Indien befähigt hat.

L'Indien Danny Almond, 29 ans, travaille habituellement comme garde-barrière sur la ligne de chemin de fer St. Pancras–Barking. Loin de faire la grève, il présente ici toute l'étendue de ses talents après de longues années de pratique du yoga en Inde.

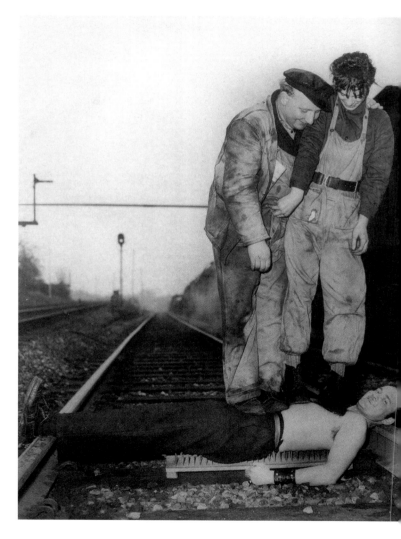

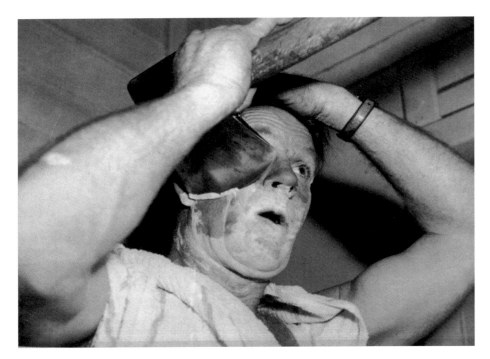

As 1954 became 1955, this photograph from Australia reinforced the Britons in their preconceptions regarding their erstwhile prison colony. "They're tough, mighty tough! But we just don't know if it's a shortage of razor blades or if this sort of thing comes naturally to these big tough Australian woodsmen!"

Zum Jahreswechsel 1954/55 erinnert dieses australische Foto die Briten an die Vorurteile gegenüber ihrer ehemaligen Sträflingskolonie: »Sie sind stark, mächtig stark! Aber wir wissen nicht, ob es lediglich zu wenig Rasierklingen gibt, oder ob so etwas zu den Dingen gehört, die für diese großen, starken australischen Holzfäller ganz natürlich sind!«

Pour la Saint-Sylvestre 1954/55, cette photo prise en Australie rappelle aux Britanniques leurs préjugés contre leur ancienne colonie servant de bagne : « Ils sont forts, très forts ! Mais nous ignorons tout simplement s'il y avait pénurie de lames de rasoir ou si ces bûcherons australiens, de solides gaillards, ont l'habitude de procéder ainsi. »

On 19 August 1955, Julia and Darvas, the new dance sensation at the London Palladium, introduced themselves to the public. Their show coincided with the première of the film *The Bridges at Toko-Ri*, based on a novel by James A. Michener about the Korean War.

Am 19. August 1955 stellen sich Julia und Darvas vor, die neue Tanzsensation der Musical-Show im Londoner Palladium. Mit ihrer Show konkurriert am gleichen Tag die Erstaufführung des Spielfilms *Die Brücken von Toko-Ri*, nach einer Romanvorlage von James A. Michener über den Korea-Krieg.

Le 19 août 1955, Julia et Darvas, les nouvelles superstars du music-hall, présentent au Palladium de Londres leur nouveau spectacle qui fait concurrence, le même jour, à la sortie du film *Les ponts de Toko-Ri*, sur la guerre de Corée, porté à l'écran d'après un roman de James A. Michener.

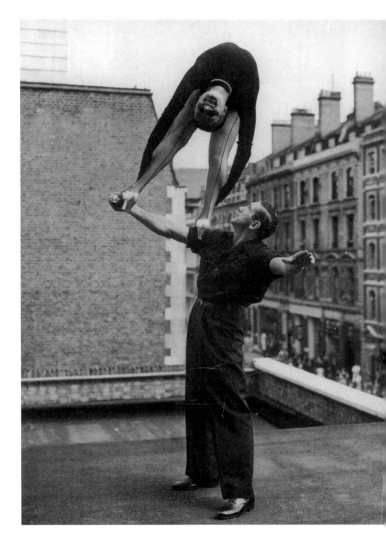

The Highland Games in Aboyne, Aberdeenshire have been one of the great popular attractions in Scotland since time immemorial. George Clark is seen here on 7 September 1962 throwing a 28-kilogram "hammer" (62 lbs), at the same time raising the age-old question: "Now what do Scotsmen wear under their kilts?"

Die Highland Games in Aboyne in Aberdeenshire sind von jeher eines der großen schottischen Volksfeste. Hier schleudert George Clark am 7. September 1962 eine 28 kg schwere Eisenkugel und wirft damit wieder einmal die weltbewegende Frage auf: »Was tragen die Schotten unter dem Kilt?«

Les Highland Games, à Aboyne, dans l'Aberdeenshire, ont toujours été l'une des plus grandes fêtes populaires écossaises. Ici, George Clark lance, le 7 septembre 1962, une boule de fer de 28 kilos soulevant du même coup la question cruciale : « Qu'est-ce que les Ecossais portent sous le kilt ? »

This English First Division soccer match between West Ham United and Sheffield United in September 1962 ended in a draw, but this particular duel, at least, made the photographer's day: Sheffield's full-back Richardson, on the left, loses his head in this tussle with West Ham forward Woosnam.

Das englische Oberliga-Spiel zwischen West Ham United und Sheffield United im September 1962 endet unentschieden. In dieser Szene birgt das Match jedoch zumindest für den Fotografen einen Höhepunkt: Sheffields Verteidiger Richardson (links) wirkt im Kampf gegen West Hams Stürmer Woosnam etwas kopflos.

Rencontre de première division, en Angleterre, entre West Ham United et Sheffield United, au mois de septembre 1962. Score : match nul. Sur cet instantané, par contre, la partie ne manque pas de piquant, au moins pour le photographe : aux prises avec Woosnam, l'attaquant de West Ham, Richardson (à gauche), le défenseur de Sheffield, perd la tête.

Fatuous contraptions

The 20th century has been an age of invention. The curious and the publicity-hungry fiddle away in their garrets, while the workshops and laboratories of professional inventors are shrouded in an aura of mystery. Yet few inventions catch on; many fail the first test or come a cropper on the maiden voyage. And apart from the inventor, no one cares. The explosive development of newspapers and magazines from about 1900 led to a veritable hunger for novelties and sensations, and often enough the press applauded inventions which were praised to the skies at first, only to appear totally futile but a short time later. Given the pressure of deadlines under which the daily press of the time operated, many reports were accepted unchecked. In any case, the information content was often less important than the entertainment value of articles about countless inventors' fairs and incredible innovations which were appearing all over the world. Indeed, we owe it to the press that we can watch this process of trial and error in progress: reporters have never been short of a suitably zany gizmo.

Erfinder auf Abwegen

Das 20. Jahrhundert gilt als Zeitalter der Erfindungen. Neugierige und Geltungssüchtige tüfteln im Verborgenen, und die Werkstätten und Laboratorien der professionellen Erfinder umgibt eine Aura des Geheimnisvollen. Doch nur die wenigsten Entdeckungen setzen sich durch und überstehen die erste Erprobung oder Jungfernfahrt. Außer den Erfindern kümmert dies niemanden. Die rasante Entwicklung der Zeitungen und Illustrierten um 1900 führt zu einer regelrechten Gier nach Neuigkeiten und Sensationen, und oftmals bejubelt die Presse Erfindungen, die zunächst hochgelobt werden, doch wenig später bereits vollkommen unsinnig erscheinen. Unter dem Zeitdruck der damaligen Tagespresse werden Meldungen vielfach ungeprüft übernommen. Dabei geht es oftmals auch gar nicht um den Informationsgehalt, sondern vielmehr um den Unterhaltungswert, den die Artikel über die unzähligen Erfindermessen und unglaublichen Innovationen aus aller Welt bieten. Daß wir diesem öffentlichen »Trial and Error«-Prozeß beiwohnen können, verdanken wir der Presse, die immer wieder Erfinder auf ihren Abwegen begleitet.

Les errements de la recherche

Le XXe siècle est aussi considéré comme le siècle des inventions. Esprits curieux et hommes en mal de célébrité bricolent dans l'anonymat de leur atelier tandis qu'une aura de mystère entoure les laboratoires des inventeurs professionnels. Mais très rares sont les inventions qui connaissent le succès et ne retombent pas dans l'oubli après leur inauguration. Mais cela ne préoccupe personne, si ce n'est l'inventeur lui-même. Vers 1900, l'essor stupéfiant des journaux et des illustrés entraîne une véritable course à la nouveauté. Tous sont à l'affût du sensationnel et il est fréquent que la presse se répande en éloges sur des inventions qui, portées aux nues en un premier temps, semblent, peu de temps après déjà, absolument dénuées de sens. Par manque de temps, la presse quotidienne de cette époque a souvent eu tendance à reproduire des communiqués sans en vérifier le contenu. Et, qu'importait la valeur de l'information. Ce qui comptait davantage, c'était le caractère ludique des articles sur les innombrables salons des inventeurs et incroyables innovations du monde entier. C'est à la presse que nous devons de pouvoir assister à ce processus public de « trial and error », une presse qui accompagne toujours les inventeurs dans leurs errements.

This picture taken in Germany sums up the aura sur-
rounding the "inventor" in the 1930s: "The workshop
with its plethora of confusing details, apparatus,
machines and high-tension cables is the milieu of the
successful inventor."

Dieses Bild aus Deutschland beschreibt den Mythos,
der den Erfinder in den dreißiger Jahren umgibt: »Die
Werkstatt mit einer Fülle verwirrender Details, mit
Apparaten, Maschinen, Starkstromleitungen, ist das
Milieu des erfolgreichen Erfinders.«

Cette photo prise en Allemagne illustre à la perfection
le mythe qui entoure « l'inventeur » des années 30 :
« Le laboratoire avec une multitude de machines
bizarres, d'appareils étranges et de lignes de courant
électrique est le royaume de l'inventeur ingénieux. »

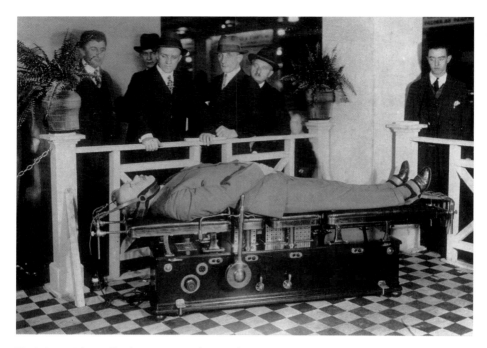

The judgment formed by the reporter on this 1920s' meteoric invention was damning: "A piece of equipment designed by an American lady, K. Schlicker, and described at the time as epoch-making, as it was said to promote human growth by means of electricity, has failed utterly."

Ein vernichtendes Urteil fällt ein Reporter in den zwanziger Jahren über diese »Meteoren-Erfindung«: »Ein Apparat, der von der Amerikanerin K. Schlicker erfunden und seinerzeit als epochemachend bezeichnet wurde, weil er mit Hilfe von Elektrizität das Wachstum des Menschen fördern kann, hat vollkommen versagt.«

Un reporter des années 20 rend un verdict sans appel sur cette invention météorique : « Un appareil inventé par l'Américaine K. Schlicker et qui devait faire date parce qu'il était censé favoriser la croissance de l'être humain à l'aide de la fée électricité. Un échec cuisant ! »

In the 1920s Berlin composer Edmund Meisel invented the orchestra machine to "underline musically the impression of every condition of life from the deathbed to the roar of the city." But the machine could not replace the noise generator used in talking movies.

Der Berliner Komponist Edmund Meisel erfindet in den zwanziger Jahren die Orchestermaschine, um »die Impression aller Lebenszustände und Ereignisse von der Sterbeszene bis zum Großstadtlärm musikalisch zu unterstreichen«. Den Geräuschemacher für Tonproduktionen konnte diese Maschine nicht ersetzen.

Dans les années 20, le compositeur berlinois Edmund Meisel invente la machine-orchestre pour « souligner musicalement l'impression faite sur notre sensibilité par tous les moments de la vie quotidienne et les grands événements, des scènes de deuil aux bruits de la métropole ». Mais cette machine ne remplacera cependant pas les bruiteurs des productions sonores.

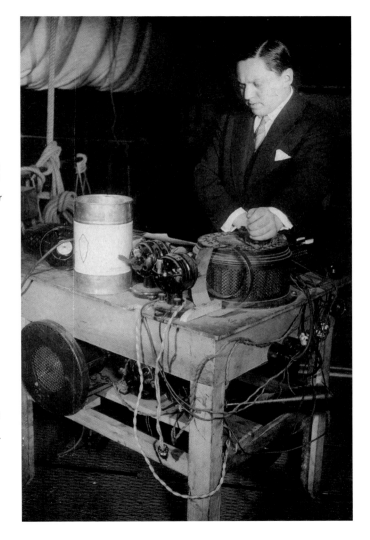

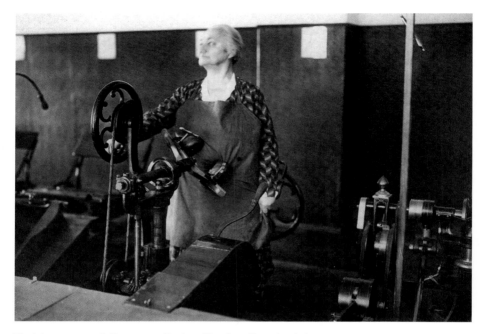

The inter-war years in Europe saw the transition from the extended to the nuclear family, opening up women's prospects of a career and better health. Inventors supported these hopes with domestic appliances of a martial nature, as here in a Berlin "health studio." The patient receives a "circular abdominal massage (passive)."

Zwischen den beiden Kriegen vollzieht sich in Europa der Übergang von der Groß- zur Kleinfamilie, und für Frauen verbinden sich damit Hoffnungen auf eine berufliche Laufbahn und eine bessere gesundheitliche Verfassung. Erfinder unterstützen diese Hoffnungen mit martialischem Gerät, wie hier in einer Berliner »Gesundheitswerkstätte«. Die Patientin erhält eine »kreisende Leibstreichung (passiv)«.

Dans l'entre-deux-guerres, la famille nombreuse perd de son attrait en Europe et les femmes peuvent enfin espérer faire carrière et préserver leur santé. Un espoir nourri par les inventeurs d'appareils martiaux en tout genre comme dans cet « atelier de santé » berlinois. La patiente reçoit un massage circulaire du ventre (passif).

In 1926 Rear Admiral Bradley Fiske declared war on books. His "reading machine" sought to reduce printed material to "reading strips". The Admiral photographed the typewritten manuscripts and developed them on photographic paper. A plan to make reading glasses redundant was another of his hopes which remained unfulfilled.

Dem Buchdruck sagt Konteradmiral Bradley Fiske 1926 den Kampf an: Seine »Lesemaschine« soll Drucksachen auf Lesestreifen reduzieren. Fiske fotografiert die getippten Manuskripte und entwickelt sie auf Fotopapier. Seine Hoffnung, in Zukunft Brillengläser überflüssig zu machen, erfüllt sich nicht.

En 1926, le contre-amiral Bradley Fiske déclare la guerre au livre : sa « machine à lire » est censée réduire les imprimés à des bandes de lecture. Fiske photographie les manuscrits tapés à la machine et les développe sur du papier photographique. C'est en vain qu'il espérera rendre les lunettes superflues à l'avenir.

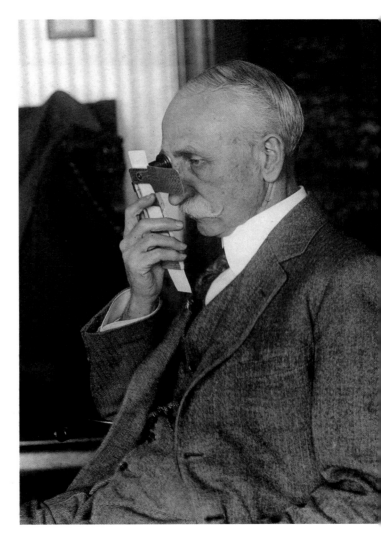

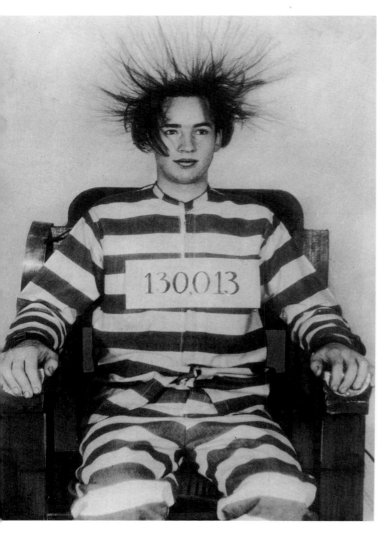

On 31 December 1931, a report stated that freshmen at Oregon Tech in Portland were being put on the "Sing-Sing Chair" by way of initiation. "He enjoyed the 200,000 volts which shot through his body." The simple rules of physics, however, tell us that nothing more than an electrostatic field is causing the young man's hair to stand on end.

Am 31. Dezember 1931 erscheint die Meldung, daß am Oregon Tech in Portland Studienanfänger auf den »Sing-Sing-Stuhl« gesetzt werden: »Er genoß 200 000 Volt, die durch seinen Körper schossen.« Das Einmaleins der Physik besagt jedoch, daß ein elektrostatisches Spannungsfeld dem Initianden die Haare zu Berge stehen läßt.

Le 31 décembre 1931, les journaux révèlent que, à l'université Oregon Tech, à Portland, les nouveaux étudiants doivent s'asseoir sur la « chaise de Sing Sing » : « Il vient de sentir 200 000 volts lui traverser le corps. » Les lois élémentaires de la physique nous apprennent en réalité qu'il suffit d'un champ de tension électrostatique pour que les cheveux se dressent sur la tête.

Denby Martin is a "cagey gentleman". On 30 December 1937, his invention allowed him to collect golf balls on the course in Phoenix, Arizona, without risk to his person. "When a stray ball comes his way, it bounces harmlessly off the wire netting of his cage."

Denby Martin ist ein umsichtiger Mann. Seine Erfindung ermöglicht es ihm, am 30. Dezember 1937 auf dem Golfplatz von Phoenix (Arizona) Golfbälle einzusammeln, ohne sich dabei in Gefahr zu begeben: »Wenn ein Irrläufer seinen Weg kreuzt, prallt er ohne Schaden am Draht des Käfigs ab.«

Denby Martin est un gentleman prudent. Son invention lui permet, le 30 décembre 1937, sur le terrain de golf de Phoenix (Arizona), de ramasser les balles sans risque. « Quand il croise la trajectoire d'une balle perdue, celle-ci ne percute que le grillage de la cage. »

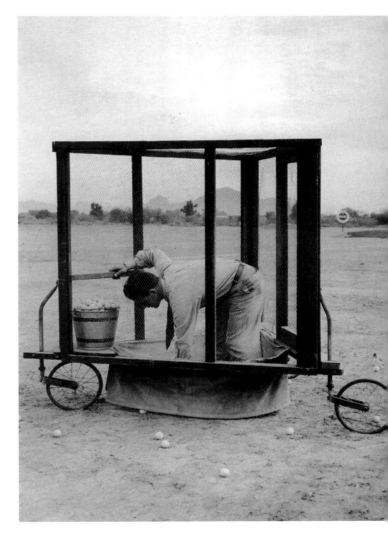

The "world's largest alarm clock" was presented by German clockmakers at an exhibition in Berlin during the 1930s. This gimmick was however indisputably overshadowed by the invention of the quartz clock with its remarkable precision, which was developed by the American Warren Melvin Marrison in 1929.

Den »größten Wecker der Welt« präsentieren deutsche Uhrmacher auf einer Ausstellung in den dreißiger Jahren in Berlin. Dieser Ausstellungsgag wird jedoch eindeutig von der Erfindung der Quarzuhr mit ihrer beachtlichen Präzision überschattet, die der Amerikaner Warren Melvin Marrison 1929 entwickelt.

Les horlogers allemands présentent « le plus grand réveil du monde » lors d'une exposition qui se tient à Berlin, dans les années 30. Ce gadget sombre cependant vite dans l'oubli avec l'avènement de la montre à quartz mise au point en 1929 par l'Américain Warren Melvin Marrison et qui se distingue par une précision incroyable.

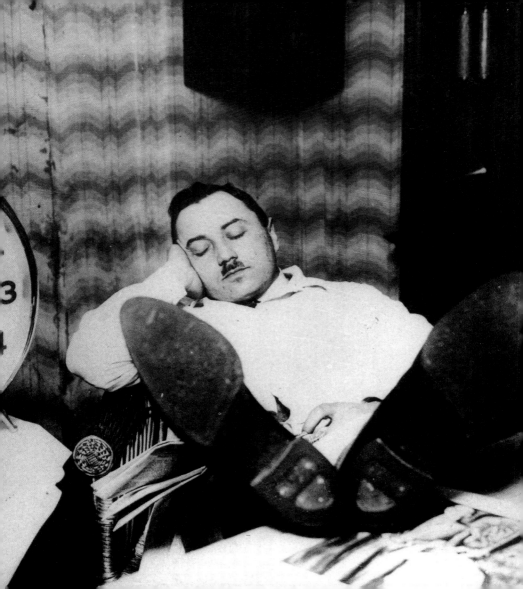

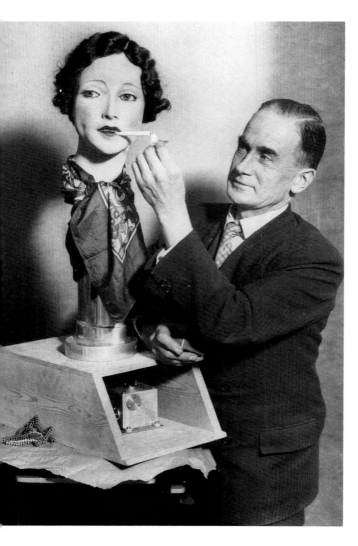

The "most human doll" was introduced by the newspapers on 17 February 1934 in the run-up to the British Industry Fair in London. With this model, sculptor Courtenay Pollock gave substance to the contemporary image of the "vamp": "She smiles, talks and smokes, gives mocking laughs and coy looks."

Im Vorfeld der Britischen Industriemesse in London stellen die Zeitungen am 17. Februar 1934 die »äußerst menschliche Puppe« vor. Der Bildhauer Courtenay Pollock verwirklicht mit diesem Modell die zeitgenössische Idealvorstellung eines Vamps: »Sie lächelt, spricht und raucht, stimmt Hohngelächter an und schaut schüchtern.«

Le 17 février 1934, peu avant la Foire de l'Industrie britannique, à Londres, les journaux présentent une « poupée très humaine ». Ce modèle dont Courtenay Pollock est le sculpteur incarne la vamp de l'époque : « Elle sourit, parle et fume, se répand en sourires dédaigneux tout en gardant un air d'ingénue. »

At the American National Congress of Inventors on 28 September 1938, the "McEase" was recommended to all those with a tendency to nod off during in lecture-halls, cinemas or theaters. This novelty may not ward off sleep, but at least it ensures correct posture.

Der »McEase« empfiehlt sich am 28. September 1938 auf dem Amerikanischen Kongreß der Erfinder in New York denjenigen, die im Kino, im Theater oder bei Vorträgen dazu neigen, einzunicken. Diese Neuheit verhindert zwar nicht das Einschlafen, gewährleistet jedoch stets eine korrekte Haltung.

Vous avez tendance à vous endormir au cinéma, au théâtre ou à une conférence ? Voilà ce qu'il vous faut : le « McEase » présenté au Congrès national américain des Inventeurs, le 28 septembre 1938 à New York. Cette nouveauté ne vous empêchera, certes, pas de dormir, mais, grâce à elle, personne ne le remarquera.

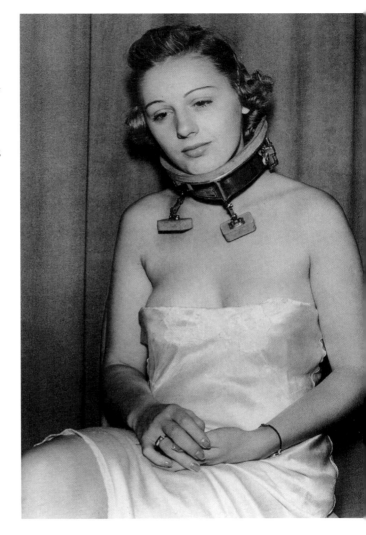

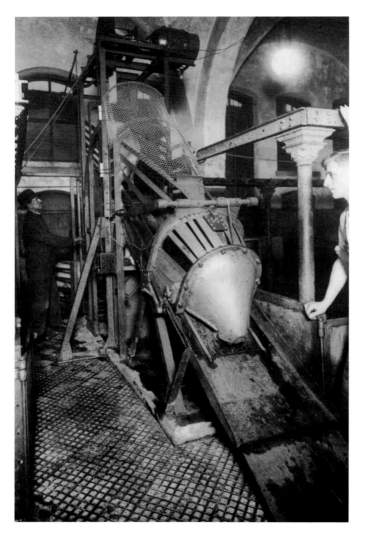

"Exclusive" German photographs of a slaughterhouse in Munich in the early 1930s showed the first automatic pig-stunning trap, called "Kitt System." The original newspaper article reports that the invention was welcomed by animal protection campaigners and slaughterhouse workers alike.

»Exklusive« deutsche Aufnahmen aus einem Schlachthof in München zeigen Anfang der dreißiger Jahre die erste automatische Schweinebetäubungsfalle, »System Kitt«. Der Original-Pressetext spricht davon, daß diese Innovation von Tierfreunden wie Schlachthofmitarbeitern gleichermaßen begrüßt wurde.

Photo prise en exclusivité dans un abattoir allemand à Munich, au début des années 30, montrant la première machine à anesthésier automatiquement les porcs, appelée « système Kitt ». Une innovation bien accueillie par les amis des animaux et les employés de l'abattoir, selon la légende initiale.

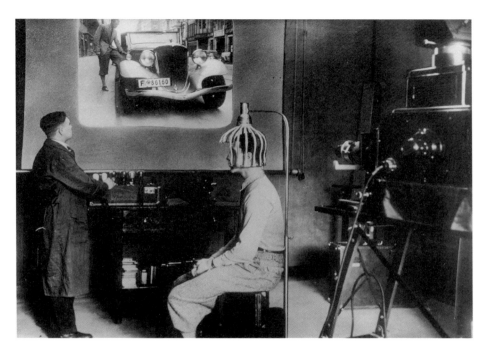

A 1930s' April Fool's joke illustrated the eternal longing to be able to read other people's thoughts: "A laboratory experiment conducted by Professor Anatole d'Aimelacque in Paris. The experimental subject is François E. R. Reur, who seems to be thinking about a drive through the Bois de Boulogne."

Ein »Aprilscherz« aus den dreißiger Jahren illustriert den ewigen Wunschtraum, die Gedanken anderer Menschen lesen zu können: »Ein Laboratoriumsversuch bei dem Pariser Professor Anatole d'Aimelacque. Als Versuchsobjekt diente François E. R. Reur, der im Augenblick des Versuchs an eine Autofahrt im Bois de Boulogne zu denken schien.«

Un « poisson d'avril » des années 30 pour montrer que l'on a toujours eu envie de lire les pensées d'autrui : « Un test en laboratoire chez le professeur parisien Anatole d'Aimelacque. Il semblerait que le cobaye, François E. R. Reur, pense à cet instant à une promenade en voiture au bois de Boulogne. »

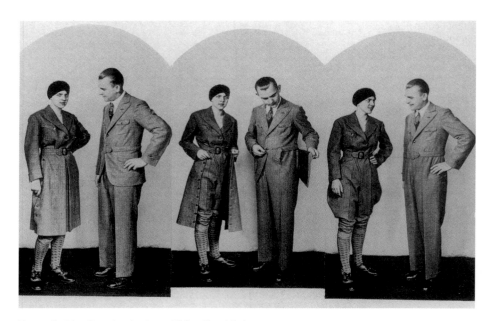

Times of crisis often give rise to multi-functional fash-
ions. In the 1930s, Berlin clothiers Baer & Sohn created
a "new patent convertible suit, made of modern sports
fabrics, which reveals its versatile potential as a gar-
ment suitable for both formal and sporting occasions."

Krisenzeiten bringen häufig einen multifunktionalen
Modestil hervor. Die Berliner Bekleidungsfirma Baer &
Sohn kreiert in den dreißiger Jahren einen »Neuen
Patent-Verwandlungsanzug, der, aus modernen Sport-
stoffen gearbeitet, seine vielfachen Verwendungs-
möglichkeiten als Straßenanzug oder Sportkostüm
offenbart«.

En période de crise apparaît souvent une mode
multifonctionnelle. La maison de confection berlinoise
Baer & Sohn crée, dans les années 30, un « nouveau
costume transformable breveté qui, taillé dans des
tissus sport modernes, est utilisable en version ville
ou sport ».

Without going more deeply into the inventor's aims, the author of the caption to this photograph conjures up the mythical aura surrounding the German inventor of the 1930s: "Observations of natural processes and natural laws are the basis of every invention. In our picture, the inventor is observing changes in crystals under mercury light."

Ohne auf das Ziel des Erfinders einzugehen, beschwört ein Autor zu dieser Aufnahme den Mythos des deutschen Erfinders der dreißiger Jahre: »Beobachtungen von Naturvorgängen und Naturgesetzen sind die Grundlage jeder Erfindung. Auf unserem Bild beobachtet der Erfinder Veränderungen an Kristallen im Quecksilberlicht.«

Négligeant l'objectif de l'inventeur, un auteur évoque, pour commenter ce cliché, le mythe de l'inventeur allemand des années 30 : « Les observations des processus naturels et des lois de la nature sont à la base de toute invention. Sur notre photo, l'inventeur observe les modifications des cristaux à la lumière du mercure. »

Whether it was planting turnips or digging asparagus, the continual stooping was torture to all those involved in agricultural work. The "iron farm-hand," introduced to the German public by an inventor in 1931, was designed to do away with all this. To no avail: it ended up in the archive of unsuccessful inventions.

Ob Rüben stecken oder Spargel stechen – das ständige Bücken bereitet den in der Landwirtschaft Tätigen körperliche Qualen. Der »Eiserne Knecht«, den ein Erfinder 1931 der deutschen Öffentlichkeit vorstellt, soll der Pein ein Ende bereiten. Er landet jedoch im Archiv der erfolglosen Erfindungen.

Planter des betteraves ou couper des asperges – à toujours être penché, on finit par avoir mal au dos. Le « valet de fer », qu'un inventeur présente en 1931 au public allemand, est censé y remédier. Il finira pourtant, lui aussi, au panthéon des inventions méconnues.

In the period immediately after the Second World War, Germany suffered a shortage of almost all the necessities of life. From this point of view, "Coko, the wonder comb, with a five-year guarantee" must have seemed something of a luxury in 1947, but this Berlin street-trader also had warm slippers for sale.

Deutschland mangelt es in der Nachkriegszeit an allen lebenswichtigen Dingen. Von daher mutet »Coko, der Wunderkamm, mit 5 Jahren Garantie und Garantieschein« aus dem Jahre 1947 eher wie Luxus an, aber diese Berliner Straßenhändlerin hat ebenfalls warme Hausschuhe im Angebot.

Durant l'après-guerre, l'Allemagne manque de toutes les choses indispensables au quotidien. « Coko, le peigne miracle garanti cinq ans, certificat à l'appui » de 1947 est plutôt un objet de luxe. Mais cette marchande ambulante berlinoise a aussi de chaudes pantoufles à son étalage.

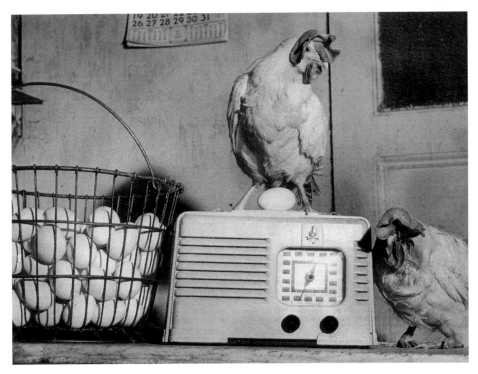

"Tune in for your omelets!" This was the headline above the article in a New York paper in 1946 about an "experiment in poultry psychology." The picture allegedly proved the discovery by self-styled "scientific egg fancier" Murray Weiss that music stimulated egg-production in his guinea fowl.

»Stell den Sender auf Omeletts ein« – unter diesem Titel informiert 1946 eine Nachricht aus New York über ein »geflügelpsychologisches Experiment«. Das Bild belegt die Erkenntnis von Murray Weiss, einem selbsternannten »Hobbywissenschaftler und Eierliebhaber«, daß Musik die Eierproduktion seiner Perlhühner stimuliert.

« Règle le poste sur omelette » – tel est l'intitulé du compte-rendu , diffusé en 1946 à New York, et consacré à une « expérience relative à la psychologie des volailles ». Le cliché est censé prouver le constat fait par Murray Weiss, qui s'est lui-même surnommé « chercheur amateur et amateur d'œufs », selon lequel la musique stimule la ponte de ses pintades.

Summer 1949 saw the advice pages of American newspapers dealing with the vital issue of how dangerous it was to play golf during a thunderstorm. Engineers of the High Voltage Engineering Laboratory at General Electric came up with an impressive answer, a recommendation to "drop your clubs and lie flat on the ground."

Die Ratgeberseiten amerikanischer Zeitungen beschäftigen sich im Sommer 1949 mit der lebenswichtigen Frage, wie gefährlich es ist, während eines Gewitters Golf zu spielen. Die Ingenieure des Hochspannungslabors der Firma General Electric demonstrieren eindrucksvoll die Antwort und erteilen den Rat: »Schleudern Sie den Schläger weg und werfen Sie sich flach auf den Boden!«

Durant l'été 1949, les pages de conseils dans les journaux américains soulèvent une question vitale : Est-il vraiment dangereux de jouer au golf pendant un orage ? Les ingénieurs du laboratoire des hautes tensions de la société General Electric semblent avoir trouvé la bonne réponse : « Jetez vite votre club et mettez-vous à plat ventre sur le green ! »

As a result of the Second World War, some 30 million Europeans, 60% of them Germans, lost their homes. By developing this portable shaving mirror, one German company tried to profit from the lack of bathrooms in many emergency apartments.

Durch den Zweiten Weltkrieg verlieren etwa 30 Millionen Europäer ihre Heimat, 60 Prozent davon sind Deutsche. Aus der Tatsache, daß in vielen Notunterkünften Badezimmer fehlen, versucht eine deutsche Firma Gewinn zu schlagen und entwickelt diesen tragbaren Rasierspiegel.

A cause de la Seconde Guerre mondiale, 30 millions d'Européens, dont 60 % d'Allemands, se retrouvent sans domicile. La pénurie de salles de bains dans de nombreux foyers provisoires a conduit une entreprise allemande à mettre au point ce miroir portatif – qui, espère-t-elle, trouvera preneur.

The American atomic bombs on Japan in 1945 ushered in the nuclear arms race between the superpowers USA and the Soviet Union. The precision of this American robot, developed to carry out work on objects contaminated by radioactivity, is demonstrated on a human subject in 1952.

Mit den amerikanischen Atombombenabwürfen in Japan beginnt 1945 der atomare Wettlauf der Supermächte USA und UdSSR. Dieser amerikanische Roboter für die Arbeit an atomar verseuchten Objekten demonstriert 1952 am menschlichen Subjekt, mit welcher Präzision er arbeitet.

Le lancement par les Américains de bombes atomiques sur le Japon, en 1945, marque le début de la course nucléaire entre les superpuissances que sont les Etats-Unis et l'URSS. Ce robot américain qui permet de manipuler des objets irradiés prouve en 1952, sur un sujet humain, de quelle précision il est capable.

Gerd Göran's waterproof blanket "Midsummer Night" represented an enhancement of bedroom comfort. The Swedish sub-editor, however, was less impressed by the fact that the blanket won 2nd prize at a Stockholm exhibition in 1957, than by the "charms wrapped up" therein.

Gerd Göran verbessert mit seiner wasserfesten Decke »Mittsommernacht« den Schlafkomfort. Den schwedischen Redakteur entzückt aber weniger die Tatsache, daß die Decke 1957 auf einer Musterschau in Stockholm den 2. Preis gewinnt, sondern er ergötzt sich an dem »Liebreiz, der in die Decke eingehüllt ist«.

Gerd Göran améliore le confort du dormeur avec sa couverture étanche « Nuit du solstice d'été ». Mais qu'importe au rédacteur suédois que la couverture ait remporté le 2e prix, à une exposition qui s'est tenue à Stockholm, en 1957. A la couverture, il préfère l'utilisatrice.

Adolf Giesin's invention did justice to the fact that German opera houses and race-courses were coming back to life. At the Munich Novelty and Inventors' Fair in June 1951, he displayed a support for opera-glasses and heavy binoculars.

Adolf Giesin trägt mit seiner Erfindung der Tatsache Rechnung, daß auf den Rängen deutscher Opernhäuser und Rennbahnen wieder Leben herrscht. Er präsentiert auf der Münchner Neuigkeiten- und Erfindermesse im Juni 1951 seine Halterung für Operngläser und schwere Ferngläser.

Adolf Giesin n'a pas manqué de constater que le public retrouve le chemin de l'opéra et des hippodromes en Allemagne. Il présente son invention à la Foire des Nouveautés et des Inventeurs de Munich en juin 1951 : un support pour lorgnettes d'opéra et grosses jumelles.

To cope with the possible failure of the radar equipment on small yachts and fishing-boats in heavy fog, Frenchman Jean Auscher developed a noise detector of futuristic design. He displayed the monster at the 1960 Brussels Inventors' Fair, eliciting the caption "Martian on board."

Für den Fall, daß das Radargerät kleiner Segelyachten und Fischerboote im Nebel ausfällt, erfindet der Franzose Jean Auscher einen Geräuschempfänger in futuristischem Design. Er stellt das Monstrum auf der Erfindermesse 1960 in Brüssel vor und verleitet den Redakteur zu der Schlagzeile: »Marsmensch an Bord«.

En cas de pannes de radar des petits voiliers et bateaux de pêche dans le brouillard, un capteur de sons au design futuriste mis au point par l'inventeur français Jean Auscher qui présente sa monstrueuse innovation à la Foire des Inventeurs de Bruxelles en 1960. Le commentaire ironique du rédacteur : « Martien à bord ».

No sooner had the bikini embarked on its triumphal march across the world's beaches in the 1950s, than traders discovered the potential of swimwear vending machines set up precisely where they were needed, on the beach. Unlike similar machines for cigarettes, drinks and candies, however, the bikini machine did not catch on.

Kaum treten in den fünfziger Jahren die Bikinis ihren Siegeszug auf den Stränden dieser Welt an, entdecken Kaufleute den Selbstbedienungsautomaten für den Verkauf von Bademoden vor Ort, am Strand. Dem Bikini-Automaten bleibt jedoch der Erfolg versagt, den bis heute der »automatische« Verkauf von Zigaretten, Getränken oder Süßigkeiten erzielt.

A peine les bikinis ont-ils commencé à triompher sur les plages du monde entier, au début des années 50, que les fabricants découvrent les avantages des distributeurs automatiques installés en bord de mer. Mais le « distributeur automatique de bikinis » ne connaîtra jamais le succès que remporte aujourd'hui encore la « vente automatique » de cigarettes, boissons et confiseries.

The blessings of technology

The explosive development of the press around the turn of the century was itself only made possible by pioneering innovations in printing and photography. In 1904, the offset process revolutionized the mass production of printed matter such as newspapers; the woodcut yielded to the printed photograph. By the middle of the century, pictures were already being relayed by wire. Technology itself became a favored topic of the newspapers and magazines. The great inventions of the 19th century were refined in the 20th. These refinements were often developed in America, because once the USA had been opened up by the railroad, the cult of technology became a component of Americanism.

The press made inventors like Thomas Alva Edison, in whose name no less than 1093 patents were registered by 1904, into icons of progress. As the 20th century matured, however, the inventor began to take a back seat. The decisive developments were now being made by the big corporations and their research departments. The two world wars, not least, gave a major boost to innovation. The technology which creates weaponry ironically simplifies and enhances the quality of civilian life.

Segen der Technik

Die rasante Entwicklung des Pressewesens um 1900 ist nur durch die bahnbrechenden technischen Innovationen in der Druckindustrie und Fotografie möglich. Der Offsetdruck revolutioniert 1904 die Herstellung von Massendrucksachen wie Zeitungen; der Holzschnitt weicht dem gedruckten Foto. Mitte der zwanziger Jahre gibt es bereits Fernübertragungen von Bildern.

Die Technik selbst wird ein Thema für Zeitungen und Illustrierte. Die großen Erfindungen des 19. Jahrhunderts werden verfeinert. Die Weiterentwicklungen sind oftmals amerikanischer Provenienz, denn spätestens seit der Erschließung der USA durch die Eisenbahn ist die Technologie-Begeisterung Teil der amerikanischen Mentalität. Die Presse stilisiert Erfinder wie Thomas Alva Edison, unter dessen Namen bis 1904 nicht weniger als 1093 Patente eingetragen werden, zu Helden des Fortschritts. Im Verlauf des 20. Jahrhunderts tritt der Erfinder jedoch in den Hintergrund – entscheidende Entwicklungen werden von den großen Konzernen und ihren Forschungsabteilungen durchgeführt. Nicht zuletzt sorgen die beiden Weltkriege für Innovationsschübe. Das Kriegsgerät steckt voller Technik, die paradoxerweise das zivile Leben vereinfacht und die Lebensqualität erhöht.

Les bienfaits de la technique

Les progrès rapides de la presse vers 1900 n'ont été possibles que grâce à des innovations techniques qui ont révolutionné l'imprimerie et la photographie. Ce fut le cas de l'impression offset en 1904 – la gravure sur bois disparaît au profit de la photo imprimée. Au milieu des années 20, déjà, on peut transmettre des clichés par télécommunication.

La technique elle-même devient un motif pour les journaux et les illustrés. Les grandes inventions du XIXe siècle se perfectionnent au cours des décennies qui suivent. Ces perfectionnements sont fréquemment dus aux Américains, car, depuis la conquête des Etats-Unis par le rail, l'enthousiasme pour la technologie fait partie intégrante de l'américanisme. La presse élève au rang de héros du progrès des inventeurs comme Thomas Alva Edison – pas moins de 1093 brevets sont déposés sous son nom jusqu'en 1904. Mais, au cours du XXe siècle, l'inventeur s'efface du devant de la scène – les progrès déterminants sont le fait de grands groupes industriels et de leurs laboratoires de recherche. Enfin, les deux guerres mondiales stimulent aussi les poussées de l'innovation. L'engin de guerre regorge d'une technique qui, fait paradoxal, simplifie le quotidien et améliore la qualité de la vie.

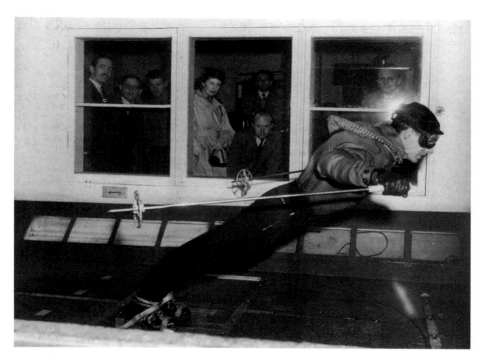

The wind tunnel was invented by Frenchman Gustave Eiffel in 1912 to investigate the characteristics of objects in flight without leaving the ground. Five decades later, in the run-up to the 1962 Winter Olympic Games in Oslo, British ski jumpers used the tunnel for an aerodynamic analysis of their technique and equipment.

Der Franzose Gustave Eiffel entwickelt 1912 den Windkanal, um am Boden die Eigenschaften von Flugobjekten zu erforschen. Fünf Jahrzehnte später dient der Tunnel auch britischen Skispringern, die vor den Olympischen Winterspielen 1962 in Oslo ihre Flugtechnik und ihr Material auf Aerodynamik überprüfen lassen.

En 1912, le Français Gustave Eiffel invente la soufflerie pour étudier, sur terre, le comportement d'objets soumis à un courant d'air artificiel. Avant de disputer les épreuves de saut à ski aux Jeux olympiques d'hiver de 1962 à Oslo, les Britanniques l'utiliseront pour tester les qualités aérodynamiques de leur technique de vol et leur matériel.

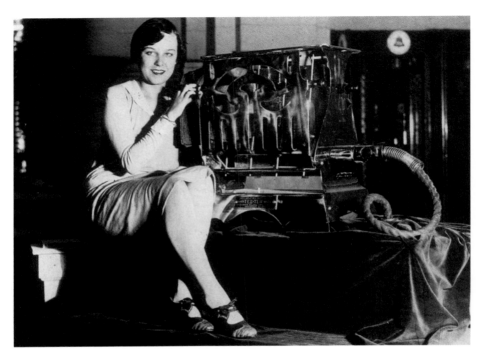

Precursors appeared on the American market as early as 1909, but the toaster was eventually patented ten years later. With a good eye for publicity, this manufacturer had a New York lady display the "world's largest toaster" at the National Electrical Exhibition in the 1920s.

Vorläufermodelle des Toasters erscheinen 1909 auf dem amerikanischen Markt, zehn Jahre später wird der Brotröster patentiert. Diese New Yorkerin stellt in den zwanziger Jahren den »größten Toast-Apparat der Welt« in eindrucksvoller Größe und werbewirksam auf der Nationalen Elektroausstellung vor.

Les premiers prototypes du grille-pain, qui sera breveté dix ans plus tard, sont présentés en 1909 sur le marché américain. Dans les années 20, cette New-Yorkaise présente « le plus grand grille-pain du monde » à la Foire nationale de l'Electricité.

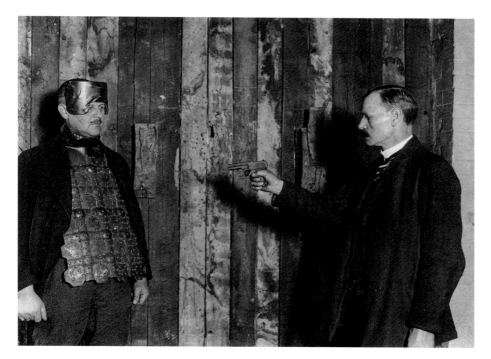

"Increasing insecurity in the city" was the reason given for the intro-
duction of bullet-proof vests for Berlin police officers in 1925. "Months
of experiment have demonstrated that this invention does indeed
afford complete protection against bullets of all kinds."

Aufgrund der zunehmenden Unsicherheit in den Großstädten werden
um 1925 für Berliner Kriminalbeamte »Panzeranzüge« eingeführt,
»nachdem durch monatelange Experimente festgestellt wurde, daß
diese Erfindung tatsächlich einen vollendeten Schutz gegen Kugeln
aller Art bietet«.

La criminalité s'aggrave dans les grandes villes et, vers 1925, les
membres de la police judiciaire berlinoise commencent à porter des
« tenues pare-balles », « de longs mois d'essai ayant prouvé que cette
invention offre réellement une protection parfaite contre les balles
de tout calibre ».

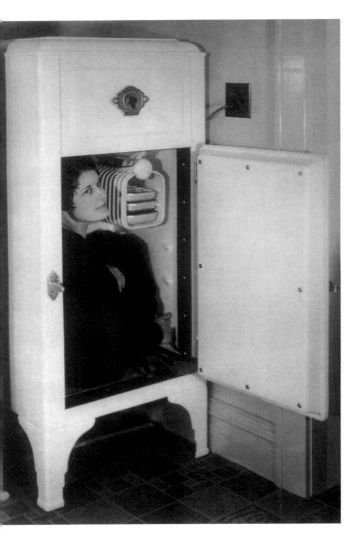

The sale of the first refrigerator for domestic use in America in 1913 was a milestone in the history of modern household management and nutrition. True, at first the appliance was no more than an exotic luxury. Thus a German sub-editor, looking at this 1920s' photograph of an American fridge, was prompted to ask: "Is this some new conservation process?"

Der Verkauf des ersten Kühlschranks für den Hausgebrauch im Jahre 1913 in den USA ist ein Meilenstein für die moderne Haushaltsführung und Ernährung. Zunächst bleibt das Gerät allerdings ein exotisches Luxusgut. Ein deutscher Redakteur stellt beim Anblick dieser Fotografie eines amerikanischen Kühlschranks aus den zwanziger Jahren die Frage: »Ein neues Konservierungsverfahren?«

C'est en 1913 que sont commercialisés les premiers réfrigérateurs domestiques aux Etats-Unis – une année à marquer d'une pierre blanche car elle annonce l'alimentation moderne et modifie les habitudes d'achat. Mais leur prix en fera longtemps un objet de luxe. L'interrogation d'un rédacteur allemand devant cette photographie d'un réfrigérateur américain des années 20 : « Un nouveau procédé de conservation ? »

In 1928 an Englishman named Richards constructed a "Man without a Soul." The first robot models – the term "robot" was coined by Czech writer Karel Čapek in 1920 – developed from the prosaic notion that total mechanization was the solution to all the world's social problems.

Der Engländer Richards baut 1928 einen »Menschen ohne Seele«. Die ersten Modelle der Roboter – ein 1920 vom tschechischen Autor Karel Čapek geprägter Begriff – entspringen prosaischen Vorstellungen, die in der vollkommenen Mechanisierung der Welt die Lösung aller gesellschaftlichen Probleme sehen.

En 1928, l'Anglais Richards construit un « homme sans âme ». Les premiers robots – terme créé en 1920 par l'écrivain tchèque Karel Čapek – sont l'illustration d'une conception prosaïque de la vie selon laquelle la mécanisation complète du monde résoudra tous les problèmes de la société.

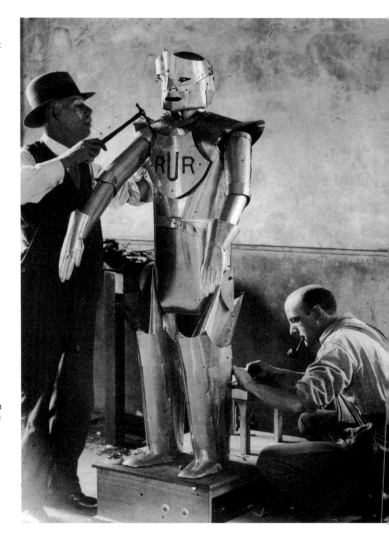

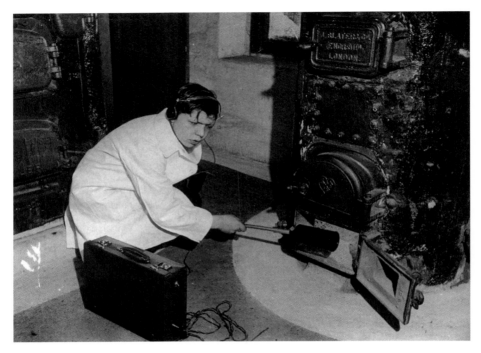

A geiger counter is used to search the boiler-house of a London hospital in the 1930s for "valuable" radium residues. Since being discovered by Marie and Pierre Curie in 1905, this radioactive substance had been deployed in cancer treatment. The initial therapeutic hopes were, however, dashed by its deleterious side effects.

Im Kesselraum eines Londoner Krankenhauses wird in den dreißiger Jahren mit einem Geigerzähler nach »wertvollen« Resten von Radium gesucht. Seit seiner Entdeckung durch das Ehepaar Curie im Jahre 1905 wird dieser radioaktive Stoff zur Behandlung von Krebserkrankungen eingesetzt. Die anfänglichen therapeutischen Hoffnungen erfüllen sich aufgrund der starken Nebenwirkungen leider nicht.

A la recherche de précieuses fractions de radium, à l'aide d'un compteur Geiger, dans la salle des chaudières d'un hôpital londonien dans les années 30. Depuis la découverte du radium par Marie et Pierre Curie, en 1905, on utilise cet élément radioactif pour soigner le cancer. Mais on constate rapidement les effets néfastes de l'utilisation thérapeutique des radioéléments.

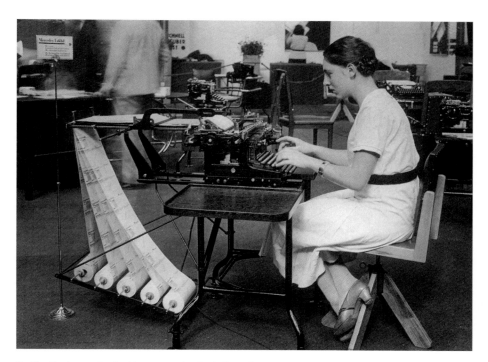

By 1875 the typewriter had become a standard piece of
equipment in the modern office, and typewriter technology
has been steadily refined ever since. This 1930s' model solves
the tiresome problem of duplication: it supplies up to 12
copies at a time.

Um 1875 erobert die Schreibmaschine einen festen Platz in
modernen Büros, und ihre Technik wird seitdem ständig
verfeinert. Diese Maschine aus den dreißiger Jahren löst
das leidige Problem der Vervielfältigung von Dokumenten:
Sie liefert bis zu 12 Durchschläge.

La machine à écrire, qui s'impose vers 1875 dans les bureaux
modernes, ne cesse dès lors d'être perfectionnée. Cet exem-
plaire des années 30 résout le fâcheux problème de la dupli-
cation des documents : elle permet d'établir jusqu'à 12 copies.

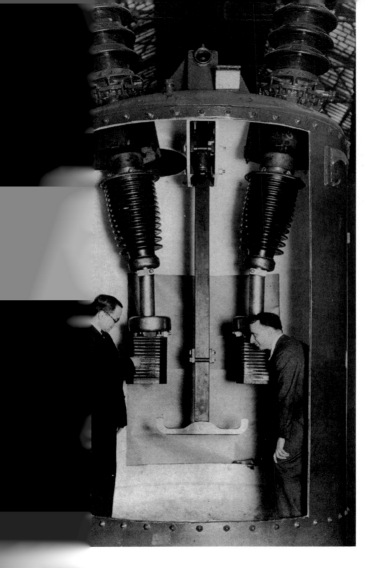

Since power stations were first built in the 1880s, oil-switches had been customarily used to switch high-tension voltages on and off. Their poor conductivity constantly led, however, to the notorious "oil-switch explosions." New switches from the USA using compressed gas were used from the 1930s on in an attempt to avoid this danger.

Beim Bau der ersten Elektrizitätswerke um 1880 werden zum Ein- und Ausschalten hoher Spannungen üblicherweise Ölschalter verwendet. Aufgrund ihrer schlechten Leitereigenschaften kommt es jedoch immer wieder zu den berüchtigten »Ölschalterexplosionen«. Seit den dreißiger Jahren soll die Verwendung neuer Schalter mit komprimiertem Gas aus den USA diese Gefahr vermeiden.

Dans les premières centrales électriques, vers 1880, on utilisait des interrupteurs à l'huile sur les lignes à haute tension. Mais, en raison de leur mauvaise conductibilité, il arrivait qu'ils « explosent ». Les nouveaux interrupteurs à gaz comprimé, en provenance des Etats-Unis, sont censés parer ce danger à partir des années 30.

French scientist Georges Claude had invented the neon lamp in 1910. In February 1939, he gave a public demonstration of applied science by experimenting with "liquid air."

Der französische Wissenschaftler Georges Claude erfindet 1910 die Neonröhre. Im Februar 1939 demonstriert er vor Publikum angewandte Wissenschaft und experimentiert mit »flüssiger Luft«.

Le scientifique français Georges Claude invente le tube au néon en 1910. En février 1939, il fait en public une démonstration de science appliquée et une expérience avec de « l'air liquide ».

The laborious search for nuggets of gold goes back to the third millennium BC. In the 1930s, Dr Gerhard Fisher from Los Angeles promised to make the search easier with the detector which he had developed. "The equipment weighs about 20 pounds and is easy to handle."

Die beschwerliche Suche nach Gold reicht bis ins 3. Jahrtausend v. Chr. zurück. Dr. Gerhard Fisher aus Los Angeles verspricht in den dreißiger Jahren Erleichterung bei der Goldsuche durch den von ihm entwickelten Detektor: »Die Anlage wiegt ca. 20 Pfund und ist für den Träger handlich konstruiert.«

Chercher des pépites d'or, une tâche ardue depuis 3000 av. J.-C. Dans les années 30, le Dr Gerhard Fisher, de Los Angeles, met au point un détecteur pour trouver plus facilement de l'or : « D'un maniement facile, la machine pèse une dizaine de kilos .»

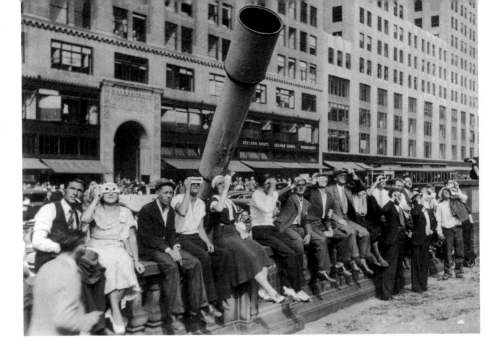

In the late afternoon of 31 August 1932, New Yorkers on Fifth Avenue had the opportunity to watch the ever-fascinating phenomenon of a solar eclipse. The first known predictions of solar eclipses date from around 2000 BC in Babylon.

New Yorker beobachten am Spätnachmittag des 31. August 1932 von der Fifth Avenue aus das immer wieder faszinierende Schauspiel einer Sonnenfinsternis. Die ersten überlieferten Vorhersagen von Sonnenfinsternissen stammen von babylonischen Astronomen um das Jahr 2000 v. Chr.

L'après-midi du 31 août 1932, des New-Yorkais observent, depuis la Fifth Avenue, le spectacle toujours fascinant d'une éclipse de soleil. Les astronomes de Babylone ont été les premiers, vers 2000 av. J.-C., à prédire des éclipses de soleil.

The First Lady of the United States, Mrs Franklin D. Roosevelt, did not give her undivided attention to the proceedings of the 2nd World Youth Congress on 21 August 1938. Modern broadcasting technology allowed her to follow the linguistic Babel of the 500 delegates from 55 countries by ear-phone, while knitting at the same time.

Eingeschränkte Aufmerksamkeit schenkt die First Lady der vereinigten Staaten, Mrs Franklin D. Roosevelt, dem Geschehen des 2. Weltjugendkongresses am 21. August 1938. Die moderne Übertragungstechnik ermöglicht ihr, zu stricken und gleichzeitig dem Sprachengewirr der 500 Delegierten aus 55 Nationen über Kopfhörer zu folgen.

La First Lady des Etats-Unis, Mrs Franklin D. Roosevelt, écoute d'une oreille distraite ce qui se dit au 2ᵉ Congrès mondial de la Jeunesse, le 21 août 1938. La technique moderne lui permet de tricoter tout en écoutant les interprètes traduire les discours de 500 délégués de 55 pays.

This German apparatus from the 1930s, known as the "Electric Man", aroused the admiration of a sub-editor, albeit tinged with incomprehension. He described it as "an appliance, which, adjusted in a certain way, mechanically performs tasks assigned to it orally." The text leaves us none the wiser.

Dieses deutsche Gerät aus den dreißiger Jahren, der »elektrische Mensch«, weckt zwar die Bewunderung, zugleich aber auch das Unverständnis eines Redakteurs: »Ein Apparat, der, in bestimmter Weise eingestellt, mündlich gegebene Aufträge mechanisch erledigt.« Mehr verrät uns der überlieferte Text nicht.

Cet appareil allemand des années 30, « l'Homme électrique », suscite autant l'admiration que le scepticisme du journaliste qui le décrit ainsi : « Un appareil qui, réglé correctement, exécute mécaniquement les ordres qui lui sont donnés par oral. » Nous n'en saurons pas plus.

The process of plucking chickens, ducks and other poultry was speeded up fivefold by this machine. With the help of a 15-pound turkey, this drum affair with rubber fingers, developed by the U.S. Rubber Company, was demonstrated by Lou Binder on 11 August 1945.

Das Rupfen von Hühnern, Enten und anderem Geflügel wird durch diese Maschine um das Fünffache beschleunigt. Am 11. August 1945 demonstriert Lou Binder diese Trommelkonstruktion mit Gummifingern, die von der U.S. Rubber Company entwickelt wurde, an einem 15 Pfund schweren Truthahn.

Cet appareil permet de plumer poulets, canards et autres volailles cinq fois plus vite qu'à la main. Le 11 août 1945, Lou Binder montre comment fonctionne cette machine à tambour et baguettes en caoutchouc mise au point par la U.S. Rubber Company. Sa victime, un dindon de 15 livres.

The Treptow Observatory near Berlin was opened in 1897. This picture, taken 35 years later, demonstrates that both technology and the art of photography had made progress in the meantime. A German commentary nevertheless maintained that the technical level of this "giant artillery-piece of German science" was still outstanding.

Die Treptower Sternwarte wird 1897 eingeweiht. 35 Jahre später wird jedoch deutlich, daß sich Fototechnik und Bildsprache weiterentwickelt haben. Ein deutscher Kommentar konstatiert dennoch, daß der technische Stand dieses »Riesengeschützes deutscher Wissenschaft« noch immer hervorragend sei.

L'observatoire de Treptow a été inauguré en 1897. Phototechnique et reproduction graphique ont fait, 35 ans plus tard, de grands progrès. Selon un commentaire allemand, ce « canon géant de la science allemande » reste pourtant quelque chose de remarquable.

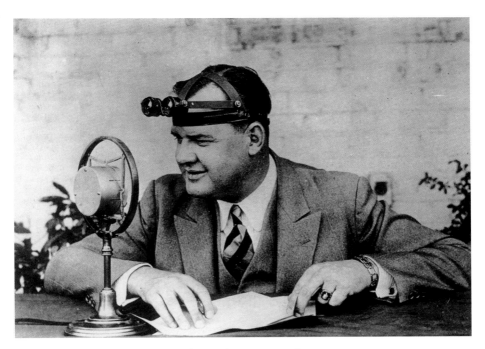

It was in the early 1920s that radio broadcasting began on a regular basis. Ten years later, events were already being broadcast live, and the sports commentator was becoming the eye of the listener. This field-glass attachment gave him an even better view, while leaving his hands free for other things.

Anfang der zwanziger Jahre nehmen verschiedene Rundfunkanstalten ihren regelmäßigen Betrieb auf. Zehn Jahre später gibt es bereits Live-Übertragungen von Veranstaltungen: Der Sportreporter wird zum Auge des Zuhörers. Diese Fernglashalterung bringt ihn noch näher an das Geschehen heran und hält ihm gleichzeitig die Hände frei.

Au début des années 20, les stations de radio commencent à émettre régulièrement. Dix ans plus tard, on peut déjà suivre des reportages en direct : le commentateur sportif devient l'œil de l'auditeur. Ce support de jumelles lui permet de suivre les choses de plus près tout en lui laissant les mains libres.

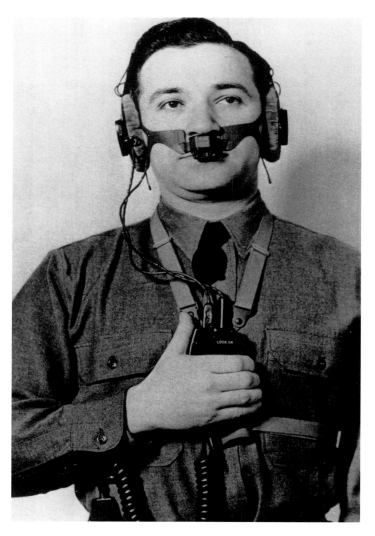

The perfection of weapons systems on land, at sea and in the air was characteristic of warfare during the Second World War. Communications technology developed to the same degree. This is an American "lip mike" for tank operators dating from 1944.

Kennzeichnend für die Kriegsführung im Zweiten Weltkrieg ist die Perfektionierung der Waffensysteme zu Lande, zu Wasser und in der Luft. Im gleichen Maße entwickelt sich die Kommunikationstechnik: hier ein amerikanisches »Lippenmikrophon« für Panzerfahrer aus dem Jahre 1944.

Au cours de la Seconde Guerre mondiale, les systèmes d'armement au sol, en mer et dans les airs se sont sans cesse perfectionnés. La technique de communication fait des progrès similaires : ici, un « micro à mettre sur les lèvres » pour conducteur de blindé, une création américaine de 1944.

In the Far East/ Pacific theater of war from 1941, a major role was played by the U.S. Navy. However, it was not the navy which brought the war in Asia to an end, but the use of the atomic bomb.

Im Zweiten Weltkrieg spielen die amerikanischen Seestreitkräfte ab 1941 im ostasiatisch-pazifischen Raum eine bedeutende Rolle. Beendet wird der Krieg in Asien jedoch nicht durch die US-Marine, sondern durch den Einsatz von Atombomben.

Lors de la Seconde Guerre mondiale, la marine américaine a joué un rôle déterminant dans le Pacifique à partir de 1941. Ce ne sera pourtant pas elle qui mettra un terme à la guerre en Asie, mais le lancement de la bombe atomique.

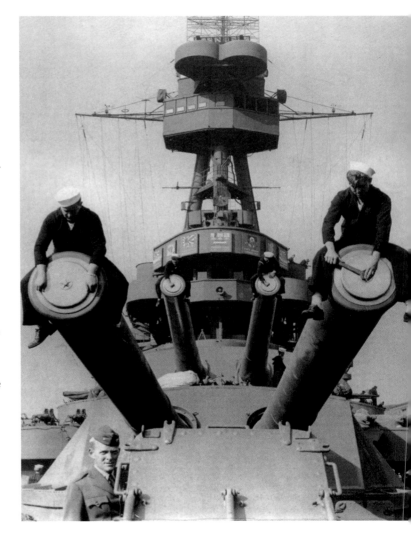

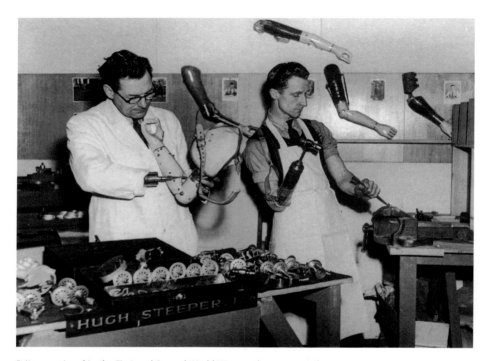

Britons maimed in the First and Second World Wars are here seen at the 1947 London exhibition "And so to Work" demonstrating the progress of a casualty from initial hospitalization to re-assimilation into society. A. Barr (left) was wounded in 1916, while R. Daish lost his arm at Tobruk in 1942 during the North African campaign.

Britische Kriegsversehrte des Ersten und Zweiten Weltkriegs zeigen im Februar 1947 bei einer Londoner Ausstellung den Weg eines Verwundeten von der Einlieferung bis hin zur Resozialisierung. A. Barr (links) wurde 1916 verwundet, R. Daish verlor seinen Arm 1942 im nordafrikanischen Tobruk.

En février 1947, à une exposition présentée à Londres, des invalides britanniques mutilés de la Première et la Seconde Guerre mondiale montrent le « parcours » d'un blessé, de son arrivée à l'hôpital à sa rééducation. A. Barr (à gauche) a été blessé en 1916. R. Daish a perdu son bras en 1942 à Tobrouk, en Lybie.

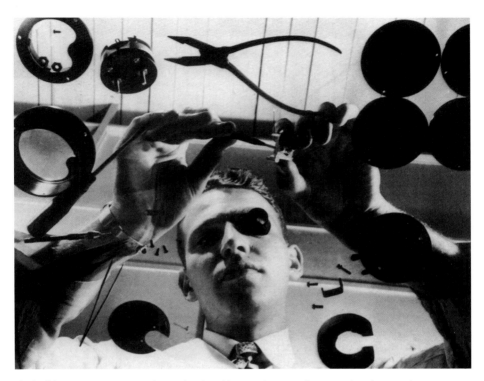

The highly accurate quartz watch was developed in 1929. In succeeding years, jewels were also used in the construction of other measuring devices to optimize their accuracy. The photographer who took this picture on 3 February 1948 chose an unusual perspective to photograph the jeweling process at the General Electric factory in Massachusetts.

1929 wird die äußerst präzise Quarzuhr entwickelt. In der Folgezeit werden auch beim Bau anderer Meßgeräte Edelsteine eingesetzt, um ihre Genauigkeit zu optimieren. Eine ungewöhnliche Perspektive wählt der Fotograf dieser Aufnahme am 3. Februar 1948, um in der Fabrik von General Electric in Massachusetts das sogenannte »Juwelieren« abzulichten.

La montre à quartz d'une précision extrême est inventée en 1929. Par la suite, on utilise aussi des pierres précieuses dans d'autres appareils de mesure pour obtenir une exactitude quasi absolue. Le 3 février 1948, le photographe choisit un angle inhabituel pour illustrer ce qu'il est convenu d'appeler le travail de joaillerie dans une usine de General Electric au Massachusetts.

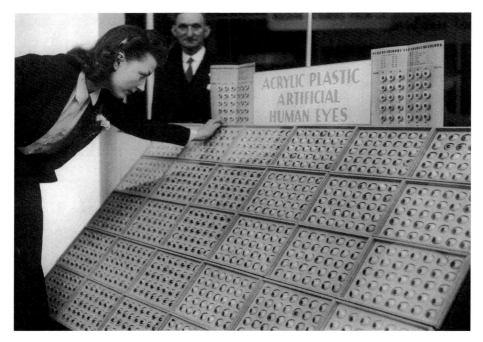

The exhibitor at this eye-stand at the 1949 British Industry Fair was called W. H. Shakespeare. In 1605, his namesake had King Lear, in the play of the same name, give the following advice to the blinded Gloucester: "Get thee glass eyes, and like a scurvy politician, seem to see the things thou dost not."

Der Aussteller dieses Augen-Standes auf der Britischen Industriemesse in London von 1949 heißt W. H. Shakespeare. Um 1605 läßt sein Namensvetter König Lear im gleichnamigen Drama dem blinden Grafen Gloucester den Rat geben: »Schaff' Augen dir von Glas, und, wie ein schändlicher Politiker, tu', als sähst du Dinge, die du doch nicht siehst.«

L'exposant à ce stand d'yeux artificiels, à la Foire de l'Industrie britannique, à Londres de 1949, s'appelle W. H. Shakespeare. Son homonyme écrivit vers 1605 *Le Roi Lear*, drame dans lequel le personnage du même nom donne au comte aveugle Gloucester ce conseil : « Procure-toi des yeux en verre et, tel un politicien mesquin, fais comme si tu voyais des choses que tu ne distingues pas en réalité ».

"Scientist John Payne has developed mechanical hands for use in radioactive environments," was the decidedly dry report accompanying this picture in a Swedish newspaper in the 1940s. The atomic bomb had inaugurated a new chapter in world politics: the era of deterrence.

»Der Wissenschaftler John Payne hat mechanische Hände für den Einsatz in radioaktivem Umfeld konstruiert«, meldet Ende der vierziger Jahre eine schwedische Zeitung betont sachlich. Mit der Erfindung der Atombombe beginnt ein neues Kapitel der Weltpolitik: die Ära der Abschreckung.

« Le scientifique John Payne a inventé des mains mécaniques pour le travail en milieu radioactif », annonce en toute objectivité, à la fin des années 40, un journal suédois. Avec la bombe atomique débute un nouveau chapitre de la politique mondiale : l'ère de la dissuasion.

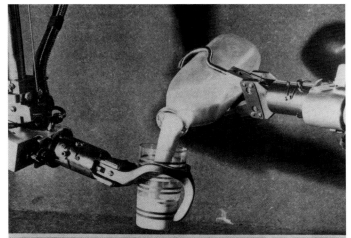

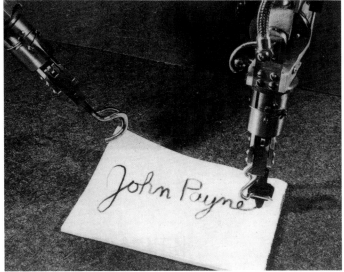

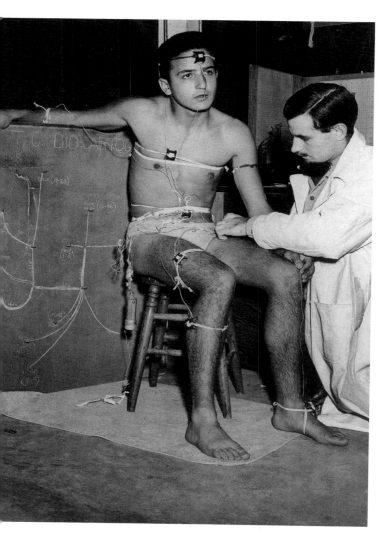

In 20th century medicine, everything is measurable. Beneath the caption "Supersonic Sizzle" these two pictures report on temperature measurements taken on students at the University of California in Los Angeles in August 1948. (1) Before the student is placed in the "Hot Box", sensors are attached to certain parts of his skin as for an electro-cardiogram. (2) The student is now in the "Hot Box". The sensors in his mouth and nose prove that the body functions as "a refrigerator". The subject registers the extraordinary heat merely as intolerably hot.

In der Medizin des 20. Jahrhunderts ist alles meßbar. Unter der Überschrift »Überschall-Brutzeln« berichten diese beiden Bilder über Temperaturmessungen an Studenten der University of California in Los Angeles im August 1948. (1) Bevor der Student in die »Hot Box« gesetzt wird, werden wie beim Elektrokardiogramm Sensoren an bestimmten Stellen der Haut angebracht.

(2) Der Student befindet sich in der »Hot Box«. Die Sensoren in Mund und Nase beweisen schließlich, daß der Körper »wie ein Kühlschrank« arbeitet: Der Proband empfindet die außergewöhnliche Hitze lediglich als unerträglich heiß.

Avec la médecine du XXᵉ siècle, tout devient mesurable. « Grésillements supersoniques » est la légende de ces deux photographies montrant des étudiants de l'Université de Californie, à Los Angeles, soumis à des tests de température en août 1948. (1) Avant de placer l'étudiant dans la « Hot Box », on procède à la pose d'électrodes à des endroits déterminés du corps comme dans le cas d'un électrocardiogramme. (2) L'étudiant est dans la « Hot Box ». Les capteurs placés dans sa bouche et sur son nez prouvent finalement que le corps fonctionne « comme un réfrigérateur », mais que la personne testée a une sensation de chaleur extrême.

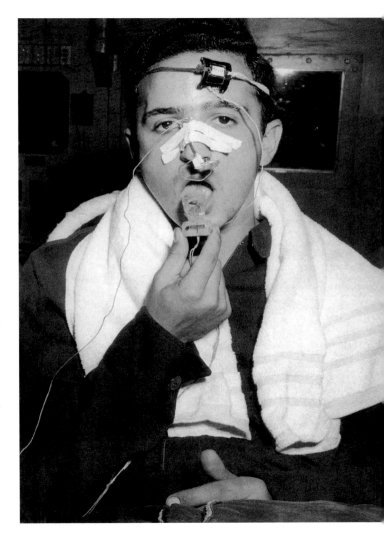

A modern snowplow clearing the way to a mountain monastery in Switzerland during the 1950s. Previously the monks had been largely cut off from the outside world in winter.

In der Schweiz schaufelt in den fünfziger Jahren ein moderner Schneepflug die Zufahrt zu einem Bergkloster frei. Bisher waren die Mönche im Winter von der Außenwelt weitgehend abgeschnitten.

En Suisse, dans les années 50, un chasse-neige moderne dégage la route menant à un monastère de montagne. Auparavant, les moines étaient presque totalement coupés du monde extérieur, en hiver.

Computer engineer Morris Vincent Wilkes inaugurated EDSAC, the world's first stored-program tube computer, the "Mechanical Brain", at the Department of Mathematics in the University of Manchester in England in 1949. The picture shows a scientist and a student working with it.

An der mathematischen Fakultät der Universität von Manchester in England nimmt der Computeringenieur Morris Vincent Wilkes 1949 den ersten speicherprogrammierbaren Röhrenrechner der Welt, EDSAC, in Betrieb. Das Bild zeigt einen wissenschaftlichen Mitarbeiter und Studenten an der Anlage.

A la faculté de mathématiques de l'université de Manchester, en Angleterre, l'ingénieur en informatique Morris Vincent Wilkes met en service, en 1949, le premier ordinateur à tubes du monde programmable par mémoire, l'EDSAC. La photo montre un assistant scientifique et des étudiants travaillant sur la machine.

The device to trace currents in the brain, known as the electroencephalogram or EEG, was invented by the German neurologist Hans Berger in 1929. By 1958, when a further development was displayed at an exhibition in Paris, the device had become an indispensable diagnostic aid.

Das 1929 von dem deutschen Neurologen Hans Berger entwickelte Elektroenzephalogramm kennt man als EEG. Auf einer Ausstellung in Paris im Jahre 1958 wird eine Weiterentwicklung des Aufzeichnungsgerätes präsentiert, das zu diesem Zeitpunkt bereits ein unverzichtbares diagnostisches Hilfsmittel darstellt.

L'électroencéphalogramme mis au point par le neurologue allemand Hans Berger en 1929 est connu sous le nom d'EEG. Lors d'une exposition à Paris, en 1958, on peut admirer une version plus perfectionnée de cet enregistreur qui est déjà devenu un appareil de diagnostic indispensable.

This practical hand-held radio transmitter-cum-receiver was manufactured in 1952 for the U.S. Army Signal Corps by the Raytheon company. But the civilian population was also benefitting from progress in radio technology. In 1954, the Regency company in America produced the first transistor radio.

Dieser praktische Handfunk-sender und -empfänger wird 1952 von der Firma Raytheon für das Fernmeldekorps der US-Armee hergestellt. Doch auch die Zivilbevölkerung profitiert von den Fortschritten der Funktechnik: 1954 produziert die amerikanische Firma Regency das erste Transistorradio.

Pratique, cet émetteur-récepteur de radio portable est fabriqué en 1952 par la société Raytheon pour les unités de télécommunication de l'Armée américaine. Mais la population civile profite aussi des progrès de la radio: en 1954, le constructeur américain Regency fabrique la première radio à transistor.

When the diagnostic instrument is bigger than the patient, it is certainly worth a photograph, as in this veterinary surgery in the United States in 1949. Invented in 1861, the stethoscope evolved into one of the most important diagnostic aids both in human and veterinary medicine.

Wenn das Diagnoseinstrument größer ist als der Patient, ist dies natürlich eine Aufnahme wert – wie 1949 in dieser amerikanischen Tierarztpraxis. Seit seiner Erfindung 1861 entwickelte sich das Stethoskop zu einem der wichtigsten ärztlichen Diagnoseinstrumente in der Human- und Tiermedizin.

Quand l'instrument de diagnostic est plus grand que le patient, cela mérite bien une photo – comme ici, en 1949, dans ce cabinet vétérinaire américain. Depuis son invention en 1861, le stéthoscope est devenu l'un des instruments de diagnostic médical le plus important de la médecine humaine et vétérinaire.

In the 1950s, the Russian Melik Bakhtamyan invented the wrist notebook. Manufacture of the device began immediately in Leningrad.

Ein Notizbuch für das Handgelenk erfindet in den fünfziger Jahren der Russe Melik Bachtamjan. In Leningrad wird umgehend mit der Fabrikation der Innovation begonnen.

Dans les années 50, le Russe Melik Bakhtamian invente le bloc-notes de poignet, une innovation dont la fabrication débute immédiatement à Leningrad.

Full speed ahead

Freie Fahrt

La voie est libre

American specialist magazines had been following the development of the automobile since the 1890s. More than 1000 tons of horse manure had to be cleared daily from the streets of New York alone in 1900; but the days of the horse and carriage were numbered – at least in America. By 1933, one American in five owned a car. Although automobile technology was developed in Europe, it was the Americans who turned the motor car into an article of mass consumption, which holds a firm place in their philosophy of life. In the American press of the 1920s, the pioneer Henry Ford occupied a position akin to that of a saint; his opinion on all matters affecting public life was reported. The figures show that Europe in 1933 was lagging far behind America in terms of "automobility." There was one car for every 20 people in France, every 23 in England, every 58 in Germany and every 108 in Italy. After the war, the European car industry largely confined itself to modest models – gas guzzlers cut to the American pattern found few buyers. In Europe, too, critical voices were raised, in view of the uninhibited macadamizing of the countryside and the growing number of traffic accidents. From the 1960s the slogan was increasingly limited: *Full speed ahead!*

Seit den 1890er Jahren verfolgen amerikanische Fachzeitschriften die Entwicklung des Automobils. Um 1900 noch fallen allein in New York City täglich über 1000 Tonnen Pferdeäpfel an. Doch die Tage von Pferd und Kutsche sind – zumindest in Amerika – gezählt. 1933 besitzt bereits jeder fünfte Amerikaner ein Auto. Die Europäer entwickeln zwar die technischen Grundlagen des Automobils, doch erst die Amerikaner machen das Auto zu einem Massenartikel, der fest in ihrer Lebensphilosophie verankert ist. Der Pionier Henry Ford nimmt in der amerikanischen Presse der zwanziger Jahre die Stellung eines Säulenheiligen ein, der zu allen Belangen des öffentlichen Lebens seine Meinung kundtut. Die Zahlen zeigen, daß Europa 1933 weit hinter der »Automobilität« Amerikas zurückliegt: Auf 20 Franzosen, 23 Engländer, 58 Deutsche und 108 Italiener kommt je ein Auto. Nach dem Zweiten Weltkrieg baut die europäische Autoindustrie bescheidene Modelle, der benzinfressende US-Straßenkreuzer kann sich hier nicht durchsetzen. Auch mehrt sich angesichts der ungehemmten Asphaltierung der Natur und der zunehmenden Unfälle die Zahl der kritischen Stimmen. Seit den sechziger Jahren gilt immer eingeschränkter: *Freie Fahrt!*

Depuis les années 90 du siècle dernier, les revues spécialisées américaines s'intéressent aux progrès de l'automobile. Vers 1900, les excréments de chevaux représentent plus de 1000 tonnes par jour rien que dans le centre ville de New York. Mais les jours du cheval et du coche sont comptés – tout au moins en Amérique. En 1933, déjà, un Américain sur cinq a une voiture. Si ce sont les Européens qui mettent au point les bases techniques de l'automobile, les Américains feront de l'automobile un bien de grande consommation ancré dans leur conception de la vie. Dans la presse américaine des années 20, le pionnier Henry Ford endosse le rôle de prophète qui donne son avis sur toutes les questions relatives à la vie publique. Les chiffres prouvent que l'Europe est, en 1933, très en retard sur « l'automobilité » de l'Amérique : on compte respectivement une voiture pour 20 Français, 23 Anglais, 58 Allemands et 108 Italiens. Après la Seconde Guerre mondiale, l'industrie automobile européenne produit des modèles simples et la belle Américaine gloutonne ne peut s'imposer sur ce continent. De surcroît, compte tenu de l'asphaltage effréné de la nature et de l'augmentation du nombre des accidents, on compte de plus en plus de détracteurs de l'automobile. A partir des années 60, la devise *la route est libre* est sujette à de plus en plus de restrictions.

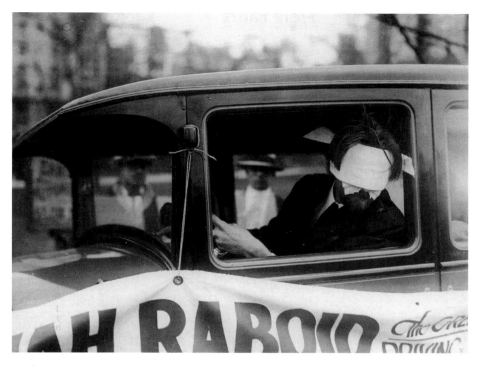

The first automobiles had hardly gone into series production around the turn of the century when the first land speed record of 143 mph (228 kph) was set up in Daytona, USA, in 1910. It was followed in the 1920s by fairground attractions like this. An Englishman drives a car around a track, his blindfold 100 percent effective. Guaranteed!

Kaum sind um 1900 die ersten Automobile in die Serienproduktion gegangen, wird 1910 in Daytona (USA) der erste Geschwindigkeitsrekord mit 228 km/h aufgestellt. In den zwanziger Jahren folgen Jahrmarktsattraktionen wie diese: Ein Engländer lenkt mit »garantiert« verbundenen Augen einen Wagen über einen Parcours.

A peine la production en série d'automobiles a-t-elle débuté que le premier record de vitesse du monde, soit 228 km/h, est établi à Daytona (Etats-Unis), en 1910. Dans les années 20, les attractions de fête foraine comme celle-ci se multiplient : un Anglais conduit une voiture, les yeux complètement bandés. Nous pouvons vous le garantir !

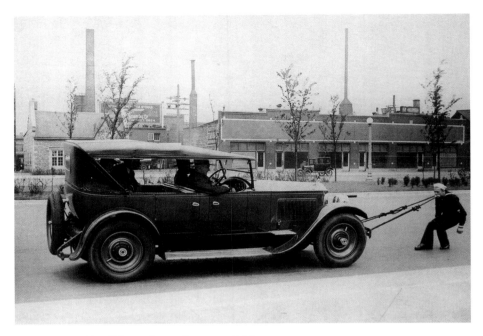

Man versus machine, Chicago, May 1926. 33-year-old John Hajnos was a fitter with the U.S. Navy. When he was not exercising his teeth by pulling limousines, he used them to unscrew bolts while his fingers were occupied breaking 12-inch (30 centimeter) nails.

Im Mai 1926 präsentiert sich in Chicago der Mensch im Kampf mit der Maschine. Wenn John Hajnos, 33 Jahre alt und Schiffsmonteur der US-Marine, mit seinen Zähnen gerade nicht Limousinen zieht, dreht er damit Schrauben los, während er mit den Fingern 30 cm lange Nägel bricht.

Chicago, mai 1926 : l'homme plus fort que la machine. Quand John Hajnos, 33 ans, mécanicien de la Marine américaine, ne déplace pas des voitures en tirant un câble qu'il retient avec les dents, il se sert de celles-ci pour dévisser des boulons tout en brisant des clous de 30 centimètres de long à mains nues.

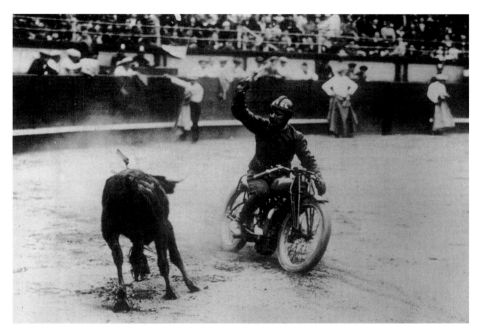

Engine noise and exhaust fumes. The bull is visibly impressed. The fascination with motorization did not stop at the gates to the bull-ring. In 1929, this toreador from northern Spain replaced his horse with a motorbike. His fellow bullfighters still prefer the good old four-legged mounts.

Motorenlärm und Abgase – der Stier ist sichtlich beeindruckt. Die Faszination der Motorisierung macht auch vor der Stierkampfarena nicht halt. Dieser nordspanische Toreador ersetzt 1929 sein Pferd durch ein Motorrad, während seine Kollegen bis heute auf den guten alten Vierbeiner schwören.

Pétarades et gaz d'échappement – le taureau est manifestement impressionné. La fascination exercée par la motorisation n'épargne pas les arènes où se déroulent des corridas. En 1929, ce toréador du Nord de l'Espagne a troqué son cheval contre une moto, contraire-ment à ses collègues qui, aujourd'hui encore, préfèrent le bon vieux quadrupède.

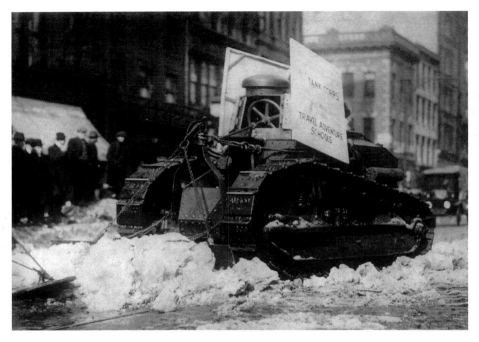

Tanks first attracted attention as war machines in Europe in 1916.
This tank, however, clears snow from the streets of Manhattan in
1924. The advertising placards attached to the vehicle tell New
Yorkers that this is an operation by the Tank Corps to publicize its
"Travel Adventure Schools."

Als Kriegsgerät sorgten Panzer erstmals 1916 in Europa für Aufsehen.
Auf den Straßen Manhattans jedoch räumt 1924 ein Panzer Schnee.
Die aufmontierten Werbeflächen klären die New Yorker darüber auf,
daß dies eine Aktion des Panzerkorps ist, das auf diese Weise für
seine »Reiseabenteuer-Schulen« wirbt.

C'est en 1916 que les chars d'assaut ont fait leur apparition sur les
champs de bataille en Europe. Dans les rues de Manhattan, par con-
tre, un char sert de chasse-neige en 1924. Les panneaux publicitaires
informent les New-Yorkais qu'il s'agit d'une opération du corps de
blindés pour promouvoir ses « écoles de voyages et d'aventures ».

Here the automobile is merely a stooge for another innovation. In less than one minute, on 6 November 1929, the "world's biggest" giant electric shovel, based at a mine in Illinois, will lift the car and the two men to a height of 50 feet (15 meters).

Hier dient das Automobil nur der Zurschaustellung einer anderen Innovation. In weniger als einer Minute wird am 6. November 1929 die »weltgrößte« elektrische Schaufel einer amerikanischen Grube in Illinois den Wagen und die beiden Personen auf eine Höhe von 15 m hieven.

Ici, l'automobile sert seulement à la présentation d'une autre innovation technique. Le 6 novembre 1929, le « plus grand excavateur électrique du monde », dans une mine de charbon de l'Illinois (Etats-Unis), va élever la voiture et les deux personnes à 15 mètres de hauteur, en moins d'une minute.

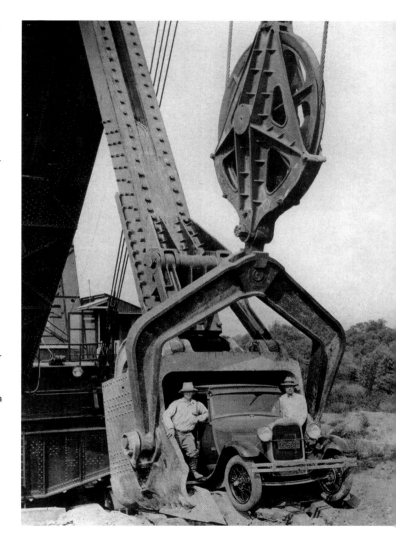

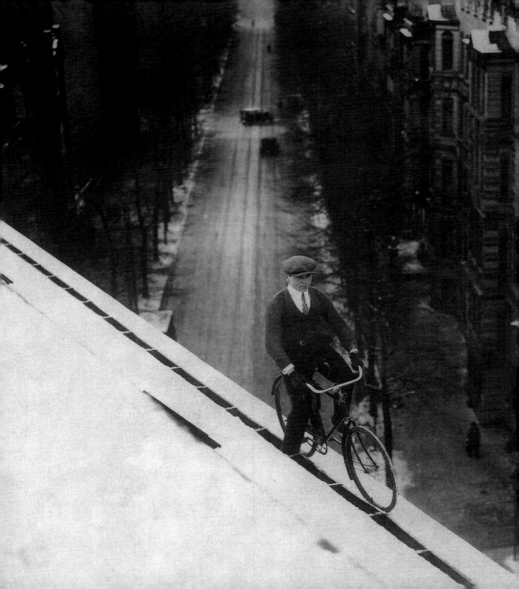

Playing with Death – the state of photographic technology in the 1920s meant that press photographers preferred outdoor shots – which led this acrobat, whose only purpose was to promote his evening appearances at one of many Berlin variety theaters, to this potentially lethal balancing act.

Spiel mit dem Tode – die Pressefotografen der zwanziger Jahre bevorzugen aufgrund der damaligen Fototechnik Außenaufnahmen, was diesen Akrobaten, der nur auf seine abendlichen Darbietungen in einem der zahlreichen Berliner Varietés aufmerksam machen möchte, zu einem todesmutigen Balanceakt verführt.

Braver la mort – les photographes de presse des années 20 privilégient les prises de vues en extérieur du fait des limites de la technique photographique de l'époque. Cela oblige cet acrobate à jouer les équilibristes et à risquer sa vie pour promouvoir sa prestation dans un spectacle présenté en soirée dans l'un des nombreux cabarets de Berlin.

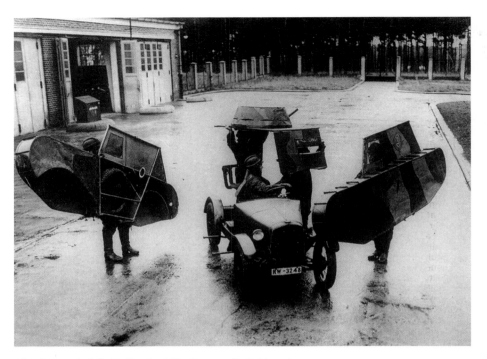

After Germany's defeat in the Great War, its army, the Reichswehr, was reduced under the terms of the 1919 Versailles Treaty to a standing force of 100,000 soldiers with restricted weaponry. Hence the malicious comment of the English sub-editor on this photograph need cause no surprise: "These tanks are really baby cars."

Die deutsche Reichswehr wird nach dem verlorenen Ersten Weltkrieg durch den Versailler Vertrag von 1919 auf ein stehendes Heer von 100 000 Soldaten mit eingeschränkter Bewaffnung reduziert. So erstaunt auch nicht der hämische Kommentator eines englischen Redakteurs: »Diese Panzer sind wirklich Spielzeugautos.«

Après avoir perdu la Première Guerre mondiale, la Reichswehr allemande est réduite à une armée de 100 000 soldats à l'armement limité conformément au Traité de Versailles de 1919. On comprend donc l'ironie du rédacteur anglais : « Ces blindés sont vraiment des voitures d'enfants ».

The low density of traffic in 1920s' London still allowed the formation of a crowd in front of the central Covent Garden produce market to watch a new world-record holder. Porter Jimmy Salisbury was able to carry 19 baskets on his head and two in his hands.

Die geringe Londoner Verkehrsdichte läßt in den zwanziger Jahren noch zu, daß sich auf der Straße vor dem Zentralmarkt am Covent Garden eine Menschentraube um einen neuen Weltrekordhalter bildet. Jimmy Salisbury vermag 19 Körbe auf dem Kopf und zwei in den Händen zu tragen.

Dans les années 20, la faible densité de la circulation à Londres permet aux curieux dans une rue non loin du marché central de Covent Garden, de faire escorte sans risque à un nouveau recordman du monde, Jimmy Salisbury, capable de transporter 19 paniers sur la tête tout en tenant un dans chaque main.

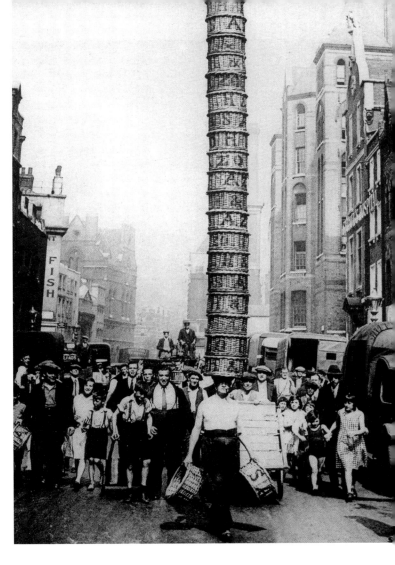

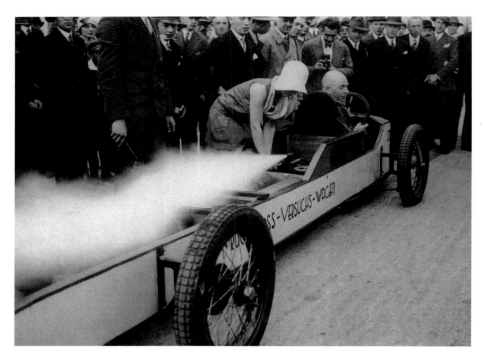

In 1928, together with Fritz von Opel, Max Valier built the first German rocket car in automobile history. Here he is seen in 1929 presenting a machine he developed single-handedly: a "recoil-driven vehicle with rocket propulsion which works totally noiselessly and without danger."

Gemeinsam mit Fritz von Opel konstruierte Max Valier 1928 den ersten deutschen Raketenwagen, der in die Automobilgeschichte eingegangen ist. Hier präsentiert er 1929 den im Alleingang entwickelten »Rückstoßwagen, dessen Antrieb durch Pulverraketen erfolgt, die völlig geräuschlos arbeitet.«

Avec Fritz von Opel, Max Valier a construit, en 1928, la première voiture-fusée allemande qui est entrée dans l'histoire de l'automobile. Ici, il présente, en 1929, la « voiture à réaction qu'il a conçue tout seul et dont la propulsion par fusée est absolument silencieuse et ne présente pas le moindre danger ».

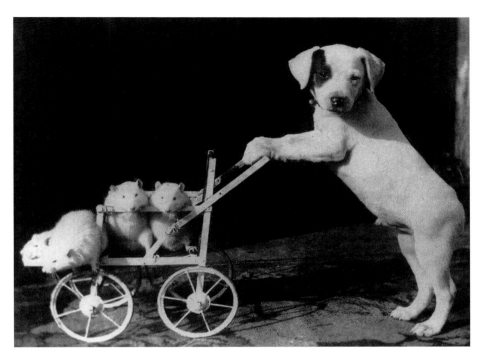

Press photographers are always on the lookout for "decorative photographs" for their weekend editions. Evergreen subjects include the weather, love, children's games and the lives and activities of pets. This idyllic scene titled "Strange Playmates" was spotted by a Berlin photographer in the 1920s.

Für die Wochenendausgabe sind Pressefotografen immer auf der Suche nach sogenannten »Schmuckbildern«. Ewige Themen sind dabei das Wetter, die Liebe, Kinderspiele oder auch das Leben und Treiben der Haustiere. Dieses Tieridyll mit dem Titel »Eigenartige Spielkameraden« entdeckt in den zwanziger Jahren ein Berliner Fotograf.

Les photographes de presse sont friands de clichés clin d'œil pour les éditions du week-end. Le temps, l'amour, des jeux d'enfants ou, tout simplement, la vie et le comportement des animaux domestiques sont les thèmes favoris. Dans les années 20, un photographe de Berlin a été témoin de cette idylle intitulée « De drôles de compagnons de jeu ».

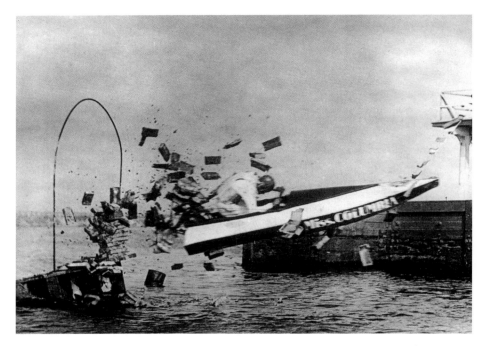

The car enthusiasts' racing bug was also caught by motor-boat operators in the 1920s. At this period, racing boats could achieve around 63 mph (100 kph). This led to "daring stunts," such as the one performed on a tour of the European lakes by Englishman Reggie Brown to entertain the crowds. This number was called "By Boat Through A Brick Wall."

Das Rennfieber der Automobilisten überträgt sich in den zwanziger Jahren auch auf die Motorbootfahrer. Rennboote erreichen zu jener Zeit etwa 100 km/h. Dies inspiriert zu tollkühnen Kunststücken, mit denen Rennbootfahrer wie der Engländer Reggie Brown auf den Seen Europas ihr Publikum begeistern. Hier der Stunt »Mit dem Boot durch die Wand«.

La fièvre de la course déteint aussi, dans les années 20, sur le motonautisme. A cette époque, les bateaux de course flirtent avec les 100 km/h, d'où les cascades spectaculaires des pilotes, comme celle de l'Anglais Reggie Brown, qui attirent le public sur les rives des lacs d'Europe. Ici la cascade « Traverser un mur en bateau ».

The Goodyear company of America, named after the inventor of vulcanization (1839), sent a giant tire on a coast-to-coast publicity trip in 1930. In the early days of advertising, those responsible put most trust in impressive on-the-spot appearances. Here the monster tire is seen rolling down New York's 42nd Street on 10 November 1930.

Die amerikanische Firma Goodyear, benannt nach dem Erfinder der Vulkanisierung (1839), schickt 1930 einen Riesenreifen auf Werbefahrt von Küste zu Küste, denn da die Werbung noch in den Kinderschuhen steckt, vertrauen die Verantwortlichen eher auf die eindrucksvolle Inszenierung ihrer Produkte vor Ort. Hier rollt das Ungetüm am 10. November 1930 durch New Yorks 42. Straße.

En 1930, la firme américaine Goodyear, du nom de l'inventeur de la vulcanisation (en 1839), fait rouler un gigantesque pneumatique d'une côte des Etats-Unis à l'autre. La publicité était encore balbutiante et les responsables de Goodyear ont choisi cette mise en scène impressionnante pour présenter leurs produits de ville en ville. Ici, un pneu géant dans la 42ᵉ Street de New York, le 10 novembre 1930.

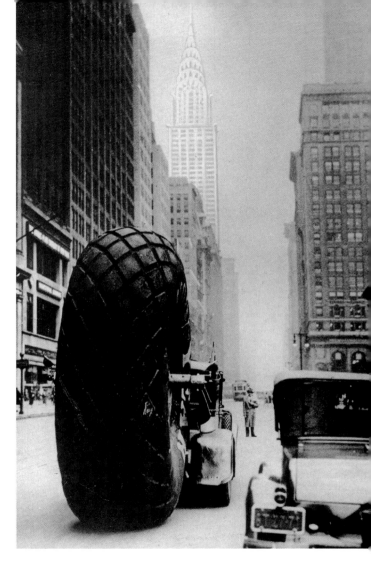

Full speed ahead 175

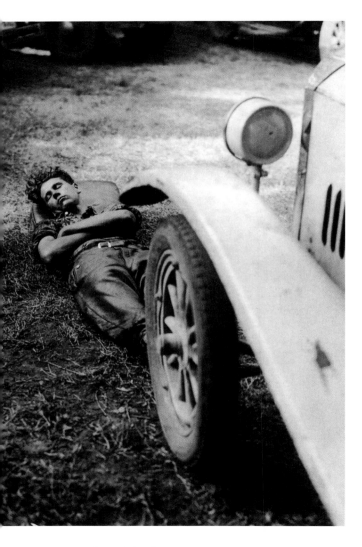

The Berlin Avus was opened with a motor race in 1921. In 1932, the racetrack hosted the German Grand Prix for the fourth time. In the motorcycle competition, driver W. Fink never got past the starting line, and lay down in the drivers' enclosure for a midday nap.

1921 wird die Berliner Avus mit einem Autorennen eröffnet. 1932 ist die Rennbahn zum vierten Mal Schauplatz des Großen Preises von Deutschland. Bei den Motorradwettbewerben kommt der Fahrer W. Fink erst gar nicht über die Startlinie hinaus und begibt sich daraufhin zum Mittagsschlaf ins Fahrerlager.

En 1921, l'Avus de Berlin est inauguré par une course automobile. En 1932, le circuit accueille, pour la quatrième fois, le Grand Prix d'Allemagne. Lors d'une course de motos, le coureur W. Fink ne parvient même pas à prendre le départ et se contente de faire la sieste au parc fermé.

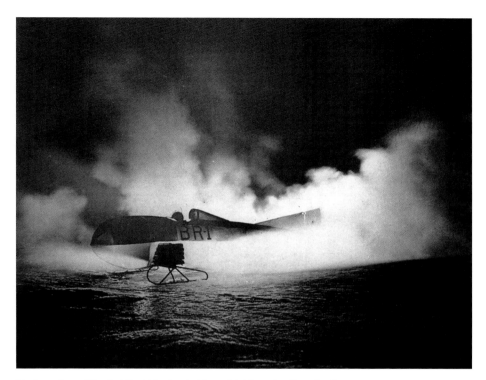

The invention of the first liquid-fuel rocket in 1926 let inventors' imaginations soar. On 10 March 1931, one such engine propelled a sled driven by Harry W. Bull, a student from Syracuse, New York state, at 110 mph (177 kph) across the marshy surface of Lake Oneida.

Die Entwicklung der ersten Raketen mit Flüssigtreibstoff im Jahre 1926 beflügelte die Phantasie der Erfinder. Harry W. Bull, ein Student aus Syracuse im Bundesstaat New York, rast am 10. März 1931 in seinem Raketenschlitten mit einer Geschwindigkeit von 177 km/h über die Sümpfe des Oneidasees.

La mise au point des premières fusées à carburant liquide, en 1926, stimule l'imagination des inventeurs. Aux commandes de son traîneau à réaction, Harry W. Bull, étudiant originaire de Syracuse, dans l'Etat de New York, survole à 177 km/h les marais du Lac Oneida, le 10 mars 1931.

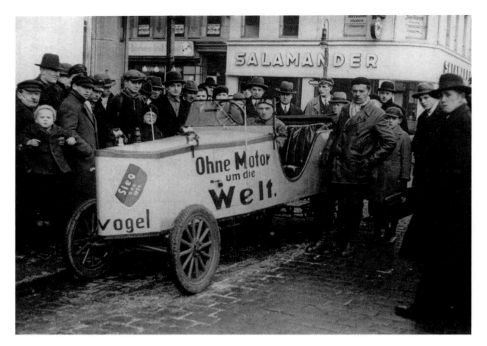

In July 1931, the international financial system temporarily broke down. The number of unemployed in Germany reached the four-million mark. Two Berliners made a virtue of necessity by setting off on a world tour in their homemade pedal driven car: "Round the World Without an Engine."

Im Juli 1931 bricht der internationale Zahlungsverkehr vorübergehend zusammen. Die Zahl der Arbeitslosen erreicht in Deutschland die 4-Millionen-Marke. Zwei Berliner machen aus der Not eine Tugend und brechen in ihrem Auto Marke Eigenbau per Pedalkraft zu einer Weltreise auf: »Ohne Motor um die Welt.«

En juillet 1931, les transactions financières internationales sont provisoirement suspendues et l'Allemagne compte quatre millions de chômeurs. Faisant contre mauvaise fortune bon cœur, deux Berlinois entament leur tour du monde au volant d'une voiture à pédales de leur fabrication : « Sans moteur autour du monde ».

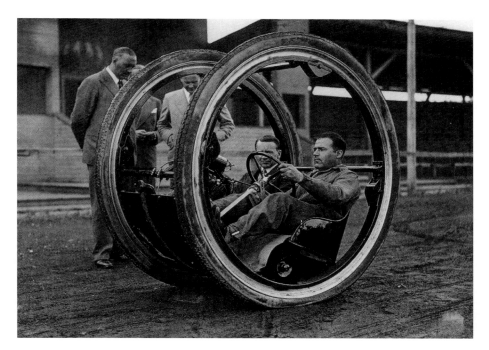

Automotive technology in the 1930s saw some curious whimsies, such as this English invention. At the same time, there were some extremely beneficial developments, such as the English civil engineer Percy Shaw's invention of the "cat's eye" in 1934.

Die Fahrzeugtechnik der dreißiger Jahre schlägt Kapriolen – wie bei dieser Entwicklung aus England. Gleichzeitig gibt es es aber auch Innovationen von hohem Nutzen. So entwickelt der englische Straßenbauingenieur Percy Shaw 1934 den Rückstrahler für Automobile.

La technique automobile des années 30 réserve bien des surprises, comme le prouve cette invention anglaise. Mais certaines innovations s'avèrent en revanche d'une réelle utilité. Ainsi le réflecteur d'automobile, mis au point en 1934 par Percy Shaw, ingénieur anglais des travaux publics.

The electric starter motor had been invented by Charles Kettering in 1911, but during the 1930s there were still many older models which had to be crank-started by hand. It was a hazardous business, because if this German lad does not succeed in pulling the crank out in time, it will continue turning with full force and could quite easily break his hand or arm.

1911 erfindet Charles Kettering den elektrischen Anlasser für Fahrzeugmotoren, doch in den dreißiger Jahren gibt es noch immer alte Modelle, die per Kurbel gestartet werden. Ein gefährliches Unterfangen, denn gelingt es diesem deutschen Jungen nicht, die Kurbel rechtzeitig abzuziehen, dreht sie mit voller Wucht weiter und droht, ihm Hände oder Arme zu brechen.

En 1911, Charles Kettering invente le démarreur électrique pour moteurs de voitures, mais, dans les années 30, il y a encore des modèles plus anciens que l'on fait démarrer à la manivelle – ce qui n'est pas sans danger. Un violent retour de manivelle et ce jeune Allemand aurait une main ou un bras cassé.

These English smiths were not just marking time in 1938.
They had cannibalized an old bicycle to provide the drive for
a grinding wheel and thus speed up their work. Electric
motors could not be taken for granted in the workshops of
this period.

In dieser englischen Schmiede in Essex wird 1938 nicht auf
der Stelle getreten. Die beiden Schmiedemeister ziehen ein
Fahrrad aus dem Verkehr, um die Arbeit am Schleifstein zu
beschleunigen. Elektromotoren sind zu jener Zeit längst
noch nicht in jeder Werkstatt selbstverständlich.

Dans cette forge anglaise de l'Essex, en 1938, on ne fait pas
du surplace. Les deux forgerons ont tout simplement
récupéré un vieux vélo pour faire tourner plus vite la meule.
A cette époque, les moteurs électriques sont, en effet, loin
d'être un équipement courant dans tous les ateliers.

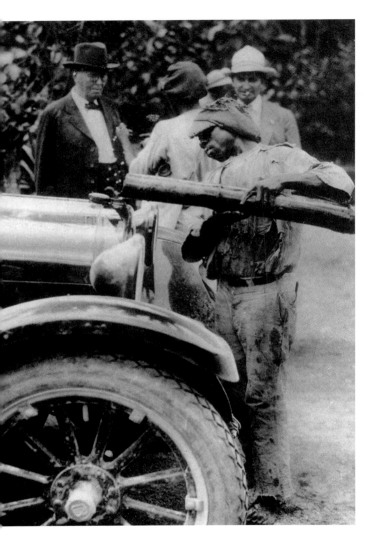

A servant fills the radiator of a car with water in the British colony of Jamaica in the 1930s. As a supplier of sugar cane and rum, the Caribbean island felt the effects of the Great Depression, too, and the resulting social conflict led to a degree of autonomy for the island in 1944.

In der britischen Kronkolonie Jamaika füllt in den dreißiger Jahren ein Bediensteter Kühlwasser in einen Wagen. Als Zuckerrohr- und Rumlieferant gerät die karibische Insel ebenfalls ins Fahrwasser der Weltwirtschaftkrise. Die ausbrechenden sozialen Konflikte bringen der Kolonie 1944 mehr Autonomie.

En Jamaïque, colonie de la Couronne britannique, un boy remplit d'eau le radiateur d'une voiture dans les années 30. Productrice de canne à sucre et de rhum, l'île des Caraïbes est affectée, elle aussi, par la crise économique mondiale et les conflits sociaux qui ont alors éclaté provoquent finalement d'importantes modifications politiques : la Jamaïque obtient une certaine autonomie en 1944.

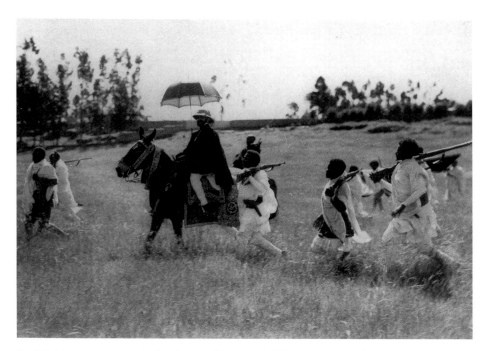

On 18 October 1935, Emperor Haile Selassie I of Abyssinia led his poorly equipped 75,000-man army into the field against Italian forces armed with tanks and aircraft. Without a formal declaration of war, Mussolini had invaded the country, now known as Ethiopia, on 3 October. The fighting ended with the formation, in 1936, of the colony of "Italian East Africa."

Der abessinische Kaiser Haile Selassie I. führt am 18. Oktober 1935 seine 75.000 Mann starke, nur leicht bewaffnete Truppe gegen die italienische Armee ins Feld, die mit Panzern und Flugzeugen ausgerüstet ist. Mussolini war am 3. des Monats ohne Kriegserklärung im heutigen Äthiopien eingefallen. Die Kampfhandlungen enden 1936 mit der Gründung der Großkolonie »Italienisch-Ostafrika«.

Le 18 octobre 1935, l'empereur abyssinien Hailé Sélassié Iᵉʳ engage son armée de 75 000 hommes à l'armement symbolique contre les troupes italiennes équipées de blindés et d'avions. Le 3 octobre, Mussolini avait envahi l'actuelle Ethiopie sans déclaration de guerre préalable. En 1936, les combats prennent fin avec la création de la grande « Colonie italienne d'Afrique orientale ».

In Romania, Joska Marouth is brought to the scene of the crime chained to the sidecar of a police motorcycle combination in 1931. He stood accused of two murders. Romania's police and judiciary were dominated by the autocratic rule of King Carol II, which in 1938 became outright dictatorship.

Der Rumäne Joska Marouth wird 1931 an den Beiwagen eines Polizeimotorrads gefesselt zu einem Lokaltermin gebracht. Er ist des zweifachen Mordes angeklagt. Polizei und Rechtsprechung in Rumänien wurden damals von der autokratischen Herrschaft König Carols II. bestimmt, die 1938 zur offenen Diktatur wird.

En 1931, le Roumain Joska Marouth ligoté dans le side-car de police est amené sur le lieu de la reconstitution des faits. Il est accusé d'un double meurtre. En Roumanie, la police et la justice sont sous les ordres du roi Carol II, souverain autocrate, qui instaurera une véritable dictature en 1938.

London's Camden Road was the scene of what strangers might have taken for unusual goings-on in the early morning of 20 August 1938. The policeman is holding up the traffic to provide a safe crossing for pigs – this was a regular occurrence in view of the proximity of the local market.

Für den Ortsunkundigen ungewöhnliche Szenen spielen sich in den Morgenstunden des 20. August 1938 in der Londoner Camden Road ab. Der Verkehrspolizist stoppt den Straßenverkehr für Schweine, die nicht nur an diesem Tag zum nahegelegenen Markt getrieben werden.

Une scène surprenante aux premières heures du 20 août 1938, dans la Camden Road de Londres. L'agent de police stoppe la circulation pour laisser passer des porcs que l'on conduit comme d'habitude au marché tout proche.

By the 1930s, the age of mobility had caught up with this German Santa Claus, too. "There are so many good children waiting for presents that he couldn't manage without a motorcycle. After all, at his age, he's not so quick on his feet."

Der zunehmenden Mobilität trägt auch dieser deutsche Weihnachtsmann in den dreißiger Jahren Rechnung: »Sankt Nikolaus muß so viele der Kleinen besuchen – da sie alle artig gewesen sind –, daß er es ohne Motorrad gar nicht schafft. Er kann sich in seinem Alter nicht mehr so beeilen.«

Dans les années 30, ce Père Noël allemand met à profit les progrès de la technique : « Sans sa moto, Saint Nicolas n'arriverait pas à se rendre chez tous les enfants qui ont été si sages et qui sont si nombreux. A son âge, il a beaucoup perdu de sa rapidité. »

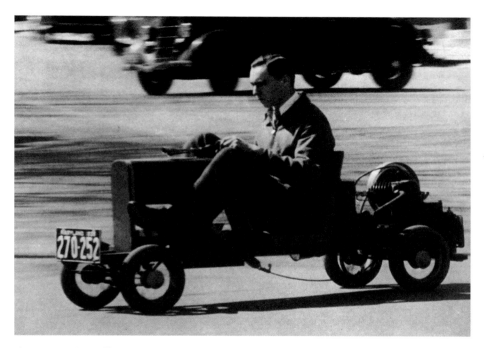

The American love-affair with spacious limousines had, it seems, not yet spread to all of Maryland by the 1930s. Small, evidently homemade, but properly registered vehicles could also be spotted on the roads. In Italy, however, the world's smallest series-produced car, the Fiat 500, left the factory in Turin for the first time in 1936.

In Maryland hat sich in den dreißiger Jahren der amerikanische Hang zu großen Limousinen noch nicht gänzlich durchgesetzt. Auch offensichtlich selbstgebaute, aber zugelassene Kleinwagen bevölkern die Straßen. In Italien hingegen ging 1936 der kleinste PKW der Welt – der Fiat 500 – in Turin in die Serienproduktion.

Dans le Maryland des années 30, les grosses voitures américaines ne se sont pas encore imposées partout. Des voiturettes, comme celle-ci apparemment construite par son conducteur, roulent dûment immatriculées. En Italie, par contre, la plus petite voiture de tourisme du monde – la Fiat 500 – est fabriquée en grande série à Turin à partir de 1936.

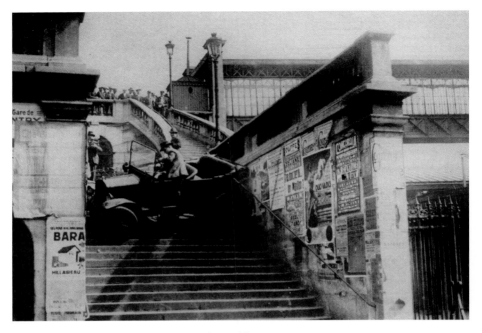

French drivers in the 1930s would brave any thoroughfare to attract attention. In view of the foolhardy operation, the poster for the film "Quo Vadis?" on the wall seems to be asking just the right question. The Latin title translates as "Where are you going?"

Um Aufsehen zu erregen, scheuen französische Automobilisten in den dreißiger Jahren auch vor unwegsamem Gelände nicht zurück. Dabei ist es nur Zufall, daß das Filmplakat »Quo vadis?« an der Wand die sinnige Frage nach dem »Wohin« dieser für Mensch und Maschine waghalsigen Unternehmung stellt.

Il semblerait que, pour attirer l'attention, les automobilistes français des années 30 ne reculent devant aucun terrain, aussi impraticable soit-il. Et ce n'est seulement par hasard que l'affiche du film « Quo vadis ? » sur le mur pose une question ironique : Où mène cette entreprise téméraire pour l'homme et la machine ?

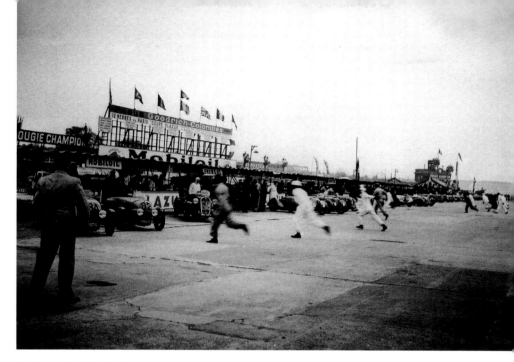

On the model of the Le Mans 24-Hour Race,
the French Automobile Sports Club organized
a "Paris 12-Hour Race" in the Parisian suburb of
Monthléry on 11 September 1938. The picture
shows the start at 6.30 in the morning.

Nach dem Vorbild der »24 Stunden von Le
Mans« richtet der französische Automobil-
sportclub am 11. September 1938 die »12 Stun-
den von Paris« in Monthléry bei Paris aus. Das
Bild zeigt den Start des Rennens um 6.30 Uhr
morgens.

S'inspirant des 24 Heures du Mans, l'Automo-
bile Club de France organise, le 11 septembre
1938, sur l'autodrome de Monthléry proche de
Paris, les 12 Heures de Paris. Les coureurs s'élan-
cent pour prendre le départ, à 6 h 30 du matin.

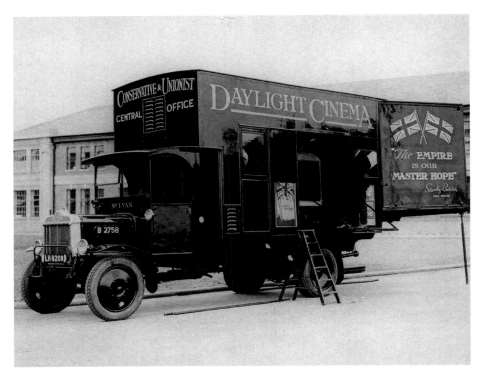

This "Daylight Cinema" was used by the Central Office of Britain's Conservative and Unionist Party to conjure up images of the good old days of the British Empire. While the Empire in fact achieved its greatest geographical extent only after the end of the First World War, by then Britain was losing its political dominance in the concert of nations to the United States.

In Freilichtkinos beschwört die Parteizentrale der Conservative and Unionist Party die guten alten Zeiten des Kolonialimperiums. Nach Ende des Ersten Weltkriegs erlangt das Britische Reich zwar seine größte geographische Ausdehnung, verliert aber seine politische Vormachtstellung im Konzert der Nationen an die USA.

Au cinéma de plein air, le bureau central du Parti conservateur fait revivre le bon vieux temps de l'Empire colonial. A la fin de la Première Guerre mondiale, l'Empire britannique atteint, certes, sa plus grande extension géographique, mais perd sa suprématie politique dans le concert des nations au profit des Etats-Unis.

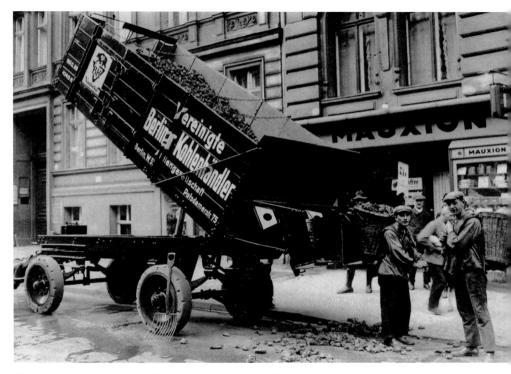

This 1930s Berlin invention was designed to keep streets and sidewalks free of coal. "The vehicle automatically fills baskets with coal and coke." A practical idea, but it did not catch on.

Für kohlefreie Straßen und Bürgersteige soll in den dreißiger Jahren diese Erfindung aus Berlin sorgen: »Der Wagen füllt selbsttätig Kohlen und Koks in Körbe.« Die praktische Idee wird sich jedoch nicht durchsetzen.

Cette invention du Berlin des années 30 se propose de faire disparaître le charbon des rues et des trottoirs : « la benne remplit automatiquement les paniers de charbon et de coke ». Pourtant bien pratique, ce système n'aura pas de succès.

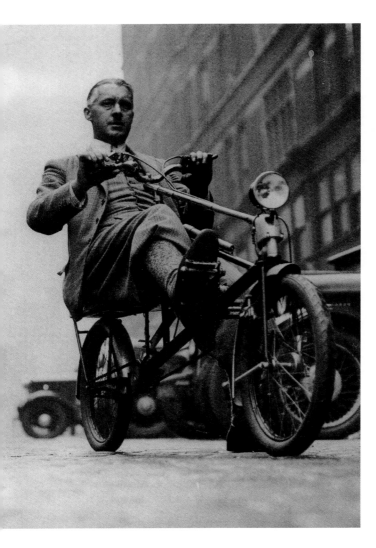

Since the first Tour de France in 1903, and the spectacular victory of Maurice Garin, the French had been considered Europe's number one cycling nation. During the 1930s, they tried to conquer the bicycle market with a new invention. Here the "velocar" is being introduced to the streets of London as "the world's fastest bicycle."

Seit der ersten Tour de France im Jahre 1903 und dem spektakulären Sieg Maurice Garins gelten die Franzosen als die Radsportnation in Europa. In den dreißiger Jahren wollen sie den Fahrradmarkt mit einer Neuentwicklung erobern. Hier wird das »Velocar« in London vorgestellt, »das schnellste Fahrrad der Welt«.

Depuis le premier Tour de France, en 1903, et la spectaculaire victoire de Maurice Garin, la France est considérée comme l'eldorado du cyclisme en Europe. Dans les années 30, les Français veulent conquérir le marché du cycle avec une innovation, le « Velocar », le « vélo le plus rapide du monde », présenté à Londres.

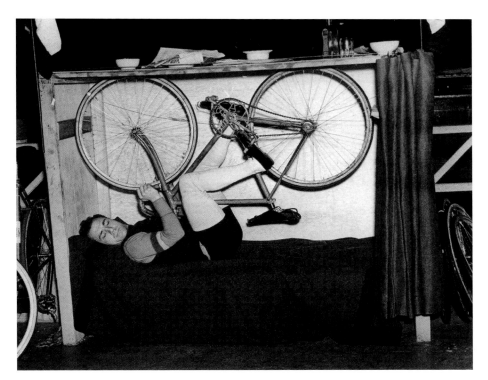

"Uninterrupted movement is the secret of success." A little joke on 1 December 1937 by French six-day racing cyclist Alfred Letourner and the photographer on the fringe of a race at Madison Square Garden. The sub-editor was pleased too: "We've discovered something new," he rejoiced.

»Ununterbrochene Bewegung ist das Geheimnis des Erfolgs.« Unter diesem Motto erlauben sich am 1. Dezember 1937 Alfred Letourner, französischer Sechs-Tage-Rennfahrer, und der Fotograf einen Spaß am Rande des Rennens im Madison Square Garden. Und der Redakteur jubelt: »Wir haben etwas Neues entdeckt.«

« Toujours se mouvoir est le secret du succès. » Le 1er décembre 1937, Alfred Letourner, coureur de Six Jours français, et le photographe se permettent une petite plaisanterie en marge de la course cycliste au Madison Square Garden pour illustrer ce crédo. Et le rédacteur de s'enflammer : « Nous avons découvert quelque chose de nouveau. »

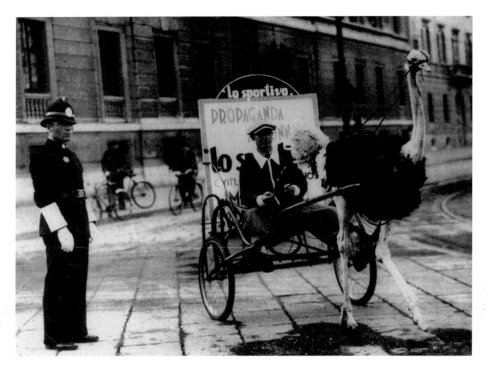

Petrol rationing in Italy produced some strange effects, as here in Milan in the spring of 1939. But given their military adventure in Albania in April, the Italians needed their reserves of fuel if they were to realize the expansionist plans of their leader Benito Mussolini.

Die Benzinrationierung in Italien treibt seltsame Blüten, wie hier in Mailand im Frühjahr 1939. Im Zuge des militärischen Vorstoßes nach Albanien im April brauchen die Italiener ihre Kraftstoffreserven, um die Expansionspolitik ihres Führers Benito Mussolini zu realisieren.

Le rationnement de l'essence en Italie a des répercussions parfois surprenantes, comme ici à Milan au printemps de 1939. Dans leur offensive militaire contre l'Albanie, en avril, les Italiens ont en effet besoin de toutes leurs réserves de carburant pour réaliser la politique expansionniste du dictateur Benito Mussolini.

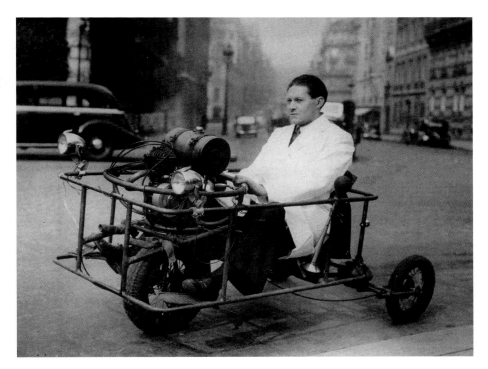

French inventor Dazin intended to use his "Dazinette" to get from Paris to Berlin in March 1936. Here he's seen introducing his one horsepower, 16 mph (25 kph) vehicle to the French capital. The eyes of the world press would soon be on Berlin – at the latest by 1 August, when the Olympic Games opened.

Der französische Erfinder Dazin plant im März 1936, mit seiner »Dazinette« von Paris nach Berlin zu fahren. Hier präsentiert er das Vehikel mit 1 PS und einer Geschwindigkeit von 25 km/h in Paris. Spätestens am 1. August würde die Weltpresse zur Eröffnungsfeier der Olympischen Spiele nach Berlin blicken.

En mars 1936, avec sa « Dazinette », l'inventeur français Dazin projette de relier Paris à Berlin. Ici, il présente, à Paris, son véhicule qui atteint une vitesse de 25 km/h avec un cheval-vapeur. Le 1er août, la presse mondiale s'intéressera plutôt à la cérémonie inaugurale des Jeux olympiques de Berlin.

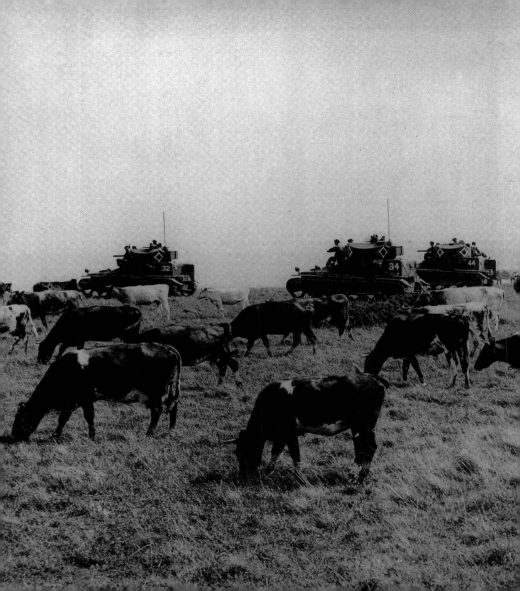

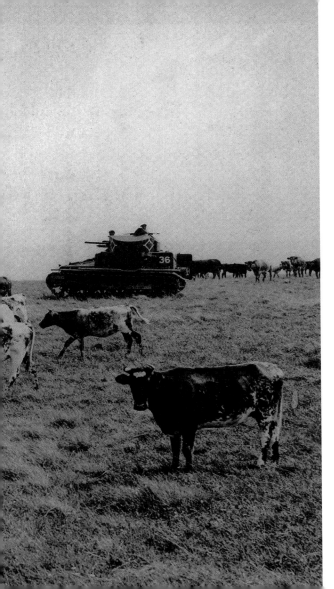

The Royal Tank Corps pictured on 17 August 1934 exercising on Salisbury Plain in England. In view of the uncertain diplomatic situation, Prime Minister James Ramsay MacDonald's coalition "National" Government was re-arming, although under his successor Stanley Baldwin the policy of "appeasement" was given greater emphasis.

Den Ernstfall probt am 17. August 1934 das Königliche Panzerkorps im englischen Wiltshire. Angesichts der unsicheren außenpolitischen Lage in Europa setzt die »Nationale« Koalition unter James Ramsay MacDonald auf Wiederaufrüstung, sein Nachfolger Stanley Baldwin hingegen betreibt ab 1935 eine internationale Politik der Beschwichtigung (»Appeasement«).

Le 17 août 1934, le Corps royal de blindés se prépare au pire dans le comté anglais du Wiltshire. Compte tenu de la précarité de la politique extérieure en Europe, la coalition nationale, sous l'égide du Premier Ministre James Ramsey MacDonald, mise sur le réarmement. A partir de 1935, le gouvernement Stanley Baldwin préconisera une politique internationale d'apaisement.

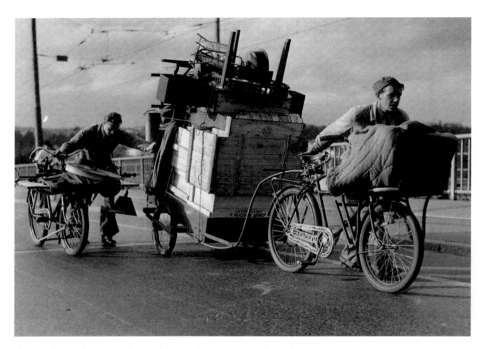

The Swedes traditionally choose the months of March and October to move house. These two Stockholm removal men are seen moving a customer's belongings on 1 October 1941. While Denmark and Norway had been occupied by German troops since April, it was business as usual in neutral Sweden.

Die klassischen Umzugstermine liegen in Schweden im März und Oktober. Diese beiden Stockholmer Möbelpacker transportieren Hab und Gut eines Klienten am 1. Oktober 1941. Während die deutschen Truppen seit April Dänemark und Norwegen besetzt halten, geht im neutralen Schweden der Alltag seinen Gang.

En Suède, on déménage généralement en mars ou en octobre. Ces deux déménageurs de Stockholm transportent tous les biens d'un de leurs clients, le 1er octobre 1941. Alors que le Danemark et la Norvège sont occupés, depuis le mois d'avril, par les troupes allemandes, en Suède, pays neutre, le quotidien a préservé ses droits.

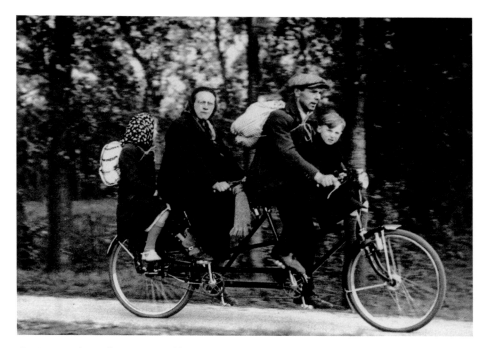

The German Blitz in the West caused large numbers of people to flee. On 27 May 1940, this Belgian family sought to reach the "safety of France" on this tandem. But on 5 June, German troops opened their offensive there too, which ended with the division of the country on 22 June.

Der deutsche Blitzkrieg im Westen führt zur Massenflucht der Bevölkerung. Am 27. Mai 1940 versucht diese belgische Familie, mit einem Tandem »das sichere Frankreich« zu erreichen. Doch auch hier beginnt am 5. Juni die Offensive deutscher Truppen, die am 22. Juni mit der Teilung des Landes endet.

La guerre éclair allemande à l'Ouest fait fuir les populations. Le 27 mai 1940, cette famille belge roule en tandem vers la France pour y trouver « la sécurité ». Mais, le 5 juin, les troupes allemandes commencent leur offensive dans ce pays qui sera divisé le 22 juin.

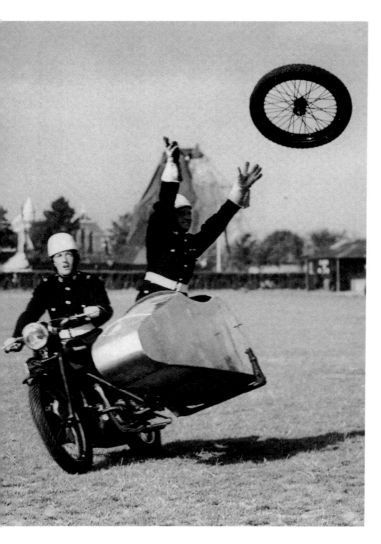

"Catch the tire!" Two English policemen seen practicing their acrobatics in the park in the summer of 1948. The eyes of the world were on London, where the first postwar Olympic Games were due to open in August. Unfortunately, the host nation won no gold medals.

»Fang den Reifen«– akrobatische Einlagen üben diese beiden englischen Polizisten im Sommer 1948 lieber auf der grünen Wiese. Alle Blicke wandten sich zu jener Zeit gen London, wo im August die ersten Olympischen Spiele seit Kriegsende stattfinden. Das Gastgeberland erringt leider keine Goldmedaille.

« Attrape la roue » – durant l'été 1948, ces deux agents de police anglais préfèrent s'entraîner dans un pré. Pendant ce temps, tous les regards sont tournés vers Londres où, en août, ont lieu les premiers Jeux olympiques de l'après-guerre. Le pays organisateur ne remportera malheureusement aucune médaille d'or.

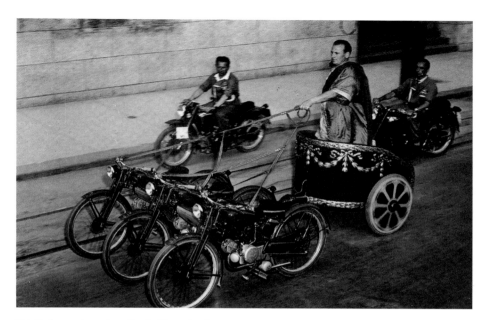

This Italian motorcycle enthusiast is paying homage to ancient Roman traditions. At the 1949 National Meeting of Motorcyclists in Lecco, he won first prize with his model "Roman Triga". A "triga" was a three-horse chariot, and indeed, he really did succeed, escorted by two outriders, in steering three motorcycles simultaneously.

Alten römischen Traditionen huldigt dieser motorradbegeisterte Italiener. Beim Nationalen Motorradtreffen in Lecco im Jahre 1949 gewinnt er den ersten Preis mit seinem Modell »Römische Triga«. Es gelingt ihm tatsächlich, eskortiert von zwei Kameraden, drei Motorräder vom Kampfwagen aus simultan zu steuern.

Cet Italien fanatique de moto fait revivre une vieille tradition romaine. Lors de la rencontre nationale des motards, à Lecco en 1949, il remporte le premier prix avec sa « Troïka à la Romaine ». Escorté par deux de ses camarades, il réussit réellement à diriger simultanément trois motos depuis son char.

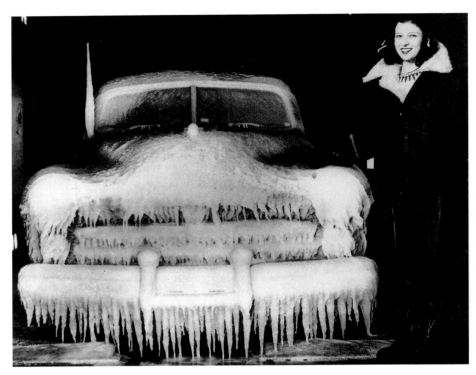

The makers of the latest Ford model, introduced in the 1947/48 season, had their car iced up in the company's wind-tunnel in Michigan for its brief and chilly press preview in 1946. This form of concealment was due not just to the fear of the competition; it also represented a piece of automobile culture.

Die Konstrukteure von Ford haben 1946 im Windkanal ihrer Firma in Michigan ihren »Erlkönig« gefrieren lassen, um der Presse einen kurzen, kühlen Blick auf das allerneueste Modell 1947/48 zu gewähren. Diese Form der Geheimhaltung beruht nicht allein auf Angst vor der Konkurrenz, sie stellt auch ein Stück Automobilkultur dar.

En 1946, à la soufflerie Ford de Michigan, les ingénieurs ont « congelé » leur prochain modèle, encore secret, pour donner à la presse un aperçu bref, mais glacial de leur toute dernière création 1947/48. Une présentation dictée par la peur de la concurrence, mais aussi un aspect de la culture automobile.

An American drama? Father and son might well have enjoyed this race on 31 October 1948, but it was in contravention of traffic regulations. While the toy car has been duly registered, the young driver has as yet no license to drive his 3000-dollar automobile. The caption informed readers that the court would reach its verdict shortly.

Amerikanisches Drama? Vater und Sohn möchten am 31. Oktober 1948 gern um die Wette fahren, sie dürfen jedoch nicht. Während das Spielzeugauto zum schlappen Preis von 3000 Dollar bereits zugelassen ist, wartet der Sohn noch immer auf die Erteilung seiner Fahrerlaubnis. Die Bildunterschrift verrät, daß das Gericht demnächst entscheidet.

Drame à l'américaine ? Le 31 octobre 1948, le père et le fils veulent se mesurer. Mais ils n'en ont pas le droit. Bien que la voiture-jouet de 3000 dollars soit déjà immatriculée, le fils n'a pas encore le permis de conduire. La légende de la photo nous révèle que la décision du tribunal est imminente.

Model makers create their own small worlds and microcosms. The greatest happiness on earth consists, however, in the public presentation of one's passion. At the 1949 Model Engineering Exhibition at the Horticultural Hall in London, R. Hammett drives young visitors on his miniature traction engine, *Free Lance*.

Modellbauer schaffen sich ihre eigene kleine Welt und herrschen über Mikrokosmen. Das höchste Glück auf Erden bleibt jedoch die öffentliche Präsentation ihrer Leidenschaft. Auf der Londoner Modellbauausstellung 1949 fährt R. Hammett jugendliche Besucher auf seinem Minitraktor *Free Lance* spazieren.

Ceux qui se passionnent pour le modélisme créent leur propre monde en miniature et dirigent des microcosmes. Présenter en public les fruits de leur passion semble être leur plus grand bonheur sur terre. À la Foire des Modèles Réduits de Londres de 1949, R. Hammett emmène se promener de jeunes visiteurs sur son minitracteur, le *Free Lance*.

Traffic density in the USA necessitated the employment of school crossing patrols. At their 13th annual parade in 1949, more than 20,000 school patrols from all the states met in Washington D.C. This traffic policeman and his son, however, seem to have forgotten, for the moment, all about road safety.

Die hohe Verkehrsdichte in Amerika bedingt den Einsatz von Schülerlotsen. Auf ihrer 13. Jahresparade 1949 treffen sich über 20 000 Lotsen aus allen Bundesstaaten in Washington D.C. Dieser Verkehrspolizist und sein Sohn scheinen für den Moment jedoch alle Verkehrspädagogik vergessen zu haben.

La densité de la circulation en Amérique oblige à faire appel à des agents de la circulation. Lors de leur 13ᵉ parade annuelle, en 1949, plus de 20 000 petits agents, venus de tous les Etats-Unis, se retrouvent à Washington D.C. Cet agent de police et son fils font oublier, un instant, tous les bons conseils de conduite.

The Redhead family attracted the attention of the photographer on a London street in August 1949. The father had installed a complete cockpit at the rear for his two-year-old son. "Now as dad drives along, the youngster copies his actions." This Englishman's quirk found no followers, however.

Auf den Straßen Londons zieht im August 1949 die Familie Redhead die Blicke der Fotografen auf sich. Der Vater hat seinem zweijährigen Sohn David ein komplettes Cockpit eingerichtet: »Nun imitiert der Sprößling während der Fahrt die Bewegungen seines Vaters.« Diese englische Marotte machte allerdings keine Schule.

Dans les rues de Londres, la famille Redhead attire les regards des photographes, en août 1949. Le père a installé un cockpit complet pour son fils David âgé de deux ans : « Maintenant, l'enfant peut copier les gestes de son père au volant. » Cette marotte anglaise ne fera cependant pas école.

1948 saw England in speed fever. The Jet 1, a gas-turbine driven automobile, was introduced to the public, and the members of private sports car clubs set out to break each other's records. Here we see J. N. Cooper in a Cooper 500 in Luton.

England befindet sich 1948 im Geschwindigkeitsrausch. Der Jet 1, ein Auto mit Gasturbinenantrieb, stellt sich der Öffentlichkeit vor, und privaten Sportwagenclubs jagen die Mitglieder persönlichen Rekorden hinterher. Hier versucht sich J. N. Cooper auf einem Cooper 500 in Luton.

En 1948, l'Angleterre succombe à l'ivresse de la vitesse. La Jet 1, une voiture propulsée par une turbine à gaz, est présentée au public. Les membres de clubs privés utilisent ce genre de voiture de sport pour tenter d'établir des records de vitesse. Ici, J. N. Cooper, sur une Cooper 500, tente sa chance à Luton.

"We maintain law and order on our roads." This little joke was staged by a Dutch photographer for his readers in 1949. The picture is one of a series in which a circus chimpanzee services his own motorcycle, sets out on a trip, and becomes entangled in a police check.

»Auf unseren Straßen herrscht Recht und Ordnung.« Diesen Spaß für die Leser inszeniert ein holländischer Fotograf 1949. Das Bild stammt aus einer Serie mit einem Zirkusschimpansen, der sein Motorrad selbst wartet, eine Spazierfahrt unternimmt und dann in eine Polizeikontrolle gerät.

« La loi et l'ordre règnent sur nos routes ». Un photographe hollandais se permet cette plaisanterie pour les lecteurs d'un journal en 1949. La photo fait partie d'une série de photos montrant un chimpanzé de cirque qui entretient lui-même sa moto et va faire une virée qu'interrompt un contrôle de la police.

While politics were causing a stir in the big wide world, a Stockholm press photographer discovered a less world-shattering event for the evening edition of 30 May 1947. "A colony of bees swarmed on the saddle of this bicycle on Malmö Street. The owner walked home."

Während in der weiten Welt die Politik hohe Wellen schlägt, entdeckt dieser Stockholmer Pressefotograf am Freitag, den 30. Mai 1947, die kleinen Dinge des Alltags für die Abendausgabe: »Ein Bienenschwarm hat sich auf diesem Fahrradsattel in der Malmögatan niedergelassen. Der Besitzer ging zu Fuß nach Hause.«

Malgré les remous de la politique dans le monde entier, les petits clins d'œil de la vie n'échappent pas à ce photographe de presse de Stockholm. C'est ainsi que cette photo paraît le vendredi 30 mai 1947 dans l'édition du soir d'un quotidien : « Un essaim d'abeilles s'est posé sur cette selle de vélo dans la Malmögatan. Bon gré mal gré, son propriétaire a dû rentrer chez lui à pied. »

The current record for London to Cape Town in 1952 was
21 days and 19 hours. At the turn of the year engineer Riandho
decided to put himself and his motor scooter to this test of
endurance. He hoped that after a successful record-breaking
trip, his model would go into series production.

Der aktuelle Rekord für die Strecke London–Kapstadt liegt 1952
bei 21 Tagen und 19 Stunden. Diesen Belastungstest für Mensch
und Material tritt zum Jahreswechsel der Ingenieur Rhiando
mit seinem Motorroller an. Er hofft, daß nach in Rekordzeit
überstandener Reise sein Modell in Serie gehen wird.

Le record actuel pour le trajet Londres–Le Cap est de 21 jours
et 19 heures en 1952, quand l'ingénieur Rhiando veut relever ce
défi pour l'homme et la machine avec son scooter à la fin de
l'année. Il espère produire son modèle en série à condition de
battre le record.

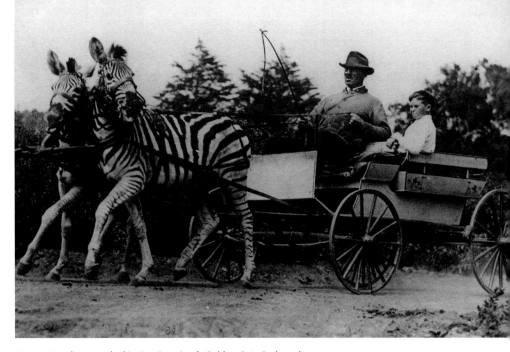

George Merchant worked in San Francisco's Golden Gate Park, and in 1952 drew attention to himself and his workplace by seeking to prove, under the eyes of the local press, that zebras were excellent draft animals – the last word in the domestication of exotic beasts.

George Merchant arbeitet im Golden Gate Park in San Francisco und macht 1952 auf sich und seinen Arbeitsplatz aufmerksam. Vor den Kameras der Lokalpresse versucht er zu beweisen, daß Zebras ausgezeichnete Zugtiere sind. Damit war auch der letzte Schritt bei der Domestizierung exotischer Tiere vollbracht.

En 1952, George Merchant, un employé du Golden Gate Park de San Francisco, veut faire parler de lui et promouvoir son lieu de travail. Devant les appareils photos de la presse locale, il tente de prouver que les zèbres font d'excellents animaux de trait. Un pas de plus est fait dans la voie de la domestication d'animaux exotiques.

On a farmyard in the southern Swedish province of Scania it may
come to pass that a pony is transported in a car. And should a photog-
rapher be present, as one was in February 1956, the event becomes a
touching story of a pony passenger's passion for automobiles.

Auf einem Bauernhof in der südschwedischen Landschaft Schonen
kommt es vor, daß ein Pony in einen Personenwagen verfrachtet
wird. Als im Februar 1956 ein Fotograf zugegen ist, wird aus dieser
Begebenheit eine rührende Geschichte über die Autoleidenschaft
eines Kleinpferdes.

Dans une ferme de la région de Schonen, dans le Sud de la Suède, il
arrive parfois qu'un poney soit transporté en voiture. Si, comme ici en
février 1956, un photographe est présent, cela fournit matière à une
histoire émouvante sur la passion d'un petit cheval pour l'automobile.

Pegasus, the flying horse who can transport creative individuals sky-wards, was the inspiration for this inventive Frenchman. On the fringe of the 1954 Autumn Household Exhibition in Paris, he presented his latest means of transport, the "Horsecycle," on the streets of the capital.

Vom Musenroß Pegasus, das kreative Menschen himmelwärts trägt, läßt sich dieser französische Erfinder inspirieren. Im Vorfeld der Herbst-ausstellung – »Rund um den Haushalt«, die 1954 in Paris stattfindet, präsentiert er im Straßenverkehr der Hauptstadt sein neuestes Mobil, das »Velo-Pferd«.

Cet inventeur français s'est inspiré du légendaire cheval Pégase qui emmène au firmament tout créateur. A la veille de la Foire des Arts ménagers qui se tient à Paris à l'automne 1954, il présente son tout nouvel engin, le « vélo hippomobile », dans les rues de la capitale.

The 1957 Geneva Motor Show saw the introduction by the Ford company of the Mercury Montclair. These five boys in the trunk show just how big the limousine is. Size was a conspicuous feature of many American models – which found little favor in Europe.

Auf dem Genfer Frühjahrssalon 1957 zeigt die Firma Ford das Modell Mercury Montclair. Die Dimensionen der Limousine verdeutlichen diese fünf Jungen, die bequem im Kofferraum Platz finden. Größe war ein markantes Merkmal der Modelle, die von den Fließbändern amerikanischer Autohersteller liefen – mit geringem Erfolg in Europa.

Au Salon de l'Automobile de Genève de 1957, Ford dévoile sa Mercury Montclair. Ces cinq jeunes garçons prenant leurs aises dans le coffre donnent une idée de ses dimensions. Les voitures qui sortent de chaînes aux Etats-Unis ont de grandes dimensions – mais elles n'ont guère de succès en Europe.

Economic realities in Europe forced car makers to think lean. Inexpensive small cars and covered scooters were popular. The "Peel P. 50" was presented at the 1962 London Motor Show. It claimed to be the world's smallest and cheapest car. "Karen Birch finds it comfortable and easy to handle."

Die wirtschaftlichen Vorzeichen in Europa zwingen die Automobilhersteller, in kleineren Dimensionen zu denken. Populär sind günstige Kabinenroller und Kleinwagen. Auf der Londoner Automobilausstellung 1962 präsentiert sich der Peel P. 50. Er rühmt sich, der kleinste und billigste Wagen der Welt zu sein: »Karen Birch findet ihn bequem und leicht zu handhaben.«

La situation économique en Europe oblige les constructeurs automobiles à faire preuve de modestie. Les voiturettes peu coûteuses connaissent alors une réelle popularité. La Peel P. 50 est prête à affronter le Salon de l'Automobile de Londres en 1962. Elle revendique le statut de voiture la plus petite et la moins chère du monde : « Karen Birch la trouve confortable et facile à garer. »

"Rickshaw boys in South Africa dress themselves up to the nines when they wait at the public transport pick-up point." In connection with the caption "Where manpower is cheapest," the sub-editor could not conceal his attitude toward apartheid, which had been state doctrine in South Africa since 1948.

»In Südafrika putzen sich die Rikscha-Fahrer heraus, wenn sie ihren Platz an der Haltstelle für ›Öffentliche Verkehrsmittel‹ beziehen.« Der Bildtitel »Wo die Arbeitskräfte am billigsten sind« verhehlt nicht die Einstellung des Redakteurs zur Apartheid, die seit 1948 Staatsdoktrin in Südafrika ist.

« En Afrique du Sud, les conducteurs de pousse-pousse se parent pour prendre leur service. ». Le rédacteur de la légende « Où la main-d'œuvre est la moins chère » ne fait pas mystère de ce qu'il pense de l'apartheid, devenue doctrine d'Etat en Afrique du Sud à partir de 1948.

Bar owner Albert Marra caused a serious car accident in Los Angeles on 28 April 1950. Officer J. D. Gilmartin was on the scene at once and, observing that Marra was staggering uncertainly out of the wreck of his station wagon, he subjected him to an immediate alcohol test. The culprit was given an on-the-spot fine.

Der Barbesitzer Albert Marra verursacht am 28. April 1950 in Los Angeles einen schweren Autounfall. Da Officer J. D. Gilmartin sofort zur Stelle ist und beobachtet, wie Marra um sein total beschädigtes Auto herumtorkelt, unterzieht er Marra einem Alkoholtest. Der Straftäter bekommt an Ort und Stelle eine Geldstrafe auferlegt.

Le 28 avril 1950, à Los Angeles, le propriétaire de bar Albert Marra cause un grave accident de la circulation. L'agent de police J. D. Gilmartin, qui s'est immédiatement rendu sur les lieux, se rend compte que Marra sort en titubant de son break totalement détruit et lui fait subir tout de suite un alcootest. Le coupable est condamné séance tenante à une amende.

Learning to fly

Photographers were on hand from the word go to record the exploits of the aviation pioneers of the late 19th century, and the press avidly printed their photos. If we can believe the Wright brothers, they were inspired by an article dating from 1894 about the gliding experiments conducted by Berlin aviator Otto Lilienthal. Nine years later, Orville Wright took off for the first-ever flight of any duration in a steerable powered aircraft. During the First World War the belligerent nations already had their Flying Corps. The "one-to-one" dogfights in the skies created press legends like the "Red Baron" Manfred von Richthofen or Frenchman René Fonck. Within a very short time, the European armed forces had transformed the fragile flying machines into robust aircraft, which in the postwar years entered into the service of civilian air transport. British aviators Alcock and Brown were the first to fly the Atlantic, but received little attention – unlike the first solo transatlantic flier Charles Lindbergh eight years later, whom the press anointed the absolute monarch of the skies. The Lindbergh euphoria generated countless imitators. The human dream of flight also expressed itself in numerous, sometimes reckless, leaps which seemed – if only for a brief moment – to defy gravity.

Flugversuche

Vom ersten Tag an begleiten Fotografen die Flugpioniere des ausgehenden 19. Jahrhunderts. Begierig druckt die Presse ihre Fotos. Glaubt man den amerikanischen Brüdern Wright, lassen sie sich 1894 von einem Artikel über die Gleitflugexperimente des Berliners Otto Lilienthal inspirieren, eigene Versuche zu unternehmen. Neun Jahre später startet Orville Wright zum ersten längeren gesteuerten Motorflug in der Geschichte. Während des Ersten Weltkriegs verfügen die kriegsführenden Nationen bereits über Fliegerkorps. Der Luftkampf »Mann gegen Mann« bringt Presselegenden wie den »Roten Baron«, Manfred von Richthofen, oder den Franzosen René Fonck hervor. Die europäischen Streitkräfte haben aus den zerbrechlichen Fluggeräten innerhalb kürzester Zeit stabile Maschinen entwickelt, die nach dem Krieg in den Dienst der zivilen Luftfahrt treten. Den Briten Alcock und Brown blieb die Ehre, als erste den Atlantik im Flugzeug zu überqueren, versagt. Statt dessen kürt die Weltpresse acht Jahre später Charles Lindbergh zum uneingeschränkten Herrscher der Lüfte. Die Lindbergh-Euphorie erfaßt von da an unzählige Menschen. Der Traum vom Fliegen äußert sich auch in mitunter waghalsigen Luftsprüngen, um die Schwerkraft – wenn auch nur für einen kurzen Moment – zu überwinden.

Apprendre à voler

D'emblée, les photographes ont accompagné dans leurs exploits des pionniers de l'aviation de la fin du XIXᵉ siècle. La presse s'est disputée leurs photos pour les reproduire. A en croire les frères américains Wright, c'est un article sur les tentatives de vol en planeur du Berlinois Otto Lilienthal qui les a incités à faire leurs propres essais, en 1894. Neuf ans plus tard, Orville Wright fait décoller son avion à moteur, pour le premier vol à longue distance piloté par un homme, dans l'histoire de l'humanité. Durant la Première Guerre mondiale, les pays belligérants possèdent déjà des escadrilles. Le combat aérien « homme contre homme » donne naissance à des légendes comme « le Baron rouge », Manfred von Richthofen, ou le Français René Fonck. En peu de temps, les armées européennes ont transformé les fragiles aéronefs en de solides machines qui, après la guerre, sont utilisées par l'aviation civile. Les Britanniques Alcock et Brown qui ont effectué la première traversée de l'Atlantique n'auront pas l'honneur d'entrer dans l'histoire, c'est de Charles Lindbergh que la presse mondiale fera, huit ans plus tard, le roi incontesté des airs. Dès lors, l'euphorie déclenchée par Lindbergh suscitera des vocations. Le rêve de l'homme, voler, donnera lieu au décollage de nombreux téméraires qui – pour un bref instant – parviennent à vaincre l'attraction terrestre.

"Look, Mom, no wings!" On 12 February 1950, three-year-old Ricki Gunderson made this attempt to overcome the law of gravity, only to disappear into the water after all. He was taking swimming lessons in America.

»Schau mal, Mami, ohne Flügel!« Ricki Gunderson versucht am 12. Februar 1950, die Schwerkraft zu überwinden, um schließlich doch kopfüber im Wasser zu verschwinden. Der Dreijährige besucht eine amerikanische Schwimmschule.

« Regarde, maman, sans ailes ! » Le 12 février 1950, Ricki Gunderson tente de se soustraire à l'attraction terrestre, le 12 février 1950, avant de disparaître finalement sous l'eau en un élégant plongeon. A trois ans, il est déjà membre d'une école de natation américaine.

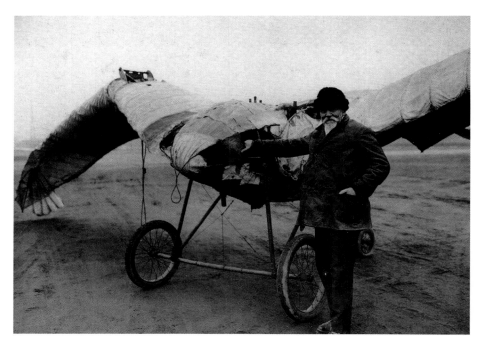

After numerous experiments with hang gliders, the German pioneer aviator Otto Lilienthal crashed to his death near Berlin in 1896. His brother Gustav (pictured here in about 1925) spent the next two decades trying to complete Otto's life's work. He died at the age of 85 while working on the construction of a flapping-wing aircraft at Berlin's Adlershof airfield.

Nach zahlreichen Versuchen mit Hängegleitern verunglückt der deutsche Flugpionier Otto Lilienthal 1896 bei Berlin. Sein Bruder Gustav (im Bild, um 1925) versucht in den folgenden zwei Jahrzehnten, Ottos Lebenswerk zu vollenden. Er stirbt im Alter von 85 Jahren bei Konstruktionsarbeiten für das Vogelschwingen-Flugzeug auf dem Berliner Flugplatz Adlershof.

Après de nombreux essais aux commandes de planeurs, le pionnier allemand de l'aviation Otto Lilienthal s'écrase à Berlin, en 1896. Son frère Gustav (sur notre photo, vers 1925) reprendra le flambeau durant les 20 années suivantes. Il meurt à 85 ans, en mettant au point son avion à ailes d'oiseau sur l'aéroport berlinois d'Adlershof.

In 1901, two years before the Wright brothers, a German-American named Whitehead undertook the first powered flight in history. The attempts by Commander Richardson on 11 February 1928, by contrast, belong to the endless series of aviation flops: his sea-plane failed to take off.

Zwei Jahre vor den Gebrüdern Wright absolviert der Deutsch-Amerikaner Whitehead 1901 den ersten Motorflug der Geschichte. Die Versuche des Commanders Richardson am 11. Februar 1928 fügen sich dagegen in die endlose Reihe der Mißerfolge ein – das Wasserflugzeug hebt nicht ab.

En 1901, deux ans avant les frères Wright, l'Américain d'origine allemande Whitehead effectue le premier vol de l'histoire à bord d'un avion à moteur. Comme tant d'autres avant et après lui, le commandant Richardson, fait le 11 février 1928 une tentative qui se solde par un échec. Son hydravion ne décolle pas.

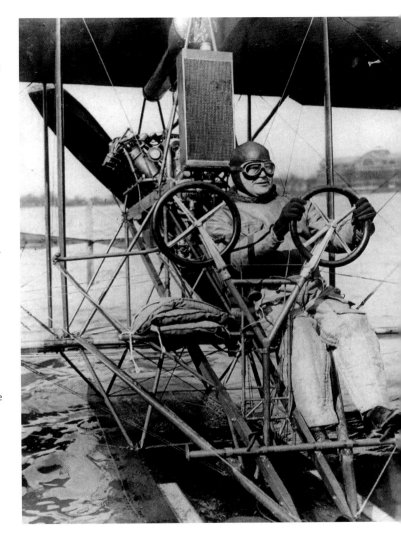

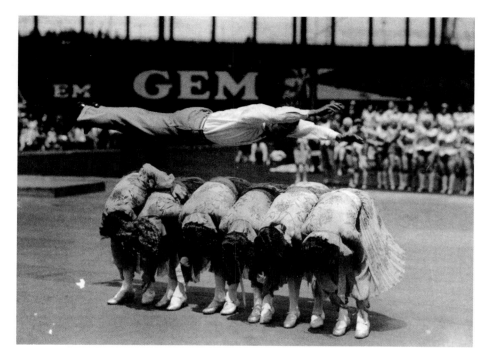

During a theatrical and sports field day on 28 June 1928 at the Polo Grounds in New York City, Nick Lang Jr. performed feats of athletic prowess for charitable purposes. The United Jewish Fund had invited 1000 Broadway stars and sportsmen to this money-raising event.

Am 28. Juni 1928 macht Nick Lang jr. während einer Sport- und Bühnenshow für wohltätige Zwecke auf dem Polospielfeld von New York City große Sprünge. Der Jüdische Fonds hat 1000 Broadway-Stars und Sportler zu dieser Benefizveranstaltung eingeladen.

Lors d'une manifestation de bienfaisance avec des célébrités de la scène et des stades, le 28 juin 1928, Nick Lang junior accomplit des prouesses sportives sur le terrain de polo de New York City. Le Fonds d'entraide juif avait invité 1000 célébrités, des athlètes et des stars de Broadway à ce gala humanitaire.

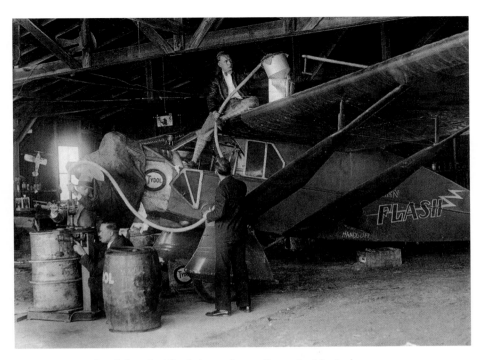

When Charles Lindbergh flew the Atlantic in 1927, he was the 93rd aviator to do so – only in his case he was solo and took just 33 hours and 39 minutes. It was a worldwide sensation, unleashing a wave of aviation euphoria. On 28 May 1929, in the state of Maine, these four gentlemen were photographed preparing their aircraft *Green Flash* for a flight to Rome.

Wie bereits 92 Flieger vor ihm überquert Charles Lindbergh 1927 den Atlantik, nur vollbringt er diese Leistung in 33 Stunden 39 Minuten im Alleinflug – eine Weltsensation, die eine wahre Flugeuphorie auslöst. Diese vier Herren bereiten am 28. Mai 1929 ihre Maschine *Grüner Blitz* im US-Bundesstaat Maine für den Flug nach Rom vor.

Comme 92 aviateurs avant lui déjà, Charles Lindbergh effectue la traversée de l'Atlantique en 1927. Mais c'est en 33 heures et 39 minutes et seul aux commandes qu'il réalise cet exploit – une sensation mondiale qui déchaîne l'engouement pour l'aviation. Le 28 mai 1929, ces quatre hommes préparent leur appareil, l'*Eclair vert*, dans l'Etat fédéré américain du Maine, avant de s'envoler pour Rome.

In the mid-1920s, grand German plans lay behind this attempt to use a powered aircraft to haul the glider *Espenlaub* (Aspen Leaf) into the air on a cable. The intention was to start a regular service, with a "locomotive" aircraft towing unpowered "wagons", which could be individually uncoupled to land at the place required.

Große deutsche Pläne standen Mitte der zwanziger Jahre hinter diesem Versuch, den Gleiter *Espenlaub* per Seil mit einem Motorflugzeug in die Luft zu hieven. Man beabsichtigte, einen Linienverkehr einzurichten: Eine »Lokomotive« zieht motorlose »Waggons«, die sich je nach Bedarf über dem gewünschten Ort ausklinken sollen.

Un ambitieux projet allemand prend forme, vers le milieu des années 20, avec ce planeur baptisé *Espenlaub* (Tremble comme une feuille) qu'un avion à moteur emmène jusqu'à l'altitude souhaitée. Ses promoteurs envisagent de créer une ligne régulière avec une « locomotive aérienne » tractant des « wagons » sans moteur se désolidarisant quand ils survolent l'endroit où ils sont censés se poser.

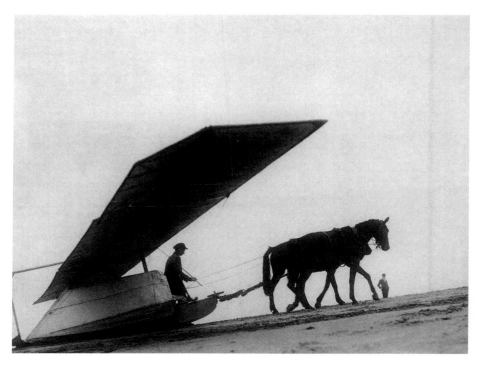

No matter how ambitious the plans or how absurd the experiments, the 1920s saw the spread of aviation fever throughout Europe and America. Many gliding clubs were formed, which arranged flying competitions like this one operating with 2 horsepower in the Rhön hills in Germany.

Auch wenn die Pläne noch so ehrgeizig und die Flugversuche noch so absurd sind, entwickelt sich in ganz Europa und Amerika in den zwanziger Jahren eine Flugeuphorie. So entstehen viele Segelfliegerclubs, die Flugwettbewerbe veranstalten, wie hier im deutschen Mittelgebirge Rhön.

Quelle que soit l'ambition du projet et l'absurdité des tentatives de décollage, toute l'Europe et l'Amérique s'enflamment, dans les années 20, pour l'aviation. Ainsi voit-on naître d'innombrables clubs de vol à voile qui, comme ici, dans les montagnes du centre de l'Allemagne, organisent des concours de vol.

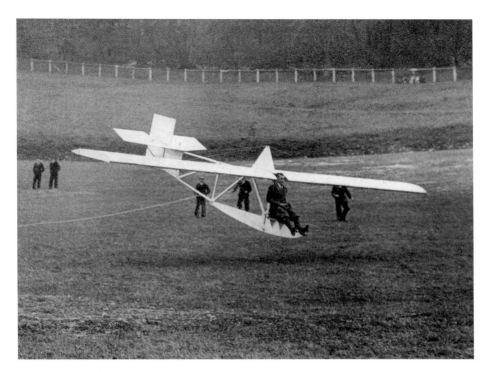

The English were also infected by the gliding bug. These glider pilots were photographed practicing their landing skills in the Chiltern Hills to the north-west of London on 3 April 1930. The numerous flying clubs prepared their members for taking the gliding license test.

Das »Gleiterfieber« infizierte auch die Engländer. In den Chilterns nordwestlich von London üben diese Segelflieger am 3. April 1930 die Landung. Die zahlreichen Fliegerclubs bereiten ihre Mitglieder auf den Erwerb eines Segelflugscheins vor.

La « fièvre des planeurs » sévit également en Grande-Bretagne. Dans les Chilterns, au nord-ouest de Londres, ces amateurs de vol à voile s'exercent à atterrir, le 3 avril 1930. Les nombreux aéro-clubs entraînent leurs membres pour obtenir leur licence de pilote.

Actor Richard Talmadge had already paid for his passion for daring leaps with a few broken vertebrae in his neck and a sprained back. This stunt, in 1926, was an attempt to clear 17 feet 6 inches (5.5 meters). "A misjudgment would cause him to crash 60 feet (18 meters) to the ground."

Dem Schauspieler Richard Talmadge hatte seine Leidenschaft für gewagte Luftsprünge bereits einige gebrochene Nackenwirbel und ein verstauchtes Rückgrat eingebracht. Bei diesem Stunt im Jahre 1926 versucht er, eine Distanz von 5,50 m zu überwinden: »Eine Fehleinschätzung hätte einen Sturz aus 18 m Höhe auf den Boden zur Folge.«

Sa passion des sauts dangereux a déja valu à l'acteur Richard Talmadge quelques vertèbres cervicales cassés et une colonne vertébrale luxée. Lors de cette cascade, en 1926, il tente de franchir une distance de 5,50 mètres : « Une erreur de calcul, et il s'écraserait 18 mètres plus bas. »

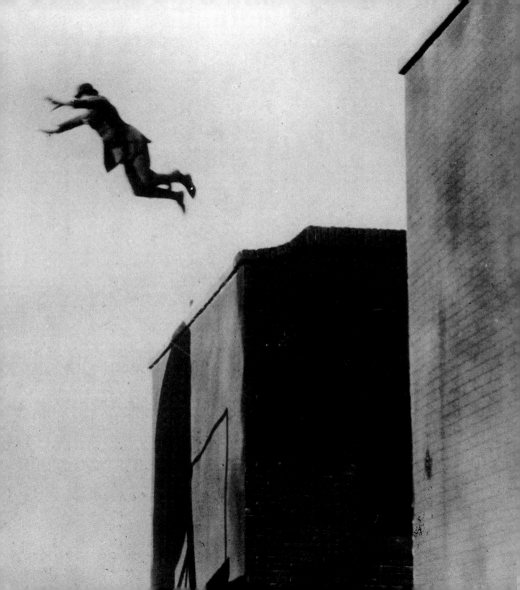

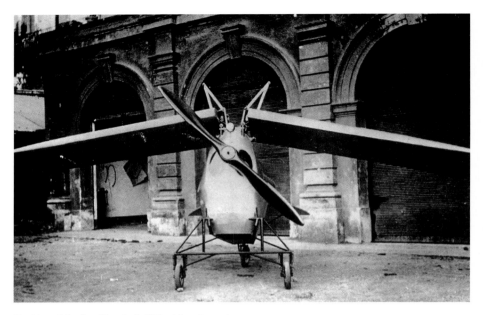

The idea of the "ornithopter" still had its adherents
as a serious alternative to powered fixed-wing
aircraft as late as the 1920s. Here we see a muscle-
powered flying machine built by a man from Rome
by the name of Mazzai, who imagined it might
become the inexpensive "people's airplane."

Die Idee des »Ornithopters« spukt bis in die
zwanziger Jahre als ernsthafte Alternative zum
Motorflugzeug in den Köpfen von Konstrukteuren
herum. Hier präsentiert sich das Muskelkraftflugzeug
des Römers Mazzai, das nach dessen Vorstellungen
ein kostengünstiges »Volksflugzeug« werden soll.

Jusque dans les années 20, le concept de
l'« ornithoptère », en tant qu'alternative sérieuse à
l'avion à moteur, hante les esprits des ingénieurs.
Entraîné par la force musculaire, l'avion du Romain
Mazzai est appelé, selon son constructeur, à devenir
un moyen de transport populaire car bon marché.

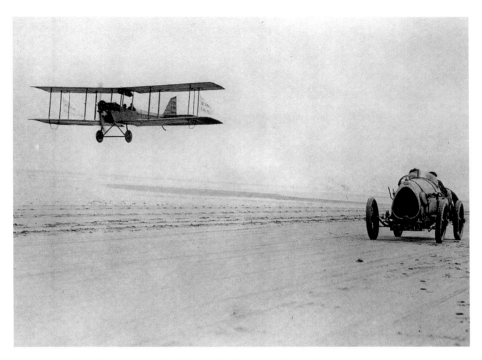

An early meeting of two giants in the history of 20th century locomotion took place on this beach in Southern England in the 1920s. The headline "Race Between Motor and Aeroplane" indicates that, for contemporaries, the outcome was still undecided.

Ein frühes Treffen zweier Giganten in der Geschichte der Fortbewegung des 20. Jahrhunderts findet in den zwanziger Jahren auf einem Strand in Südengland statt. Die Schlagzeile »Wettlauf zwischen Motor und Flugzeug« deutet darauf hin, daß das Rennen für die Zeitgenossen noch längst nicht entschieden ist.

Une rencontre précoce entre deux géants de l'histoire de la locomotion du XXᵉ siècle a lieu, dans les années 20, sur une plage du Sud de l'Angleterre. La manchette de journal « Défi entre le moteur et l'avion » incite à penser que, pour les spectateurs, le gagnant de la course n'est pas clairement désigné.

The hopes of the age of transatlantic airship services were dashed with the 1937 Zeppelin disaster at Lakehurst, New Jersey. This picture with its accompanying text, dating from 2 April 1930, suggested the Seminole Indians of Florida were awestruck in the face of the achievements of Western civilization: "A number of Seminole Indians have been taking their first trip in an airship. Among them are the grandchildren of the famous Seminole chief who, a century ago, scalped more than 100 white men. Now it is the whites' turn to triumph, and in amazement the last of the Indians follow the glittering airship with their gaze."

Die Hoffnungen der Ära der transatlantischen Luftschiffahrt werden mit dem Zeppelin-Unglück in Lakehurst (USA) im Jahre 1937 begraben. Bild und Bildtext vom 2. April 1930 lassen jedoch die Seminole-Indianer in Florida in Ehrfurcht vor den Errungenschaften der westlichen Zivilisation erstarren: »Einige Seminola-Indianer unternahmen dieser Tage ihre erste Reise mit einem Luftschiff. Darunter waren Enkel des berühmten Seminola-Häuptlings, der vor einem Jahrhundert über 100 weiße Männer skalpiert hat. Jetzt triumphieren die Weißen, und staunend sehen die letzten Indianer dem glitzernden Luftschiff nach.«

L'accident du Zeppelin de Lakehurst (Etats-Unis), en 1937, porte un coup fatal aux espoirs de traverser l'Atlantique en dirigeable. Selon la photo et sa légende du 2 avril 1930, ces Indiens Séminoles de Floride éprouvent crainte et respect pour les conquêtes de la civilisation occidentale : « Ce jour-là, quelques Indiens Séminoles ont fait leur baptême de l'air, dont des petits enfants du célèbre chef Séminole qui, un siècle auparavant, avait scalpé plus de 100 hommes blancs. Maintenant, c'est l'homme blanc qui triomphe et les derniers Indiens sont frappés d'étonnement à la vue du dirigeable scintillant. »

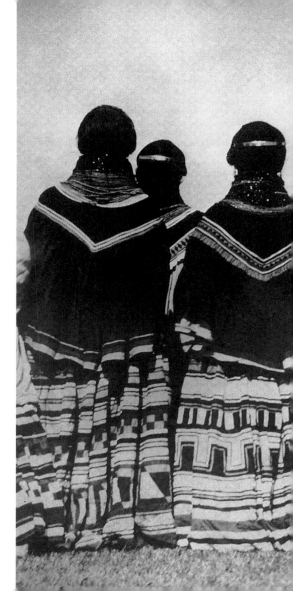

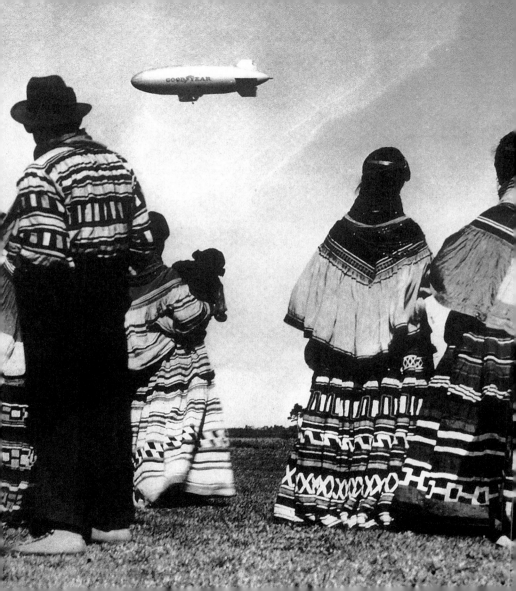

By the 1930s at the latest, the age of the aviation pioneers was over, to be followed by the age of intensive flight training. On 16 March 1931, Morton Helper from Cleveland, Ohio, introduced the "captive" training plane which he had developed, designed to get his pupils "ready for take-off".

Spätestens in den dreißiger Jahren ist die Zeit der Flugpioniere vorbei – jetzt beginnt die Phase konzentrierter Flugschulung. Am 16. März 1931 stellt Morton Helper aus Cleveland (Ohio) den von ihm entwickelten »realistischen Flugsimulator« vor, der seine Schüler startklar machen soll.

Dans les années 30 au plus tard, l'ère des pionniers de l'aviation est révolue – les stages de pilotage sont maintenant monnaie courante. Le 16 mars 1931, Morton Helper, de Cleveland (Ohio), dévoile son simulateur de vol « réaliste », censé faire de ses élèves de fins pilotes.

It takes a photomontage to demonstrate the individual phases of the stunt performed by American "bird-man" Clem Sohn at Hanworth Aerodrome on 2 May 1936. The landing was not documented, but the reader is reminded of pictures of crash-landings from the early days of flying.

Die Fotomontage ermöglicht, die einzelnen Flugphasen von Clem Sohn, dem amerikanischen »Vogelmenschen«, am 2. Mai 1936 auf dem Flugplatz von Hanworth nachzuvollziehen. Die Landung ist zwar nicht dokumentiert, aber der Betrachter fühlt sich an Bilder von Bruchlandungen aus den Anfangstagen der Fliegerei erinnert.

Il faut recourir à un photomontage pour reconstituer les différentes phases du vol de Clem Sohn, l'« homme-oiseau » américain, lors de sa démonstration du 2 mai 1936, sur l'aéroport de Hanworth. Mais comment a-t-il atterri ? A la vue des photos, on pense immédiatement aux atterrissages ratés des tout débuts de l'aviation.

While technology was progressing by leaps and bounds –
the first jet engine was patented in 1930 – open days at
Berlin's Tempelhof Aerodrome in the 1930s included demon-
strations of "acrobatics in the air". "Flying gymnast Fritz
Schindler as a living weather vane."

Während sich die Technik in Riesenschritten weiterentwi-
ckelt – 1930 erhält das erste Düsentriebwerk ein Patent –,
wird in den dreißiger Jahren bei einem Flugtag auf dem Ber-
liner Flugplatz Tempelhof »Akrobatik in der Luft« gezeigt:
»Flugturnkünstler Fritz Schindler als lebende Wetterfahne«.

Alors que le progrès fait des pas de géant – le premier brevet
de réacteur est déposé en 1930 – les acrobaties aériennes
attirent l'attention sur le décollage des avions, dans les
années 30, à l'aéroport berlinois de Tempelhof : l'acrobate
aérien Fritz Schindler joue les « girouettes humaines ».

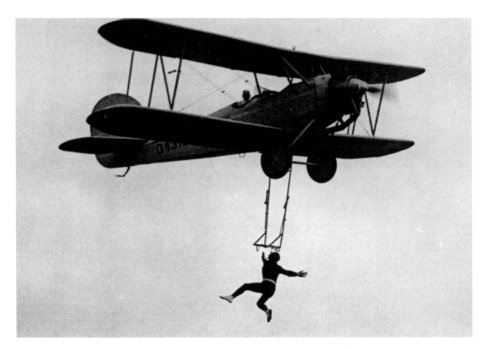

Although airlines had been around since the mid-1920s, civil aviation was still in its infancy. Flying enthusiasts, looking for something to do, were offering round trips, or else hiring themselves out to air shows, as here at Berlin's Tempelhof Aerodrome in 1932. Oskar Dimpfel is seen hanging by his teeth from a trapeze.

Obwohl seit Mitte der zwanziger Jahre Fluglinien existieren, steckt der zivile Luftverkehr noch in den Kinderschuhen. Flugenthusiasten suchen Betätigung und bieten Rundflüge an oder verdingen sich bei Flugschauen, wie hier auf dem Berliner Flugplatz Tempelhof im Jahre 1932. Fritz Dimpfel hängt freischwebend mit den Zähnen am Trapez.

Bien qu'il existe des lignes aériennes régulières depuis le milieu des années 20, la navigation aérienne civile en est encore à ses premiers balbutiements. Les emplois sont rares pour les amateurs de l'aviation, qui proposent alors des excursions ou se produisent lors des meetings aériens, comme ici à l'aéroport berlinois de Tempelhof en 1932. Sans la moindre protection, Oskar Dimpfel s'accroche au trapèze uniquement avec les dents.

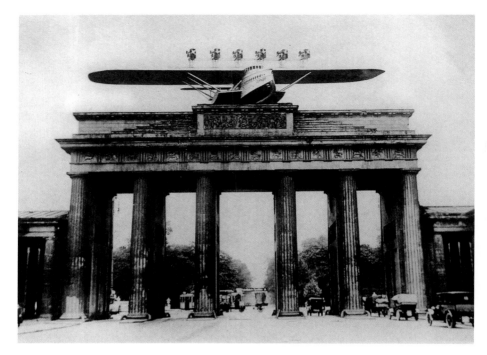

The giant DO-X flying boat, which left the Dornier factory on Lake Constance for its maiden flight in 1929, was one of the prestigious successes of German technology between the wars. On 1 April 1930, one Berlin newspaper published this photo-montage, with the flying boat taking the place of the chariot on the Brandenburg Gate.

Das deutsche Riesenflugboot DO-X, das 1929 die Dornier-Flugzeugwerke am Bodensee zum Jungfernflug verläßt, ist eines der Prestigeobjekte deutscher Technik in der Zeit zwischen den beiden Weltkriegen. Als Aprilscherz fotomontiert eine Berliner Zeitung 1930 das Flugvehikel anstelle der Quadriga auf das Brandenburger Tor.

Le gigantesque hydravion allemand DO-X, qui a quitté les usines Dornier au Lac de Constance en 1929 pour son vol inaugural, est l'un des porte-drapeaux de l'industrie allemande de l'entre-deux-guerres. En 1930, un journal berlinois saisit l'occasion du 1er avril pour publier un photomontage, l'avion remplaçant le quadrige de la Porte de Brandebourg.

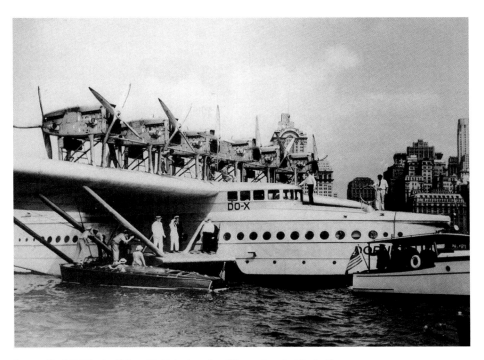

In 1931, the DO-X took off for a flight to America. After various incidents, the pride of German technology landed safely in New York with 100 passengers on board on 27 August 1931. In spite of the fact that it could transport a considerable number of passengers at a respectable speed, the DO-X was not a commercial success.

1931 startet die DO-X zu einer Flugreise nach Amerika. Nach diversen Zwischenfällen landet der Stolz deutscher Technik mit 100 Gästen am 27. August 1931 glücklich in New York. Trotz hoher Passagierkapazität und passablem Reisetempo wird die DO-X kein kommerzieller Erfolg.

En 1931, le DO-X décolle pour un vol qui le mènera jusqu'en Amérique. Après divers avatars, la fierté de l'industrie allemande amerrit saine et sauve à New York, le 27 août 1931, avec 100 passagers à bord. Malgré sa grande capacité de transport et sa vitesse de croisière acceptable, le DO-X ne connaîtra jamais le succès commercial.

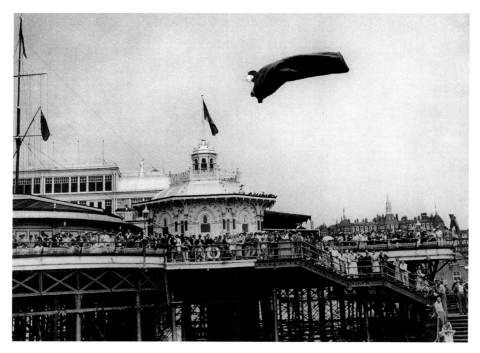

This stuntman was good for a few thrills in the English seaside resort of Brighton on 4 August 1936, a public holiday. Spellbound, the spectators watched as he flew through the air. The only question was whether, completely wrapped in a sack as he was, he would manage to surface again after plunging into the water.

Spannende Unterhaltung bietet am 4. August 1936 dieser Stuntman im englischen Seebad Brighton. Gebannt verfolgen die Zuschauer an diesem Ferientag die Flugbahn des Mannes. Es stellt sich die Frage, ob er – vollständig eingehüllt in einen Sack – wieder aus dem Wasser auftauchen wird.

Le 4 août 1936, ce cascadeur tient en haleine la foule massée sur la promenade de la station balnéaire anglaise de Brighton. Fascinés, les spectateurs suivent le vol de l'homme, par cette belle après-midi d'été. Mais ne risque-t-il pas de se noyer, empêtré complètement dans un sac.

Progress in aviation opened up completely new horizons for military strategists. The Soviet P-5 aircraft is seen here in 1936 being tested, with a touch of humor, for its suitability as a freighter. At the same time, Soviet aircraft were already being deployed in the Spanish Civil War.

Der Fortschritt der Fliegerei eröffnet den Strategen des Militärs vollkommen neue Möglichkeiten. Hier wird 1936 die sowjetische Maschine P-5 mit Humor auf ihre Fähigkeiten als Frachtmaschine getestet. Zur gleichen Zeit finden sowjetische Flugzeuge bereits im Spanischen Bürgerkrieg Einsatz.

Les progrès de l'aviation offrent des possibilités stratégiques insoupçonnées à l'armée. En 1936, l'Armée de l'air soviétique teste avec humour son appareil P-5 quant à ses aptitudes de transporteur de fret. Au même moment, des avions de chasse soviétiques participent déjà à la guerre civile d'Espagne.

In spite of all the innovations, aircraft technology was still in its early stages in the 1930s. This photograph shows James Terry in the skies above Miami, Florida, demonstrating a kind of frame which enabled acrobatic mechanics to conduct emergency external repairs during flight, in the hope of averting emergency landings.

Trotz aller Innovationen ist die Flugzeugtechnik in den dreißiger Jahren noch nicht ganz ausgereift. Hoch über Miami (Florida) demonstriert James Terry die Steighilfe für versierte Mechaniker, die im Notfall Außenreparaturen in der Luft ermöglicht und Notlandungen verhindern soll.

Malgré tous les progrès, la technique aéronautique n'est pas encore toujours fiable dans les années 30. Survolant Miami (Floride), James Terry montre comment fonctionne un système permettant à un mécanicien qui n'a pas le vertige de faire, en cas d'urgence, des réparations en vol et, ainsi, d'éviter un atterrissage forcé.

Weather maps are drawn up in the same way today as they have been since 1863. Aviation, however, transports even meteorologists into higher spheres. Here, the "flying weathermen" of the Prussian Aeronautical Observatory in Berlin are researching clouds in the 1930s.

Seit 1863 werden Wetterkarten in der uns heute bekannten Form erstellt. Die Luftfahrt führte aber auch die Meteorologen selbst in höhere Gefilde. »Die fliegenden Wetterfrösche« des Preußischen Aeronautischen Observatoriums in Berlin betreiben hier in den dreißiger Jahren Wolkenforschung.

Depuis 1863, les cartes météorologiques sont établies de la même manière qu'aujourd'hui. Mais l'avion permet aussi aux météorologues eux-mêmes de prendre de l'altitude. Dans les années 30, les « grenouilles volantes » de l'Observatoire aéronautique prussien, à Berlin, prennent les choses de haut pour étudier les nuages.

In 1946, American airplane and automobile makers realized their dream of individual airborne transport. The additions required for flight could be dismantled within five minutes, allowing the "car-plane" to be parked in the garage at home.

Amerikanische Flugzeug- und Autokonstrukteure verwirklichen 1946 mit diesem Modell ihre Vision vom Individualverkehr in der Luft. Die Aufbauten sind innerhalb von fünf Minuten zu entfernen, und das »Automobil-Flugzeug« kann einfach in der heimischen Garage geparkt werden.

En 1946, des ingénieurs aéronautiques et automobiles américains concrétisent leur conception de la locomotion individuelle dans les airs. Les ailes et l'empennage se démontent en cinq minutes et la « voiture-avion » peut alors poursuivre son chemin par la route.

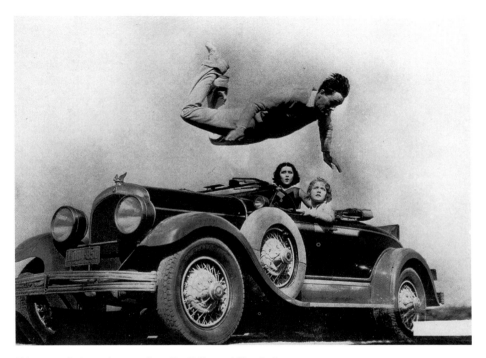

This 1940s photograph comes from the Hollywood film studios. With this stunt, Eddie Nugent was clearly making an impression on the two beauties, Raquel Torres (left) and Anita Page. In spite of this remarkable action photo, the trio did not achieve a place in film history.

Aus den Hollywood-Studios stammt diese Aufnahme der vierziger Jahre. Eddie Nugent beeindruckt mit seinem Stunt die beiden Schönen Raquel Torres (links) und Anita Page. In die Filmgeschichte ging das Trio trotz dieses beachtlichen Action-Fotos nicht ein.

Cette photo a été prise dans les studios d'Hollywood dans les années 40. Par sa cascade, Eddie Nugent cherche à impressionner les deux belles, Raquel Torres (à gauche) et Anita Page. Malgré cette photo dynamique, le trio n'entrera pas dans les annales de l'histoire du cinéma.

In 1923, the U.S. Army succeeded in refueling a plane in flight – the first time it had been done. The two American pilots of the *Sunkist Lady* used this technology to their advantage in their attempt to break the ten-year-old record of 726 hours in the air in Miami in 1949.

Der US-Armee gelingt 1923 die erstmals die Betankung eines Flugzeugs in der Luft. Diese Technik machen sich die beiden amerikanischen Piloten der *Sunkist Lady* 1949 bei ihrem Rekordversuch in Miami zunutze. Sie versuchen, den 1939 aufgestellten Dauerflugrekord von 726 Stunden zu brechen.

En 1923, l'Armée américaine réussit pour la première fois à ravitailler un avion en vol. Les deux pilotes américains du *Sunkist Lady* reprennent cette technique, en 1949, lors de leur tentative, à Miami, de battre le record de vol sans escale et d'une durée de 726 heures établi en 1939.

The Dutch airline KLM had special bassinets made for its smallest passengers in 1949. A contemporary commentator noted: "The bassinets can be carried as hand luggage. The baby on the right is nonchalantly sucking its thumb as it ponders, no doubt, the rapid march of progress."

Die niederländische Fluggesellschaft KLM läßt 1949 für ihre kleinsten Kunden spezielle Babykörbe anfertigen. Ein Zeitgenosse kommentiert diesen Service: »Die Körbchen können wie Handgepäck getragen werden. Das Baby rechts nuckelt lässig am Daumen, während es zweifelsohne über die rapide Entwicklung des Fortschritts nachdenkt.«

En 1949, la compagnie aérienne néerlandaise KLM fait réaliser des berceaux spéciaux pour ses plus jeunes clients. Commentaire d'un témoin de l'époque : « Les berceaux se portent comme des bagages à main. Le bébé de droite suce tranquillement son pouce en réfléchissant sans nul doute à la rapidité du progrès. »

While making an attempt on the flight endurance record on 21 September 1947, the pilot of the *City of Chicago* risked his life to keep his plane in the air. That very same year, American test pilot Charles Yeager broke the sound barrier for the first time in a Bell X-1 aircraft.

Bei einem Rekordversuch im Dauerfliegen am 21. September 1947 riskiert der Pilot der *City of Chicago* sein Leben, um die Flugdauer seiner Maschine zu verlängern. Im gleichen Jahr durchbricht der Amerikaner Charles Yeager mit seiner Maschine Bell X-1 die Schallmauer.

Lors d'une tentative de record de vol sans escale, le 21 septembre 1947, le pilote du *City of Chicago* risque sa vie pour prolonger la longévité de son appareil. La même année, l'Américain Charles Yeager franchit le mur du son avec son avion Bell X-1.

Inhabitants of a Stockholm old people's home visiting an airfield on 12 September 1949. These two octogenarians are visibly impressed. Every development in aviation, from the first glider to the propeller-driven airplane, had occurred within their lifetime.

Die Bewohner eines Stockholmer Altersheimes besuchen am 12. September 1949 einen Flugplatz. Diese beiden Achtzigjährigen, zu deren Lebzeiten alle wichtigen Stufen der modernen Luftfahrt durchlaufen wurden – vom ersten Gleiter bis hin zur Propellermaschine –, sind sichtlich beeindruckt.

Le 12 septembre 1949, les habitants d'une maison de retraite de Stockholm visitent un terrain d'aviation. Ces deux octogénaires, qui ont été témoins de toutes les étapes importantes de l'aéronautique moderne, du premier vol non motorisé à l'avion à hélice, sont manifestement impressionnés.

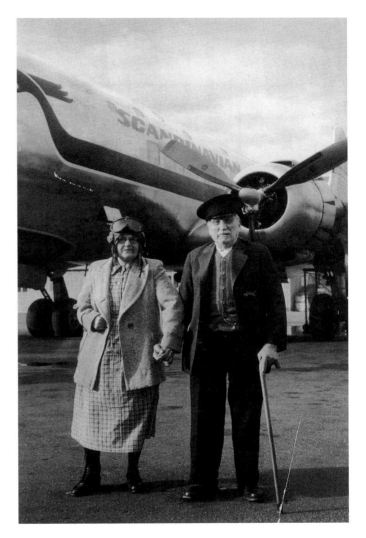

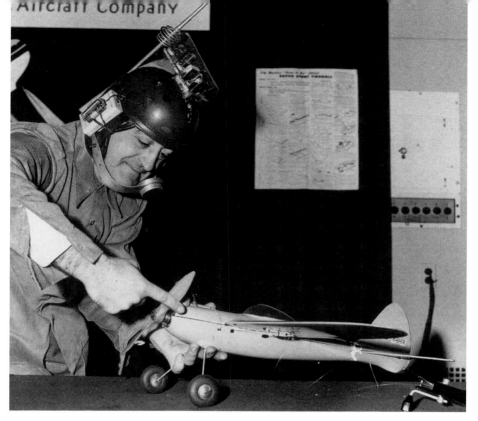

A particularly ingenious model aircraft was displayed by Jim Walker at the 1947 National Hobby, Crafts and Science Show in New York's Madison Square Garden. He used the "Man-from-Mars helmet" to control the flightpath of his model, thus illustrating that even model airplane enthusiasts were already dreaming of the next challenge: space flight.

Ein besonders ausgeklügeltes Modellflugzeug präsentiert Jim Walker 1947 auf der Hobby-, Handwerks- und Wissenschaftsausstellung im New Yorker Madison Square Garden. Über den »Marsmenschen-Helm« steuert er die Flugbahn seines Modells und zeigt, daß auch der Modellflieger bereits von der nächsten Dimension für Flugkörper träumt: dem All.

A la Foire des Loisirs, de l'Artisanat et des Sciences au Madison Square Garden de New York en 1947, Jim Walker présente une maquette d'avion particulièrement sophistiquée. A l'aide de son « casque de martien », il télécommande son avion et prouve que même le pilote de maquette rêve déjà de la prochaine dimension pour des engins volants : l'espace.

This Christmas fiasco happened on 10 December 1949 in Fort Lauderdale, Florida. Thousands of children were waiting for Santa Claus to drift down from the sky, but instead the parachutist in the festive garb got tangled up in some overhead cables. When not thus engaged, Robert Niles earned a living by jumping off bridges.

Dieses weihnachtliche Fiasko vollzieht sich am 10. Dezember 1949 in Fort Lauderdale (Florida). Tausende von Kindern warten auf den Weihnachtsmann, der vom Himmel her einschweben soll, doch statt dessen verfängt sich der kostümierte Fallschirmspringer in einer Überlandleitung. Robert Niles verdingt sich normalerweise als geübter Brückenspringer.

Ce parachutiste se souviendra sans doute longtemps de son atterrissage du 10 décembre 1949 à Ford Lauderdale (Floride). Des milliers d'enfants impatients attendent le père Noël censé descendre du ciel, mais le parachutiste déguisé se retrouve prisonnier d'une ligne à haute tension. Normalement, Robert Niles gagne sa vie en sautant des ponts.

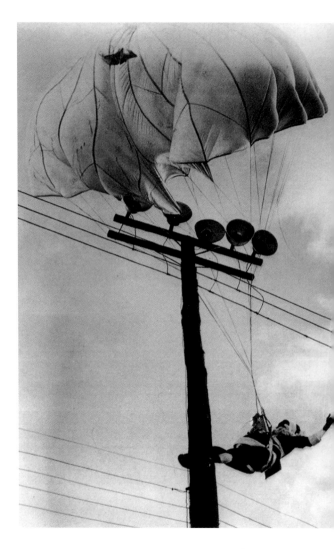

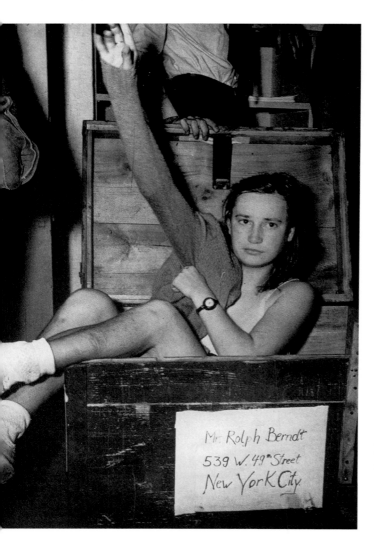

Before this stowaway could set off on her flight to New York in her box, in December 1947, Miss Doris von Knobloch was discovered by the U.S. military in Frankfurt. The supply situation in the Western zones of Germany was precarious at the time and seemingly many Germans would stop at nothing to leave their homeland.

Bevor dieser blinde Passagier im Dezember 1947 in seiner Kiste auf die Reise nach New York gehen kann, wird »Frollein« Doris von Knobloch vom amerikanischen Militär in Frankfurt entdeckt. Die Versorgungslage in den Westzonen Deutschlands ist prekär. Daher scheinen manchen Deutschen alle Mittel recht, die Heimat zu verlassen.

Des soldats américains en poste à Francfort découvrent Mlle Doris von Knobloch dissimulée dans une caisse avant que la passagère clandestine ne s'envole pour New York, en décembre 1947. La vie quotidienne dans les zones occidentales de l'Allemagne est si précaire que tous les moyens semblent bons à certains Allemands pour quitter leur patrie.

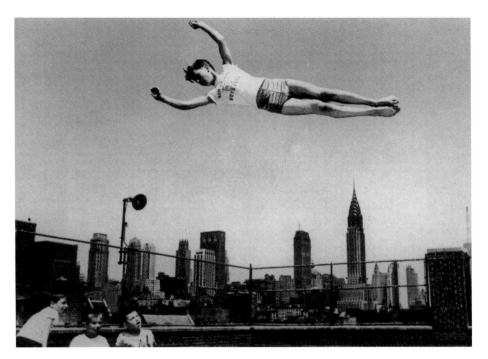

Not all New Yorkers can flee the city in summer. In 1951, the Madison Square Garden Boys' Club was the venue for a summer camp for boys and girls who stayed at home. On the building's roof terrace, Larry Schwanzer is seen challenging the law of gravity with a homemade trampoline.

Nicht alle New Yorker können im Sommer der Stadt entfliehen. Im »Madison Square Garden Boys' Club« findet 1951 ein Sommerlager für daheimgebliebene Jungen und Mädchen statt. Auf der Dachterrasse des Gebäudes fordert Larry Schwanzer die Schwerkraft mit einem selbstgebauten Trampolin heraus.

En été, les habitants de New York ne peuvent pas tous partir en vacances. En 1951, le « Madison Square Garden Boys' Club » organise un camp d'été pour les jeunes garçons et filles obligés de rester chez eux. Sur le toit-terrasse du gratte-ciel, Larry Schwanzer brave l'attraction terrestre sur un trampoline bricolé par lui-même.

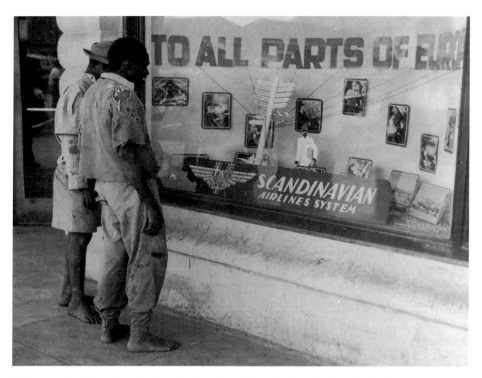

This 1950s advertisement by the Scandinavian airline SAS in South Africa doubtlessly interested a number of locals, but was beyond the means of all but a few. And besides, Europe was connected in their minds with the specter of colonialism, from which most African nations were seeking to liberate themselves at this time.

Diese Werbung der skandinavischen Luftlinie SAS in Südafrika aus den fünfziger Jahren interessiert sicherlich viele Einheimische, ist aber für die wenigsten erschwinglich. Außerdem ist der Begriff Europa mit dem Schreckgespenst des Kolonialismus besetzt, von dem sich in dieser Zeit die meisten afrikanischen Nationen zu befreien versuchen.

Cette publicité, faite en Afrique du Sud, par la compagnie aérienne scandinave SAS, dans les années 50, intéresse assurément beaucoup d'autochtones, mais elle restera un rêve pour presque tous. D'autant plus que la notion d'Europe fait surgir le spectre du colonialisme auquel beaucoup de nations africaines cherchent à se soustraire à cette époque.

This young American is pictured rehearsing for a moon landing as long ago as the 1950s. During the Cold War, the space race between the USA and USSR became a touchstone for the efficiency of political systems. The conquest of space represented the fulfilment of one of mankind's boldest visions.

Dieser kleine Amerikaner probt in den fünfziger Jahren schon einmal die Mondlandung. Der Wettlauf zum Mond zwischen den USA und der UdSSR wird in der Zeit des Kalten Krieges zu einer Frage der Leistungsfähigkeit der politischen Systeme. Mit dem Aufbruch ins Weltall erfüllt sich eine der kühnsten Visionen der Menschheit.

Dans les années 50, ce petit Américain s'entraîne déjà à partir pour la lune. La course à l'espace entre les Etats-Unis et l'URSS s'exacerbe, durant la Guerre froide, en une question de suprématie des systèmes politiques. Avec la navigation spatiale s'accomplit l'une des visions les plus ambitieuses de l'humanité.

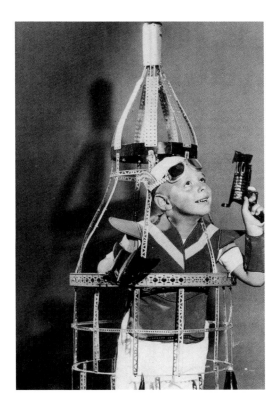

You'll never walk alone

The world's press in the mid-1930s owed one of its most moving stories to a love affair. A few months after the death of the British king, George V, his eldest son, who had become King Edward VIII, abdicated the throne in December 1936 in order to marry Wallis Simpson, a twice-divorced American commoner. But readers were not just interested in the love-lives of royal highnesses. They were amused, too, by the exploits of two Americans brought together quite literally by a collision at a crossroads and who shortly afterwards took the marriage vows. The truth of such anecdotes is beside the point; their purpose was to fuel conversation, and in this they succeeded. The fundamental unit of civilized society is the respectable married couple. Press photographers, by contrast, are grateful for any of the many stranger manifestations of love, passion, friendship, family relationship or chance acquaintanceship. For them, rushing from one deadline to the next, couples are mere passers-by.

Paare und Passanten

Der Liebe verdankt die Welt-presse Mitte der dreißiger Jahre eine rührende Geschichte. Nach dem Tod des britischen Königs Georg V. verzichtet Edward VIII. im Dezember 1936 auf die Thronfolge und heiratet die Amerikanerin Wallis Simpson, eine Bürgerliche, die bereits zweimal schuldlos geschieden wurde. Doch nicht nur das Liebesleben königlicher Hoheiten interessiert den Leser. Er amüsiert sich ebenso über zwei Amerikaner, die mit ihren Autos in den zwanziger Jahren auf einer Kreuzung zusammen-stoßen und sich wenig später auf dem Standesamt das Ja-Wort geben. Der Wahrheits-gehalt solcher Anekdoten ist dabei eher nebensächlich, zählt doch vielmehr der neue Gesprächsstoff. Die Keimzelle der bürgerlichen Gesellschaft ist das rechtschaffene Ehepaar. Der Pressefotograf hingegen ist dankbar für die vielen seltsamen Wege, die Liebe, Leidenschaft, Freundschaft, Verwandtschaft oder Zufalls-bekanntschaft beschreiten. Für ihn, der von Termin zu Termin hastet, bleiben alle Paare nur Passanten.

Couples et flâneurs

Vers le milieu des années 30, la presse mondiale est rede-vable à l'amour de l'une de ses plus émouvantes histoires. Après le décès du roi de Grande-Bretagne, Georges V, Edouard VIII renonce au trône, en décembre 1936, pour épouser l'Américaine Wallis Simpson, une roturière déjà divorcée deux fois. Mais le lecteur ne s'intéresse pas seulement à la vie amoureuse des altesses royales. L'histoire de deux Américains dont les voitures sont entrées en collision au milieu d'un carrefour, dans les années 20, et qui, peu de temps après, se passent la bague au doigt devant monsieur le Maire le distrait tout autant. La véracité de telles anecdotes est d'une importance plutôt secondaire, le principal, c'est que l'on ait un nouveau sujet de discussion. Le couple respectueux du droit et des bonnes mœurs est le fondement de la société civile. Le photographe de presse, par contre, apprécie que l'amour, la passion, l'amitié, les liens familiaux ou les rencontres fortuites soient à l'origine de clichés surprenants et inattendus. Pour lui qui court d'un rendez-vous à l'autre, tous les couples ne sont que des passants.

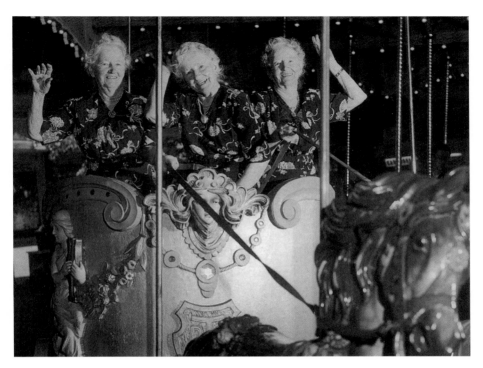

Nora "Faith" Murphy, Nellie "Hope" Daniels and Annie "Charity" McDonnell (from left) were, at 84, the oldest participants in a triplets' convention at the Palisades Pleasure Grounds in New Jersey on 7 May 1952. They were also thought to be the oldest triplets in the world.

Nora »Faith« Murphy, Nellie »Hope« Daniels und Annie »Charity« McDonnell (von links) sind mit ihren 84 Lebensjahren die ältesten Teilnehmer eines Drillingstreffens am 7. Mai 1952 im Palisades-Vergnügungspark in New Jersey. Sie gelten als die ältesten Drillinge der Welt.

Agées de 84 ans, Nora « Faith » Murphy, Nellie « Hope » Daniels et Annie « Charity » McDonnell (à partir de la gauche) sont les doyennes d'une rencontre de triplés, le 7 mai 1952, au parc d'attractions de Palisades, dans le New Jersey. On les considère en outre comme les plus vieilles triplées du monde.

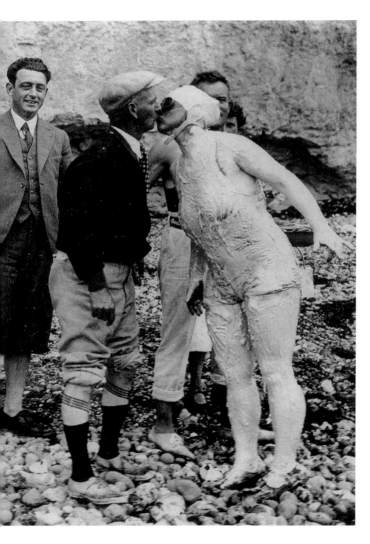

Before setting out, in the 1920s, to become the first woman to swim the English Channel from Dover to France, Clemington Corson, from England, kisses her husband goodbye. However, it was the swim by an American, Gertrude Eberle, in 14 hours 39 minutes on 7 August 1926, that went down in the record books.

Bevor sich in den zwanziger Jahren die Engländerin Clemington Corson als erste Frau aufmacht, den Kanal von Dover nach Frankreich zu durchschwimmen, verabschiedet sie sich von ihrem Mann. In die Annalen geht jedoch am 7. August 1926 der Rekord der US-Amerikanerin Gertrude Eberle mit 14 Stunden und 39 Minuten ein.

Avant de se jeter à l'eau, dans les années 20, pour être la première femme à traverser la Manche à la nage, au départ de Douvres pour la France, l'Anglaise Clemington Corson prend affectueusement congé de son mari. C'est pourtant le record de la nageuse américaine Gertrude Eberle, soit 14 heures et 39 minutes, qui entrera dans les annales, le 7 août 1926.

This photo from America tells an amazing love story dating from the early days of motoring in the late 1920s. The two met in a collision at a crossroads, were taken to hospital together and ended up before the altar.

Dieses Foto aus Amerika erzählt eine unglaubliche Liebesgeschichte aus den Anfangstagen des Autoverkehrs Ende der zwanziger Jahre. Die beiden stießen auf einer Kreuzung zusammen, fuhren gemeinsam ins Krankenhaus und treten nun gemeinsam vor den Traualtar.

Cette photo prise aux Etats-Unis témoigne d'une incroyable histoire d'amour aux tout débuts de l'automobile, à la fin des années 20. Les deux protagonistes ont fait connaissance lors d'une collision à un carrefour, se sont rendus ensemble à l'hôpital et vont maintenant passer ensemble devant Monsieur le maire.

Together with their wives, Siamese twins Simplicio and Lucio Godino present themselves to the press at a New York hotel. The term "Siamese" for twins physically joined goes back to two brothers, Chang and Eng Bunkes (1811–1874) from Siam.

Die siamesischen Zwillinge Simplicio und Lucio Godino stellen sich in den zwanziger Jahren mit ihren Gattinnen den Pressefotografen in einem New Yorker Hotel. Die Bezeichnung für diese Mißbildung, die bei eineiigen Zwillingen auftritt, geht auf die Brüder Chang und Eng Bunkes aus Siam zurück (1811–1874).

Dans les années 20, les frères siamois Simplicio et Lucio Godino se présentent avec leur épouse respective aux photographes de presse dans un hôtel de New York. Les frères Chang et Eng Bunkes, du Siam (1811–1874), sont à l'origine de ce terme qui désigne des jumeaux univitellins soudés l'un à l'autre.

Mary and Margaret Gibb from Massachusetts performing as a piano and singing duo in Paris during the 1930s. Siamese twins like the 18-year-old Gibbs sisters used to demonstrate their viability by appearing as artistes at fairs and on the variety stage.

Mary und Margaret Gibb aus Massachusetts geben in den dreißiger Jahren in Paris ein Gastspiel als Klavier- und Gesangsduo. Siamesische Zwillinge wie die 18jährigen Gibbs demonstrieren den Zeitgenossen ihre Lebensfähigkeit mit artistischen Auftritten in Varietés und auf Jahrmärkten.

Mary et Margaret Gibb, du Massachusetts, donnent un concert à Paris, dans les années 30, l'une chantant, l'autre jouant du piano. Sœurs siamoises, les Gibb âgées de 18 ans se produisent dans les music-halls et les fêtes foraines, montrant ainsi à leurs contemporains leur formidable vitalité.

"Happy Ending in the Republic of Lilliput." The engagement was announced on 9 April 1932 in Berlin between Herr Behrens and Miss Lawson. The couple celebrated "with guests large and small" in their fictitious republic, whose name was borrowed from the kingdom of the little people in Jonathan Swift's satirical fantasy *Gulliver's Travels*.

»Happy-End in der Liliputaner-Republik« – in Berlin verloben sich am 9. April 1932 Herr Behrens und Miss Lawson. Frei nach dem Roman *Gullivers Reisen*, in dem Jonathan Swift den Begriff Liliput prägt, feiert das Paar mit »großen und kleinen Gästen« ein Fest in ihrer fiktiven Republik.

« Happy End dans la république des lilliputiens » – le 9 avril 1932, à Berlin, Herr Behrens célèbre ses fiançailles avec Miss Lawson. Librement interprété d'après le roman *Les Voyages de Gulliver*, dans lequel Jonathan Swift crée le néologisme de Lilliput, le couple fait la fête avec « de grands et petits invités » dans sa république fictive.

Ballerina Gloria Rich and former football star Ralph Byrd were immortalized on 14 September 1937 by a Hollywood stills photographer. "The ballet and the gridiron seem far removed at first, but here we see the fallacy of such an idea," so the sub-editor.

Der Standfotograf dieser Filmproduktion in Hollywood verewigt am 14. September 1937 die Ballettänzerin Gloria Rich und den Ex-Football-Star Ralph Byrd. »Denken wir an das Ballett und das Spielfeld, scheinen sie weit voneinander entfernt«, sinniert der Redakteur, »aber hier sehen wir, daß dies ein Trugschluß ist.«

Le 14 septembre 1937, le photographe de plateau de cette production cinématographique d'Hollywood immortalise la danseuse de ballet Gloria Rich et l'ex-vedette de football américain Ralph Byrd. « Si l'on pense au ballet et au terrain de football, ils semblent très éloignés l'un de l'autre », fait remarquer le rédacteur, « mais, ici, nous voyons combien une telle idée est fallacieuse. »

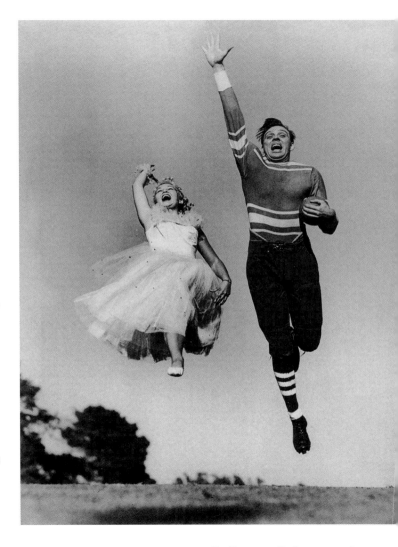

During the 1930s, British magazines gave illustrated courses in self-defense for the modern British woman. "When you have got someone into this position, you can break his arm in three different places... I have no need to explain the predicament of your victim."

In den dreißiger Jahren geben englische Illustrierte in Fotoserien Selbstverteidigungskurse für die moderne britische Frau. »Wenn Sie jemanden in diese Position gebracht haben, können Sie ihm den Arm an drei verschiedenen Stellen brechen... Ich brauche Ihnen die heikle Lage Ihres Opfers nicht näher zu erläutern.«

Dans les années 30, des illustrés anglais publient des séries de photos pour enseigner à la femme britannique moderne les techniques de l'auto-défense. « Lorsque vous avez placé votre agresseur dans cette position, vous pouvez lui briser le bras à trois endroits différents... Inutile de vous expliquer plus en détail la situation scabreuse de votre victime. »

This German married couple in the 1930s did not accord with the notions of the racial ideal propounded by the sub-editor. Under the heading "Grotesque Marriages", his malicious comment on this liaison ran: "Love is blind! What she has too much of, he has too little."

Dieses deutsche Ehepaar entspricht in den dreißiger Jahren ganz und gar nicht den »völkischen« Ideal-vorstellungen des Redak-teurs. Unter der Überschrift »Groteske Ehen« schreibt er voller Häme über diesen Lebensbund: »Liebe macht blind! Was Sie zuviel hat, hat er zu wenig.«

Ce couple allemand des années 30 ne correspond absolument pas à l'idéal « racial » du rédacteur. Sous le titre « Couples grotesques », il décrit narquoisement cette union pour la vie : « L'amour est aveugle ! Ce qu'elle a en trop lui manque. »

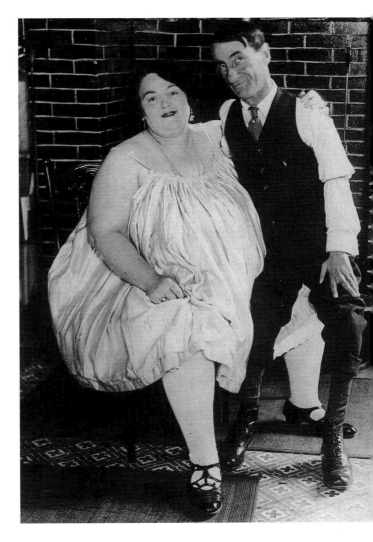

The spectators in the Danish block at Stockholm's Råsunda Stadium in 1937 are avidly following the events on the field during the soccer international between Denmark and Sweden. The Danes beat their arch-rivals by two goals to one. It was a particularly bitter defeat for the Swedes, because this was the inaugural game in their new stadium.

Der dänische Block im Råsunda-Stadion in Stockholm verfolgt 1937 beim Fußball-Länderspiel Schweden gegen Dänemark gebannt das Geschehen auf dem Rasen. Die Dänen gewinnen mit 2:1 gegen den Erzrivalen. Die Niederlage ist besonders bitter für die Schweden, da sie sich die Einweihung des neuen Stadions glorreicher gewünscht hätten.

Au stade Råsunda de Stockholm, le bloc danois est captivé par le déroulement du match de football qui oppose la Suède au Danemark, en 1937. Les Danois remportent la victoire sur leur rival de longue date par deux buts à un. La défaite est particulièrement amère pour les Suédois qui auraient souhaité une inauguration plus glorieuse du nouveau stade.

600 mothers of the Hexton Market Mission, a charitable organization based in the town of Hexton in north-western New Zealand, set out for their annual excursion to the seaside on 14 July 1936. The photo shows the oldest of those making the trip – aged 77 and 70.

600 Mütter der Hexton Market Mission, einer karitativen Organisation der Stadt Hexton im Nordwesten Neuseelands, starten am 14. Juli 1936 zu ihrem jährlichen Ausflug ans Meer. Das Foto zeigt die ältesten Teilnehmerinnen, 77 und 70 Jahre jung, bei der Abfahrt.

600 mères de l'Hexton Market Mission, une organisation caritative de la ville de Hexton dans le nord-ouest de la Nouvelle-Zélande, partent, le 14 juillet 1936, comme chaque année en excursion au bord de la mer. La photo montre lors du départ les doyennes des participantes, âgées de 77 et 70 ans.

The caption to this 1933 photograph ran "When Circus Midget meets J. P. Morgan." Morgan, one of the most powerful American bankers of the age, was waiting to testify before the Senate in Washington when without warning an intrepid press agent sat circus artiste Lya Graf on the banker's knee.

Unter der Überschrift »Wenn der Zirkusknirps J. P. Morgan trifft« kursiert 1933 dieses Bild. Morgan, einer der mächtigsten amerikanischen Bankiers jener Zeit, wartet auf seine Zeugenaussage vor dem Senat in Washington, als ein kühner Presseagent dem Bankier unvermittelt die Zirkusartistin Lya Graf aufs Knie setzt.

Cette photo qui date de 1933 a pour légende « Quand la naine du cirque rencontre J. P. Morgan ». L'un des banquiers les plus puissants de l'époque, J. P. Morgan attend de témoigner devant le Sénat, à Washington, lorsqu'un agent de presse téméraire fait asseoir sans crier gare l'artiste Lya Graf sur les genoux du banquier.

This photo opportunity in Paris on 12 June 1937 was entitled "Meeting of Extremes." Elisabeth from Austria was just 3 feet 10 inches (1.18 meters) tall, while Vaimo from Finland was all of 8 feet 3 inches (2.51 meters), and weighed 408 lbs. (185 kilograms).

Dieser Fototermin in Paris am 12. Juni 1937 steht unter dem Motto »Berühren sich hier Extreme?«. Die Österreicherin Elisabeth mißt 1,18 m, der Finne Vaimo bringt bei einer Körperlänge von 2,51 m ein Gewicht von 185 kg auf die Waage.

Cette séance de photo, à Paris le 12 juin 1937, a pour thème « Les extrêmes se rejoignent-ils ici ? ». L'Autrichienne Elisabeth mesure 1,18 mètres, le Finlandais Vaimo, la domine du haut de ses 2,51 mètres, pour un poids de 185 kilos.

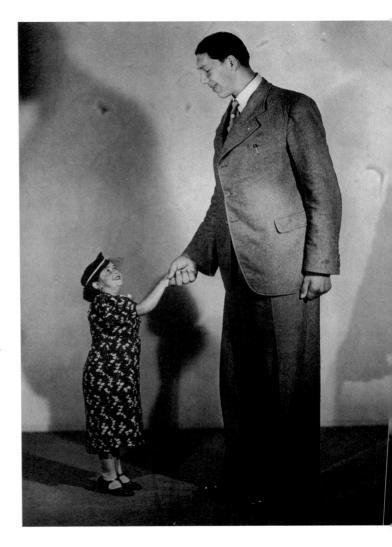

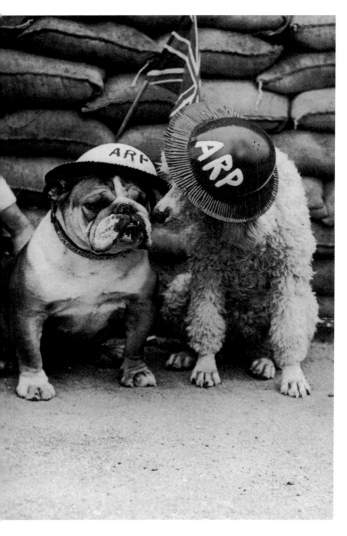

After Hitler's invasion of Poland, France and Britain declared war on Germany on 3 September 1939. On 15 October, these two "Allied" dogs, a French poodle and a British bulldog, posed for the camera during an air-raid exercise in London.

Nach dem Einmarsch deutscher Truppen in Polen erklären Frankreich und Großbritannien Hitler-Deutschland am 3. September 1939 den Krieg. Am 15. Oktober posieren diese »alliierten« Hunde, ein französischer Pudel und eine englische Bulldogge, am Rande einer Fliegeralarm-Übung in London für die Kamera.

Après l'invasion de la Pologne par les troupes allemandes, la France et la Grande-Bretagne déclarent la guerre à l'Allemagne hitlérienne, le 3 septembre 1939. Le 15 octobre, ces chiens « alliés », un caniche français et un bouledogue anglais, posent pour les photographes en marge d'un exercice d'alerte aérienne à Londres.

September 1940 saw the second phase of the German air attacks on Britain. The Luftwaffe bombarded the island on 65 consecutive days. Mr Charles Rolfe and his wife, both 76, were among those bombed out. Under wartime censorship regulations, the exact location could not be mentioned.

Im September 1940 beginnt die zweite Phase deutscher Luftangriffe auf Großbritannien. Es setzt ein 65tägiger Bombenhagel der deutschen Luftwaffe auf die britischen Inseln ein. Auch das Haus von Charles Rolfe und seiner Frau, beide 76 Jahre alt, bleibt nicht verschont. Den genauen Ort verschweigt die Zensur.

Septembre 1940 marque le début de la seconde phase des bombardements aériens de la Grande-Bretagne par les Allemands. Les îles britanniques sont pilonnées pendant 65 jours. La maison de Charles Rolfe et de son épouse, tous deux âgés de 76 ans, n'est malheureusement pas épargnée. La censure interdit de mentionner le lieu exact.

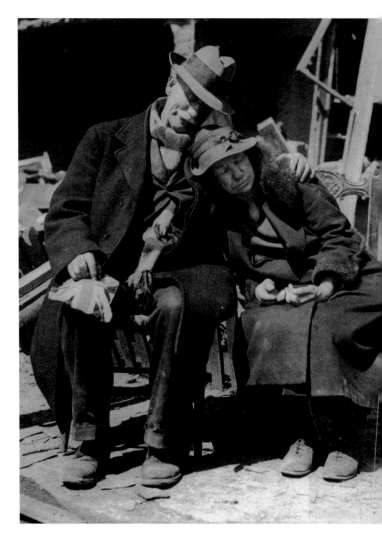

Even after the surrender of German troops in Italy was announced on 2 May 1945, some units went on fighting. Unconcerned, this British soldier found some company – albeit somewhat cool and taciturn – in the form of a tailor's dummy from the ruin of a store.

Auch nach der Bekanntgabe der Kapitulation der deutschen Truppen in Italien am 2. Mai 1945 gibt es dort noch einige Randgefechte. Unbeeindruckt von diesen Scharmützeln sucht dieser britische Soldat Gesellschaft und findet sie in der Schaufensterpuppe eines zerstörten Geschäfts, auch wenn die Dame ein wenig kühl und wortkarg ist.

Même après l'annonce de la capitulation des troupes allemandes en Italie, le 2 mai 1945, des combats d'arrière-garde se poursuivent ici et là. Nullement impressionné par les évènements, ce soldat britannique recherche de la compagnie, qu'il trouve en un mannequin d'étalage provenant d'un magasin détruit, même si la dame est quelque peu froide et silencieuse.

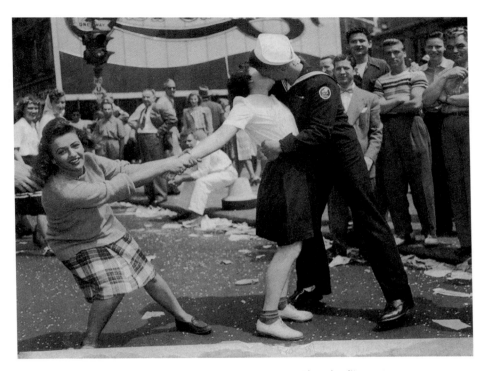

On 2 September 1945, New York celebrated the victory over Japan. The sub-editor was somewhat overwhelmed: "Never before in history has a victory stirred the American people to such joyous outbursts. New York City holds the wildest celebration of all. Over two million gather in Times Square…"

Am 2. September 1945 feiern die New Yorker die Kapitulation der Japaner. Der Redakteur schreibt überwältigt: »Nie zuvor hat ein Sieg das amerikanische Volk zu solchem Freudentaumel animiert. In New York City findet die ausgelassenste Feier von allen statt. Über 2 Millionen versammeln sich am Times Square…«

Le 2 septembre 1945, les New-Yorkais célèbrent la capitulation des Japonais. Le rédacteur écrit, lui-même profondément ému : « Jamais dans l'histoire, une victoire du peuple américain n'a suscité autant d'allégresse. A New York City se déroule la fête la plus folle de toute son histoire. Plus de deux millions de personnes se rassemblent à Times Square… »

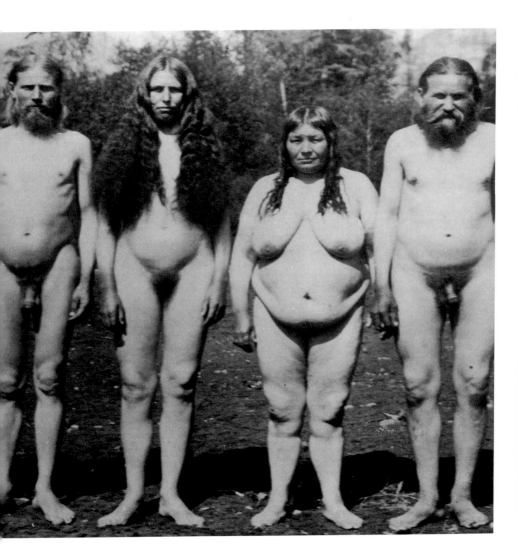

You'll never walk alone

The "Sons of Freedom" were a radical offshoot of a sect whose members had fled Czarist Russia for Canada. They attracted attention in the 1940s by their protest demonstrations, which took the form of nudist parades. Their teaching on "marriage" was: when love grows cold, our ways part and each chooses a new partner.

Die radikalen »Söhne der Freiheit« sind eine Sekte, deren Mitglieder aus dem zaristischen Rußland nach Kanada flohen. In den vierziger Jahren fallen sie durch diverse Nacktdemonstrationen auf. Ihr partnerschaftliches Credo lautet »Wenn die Liebe erkaltet, trennen sich unsere Wege und beide wählen neue Partner.«

Les radicalistes « Fils de la liberté » constituent une secte dont les membres ont fui de la Russie tsariste au Canada. Dans les années 40, ils attirent l'attention sur eux par diverses manifestations de nudisme. Le credo de leur communauté est « Lorsque l'amour se refroidit, nos chemins se séparent et nous choisissons tous les deux un nouveau partenaire. »

"With this still, Toni Seven or Toni 7 is launching her career." The daughter of the silent-movie star June Caprice made her 1940s Hollywood debut with an out-of-the-ordinary pin-up photo in the hope that this would soon lead to an appearance in front of the movie cameras.

»Mit dieser Aufnahme lanciert Toni Seven oder Toni 7 ihre Karriere.« Die Tochter des Stummfilmstars June Caprice startet in den vierziger Jahren ihr Debüt in Hollywood mit einem Pin-up-Foto der besonderen Art und hofft, auf diese Weise bald vor die Filmkameras treten zu können.

« Toni Seven ou Toni 7 donne un coup d'accélérateur à sa carrière ! » La fille de la vedette du cinéma muet June Caprice fait ses débuts, dans les années 40, à Hollywood avec une photo de pin-up d'un genre tout particulier et espère bientôt voir braquées sur elle les caméras du cinéma.

Ever since newspapers first appeared, illustrated reports of whatever kind from the "Big Apple" have attracted interest. On 12 November 1947 tiresome westerlies had these New York passers-by at City Hall Park "dancing with the wind."

Seit es Zeitungen gibt, sind illustrierte Meldungen jedweder Art über den »Big Apple« interessant. Am 12. November 1947 veranlassen lästige Westwinde diese New Yorker Passanten am City Hall Park zu einem »Tanz mit dem Wind«.

Depuis qu'il y a des journaux, la moindre photo de « Big Apple » quelle qu'elle soit, est toujours intéressante. Le 12 novembre 1947, de violents vents d'Ouest contraignent ces deux passants new-yorkais, devant le City Hall Park, à improviser cette bizarre « danse avec le vent ».

The marriage of 18-year-old Delbert Sprouse and his 79-year-old bride Mrs Mattie Lyons Large in Cat Hollow, Kentucky, had already hit the headlines nationwide in June 1946. The couple are seen here on their honeymoon on Coney Island, with the comment from Delbert: "Chickens don't come this big in Kaintuck!"

Bereits die Hochzeit von Delbert Sprouse, 18 Jahre jung, und seiner 79 Jahre alten Braut Mrs Mattie Lyons Large in Cat Hollow (Kentucky), machte im Juni 1946 amerikaweit Schlagzeilen. Die Flitterwochen verbringen die beiden auf Coney Island, und Delbert kommentiert seine Eindrücke: »So riesige Hühner gibt es nicht in Kaintuck!«

Le mariage à Cat Hollow (Kentucky), de Delbert Sprouse, âgé de 18 ans, avec Mme Mattie Lyons Large, qui a 79 ans, avait déjà fait les gros titres des journaux de toute l'Amérique en juin 1946. Le couple passe son voyage de noces à Coney Island, et la vue de ces énormes bipèdes inspire ce commentaire à Delbert : « Des poulets aussi énormes, il n'y en a pas au Kaintuck ! »

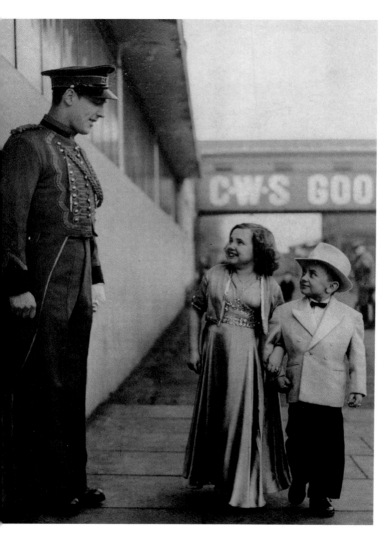

This liaison of little people was accompanied by big words on 16 January 1950: "Olympian Love." The two 20-year-old circus artistes Hermine Pramhaas and Freddy Hakl from Vienna were appearing at Bertram Mills Circus in London. They were planning to marry in February.

Mit großen Worten wird am 16. Januar 1950 diese Liaison kleiner Leute vorgestellt: »Olympische Liebe«. Die beiden 20jährigen Zirkusartisten Hermine Pramhaas und Freddy Hakl aus Wien treten im Bertram-Mills-Zirkus in London auf und beabsichtigen, im Februar zu heiraten.

C'est en grosses lettres que l'on annonce, le 16 janvier 1950, cette liaison de petites gens : « Amour olympique ». Les deux artistes viennois, Hermine Pramhaas et Freddy Hakl, âgés de 20 ans, se produisent au cirque Bertram Mills de Londres et envisagent de se marier en février.

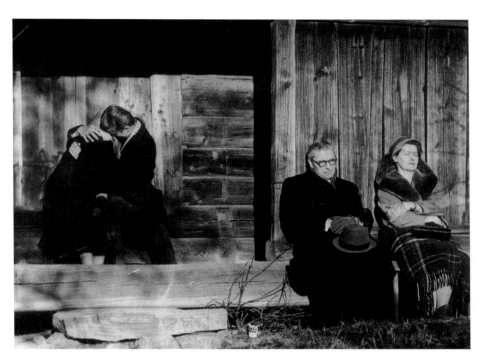

On Monday 2 March 1959, the Stockholm newspapers reported the first warm spring weather over the weekend. These two couples are spending their Sunday in Skansen. Since 1891, the open-air museum had provided a place to relax in the middle of town, preserving Sweden's folk heritage in 125 traditional buildings.

Am Montag, den 2. März 1959, berichten die Stockholmer Tageszeitungen über den ersten warmen Frühlingstag am Wochenende. Diese beiden Paare verbringen den Sonntag in Skansen. Das Freilichtmuseum bietet seit 1891 Naherholung mitten in der Stadt und bewahrt in 125 traditionellen Gebäuden das volkskundliche Erbe der Schweden.

Le lundi 2 mars 1959, les quotidiens de Stockholm consacrent quelques lignes à la première chaude journée d'un week-end de printemps. Ces deux couples passent leur dimanche à Skansen. Depuis 1891, l'écomusée est un lieu de détente et de repos au centre de la ville et restitue, dans 125 édifices traditionnels, traditions et arts populaires de Suède.

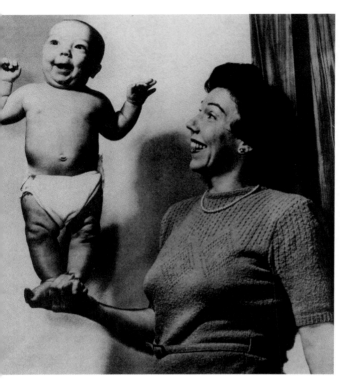

On his 1951 European tour, Hungarian fencing master Gladies, former trainer of the Hungarian National Fencing Team, slices apples on the throat of his partner, provoking the caption: "The world's most dangerous variety trick."

Der ungarische Artist Gladies, Fechtmeister und ehemaliger Trainer der Nationalmannschaft, spaltet auf seiner Europatournee 1951 mit dem Degen Äpfel auf dem Hals seiner Partnerin und provoziert damit die Überschrift, dies sei der »weltweit gefährlichste Artisten-Trick«.

Lors de sa tournée européenne de 1951, l'artiste hongrois Gladies, maître d'escrime et ancien entraîneur de l'équipe nationale, tranche d'un coup d'épée, des pommes placées sur le cou de sa partenaire, performance artistique citée comme étant « la plus dangéreuse du monde ».

On 28 April 1950, a photographer discovered tiny Tim Wooster, just five-and-a-half months old, in San Francisco, and posed the question: "A potential athlete?" His mother Kay shows off her 18 lbs (9 kilograms) bundle of joy and his ability to stand upright – which, according to her, he had been able to do since shortly after his birth.

In San Francisco entdeckt ein Fotograf am 28. April 1950 den erst 5 ½ Monate alten Tim Wooster und fragt: »Ein potentieller Athlet?« Seine Mutter Kay zeigt das Stehvermögen des 9 kg schweren Wonneproppens, der ihren Angaben zufolge bereits kurz nach der Geburt stehen konnte.

A San Francisco, un photographe découvre, le 28 avril 1950, Tim Wooster, qui a tout juste cinq mois et demi, et demande : « Un athlète potentiel ? » Sa mère Kay montre les dons de son magnifique bambin de 9 kg qui, selon ses dires, se tenait déjà debout peu de temps après sa naissance.

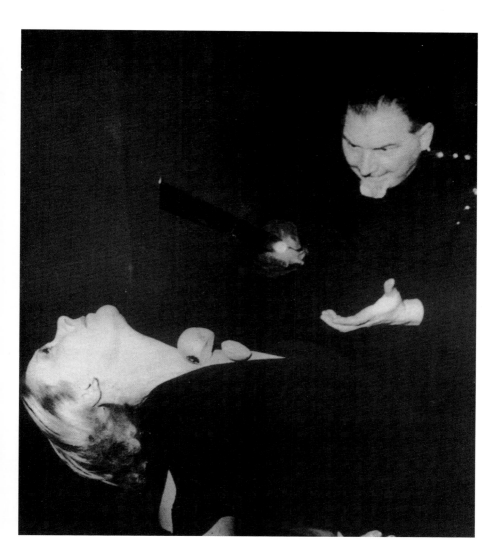

On 16 July 1951, 32 refugees from the civil war in Greece arrived in New York. A special dispensation allowed them to become the first immigrants in U.S. history to land on Liberty Island instead of Ellis Island.

Am 16. Juli 1951 treffen 32 Bürgerkriegsflüchtlinge aus Griechenland in New York ein. Sie sind die ersten Einwanderer in der Geschichte der USA, denen gestattet wird, das gelobte Land an der Freiheitsstatue zu betreten und nicht auf Ellis Island.

Le 16 juillet 1951, fuyant la guerre civile qui sévit dans leur patrie, 32 réfugiés de Grèce arrivent à New York. Ce sont les premiers immigrants dans l'histoire des Etats-Unis, autorisés à débarquer près de la statue de la liberté.

On 8 June 1950, King Gustav V of Sweden receives U.N. delegate Eleanor Roosevelt, the widow of American President Franklin D. Roosevelt who had died in 1945. The king died on 29 October 1950. Throughout his reign he had always advocated his country's neutrality.

Der schwedische König Gustav V. empfängt am 8. Juni 1950 Eleanor Roosevelt, UN-Delegierte und Witwe des 1945 gestorbenen US-Präsidenten Franklin D. Roosevelt. Am 29. Oktober 1950 stirbt der Monarch, der während seiner Amtszeit immer für die Neutralität seines Landes eingetreten war.

Le roi de Suède Gustave V reçoit, le 8 juin 1950, Eleanor Roosevelt, déléguée de l'ONU et veuve du président américain Franklin D. Roosevelt décédé en 1945. Le monarque qui, durant sa législature, s'est toujours fait l'avocat de la neutralité de son pays, meurt le 29 octobre 1950.

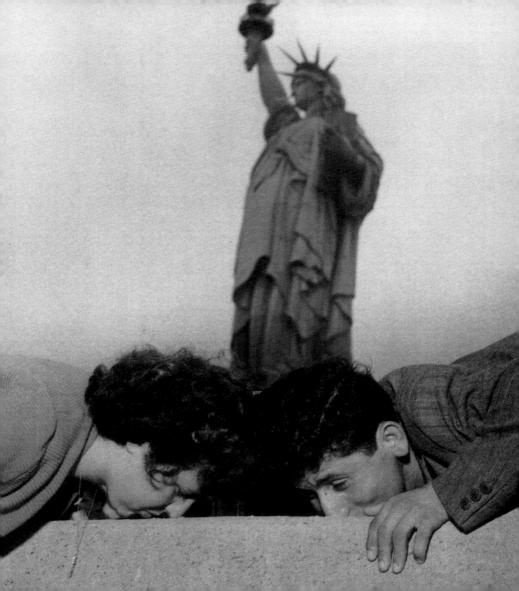

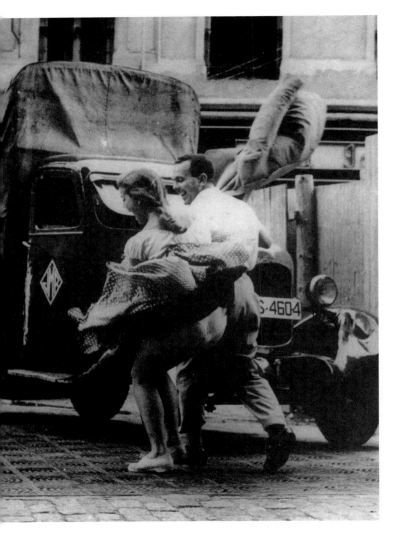

The photographer entitled this picture, taken in 1956, "An embarrassing moment in Madrid". However the couple, who are just walking across the outlet to a subway ventilation shaft, and have been surprised by the sudden rush of air produced by a passing train, seem to be enjoying the episode.

Der Fotograf überschreibt dieses Bild 1956 mit »Ein peinlicher Moment in Madrid«. Die Passanten hingegen, die gerade einen der U-Bahn-Schächte überqueren und im Luftzug des unterirdisch dahindonnernden Zuges stehen, scheinen ihren Spaß zu haben.

Le photographe intitule cette photo prise en 1956 « Situation embarrassante à Madrid ». Les passants, qui franchissent une grille d'aération du métro et auxquels le courant d'air de la rame souterraine, qui passe en vrombissant, joue des tours, semblent au contraire y prendre plaisir.

An American variation on the theme of the successful businessman, demonstrated by bodybuilder Alan Stephan on 31 August 1947. While he telephones a client from the office of his studio, his wife sits perched on his desk ready to take the next dictation. The two had only been married shortly before, and Mrs Stephan was helping her husband in the studio "as far as her household duties permitted."

Die amerikanische Variante des erfolgreichen Geschäftsmanns demonstriert der Bodybuilder Alan Stephan am 31. August 1947. Während er im Büro seines Studios mit einem Kunden telefoniert, sitzt seine Frau bereit, um das nächste Diktat aufzunehmen. Die beiden haben erst vor kurzem geheiratet, und Mrs Stephan hilft ihrem Ehemann im Studio, »soweit es ihr der Haushalt erlaubt«.

Le culturiste américain Alan Stephan montre, le 31 août 1947, la variante américaine de l'homme d'affaires comblé. Pendant qu'il téléphone à un client depuis le bureau de son studio de musculation, sa femme s'apprête à écrire sous sa dictée. Ils sont jeunes mariés et Mme Stephan aide son mari au studio « dans la mesure où ses tâches domestiques lui en laissent le temps ».

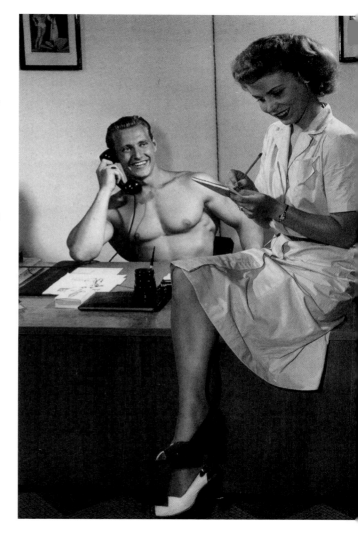

In the mass

During the 20th century cities like San Francisco, New York, Paris, Berlin and London have exercised a magnetic attraction on people looking for work. London in the late 1920s had a population of 7.6 million. In 1928, one Swedish journalist was mightily impressed by the flourishing commercial life of the hub of the British Empire, but he also saw the other side of the coin. Slum quarters like the East End were bursting at the seams; the stench was stomach-turning, the people were ill-clad, and their faces reflected dejection and despair. Chaos may be one principle of the mass society, but the press photographer's viewfinder finds order. In the factories people stand at the assembly line, the norm in mass-production since being introduced by the automotive industry in 1913. Hospitals confront the challenge of a tidal wave of out-patients and treat them in the mass. On parades, the massed participants march with military precision. When out on location, though, the photographer intervenes in the event he is recording by arranging his subjects in groups and shaping the picture through his instructions, even while the picture is being taken. He decides on his vantage point and poses his subjects wherever he can.

Am laufenden Band

Im 20. Jahrhundert ziehen Großstädte wie San Francisco, New York, Paris, Berlin und London die Menschen auf der Suche nach Arbeit magnetisch an. London zählt Ende der zwanziger Jahre 7,6 Millionen Einwohner. Das emsige Geschäftstreiben in der britischen Handelsmetropole beeindruckt im Jahre 1928 einen schwedischen Journalisten stark, er sieht aber auch die Kehrseite der Medaille. Elendsviertel wie das East End platzen aus allen Nähten, der Gestank ist widerwärtig, die Menschen sind schlecht gekleidet, und in ihren Mienen spiegeln sich Mutlosigkeit und Verzweiflung. Chaos mag ein Prinzip der Massengesellschaft sein, der Pressefotograf jedoch schaut durch den Sucher seiner Kamera und findet Ordnung. Die Menschen stehen in den Fabriken an Fließbändern, die seit der Einführung in der Autoproduktion im Jahre 1913 bei der Massenfertigung gang und gäbe sind. Kliniken richten sich auf den Ansturm ambulanter Patienten ein und behandeln sie en masse. Auf Paraden marschieren die Teilnehmer in Reih und Glied. Bei Ortsterminen hingegen greift der Fotograf selbst in das Geschehen ein, er dirigiert die Menschen zu Gruppen zusammen, bestimmt seinen Blickwinkel und inszeniert, wo er nur kann.

A la chaîne

Au XXe siècle, les grandes métropoles comme San Francisco, New York, Paris, Berlin et Londres attirent comme un aimant les hommes en quête de travail. A la fin des années 20, Londres compte 7,6 millions d'habitants. En 1928, l'activité trépidante dans la métropole commerciale britannique impressionne fortement un journaliste suédois, mais celui-ci n'en oublie pas pour autant le revers de la médaille. Les quartiers miséreux comme dans l'East End sont surpeuplés, la puanteur est épouvantable, les habitants sont mal vêtus et, sur leur visage se lisent découragement et désespoir. Le chaos peut être un principe de la société de masse, mais l'ordre s'impose au photographe de presse à travers le viseur de son appareil. Il voit des ouvriers sur des chaînes de montage qui, depuis leur apparition dans l'industrie automobile en 1913, se sont généralisées dans la fabrication industrielle, des cliniques qui se préparent à l'arrivée massive de patients et les traitent sur le tas, des parades dont les participants défilent comme des petits soldats de plomb. Par contre, lors d'événements locaux, le photographe prend une part active : il regroupe les protagonistes, donne des instructions pour réaliser la prise de vue souhaitée. Il choisit son angle de vue et réalise des clichés et les met en scène à chaque fois qu'il le peut.

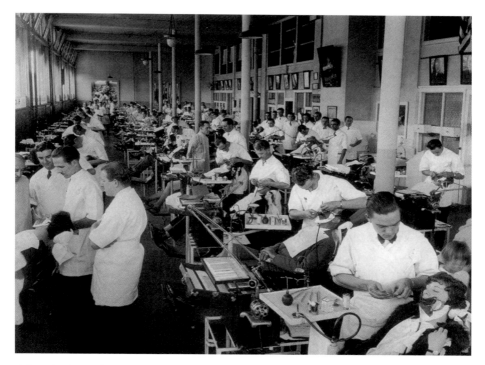

Trainee dentists at the University of Los Angeles are not shielded
from the reality of everyday practice. During 1928, they treated
23,000 patients, and thus made a major contribution to basic
medical provision in the sprawling metropolis.

Nachwuchszahnärzte werden an der Universität von Los Angeles
praxisnah ausgebildet. Im Jahre 1928 behandeln sie in der
Ambulanz fast 23 000 Patienten und leisten damit einen wichti-
gen Beitrag zur ärztlichen Grundversorgung der Millionenstadt.

De futurs dentistes de l'Université de Los Angeles sont formés
sur le tas. En 1928, au service des soins ambulatoires, ils soignent
près de 23 000 patients et contribuent ainsi dans une large
mesure à fournir à la population de la métropole une assistance
médicale de base.

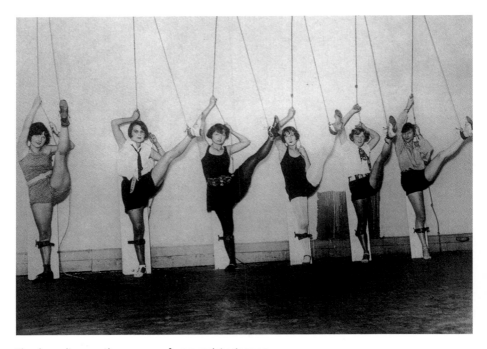

The chorus line was the cynosure of every variety stage on both sides of the Atlantic during the 1920s. This shot taken in a Los Angeles training studio gives just a hint of the backstage tortures endured by the dancing girls as they practiced their high kicks.

Der Blickfang aller Bühnen sind in den zwanziger Jahren die Revuetänzerinnen – ob in den USA oder in Europa. Welche Torturen jedoch das Erlernen des richtigen »Kicks« mit sich bringt, läßt diese Aufnahme aus einem Trainingsstudio in Los Angeles nur erahnen.

Dans les années 20, les danseuses de variété sont les vedettes de la scène, que ce soit aux Etats-Unis ou en Europe. Cette photographie prise dans un studio de répétition de Los Angeles ne donne qu'une vague idée des tortures qu'elles doivent endurer pour maîtriser à la perfection les pas de danse.

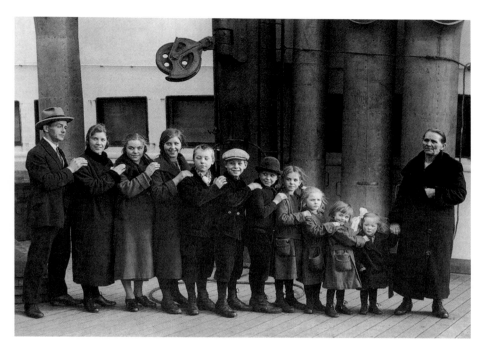

Immigration was an evergreen topic in American newspapers. In 1924, this photo was provided with the caption: "A serious attack on the immigration quota from Germany." Ida Zahler was pictured in New York with her eleven children on the way to their father, who was already in Ohio preparing for their arrival.

Die Einwanderung ist ein Dauerthema amerikanischer Zeitungen. Ein Redakteur bemerkt 1924 zu diesem Foto: »Ein ernsthafter Angriff auf die Einwanderungsquote aus Deutschland«. Ida Zahler passiert mit ihren elf Kindern New York auf dem Weg zum Vater der Familie, der in Ohio die Einwanderung vorbereitet hat.

L'immigration est un thème récurrent des journaux américains. En 1924, un rédacteur commente cette photo en ces termes : « Une attaque sérieuse de l'Allemagne contre les quotas d'immigration ». Ida Zahler fait étape à New York, avec ses onze enfants, avant de rejoindre son mari qui a préparé la venue de sa famille dans l'Ohio.

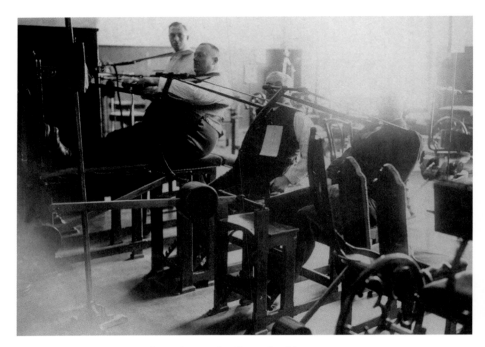

German newspapers occasionally tried to comfort those who did not live up to the ideals of beauty prevalent during the Roaring Twenties. The report accompanying this photo was headed "Science discovers the brain center responsible for regulating obesity." It was taken in the health studio of the Zander Institute.

Deutsche Zeitungen versuchen mitunter, denen Trost zuzusprechen, die dem Schönheitsideal der »Goldenen Zwanziger« nicht genügen. Die Meldung »Die Wissenschaft entdeckt das Gehirnzentrum, das die Fettleibigkeit reguliert« wird mit diesem Foto aus der Gesundheitswerkstätte des Zander-Instituts illustriert.

Les journaux allemands s'efforcent de remonter le moral de ceux qui ne correspondent pas à l'idéal de beauté des « folles années » 20. L'information « La science découvre la partie du cerveau qui régule l'obésité » est illustrée par cette photo prise dans les studios de remise en forme de l'Institut Zander.

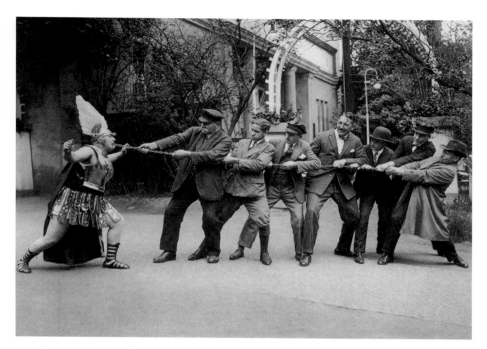

To entice visitors to her daily evening show in 1920s' Berlin, an artiste who went by the name of Nobody demonstrated her abilities to the press photographers. "Seven muscular men try in vain to tear the chain from the strongwoman's mouth."

Um Besucher in ihre Abendvorstellung im Berlin der zwanziger Jahre zu locken, demonstriert die Artistin Nobody dem Pressefotografen ihre Fähigkeiten: »Sieben kräftige Männer versuchen vergeblich, der Kraftdame die Kette aus dem Munde zu entreißen.«

Pour promouvoir son spectacle quotidien, dans le Berlin des années 20, l'artiste Nobody montre au photographe de presse toute l'étendue de ses talents : « Sept hommes forts essaient en vain de faire lâcher prise à cette dame herculéenne qui tient la chaîne entre ses dents. »

The sub-editor who supplied the caption to this photograph was dismissive of an attempt in 1933 to put cooking on the curriculum for boys at London schools. "People evidently consider it necessary that men of today should know all about the art of cooking."

Abfällig äußert sich ein Redakteur über den Versuch, 1933 an Londoner Schulen Kochunterricht für Jungen einzuführen: »Offensichtlich hält man es für notwendig, daß der Mann von heute alles über die Kunst des Kochens wissen sollte.«

En 1933, dans les écoles de Londres, on introduit des cours de cuisine pour les garçons. Cette photo inspire au rédacteur ce commentaire ironique : « Apparemment, on estime nécessaire que l'homme d'aujourd'hui soit incollable en matière d'art de la cuisine. »

This Berlin candle factory was working flat-out pre-Christmas. The number of women working in German factories rose in the mid-1920s to 4.5 million, while at the same time females were increasingly being employed in offices and large stores.

In dieser Berliner Kerzenfabrik läuft die Produktion in der Vorweihnachtszeit auf Hochtouren. Die Zahl der deutschen Industriearbeiterinnen steigt Mitte der zwanziger Jahre auf 4,5 Millionen, zugleich erobern die Frauen auch Büros und Warenhäuser als Angestellte.

A Berlin, dans cette fabrique de bougies, la production est à son maximum à quelques semaines de Noël. Au milieu des années 20, le nombre des ouvrières de l'industrie allemande s'élève à 4,5 millions et les femmes font une entrée massive dans les bureaux et les grands magasins en tant qu'employées.

New Year 1933 was to be celebrated in an original manner at Long Beach, California. Here, the living figures and Father Time are seen at rehearsal. Roosevelt's election and his New Deal program had given rise to new hope for the coming year.

Der Jahreswechsel 1932/33 soll am Strand von Long Beach in Kalifornien auf besondere Weise begangen werden: Hier proben die »Lebenden Ziffern« und die »Zeit« ihren Auftritt. Mit der Wahl Roosevelts und seinem Programm des »New Deal« keimt zum neuen Jahr Hoffnung auf.

Sur la plage de Long Beach, en Californie, on s'apprête à célébrer de façon particulière la Saint-Sylvestre 1932–1933 : les «chiffres vivants» et le « temps » répètent pour leur représentation. L'élection de Roosevelt et son programme du « New Deal » font renaître l'espoir au début de la nouvelle année.

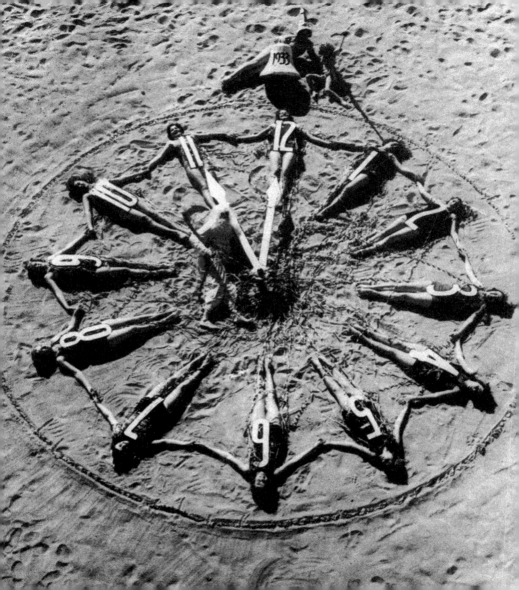

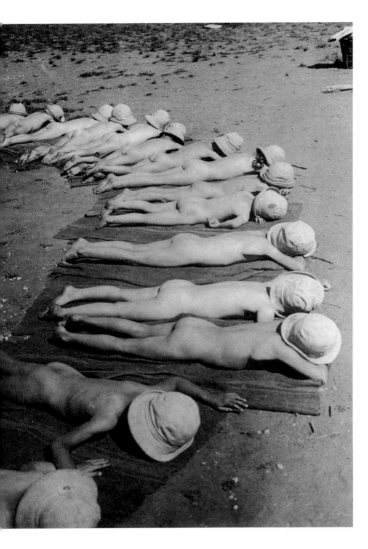

These French children on the Côte d'Azur are taking a "light bath." For France, the period following the First World War was characterized by a decline in population. Immigration was encouraged.

Ein »Sonnenbad« nehmen diese französischen Kinder an der Côte d'Azur. Die Zeit nach dem Ersten Weltkrieg ist in Frankreich demographisch von einem Rückgang der Bevölkerung gekennzeichnet. Gleichzeitig wird die Einwanderung gefördert.

Ces petits Français prennent un « bain de soleil » sur la Côte d'Azur. En France, la Première Guerre mondiale a été suivie d'une chute de la natalité. C'est pourquoi le gouvernement a encouragé l'immigration.

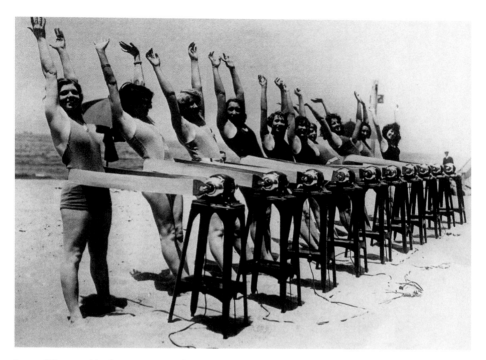

In good times and bad, newspaper readers have always enjoyed the sight of shapely young ladies. The German caption writer made the following comment on this scene in Venice Beach, California, on 5 April 1932: "Before and after bathing, they attack the excess pounds with electrical massage devices."

In guten wie in schlechten Zeiten erfreuen sich die Zeitungsleser an der Erscheinung wohlgeformter junger Damen. Diese Strandszene in Venice Beach (Kalifornien) kommentiert der deutsche Schreiber am 5. April 1932 mit den Worten: »Vor und nach dem Bade gehen sie den Überpfunden mit elektrischen Massageapparaten zu Leibe.«

Aux meilleurs comme aux pires instants , la vue de jeunes dames aux courbes généreuses réjouit toujours les lecteurs de journaux. Le rédacteur allemand commente, le 5 avril 1932, cette scène photographiée sur la plage de Venice Beach (Californie) en ces termes : « Avant et après la baignade, elles s'attaquent à leurs kilos superflus à l'aide d'appareils de massage électriques. »

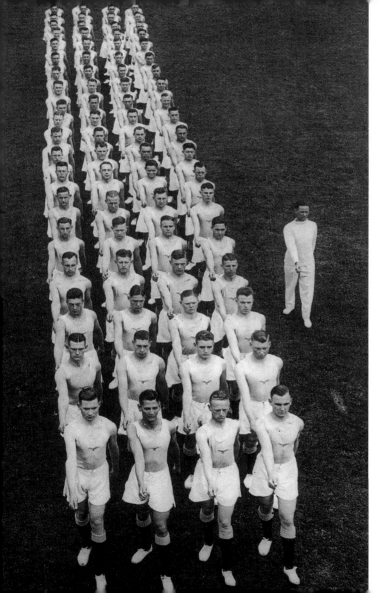

Britain's Royal Air Force spent the 1930s getting its men into good physical shape for history's first "War in the Air." These "war babies," all born in 1915 or 1916, are seen training at Uxbridge RAF base for the Royal Tournament due to be opened on 17 May 1935 by King George V.

Die britische Luftwaffe rüstet sich in den dreißiger Jahren körperlich für den ersten Luftkrieg, der da kommen mag. Hier trainieren »Kriegskinder«, die alle in den Jahren 1915 und 1916 geboren wurden, im Luftwaffendepot Uxbridge für eine Parade, die König Georg V. am 17. Mai 1935 in London eröffnen wird.

Dans les années 30, l'Armée de l'air britannique se prépare physiquement à la première « guerre aérienne » qui risque de se produire. Ici, des « enfants de la guerre » qui sont tous nés en 1915 ou 1916, répètent, au dépôt de l'Armée de l'air d'Uxbridge, pour la parade en présence du roi Georges V, le 17 mai 1935, à Londres.

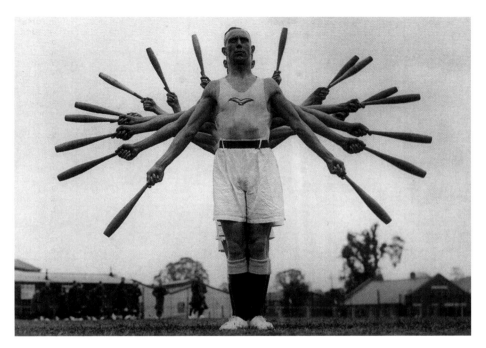

Germany's massive rearmament program provoked counter-measures in Great Britain. 1934 saw the expansion of the Royal Air Force, and a comprehensive defense program was begun the following year. The foreign policy of Stanley Baldwin's government, by contrast, was directed towards the avoidance of war through diplomacy and negotiation.

Die enorme Aufrüstung Deutschlands provoziert auch in Großbritannien die Wiederaufrüstung. 1934 wird die britische Luftwaffe ausgebaut, ein Jahr später ein umfangreiches Wehrprogramm gestartet. Außenpolitisch versucht die Regierung Baldwin jedoch, durch Verhandlungen und Diplomatie einen Krieg zu vermeiden.

Le réarmement considérable de l'Allemagne entraîne aussi celui de la Grande-Bretagne. En 1934, l'Armée de l'air britannique renforce ses effectifs et, un an plus tard, un important programme militaire est mis sur pied. Mais, en politique extérieure, le gouvernement Baldwin s'efforce cependant d'éviter une guerre à force de négociations et de diplomatie.

Buckingham Palace and the palace guard are without doubt one of London's major tourist attractions. These visitors on 20 April 1939 are a news item in themselves, however. 35-year-old Dutchman Jan van Albert was 9 feet 2 inches (2.76 meters) in height, while his 42-year-old Swiss friend Seppetoni was just over 2 feet (61 centimeters) tall.

Buckingham Palace und die Palastwache gehören zu den touristischen Hauptattraktionen Londons. Am 20. April 1939 sind diese Besucher allerdings ein Ereignis für sich: Der 35jährige Holländer Jan van Albert mißt 2,76 m, sein 42jähriger Schweizer Freund Seppetoni 61 cm.

Le Palais de Buckingham et la Garde du Palais font assurément partie des grandes attractions touristiques de Londres. Le 20 avril 1939, toutefois, ce sont ces visiteurs qui créent l'événement : le Hollandais Jan van Albert, âgé de 35 ans, mesure 2,76 m et Seppetoni, son ami suisse de 42 ans, 61 cm.

A new kind of strength training was discovered in the 1930s by the oarsmen of the Washington University rowing team. Using huge saws, they make short work of the trunks of trees which they had previously felled in the woods around their team quarters.

Eine neue Art von Krafttraining entdecken die Ruderer der Universitätsmannschaft von Washington in den dreißiger Jahren. Mit Riesensägen zerlegen sie in Windeseile Baumstämme, die sie zuvor in den Wäldern um das Mannschaftsquartier geschlagen haben.

Les rameurs composant l'équipe de l'Université de Washington découvrent, dans les années 30, un nouveau genre d'entraînement physique. A l'aide de gigantesques scies, ils tronçonnent en quelques minutes des arbres qu'ils ont abattus auparavant dans les forêts entourant leur quartier général.

After a global influenza epidemic had claimed millions of lives in July 1918, thought was increasingly given to preventive measures. To fortify the immune systems of these Bucharest city children, they were sent to spend the summer in the mountains. Every morning they turned out for a "gargle parade."

Nachdem im Juli 1918 eine weltweite Grippeepidemie Millionen von Todesopfern gefordert hat, verbreitet sich zunehmend der Gedanke der Prävention. Um die Abwehrkräfte dieser Bukarester Stadtkinder zu stärken, verbringen sie den Sommer in den Bergen. Jeden Morgen treten sie zu einer »Gurgelparade« an.

Une épidémie de grippe ayant fait des millions de victimes dans le monde entier en juillet 1918, le principe de la prévention est de plus en plus respecté par la population. Pour renforcer les défenses de leur organisme, ces enfants de Bucarest passent l'été dans les montagnes. Tous les matins, ils se réunissent pour une « parade de gargarismes ».

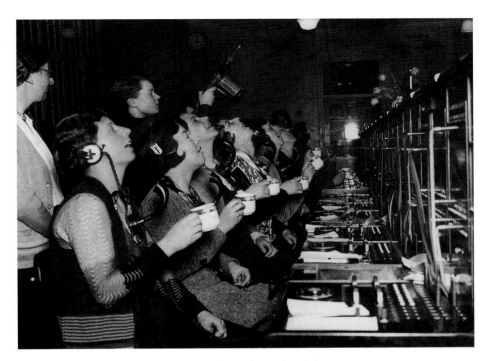

The operators at London's main telephone exchange also took up daily gargling as a prophylactic measure against further flu epidemics. In addition, the air in the room was impregnated with an anti-influenza mixture in order to banish a disease which had been recurring at intervals for centuries.

Auch in der Vermittlungsstelle des Londoner Hauptpostamts beugen die Damen mit täglichem Gurgeln weiteren Grippewellen vor. Die Raumluft wird zusätzlich mit einer Anti-Influenza-Mixtur angereichert, um diese seit Jahrhunderten periodisch auftretende Infektionskrankheit zu bekämpfen.

Au standard de la Poste principale de Londres, les standardistes se gargarisent chaque jour pour prévenir toute affection grippale. De plus, on vaporise dans l'air ambiant une préparation anti-grippe pour lutter contre cette maladie contagieuse qui sévit périodiquement depuis des siècles.

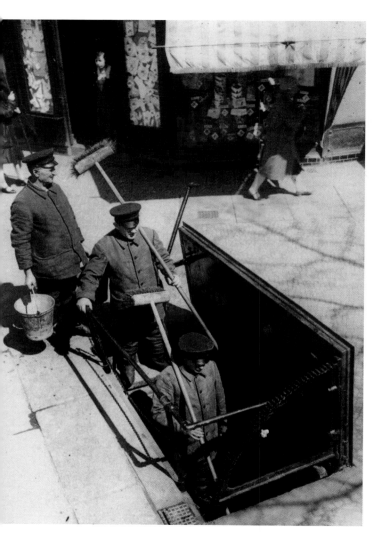

Early one morning in 1932, these sewage workers descend to their murky workplace, as Germany's capital, Berlin, is beginning to awaken. Since the mid 19th century, Germany had been building underground systems to dispose of waste and sewage.

Frühmorgens in der Reichshauptstadt Berlin steigen diese Kanalarbeiter 1932 hinab an ihren dunklen Arbeitsplatz, während das Leben in der Stadt zu erwachen beginnt. Seit Mitte des 19. Jahrhunderts baut man in Deutschland unterirdische Kanalsysteme, die der Entsorgung von Unrat und Fäkalien dienen.

Tôt le matin, à Berlin, la capitale du Reich, ces égoutiers descendent, en 1932, dans la pénombre de leur poste de travail tandis que la ville s'éveille. Depuis le milieu du XIXᵉ siècle, on construit en Allemagne des systèmes d'égouts souterrains pour l'évacuation des déchets et des matières fécales.

Before these cosmeticians were allowed to enter into the service of beauty, they had to take their exams at a Los Angeles vocational college on 13 June 1932. The current ideals of beauty were right next door in Hollywood, in the shape of such screen idols as Mae West, Katharine Hepburn and Bette Davis.

Bevor diese Kosmetikerinnen in den Dienst der Schönheit treten dürfen, müssen sie am 13. Juni 1932 ihr Examen an einer Berufsschule in Los Angeles ablegen. Die Schönheitsideale der Zeit werden in unmittelbarer Nähe kreiert – in Hollywood: Mae West, Katharine Hepburn oder Bette Davis.

Avant que ces esthéticiennes ne puissent se mettre au service de la beauté, le 13 juin 1932, passer leur examen dans une école professionnelle de Los Angeles. L'idéal de beauté de cette époque est créé tout près de là, à Hollywood : il a les traits de Mae West, Katharine Hepburn ou Bette Davis.

States like Sweden, which remained neutral
in both world wars, nevertheless maintained
military forces to protect their borders. These
Swedish soldiers are seen refreshing them-
selves while on maneuvers near Gävle in the
middle of the country in 1936.

Auch Staaten, die – wie Schweden – im
Ersten und Zweiten Weltkrieg neutral
bleiben, unterhalten zum Schutz ihrer
Landesgrenzen eigenes Militär. Diese
schwedischen Soldaten erfrischen sich
1936 während eines Manövers in der Nähe
von Gävle in Mittelschweden.

Même des pays comme la Suède, restés neu-
tres durant la Première et la Seconde Guerre
mondiale, entretiennent leur propre armée
pour protéger leurs frontières nationales. Ces
soldats suédois se rafraîchissent durant leurs
manœuvres, en 1936, à proximité de Gävle,
dans le centre de la Suède.

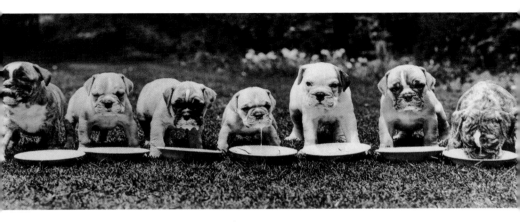

On 1 July 1931, this English photographer summed up these seven bulldog puppies under the caption "A fine litter." Of little use to posterity, however, was the information that Miss Marjorie Elliott was intending to display the canine youngsters at a dog show in Richmond later that month.

Unter dem Titel »Ein feiner Wurf« porträtiert ein englischer Fotograf diese sieben Bulldoggenwelpen am 1. Juli 1931. Von geringem Nutzen für die Nachwelt ist jedoch die Information, daß Miss Marjorie Elliott den Wurf noch im gleichen Monat auf einer Show in Richmond ausstellen wird.

« Une belle portée », tel est le titre de cette photo présentant, le 1er juillet 1931, dans la presse anglaise ces sept chiots bouledogues. L'information selon laquelle Miss Marjorie Elliott a l'intention de les présenter, ce même mois, à une exposition canine à Richmond est évidemment d'une grande importance pour l'humanité.

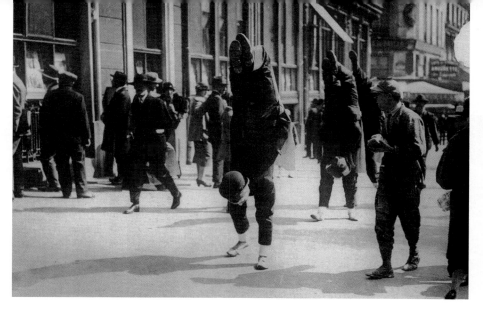

The indifference being shown by the passers-by suggests that the Parisian boulevards of the 1930s were frequently the scene of artistic improvisations of this sort. Here, three young Frenchmen are pictured holding a race walking on their (shod) hands.

Die unbeteiligte Haltung der Passanten läßt vermuten, daß Pariser Boulevards in den dreißiger Jahren wohl häufiger Schauplatz solcher artistischen Improvisationen sind. Hier erlauben sich drei junge Franzosen den Scherz, auf ihren in Schuhen steckenden Händen um die Wette zu laufen.

L'indifférence manifeste des passants incite à penser que de telles improvisations artistiques n'étaient pas rares sur les boulevards parisiens des années 30. Ici, trois jeunes Français qui ne manquent pas d'humour, font une course sur les mains, qu'ils ont glissées dans des chaussures.

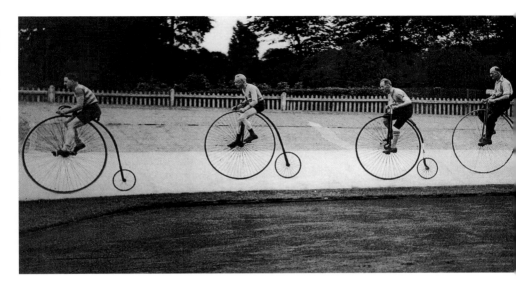

Penny-farthing veterans back in training. On 31 August 1937, the Herne Hill Racing Track was the venue of a memorial penny-farthing race. It was in 1861 that Frenchman Pierre Michaux dreamt up this monster. Englishman Thomas Shergold built the first "safety" bicycle with modern-size wheels in 1878.

Veteranen des Hochradsports trainieren wieder. Am 31. August 1937 findet auf der Herne-Hill-Rennbahn in London ein Gedächtnisrennen auf Hochrädern statt. 1861 ersann der Franzose Pierre Michaux dieses Ungetüm, 1878 baute der Engländer Thomas Shergold die ersten Niederräder.

D'anciens amateurs de bicycle reprennent l'entraînement, pour disputer le 31 août 1937, une course commémorative, au vélodrome de Herne Hill, à Londres. C'est le Français Pierre Michaux qui a inventé cet engin en 1861, l'Anglais Thomas Shergold ayant construit les premiers cycles conventionnels en 1878.

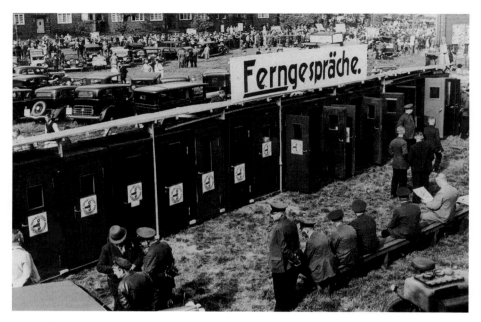

Hamburg's trotting-racetrack was ringed with telephone kiosks for the journalists at the boxing match between Max Schmeling and Walter Neusel on 26 August 1934. Schmeling won and crowned his comeback with a knock-out victory over Joe Louis in New York in 1936.

An Hamburgs Trabrennbahn stehen Telefonzellen für die Journalisten, die am 26. August 1934 den Boxkampf Max Schmelings gegen Walter Neusel verfolgen. Schmeling gewinnt und krönt sein Comeback 1936 mit einem K.O.-Sieg gegen Joe Louis.

A l'hippodrome de trot de Hambourg, des cabines téléphoniques sont à la disposition des journalistes qui suivent, le 26 août 1934, le match de boxe opposant Max Schmeling et Walter Neusel. Schmeling remporte la victoire et couronne son come-back par un K.-O. contre Joe Louis, en 1936 à New York.

Even in the early days of motorized private transport, parking space was at a premium in Manhattan. One of the first multi-story parking lots opened in 1932, following the skyscraper principle – a large floor area on a small plot.

In Manhattan gibt es bereits in den Anfangstagen des amerikanischen Individualverkehrs zu wenig Parkraum. Eines der ersten Parkhäuser eröffnet 1932 und folgt dem Prinzip des Wolkenkratzers: geringe Grundfläche und dennoch viel Nutzraum.

A Manhattan, dès les débuts de la locomotion individuelle, les Américains sont confrontés à une pénurie d'aires de stationnement. L'un des premiers parkings ouvre ses portes en 1932 et reprend le principe du gratte-ciel : peu de surface occupée au sol et pourtant beaucoup d'espace utile.

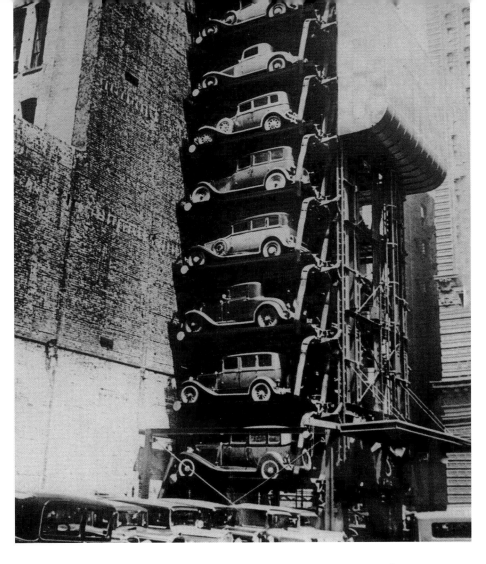

Since 1905, Sweden has seen the celebration of a "children's day" in some 135 towns. The aim is to collect money for holidays for needy children. A procession on 4 September 1938 featured a float by the Solstickan foundation, which drew its funds from the sale of matches and promoted special educational projects.

Seit 1905 wird in Schweden in etwa 135 Städten der »Kindertag« gefeiert, an dem für den Ferienaufenthalt bedürftiger Kinder gesammelt wird. Am Umzug am 4. September 1938 nimmt auch die Stiftung Solstickan teil, die sich durch den Verkauf von Streichhölzern finanziert und sonderpädagogische Projekte fördert.

Depuis 1905, en Suède, environ 135 villes fêtent la « Journée des Enfants » durant laquelle on collecte de l'argent pour permettre aux plus défavorisés de partir en vacances. La fondation Solstickan qui assure son financement par la vente d'allumettes et subventionne des projets pédagogiques particuliers, participe elle aussi au défilé le 4 septembre 1938.

Following a service in Westminster Abbey, England's judges keep up a 250-year-old custom on the occasion of the start of the legal year at the Royal Court of Justice. On 12 October 1938, the Lord Chancellor invited them to breakfast in his private chambers. The reception had not been held for seven years due to the poor economy.

Nach einem Gottesdienst in Westminster Abbey folgen die Richter zur alljährlichen Eröffnung des Königlichen Gerichtshofs in London wieder einem 250 Jahre alten Brauch. Der Lordkanzler lädt am 12. Oktober 1938 zu einem Frühstück in seine privaten Gemächer. Aus ökonomischen Gründen war der Empfang in den vorangegangenen sieben Jahren ausgefallen.

Après une messe célébrée à l'Abbaye de Westminster, les juges renouent avec une coutume vieille de 250 ans marquant l'ouverture annuelle de la Cour de justice royale à Londres. Le 12 octobre 1938, le Chancelier de l'Echiquier les invite à un petit déjeuner dans ses appartements privés. Par souci d'économie, la réception avait été supprimée durant les sept années précédentes.

"Pastorale Kennels" was the name of an institution which bred Old English sheepdogs not far from the town of Cheshunt. On 14 November 1930, the breeder arranged this tidbit for the photographer: six pedigree specimens in harness, guided by a young admirer.

»Pastorale Kennels« nennt sich der Zuchtbetrieb, der diese alte Rasse englischer Hütehunde in der Nähe von Cheshunt aufzieht. Die Züchterin präsentiert am 14. November 1930 dem Fotografen ein Gespann von sechs Rassetieren, das ein kleiner Bewunderer lenkt.

Proche de Cheshunt, l'élevage de chiens de garde, une vieille race anglaise, a pour nom Pastorale Kennels. Le 14 novembre 1930, l'éleveuse présente au photographe un attelage de six animaux de race que dirige un petit admirateur.

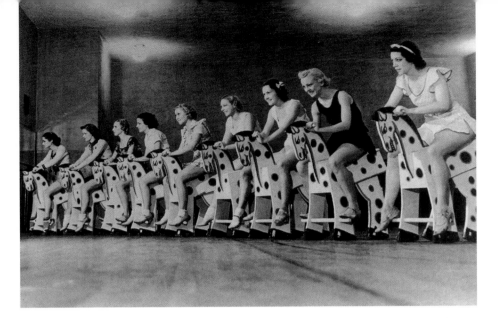

Visitors could only rub their eyes in amazement at the dimensions of what was then the world's largest and most magnificent Art deco auditorium in the Radio City Music Hall. On 21 October 1937 the photographer took a look behind the scenes of this flourishing stage in New York's Rockefeller Center.

Die Dimensionen des bis dahin weltweit größten und prächtigsten Art-déco-Saales in der Radio City Music Hall rufen bei den ersten Besuchern nur Kopfschütteln hervor. Hier blickt der Fotograf am 21. Oktober 1937 hinter die Kulissen der erfolgreichen Bühne im Rockefeller Center in New York.

Les premiers visiteurs sont ébahis par les dimensions de la plus luxueuse et la plus grande salle Art déco de l'époque à la Radio City Music Hall, au Rockefeller Center New York. Les spectacles que l'on y présente remportent un grand succès. Ici, le photographe jette un coup d'œil en coulisses, le 21 octobre 1937.

This picture of the Soviet factory "Red Flag" in 1947 shows the hall where stockings were dyed. The goals of the 4th Five-Year-Plan, covering the period 1946–1950, were to clear the damage resulting from the War, to rearm, and to rebuild the country's industry, which had been moved eastward during the war.

Dieses Bild aus der sowjetischen Fabrik »Rote Fahne« zeigt die Färberei bei der industriellen Strumpfproduktion 1947. Der vierte Fünfjahresplan für 1946–1950 hat die Beseitigung der Kriegsschäden, die Aufrüstung und den Wiederaufbau der Industrie, die im Krieg nach Osten verlagert worden war, zum Ziel.

Cette photo prise à l'usine soviétique « Drapeau rouge » montre un atelier de teinture industrielle de bas en 1947. Le 4ᵉ plan quinquennal de 1946–1950 a pour objectif la reconstruction du pays, le réarmement et la remise à flot de l'industrie qui, pendant la guerre, avait été transférée à l'Est.

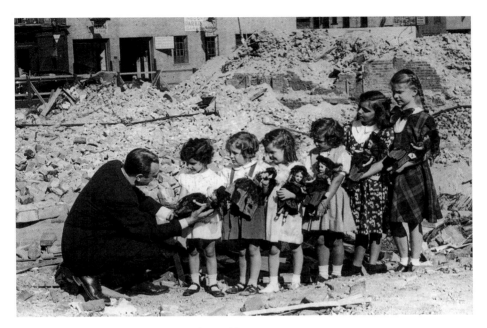

In postwar Europe there was a shortage of everything, and American readiness to help went far beyond purely economic measures like the Marshall Plan. Here, New York girls are seen handing over their favorite dolls to a member of an aid organization in September 1948.

Im Nachkriegseuropa fehlt es an allem, und die amerikanische Hilfsbereitschaft geht weit über die wirtschaftliche Hilfe durch den Marshall-Plan hinaus. Hier übergeben im September 1948 New Yorker Mädchen ihre Lieblingspuppen an den Mitarbeiter einer Hilfsorganisation.

Dans l'Europe de l'après-guerre, on manque de tout et l'aide américaine ne se limite pas à celle purement économique dans le cadre du plan Marshall. Ici, en septembre 1948, des fillettes de New York offrent leurs poupées préférées à un collaborateur d'une organisation caritative.

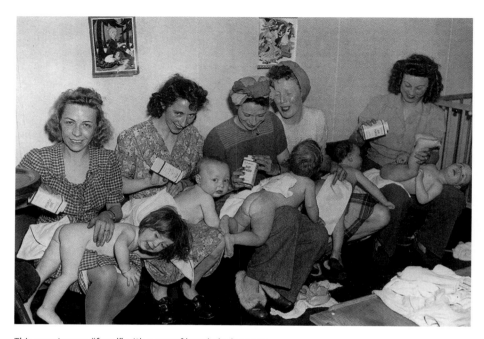

This reporter was "faced" with a row of bare baby bottoms when he went to welcome some new U.S. citizens in March 1946. "Irish GI brides who arrived on the *S.S. Henry Griffin* to join their husbands today are preparing their babies to meet their American daddies."

Blanke Kinderpopos empfangen diesen Reporter, der im März 1946 neue US-Bürger begrüßt: »Irische Kriegsbräute, die heute mit der *SS Henry Griffin* in New York angekommen sind, um mit ihren Ehemännern hier zu leben, bereiten die Babys für das erste Treffen mit ihren amerikanischen Vätern vor.«

Des fesses de bébés talquées accueillent ce reporter qui souhaite la bienvenue, en mars 1946, à ces nouveaux citoyens américains : « Des fiancées de guerre irlandaises, arrivées aujourd'hui par le *SS Henry Griffin* à New York où elles ont l'intention de s'installer avec leur mari, préparent les bébés pour la première rencontre avec leur père américain. »

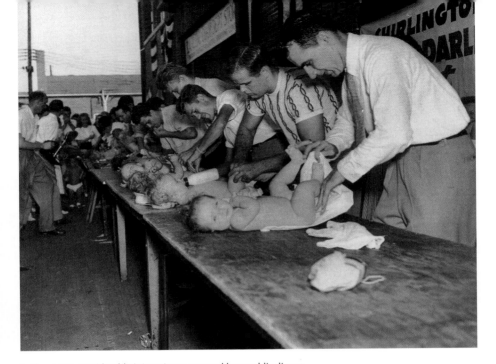

In the 1950s, considerable interest was aroused by a public diaper-changing contest for American fathers, organized by a group of local businessmen in Shirlington, Virginia. "The babies are all unconcerned about the whole show, although the daddies did work up a considerable sweat during the pinning up."

In den fünfziger Jahren erregt ein öffentlicher Wickelwettbewerb für amerikanische Väter, der von örtlichen Geschäftsleuten in Shirlington (Virginia) veranstaltet wird, erhebliches Aufsehen: »Die Babys zeigen sich gänzlich unbeeindruckt von der Veranstaltung, obwohl die Väter beim Befestigen der Sicherheitsnadeln erheblich ins Schwitzen gerieten.«

Dans les années 50, un concours public du meilleur « langeur » parmi les pères américains, qui a été organisé par des hommes d'affaires locaux de Shirlington (Virginie), défraye la chronique : « Les bébés ne se laissent pas impressionner le moins du monde par l'animation qui règne autour d'eux, même si les pères, quand il s'agit de fixer les langes avec des épingles de sûreté, se mettent à suer à grosses gouttes. »

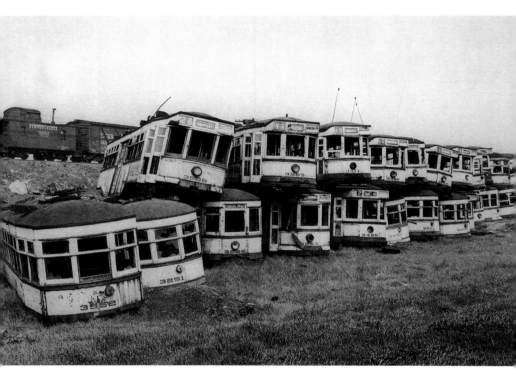

This shot of disused streetcars, taken on 24 May 1948 in America's "Motown," Detroit, heralds the end of an era. Since 1913, cars had been rolling off the city's assembly lines, and the following decades saw America become the world's leading automobile nation.

Diese Aufnahme vom 24. Mai 1948 aus der amerikanischen Motorstadt Detroit kündet vom Ende einer Ära: Straßenbahnwagen werden ausgemustert. Seit 1913 laufen in Detroit Automobile vom Fließband, und Amerika entwickelt sich in den folgenden Jahrzehnten zur bedeutendsten Autonation der Welt.

Cette photo prise le 24 mai 1948 dans la capitale américaine de l'automobile, Detroit, symbolise la fin d'une époque: les tramways sont mis à la casse. A Detroit, des automobiles sortent déjà de chaînes depuis 1913 et, au cours des décennies qui suivent, l'Amérique devient la nation automobile la plus importante du monde.

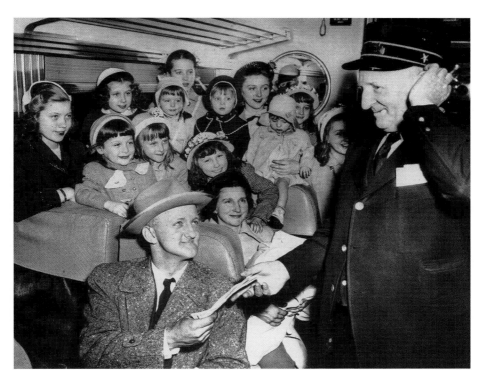

On the coast of New Hampshire (USA), the Brandt family lived by catching lobsters. In 1954, a local milliner made a present of Easter bonnets to all his regular female customers. This picture shows Mrs Brandt and her 13 daughters in their splendid new headgear, while Mr Brandt negotiates a family discount with the conductor.

An der Küste New Hampshires (USA) lebt Familie Brandt vom Hummerfang. Zu Ostern 1954 verschenkt ein Hutgeschäft in der nahegelegenen Stadt Hüte an seine weiblichen Stammkunden. Dieses Bild zeigt Mutter Brandt und ihre 13 Töchter im Glanz der neuen Kopfbedeckungen, während Vater Brandt mit einem Schaffner den Familienrabatt aushandelt.

Sur le littoral du New Hampshire (Etats-Unis), la famille Brandt vit de la pêche au homard. A Pâques 1954, un chapelier de la ville toute proche offre des chapeaux à ses clientes les plus fidèles. Ce cliché montre Madame Brandt et ses 13 filles portant leur nouvelle coiffure, tandis que le père Brandt négocie avec un contrôleur une réduction pour famille nombreuse.

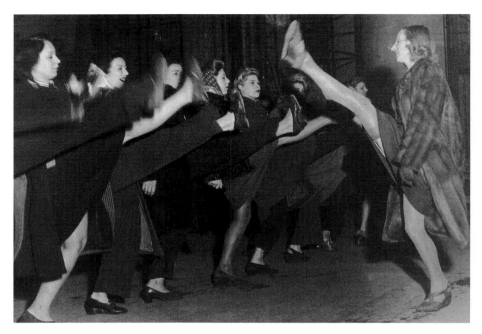

The dancing girls at the Pigalle Theater in Paris, which reopened in 1948, are here seen rehearsing their evening high kicks in chilly surroundings. Whenever coal did happen to be available in the postwar period, Europe's cinemas, theaters and variety stages would make sure they displayed notices with the words "heated auditorium."

Die Tänzerinnen des Pigalle-Theaters, das 1948 seine Pforten wieder öffnet, proben ihre abendlichen Darbietungen in lausiger Kälte. Wann immer in der Nachkriegszeit Kohlen erhältlich sind, weisen die Kinos, Theater und Varietés in Europa per Aushang ausdrücklich darauf hin: »Der Saal ist geheizt.«

Les danseuses du cabaret Pigalle, qui rouvre ses portes en 1948, répètent dans un froid glacial avant de se produire sur scène en soirée. Après la guerre, chaque fois qu'ils peuvent obtenir du charbon les cinémas, théâtres et cabarets d'Europe attirent le public avec un argument de poids placardé en toutes lettres : « La salle est chauffée. »

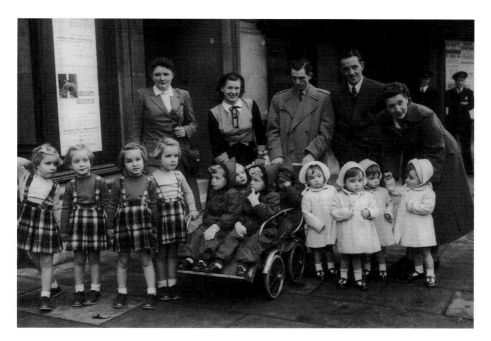

It was not until the 1960s that improved perinatal care lowered the mortality rate for multiple births. With this in mind, it is easier to understand the excitement of the English reporter in 1952 when he wrote, "Quads are unusual, but when you get three sets of quads all in one place at the same time, *it's news.*"

Erst in den sechziger Jahren senkt eine verbesserte Perinatalmedizin die Sterblichkeitsrate bei Mehrlingsgeburten. Daher ist die Begeisterung des englischen Schreibers angesichts dieses Bildes von 1952 nachzuvollziehen: »Vierlinge sind schon ungewöhnlich – aber wenn man drei Ausgaben von Vierlingen am gleichen Ort und zur gleichen Zeit begegnet, in der Tat, das sind Nachrichten.«

Il faut attendre les années 60 pour que grâce à une meilleure médecine périnatale le taux de mortalité diminue lors des naissances multiples. On comprend donc aisément l'enthousiasme du rédacteur anglais à la vue de cette photographie de 1952 : « Des quadruplés, cela est déjà extraordinaire – mais rencontrer autant de quadruplés au même endroit et au même moment, de fait, une scène qui mérite d'être immortalisée. »

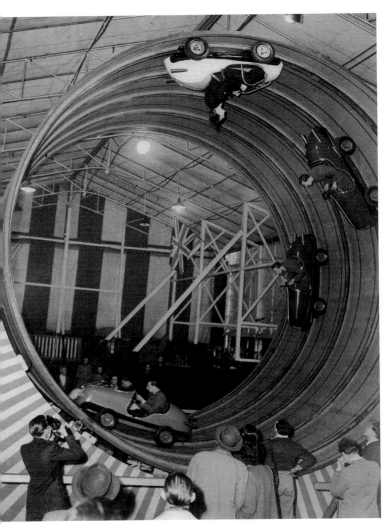

When Sir Isaac Newton formulated the laws of gravity in 1666, he could have had no inkling of the variety of means that would be used by the world's fairground operators to try and make a profit by apparently proving him wrong – as for example here in London in May 1951.

Als Newton 1666 die Schwerkraft in einem physikalischen Gesetz formulierte, konnte er in keiner Weise ahnen, welche Versuche auf den Jahrmärkten der Welt unternommen werden würden, um die Gesetze der Gravitation spielerisch in klingende Münze umzusetzen – so im Mai 1951 in London.

Lorsque Newton découvrit la loi de l'attraction universelle, en 1666, il ne pouvait nullement se douter de tout ce dont on serait capable, lors des fêtes foraines du monde entier, pour rentabiliser cette découverte sur le mode ludique, comme ici, en mai 1951 à Londres.

The ladies of Philadelphia's high society organized a Charity Race in 1952 on behalf of the city's distressed animals. Here we see the finish of the Turtle Race with Mrs Wallace Backhus, the winner, leading her "steed of lightning."

Die Damen der höheren Gesellschaft Philadelphias veranstalten 1952 ein Wohltätigkeitsrennen für notleidende Tiere in dieser amerikanischen Stadt: »Hier sehen wir den Zieleinlauf des Schildkrötenrennens mit Mrs Wallace Backhus, der Siegerin, die ihr ›Blitzroß‹ führt.«

En 1952, les dames de la haute société de Philadelphie organisent une course de bienfaisance pour les animaux défavorisés de cette ville des Etats-Unis : « Ici, nous assistons à l'arrivée de la course de tortues avec Mme Wallace Backhus, qui guide la championne, Cheval fulgurant. »

In order that the juror not be distracted by any extraneous aesthetic impressions, the subjects in these manicure championships, held in Paris on 21 March 1960, had all but their hands concealed from her.

Um die Aufmerksamkeit der Jurorin nicht durch sonstige ästhetische Eindrücke zu beeinflussen, werden die Probanden durch diese Form der Präsentation auf die Leistungen der Maniküre reduziert. Das Foto entsteht während der Maniküremeisterschaften in Paris am 21. März 1960.

Pour que cette femme membre du jury ne soit pas influencée par de quelconques impressions esthétiques, on l'oblige par cette forme de présentation à se concentrer uniquement sur la qualité de la manucure. La photo a été prise lors d'un championnat de manucure, à Paris le 21 mars 1960.

The Czechoslovak Socialist Republic had been a Soviet satellite since 1948. In 1960, state propaganda pointed proudly to its successes in the field of housing. "The first new social towns have been built for miners and their families. Special health service centers and recreation resorts in the mountains serve the miners."

Die ČSSR ist seit 1948 sowjetischer Satellitenstaat. 1960 verweist die staatliche Propaganda stolz auf die Erfolge im Wohnungsbau: »Die ersten sozialen Städte sind für die Bergleute und ihre Familien errichtet worden. Spezielle Gesundheitszentren und Freizeitanlagen in den Bergen dienen den Bergleuten.«

Depuis 1948, la Tchécoslovaquie est un Etat satellite de l'Union soviétique. En 1960, la propagande officielle souligne les succès remportés dans la construction de logements : « Les premières villes sociales ont été construites pour les mineurs et leurs familles. Des dispensaires spéciaux et des équipements de loisirs sont à la disposition des mineurs dans les montagnes. »

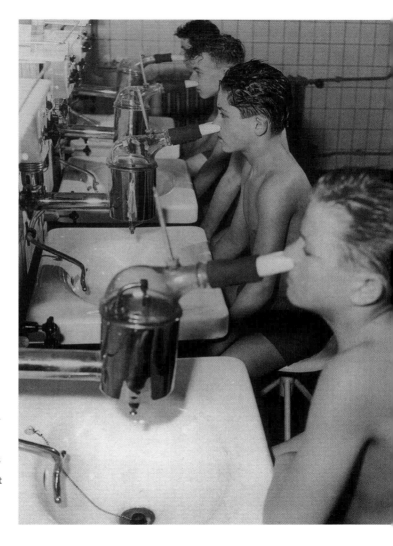

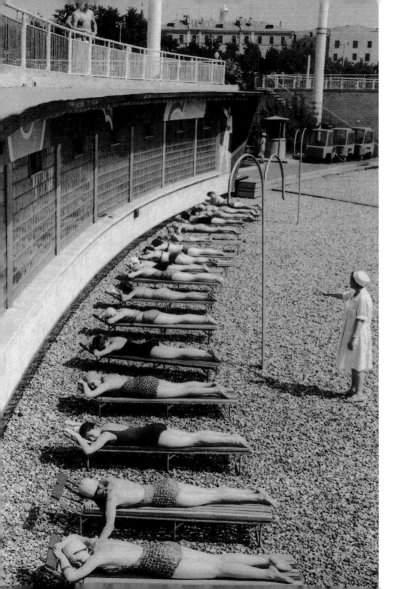

In the early 1960s, at the height of the Cold War, the caption to this picture used a leisure park in the center of Moscow to praise the achievements of Soviet communism. "Some 10,000 people every day visit the 'Moskva' water sports center, the biggest of its kind in the world."

Auf dem Höhepunkt des Kalten Krieges Anfang der sechziger Jahre preist dieser Bildkommentar die Errungenschaften des sowjetischen Kommunismus anhand einer Freizeitanlage mitten in Moskau: »Täglich besuchen etwa 10 000 Menschen den größten Wassersportbau Europas und der Welt, ›Moskva‹.«

A l'apogée de la Guerre froide, au début des années 60, la légende de cette photo d'un centre de loisirs en plein cœur de Moscou fait l'éloge des acquis du communisme soviétique : « Chaque jour, environ 10 000 personnes se rendent à la ‹ Moskva ›, la plus grande piscine d'Europe et du monde. »

On the eve of the Miss World contest in London on 6 November 1963, the candidates were pictured in a less glamorous context – under the hair-drier. Seen here from left to right are Miss Finland, Miss Brazil, Miss Spain, Miss South Africa, Miss Israel, Miss Japan, Miss Malaysia and Miss Israel's twin sister.

Am Vorabend der Wahlen zur Miss World in London, am 6. November 1963, kommen die Kandidatinnen zunächst einmal unter die Haube: (von links nach rechts) Miss Finnland, Miss Brasilien, Miss Spanien, Miss Südafrika, Miss Israel, Miss Japan, Miss Malaysia und Miss Israels Zwillingsschwester.

La veille de l'élection de Miss Monde, à Londres, le 6 novembre 1963, les concurrentes sont assises côte à côte tout d'abord sous le casque : (de gauche à droite) Miss Finlande, Miss Brésil, Miss Espagne, Miss Afrique du Sud, Miss Israël, Miss Japon, Miss Malaisie et la sœur jumelle de Miss Israël.

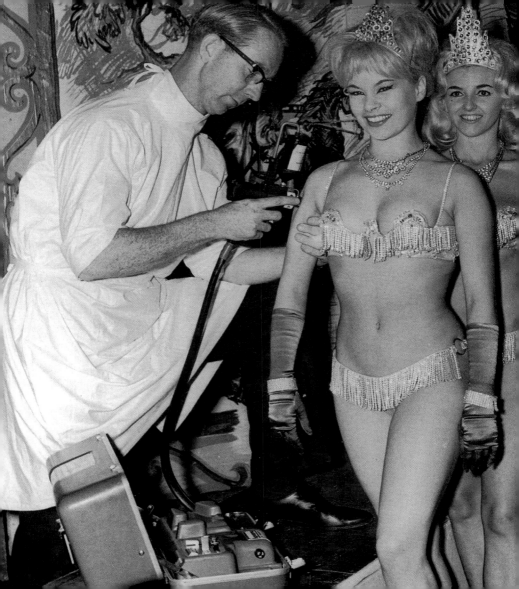

Influenza continued to be a virulent problem into the 1960s. To forestall a flu epidemic in England in 1963, a team from Crookes Laboratories was employed to carry out a nationwide immunization program. Here Mr Willerby is seen immunizing the ensemble at London's Windmill Theatre.

Die Influenza ist auch in den sechziger Jahren ein virulentes Problem. Um 1963 einer Grippewelle in England vorzubeugen, wird das Team der Crookes-Laboratorien beauftragt, landesweit Impfungen durchzuführen. Mr Willerby impft das Ensemble des Windmill Theatre in London.

Dans les années 60, la grippe reste encore un problème préoccupant. Pour prévenir une épidémie en Angleterre vers 1963, l'équipe des laboratoires Crookes est chargée de procéder à des vaccinations à l'échelle nationale. M. Willerby vaccine la troupe du Théâtre Windmill, à Londres.

All creatures great and small

Laika the dog blasted off into space on board the Soviet satellite Sputnik II on 3 November 1957, and proved that mammals could survive in weightless conditions. The world's press writers agreed that this round of the space race had been lost by the USA, and stock values on Wall Street fell. The fact that Laika's "survival" lasted just six days before her oxygen ran out was noted merely in passing, if at all. Progress and research did, however, provide the 20th century press with striking, if controversial, images of experiments involving animals. Many photographers illustrated the allegedly idyllic relationship between man and beast. On the one hand, industrial society was destroying natural habitats, while on the other, individual human beings were making up for this destruction by exaggerated love of pets, along with visits to circuses or zoos.
The press sought out the extreme examples of man-beast relationships. One often has the impression that animal lovers were creating an experimental zoo in which they were exposing their protégés to the blessings of Western civilization. Many stories are so weird that one is forced to entertain just a wee suspicion that (perish the thought!) they might not actually be true.

Tierfreunde

Die Hündin Laika startet am 3. November 1957 an Bord des sowjetischen Satelliten Sputnik II in den Weltraum und beweist, daß Säugetiere auch in der Schwerelosigkeit überleben können. Die Weltpresse konstatiert, damit sei der Wettlauf ins All vorerst zum Nachteil der USA entschieden. Der Sputnik-Schock läßt die Börsenkurse an der Wall Street fallen. Eher beiläufig wird die Nachricht gehandelt, daß Laika wegen Sauerstoffmangels nach sechs Tagen im All stirbt. Fortschritt und Forschung liefern der Presse im 20. Jahrhundert aufregende, aber auch umstrittene Motive von Tierversuchen. Viele Fotografien zeigen die vermeintliche Idylle zwischen Mensch und Tier. Einerseits zerstört die Industriegesellschaft zwar den Lebensraum der Tiere, andererseits kompensiert der Einzelne diesen Verlust der Natur mit einer übersteigerten Liebe zu seinen Haustieren sowie durch Besuche im Zirkus und in Zoologischen Gärten. Die Presse spitzt das Verhältnis zwischen Mensch und Tier zu. Oft entsteht der Eindruck, Tierliebhaber schafften einen Versuchszoo, in dem sie ihre Lieblinge den Segnungen der westlichen Zivilisation aussetzen. Manche Geschichten sind so skurril, daß sich die Frage stellt, ob sich nicht die eine oder andere Zeitungsente eingeschlichen hat.

Amis des bêtes

Le 3 novembre 1957, la chienne Laïka est envoyée dans l'espace à bord du satellite soviétique Spoutnik II et prouve que des mammifères sont capables de survivre en état d'apesanteur. La presse mondiale fait remarquer que la conquête de l'espace dans un premier temps, relègue les Etats-Unis au second rang. L'annonce de l'exploit russe fait chuter les cours de la bourse à Wall Street. On apprendra fortuitement que Laïka est morte, après six jours passés dans l'espace, des suites d'un manque d'oxygène. Le progrès et la recherche livrent à la presse du xxᵉ siècle des images excitantes, mais aussi contestées d'animaux, utilisés lors de différents essais. De nombreuses photographies représentent l'idylle prétendue entre l'homme et l'animal. D'une part, la société industrielle détruit, en effet, les biotopes naturels et, d'autre part, l'individu compense cette perte par son amour excessif pour les animaux domestiques ainsi que par des visites au cirque ou au jardin zoologique. La presse a tendance à caricaturer le rapport entre l'homme et l'animal. On a souvent l'impression que les amis des animaux créent un zoo expérimental pour exposer leurs protégés aux bienfaits de la civilisation occidentale. Certaines histoires sont si bizarres que l'on peut se demander si l'une ou l'autre n'est pas en réalité un canular.

American stewardess Lolly Allen visits lioness Little Tyke at Westbeau Ranch in Washington state on 17 September 1950. This denizen of the savanna, able to break a zebra's neck with one blow of its paw, loves cuddling and traveling – in cars, in planes, on rafts, in elevators and on escalators.

Die amerikanische Stewardeß Lolly Allen besucht am 17. September 1950 auf der Westbeau Ranch im Bundesstaat Washington die Löwin Little Tyke. Dieses Savannentier, das einem Zebra mit einem Prankenschlag das Genick brechen kann, liebt das Schmusen und das Reisen – in Automobilen und Flugzeugen, auf Flößen, Aufzügen und Rolltreppen.

Le 17 septembre 1950, l'hôtesse de l'air américaine Lolly Allen rend visite à la lionne Little Tyke au Westbeau Ranch, dans l'Etat fédéré de Washington. Cette bête de la savane capable de briser la nuque d'un zèbre d'un seul coup de patte aime les caresses et les voyages, en voiture, en avion et par radeau. Elle apprécie aussi les ascenseurs et les escaliers roulants.

In their Australian homeland kangaroos were intensively hunted during the 1920s, as they were regarded as vermin by sheep farmers. In Europe, as here in this English private zoo in Epsom in 1927, the nimble marsupials served as sparring partners for young sportsmen.

In ihrer Heimat Australien werden die Känguruhs in den zwanziger Jahren stark bejagt, da sie als schädlich für die Schafzucht gelten. In Europa, wie in diesem englischen Privatzoo in Epsom im Jahre 1927, dienen die Beuteltiere mit der guten Beinarbeit als Sparringspartner für junge Sportsmänner.

Dans leur pays, l'Australie, les kangourous ont été décimés dans les années 20, car ils mettaient en péril l'élevage de moutons. En Europe, comme dans ce zoo privé anglais à Epsom, en 1927, les marsupiaux, qui se distinguent par leur excellent jeu de jambes, servent souvent de sparring-partners aux jeunes sportifs.

Adam Breede, publisher of the *Hastings Daily Tribune* in Nebraska, obtained this vast array of trophies on his hunting trips to Africa. On 3 February 1927, his newspaper reported that he wished to bequeath his collection to the state of Nebraska for research and educational purposes. The competent authority was still considering the matter.

Adam Breede, Herausgeber des *Hastings Daily Tribune* in Nebraska, erjagte auf seinen Reisen nach Afrika diese Unmenge von Trophäen. Seine Zeitung meldet am 3. Februar 1927, daß Breede seine Sammlung dem Staat Nebraska für Forschungs- und Lehrzwecke vermachen wolle. Die zuständige Behörde berate dies noch.

Adam Breede, l'éditeur du *Hastings Daily Tribune*, journal du Nebraska, a rapporté de ses voyages en Afrique cette quantité inimaginable de trophées. Le 3 février 1927, son journal annonce que Breede souhaite faire don de sa collection à l'Etat du Nebraska pour l'enseignement et la recherche. Mais les autorités compétentes réfléchissent encore à la question.

Outside his shop in Halifax, Nova Scotia, John Earl takes delivery of a new consignment of moose antlers. Earl, who had been in the business for 30 years, had by his own account the world's largest store of these characteristic palmate antlers, which can grow to 6 feet (2 meters) across.

John Earl nimmt vor seinem Laden in Halifax (Neuschottland) in den zwanziger Jahren eine neue Lieferung Elchgeweihe entgegen. Earl, seit 30 Jahren im Geschäft, verfügt nach eigenen Aussagen über das weltweit größte Lager dieser charakteristischen, bis zu 2 m großen Schaufeln.

Dans les années 20, John Earl réceptionne une nouvelle livraison de bois d'élan devant son magasin de Halifax, en Nouvelle-Ecosse. Earl, spécialiste de ce négoce depuis 30 ans, gère selon ses propres dires le plus grand stock mondial de ces bois caractéristiques qui peuvent atteindre une envergure de 2 mètres.

The idea behind this 1920s German invention was to allow more targeted attacks on ducks. "A box which can be lowered into the water, in which the sportsmen can watch the game from a position of near invisibility. Artificial ducks make the floating hide look particularly harmless."

Gezieltere Angriffe auf Enten will diese deutsche Innovation der zwanziger Jahre ermöglichen: »Ein versenkbarer Kasten, in dem die Jäger fast unsichtbar dem Wild auflauern können. Künstliche Enten lassen den schwimmenden Ausstand besonders harmlos erscheinen.«

Le but de l'innovation allemande des années 20 est de permettre de se rapprocher subrepticement des canards. « Un caisson submersible dans lequel les chasseurs peuvent guetter le gibier en restant pratiquement invisibles. Des canards artificiels servant d'attrapes créent l'illusion d'une grève flottante. »

Circuses were among the most popular
leisure entertainment in the 1920s. With a
strong grip, the animal tamer is seen here
training his favorite tiger to smoke a good
Havana cigar after a hard day's work.

Der Zirkus gehört in den zwanziger Jahren zu
den beliebtesten Freizeitvergnügungen. Mit
festem Griff bewegt hier ein Dompteur seinen
Lieblingstiger dazu, ihm nach getaner Arbeit
eine gute Havanna anzuzünden.

Dans les années 20, le cirque est l'une des
activités de loisirs les plus populaires. Ici, un
dompteur qui a les choses bien en mains
apprend à son animal favori à fumer un bon
havane avec lui, une fois le travail terminé.

The Swiss village of Morat in the Bernese Oberland
was where the photographer discovered a skiing monk
accompanied by a St Bernard in the 1920s. These dogs,
bred on the Great St Bernhard since 1665, are used as
avalanche rescue dogs in this region.

Im Schweizer Ort Murten im Berner Oberland entdeckt
ein Fotograf in den zwanziger Jahren einen skilaufenden
Mönch in Begleitung eines Bernhardiners. Diese seit 1665
auf dem Großen St. Bernhard gezüchtete Rasse wird in
dieser Region als Lawinensuchhund eingesetzt.

A Morat, localité de l'Oberland bernois, en Suisse, un
photographe découvre dans les années 20 un moine skieur
accompagné d'un saint-bernard. Elevés depuis 1665 au
Grand St. Bernard, ces chiens sont utilisés dans cette région
pour retrouver des personnes enfouies sous des avalanches.

All creatures great and small

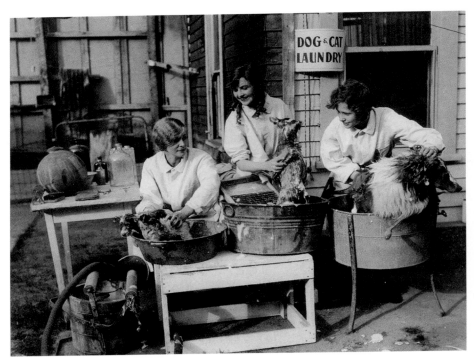

This "Dog & Cat Laundry" in Los Angeles in the 1920s charged customers by weight – 10 cents per pound of dog or cat. Manager Richard Goodwin said business was good; the sub-editor added the sober comment: "They scrub 'em in a tub and hang 'em up to dry."

Dieser »Hunde-und-Katzen-Waschsalon« im Los Angeles der zwanziger Jahre berechnet 10 Cents pro Pfund Körpergewicht der vierbeinigen Kunden. Geschäftsführer Richard Goodwin spricht von einem Erfolg, der Redakteur bemerkt jedoch nüchtern: »Sie schrubben sie in einem Bottich und hängen sie zum Trocknen auf.«

Ce « salon de toilettage pour chiens et chats » du Los Angeles des années 20 facture ses services en fonction du poids des quadripèdes : 20 cents par kilo. Le gérant se déclare satisfait du succès de son affaire qui n'inspire qu'un seul commentaire au rédacteur : « Elles lavent les animaux dans une bassine et les accrochent pour les faire sécher. »

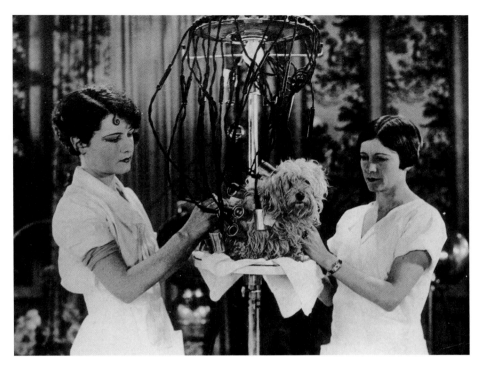

In 1920s' Berlin dog parlors were elegant and employed state-of-the-art technology. These ladies are giving the terrier a permanent wave. The caption remarked laconically: "If you want to be beautiful, you have to suffer."

Im Berlin der zwanziger Jahre sind die Hundesalons gediegen und die Arbeitsmethoden auf dem neuesten Stand der Technik. Diese Damen demonstrieren an einem Terrier das Legen einer Dauerwelle. Die damalige Bildunterschrift lautet lakonisch: »Wer schön sein will, muß leiden.«

A Berlin, dans les années 20, les salons de toilettage pour chiens sont luxueux et reposent sur l'application de techniques modernes. Ces deux jeunes femmes montrent comment permanenter un terrier. Commentaire laconique au sujet de cette photo d'époque : « Il faut souffrir pour être beau. »

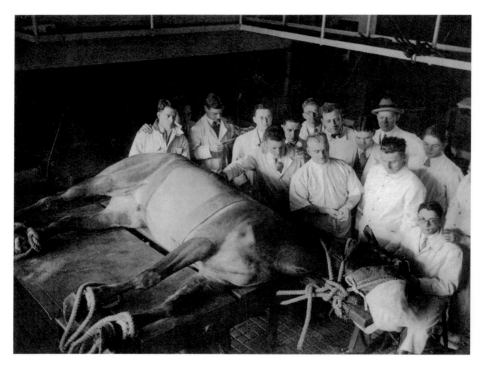

On 7 January 1927, these veterinary students at the University of Pennsylvania watched their teacher Dr William Lee perform a difficult operation. The hunting horse was suffering from a chronic cough caused by a dysfunction of the larynx.

Am 7. Januar 1927 beobachten diese angehenden Veterinärmediziner der Universität von Pennsylvania ihren Lehrer Dr. William Lee bei einer schwierigen Operation. Das Jagdpferd leidet an chronischem Husten, der durch eine Funktionsstörung des Kehlkopfes hervorgerufen wird.

Le 7 janvier 1927, les futurs vétérinaires de l'Université de Pennsylvanie observent le professeur, le Dr William Lee, qui s'apprête à faire une opération complexe. Le cheval qui dispute des épreuves de steeple-chase a une toux chronique du fait d'un dysfonctionnement du larynx.

According to its caption, this 1920s picture documents a hitherto unknown phenomenon. In the Bois de Vincennes near Paris, a two-headed frog was said to have been discovered.

Dieses Bild aus den zwanziger Jahren dokumentiert seiner Unterschrift zufolge ein bis dato unbekanntes Phänomen. Sie besagt, im Bois de Vincennes in der Nähe von Paris sei ein zweiköpfiger Frosch entdeckt worden.

Selon sa légende, cette photo datant des années 20 montre un phénomène inconnu à ce jour : une grenouille à deux têtes que l'on aurait découverte dans le bois de Vincennes, à l'est de Paris.

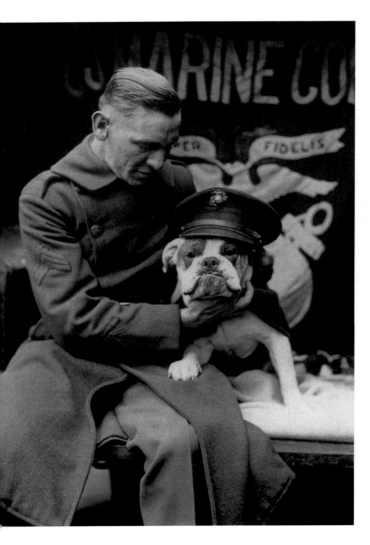

This pedigree British bulldog was a present from the then world boxing champion Gene Tunney to his former unit in the U.S. Marines. Here we see the inauguration of the new mascot on 24 March 1927, looking amazingly like his beloved, and unfortunately deceased, predecessor, Sergeant Major Jiggs.

Diese englische Bulldogge mit Stammbaum ist ein Geschenk des amtierenden Boxweltmeisters Gene Tunney an seine ehemalige US-Marine-Einheit. Hier sehen wir die Amtseinfüh-rung des neuen Maskott-chens am 24. März 1927, das seinem beliebten, leider verstorbenen Vorgänger Sergeant Major Jiggs ver-blüffend ähnlich sieht.

Ce bouledogue anglais avec pedigree est un cadeau offert par le champion du monde de boxe en titre, Gene Tunney, à son ancienne unité de la marine américaine. Cette photo a été prise le 24 mars 1927, lors de l'entrée en fonction de la nouvelle mascotte, qui présente une similitude stupéfiante avec son prédécesseur malheureusement décédé, Sergeant Major Jiggs.

This archive photo announced the 93rd birthday of Lord North on 5 October 1929. The caption noted that his lordship intended to open the drag hunt in the morning, and in the evening would close the day in the company of his friends at his country seat, Wroxton Abbey.

Dieses Archivfoto kündigt am 5. Oktober 1929 den 93. Geburtstag von Lord North an. Der Text vermerkt, daß seine Lordschaft am Morgen die Schleppjagd zu eröffnen gedenkt, um am Abend in Gesellschaft seiner Freunde auf seinem Landsitz Wroxton Abbey den Tag ausklingen zu lassen.

Cette photo d'archives annonce, le 5 octobre 1929, le 93ᵉ anniversaire de Lord North. Selon la légende, Sa Seigneurie, inaugurera le matin la chasse à courre et passera la soirée en compagnie de ses amis dans sa propriété rurale à Wroxton Abbey.

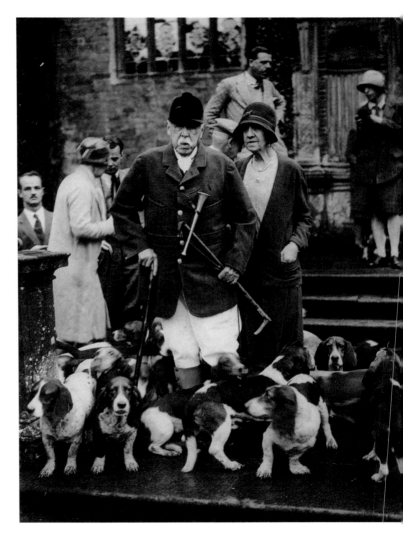

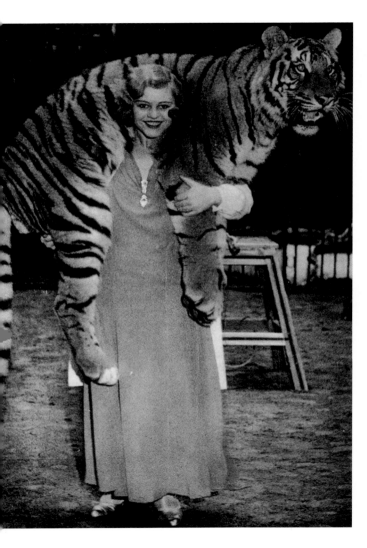

Tigers are the kings among the five great beasts of prey, and were also among the main attractions at Germany's Krone Circus. Miss Cilly, at 17 the youngest wild animal tamer in Germany, had been in the job for a year. Here she is seen with her favorite tiger, Ceylon, on 8 April 1931.

Die Tiger sind die Könige der fünf großen Raubtiere und gehören auch im deutschen Zirkus Krone zu den Hauptattraktionen. Fräulein Cilly, mit 17 Jahren die jüngste deutsche Raubtierdompteuse und seit einem Jahr in der Manege tätig, präsentiert hier am 8. April 1931 ihren Lieblingstiger Ceylon.

Les tigres, rois des cinq grands carnassiers sont aussi l'une des principales attractions au cirque allemand Krone. Mademoiselle Cilly, qui a 17 ans, est la plus jeune dompteuse d'animaux sauvages d'Allemagne. Elle exerce ce métier depuis un an et présente ici son animal préféré Ceylon, le 8 avril 1931.

On 7 July 1938, Whipsnade Zoo in Bedfordshire was the scene of a battle of the sexes. Following the death of her mate Sam, Barbara was paired up in the polar bear enclosure with a new escort, Fritz. Here Barbara is seen triumphant in the fight for possession of a piece of clothing, Fritz having withdrawn in annoyance.

Am 7. Juli 1938 spielt sich im Zoo von Whipsnade in Bedfordshire ein Geschlechterkampf ab. Nach dem Tod ihres Gefährten Sam soll Barbara mit Fritz, dem neuen Anführer im Eisbärenkäfig, gepaart werden. Hier triumphiert Barbara nach einem Streit um den Besitz eines Kleidungsstücks, aus dem Fritz sich verärgert zurückgezogen hat.

Le 7 juillet 1938, une guerre des sexes éclate au zoo de Whipsnade, dans le Bedfordshire. Après la mort de son compagnon Sam, Barbara est censée s'accoupler avec le nouveau chef de meute Fritz, dans la fosse à ours blancs. Sur notre photo, Barbara n'a d'intérêt que pour un vêtement, tandis que Fritz, vexé, est allé bouder dans son coin.

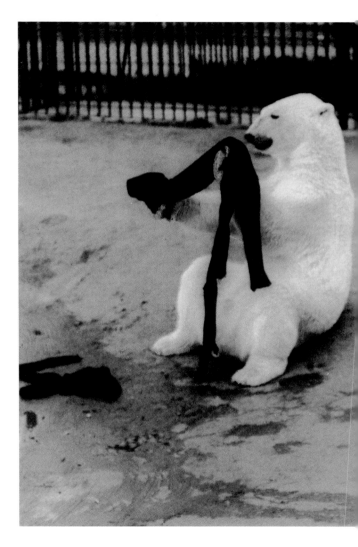

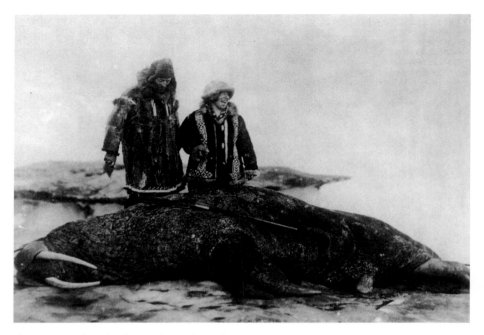

The Arctic expedition by the American polar explorer
Kleinschmidt in the 1930s, here seen hunting walrus together
with his wife, has not gone down in the history of exploration.
The race to the North Pole between Cook and Peary had
already been decided in favor of the latter in April 1909.

Die Arktisexpedition des amerikanischen Forschungsreisenden
Kleinschmidt in den dreißiger Jahren, hier mit seiner Frau
auf Walroßjagd, ist nicht in die Geschichtsschreibung einge-
gangen. Der Wettlauf zum Nordpol war bereits im April 1909
unter Cook und Peary zugunsten des letzteren entschieden
worden.

L'expédition en Arctique, dans les années 30, de l'explorateur
américain Kleinschmidt – ici à la chasse au morse avec sa
femme – n'est pas entrée dans les annales de la recherche
polaire. La course au pôle Nord entre Cook et Peary avait déjà
été remportée par ce dernier en avril 1909.

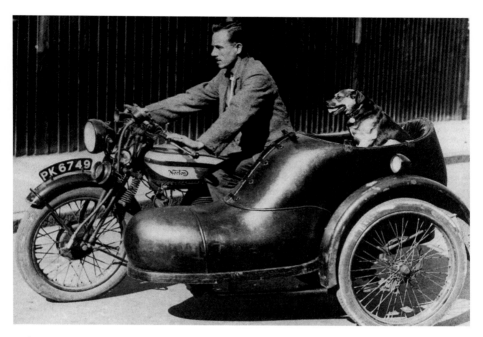

In the 1930s, an enterprising shoemaker from London had a sidecar for his motorcycle made in the form of a shoe and thus attracted the attention not only of the photographer. The age of advertising had begun.

Ein geschäftstüchtiger Schuhmacher aus London läßt in den dreißiger Jahren den Seitenwagen seines Motorrades in Schuhform umbauen und erregt damit nicht nur die Aufmerksamkeit des Fotografen. Das Zeitalter der Werbung hat begonnen.

Un astucieux marchand de chaussures de Londres a fait construire, dans les années 30, le side-car de sa moto en forme de soulier. L'attention des photographes, entre autres, lui est assurée. L'ère de la publicité a commencé.

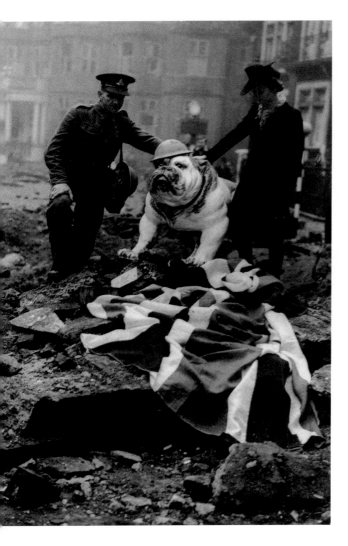

"Still defiant" was the British newspapers' response to German bomb attacks on the British Isles in October 1940. This plastic bulldog had served as window dressing prior to the air-raid of 16 October.

»Stur bis zum bitteren Ende« – mit dieser Überschrift trotzen die englischen Zeitungen dem deutschen Bombenhagel auf die britischen Inseln im Oktober 1940. Die Plastikbulldogge war vor diesem Angriff am Mittwoch, den 16. Oktober, Teil einer Londoner Schaufensterdekoration.

« Et toujours cet air provocateur » – avec ce titre, les journaux anglais bravent le déluge de bombes allemandes sur les îles britanniques en octobre 1940. Jusqu'au bombardement du mercredi 16, ce bouledogue en plastique servait encore de décoration dans la vitrine d'un magasin londonien.

On 10 April 1940, a drama was played out at Danville Falls in the state of Virginia. While he was crossing the River Dan on his mare, the rider's saddle had come loose and he had been thrown into the water. The spectacle drew hundreds of onlookers, but the fate of the rider is not recorded.

Am 10. April 1940 ereignet sich dieses Drama an einem Wasserfall in Danville (Virginia). Beim Überqueren des Flusses Dan lockert sich der Sattelgurt, und die Stute wirft ihren Reiter in die Fluten. Das Schauspiel lockt Hunderte von Zuschauern an, über das Schicksal des Reiters ist nichts bekannt.

Un drame se déroule, le 10 avril 1940, à la cascade de Danville (Virginie). Lors du passage à gué de la rivière Dan, la sangle de la selle se desserre et la jument projette son cavalier dans les flots. Cet accident attire des centaines de curieux, mais nul ne sait ce qu'il advint du cavalier.

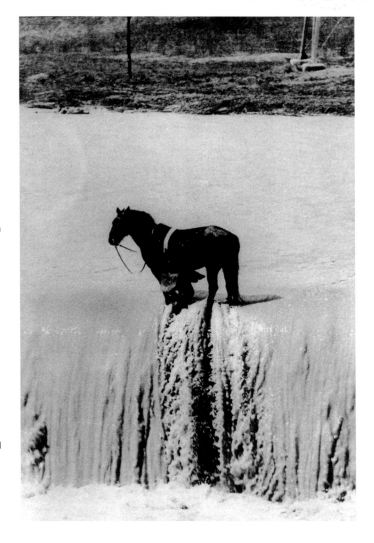

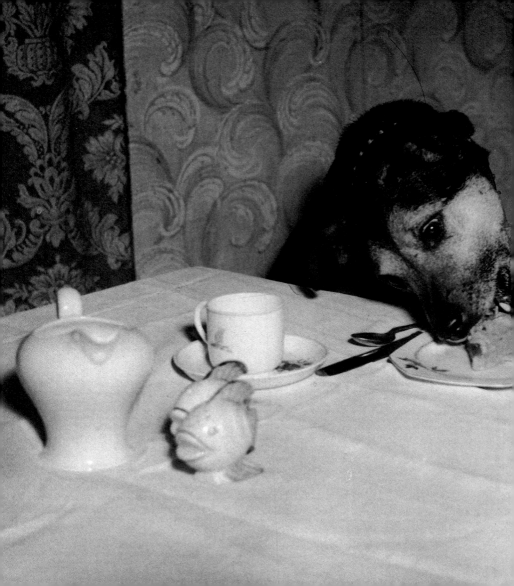

This snapshot taken in 1947 makes a mockery of all attempts by parents to bring up their children in Christian piety, not to mention teach them good table manners. But little Diane Vincent will no doubt have forgiven her favorite dog Raf.

Dieser Schnappschuß aus dem Jahre 1947 spottet allen elterlichen Erziehungsversuchen der Kinder zu christlicher Ehrfurcht und guten Tischsitten. Die kleine Diane Vincent wird ihrem Lieblingshund Raf jedoch vergeben haben.

Cet instantané de 1947 tourne en dérision les parents qui s'évertuent à donner à leurs enfants une éducation chrétienne et à leur apprendre les bonnes manières à table. Mais la petite Diane Vincent aura sans aucun doute pardonné à son chien préféré Raf.

An English photographer found an original lead for the wedding of Captain Brudenell-Bruce and Miss Diana Joel. The cosmetic attention being paid to Diana's poodle Andrew is in preparation for the couple's nuptials, with dog in attendance, at St Peter's church on 2 November 1949.

Ein englischer Fotograf findet diesen originellen Aufmacher für einen Bericht über die Hochzeit von Captain Brudenell-Bruce und Miss Diana Joel. Die kosmetische Vorbereitung von Dianas französischem Pudel Andrew verweist auf die Trauung des Paares in Anwesenheit des Hundes in der St.-Peters-Kirche am 2. November 1949.

Un photographe anglais a eu cette idée originale qui tient lieu d'introduction de son reportage sur le mariage du capitaine Brudenell-Bruce et de Miss Diana Joel. Les derniers soins de beauté donnés au caniche français de Diana, Andrew, annoncent le mariage imminent du couple en présence du chien à l'église St. Peters, le 2 novembre 1949.

On 14 September 1946, Tine, the lap-dog belonging to Dorothy Ture from Baltimore, won 1st prize in the "small female dog" class at the Carroll Park Children's pet show. But as if that was not enough, it was followed in the next few weeks by three more city-wide competitions sponsored by the *Baltimore News Post*.

Tine, das Kuscheltier von Dorothy Ture aus Baltimore, gewinnt am 14. September 1946 den 1. Preis in der Kategorie »Kleine Hündinnen« auf einer Haustier-Show für Kinder im Carroll Park. Doch damit nicht genug, folgen in den nächsten Wochen drei weitere stadtweite Wettbewerbe, gesponsert von der *Baltimore News Post*.

Le 14 septembre 1946, Tine, l'animal de compagnie de Dorothy Ture, de Baltimore, remporte le premier prix dans la catégorie « Petites chiennes », lors d'un salon d'animaux domestiques destiné à des enfants à Carroll Park. Mais ce n'est qu'une entrée en matière puisque d'autres concours suivront au cours des trois prochaines semaines, tous sponsorisés par le *Baltimore News Post*.

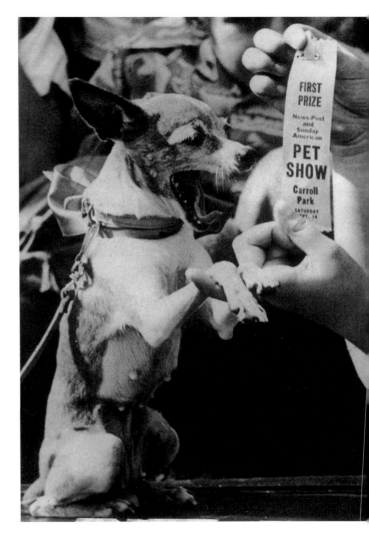

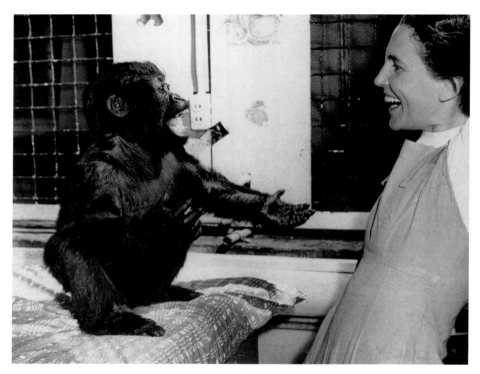

The caption to this photograph dated 26 March 1950 freely acknowledges the relationship between chimpanzees and humans. This ape "is far more intelligent than a human baby of the same age, 18 months." What the caption failed to mention is that in the wild, chimps leave their mothers at the age of one year.

Der Verfasser der Bildunterschrift dieses Fotos vom 26. März 1950 bekennt sich freimütig zu der Verwandtschaft von Schimpansen und Menschen: »Dieser Affe ist weit intelligenter als ein menschliches Baby im gleichen Alter von 18 Monaten.« Nicht erwähnt wird dabei, daß Mutter und Affenkind in freier Wildbahn bereits nach einem Jahr getrennte Wege gehen.

La légende de cette photo prise le 26 mars 1950 ne fait pas mystère de la parenté entre le chimpanzé et l'homme : « Ce singe est beaucoup plus intelligent qu'un bébé humain âgé lui aussi de 18 mois. » Ce que l'auteur passe sous silence, c'est qu'à l'état sauvage, la mère se sépare de son petit dès qu'il a un an.

This 1950s' American picture shows that the advice of animal psychologists is often misunderstood. "In captivity chimpanzee babies in particular need care, security and a great deal of skin contact."

Dieses amerikanische Bild aus den fünfziger Jahren beweist, daß die Ratschläge von Tierpsychologen oftmals falsch verstanden werden: »Besonders Schimpansenbabys brauchen in der Gefangenschaft permanente Pflege, Geborgenheit und viel Hautkontakt.«

Cette photo américaine des années 50 prouve que les conseils donnés par les psychologues d'animaux sont souvent mal compris : « Les bébés chimpanzés, en particulier, ont besoin de soins permanents, d'attention et de beaucoup de contacts en captivité. »

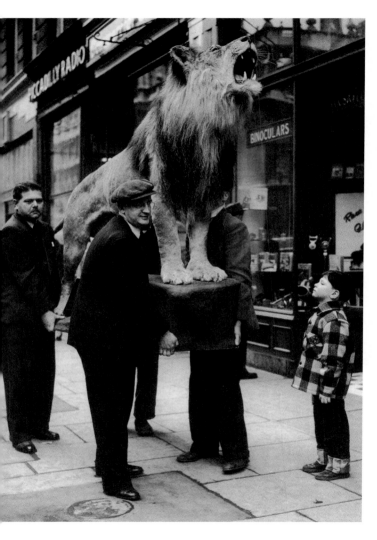

1956, the year following Sir Winston Churchill's departure from his last political office as Britain's Prime Minister, saw the death of his favorite animal, a 17-year-old lion named Rota. The photo shows the lion after it had been stuffed by Mosers Howland Wards, a famous London firm of taxidermists in Piccadilly.

1956, ein Jahr nach dem Rücktritt Winston Churchills von seinem letzten politischen Amt als britischer Premierminister, stirbt sein Lieblingstier namens Rota, ein 17 Jahre alter Löwe. Das Foto zeigt den Löwen nach dem Ausstopfen bei Mosers Howland Wards, einem berühmten Präparator am Piccadilly.

En 1956, un an après la démission de Winston Churchill de son dernier poste politique, celui de Premier ministre britannique, son animal favori, Rota, un lion de 17 ans, décède. La photo représente le lion qui vient d'être empaillé chez Mosers Howland Wards, un célèbre magasin de Piccadilly spécialisé dans la naturalisation d'animaux.

A London photographer spotted this urban idyll on the banks of the Thames in the 1950s. The two white mute swans are building their nest. Each pair breeds in isolation, though swans otherwise form large bevies.

An den Ufern der Themse entdeckt ein Londoner Fotograf in den fünfziger Jahren diese städtische Idylle. Die beiden weißen Höckerschwäne bauen ihr Nest. Die Paare brüten isoliert, obwohl diese Tiere ansonsten Schwärme bilden.

Sur les rives de la Tamise, un photographe londonien découvre cette idylle urbaine dans les années 50. Les deux cygnes blancs construisent leur nid. Les couples couvent leurs œufs séparément. Le reste du temps, ils vivent en groupe.

All creatures great and small

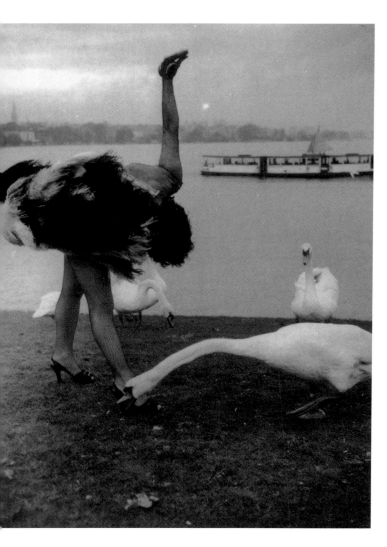

When dancer Renita Kramer posed for photographers on the banks of Hamburg's Alster in 1955, she had already been touring the world for some years with her stage program "Strauss Waltzes". The title was a play on words: "Strauss" means "ostrich" in German, and her costume consists of 500 genuine ostrich feathers.

Als die Tänzerin Renita Kramer 1955 für die Hamburger Fotografen an der Alster posiert, reist sie bereits seit mehreren Jahren mit ihrem Bühnenprogramm »Walzer von Strauß« durch die Welt. Ihr Kostüm ist aus 500 echten Straußenfedern gefertigt.

Lorsque, en 1955, la danseuse Renita Kramer pose pour les photographes de Hambourg sur les rives de l'Alster, elle est déjà célèbre depuis des années dans le monde entier comme un interprète des « Valses de Strauss ». Le titre est un jeu de mots : « Strauss » signifie autruche en allemand. Son costume se compose de 500 véritables plumes d'autruche.

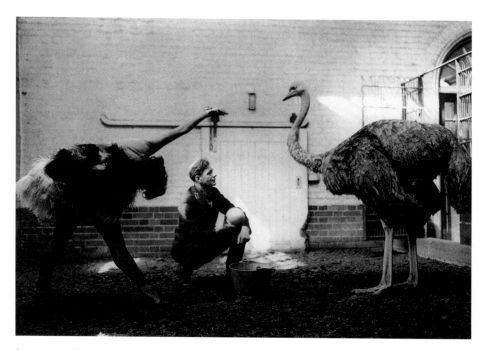

Four years earlier, in 1951, Renita Kramer put her role-play to the test in London. But not even the supportive intervention of the keeper could entice the real ostrich out of its reticent attitude.

Vier Jahre zuvor, 1951, machte Renita Kramer in London mit ihrer Darbietung die Probe aufs Exempel. Doch auch das unterstützende Eingreifen des Tierpflegers kann den echten Strauß nicht aus der Reserve locken.

Quatre ans plus tôt, en 1951 à Londres, Renita Kramer répète avec une autruche en chair et en os. Mais, malgré l'aide bienveillante du gardien, la véritable autruche reste imperturbable.

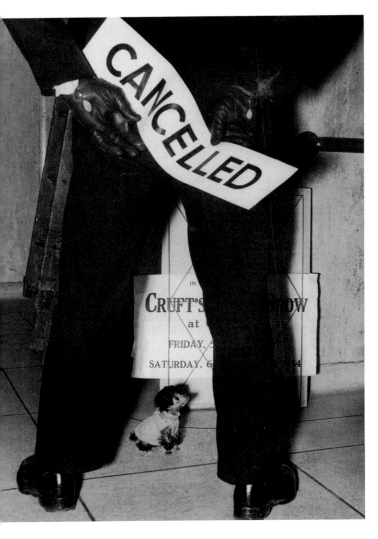

The legendary Crufts Dog Show at London's Olympia was unfortunately canceled in 1954. One Sunday newspaper on 7 February accompanied this news with a witty photo and the caption: "Someone's going to get a shock."

Die legendäre Crufts Hundeschau im Londoner Olympia fällt 1954 leider aus. Die Sonntagszeitung vom 7. Februar bereitet die Nachricht mit einem launigen Foto und der Zeile auf: »Gleich wird jemand einen Schock bekommen.«

En 1954, le légendaire Crufts Dog Show, à l'Olympia de Londres, est malheureusement annulé. Le journal du dimanche du 7 février qui en informe ses lecteurs publie aussi une photo humoristique ainsi légendée : « Quelqu'un se prépare à recevoir un choc. »

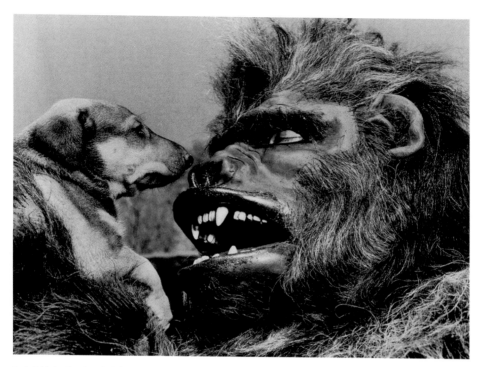

Insight into the family life of an American gorilla double was
provided by this picture dated 9 July 1950. Steve cannot even
frighten his dog Major, "whose educated nose tells him that
behind that fearsome face is a friend."

Einblicke in das Familienleben eines amerikanischen Gorilla-
Doubles gibt dieses Bild vom 9. Juli 1950. Steve erschreckt
nicht einmal seinen Hund Major, »dessen feine Nase ihm
sagt, daß sich hinter dem furchterregenden Gesicht sein
Freund verbirgt«.

Instantané de la vie de famille d'un sosie de gorille américain,
le 9 juillet 1950. Steve ne parvient même pas à effrayer
son petit chien Major, « dont le flair incorruptible lui prouve que
son ami se dissimule derrière le masque terrifiant. »

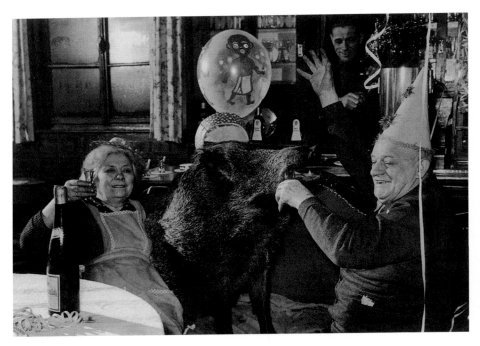

On 27 February 1950, this German agency photo reported on a pet wild boar named Fritz in connection with the carnival season in the city of Mainz. At the same time, the headlines were announcing two million unemployed in West Germany, with that figure on the increase.

Am 27. Februar 1950 berichtet dieses deutsche Agenturfoto vom Hauswildschwein Fritz und dem Beginn des närrischen Treibens in der Karnevalshochburg Mainz. Gleichzeitig verkünden die Schlagzeilen, daß die Zahl der Arbeitslosen in der Bundesrepublik mehr als zwei Millionen beträgt, Tendenz steigend.

Le 27 février 1950, cette photo d'une agence de presse allemande montre le sanglier apprivoisé Fritz et fait allusion au début de la saison du carnaval, à Mayence où cette fête repose sur une longue tradition. Simultanément, les manchettes des journaux parlent de deux millions de chômeurs en République fédérale et la tendance est à la hausse.

English humor in November 1952; the caption read: "Flying saucers? No such thing when I'm around!" It went on to tell us that 3-year-old collie bitch Jane from Bristol had been showing off this trick for ages, and was already practicing for a Christmas tea party.

Englischer Humor manifestiert sich im November 1952 in der Überschrift: »Fliegende Untertassen? Nicht, wenn ich dabei bin!« Weiterhin wird verraten, daß die dreijährige Collie-Dame Jane aus Bristol diesen Trick seit Ewigkeiten beherrscht und bereits für die Weihnachtsteeparty übt.

L'humour anglais conserve ses droits, en novembre 1952, avec cette question : « Soucoupes volantes ? Pas tant que je suis là ! » La légende précise que Jane, femelle collie de trois ans de Bristol, n'est jamais lasse de présenter ce numéro et s'entraîne déjà pour le cérémonial du thé de Noël.

This snapshot from Helsinki in May 1962 was proof enough for one author that cats are fickle creatures. "If food beckons, one shoulder is as good as another." In spite of all attempts at domestication, this pet follows its own hunting instincts. There are said to have been tame cats around as long ago as 3000 BC.

Dieser Schnappschuß aus Helsinki ist einem Autor im Mai 1962 Beweis genug, daß Katzen wankelmütige Kreaturen sind: »Lockt ein Leckerbissen, ist die eine Schulter so gut wie die andere.« Allen Domestizierungsversuchen zum Trotz hat dieses Haustier seine Jagdinstinkte nicht verloren. Bereits 3000 v. Chr. soll es gezähmte Katzen gegeben haben.

Cet instantané pris à Helsinki en mai 1962 est, pour son auteur, la preuve plus que suffisante que les chats sont des créatures versatiles : « Quand on vous propose une friandise, une épaule en vaut bien une autre. » Malgré toutes les tentatives de domestication, cet animal semble avoir conservé son instinct de chasseur. Selon la légende, les premiers chats auraient déjà été domestiqués 3000 ans av. J.-C.

The rumor persists that some lions living in the wild are man-eaters. All the more impressive, then, is the courage of Spanish lion-tamer Pablo Noel who, in June 1962, treated his audiences in Hamburg to a few thrilling but anxious moments every evening.

Hartnäckig hält sich das Gerücht, daß Löwen in freier Wildbahn notorische Menschenfresser seien. Um so größer scheint der Mut des spanischen Dompteurs Pablo Noel, der im Juni 1962 dem Hamburger Publikum allabendlich Angstsekunden und Nervenkitzel bereitet.

Selon une rumeur tenace, les lions vivant à l'état sauvage seraient friands d'êtres humains. On admirera donc d'autant plus le courage du dompteur espagnol Pablo Noel, qui, en juin 1962, réserve chaque soir à son public de Hambourg quelques secondes de frayeur et de suspense.

Higher education

The modern press rarely functions as an instance of moral education. On the contrary, in turn-of-the-century America, gutter newspapers like the *Daily Graphic* exposed the secret love nests of prominent and not-so-prominent citizens and vied for readers with headlines like "I stabbed my wife 40 times because she wouldn't screw the top back on the toothpaste tube." But the serious newspapers, no less in thrall to their circulation figures, saw their salvation in sex and crime, too, and not just in the headlines.

The daily reading of the newspaper has become one of the rituals to be performed by adults in the mass society. Educators and intellectuals may shudder at the vast circulation of the tabloid press, but even their shock-horror stories always contain a grain of morality. Their school of life is governed by double standards, narrow-mindedness and prudishness. This experience is shared by students and apprentices on both sides of the Atlantic; and the masters are not slow to wield the cane.

Höhere Schulbildung

Die moderne Presse fungiert nur selten als moralische Bildungsanstalt. Im Gegenteil: In Amerika decken um 1900 Rinnsteinblätter wie der *Daily Graphic* fast täglich geheime Liebesnester prominenter und weniger prominenter Bürger auf und kämpfen um die Gunst der Leser mit Schlagzeilen wie: »Ich habe meiner Frau 40 Messerstiche versetzt, weil sie nie die Zahnpastatube zumachte.« Aber auch seriösere Blätter starren in den zwanziger Jahren wie gebannt auf ihre Auflagenzahlen und setzen immer häufiger auf »Sex and Crime«, nicht nur in den Schlagzeilen.

Die tägliche Zeitungslektüre gehört in der Massengesellschaft zu den von Erwachsenen gepflegten Ritualen. Pädagogen und Intellektuelle mögen vor den hohen Auflagen der Regenbogenpresse erschauern. Aber selbst in deren Schauergeschichten findet sich immer noch ein Stück Moral: In ihrer Schule des Lebens regieren Doppelmoral, Engstirnigkeit und Prüderie. Diese Erfahrung teilen Schüler und Lehrlinge in Europa und Amerika, wobei die Lehrmeister ihren Lebensregeln mit Rohrstock und Prügelstrafe Nachdruck verleihen.

L'enseignement supérieur

La presse moderne a rarement un rôle d'éducatrice et ne s'emploie guère à inculquer les principes de la morale. Au contraire : dans l'Amérique de 1900, les tabloïdes comme le *Daily Graphic* dévoilent presque chaque jour des nids d'amour secrets de citoyens, célèbres ou moins célèbres, et se disputent les lecteurs avec des manchettes comme : « J'ai donné 40 coups de couteau à ma femme parce qu'elle ne refermait jamais le tube de dentifrice ». Mais les journaux plus sérieux des années 20, sont eux aussi omnubilés par leurs tirages et s'intéressent de plus en plus au « sex and crime », pas seulement dans les gros titres. Dans la société de masse, la lecture quotidienne du journal fait partie des rituels auxquels se plient les adultes. Pédagogues et intellectuels s'effraieront peut-être des tirages élevés de ces feuilles de boulevard. Mais, même dans les histoires qui donnent la chair de poule, il y a toujours une leçon de morale : à leur éducation de la vie c'est la morale hypocrite, l'étroitesse d'esprit et la pruderie qui l'emportent. Cette expérience est commune aux élèves et aux apprentis d'Europe et d'Amérique, à qui les enseignants inculquent les règles de vie, en leur faisant subir, si nécessaire, des châtiments corporels à l'aide de la canne de bambou.

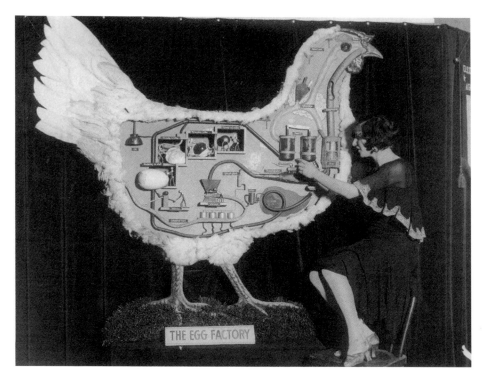

The U.S. Department of Agriculture did its bit towards the education of the public at a poultry and pet stock exposition in December 1930. The mechanical hen demonstrates where eggs come from.

Das amerikanische Landwirtschaftsministerium leistet im Dezember 1930 auf der Geflügel- und Haustierausstellung in Chicago seinen Beitrag zur Volksaufklärung. Die mechanische Henne demonstriert den Besuchern die Entstehung ihrer Frühstückseier.

En décembre 1930, à l'Exposition de Volailles et d'Animaux domestiques de Chicago, le ministère américain de l'Agriculture contribue à l'information de la population. La poule mécanique montre aux visiteurs comment sont produits les œufs dont ils se régalent au petit déjeuner.

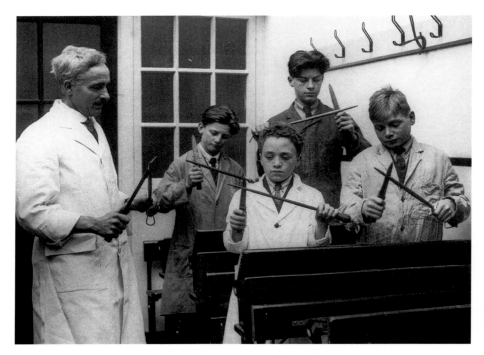

On 2 December 1929, this picture illustrated the opening of England's first school for butchers. The students at the Smithfield Institute were facing hard times ahead, though. The Depression was beginning to hit Britain, too, and unemployment was on the increase.

Am 2. Dezember 1929 illustriert dieses Bild die Eröffnung der ersten Schlachterschule Englands. Die Schüler des Smithfield-Instituts blicken jedoch unsicheren Zeiten entgegen, denn die Weltwirtschaftskrise läßt auch in England die Konjunktur zurückgehen und die Zahl der Arbeitslosen steigen.

Cette photo a été prise le 2 décembre 1929 pour l'inauguration de la première école de bouchers d'abattoirs d'Angleterre. Mais les élèves de l'Institut Smithfield n'ont guère de perspectives, car en Angleterre aussi, la crise économique mondiale entraîne un ralentissement de l'activité et l'augmentation du nombre des chômeurs.

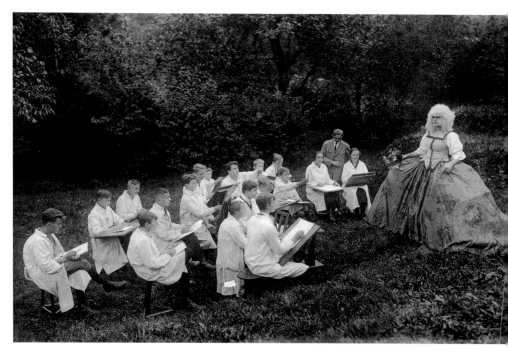

Students at the school of painting attached to the state porcelain factory in Meissen attend a "life class." The Meissen factory in Germany had two centuries of tradition behind it; founded in 1710, it extended its range from figurines to tableware in 1731.

In den zwanziger Jahren erproben die Lehrlinge der Malschule der staatlichen Porzellanmanufaktur in Meißen ihre Künste an einem Modell. Die deutsche Traditionsfabrik wurde 1710 gegründet und stellt seit 1731 außer Plastiken auch Tafelgeschirr her.

Dans les années 20, les élèves de l'école de peinture de la manufacture de porcelaine de Meissen s'exercent à reproduire un modèle. Fondée en 1710, la prestigieuse usine de porcelaine allemande fabrique, depuis 1731, outre des sculptures, de la vaisselle de table.

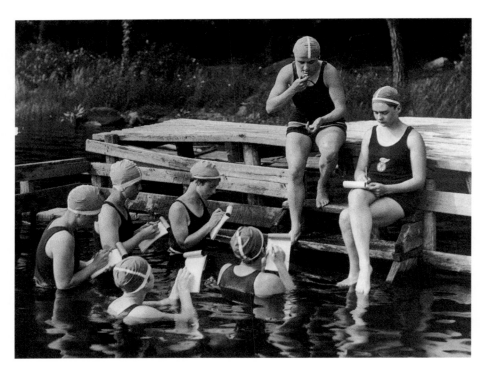

At Camp Kitteredge in New York State in the 1920s, American stenographers combine business with pleasure, training their shorthand in daily competitions. The system of shorthand had been devised by an Englishman named Willis as long ago as 1602. He also coined the word "stenography."

Im Camp Kitteredge im Bundesstaat New York verbinden amerikanische Stenographinnen in den zwanziger Jahren das Angenehme mit dem Geschäftlichen. In täglichen Wettbewerben trainieren sie die Kurzschrift, die der Engländer Willis bereits 1602 erfand und unter dem Namen »Stenographie« einführte.

A Camp Kitteredge, dans l'Etat de New York, des sténographes américaines joignent l'utile à l'agréable dans les années 20. Lors des compétitions, elles s'exercent à écrire en sténo, technique mise au point par l'Anglais Willis, qui l'a baptisée « sténographie », en 1602.

The Torreys and their 7-year-old daughter are seen keeping up the good old tradition of realistic sculpture in the Art Colony at the University of Chicago. The caption to this picture, dated 29 March 1928, stresses the fact that the parents were artists of repute, and that art dominated the life of the family.

Das Ehepaar Torrey und seine siebenjährige Tochter pflegen die gute alte Tradition der realistischen Skulptur in der Künstlerkolonie an der Universität von Chicago. Die Bildunterschift vom 29. März 1928 betont, daß die Eltern renommierte Künstler seien und Kunst ihr Familienleben bestimme.

Dans la colonie d'artistes de l'Université de Chicago, le couple Torrey et leur fille de sept ans perpétuent la tradition de la sculpture réaliste. La légende de la photo datant du 29 mars 1928 précise que les parents sont des artistes de renom et que leur vie familiale est vouée aux arts.

This picture of a street scribe and his client in 1920s' Turkey, moved
the German sub-editor to the skeptical comment: "The Turkey of
yesterday – and today." He obviously did not yet trust the republic,
formed in 1923, or the reforms announced by Kemal Atatürk.

Der Anblick eines Straßenschreibers und seiner Kundin in der
Türkei der zwanziger Jahre veranlaßt den deutschen Redakteur
zu der ungläubigen Bemerkung: »Türkei von gestern – und noch
heute.« Offenbar traut er der 1923 gegründeten Republik und den
angekündigten Reformen unter Kemal Atatürk noch nicht.

Cette photo d'un écrivain public et de sa cliente, dans la Turquie
des années 20, a inspiré au rédacteur allemand ce commentaire
teinté de scepticisme : « La Turquie d'hier – et d'aujourd'hui
encore. » Manifestement, la république fondée en 1923 et les
réformes annoncées sous Kemal Atatürk ne lui inspirent pas
confiance.

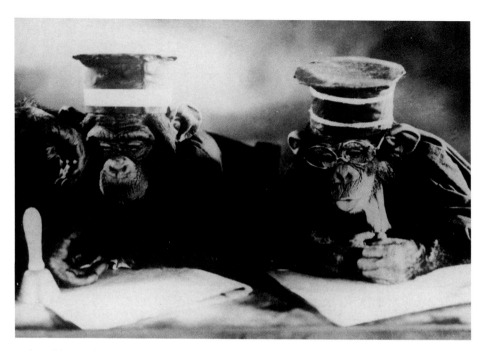

In the Californian film industry of the 1920s, there were jurists among the animal actors. In July 1925, the town of Dayton was the scene of a court case which went down in history as the "Tennessee Monkey Trial." Tennessee was one of the states in which it was forbidden by law to infer that human beings were descended from apes.

In der Filmindustrie Kaliforniens gibt es in den zwanziger Jahren Juristen unter den Tierschauspielern. Im Juli 1925 findet in der Stadt Dayton ein Gerichtsverfahren statt, das als »Affenprozeß von Tennessee« in die Geschichte eingehen wird. Tennessee ist einer jener Staaten, in denen es gesetzlich verboten war, die Entstehung des Menschen vom Affen herzuleiten.

Dans les années 20, l'industrie cinématographique californienne compte des juristes parmi les animaux acteurs. En juillet 1925 a lieu, dans la ville de Dayton, un procès qui entrera dans les annales de l'histoire en tant que « procès des singes du Tennessee ». Le Tennessee est l'un de ces Etats où il était interdit par la loi de déclarer que l'homme descendait du singe.

In the 1930s, in order to create a niche for themselves in the enormous economic community constituted by the British Empire and its Commonwealth, small English institutions such as the Chertsey Agricultural Society held annual exhibitions of produce. This giant cabbage won a 1st prize.

Um sich in der riesigen Wirtschaftsgemeinschaft des britischen Weltreichs und seines Commonwealth darzustellen, veranstalten in den dreißiger Jahren auch kleine englische Institutionen wie der Landwirtschaftsverband von Chertsey alljährlich eine Leistungsschau. Dieser Riesenkohl gewinnt einen ersten Preis.

Pour assurer leur promotion dans l'immense commu-nauté économique de l'Empire britannique et de son Commonwealth, même de petites institutions comme la Fédération des Agriculteurs de Chertsey organisent annuellement, dans les années 30, des comices agricoles. Ce chou géant remporte un 1er prix.

The English Christmas Pudding is a science in itself, as this young would-be cook is discovering in the 1930s. The caption: "Perhaps she'd better let mother finish the job after all."

Der englische Weihnachtspudding ist eine Wissenschaft für sich. Das erfährt auch diese junge Nachwuchsköchin in den dreißiger Jahren und erntet den Kommentar: »Vielleicht sollte sie den Rest doch lieber ihrer Mutter überlassen.«

En Angleterre, le pudding de Noël est une « science » en soi. C'est ce que découvre aussi cette apprentie cuisinière dans les années 30, ce qui lui vaut ce conseil : « Peut-être vaut-il mieux de laisser maman faire le reste. »

Vocational colleges were an educational invention of the early 20th century. This picture is part of a photographic report on a "dairy school" in the early 1930s, and depicts the "preparation of the udder using a rubber model."

Berufsschulen sind eine pädagogische Einrichtung, die seit Anfang des 20. Jahrhunderts bestehen. Dieses Foto entstammt einer Fotoreportage über die »Schule der Melker« Anfang der dreißiger Jahre und zeigt am Gummimodell, wie das Euter anzufassen ist.

Les écoles professionnelles sont des institutions pédagogiques dont la création date du début du xxᵉ siècle. Cette photo fait partie d'un reportage sur l'« école des trayeurs », au début des années 30, et montre, « à l'aide d'un modèle en caoutchouc, comment saisir les pis ».

Dairy expert G. E. Gordon sought to prevent the alienation of city life in the 1930s. At an agricultural show in California, he is shown imparting the secrets of milking to these young visitors who have never seen a cow before and have not the slightest idea where milk comes from.

Der Entfremdung des Stadtlebens in Amerika in den dreißiger Jahren versucht der Molkerei-Experte G. E. Gordon vorzubeugen. Auf einer Landwirtschaftsschau in Kalifornien führt er diese kleinen Besucher, die nie zuvor eine Kuh gesehen und keine Vorstellung davon haben, woher die Milch kommt, in die Geheimnisse des Melkens ein.

Dans les années 30, l'expert en laiterie G. E. Gordon veut combattre l'aliénation suscitée par la vie dans les grands centres urbains en Amérique. Lors de comices agricoles organisés en Californie, il révèle les secrets de la traite à ses deux petits visiteurs qui n'ont jamais vu de vache auparavant et ignorent d'où provient le lait.

A news item dated 10 March 1938 reported on this "upside-down writer," 11-year-old Frank Balek from Chicago. It was said that some disability prevented him from writing from left to right, and that he solved this problem in the manner depicted above. His teachers are said to have got used to it.

Eine Nachricht vom 10. März 1938 berichtet vom 11jährigen Frank Balek aus Chicago, der auf dem Kopf schreibt. Es heißt, daß er aufgrund einer Behinderung nicht in der Lage sei, von links nach rechts zu schreiben, und sein Problem auf diese Weise löse. Die Lehrer sollen sich daran gewöhnt haben.

Un communiqué du 10 mars 1938 est consacré à cet élève de Chicago, Frank Balek, qui, à onze ans, écrit à l'envers. En raison d'un handicap, nous dit-on, il n'est pas en mesure non plus d'écrire de gauche à droite et résout son problème à sa manière. Il paraît que ses maîtres s'y sont habitués.

This picture, from the department of medicine at Philadelphia's Temple University shows three patients in the 1930s. The children have speech impediments, and are using the mirrors to study their mouth movements for themselves.

Diese Aufnahme aus der medizinischen Abteilung der Temple-Universität in Philadelphia zeigt drei Patienten in den dreißiger Jahren. Die Kinder haben einen Sprachfehler und überprüfen sich selbst bei ihren Sprechübungen im Spiegel.

Cette photo prise au département de médecine de l'Université de Temple, à Philadelphie, montre trois patients dans les années 30. Les enfants ont un défaut d'élocution et font des exercices de prononciation devant la glace pour contrôler leur articulation.

10 June 1938: "The summer is here." The "helmets" on the heads of these students at an open-air school in London's St James's Park are a sure sign of the first real sunshine.

10. Juni 1938: »Der Sommer ist da«. Die »Helme« auf den Köpfen der Schüler in der Freiluftschule im Londoner St. James's Park sind das untrügliche Zeichen für die ersten Sonnenstrahlen.

10 juin 1938 : « L'été est là » – ce que portent les élèves de l'école en plein air dans le St. James's Park de Londres est le signe irréfutable de l'arrivée des premiers rayons du soleil.

13 January 1933. These 13-year-old pantomime artists were currently engaged in a production of *Mother Goose* at Daly's Theatre in London. The local education authority had stipulated that the theater lay on four hours' classroom teaching a day for the girls.

13. Januar 1933. Diese 13jährigen Pantomiminnen sind zur Zeit am Daly's Theatre in London für die Produktion *Mother Goose* engagiert. Die örtliche Schulbehörde verpflichtet das Theater, jeden Tag einen vierstündigen Unterricht für die Mädchen zu organisieren.

13 janvier 1933. Ces pantomimes âgées de 13 ans sont actuellement engagées, au Daly's Theatre de Londres, pour la production de *Mother Goose*. Les services scolaires locaux obligent le théâtre à donner chaque jour quatre heures de cours aux fillettes.

The "Delia Collins School of Beauty Culture" devoted
lessons to the subject of "the anatomy of beauty."
In 1940s' America these trainee beauticians were
taught about all the major bodily functions.

Die »Delia-Collins-Schule für Schönheitskultur«
widmet sich in ihren Lektionen dem Thema
»Anatomie der Schönheit«. Im Amerika der vierziger
Jahre werden diese angehenden Kosmetikerinnen
über alle wesentlichen Körperfunktionen aufgeklärt.

L'« Ecole Delia Collins de culture de l'esthétique »
se consacre au thème de l'« anatomie de la beauté ».
Dans l'Amérique des années 40, ces futures
esthéticiennes apprennent à découvrir toutes les
fonctions essentielles du corps.

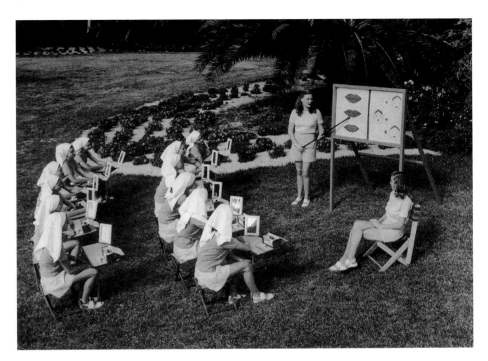

The "Cradle of Glamor" is the subject of this picture, dated 27 June 1948.
"In this glamor-filled atmosphere of Florida's sunshine, the future models
learn how to make the most of what Mother Nature has given them. The
class is learning that the curve is the thing, when making up lips."

Die »Wiege des Glamours« stellt dieses Bild vom 27. Juni 1948 vor. »In
der glamourösen Atmosphäre des Sonnenscheins in Florida lernen die
zukünftigen Models, wie sie aus dem, was ihnen Mutter Natur mitgegeben
hat, das Beste machen können. Die Klasse lernt gerade, daß es beim
Lippen-Make-up vor allem auf die Kurvenzeichnung ankommt.«

Le « berceau du Glamour » est le titre de ce cliché pris le 27 juin 1948. « Dans
l'atmosphère glamoureuse de la Floride ensoleillée, les futurs mannequins
apprennent à tirer le plus grand parti des avantages que Mère Nature leur a
donnés. A ce moment précis, la classe apprend que, pour le maquillage des
lèvres, c'est le dessin des contours qui est le plus important. »

The baby boom of three-and-a-half million new-born infants predicted for the postwar year 1947 in America led the Red Cross to make preparations for their welfare. Evening classes in baby care were laid on for fathers-to-be.

Der für das Nachkriegsjahr 1947 vorausgesagte amerikanische Babyboom von 3,5 Millionen Säuglingen veranlaßt das Rote Kreuz in New York, Vorkehrungen für die neuen Erdenbürger zu treffen. In Abendkursen bereiten sich die werdenden Väter auf die kommenden Aufgaben vor.

Le baby-boom américain – 3,5 millions de naissances annoncées pour l'année d'après-guerre 1947 – incite la Croix rouge de New York à prendre les mesures nécessaires pour accueillir les nouveaux petits citoyens du monde. Des cours du soir préparent les futurs pères aux tâches qu'ils devront assumer.

Twins Penelope and Susan Sullivan were born in Los Angeles on
15 October 1948. The two received a blood transfusion six hours
after their birth as a result of incompatible parental rhesus
factors; without it, they could have suffered severe anemia.

Am 15. Oktober 1948 werden die Zwillinge Penelope und Susan
Sullivan in Los Angeles geboren. Die beiden haben aufgrund
unverträglicher Rhesusfaktoren der Eltern sechs Stunden nach
der Geburt eine Bluttransfusion erhalten, da sonst eine schwere
Anämie gedroht hätte.

Le 15 octobre 1948 naissent, à Los Angeles, les jumelles Penelope
et Susan Sullivan. En raison d'un facteur rhésus incompatible
des parents, les deux enfants ont été transfusés six heures
après leur naissance faute de quoi ils auraient risqué une grave
anémie.

Shortly before the Japanese attack on Pearl Harbor in 1941, paleontologist Gustav Koenigswald discovered the remains of a primate on Java. He hid the find before being captured by the Japanese who also took Java. Here he is seen showing the skull of the "Javanese giant" to his daughter at the New York Museum of Natural History.

Kurz vor dem japanischen Überfall auf Pearl Harbor im Jahre 1941 entdeckt der Paläontologe Gustav Koenigswald auf Java die Überreste eines Primaten. Er versteckt den Fund, bevor er von den Japanern, die auch Java einnehmen, gefangengenommen wird. Hier zeigt er seiner Tochter den Schädel des »javanischen Riesen« im New Yorker Naturkundemuseum.

Juste avant l'attaque de Pearl Harbor par les Japonais en 1941, le paléontologue Gustav Koenigswald avait découvert, à Java, le squelette d'un primate. Il a réussi à cacher sa trouvaille avant d'être fait prisonnier par les Japonais qui ont aussi envahi Java. Ici, il montre à sa fille le crâne du « géant de Java », au Musée d'Histoire naturelle de New York.

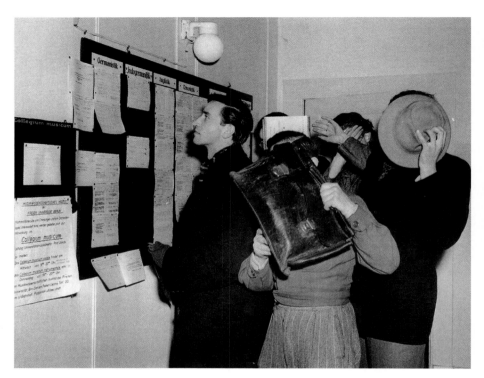

This picture, taken in March 1951 at the Free University founded three years earlier in the Western sectors of Berlin, speaks volumes about the division of Germany. Three students, refugees from East Germany, cover their faces for fear of reprisals against their families back home by the communist secret police.

Diese Aufnahme, die im März 1951 an der drei Jahre zuvor gegründeten Freien Universität im Westteil Berlins entstand, spricht Bände über die Teilung Deutschlands. Drei aus der DDR geflohene Studenten verbergen sich vor der Kamera aus Angst, daß ihre Familien vom Staatssicherheitsdienst belangt werden, wenn in der Bundesrepublik Fotos von ihnen erscheinen.

Cette photo prise en mars 1951 à l'Université Libre fondée trois ans plus tôt dans le secteur occidental de Berlin en dit long sur la partition de l'Allemagne. Trois étudiants qui ont fui la RDA cachent leur visage pour ne pas pouvoir être identifiés sur des photos publiées en République fédérale et éviter à leur famille des ennuis avec la sécurité d'Etat.

Allan Lundberg from Sweden held "the world record on the tightrope" at 31 hours and 35 minutes. On 29 April 1955, he was challenged to a world championship duel by O. Riccardo from Germany. "But first the title holder fortifies himself with a cigarette and a letter from a lady admirer."

Der Schwede Allan Lundberg hält den »Weltrekord auf dem Seil« mit 31 Stunden und 35 Minuten. Am 29. April 1955 fordert ihn der deutsche O. Riccardo zum Weltmeisterschaftsduell heraus. »Doch vorher stärkt sich der Titelverteidiger mit einer Zigarette und dem Brief einer Bewunderin.«

Le Suédois Allan Lundberg détient le « record du monde de l'équilibre sur un fil » avec 31 heures et 35 minutes. Le 29 avril 1955, l'Allemand O. Riccardo lui dispute le titre de champion du monde. « Mais, auparavant, le tenant du titre se détend en fumant une cigarette et en lisant la lettre d'une admiratrice. »

Press photos are forever creating little stars. This one, from the USA on 23 September 1951, is no exception. "Mary Happy is not the least bit bored when she works at the ironing board. While Mary likes playing with dolls, she plays at doing the housework with no less gusto."

Pressefotografen schaffen immer wieder kleine Stars, so auch mit dieser Aufnahme aus den USA vom 23. September 1951: »Mary Happy langweilt sich überhaupt nicht, wenn sie ihre Arbeit am Bügelbrett versieht. Mary spielt zwar gern mit Puppen, aber sie spielt mit gleich großem Einsatz Hausfrau.«

Les photographes de presse ne cessent de créer de petites stars, comme ici, avec cette photo prise aux Etats-Unis le 23 septembre 1951 : « Mary Happy ne s'ennuie pas lorsqu'elle s'active devant sa table à repasser. Mary aime bien, certes, jouer à la poupée, mais elle joue avec autant d'empressement à faire le ménage. »

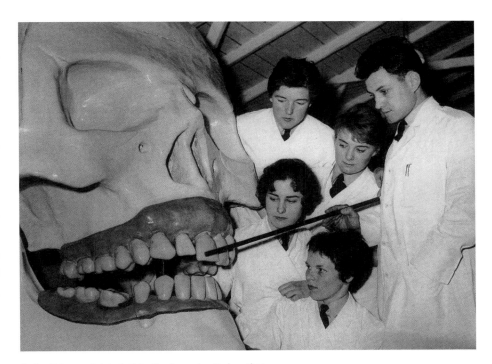

An English report dated 28 April 1960 makes it clear that
oral hygiene is writ large in the Royal Air Force, which had
trained thousands of dental hygienists and assistants since
1941, many of them women.

Eine englische Meldung vom 28. April 1960 verweist darauf,
daß Mundhygiene in der Royal Air Force großgeschrieben
wird. In der britischen Luftwaffe wurden seit 1941 Tausende
von Dentalhygienikern und Zahnarztassistenten ausgebildet,
darunter auch viele Frauen.

Cette information parue dans la presse anglaise du 28 avril
1960 rappelle qu'à la Royal Air Force, on ne badine pas avec
l'hygiène buccale. Depuis 1941, l'Armée de l'air britannique a
formé des milliers de spécialistes en hygiène dentaire et
d'assistants-dentistes, dont de nombreuses femmes.

The pleasures of the palate

Travel reports from 1920s' Paris praised the culinary culture of France. One Swedish sub-editor talked of the country in 1928 as "the gourmets' Garden of Eden." The restaurant for him "had become an indispensable institution for the whole civilized world." At the same time, articles were reporting on the fast-food culture evolving in the USA. In 1923, Tacona confectioner John C. Mars invented the chocolate bar that bears his name, and by 1932 he was already exporting it to Britain. Fast Food reached its peak during the atomic euphoria of the 1950s when one outlet in Salt Lake City had uranium-burgers on the menu.

The various national predilections for different delicacies are governed by culture and the spirit of the age, but it is the contents of the purse that continues to determine what reaches the family table. The press and its readers, though, are more interested in the exception than the rule, and some culinary exceptions generated amazement, incomprehension, and occasionally disgust. Thus in the hungry 1940s, there were frequent reports of cats and dogs finding their way into the cooking pot – only in other countries, mind you. Modern myths wander through the pages of the 20th century press in every conceivable garb.

Gaumenkitzel

Reiseberichte aus Paris preisen in den zwanziger Jahren die französische Gourmetkultur: Ein schwedischer Redakteur schwärmt 1928 vom »Garten Eden des Feinschmeckers«; das Restaurant sei für ihn »zu einer unverzichtbaren Einrichtung der gesamten zivilisierten Welt geworden«. Zur gleichen Zeit berichten Artikel über die in den USA entstehende Fast-Food-Kultur. 1923 kreiert der Konditor John C. Mars in Tacona den nach ihm benannten Schokoriegel und exportiert ihn ab 1932 nach England. Fast Food als schnelle Mahlzeit zwischendurch gipfelt während der Atomeuphorie der fünfziger Jahre im Uranium-Burger, der in einem Schnellrestaurant in Salt Lake City feilgeboten wird. Kultur und Zeitgeist bestimmen die unterschiedlichen nationalen Vorlieben und Gaumenfreuden. Nach wie vor diktiert jedoch die Haushaltskasse, was auf den Tisch kommt. Die Presse und ihre Leser hingegen interessiert die kulinarische Ausnahmesituation, die Erstaunen, Kopfschütteln und mitunter auch Ekel auslöst. So tauchen in der Notlage der vierziger Jahre regelmäßig Meldungen auf, daß in den Kochtöpfen der Nachbarstaaten auch Hunde oder Katzen schmorten. Moderne Sagen geistern in allen erdenklichen Variationen durch die Zeitungen des 20. Jahrhunderts.

Régal pour le palais

Dans les années 20, les voyages à Paris donnent lieu à des reportages qui encensent la gastronomie française : en 1928, un rédacteur suédois parle du « paradis terrestre du gourmet » et dit que le restaurant est devenu selon lui « quelque chose d'indispensable à l'ensemble du monde civilisé ». A la même époque, des articles de journaux sont consacrés à la culture du fast food qui est née aux Etats-Unis. En 1923, le pâtissier John C. Mars crée, à Tacona, la barre de chocolat qui porte son nom et qu'il exporte en Angleterre dès 1932. Avec le hamburger à l'uranium que propose une cafétéria de Salt Lake City, le fast food devient révélateur de l'état d'esprit des années 50, placées sous le signe de l'atome. La culture et l'esprit du temps déterminent les préférences nationales en matière de restauration. Mais ce qui est servi à table dépend toujours du budget des ménages. La presse et ses lecteurs, par contre, s'intéressent à toute préparation culinaire exceptionnelle qui suscite étonnement ou hochements de tête désapprobateurs et, parfois aussi, dégoût. Ainsi, durant les périodes de vaches maigres des années 40, lit-on régulièrement que, dans les casseroles des habitants des pays voisins, on mijote parfois aussi du chien ou du chat. Les rumeurs les plus saugrenues sont colportées par les journaux du xxᵉ siècle.

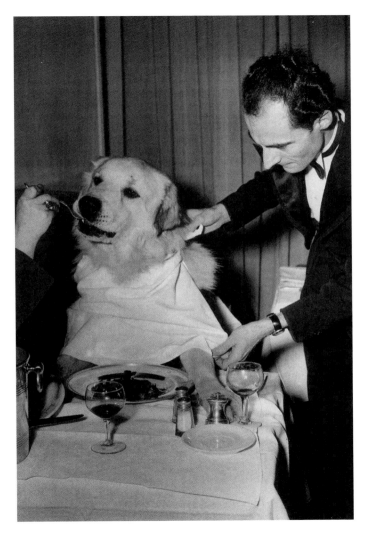

The station restaurant at the Gare de l'Est in Paris tried in 1951 to entice animal-loving gourmets to its tables. Notwithstanding the strict ban on animals in restaurants and shops, the staff are here seen showing themselves particularly solicitous toward their canine customer, Pal by name, serving him a breakfast of beefsteak and watercress.

Das Bahnhofsrestaurant im Pariser Gare de l'Est versucht 1951 tierliebende Gourmets an seine Tische zu locken. Entgegen dem strikten Hundeverbot in sonstigen Pariser Restaurants und Geschäften zeigt sich das Personal hier besonders hundefreundlich und serviert diesem Gast namens Pal ein Beefsteak an Brunnenkresse.

En 1951, le restaurant de la Gare de l'Est, à Paris, accueille aussi les gourmets et leurs animaux domestiques. Contrairement à certains restaurants et magasins parisiens strictement interdits aux chiens, cet établissement est particulièrement accueillant et ce client prénommé Pal se voir servir un steak accompagné de cresson.

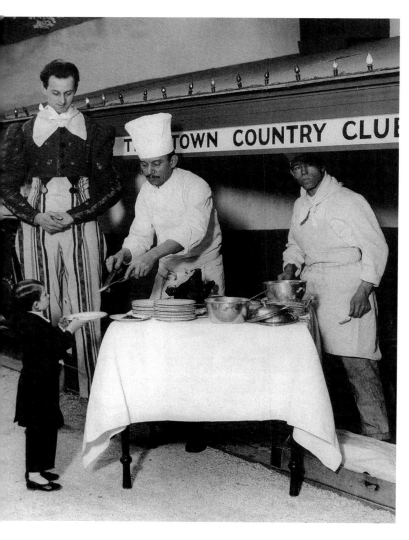

This 1920s' picture shows a scene on the fringe of the "Midgets' Christmas Dinner" at the Olympia in London. "The smallest midget, acting as a waiter, is being given turkey by the chef."

Dieses Bild aus den zwanziger Jahren zeigt eine Szene am Rande des »Weihnachtsdiners der Zwerge« im Londoner Olympia: »Der kleinste Zwerg, der als Kellner agiert, empfängt vom Küchenchef den Truthahn.«

Cette photographie des années 20 montre une scène en marge du « dîner de Noël des nains » à l'Olympia de Londres : « Le plus petit nain travaillant comme serveur reçoit un morceau de dindon du chef de cuisine. »

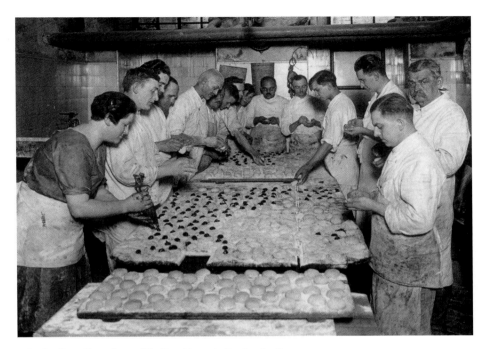

In Berlin, the culinary farewell to the old year in the Roaring Twenties consisted of the New Year's Eve doughnuts known as "Berliners." The caption reveals that in the last two days of the year, to satisfy the appetite of the human Berliners, 5000 people were employed making them.

Den kulinarischen Jahresabschluß bilden im Berlin der »Goldenen Zwanziger« Silvesterpfannkuchen, die sogenannten Berliner. Die Bildunterschrift verrät, daß in den letzten beiden Tagen des Jahres 5000 Menschen mit der Herstellung dieses Gebäcks beschäftigt sind, um den Appetit der Hauptstädter zu stillen.

Les beignets de la Saint Sylvestre, les fameux « Berliner », servis dans les belles années 20. La légende de la photo nous apprend que, durant les deux derniers jours de l'année, 5000 personnes sont employées à leur fabrication afin de rassasier les habitants de la capitale allemande.

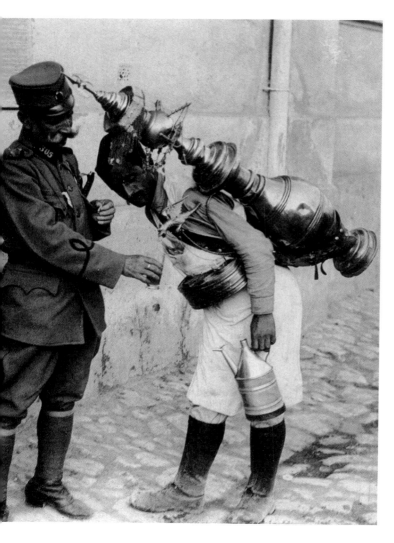

On the fringe of the wedding of Alexander I, who had been crowned king of the Serbs, Croats and Slovenes in 1921, a lemonade vendor is selling refreshments to a member of the palace guard. Alexander, son of the Serbian king Peter I, did not succeed in pushing through Serbian claims to hegemony in the new multinational state.

Am Rande der Hochzeit von Alexander I., der 1921 zum König der Serben, Kroaten und Slowenen gekrönt wird, verkauft ein Limonadenverkäufer der Palastwache eine Erfrischung. Alexander, Sohn des serbischen Königs Peter I., gelingt es nicht, in dem neuen Vielvölkerstaat die serbischen Vormachtsansprüche durchzusetzen.

Un vendeur de limonade sert un rafraîchissement à un garde du palais en marge du mariage d'Alexandre Iᵉʳ, roi des Serbes, des Croates et des Slovènes depuis 1921. Alexandre, fils du roi Pierre Iᵉʳ de Serbie, ne parvient pas à imposer la suprématie serbe dans le nouvel Etat pluriethnique.

While the era of Prohibition divided Americans into "wet" and "dry" in the early 1920s, the New York Tobacco Exhibition dealt in lawful delights. "Miss Olga Joy" is seen introducing what, at six feet (1.83 meters), was the largest cigar, along with the ultimate cigarillo.

Während die Prohibition die Amerikaner Anfang der zwanziger Jahre in »naß« und »trocken« unterteilt, geht es auf der Tabakausstellung in New York um legale Genüsse. »Miss Olga Joy« präsentiert die längste Zigarre, die 1,83 m mißt, und den kleinsten Zigarillo.

Au début des années 20, alors que la prohibition partage les Américains en « amateurs d'alcool » et en « abstinents », la Foire du Tabac de New York cultive des plaisirs légaux. « Miss Olga Joy » présente simultané-ment le plus long cigare, qui mesure 1,83 mètre, et le plus petit cigarillo.

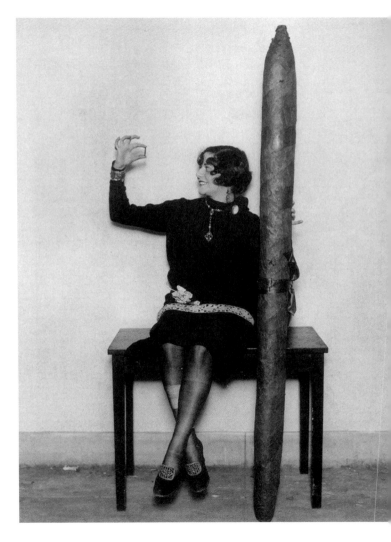

A child's game in 1920s' Germany moved the sub-editor here to pen the following line: "Easter lambs in good hands." But the approaching Easter festival threatened to put an end to the idyll. The grown-ups doubtless were not prepared to go without their roast lamb.

Dieses spielende Kind im Deutschland der zwanziger Jahre bewegt den Redakteur zu der Zeile: »Osterlämmchen in guter Hut«. Doch mit dem näherrückenden Ostertermin droht zugleich das Ende der Idylle zwischen Mensch und Tier. Denn die Erwachsenen wollen sicherlich nicht auf ihren Osterbraten verzichten.

Des jeux d'enfants dans l'Allemagne des années 20 inspirent cette réflexion au rédacteur : « Agneau pascal sous bonne garde ». Pourtant, les fêtes de Pâques imminentes risquent de mettre fin à cette idylle entre l'homme et l'animal. Les adultes ne renonceront probablement pas à leur délicieux gigot de Pâques.

On 22 October 1924, an Englishman, Eric Charell, opened his great
variety show *To All* at the former Grosses Schauspielhaus in Berlin.
It ran till 1927. The show's highlight was its dancing girls, but it
included other sketches, such as "the English eccentrics" Agar and
Jonny.

Am 22. Oktober 1924 eröffnet der Engländer Eric Charell seine große
Revue *An alle* im ehemaligen Großen Schauspielhaus in Berlin
und gastiert dort bis 1927. Im Mittelpunkt der Show stehen Revue-
tänzerinnen, daneben werden aber auch Sketche wie die der
»englischen Exzentriker« Agar und Jonny geboten.

Le 22 octobre 1924, l'Anglais Eric Charell présente sa nouvelle revue
An Alle (A tous) dans l'ancien Grosses Schauspielhaus de Berlin où il
se produira jusqu'en 1927. Les danseuses constituent le clou de ce
spectacle à sketches, comme ceux des « Anglais excentriques » Agar
et Jonny.

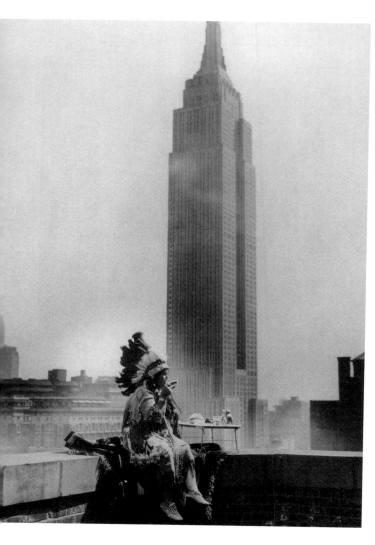

The aboriginal inhabitants of North America were mentioned in the press of the 1920s, if at all, only as bit part players in modern city life. Here, Red Wing, a member of the Winnebago nation, is seen taking her tea-break on the roof of a hotel against the backdrop of New York's Empire State Building.

Die Ureinwohner Nordamerikas finden in der Presse der zwanziger Jahre nur noch als Statisten im modernen Großstadtleben Erwähnung. Hier legt Roter Flügel, eine Angehörige der Winnebago-Indianer, vor der Kulisse des Empire State Buildings in New York eine Teepause auf einem Hoteldach ein.

Les Indiens d'Amérique ne sont plus évoqués dans la presse des années 20 que comme des figurants dans la vie moderne des grandes villes. Ici, Aile rouge, de la tribu des Winnebago, boit une tasse de thé sur le toit-terrasse d'un hôtel, devant l'Empire State Building, à New York.

On 7 February 1927, Phelps Dodge, a copper-smelting company, opened a new factory in Douglas, Arizona. While the guests at the inaugural banquet sat around a table at the bottom of a 350 foot (107 meter) chimney, smoke from the blast furnaces, which were already in operation, was going up the stack above them.

Am 7. Februar 1927 eröffnet das kupferverarbeitende Unternehmen Phelps Dodge eine neue Fabrik in Douglas (Arizona). Während die Teilnehmer des Festbanketts am Fuße eines 107 m hohen Schornsteins tafeln, zieht schon Rauch der aktiven Hochöfen über ihren Köpfen ab.

Le 7 février 1927, l'entreprise de traitement du cuivre Phelps Dodge ouvre une nouvelle usine à Douglas (Arizona). Tandis que les convives festoient au pied d'une cheminée de 107 mètres de haut, au-dessus de leurs têtes, la fumée s'échappe des fourneaux déjà en activité.

One Sunday in October 1929, 37 waiters, all employed at cafés in Montmartre, held a race which involved carrying a tray with four glasses and a bottle over a 2-kilometer course (about 1.25 miles). Here the leading threesome are seen on the Boulevard de Clichy.

An einem Sonntag im Oktober 1929 bestreiten 37 Kellner, die alle in Cafés auf dem Montmartre arbeiten, ein Wettrennen. Vier Gläser und eine Flasche müssen über einen 2 km langen Parcours balanciert werden – hier das führende Trio auf dem Boulevard de Clichy.

En ce dimanche d'octobre 1929, 37 serveurs, tous employés dans des cafés de Montmartre, disputent une course. Ils doivent porter un plateau avec quatre verres et une bouteille sur une distance de 2 kilomètres – ici, le groupe de tête sur le Boulevard de Clichy.

London society ladies met at the Ranelagh Club on 24 June 1929
for a day whose highlight was an "apple-and-bucket race." This
picture shows Miss Irene Mann-Thompson attempting to
remove an apple from a bucket of water without using her
hands.

Damen der Londoner Gesellschaft finden sich am 24. Juni 1929
im Gesellschaftsclub in Ranelagh zusammen. Höhepunkt des
Tages ist das »Apfel-und-Eimer-Rennen«. Hier übt sich Miss
Irene Mann-Thompson darin, ohne Zuhilfenahme ihrer Hände
einen Apfel aus dem Eimer zu fischen.

Des membres féminins de la société londonienne se réunissent
au club mondain du Ranelagh, le 24 juin 1929. Temps fort de
la journée : « la course avec seau et pomme ». Ici, Miss Irene
Mann-Thompson s'entraîne à extraire une pomme d'un seau
sans la toucher des mains.

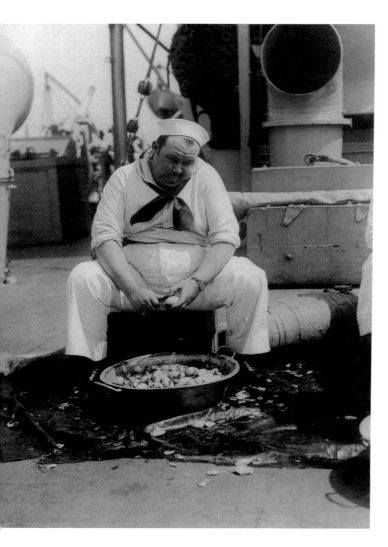

On 9 June 1927, prominent jazz musician Paul Whiteman went on board the U.S. Navy cruiser *Trenton* to gather first-hand experience for his new show. The "Master of Syncopation" invited the press to witness a spell of spud-bashing.

Der prominente Jazzmusiker Paul Whiteman geht am 9. Juni 1927 an Bord des US-Kreuzers *Trenton*, um aus erster Hand Erfahrungen für seine neue Show zu sammeln. Der »Meister der Synkope« versucht sich hier als Küchenbulle und lädt die Presse dazu ein.

Le 9 juin 1927, le célèbre musicien de jazz Paul Whiteman monte à bord du croiseur américain *Trenton* pour y obtenir des informations de première main en vue de son prochain spectacle. Le « roi de la syncope » s'essaie ici comme marmiton et invite pour cela la presse.

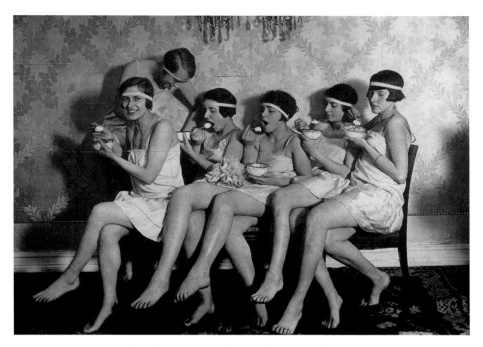

German news agencies in the mid-1920s reported on the "Zikel system", named after its inventor, a gynecologist. The system allegedly represented an "epoch-making innovation in the area of rejuvenation therapy." Alongside the direct injecting of patients with the glandular secretions of living animals, Dr Zikel recommended the regular eating of yogurt.

Deutsche Nachrichtendienste berichten um 1925 über das »Zikel-System« – so benannt nach seinem Erfinder –, das eine »epochale Neuerung auf dem Gebiet der Verjüngungstherapie« darstelle. Neben der direkten Injektion tierischer Drüsensekrete beim Patienten empfiehlt der Frauenarzt den regelmäßigen Genuß von Joghurt.

Vers 1925, les agences de presse allemandes célèbrent le « Système Zikel » – du nom de son inventeur – une « innovation qui fera date dans la thérapie du rajeunissement ». Outre l'injection directe aux patients de sécrétions de glandes animales, le gynécologue recommande de consommer régulièrement des yaourts.

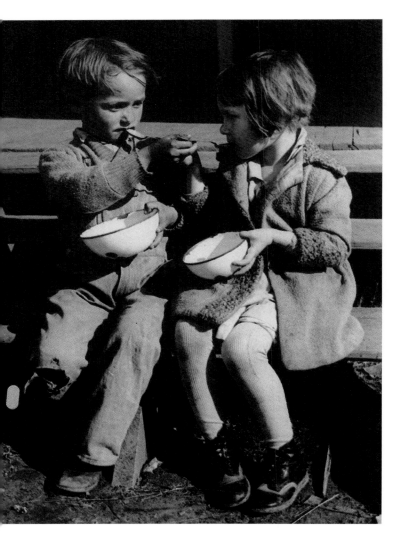

During the 1920s, American agriculture was in a state of permanent crisis, which was only made worse by the Depression. Farming families in the Deep South – like these children from Arkansas – were additionally plagued by drought in 1931.

Die amerikanische Landwirtschaft steckt in den zwanziger Jahren in einer Dauerkrise, die durch die Lage der Weltwirtschaft noch verstärkt wird. Die Farmersfamilien im Süden sind zusätzlich noch Dürrekatastrophen ausgesetzt, wie hier in Arkansas im Jahre 1931.

Dans les années 20, l'agriculture américaine traverse une longue crise aggravée par la situation économique mondiale. En outre, les familles de fermiers du Sud sont affectées par des sécheresses catastrophiques, comme en témoignent ces deux enfants photographiés dans l'Arkansas en 1931.

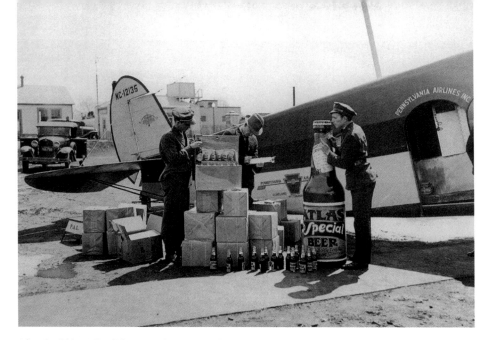

After the lifting of Prohibition in the USA, two brewing firms surprised President Roosevelt and the Congress with a consignment of free beer on 7 April 1933. The caption gives some hint of the thirst of the writer: "Washington-Hoover Airport was literally flooded with beer."

Nach der Aufhebung der Prohibition in den USA überraschen am 7. April 1933 zwei Bierfirmen den Präsidenten Roosevelt und den Kongreß mit einer Gratislieferung Bier. Die Bildunterschrift läßt auf den Durst des Schreibers schließen: »Der Hoover-Flughafen in Washington wurde sprichwörtlich mit Bier überflutet.«

Après l'abolition de la prohibition aux Etats-Unis, deux brasseries surprennent le président Roosevelt et le Congrès, le 7 avril 1933, par une livraison gratuite de bière. A en juger la légende de la photo, son auteur avait très soif : « L'aéroport Hoover à Washington fut littéralement inondé de bière. »

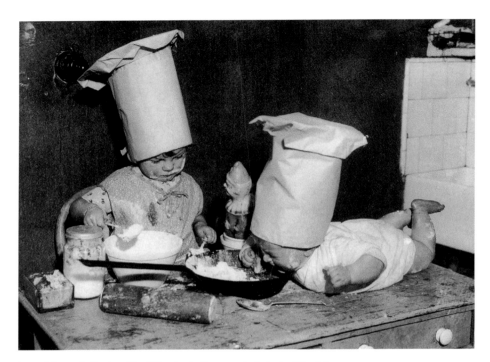

In 1936, beneath the headline "Disaster in the pancake industry," English newspapers pointed out that there was still plenty of time till Shrove Tuesday. This, the last day before Lent, is traditionally the day when the English hold pancake races, a custom which can be traced back to 1445.

Unter der Überschrift »Desaster in der Pfannkuchenindustrie« weisen englische Zeitungen 1936 darauf hin, daß noch genügend Zeit bis zum »Shrove Tuesday«, dem Tag vor Aschermittwoch, bleibe. An diesem Tag findet in England das traditionelle Pfannkuchenrennen statt, dessen Wurzeln bis in das Jahr 1445 zurückreichen.

En 1936, sous le titre « Désastre dans l'industrie de la crêpe », des journaux anglais rappellent aux lecteurs que le « Shrove Tuesday », la veille du Mercredi des Cendres approche. Ce jour-là, les Anglais disputent la traditionnelle course aux crêpes dont l'origine remonte à 1445.

On the fringe of the 1938 six-day race at Wembley, an English photographer observed a rider named Buysse, who had been a member of the winning team the year before, taking his morning snack. This year too, teams from 12 countries covered 2000 miles in 143 hours.

Am Rande des Sechs-Tage-Rennens 1938 in Wembley beobachtet ein englischer Fotograf den Fahrer Buysse, der im Vorjahr zum Siegerteam gehörte, beim morgendlichen Imbiß. 12 internationale Mannschaften legen auch in diesem Jahr wieder 2000 Meilen in 143 Stunden zurück.

En 1938, en marge de la Course des Six jours, à Wembley, un photographe anglais immortalise le coureur Buysse, membre de l'équipe gagnante de l'année précédente, pendant son casse-croûte matinal. Cette année-là, 12 équipes internationales couvrent de nouveau une distance de 2000 miles en 143 heures.

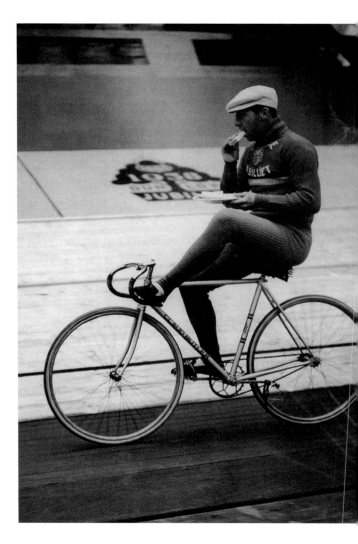

The pleasures of the palate

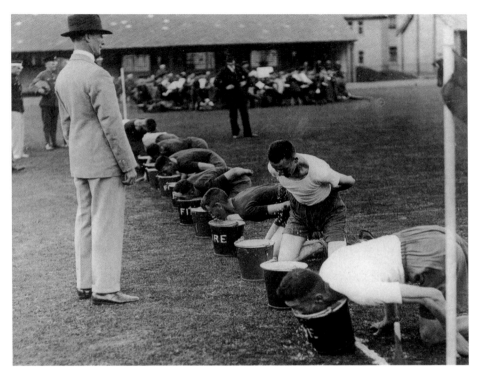

On 21 July 1932, while all eyes were otherwise on Los Angeles, where the Olympic Games were due to take place the next month, these Englishmen were practicing their own peculiar sports, such as the "apple-and-bucket" race. At their regimental barracks in Caterham the soldiers are attempting to use their teeth alone to remove apples from fire-buckets borrowed for the purpose.

Während die Weltöffentlichkeit bereits den im August stattfindenden Olympischen Sommerspielen in Los Angeles entgegenfiebert, pflegen diese Engländer am 21. Juli 1932 ihre ureigenen Sportarten wie das »Apfel-und-Eimer-Rennen«. Im Kasernenhof des Regiments von Caterham versuchen die Soldaten, nur mit Hilfe ihrer Zähne Äpfel aus den zweckentfremdeten Feuerlöscheimern zu fischen.

Tandis que le monde attend impatiemment l'ouverture des Jeux olympiques en août à Los Angeles, ces Anglais pratiquent des disciplines sportives bien personnelles comme la « course avec seau et pomme », le 21 juillet 1932. Dans la cour de la caserne du régiment de Caterham, les soldats s'entraînent à retirer des pommes des seaux, utilisés normalement pour éteindre des incendies, rien qu'avec les dents.

In 1930, nature-photographer H. B. Crisler from Seattle, taking no food with him and armed only with a knife, went on a 30-day trek. In the Olympic Mountains in the extreme north-west, he discovered "America's last wilderness." Using a delayed-action release, Crisler photographed himself "bolting juicy morsels of the marmot."

Der Naturfotograf H. B. Crisler aus Seattle unternimmt 1930 ohne Proviant und nur mit einem Messer bewaffnet einen 30-Tage-Treck. In der Gebirgslandschaft um den Mount Olympus im äußersten Nordwesten entdeckt er »Amerikas letzte Wildnis«. Dort fotografiert Crisler sich per Selbstauslöser, während er »einen saftigen Bissen Murmeltier hinunter-schlingt«.

En 1930, le photographe naturaliste H. B. Crisler, de Seattle, entreprend, muni seulement d'un couteau, une expédition de 30 jours sans provisions. Au Mont Olympe, à l'extrême Nord-Ouest, il découvre « les dernières contrées sauvages d'Amérique ». C'est devant ce panorama que Crisler se photographie lui-même grâce à un déclencheur automatique tout en « mordant à belles dents un succulent morceau de marmotte ».

The 1935 Royal Horticultural Society's Fruit and Vegetable Show included a parsnip 44 inches (1.12 meters) long. A member of the umbellifer family and a relative of the carrot, this root crop, though popular in Britain, has never really caught on in continental Europe.

Auf der Obst- und Gemüseausstellung der Königlichen Gartenbaugesellschaft in London wird 1935 die 1,12 m lange Pastinakpflanze präsentiert. Dieses Doldengewächs aus der Gattung der Möhren bietet zwar ein beachtenswertes Fotomotiv, setzt sich aber nicht auf den europäischen Speiseplänen durch.

L'Exposition londonienne de Fruits et Légumes organisée par l'Association d'horticulture présente en 1935 une racine de panais longue de 1,12 mètre. Cette ombellifère de la famille des carottes offre certes un remarquable motif pour une photographie, mais elle ne parviendra pas à s'imposer au menu des foyers européens.

A series of photo reports in the 1930s entitled "What kitchens in different countries look like" gave German housewives a perspective which went well beyond their domestic cookers. "Black cooks in Africa using a wood fire to prepare a meal which will be ladled out from a communal cooking pot."

Die in den dreißiger Jahren in Fortsetzungen veröffentlichte Zeitungsreportage »Wie die Küche in den verschiedenen Ländern aussieht« erlaubt deutschen Hausfrauen einen Blick über den heimischen Herd hinaus: »Schwarze Köchinnen aus Afrika beim Zubereiten von Speisen, die auf einem Holzfeuer abgekocht werden und bei der Mahlzeit gemeinsam aus den Töpfen gelöffelt werden.«

Publiée dans les années 30, la série de reportages sur la cuisine dans les différents pays permet aux ménagères allemandes de voir plus loin que le bout de leurs propres casseroles : « Cuisinières noires d'Afrique préparant au feu de bois un plat dans une marmite, chacun y plongeant ensuite sa cuillère lors du repas pris en commun. »

These Padaung women from what was then the British colony of Burma went on a circus tour of England and Scotland in 1935. The brass rings they wear round their necks are added on year by year from the age of two. The original intention was to ward off tiger attacks. Here the women are seen enjoying Scottish beer brewed for export to their homeland.

Diese Padaung-Frauen aus der britischen Kolonie Birma treten 1935 im Rahmen einer Zirkustournee durch England und Schottland auf. Die Messingringe, die sie um den Hals tragen, werden ab dem zweiten Lebensjahr angelegt und jedes Jahr um einen weiteren ergänzt. Die ursprünglich zugrunde liegende Absicht war, Tigerangriffe abzuwehren. Hier verkosten die Frauen schottisches Bier, das für den Export in ihre Heimat gebraut wird.

En 1935, ces femmes de l'ethnie Padaung de la colonie britannique de Birmanie se produisent dans le cadre d'une tournée de cirque à travers l'Angleterre et l'Ecosse. Dès leur deuxième année, on leur fait porter autour du cou des anneaux de laiton auxquels s'en ajoutent d'autres chaque année, ceci pour les protéger contre les attaques des tigres. Ici, elles goûtent de la bière écossaise destinée à être exportée dans leur pays.

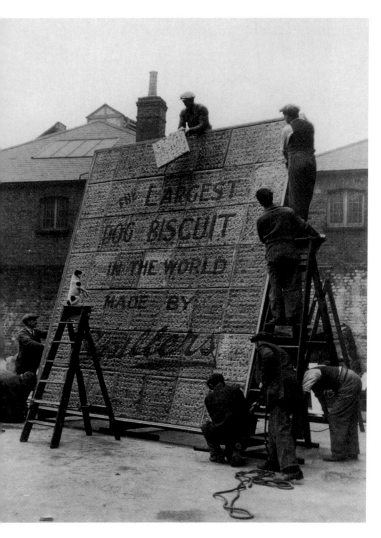

The Great Depression also affected the pets of the poor. "The largest dog biscuit in the world" was donated by the Spillers company in the run-up to Christmas 1932. At the Christmas Market of the People's Dispensary for Sick Animals of the Poor in London's Royal Albert Hall, the hungry animals were able to eat their fill.

Die Weltwirtschaftskrise trifft auch die Versorgung der Haustiere armer Leute. »Den größten Hundekuchen der Welt« spendet die Firma Spillers in der Vorweihnachtszeit 1932. Auf dem Weihnachtsbasar der Londoner Royal Albert Hall kommen die hungernden Vierbeiner in den Genuß dieses tonnenschweren Leckerbissens.

La crise économique mondiale n'épargne pas non plus les animaux domestiques des plus démunis. La firme Spillers fait don de « la plus grande croquette pour chien » lors de la fête de Noël organisée en 1932 par le dispensaire pour animaux malades des gens démunis. Les quadrupèdes affamés se pourlèchent devant cette friandise de plusieurs tonnes, au bazar de Noël du Royal Albert Hall, à Londres.

The New York scene was increasingly dominated by street-vendors in the years around 1930. Thus the widow of theater producer Oscar Hammerstein tried her luck selling apples in the business quarter of Manhattan. It was not until after Roosevelt's reforms in 1933 that the U.S. economy took a turn for the better.

Das Straßenbild New Yorks wird um 1930 zunehmend von Straßenverkäufern dominiert. So versucht die Witwe des Theaterproduzenten Oscar Hammerstein im Geschäftsviertel von Manhattan ihr Glück mit dem Verkauf von Äpfeln. Erst das Reformwerk Roosevelts konnte 1933 in den USA einen wirtschaftlichen Umschwung einleiten.

Vers 1930, on voit de plus en plus de marchands ambulants dans les rues de New York. La veuve du producteur de théâtre Oscar Hammerstein tente ici sa chance en vendant des pommes dans le quartier des affaires de Manhattan. Il fallut attendre les réformes de Roosevelt, en 1933, pour que l'économie américaine se redresse.

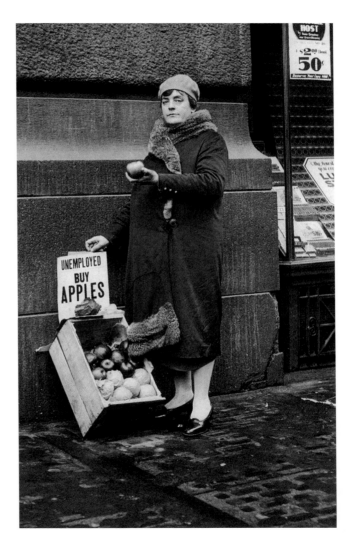

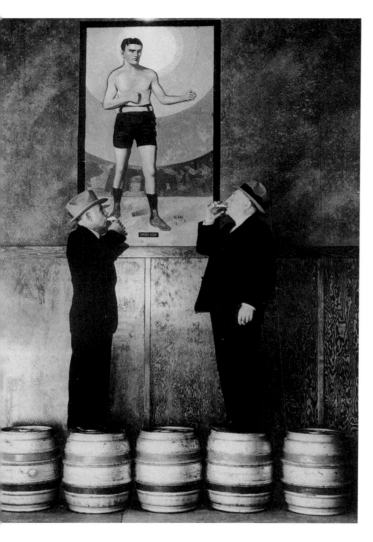

Two old comrades recall America's lightweight boxer "Spider" Kelly. His former manager (left) and the referee at his greatest fights are seen drinking a toast to the master in front of an oil painting of him on 10 November 1933. The picture is hanging in the San Francisco bar named after Kelly, which was reopened after the end of Prohibition.

Zwei alte Weggefährten erinnern an Amerikas Leichtgewichtsboxer »Spider« Kelly. Sein ehemaliger Manager (links) und der Schiedsrichter seiner größten Kämpfe sprechen am 10. November 1933 vor dem Ölgemälde des Meisters einen Toast auf ihn aus. Das Bild hängt in der nach Aufhebung der Prohibition wiedereröffneten und nach Kelly benannten Bar in San Francisco.

Deux vieux compagnons de route se souviennent du poids plume américain, le boxeur « Spider » Kelly. Son ancien manager (à gauche) et l'arbitre de ses plus grands combats portent un toast en son honneur le 10 novembre 1933 devant le portrait du champion. Ce tableau est accroché dans un bar de San Francisco réouvert après la fin de la prohibition et portant le nom de Kelly.

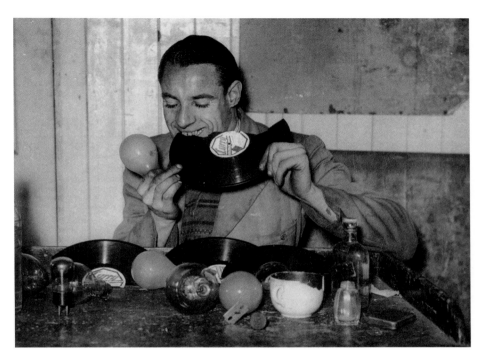

26-year-old Londoner Arthur Haylock entertained the city's reporters in 1938 with the following tall story. A vegetarian since boyhood, he claimed to have been breathing on his glasses one day when he swallowed one of the lenses. Since then, he had eaten nothing but tumblers, crockery, razor blades and gramophone records.

Der 26jährige Londoner Arthur Haylock unterhält 1938 die Reporter der Stadt mit folgender Legende: Während er, der von Kind an Vegetarier war, seine Brille behauchte, verschluckte er eines der Brillengläser. Seitdem esse er nur noch Wassergläser und Geschirr sowie Rasierklingen und Schallplatten.

En 1938, Arthur Haylock, un Londonien de 26 ans, amuse les journalistes de la ville avec la légende suivante : alors qu'il essayait de nettoyer ses verres de lunettes en utilisant son haleine, il en avala un – lui qui était végétarien depuis sa plus tendre enfance. Dès lors, il ne se nourrit plus que de verres à eau, de vaisselle, de lames de rasoirs et de disques.

The Children's Aid Society provided a refuge for needy youngsters on New York's East Side. On 24 July 1946, 11-year-old Gus was photographed tucking in to a pancake in the day center on the ninth floor. It was run by private benefactors.

Einen Zufluchtsort für bedürftige Kinder bietet die »Children's Aid Society« in der New Yorker East Side. Am 24. Juli 1946 genießt der elfjährige Gus einen Pfannkuchen in der im neunten Stock gelegenen Tagesstätte, die von privaten Wohltätern betrieben wird.

La « Children's Aid Society », dans la East Side de New York, accueille les enfants miséreux. Le 24 juillet 1946, Gus, âgé de onze ans, dévore une crêpe dans la crèche aménagée au neuvième étage et dirigée par des bienfaiteurs privés.

Incessant rainfall caused the River Tiber in Rome to burst its banks on 29 January 1948. Large areas of the Eternal City and its outskirts were underwater. This milk bar waiter in one suburb seems unperturbed, however.

Ununterbrochene Regenfälle lassen am 29. Januar 1948 den Tiber in Rom über die Ufer treten. Große Teile der Ewigen Stadt und ihrer Außenbezirke stehen unter Wasser. Dieser Kellner einer Milchbar in einem Vorort zeigt sich jedoch unbeeindruckt von den Fluten.

Le 29 janvier 1948, des pluies incessantes font déborder le Tibre, à Rome. Une grande partie de la Ville éternelle et de ses quartiers extérieurs est inondée. Mais ce serveur d'un milk-bar de banlieue ne se laisse pas impressionner par la montée des eaux.

Improvised emergency accommodation, like this on one bomb site, was a common sight in postwar Germany. But even in the desperate conditions of 1947, the Germans still kept a sense of propriety – the sign in the background reads "Private Property. No Trespassing".

Improvisierte Notunterkünfte wie diese auf einem Trümmergrundstück sind im Nachkriegsdeutschland keine Seltenheit. Doch auch in der Not von 1947 zieht der Deutsche gerne Grenzen, wie das Schild auf diesem Unterschlupf aus Ziegelsteinen beweist: »Das Betreten der Bude ist verboten.«

Les refuges improvisés, comme ici sur ce périmètre de ruines, ne sont pas rares dans l'Allemagne d'après-guerre. Et pourtant, même dans la misère, en cette année 1947, l'Allemand garde le sens de la propriété, comme le prouve l'écriteau devant cet abri en briques : « Il est interdit de pénétrer dans cette baraque. »

While the other states of the union were suffering from a shortage of meat, this picture, dating from 7 August 1946, shows that the hill farmers of North Carolina knew the problem only from hearsay. In view of the giant ham, the hunger problem here seemed to be merely one of distribution.

Während in den übrigen Staaten der USA eine akute Fleischknappheit herrscht, zeigt dieses Bild vom 7. August 1946, daß die Farmer in den Bergen North Carolinas das Problem nur vom Hörensagen kennen. Angesichts des Riesenschinkens scheint den hungrigen Zeitgenossen die Krise nur ein Verteilungsproblem zu sein.

Tandis qu'une pénurie de viande menace les autres Etats d'Amérique, cette photo prise le 7 août 1946 montre que les fermiers des montagnes de Caroline du Nord ne connaissent ce problème que par ouï-dire. Vu la taille de ce jambon, la crise ne semble être qu'un simple problème de répartition.

In postwar Paris, bistro-owners constantly bemoaned the tendency of customers to walk off with sugar cubes. But France had been in the grip of severe shortages since 1945, which could only be overcome by American loans and a long-term economic policy.

Im Paris der Nachkriegszeit klagen Bistrowirte über die Unsitte der Gäste, die Zuckerstücke von den Tischen zu stibitzen. Doch in Frankreich herrscht nach 1945 große Not, die nur durch amerikanische Kredite und eine langfristige Wirtschaftspolitik überwunden werden kann.

Dans le Paris de l'après-guerre, les patrons de bistrot se plaignent des mauvaises manières des clients qui empochent discrètement les morceaux de sucre mis sur les tables. Depuis 1945, la France est plongée dans la misère. Seuls les crédits américains et une politique économique à long terme y mettront fin.

The restaurant of the U.S. Senate in Washington D.C. was the venue on 24 March 1949 for an encounter between columnist Tris Coffin and photographer Marion Carpenter. Miss Carpenter felt that she and her profession had been defamed in a column by Mr Coffin, and repaid him with a plate of bean soup.

Im Restaurant des Senats in Washington D. C. geraten am 24. März 1949 der Kolumnist Tris Coffin und die Fotografin Marion Carpenter aneinander. Miss Carpenter ist der Ansicht, eine frühere Kolumne des Kollegen habe sie und ihren Berufsstand diffamiert und attackiert den Urheber nun mit einem Teller Bohnensuppe.

Au restaurant du Sénat, à Washington D.C., le 24 mars 1949, une dispute éclate entre l'éditorialiste Tris Coffin et la photographe Marion Carpenter. Miss Carpenter s'estime diffamée, elle et son métier, par un vieil éditorial de son collègue et se venge maintenant en jetant au visage de son auteur une assiette de soupe de haricots.

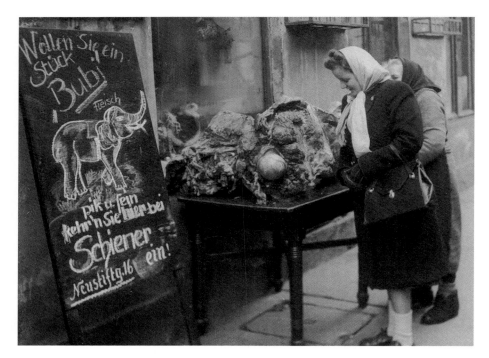

A very special dish was advertised by Viennese restaurateur Franz Schiener on 6 January 1949. He had acquired the carcass of Bubi, a popular circus elephant, and was serving up elephant schnitzels to his guests. A newspaper report spoke of a phenomenal success.

Ein Schnitzel der besonderen Art kredenzt der Wiener Gastwirt Franz Schiener am 6. Januar 1949. Er hatte den Kadaver von Bubi, einem vormals beliebten Zirkuselefanten, erworben und serviert nun seinen Gästen »Elefanten-Schnitzel«. Die Zeitungsnotiz berichtet von einem phänomenalen Erfolg.

L'aubergiste viennois Franz Schiener inscrit à son menu, le 6 janvier 1949, une escalope d'un genre tout particulier. Il a fait l'acquisition du cadavre de Bubi, un éléphant de cirque très populaire à cette époque et sert des escalopes d'éléphant à sa clientèle. Selon une manchette de journal, c'est un succès phénoménal.

THE VANISHING SWEETS

TAKE ONE – IF YOU CAN!!

Where have they gone —
what is the answer ?

The British Ministry of Supply showed its sense of humor at the Schoolboy's Own Exhibition in January 1951. An optical illusion worked up visitors' appetites for candies, inviting them to "take one if you can." But as soon as a hand went through the opening, the image disappeared.

Das britische Versorgungsministerium erlaubt sich bei einer Ausstellung im Januar 1951 einen Scherz. Ein optischer Trick macht dem Betrachter Appetit auf Süßes und lädt ihn ein, danach zu greifen. Sobald jedoch die Hand durch die Öffnung schlüpft, verschwindet das Bild.

Le ministère anglais de l'Approvisionnement se permet une petite plaisanterie lors d'une exposition en janvier 1951. Un trompe-l'œil donne à l'observateur une envie de sucré et l'invite à saisir cette gourmandise. Mais dès que l'on glisse la main dans l'ouverture, l'image disparaît.

American newspapers in the 1950s liked to give the up-and-coming young men among their readers advice on how to increase their performance. A balanced breakfast of fruit juice, cornflakes with milk, toast and coffee "pays great dividends in greater efficiency and mental freshness."

Amerikanische Zeitungen geben in den fünfziger Jahren den aufstrebenden jungen Männern unter ihren Lesern gern Ratschläge zur Steigerung ihrer Leistungskraft. Ein ausgewogenes Frühstück mit Saft, Kleieflocken mit Milch, Toast und Kaffee »bringt hohe Dividenden bezüglich größerer Effektivität und geistiger Frische«.

Dans les années 50, des journaux américains donnent aux jeunes hommes ambitieux parmi leurs lecteurs des conseils pour être plus performants. Un petit déjeuner équilibré composé de jus de fruits, de flocons de céréales avec du lait, de toasts et de café « est synonyme de dividendes élevés, à savoir d'une plus grande efficacité et une plus grande mobilité d'esprit. »

Shrove Tuesday is traditionally the day for pancake races in England. In the town of Olney, the race developed into an international event. Since 1950, ladies from a twin town in the state of Kansas had also taken part. This photo from January 1952 shows that the "home team" were already in training.

»Shrove Tuesday«. Das alljährliche Pfannkuchenrennen am Vortag des Aschermittwochs entwickelt sich im englischen Ort Olney in Buckinghamshire zu einem internationalen Wettbewerb. Seit 1950 nehmen hier auch Frauen aus einer Partnergemeinde im US-Bundesstaat Kansas teil. Die Damen aus Olney nehmen 1952 bereits im Januar das Training auf.

« Shrove Tuesday ». A Olney, en Angleterre, dans le Buckinghamshire, la course aux crêpes organisée chaque année la veille du Mercredi des Cendres se mue en une compétition internationale. Depuis 1950, des femmes, venues d'une commune jumelée de l'Etat fédéré américain du Kansas, y participent aussi. En janvier 1952, celles d'Olney commencent à s'entraîner.

During the 1940s, Sweden not only brought forth the world star among children's storybook heroines, *Pippi Longstocking*, but also started children's TV shows for its younger viewers, such as this one on 20 April 1955.

Schweden bringt in den vierziger Jahren nicht nur den weltweit größten Bestseller unter den Kinderbüchern, *Pippi Langstrumpf*, hervor. Das schwedische Fernsehen präsentiert seinen kleinen Zuschauern auch Kindersendungen, wie diese am 20. April 1955.

Dans les années 40, la Suède ne produit pas seulement le best-seller mondial pour enfants, *Fifi Brindacier*. La télévision suédoise présente aussi à ses petits spectateurs des émissions qui leur sont destinées, comme en ce 20 avril 1955.

The famous cancan theater Tabarin in Paris
announced its reopening on 1 April 1953
with an April Fool's Day joke. The new ver-
sion of the *Rainbow* show demonstrated
how cows were milked in this theater.

Mit einem Aprilscherz kündigt sich am
1. April 1953 die Wiedereröffnung des
bekannten Cancan-Lokals Tabarin in
Paris an. In der neu bearbeiteten Show
Regenbogen wird gezeigt, wie in diesem
Lokal Kühe gemolken werden.

Le 1er avril 1953, un poisson d'avril annonce
la réouverture du célèbre cabaret de
Tabarin de Paris où l'on danse le cancan.
Dans le spectacle revu et corrigé *Arc en
ciel*, on montre comment on trait
« les vaches à lait ».

In the 1950s, Germany saw the introduction of a telephone help-line for housewives and bachelors who could not cope in the kitchen. "By dialing 4165, callers can hear a two-minute recorded message with cooking tips and suggestions for lunch and dinner for a family of four."

In Deutschland wird in den fünfziger Jahren ein »Fernsprech-Küchendienst« für ratlose Junggesellen und Hausfrauen eingerichtet. »Bei Anruf der Nummer 4165 werden in zweiminütigen-Banddurchsagen Kochvorschläge und Hinweise für ein Mittag- und Abendessen eines 4-Personen-Haushalts gegeben.«

En Allemagne, dans les années 50, est instauré un « service téléphonique de cuisine » pour célibataires et ménagères désemparés. « En composant le numéro 4165, on peut entendre une bande enregistrée de deux minutes qui propose des idées de plats et des conseils pour préparer un déjeuner et un dîner pour quatre personnes. »

In 1954, the Conservative Member of Parliament for Hexham in northern England promised his voters: "If the Chancellor of the Exchequer does not bring down duties on oil and fuel, I'll eat my hat." Here he is seen doing just that – albeit a marzipan hat donated by local party colleagues.

Der konservative Parlamentarier Rupert Spier aus dem englischen Hexham versprach seinen Wählern 1954: »Wenn der Schatzkanzler nicht die Steuern auf Öl und Benzin senkt, esse ich meinen Hut.« Hier über- reicht ihm die örtlichen Parteifreunde wenig später einen Hut aus Marzipan.

Le parlementaire conservateur Rupert Spier, de Hexham en Angleterre, promit à ses électeurs, en 1954 : « Si le chancelier de l'Echiquier n'abaisse pas l'impôt sur le pétrole et l'essence, je mange son chapeau. » Un peu plus tard, ses camarades du parti lui remettent un chapeau en massepain.

In 1955, "Dicker Heinrich" ("Fat Henry"), a restaurant on West Berlin's main shopping street, the Kurfürstendamm, laid on a competition to find the three fattest Berliners. The winner was one Herr Schilling, who weighed in at 335 lbs (152 kilograms) – here seen holding the smallest Berliner (40 lbs, 18 kgs) on his arm. This advertising gimmick by the restaurant also reflected the economic upturn in West Berlin.

Das Restaurant »Dicker Heinrich« am Kurfürstendamm sucht 1955 die drei dicksten Berliner. Der Sieger, Herr Schilling, wiegt 335 Pfund und hält hier den kleinsten Berliner auf dem Arm. Dieser Werbegag des Lokals symbolisiert zugleich: Es geht wieder aufwärts mit Westberlin.

Le restaurant « Dicker Heinrich » (Chez le Gros Henri) sur le Kurfürstendamm, recherche, en 1955, les trois plus gros Berlinois. Le vainqueur, Monsieur Schilling, pèse près de 152 kilos et tient ici dans ses bras le plus petit Berlinois, 18 kilos. Ce gag publicitaire du restaurant a valeur de symbole : « Berlin-Ouest se porte de mieux en mieux. »

Unrestrained gluttony after the lean
postwar years was a regular theme of
the 1950s' press in France, too. A Parisian
gourmand is here seen tucking in to an
immense platter with great gusto.

Unbändige Freßlust nach den kargen
Jahren ist in den fünfziger Jahren auch
in Frankreich ein Thema. In Paris fängt
ein Fotograf diesen Gourmand ein, der
sich hemmungslos einem Fleischteller
hingibt.

Après la période de vaches maigres, la
gloutonnerie est aussi à la une dans la
France des années 50. A Paris, un photo-
graphe immortalise ce gourmand devant
une assiette de charcuterie.

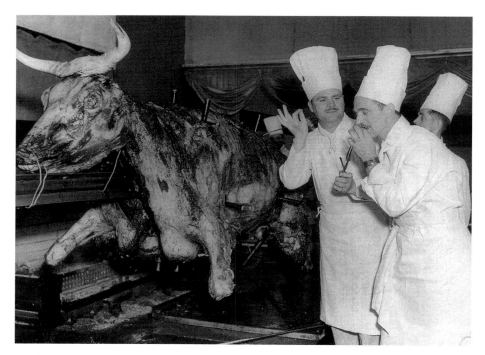

It took 15 hours to roast this ox on a spit over a fire at London's Olympia on 24 July 1954. The chef is about to carve the first slice, with 800 guests at an indoor barbecue waiting for their share.

15 Stunden schmort dieser Ochse am 24. Juli 1954 über dem Feuer im Londoner Olympia. Gleich wird der Chefkoch den Braten anschneiden, denn 800 Teilnehmer einer Zimmergrillparty warten bereits auf den versprochenen Gaumenkitzel.

Le 24 juillet 1954, ce bœuf a cuit 15 heures à petit feu à l'Olympia de Londres. Le chef de cuisine s'apprête à le découper, car les 800 invités à un barbecue se déroulant à l'intérieur attendent impatiemment ce mets fin qu'on leur a promis.

By the mid-20th century, wild brown bears in Western and Southern Europe had withdrawn to just a few fastnesses. This courageous French-woman had decided to confine one example of this large carnivorous mammal – which in the wild is a nocturnal prowler – in her house.

Der Braunbär ist Mitte des 20. Jahrhunderts in West- und Südeuropa nur noch in einigen Rückzugsgebieten anzutreffen. Diese mutige Französin hat sich entschieden, ein Exemplar dieser größten fleischfressenden Säugetiere, die in freier Wildbahn nachtaktive Einzelgänger sind, in ihr Domizil zu sperren.

Au milieu des années 20, en Europe occidentale et méridionale, on ne rencontre guère plus l'ours brun que dans des contrées éloignées. Cette courageuse Française a choisi de garder chez elle cet exemplaire du plus gros mammifère carnivore, également réputé comme chasseur solitaire nocturne.

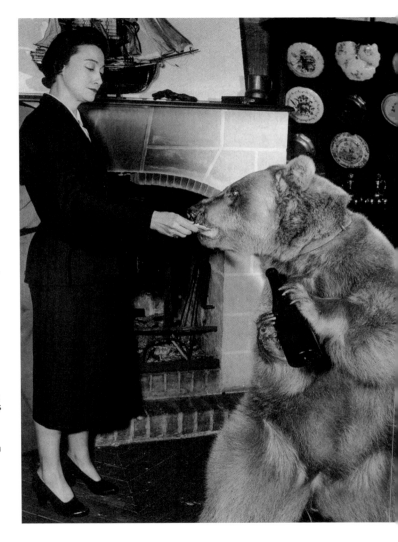

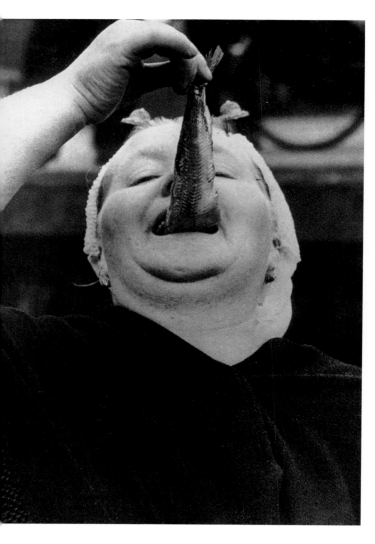

The northern coast of Holland, 1953 – a fishwife samples the "first herring" herself. Herring fishing has been going on here since the Middle Ages. It is a major economic factor in the lives of those living around the North Sea and Baltic coasts.

Den »ersten Hering« läßt sich diese Fischarbeiterin 1953 an der nordholländischen Küste selbst schmecken. Die Heringsfischerei ist seit dem Mittelalter überliefert und von herausragender wirtschaftlicher Bedeutung für die Anrainer der Nord- und Ostsee.

En 1953, cette poissonnière de la côte Nord hollandaise se délecte du « premier hareng ». Traditionnelle depuis le Moyen Age, la pêche aux harengs constitue une importante ressource économique pour les riverains de la mer du Nord et de la Baltique.

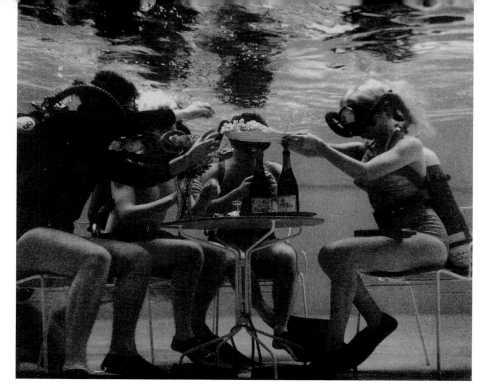

An underwater New Year's Eve party with a champagne buffet at a swimming club near London in 1960. The star guest was Jane Baldasare from America, who the previous summer had tried, unsuccessfully, to swim the English Channel beneath the waves.

Mit einem Unterwasserbuffet und Champagner wird 1960 in einem Schwimmclub in der Nähe von London Silvester gefeiert. Stargast ist die Amerikanerin Jane Baldasare, die im vorangegangenen Sommer vergeblich versuchte, den Ärmelkanal zu durchtauchen.

En 1960, un club de natation londonien fête la Saint Sylvestre autour d'un buffet sous-marin avec du champagne. L'invité d'honneur est l'Américaine Jane Baldasare, qui avait vainement tenté, l'été précédent, de traverser la Manche en plongée.

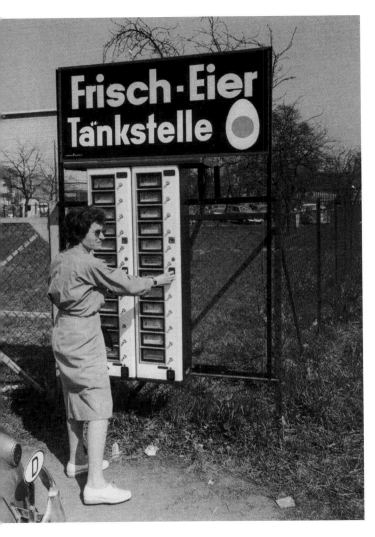

This farm not far from the German port of Hamburg not only mechanized its milking, plowing, sowing and harvesting in the 1960s, it also set up a "fresh egg filling station" where customers could insert one mark and obtain five eggs. A further saving on the payroll.

Auf diesem deutschen Bauernhof in der Nähe von Hamburg breitet sich in den sechziger Jahren die Mechanisierung nicht nur in den Ställen und auf den Feldern aus. An der »Frisch-Eier Tankstelle« bekommen die Kunden fünf Eier für eine deutsche Mark, und der Bauer spart auch hier an Arbeitskraft.

Dans cette ferme allemande proche de Hambourg, la mécanisation dans les années 60 ne se limite pas seulement aux étables et aux champs. A la « pompe à œufs frais », les clients peuvent acheter cinq œufs pour un mark, et cela permet en outre au fermier de faire des économies de personnel.

At the International Poultry Show at London's Olympia on 9 December 1966, Jan Downing, clad in an turkey-feather bikini, presents the winner in the "heaviest turkey" category. In the Anglo-American world, roast turkey is a traditional Christmas delicacy.

Auf der Geflügelausstellung im Londoner Olympia am 9. Dezember 1966 präsentiert Jan Downing in einem Bikini aus Truthahnfedern den Sieger in der Kategorie »Schwerster Truthahn«. In der anglo-amerikanischen Welt erfreut sich dieses Federvieh als Weihnachtsbraten traditionell großer Beliebtheit.

Lors de l'Exposition de Volailles à l'Olympia de Londres, le 9 décembre 1966, Jan Downing présente, dans un bikini de plumes de dindon, le vainqueur dans la catégorie du « Plus gros dindon ». Ce volatile est très apprécié comme traditionnel rôti de Noël dans la société anglo-américaine.

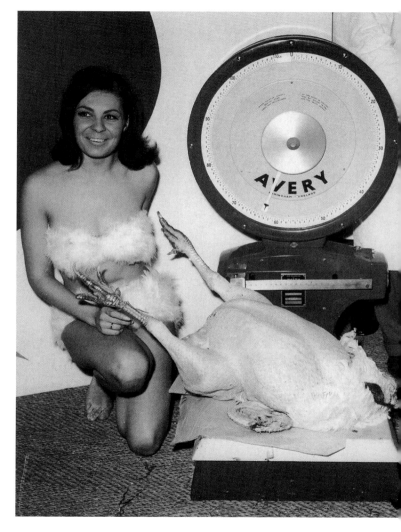

The sunny side of life

Summer. For journalists, the Silly Season. Parliaments and city councils are in recess. Local public activities cease. As far as possible, people flee the cities for the sun and the sea and the sand. And editors, looking for material to fill their columns, send their photographers to take summery photographs, preferably comical scenes which can be accompanied by some amusing story. Vacation as leisure in its most concentrated form for broad sectors of the community is a 20th century phenomenon. The introduction of the 8-hour working day and union-negotiated guaranteed leave meant that what had hitherto been a middle-class privilege was now attainable for everyone. In America and Europe, a lively and socially broad-based leisure and vacation culture grew up. The Second World War brought the trend to an abrupt halt, but within a few years of the war's end, people were traveling once more. Foreign trips, however, continued to be the privilege of the few for some time. Editors gladly fell back on agency photographs telling stories of beach life around the world. The sunny pictures illustrating life in the country and by the seaside not only entertained the readers, but invited them to do the same.

Sommerfrische

Es ist Sommer. Für die Presse beginnt die Sauregurkenzeit. Parlamente und Stadtversammlungen gehen in die Sommerpause. Das Geschehen auf den örtlichen Bühnen ruht. Soweit es ihnen möglich ist, fliehen die Menschen aus den Städten an die Strände. Für die Redakteure beginnt nun die Suche nach Themen. Sie beauftragen ihre Fotografen mit der Produktion von Sommerbildern – am besten eine witzige Szene, zu der sich eine amüsante Geschichte erzählen läßt. Urlaub als konzentrierteste Form der Freizeit für breite Bevölkerungsschichten ist ein Phänomen des 20. Jahrhunderts. Das vormals bürgerliche Privileg wird durch die Einführung des Achtstundentags und tariflich zugesicherte Urlaubsansprüche zu einem erreichbaren Ziel für jedermann. In Amerika und Europa entwickelt sich seit den zwanziger Jahren eine rege und sozial breite Freizeit- und Urlaubskultur. Der Zweite Weltkrieg unterbricht diesen Trend abrupt, aber bereits wenige Jahre nach Kriegsende verreisen die Menschen wieder. Fernreisen bleiben jedoch nach wie vor exklusiv. Gerne greifen Redakteure in der Ferienzeit auf Agenturbilder zurück, die vom Urlaubsgeschehen an den Stränden der Welt erzählen. Die sommerfrischen Bilder amüsieren und regen zur Nachahmung an.

Fraîcheur estivale

C'est l'été. Pour la presse, c'est le calme plat. Parlements et conseils municipaux sont partis en vacances. Sur les scènes locales, il ne se passe rien qui mérite d'être rapporté. Tous ceux qui le peuvent, fuient les villes pour les plages. Les rédacteurs doivent maintenant se mettre en quête de sujets. Ils chargent donc leurs photographes de leur procurer des clichés estivaux, si possible une scène humoristique à partir de laquelle on pourrait écrire une histoire amusante. Les vacances, synonymes de loisirs pour de larges couches de la population, sont un phénomène du XXᵉ siècle. Jusque-là privilège de la bourgeoisie, elles deviennent accessibles à tous avec l'introduction de la journée de huit heures et l'octroi aux congés payés en vertu des conventions collectives. Depuis les années 20, les loisirs et les vacances se démocratisent en Amérique et en Europe. La Seconde Guerre mondiale donne un coup de frein brutal à cette tendance, mais, peu après 1945, les hommes recommencent à voyager. Les destinations lointaines restent toutefois à la portée d'une minorité. Pendant les périodes de congés, les rédacteurs recourent volontiers aux photos d'agences de presse pour témoigner de ce qui se passe sur les plages du monde entier. Les images estivales de vacances amusent les gens et les invitent à en faire autant.

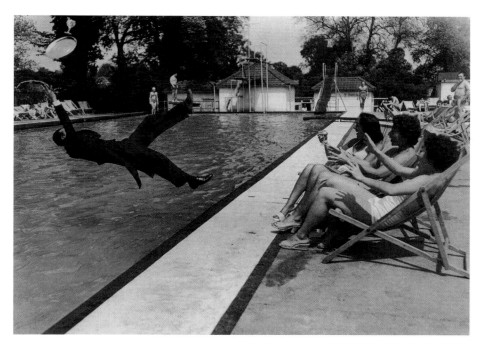

In spring and summer, hungry for the sun, people streamed out of their homes, and press photographers could breathe again. There was always something new happening – even if it was just a waiter falling into the water while serving cool drinks on a very hot day at the poolside in the English town of Watford.

Im Frühling und Sommer strömen die Menschen sonnenhungrig aus ihren Wohnungen, und die Pressefotografen können endlich aufatmen: Es passiert wieder jeden Tag etwas in der Region, und sei es, daß an einem sehr heißen Tag im englischen Watford der Oberkellner beim Servieren der kühlen Drinks in den Pool fällt.

Au printemps et en été, dès les premiers rayons du soleil, les gens quittent leur appartement et les photographes de presse se frottent les mains : il se passe tous les jours quelque chose dans la région. Ne serait-ce, comme ici à Watford, en Angleterre, où par une après-midi torride, un garçon de café tombe dans la piscine au moment de servir des rafraîchissements à ses clients.

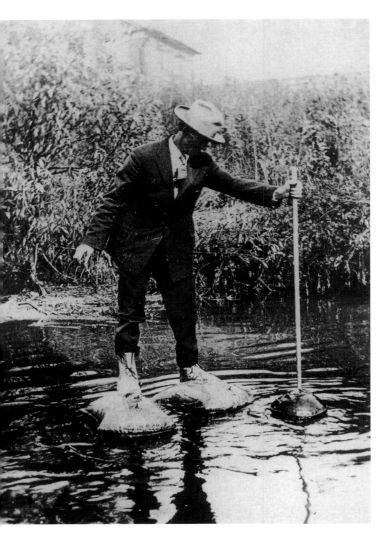

The notion of "walking on the water" was interpreted by one American, J. "Happy" Hazard, in his own way. In 1929, he made himself special shoes for the purpose, along with an appropriate walking stick. What is more, he apprised the press of his plan to cross the English Channel this way the following year.

Den Begriff »Seepromenade« interpretiert der Amerikaner J. »Happy« Hazard aus Ohio auf neue Weise und baut sich 1929 Wasserläufer mit passendem Spazierstock. Darüber hinaus erwähnt er gegenüber der Presse den Plan, im darauffolgenden Jahr den englischen Kanal in gleicher Manier zu überqueren.

L'Américain J. « Happy » Hazard, de l'Ohio, a sa propre conception des promenades sur le lac et se fait, en 1929, des chaussures et une canne spéciales. Accessoirement, il signale à la presse son intention de traverser la Manche de la même manière l'année suivante.

After women first took part in the Olympic Games in 1900 – in the Tennis and Golf events – more and more women were engaging in sporting activities in their leisure time. As this picture, taken a few years later, shows, it was still a privilege of the leisured classes, and there was as yet no thought of actual competition.

Nachdem im Jahre 1900 erstmals Frauen an den Olympischen Spielen – in den Sparten Tennis und Golf – teilnehmen, beginnen immer mehr Frauen, sich in ihrer Freizeit sportlich zu betätigen. Wie dieses wenige Jahre später aufgenommene Bild zeigt, handelt es sich hierbei jedoch noch immer um ein bürgerliches Privileg, und der Wettkampfgedanke bleibt vorerst außen vor.

Après la première participation de femmes aux Jeux olympiques de 1900, disciplines tennis et golf, les adeptes du sport durant les loisirs sont de plus en plus nombreuses. Comme sur cette photo prise quelques années plus tard, il s'agit en l'occurrence le plus souvent d'un privilège de la bourgeoisie et l'esprit de compétition en demeure exclu, tout au moins les premiers temps.

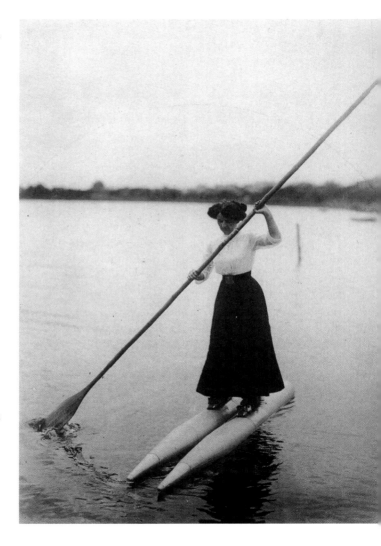

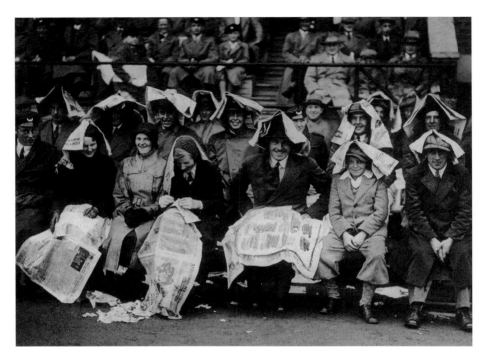

Watching soccer matches was one of the favorite pastimes
in Sweden during the 1930s. The spirits of these spectators
in the cheap seats, exposed to the elements, were not
dampened by a passing shower.

Der Gang ins Fußballstadion gehört in den dreißiger
Jahren auch in Schweden zu den populären Freizeit-
beschäftigungen. Diese Zuschauer auf den billigen,
unüberdachten Plätzen in Gävle lassen sich das Vergnügen
nicht durch einen kurzen Regenschauer verdrießen.

Dans la Suède des années 30, assister aux matchs de
football est l'une des activités de loisirs les plus populaires.
Une brève averse ne saurait gâcher le plaisir de ces
spectateurs qui, à Gävle occupent les tribunes en plein
air où les places sont moins chères.

More and more bathing areas were opened on German coasts and lakesides during the 1920s and 1930s. The operators increasingly understood leisure to mean entertainment. Here in Berlin, visitors were given the opportunity to pass the time with a game of checkers while enjoying the cool water.

Immer mehr Strandbäder sprießen in den zwanziger und dreißiger Jahren an deutschen Seen und Küsten aus dem Boden. Die Betreiber verstehen Freizeit auch zunehmend als Unterhaltung. Hier in Berlin wird den Besuchern die Möglichkeit geboten, sich die Zeit im kühlen Naß bei einer Partie Dame zu vertreiben.

Dans l'Allemagne des années 20 et 30, de plus en plus de plages sont aménagées au bord des lacs et sur les côtes. Les exploitants conçoivent de plus en plus souvent les loisirs comme des instants ludiques. Ici, à Berlin, on peut jouer aux dames tout en se rafraîchissant.

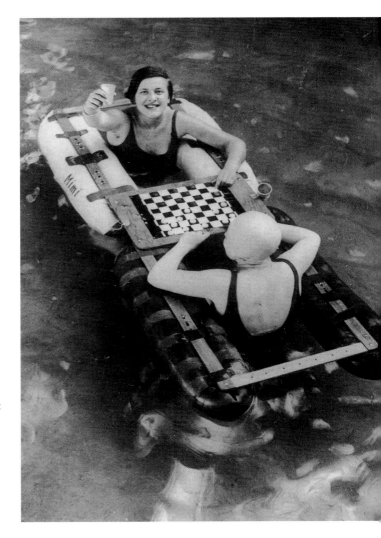

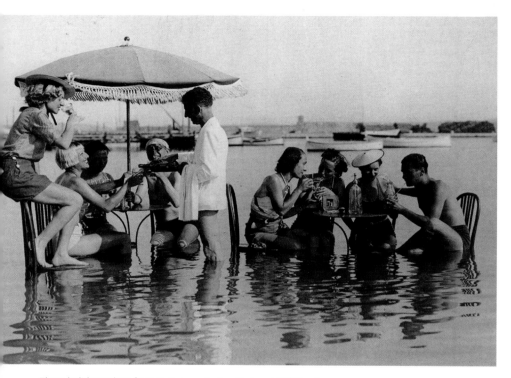

These holidaymakers from Paris are enjoying their apéritif literally in the harbor of Sainte-Maxime on the Côte d'Azur in 1938. For most French newspaper readers of the period, this pleasure must have seemed lunatic and inaccessible in equal measure.

Diese Sommerfrischler aus Paris nehmen 1938 ihren Aperitif direkt im Hafenbecken von Sainte-Maxime an der Côte d'Azur. Für die meisten zeitgenössischen französischen Zeitungsleser mag dieser Anblick ebenso verrückt wie unerreichbar gewesen sein.

En 1938, ces Parisiens en vacances prennent l'apéritif directement dans le bassin portuaire de Sainte-Maxime, sur la Côte d'Azur. Pour la majorité des lecteurs de journaux français de l'époque, ce qu'ils voient sur cette photo est aussi insensé qu'inaccessible.

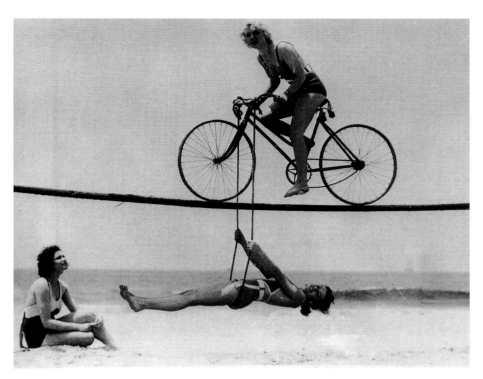

The beaches of California were the place to find
this particular form of amusement in the 1930s.
More and more sporting activities were devel-
oping alongside bathing during this period.

An den Stränden Kaliforniens findet sich in den
dreißiger Jahren diese Strandbelustigung. Rund
um das Baden entwickeln sich in dieser Zeit
immer mehr sportliche Aktivitäten.

Ce genre de divertissement était proposé
dans les années 30 sur les plages de Californie
où les activités sportives liées à la baignade
se multiplient.

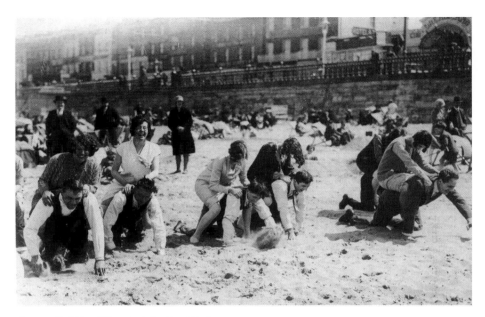

The so-called Isle of Thanet, at the tip of Kent some 60 miles (100 kilometers) east of London, enticed many holidaymakers in May 1935. The bathing season at the resort of Margate had not officially opened, but that did not stop these relaxed visitors enjoying a piggy-back race.

Die 100 km östlich von London am äußersten Zipfel Kents gelegene Isle of Thanet lockt im Mai 1935 viele Urlauber an. Im Seebad Margate ist die Badesaison zwar noch nicht eröffnet, doch die ausgelassenen Besucher vergnügen sich beim »Huckepack-Rennen«.

En mai 1935, l'Isle of Thanet, une presqu'île dans le Kent, à 100 kilomètres à l'est de Londres, attire de nombreux vacanciers. Si la saison balnéaire n'a pas encore commencé à Margate, les touristes disputent néanmoins avec le plus grand plaisir des « courses de chevaux ».

In August 1931, Mr
Selfridge set up a trans-
portable swimming pool
on the rooftop of his
department store, with a
view over London. The
caption speaks only of
"bathing enthusiasts"
and fails to mention
whether the facility was
open to the public or
was just for the staff.

Über den Dächern des
sommerlichen London
hat Mr Selfridge im
August 1931 auf seinem
Kaufhaus ein transporta-
bles Schwimmbecken
aufgebaut. Die Bild-
unterschrift spricht von
»Bade-Enthusiasten«,
läßt uns jedoch im
unklaren darüber, ob das
kühle Naß lediglich für
seine Angestellten
zugänglich ist.

En août 1931, alors que
l'été règne en maître à
Londres, M. Selfridge fait
installer une piscine
gonflable, sur le toit de
son grand magasin.
D'après la légende, les
baigneurs sont enthou-
siastes mais on ignore si
les employés sont seuls
à se rafraîchir ainsi.

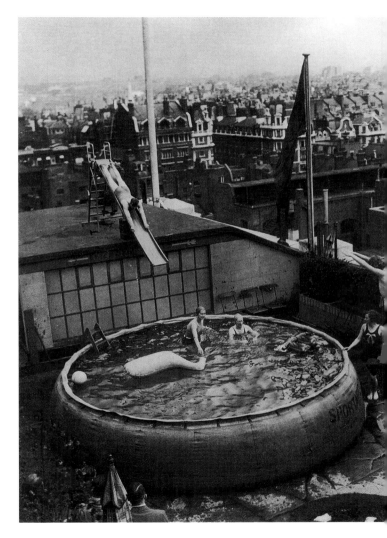

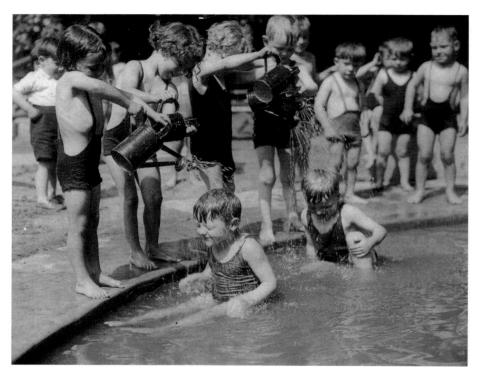

Life was more relaxed in summer for English children, too, during the 1930s. These youngsters at Broomhall Street Nursery School in Sheffield are taking a refreshing dip in the paddling pool.

Im Sommer ist der englische Alltag auch für die Kinder der dreißiger Jahre ungezwungener. Im Planschbecken des Broomhall Street Kindergartens in Sheffield erfrischen sich die Sprößlinge.

Durant les années 30, la vie quotidienne de ces petits Anglais est aussi plus décontractée en été. Les pensionnaires du jardin d'enfants de la Broomhall Street, à Sheffield, se rafraîchissent en groupe dans le bassin.

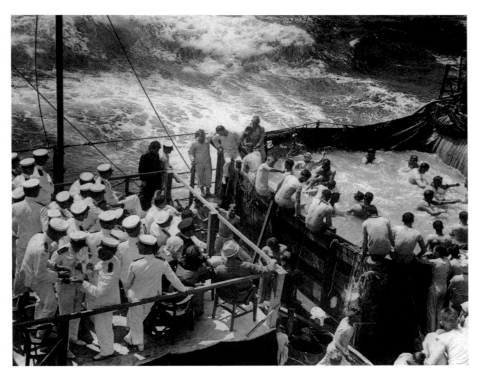

This American warship had not yet been overtaken by the emergency when this photo was taken in the late 1930s. The old sea dogs insist on their right to "christen" the greenhorn sailors who are "crossing the line" – the Equator – for the first time.

Der Ernstfall ist für dieses amerikanische Kriegsschiff Ende der dreißiger Jahre noch nicht eingetreten. So lassen es sich die altgedienten Seebären auch nicht nehmen, ihre Kameraden bei der ersten Überquerung des Äquators zu taufen.

A la fin des années 30, la guerre est encore loin pour ce bâtiment de la marine américaine, aussi les vieux loups de mer ne laissent-ils pas passer l'occasion de baptiser leurs camarades lors de leur premier passage de l'Equateur.

This miniature car-and-trailer combination is on its way to the London Open Air Exhibition on 24 March 1939. In view of the tense diplomatic situation, though, there was no thought of traveling abroad. Long-distance tourism developed only after the War.

Dieses Miniatur-Wohnwagen-gespann ist am 24. März 1939 auf dem Weg zur Londoner Freiluft-Ausstellung. An Reisen außer Landes ist aufgrund der angespannten weltpolitischen Lage gar nicht zu denken. Der Ferntourismus entwickelt sich erst nach dem Zweiten Weltkrieg.

Cette voiture miniature avec caravane modèle réduit se rend, le 24 mars 1939, à la Foire-exposition de plein air de Londres. Mieux vaut ne pas aller à l'étranger compte tenu des tensions politiques dans le monde entier. Les voyages à l'étranger ne se développeront qu'après la Seconde Guerre mondiale.

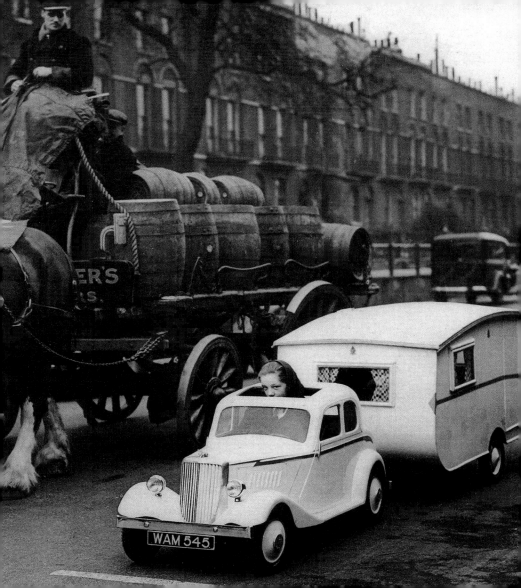

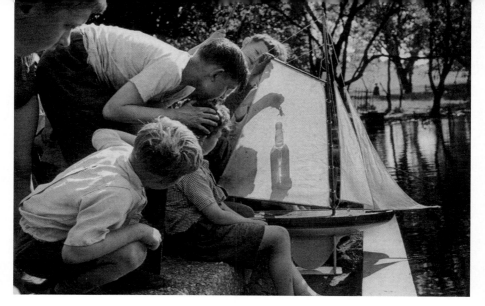

The title of this London press photo dated 30 July 1947 stressed that these children were forced to spend their holidays in the city. The photo nevertheless tries to comfort the stay-at-homes by showing that discovering nature within the city limits can still be fun.

Die Überschrift dieses Londoner Pressefotos vom 30. Juli 1947 betont, daß diese Kinder die Ferien in der Stadt verbringen müssen. Das Foto versucht, den Daheimgebliebenen Trost zu spenden und illustriert, daß es durchaus spannend sein kann, die Natur innerhalb der Stadt zu entdecken.

La légende de cette photo de la presse londonienne du 30 juillet 1947 souligne que ces enfants sont contraints de passer leurs vacances dans la ville. La photo tente de consoler ceux qui sont restés chez eux et montre que la découverte de la nature dans la ville même peut être tout à fait passionnante.

An American reporter enjoyed the sight of these boys in the U.S. Sector of Berlin in August 1949. "Now the water-filled crater is serving as a private swimming pool." By this time, the political die had been cast. There were two German states and Berlin, too, was divided.

Mit Vergnügen betrachtet im August 1949 ein amerikanischer Reporter das Treiben dieser Jungen an einem wassergefüllten Bombenkrater im US-Sektor Berlins: »Nun dient der Krater als privates Schwimmbecken.« Politisch sind zu diesem Zeitpunkt die Würfel gefallen: Es gibt zwei deutsche Staaten und Berlin ist geteilt.

En août 1949, un reporter américain observe non sans plaisir ces jeunes garçons qui plongent dans un cratère de bombe empli d'eau, dans la partie de Berlin placée sous contrôle américain : « Maintenant, le cratère sert de piscine privée. » A cette date, les dés sont jetés sur le plan politique : il y a deux Etats allemands et Berlin est divisé en deux.

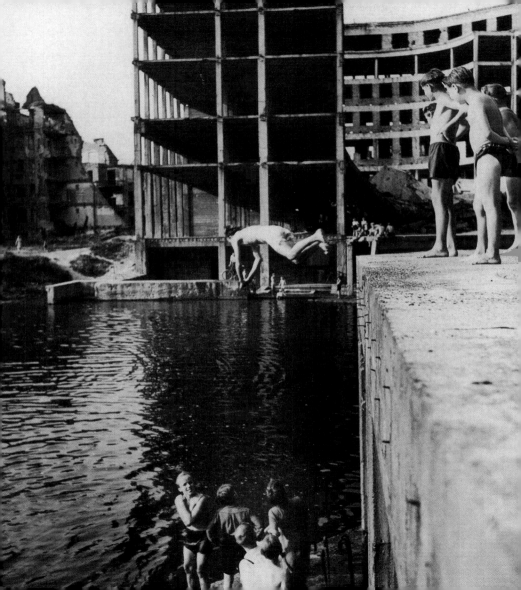

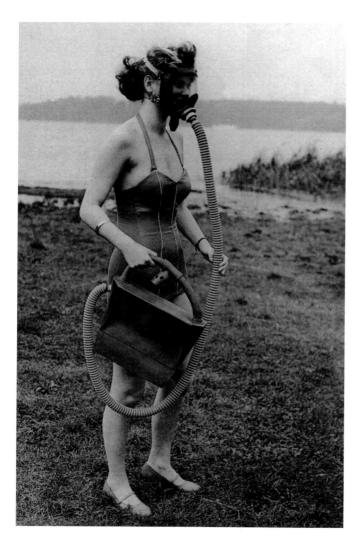

This "dolphin" with a full-vision mask was not parading some new bathing fashion the Berlin newspapers had discovered in the summer of 1954. The bathing beauty on the banks of the River Havel is in fact demonstrating a "new life-saving and fresh-air apparatus."

»Tümmler mit Vollblickmaske« – unter dieser Überschrift präsentieren Berliner Zeitungen im Sommer 1954 nicht etwa die neue Bademode der Saison. Vielmehr führt diese Badenixe an der Havel ein »neues Rettungs- und Schwimm-Frischluftgerät« vor.

« Plongeuse avec masque à vision intégrale » – contrairement à ce que l'on pourrait croire, ce n'est pas le titre d'un article consacré à la nouvelle mode des maillots de bain de l'été 1954, dans la presse berlinoise. Cette nageuse montre bien au contraire comment fonctionne un nouvel appareil respiratoire pour le sauvetage et la natation sur les rives de la Havel.

In the 1950s, Paris experienced a veritable flood of foreign tourists. This Scotsman and his lady exemplify the wanderlust which had overtaken the people of Europe as their economies gradually emerged from the confusion of the wartime and postwar years.

Paris erlebt in den fünfziger Jahren geradezu einen Ansturm ausländischer Touristen. Diese Schotten belegen die Reiselust der Europäer, deren Volkswirtschaften sich langsam von den Kriegs- und Nachkriegswirren erholen.

Dans les années 50, Paris est littéralement envahi par les touristes étrangers. Ces Ecossais montrent que les Européens aiment voyager, la situation économique dans leur pays se redressant lentement et leur faisant oublier les privations de la guerre et de l'après-guerre.

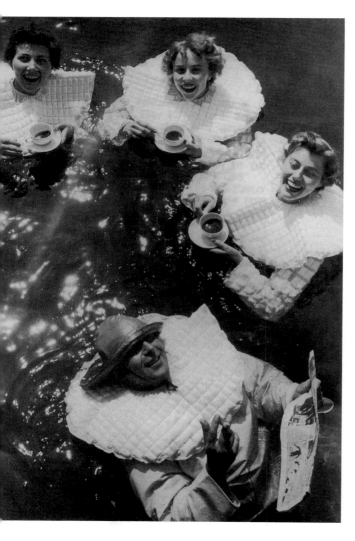

On 19 June 1954, a German inventor demonstrated a new wave-proof life jacket in Hamburg harbor. Known as the Isoretta, this innovation had already been ordered, he said, by Germany's Life-Saving Association, which organizes rescue services around the country's coasts.

Ein deutscher Erfinder stellt am 19. Juni 1954 in einem Hamburger Hafenbecken eine neue Schwimmweste mit Wellenschutz vor, die den Namen Isoretta trägt. Seinen Angaben zufolge hat die Deutsche Lebens-Rettungs-Gesellschaft, die sich um Notfälle auf deutschen Gewässern kümmert, seine Innovation bereits bestellt.

Le 19 juin 1954, un inventeur allemand présente, dans un bassin du port de Hambourg, un nouveau gilet de sauvetage baptisé Isoretta qui protège aussi des vagues. Selon ses propres déclarations, la Société allemande de sauvetage, qui vient en aide aux personnes en difficulté sur les côtes et les rivages nationaux, a déjà commandé son innovation.

The unusually hot summer of 1955 led German workers to take no less unusual measures. This Hamburg secretary has moved her workplace to the roof of the office building.

Die außergewöhnlichen Temperaturen veranlassen im Sommer 1955 deutsche Arbeitnehmer zu besonderen Maßnahmen. Diese Hamburger Sekretärin hat ihren Arbeitsplatz kurzerhand auf das Dach des Kontorhauses verlegt.

Les températures estivales extrêmes de 1955 amènent les salariés allemands à prendre des mesures exceptionnelles. Cette secrétaire de Hambourg n'a pas hésité à transférer son poste de travail sur le toit de l'immeuble de l'entreprise qui l'emploie.

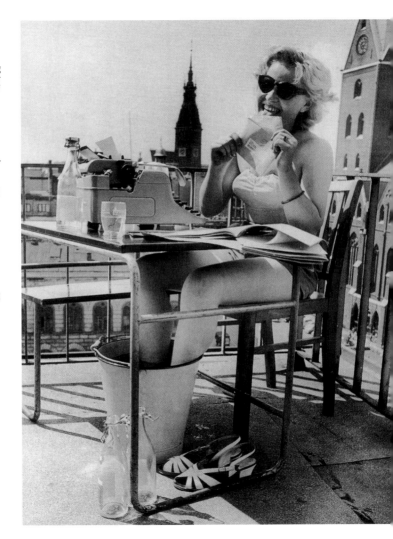

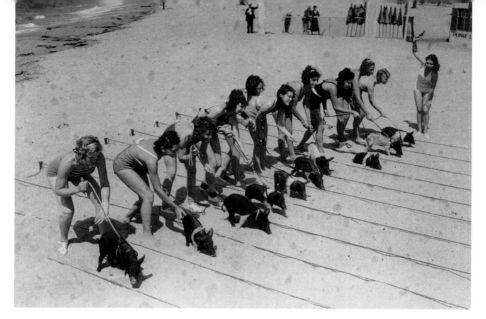

This American shot depicts Californian beach life in the 1950s. Oscar, the third pig from the left, is pictured winning the Venice Beach "Grunt Derby" by a snout. The pigs could only be motivated to take part by threatening them with a trip to the sausage works.

Diese amerikanische Aufnahme aus den fünfziger Jahren zeigt das Strandleben in Kalifornien. Oscar, das dritte Schwein von links, gewinnt das »Grunz-Derby« in Venice Beach. Die Schweine konnten nur durch die Drohung, bei Verweigerung in der Wurstfabrik zu landen, zur Teilnahme bewegt werden.

Cette photo prise aux Etats-Unis dans les années 50 montre comment on se distrait sur les plages californiennes. Oscar, le troisième cochon en partant de la gauche, gagne le « derby du grognement », à Venice Beach. On incita les porcs à disputer l'épreuve en les menaçant de les envoyer dans une fabrique de saucisses.

This picture taken in the English resort of Scarborough centers on the corpulence of this holidaymaker. The problem in 1950s' England was no longer the rumbling of hungry stomachs, but sensible eating in face of the temptations posed by the sudden surplus of food.

Die Leibesfülle einer englischen Urlauberin in Scarborough steht im Mittelpunkt dieses Bildes. In den fünfziger Jahren besteht in England das Problem nicht mehr darin, den knurrenden Magen zum Schweigen zu bringen, sondern es geht eher darum, sich angesichts des plötzlichen Überangebots an Lebensmitteln sinnvoll zu ernähren.

L'obésité de cette Anglaise, en vacances à Scarborough, est le sujet de cette photo. Dans l'Angleterre des années 50, il ne s'agit plus de calmer la faim des habitants, mais de leur apprendre à se nourrir judicieusement compte tenu de la surabondance soudaine de denrées alimentaires.

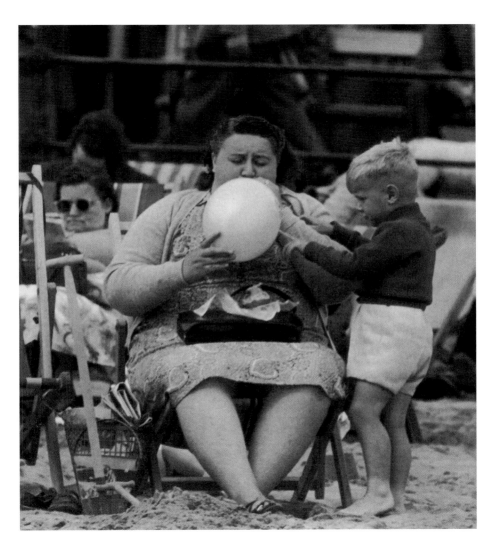

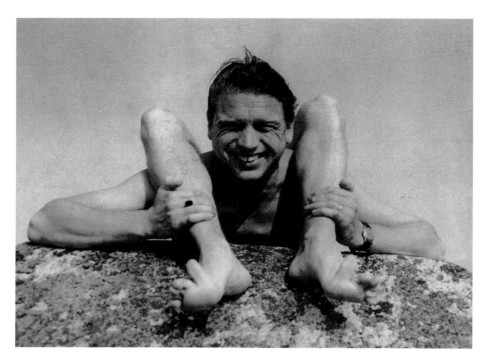

Swedish holidaymakers demonstrating optical illusions on
the skerries north of Gothenburg. In the so-called "people's
haven" – the post-1945 Swedish welfare state – employees'
right to leisure time was given its due place.

Schwedische Urlauber demonstrieren in den fünfziger
Jahren optische Täuschungen auf den Schären nördlich
von Göteborg. Im sogenannten »Volksheim«, dem schwedi-
schen Wohlfahrtsstaat nach 1945, nimmt das Recht des
Arbeitnehmers auf Freizeit den ihm gebührenden Platz ein.

Illusion d'optique sur un îlot rocheux proche de Göteborg,
en Suède, dans les années 50. Après 1945, dans l'Etat-
providence suédois qu'on appelle à l'époque le « foyer
populaire », le droit des salariés aux loisirs est respecté par
l'Etat.

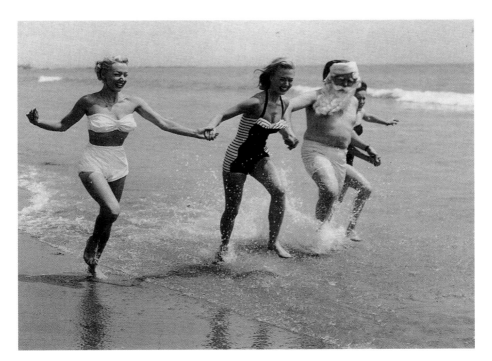

"Santa Claus recuperates from the Christmas ballyhoo
on a beach in California." This 1950s caption alludes to
the fact that Christmas more than any other season is
the climax of advertising and retail sales in the USA.

»Santa Claus erholt sich an einem kalifornischen
Strand vom Weihnachtstrubel.« Diese Bildzeile aus
den fünfziger Jahren spielt darauf an, daß Konsum
und Werbung in den USA gerade zur Weihnachtszeit
Hochkonjunktur haben.

« Santa Claus se repose de la frénésie de Noël
sur une plage de Californie. » Cette légende des
années 50 est une allusion au fait que, aux Etats-Unis,
la consommation et la publicité atteignent leur
paroxysme à l'époque de Noël.

On the beach at Atlantic City, New Jersey, one American takes shelter from the scorching sun and baking temperatures of more than 99 °F (37 °C), in September 1961. For many, who were only waiting for the city's casino doors to open, the heat of the day was pure torture.

Am Strand von Atlantic City (New Jersey) flieht ein Amerikaner im September 1961 vor den Sonnenstrahlen und Temperaturen von über 37 °C. Für viele, die nur auf die Öffnung der Casinos im Spielerparadies Atlantic City warten, wird die Hitze des Tages zur Qual.

En septembre 1961, sur la plage d'Atlantic City, dans le New Jersey, un Américain se protège à sa façon du soleil torride et de la chaleur accablante : il fait plus de 37 °C. Pour beaucoup qui n'attendent que l'ouverture du casino d'Atlantic City, un paradis du jeu, la canicule est insupportable.

In 1965, on Corsica, an inventive French swimming teacher from Lyon demonstrated an apparatus for beginners great and small. It was not, however, a serious competitor to the most popular aid for would-be swimmers, namely inflatable water wings.

Ein findiger französischer Schwimmlehrer aus Lyon präsentiert 1965 auf Korsika einen Lernapparat für kleine und große Anfänger. Das Gerät ist jedoch kein ernsthafter Konkurrent für das beliebteste Hilfsmittel der ersten Versuche im Wasser – die aufblasbaren Schwimmflügel.

Un astucieux maître nageur français de Lyon présente, en 1965, sur une plage de Corse, un appareil qui permet à petits et grands d'apprendre à nager. Néanmoins, cet appareil ne concurrencera pas sérieusement la bouée gonflable passée autour des bras.

Music in the air

Musik liegt in der Luft

La musique est dans l'air

Photographers are usually present in such numbers at musical occasions that it is impossible to get any exciting pictures of the performers themselves. Young stars enjoy appearing before the camera, though, and amateur musicians also offer the photoreporter considerable scope. At the start of the 20th century, musical culture meant active music-making. Whether at home or at the piano in the bar, in a chamber orchestra or accompanying a silent movie – people either played instruments themselves, or listened to them being played live. However, the 1920s saw the start of intensive saturation with second-hand productions. The phonograph and radio delivered canned music, which increasingly replaced amateur performances. People only picked up an instrument themselves if they were seeking a musical career, or if they played in clubs or amateur ensembles. Otherwise, one could say, almost literally, music was in (or on) the air.

Das Gedränge der Fotografen bei Musikveranstaltungen ist zumeist so groß, daß es unmöglich ist, ein spannendes Bild von den Hauptakteuren zu machen. Die kleinen Stars hingegen produzieren sich gerne vor der Kamera und auch das Spiel der Hobbymusiker bietet dem Fotoreporter eine Unzahl von Motiven. Musikkultur bedeutet zu Beginn des 20. Jahrhunderts aktives Musizieren. Ob Hausmusik oder Barpiano, Salonorchester oder Stummfilmbegleitung – die Menschen machen selbst Musik oder erleben sie vor Ort. In den zwanziger Jahren jedoch beginnt die intensive Berieselung der Hörer: Grammophon und Radio liefern Musik aus der Konserve und verdrängen die Laienmusik. Die Menschen greifen nur noch selbst zum Instrument, wenn sie eine musikalische Karriere anstreben oder in Vereinen und Laienensembles gemeinsam mit anderen musizieren. Ansonsten heißt es: *Musik liegt in der Luft.*

Les photographes sont souvent si nombreux aux soirées musicales qu'il leur est impossible de prendre une photo originale des acteurs principaux. Les vedettes en herbe posent devant l'objectif et les prestations des musiciens amateurs offrent aux photographes une multitude de motifs. Au début du XXe siècle, apprécier la musique, c'est en jouer soi-même – que ce soit chez soi ou dans un piano-bar, au sein d'un orchestre de salon ou pour accompagner un film muet – les gens font eux-mêmes de la musique ou la vivent sur place. Dans les années 20, pourtant, les auditeurs commencent à avoir l'embarras du choix : phonographes et radios leur permettent d'écouter la musique par les ondes et éclipsent la musique des amateurs. L'homme ne prend plus lui-même un instrument en main que lorsqu'il aspire à faire une carrière musicale ou pour jouer de la musique au sein d'associations ou d'ensembles d'amateurs. Pour le reste, la devise est : *La musique est dans l'air.*

36-year-old Austrian-born Freddie Harrison presented himself to photographers at London's Windmill Theatre in 1952 with a somersault at the piano. He came from an old performing family, and his act combined acrobatics and music.

Mit einem Salto vom Piano stellt sich der gebürtige Österreicher Freddie Harrison 1952 den Fotografen im Windmill Theatre in London. Der 36jährige stammt aus einer alten Artistenfamilie und verbindet in seinen Darbietungen Akrobatik und Musik.

En 1952, Freddie Harrison, d'origine autrichienne, exécute devant les photographes, au Théâtre Windmill de Londres, un superbe salto au piano. Âgé de 36 ans, il est issu d'une vieille famille d'artistes et, dans ses représentations, il associe acrobaties et musique.

The American dance craze, the Charleston, named after the town in South Carolina, took the world by storm in the 1920s, but in 1926 it provoked critical voices in the medical profession. This skeleton is being used to demonstrate the deleterious effects of the "dislocations" required by the dance.

Der amerikanische Modetanz Charleston, benannt nach der gleichnamigen Stadt in South Carolina, tritt in den zwanziger Jahren seinen weltweiten Siegeszug an. Doch 1926 ruft er kritische Ärzte auf den Plan, die anhand dieser Demonstration die gesundheitsschädliche Wirkung der »Verrenkungen« nachweisen wollen.

Le charleston, danse américaine à la mode qui doit son nom à une ville de Caroline du Sud, part à la conquête du monde dans les années 20. En 1926, cette danse provoque l'entrée en lice de médecins critiques qui, à l'aide de cette démonstration, veulent prouver que de telles « contorsions » sont préjudiciables à la santé.

Professor Burt from Jamestown outdid even himself on 8 September 1926. He held the world duration record for piano playing, and broke his own record of 52 hours by a further 480 minutes – without eating, drinking or sleeping. The photograph shows him five minutes before the marathon ended.

Professor Burt aus Jamestown übertrifft sich am 8. September 1926 selbst. Er hält den Weltrekord im Dauerklavierspielen und hat seine einstige Rekordmarke von 52 Stunden noch um 480 Minuten überboten, ohne zu schlafen, zu essen oder zu trinken. Das Foto zeigt Burt fünf Minuten vor Ende seiner Aktion.

Le 8 septembre 1926, le professeur Burt, de Jamestown, se surpasse lui-même. Il détient déjà le record du monde d'endurance au piano et bat de 480 minutes son propre record qui était de 52 heures sans dormir, sans boire ni manger. La photo montre Burt cinq minutes avant la fin de son exploit.

After a strenuous concert season, violinist Mellie Dunham, who had already performed for automobile magnate Henry Ford, is seen relaxing in the bosom of his family in his home town of Norway, Maine, in 1926. The oversize violin above the door was a gift from an admirer.

Nach einer anstrengenden Konzertsaison erholt sich der Geiger Mellie Dunham, der bereits für den Automobilmagnaten Henry Ford aufspielte, 1926 im Kreise der Familie in seinem Heimatort Norway im US-Bundesstaat Maine. Die überdimensionale Geige über seiner Haustür ist ein Geschenk eines Bewunderers.

En 1926, après une saison de concerts très harassante, le violoniste Mellie Dunham, qui a même joué pour le magnat de l'automobile Henry Ford, se repose parmi les siens à Norway, sa ville natale, dans l'Etat fédéré américain du Maine. Le violon surdimensionné au-dessus de la porte d'entrée de son domicile est le cadeau d'un admirateur.

When Germany joined the League of Nations in 1926, German composer and conductor Dr Erich Fischer composed an anthem for the supranational organization, to which many countries belonged between 1920 and 1946. Fischer planned to conduct the performance "from afar" – that is to say, from Zurich, while the four orchestras involved would be in Berlin, London, Paris and Milan.

Der deutsche Komponist und Dirigent Dr. Erich Fischer komponiert nach dem Beitritt Deutschlands im Jahre 1926 eine Hymne für den Völkerbund, der von 1920 bis 1946 viele Nationen zu einer Weltorganisation vereinte. Fischer plant für die Aufführung eine »Ferndirigierung« vier verschiedener Orchester in Berlin, London, Paris und Mailand von Zürich aus.

En 1926, le compositeur et chef d'orchestre allemand Dr Erich Fischer compose un hymne pour la Société des Nations, après l'admission de l'Allemagne dans cette organisation mondiale, qui, de 1920 à 1946, regroupa de nombreux pays. Pour exécuter cet hymne depuis Zurich, Fischer prévoit la « direction à distance » de quatre orchestres se trouvant respectivement à Berlin, Londres, Paris et Milan.

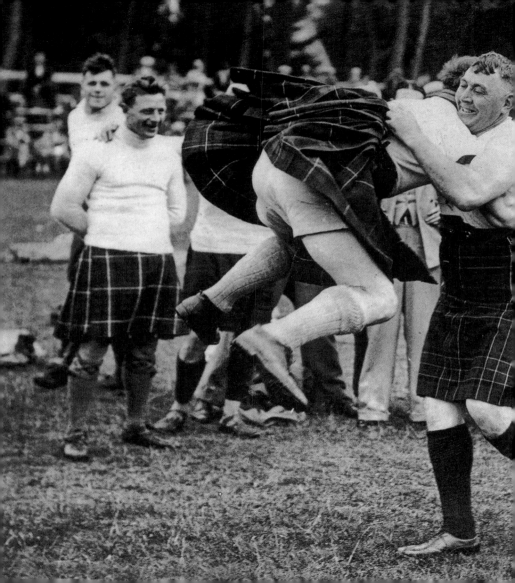

The Highland Games in the Scottish town of Aboyne have been held since time immemorial, to keep alive the Scots cultural heritage. The 1929 Games have been preserved for us in this picture; however, the original German caption "Scottish highlanders dancing" can only reflect a deliberate misunderstanding on the part of the author.

Bei den schottischen Highland Games in Aboyne wird von jeher die Kultur des Landes gepflegt. Die Spiele von 1929 sind mit diesem Bild überliefert, wobei der ursprüngliche deutsche Bildkommentar »schottische Hochländer beim Tanz« nur auf einer bewußten Fehleinschätzung des Autors beruhen kann.

Les jeux des Highlands écossais, à Aboyne, perpétuent depuis toujours la tradition du pays. Les jeux de 1929 passent à la postérité grâce à cette photo, dont la légende initiale en allemand, ne peut être qu'une interprétation volontairement erronée des choses : « Au bal des Highlanders écossais. »

This 1930s' photo, entitled "The Musical Fish" is more likely to be an
April Fool's Day joke. New York tuba player Louis Katzman claimed
to have proved, with this concert in an aquarium, that fish can hear.
"After the first few notes, all the fish turned their heads to
Katzman."

Die Aufnahme mit dem Titel »Die musikalischen Fische« aus den
dreißiger Jahren kommt eher als Aprilscherz daher. Der New Yorker
Tubaspieler Louis Katzman behauptet, mit diesem Konzert in einem
Aquarium bewiesen zu haben, daß Fische hören können: »Nach den
ersten Tönen wandten sämtliche Fische ihren Kopf Katzman zu.«

La photo des « Poissons Musiciens », datant des années 30, fait
plutôt penser à un poisson d'avril. Louis Katzman, tubiste
new-yorkais, croit nous avoir apporté la preuve par ce concert
que les poissons peuvent entendre: « Aux premières notes, tous
les poissons tournèrent la tête vers lui. »

The pianist had previously only accompanied the silent movies from the wings, but the triumphal march of the "talkies" in the 1920s placed him center stage. This shot of a film set in Berlin shows the lead actor playing a grand piano.

Der Siegeszug des Tonfilms in den zwanziger Jahren rückt den Klavierspieler, der zuvor nur die laufenden Bilder aus den Kulissen begleitet hat, selbst in den Mittelpunkt einer Geschichte. Hier werden in Berlin Filmaufnahmen gemacht, bei denen der Hauptdarsteller am Flügel musiziert.

Le triomphe du film parlant, dans les années 20, place le joueur de piano, qui avait, jusque-là, simplement accompagné depuis les coulisses les images qui défilaient, au centre d'une histoire. Sur notre photo, le tournage d'un film à Berlin, dans lequel le personnage principal joue du piano.

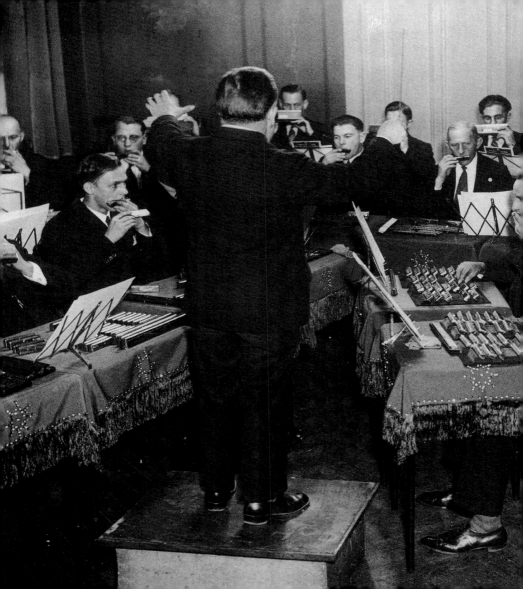

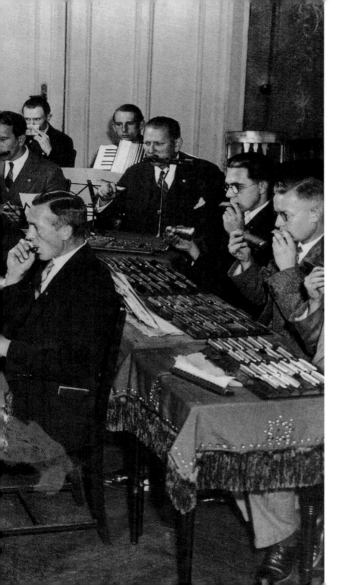

Conductor Arthur Marquard is seen here with the Berlin Mouth Organ Orchestra, part of an attempt to give the folksy instrument a more highbrow image. This concert, in 1932, shows that the members of the orchestra had up to 40 instruments each to play, sometimes in quick succession.

Der Dirigent Arthur Marquard, der das Berliner Mundharmonika-Orchester leitet, versucht, dem volkstümlichen Instrument höhere künstlerische Weihen zu verleihen. Diese Aufnahme aus dem Jahre 1932 zeigt das Orchester, dessen einzelne Musiker im Laufe des Konzerts bis zu 40 verschiedene Mundharmonikas spielen.

Arthur Marquard dirige l'orchestre d'harmonicas de Berlin et tente d'amener cet instrument populaire à une consécration artistique. Ce concert datant de 1932 présente l'orchestre, dont les différents musiciens peuvent jouer de plusieurs harmonicas – jusqu'à 40 – l'un après l'autre.

The 1938 Radio Exhibition at London's Olympia showed the latest achievements in the field both of the wireless and of television – and this "at amazing prices." One of the exhibits is seen here providing two charwomen with music while they work.

Die Radioausstellung im Londoner Olympia 1938 zeigt die neuesten Errungenschaften auf den Gebieten der Audio- und Television und dies »erstaunlichen Preisen«. Die beiden abgebildeten Putzfrauen steigern ihre Arbeitslaune durch die Klänge eines Ausstellungsstückes.

L'Exposition de la Radio qui a lieu en 1938 à l'Olympia de Londres présente les toutes nouvelles inventions dans les domaines de l'audiovisuel et de la télévision, et ce à des « prix étonnants ». Cet appareil exposé donne du cœur à l'ouvrage aux deux femmes de ménage photographiées ici.

The tradition of the British military band and its competitions is long and glorious. This bass drummer is taking part in a race at an army Sports Day in Chelsea, being held in honor of the Duke of York.

Die Tradition der britischen Militärkapellen und ihrer Wettbewerbe ist lang und ruhmreich. Dieser Paukenschläger nimmt in den dreißiger Jahren an einem Rennen im Rahmen eines Militärsportfests in Chelsea teil, das zu Ehren des Herzogs von York veranstaltet wird.

La musique militaire britannique et ses concours s'appuient sur une longue et glorieuse tradition. Ce tambour participe à une course dans les années 30, dans le cadre d'une fête sportive militaire organisée à Chelsea en l'honneur du Duc de York.

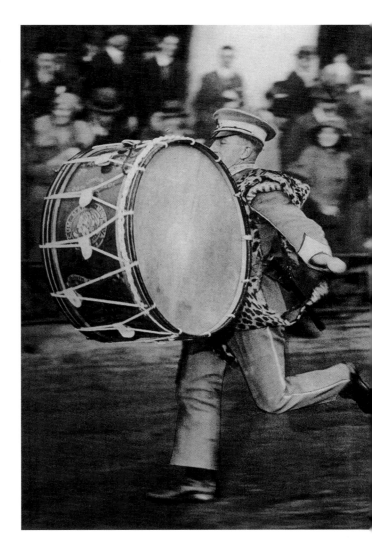

Music in the air

In 1948, Miss Armitage's cocker spaniel provides a scale against which to measure the dimensions of the miniature instruments she produced. A New Yorker, she made a business of her passion for meticulous miniature copies of original instruments, for example this melodeon in walnut, and was worth an article in the American local press.

Der Cockerspaniel von Miss Armitage verdeutlicht 1948 die Dimensionen der von ihr hergestellten Miniaturinstrumente. Die Dame aus New York hat aus ihrer Leidenschaft für originalgetreue Miniaturen, wie zum Beispiel dieses Harmonium aus Walnußholz, ein Geschäft gemacht und ist der amerikanischen Lokalpresse einen Artikel wert.

En 1948, le cocker de Miss Armitage met en exergue le format réduit de la production d'instruments miniatures de sa maîtresse. Cette dame originaire de New York se passionne pour les miniatures fidèles à l'original, tel cet harmonium en bois de noyer, et en fait commerce. La presse locale américaine lui a même consacré un article.

The television concert given by these springer spaniels under their feline conductor on 12 July 1938 was probably not enjoyed by many British viewers at the time. The BBC's television service was on air for only a few hours each week, and television sets were almost unaffordable.

Das Fernsehkonzert dieser Springerspaniels, dirigiert von einer Katze, haben am 12. Juli 1938 sicherlich nur wenige englische Zuschauer am Bildschirm und im Originalton verfolgt. Das britische Fernsehen sendet nur wenige Stunden in der Woche, und die Empfangsgeräte sind beinahe unerschwinglich.

Très peu de téléspectateurs anglais problablement ont vu et entendu le concert télévisé de ces épagneuls, dirigé par un chat et diffusé le 12 juillet 1938. En effet, la télévision britannique n'émet que quelques heures par semaine et les appareils récepteurs sont pratiquement hors de prix.

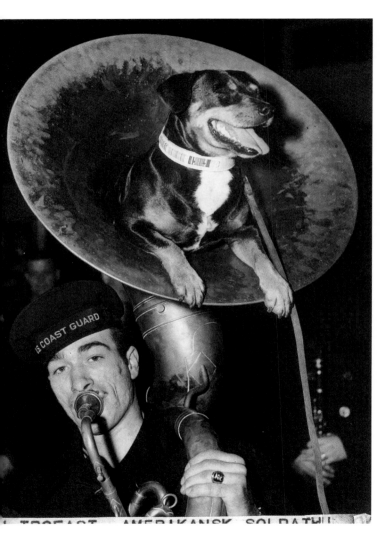

Second World War veterans on their homecoming to New York in 1946. Sinbad, the mascot of a U.S. Coastguard vessel, had been at sea for eight years, during which he had covered more than a million nautical miles. Here he is residing in the tuba of seaman Stefano Condatore at the reception in Manhattan.

Veteranen des Zweiten Weltkriegs kehren 1946 heim nach New York. Sindbad, das Maskottchen eines Boots der amerikanischen Küstenwache, war acht Jahre auf See und blickt auf über eine Million Seemeilen zurück. Hier thront er in der Tuba des Seebären Stefano Condatore beim Empfang in Manhattan.

En 1946, des vétérans de la Seconde Guerre mondiale rentrent chez eux à New York. Sindbad, la mascotte d'un bateau de garde-côtes américain, a passé huit ans en mer et parcouru plus d'un million de miles marins. Ici, il se tient fièrement dans le tuba du loup de mer Stefano Condatore, lors du débarquement à Manhattan.

On 28 October 1950, 17 brass bands from England, Scotland and Wales met in London's Royal Albert Hall for the finals of a nationwide championship following a series of local and regional heats. The son of the conductor of the Coventry City Band is seen giving the instruments a final check before the performance.

Am 28. Oktober 1950 treffen sich 17 Blaskapellen aus England, Schottland und Wales in der Royal Albert Hall in London. Die nationale Meisterschaft ist der Höhepunkt einer Reihe von regionalen Ausscheidungen. Der Sohn des Kapellmeisters der Coventry City Band prüft vor dem Auftritt noch einmal die Instrumente.

Le 28 octobre 1950, 17 fanfares d'Angleterre, d'Ecosse et du Pays de Galles se réunissent au Royal Albert Hall de Londres. Le championnat national est l'apogée d'une série de qualifications régionales. Le fils du chef de la fanfare de Coventry vérifie encore une fois les instruments avant leur utilisation.

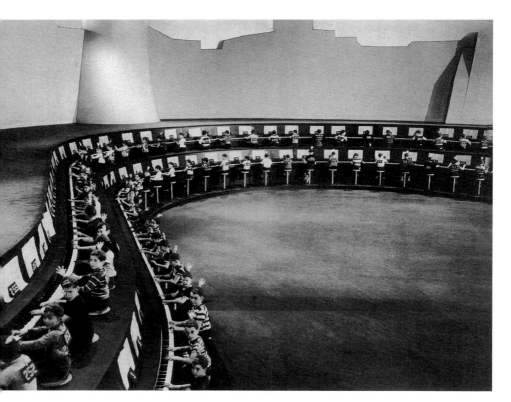

In May 1952, Columbia Studios in Hollywood were being used for the shooting of *The 5000 Fingers of Dr T.* Sitting at this giant piano, 150 children illustrate the nightmare of a 9-year-old pianophobe plagued by the ambitions of his merciless teacher.

In den Columbia Studios in Hollywood finden im Mai 1952 Dreharbeiten zu dem Film *Die 5000 Finger des Dr. T.* statt. 150 Kinder illustrieren an diesem Riesenklavier die Alpträume eines neunjährigen Klavierhassers, den die Ambitionen seines gnadenlosen Klavierlehrers plagen.

Aux studios Columbia de Hollywood, en mai 1952, a lieu le tournage du film *Les 5000 doigts du Dr T.* 150 enfants assis à ce piano géant montrent le cauchemar d'un garçonnet de neuf ans détestant cet instrument et torturé par les ambitions de son impitoyable professeur de musique.

Director Oscar Asche gives his final instructions at the rehearsals for Shakespeare's *Julius Caesar*, in which he also played the part of Casca. The premiere was due to take place at His Majesty's Theatre, London, on 8 February 1952.

Bei den Proben zu Shakespeares *Julius Cäsar* gibt Oscar Asche letzte Regieanweisungen. Er spielt außerdem die Figur des Casca in dieser Inszenierung, die am 8. Februar 1952 im His Majesty's Theatre in London ihre Premiere hat.

Pendant les répétitions de *Jules César*, de Shakespeare, Oscar Asche donne ses dernières indications scéniques. Il joue en outre le personnage de Casca dans cette mise en scène, qui fêtera sa première le 8 février 1952 au His Majesty's Theatre de Londres.

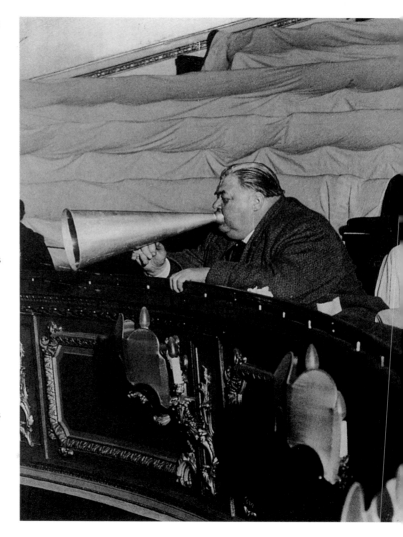

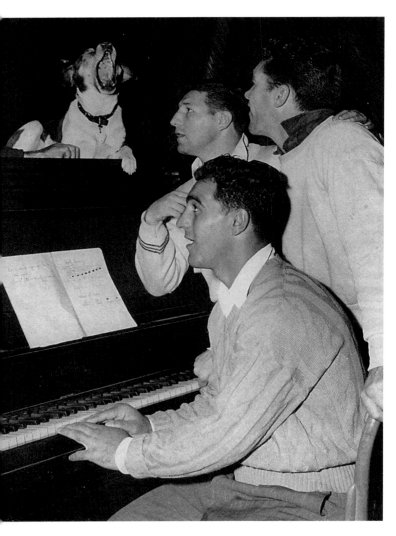

In 1951, American boxer Rocky Marciano tried out his musical abilities. A year later, his victory over Jersey Walcott made him heavyweight champion of the world. Undefeated from then on, he showed himself to be a hard-hitting rather than sophisticated fighter.

Der amerikanische Boxer Rocky Marciano versucht sich 1951 als musischer Schöngeist. Ein Jahr später wird er mit seinem Sieg über Jersey Walcott zum Schwergewichts-Weltmeister, erweist sich jedoch fortan im Ring eher als Schläger denn als Filigrantechniker.

En 1951, le boxer américain Rocky Marciano s'essaie au registre musical. Un an plus tard, sa victoire sur Jersey Walcott lui vaut le titre de champion du monde poids lourds, mais, sur le ring, il se fera désormais plutôt une réputation de puncheur que de technicien filigrane.

With the album *Rubber Soul* in their luggage, the Beatles set off on a European tour in 1965. At the concerts, the pictures were always the same. As here in Paris on 19 June, the four mop-tops sent their female fans into a veritable hysteria. A year later, the pop heroes of the 1960s gave up live concerts for good.

Mit der Langspielplatte *Rubber Soul* im Gepäck gehen die Beatles 1965 auf Europatournee. Wie sich die Bilder ihrer Konzerte gleichen – auch am 19. Juni in Paris versetzen die vier Pilzköpfe ihr weibliches Publikum in Hysterie. Ein Jahr darauf stellen die Pop-Heroen der sechziger Jahre jegliche Live-Auftritte ein.

Leur 33 tours *Rubber Soul* dans leurs bagages, les Beatles entament une tournée européenne en 1965. Et comme partout où ils donnent des concerts – à Paris aussi, le 19 juin – les quatre chevelus déclenchent l'hystérie parmi leur public féminin. Un an plus tard, les stars de la pop des années 60 renoncent à donner des concerts à l'avenir.

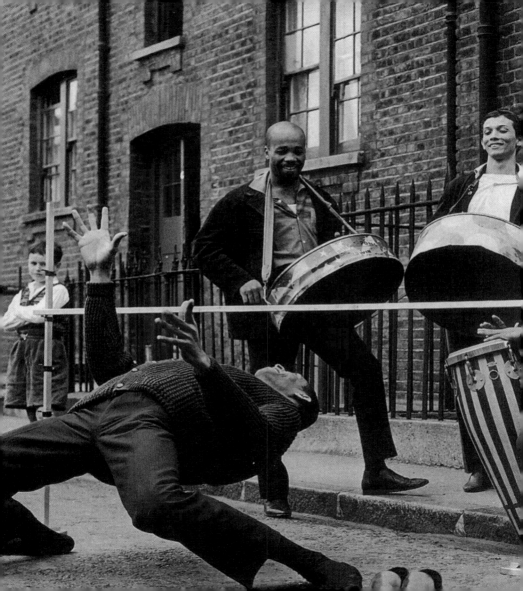

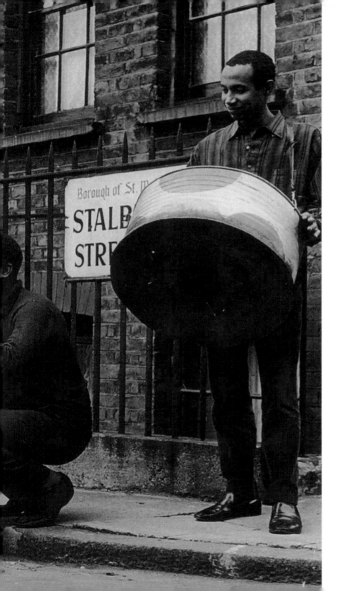

Immigrants from Jamaica or the Bahamas brought their own culture to the mother country of the British Commonwealth. This Caribbean steel band are seen here posing for a photograph in a London street, before taking their show, *Blackbirds of 1964*, on tour around the country.

Einwanderer aus Jamaika oder den Bahamas bringen ihre eigene Kultur mit ins Mutterland des British Commonwealth. Diese karibische Steelband posiert für einen Fotografen in London, bevor sie mit ihrer Show *Blackbirds of 1964* auf Tournee durch die Provinzstädte der Insel geht.

Les émigrés de Jamaïque ou des Bahamas apportent leur propre culture dans la mère patrie du British Commonwealth. Ce steelband des Caraïbes pose à Londres pour un photographe, avant d'entamer avec son spectacle *Blackbirds of 1964* une tournée à travers les villes de province.

Home sweet home

Local reporters are not out and about to document the finer points of interior design, be it art nouveau, art deco or bauhaus. Their editorial task is to track down people in their dwellings and to report on their aspirations or individualities. Even on the local pages we find history in the making. The trophy room of a rich American is the modern variation on the robber baron theme. Other pictures testify that even while traveling, 20th century Man would not go without his own four walls, and seems to be driven by the anthropological constant of building nests and creating retreats wherever he rests.

No matter how hard individuals endeavor to draw a line between themselves and the outside world, the world and its doings do not stop before the front door. The efforts of the industrialized nations to increase their standard of housing can be seen to have been overshadowed by economic crises and the results of two world wars. Nor can there be any doubt that the gap between rich and poor is widening rather than narrowing.

Schöner Wohnen

Lokalreporter sind nicht unterwegs, um die Hohe Schule der Innenarchitektur am Beispiel von Jugendstil, Art déco oder Bauhaus zu dokumentieren. Ihr redaktioneller Auftrag ist es, Menschen in ihrem Zuhause aufzuspüren und über ihre Wünsche oder persönlichen Eigenarten zu berichten. Daneben wird aber auch in der Lokalberichterstattung Geschichte geschrieben. Der Trophäenraum des amerikanischen Großbürgers steht für die moderne Variante des Raubrittertums. Wiederum andere Bilder bezeugen, daß der Mensch im 20. Jahrhundert selbst auf Reisen nicht auf seine eigenen vier Wände verzichten will und von der anthropologischen Konstante getrieben zu sein scheint, sich an allen Aufenthaltsorten Nester zu bauen und Rückzugswinkel zu schaffen.

So sehr das Individuum auch versucht, sich gegen die Außenwelt abzugrenzen, bleibt das Weltgeschehen dennoch nicht draußen vor der Tür. Es zeigt sich, daß die Bemühungen der Industrienationen, den Wohnstandard zu steigern, von wirtschaftlichen Krisen und den Folgen der beiden Weltkriege überschattet werden. Auch kann kein Zweifel daran bestehen, daß sich die Diskrepanz zwischen Arm und Reich eher vergrößert als verkleinert.

Confort de l'habitat

Les reporters locaux ne se déplacent pas pour intéresser le lecteur à la Grande Ecole de l'architecture intérieure à l'exemple du Jugendstil, de l'Art déco ou du Bauhaus. Leur rédaction les a chargés d'interviever les gens à leur domicile et de leur faire raconter leurs désirs ou leurs lubies personnelles. Mais, outre les anecdotes personnelles, les reportages locaux n'en oublient pas pour autant l'histoire. La salle des trophées du millionnaire américain est la variante moderne du pillage des chevaliers. D'autres clichés témoignent que l'homme du xxᵉ siècle ne renonce, pas même en voyage, au confort auquel il est habitué chez lui et qu'il a tendance à se construire un nid douillet quel que soit l'endroit où il se trouve et à se créer son jardin secret personnel.

Autant l'individu s'efforce de se protéger du monde extérieur, autant l'histoire mondiale lui rappelle qu'il ne peut s'y soustraire. Il s'avère que les pays industrialisés sont contrariés par des crises économiques et les conséquences des deux guerres mondiales, dans leurs efforts pour accroître le standard de leur habitat. De même, à n'en pas douter, le fossé entre pauvres et riches a plutôt tendance à se creuser qu'à se combler.

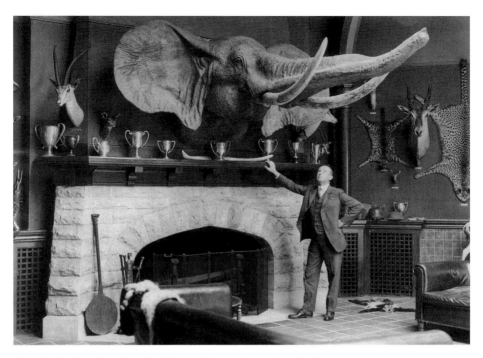

Alfred Collins from Bryn Mawr in Philadelphia has not gone down in the annals of sporting history, but he did make an impression in 1927 when he was photographed in his trophy room at home, surrounded by souvenirs of his big game hunting expeditions from Alaska to Siberia.

In die Annalen der Expeditionsgeschichte ist Alfred Collins aus Bryn Mawr in Philadelphia nicht eingegangen. Als Beispiel für die Wohnkultur amerikanischer Großwildjäger fungiert aber sein Porträt aus dem Jahre 1927 im häuslichen Trophäenraum, in dem er seine Beutezüge von Alaska bis Sibirien auf imposante Weise dokumentiert.

Alfred Collins, de Bryn Mawr, à Philadelphie, n'est pas entré dans les annales de l'histoire des expéditions. Cette photo datant de 1927, prise chez lui dans la salle des trophées documente de manière impressionnante son tableau de chasse de l'Alaska jusqu'à la Sibérie, nous révèle le cadre de vie de certains chasseurs américains de gros gibier.

During the night of 14/15 April 1912, the "unsinkable" *Titanic* struck an iceberg and sank. For her maiden voyage, her owners wanted to set new standards not only of speed and safety, but also of luxury. The pictures show the gymnasium and a first-class cabin. Following the collision, 1500 people drowned or died of exposure.

In der Nacht vom 14. auf den 15. April 1912 rammt die für unsinkbar gehaltene *Titanic* einen Eisberg. Der Luxusdampfer will auf seiner Jungfernfahrt nicht nur in Sachen Sicherheit und Geschwindigkeit, sondern auch hinsichtlich der Ausstattung Maßstäbe setzen: im Bild ein Fitneßraum und ein Schlafraum der 1. Klasse. Das Schiff sinkt nach der Kollision, und 1500 Menschen ertrinken oder erfrieren.

Dans la nuit du 14 au 15 avril 1912, le *Titanic*, que l'on disait insubmersible, heurte un iceberg. Lors de son voyage inaugural, le paquebot de luxe veut définir de nouvelles normes en matière de sécurité, de vitesse et de confort : sur notre photo, une salle de musculation et une couchette de première classe. Le bateau coule après la collision, et 1500 personnes se noient ou meurent de froid.

In the 1920s, furniture manufacturers, such as the American company represented here, looked to extremes of size to attract the attention of customers to their new collections. By contrast, avant-garde furniture design, such as the Bauhaus style in Germany, had few adherents at the time.

Möbelhersteller wie das hier vertretene amerikanische Unternehmen setzen in den zwanziger Jahren auf ein Spiel mit den Größenordnungen, um die Aufmerksamkeit der Käufer auf ihre neue Kollektion zu lenken. Avantgardistisches Möbeldesign wie der Bauhaus-Stil aus Deutschland findet hingegen zu seiner Zeit nur wenige Anhänger.

Dans les années 20, des fabricants de meubles, comme l'entreprise américaine dont on voit quelques modèles ici, jouent avec les échelles de grandeur pour promouvoir leur nouvelle collection auprès d'acheteurs potentiels. Par contre, un design de meubles avant-gardiste tel le style du Bauhaus en Allemagne ne fait que peu d'adeptes à son époque.

The man commissioned to take this 1920s' photograph was required to portray "a typical American family at home." Leisure had become a basic human right; after the war of "important concerns," Americans wanted more private life and less world history.

Der Fotograf dieses Bildes aus den zwanziger Jahren hatte den Auftrag, »eine typisch amerikanische Familie in ihrem Heim« zu porträtieren. Freizeit wird zu einem Grundrecht, denn die Amerikaner fordern nach dem Weltkrieg, der für »bedeutende Anliegen« geführt wurde, mehr Privatleben und weniger Weltgeschichte.

On avait demandé à l'auteur de cette photo datant des années 20 de montrer « une famille américaine typique chez elle ». Les loisirs deviennent un droit fondamental, car, après la guerre mondiale menée au nom « d'intérêts vitaux », les Américains exigent plus de vie privée et moins d'histoire universelle.

The late 19th century saw the establishment in Great Britain of many educational institutions by the voluntary sector. Alongside denominational groups, educational reformers also set up their own schools like this one, for example, which in the 1920s taught children gardening in an attempt to bring them closer to nature.

Ende des 19. Jahrhunderts etablieren sich in Großbritannien viele freie Bildungsanstalten. Neben konfessionell orientierten entstehen auch reformpädagogische Schulen, die zum Beispiel, wie hier in den zwanziger Jahren, Kinder über den Gartenbau in den Umgang mit der Natur einführen.

A la fin du xixᵉ siècle, de nombreux établissements d'enseignement libres ouvrent leurs portes en Grande-Bretagne. Outre des écoles religieuses apparaissent également des centres de pédagogie réformatrice qui, comme ici dans les années 20, apprennent par exemple aux enfants à respecter la nature en les initiant à l'horticulture.

Mr and Mrs Wade from the Mississippi valley set off on a
world tour in the 1920s. When this picture was taken, they
had just arrived in Topeka, Kansas. Their mobile home, made
from the trunk of a 434-year-old fir tree, provided every
possible comfort, including a library.

Mr und Mrs Wade stammen aus dem Mississippi-Tal und
begeben sich in den zwanziger Jahren auf Weltreise. Hier
haben sie gerade Topeka in Kansas erreicht. Ihr mobiles Heim
ist aus dem Stamm einer 434 Jahre alten Tanne gebaut und
bietet jeden erdenklichen Komfort bis hin zur Bibliothek.

M. et Mme Wade sont originaires de la vallée du Mississippi et
entreprennent, dans les années 20, un tour du monde. Ici, ils
viennent d'atteindre Topeka, au Kansas. Leur maison mobile
construite dans le tronc d'un sapin de 434 ans offre tout le
confort imaginable, et comporte même une bibliothèque.

On 22 February 1927, together with his wife, furniture designer
P.T. Frankl introduced his "skyscraper" collection in New York. In his
designs he tried to unite the spirit of the age as expressed in
modern skyscraper architecture with futuristic painting. The
furniture was exhibited in the Art Center on 56th Street.

P.T. Frankl stellt am 22. Februar 1927 in New York gemeinsam mit
seiner Frau seine »Hochhaus«-Kollektion vor. Der Möbeldesigner
versucht, in seinen Entwürfen den Zeitgeist der modernen
Hochhausarchitektur und der futuristischen Malerei zu vereinen.
Ausgestellt werden die Möbel im Kunst-Center in der 56. Straße.

Le 22 février 1927, à New York, P.T. Frankl présente, en compagnie
de son épouse, sa collection « Buildings ». Le designer conçoit
des meubles qui tentent de concilier l'esprit de l'architecture
d'immeubles modernes d'alors et la peinture futuriste. Ses
créations sont exposées au Centre artistique de la 56ᵉ Rue.

The airplane's name *Auf der Weltreise* (Touring the World) is a memory of the better days that the aircraft and its present occupant may have seen. During the Depression, unemployment in Germany often went hand in hand with homelessness. The sub-editor by contrast merely found the photo "curious."

Der Name des Flugzeugs *Auf der Weltreise* kündet noch von besseren Zeiten, die die Maschine und der jetzige Bewohner gesehen haben mögen. Während der Weltwirtschaftskrise ist in Deutschland Arbeitslosigkeit oftmals gleichbedeutend mit Obdachlosigkeit. Der Redakteur des Beitrags findet das Foto hingegen nur »eigenartig«.

Le nom de l'avion *Auf der Weltreise* (Voyage autour du monde) évoque encore les temps meilleurs qu'auraient soi-disant connus la machine et son occupant actuel. En Allemagne, durant la crise économique mondiale, être chômeur signifie aussi le plus souvent être sans logis. Cependant, le rédacteur de l'article trouve la photo simplement « bizarre ».

These German women are making toys at home.
Although wages for homeworkers between the
wars were at the bottom end of the pay scale, many
women saw this as the only possibility of combining
housework with paid employment.

Diese deutschen Frauen stellen in Heimarbeit Spielzeug
her. Obwohl die Löhne für Heimarbeit zwischen den
beiden Weltkriegen am untersten Ende der Lohnskala
stehen, sehen viele Frauen hierin die einzige Möglichkeit,
Erwerbstätigkeit und Hausarbeit miteinander zu
verbinden.

Ces femmes allemandes fabriquent des jouets à domicile.
Bien que, durant l'entre-deux-guerres, la rémunération
du travail à domicile figure tout en bas de l'échelle des
revenus, c'est pour de nombreuses femmes la seule
activité rétribuée, conciliable avec les tâches domestiques.

Summer draws the whole of France to the beach. These bridge players on vacation in 1938 could hardly have given a clearer signal that they did not want to be disturbed. Nonetheless, they provided an unusual subject for the photographer.

Im Sommer strömt ganz Frankreich an den Strand. Diese Bridgespieler könnten im Sommer 1938 an ihrem Urlaubsort jedoch kaum deutlicher signalisieren, daß sie nicht behelligt werden möchten. Dem Fotografen bieten die Individualisten immerhin ein außergewöhnliches Motiv.

En été, la France entière afflue sur les plages. Pourtant, ces joueurs de bridge, photographiés l'été 1938, ne sauraient indiquer plus clairement qu'ils ne souhaitent pas être dérangés sur leur lieu de vacances. Ces individualistes offrent toutefois au photographe un motif pour le moins inhabituel.

Under Emperor Hirohito, who reigned from 1926, Japan became a great power in the Pacific, harking back even more vehemently the traditions of Shinto, much to the consternation of a German sub-editor who wrote: "Even the modern Japanese woman still sleeps on a wooden pillow. Even today, the Japanese do not use European beds."

Unter Kaiser Hirohito (ab 1926) wird Japan zur Großmacht im pazifischen Raum und beruft sich noch vehementer als zuvor auf alte Traditionen des Shintoismus. Dies verwundert den deutschen Redakteur: »Auch die moderne japanische Frau schläft noch auf dem hölzernen Kissen. Man benutzt in Japan noch immer keine europäischen Betten.«

Sous le règne de l'empereur Hirohito (à partir de 1926), le Japon devient une grande puissance du Pacifique et se réclame avec plus de véhémence que jamais des vieilles traditions du shintoïsme. Cela étonne le rédacteur allemand : « Même la femme japonaise moderne utilise encore un repose-tête en bois. Aujourd'hui encore, on ne connaît pas les lits européens au Japon. »

Lillian Harvey seen lolling in an easy chair in the 1928 German film *Du sollst nicht stehlen* (Thou shalt not Steal). In the 1930s, she and Willy Fritsch were the dream couple of German musical cinema. She was the embodiment of the "good comrade." In 1939, she emigrated to the United States.

Lillian Harvey lümmelt sich im UFA-Film *Du sollst nicht stehlen* 1928 in die Polster. Gemeinsam mit Willy Fritsch bildet sie in den dreißiger Jahren das Traumpaar des deutschen Musikfilms und verkörpert den Typ der guten Kameradin. 1939 emigriert sie in die Vereinigten Staaten.

Lillian Harvey lovée dans un fauteuil, dans le film *Du sollst nicht stehlen* (Tu ne voleras point) de l'UFA, de 1928. Elle forme avec Willy Fritsch le couple idéal du film musical allemand des années 30 où elle joue le rôle de la bonne copine. Elle émigre aux Etats-Unis en 1939.

On 27 July 1939, Henderson Stewart, member of parliament for Woldingham, shows his parents the air-raid shelter just built in his garden. In view of Hitler's unconcealed threats of "bombs on England," Great Britain had introduced conscription on 20 April 1939.

Der Parlamentsabgeordnete Henderson Stewart aus Woldingham führt am 27. Juli 1939 seinen Eltern den gerade errichteten Luftabwehrbunker in seinem Garten vor. Aufgrund der offen ausgesprochenen Drohung Hitlers, »Bomben auf Engelland« abzuwerfen, führt Großbritannien am 20. April 1939 die allgemeine Wehrpflicht ein.

Le 27 juillet 1939, le parlementaire Henderson Stewart, de Woldingham, montre à ses parents l'abri qu'il vient de faire construire dans son jardin pour s'y réfugier en cas de bombardements aériens. Hitler menaçant de « bombarder l'Angleterre », la Grande-Bretagne instaure, le 20 avril 1939, le service militaire obligatoire général.

This photo, taken on the border between Sweden and Finland on 14 December 1939, documents the life of refugee Finns fleeing the advance of the Red Army. On 30 November, the Soviets invaded Finland without declaring war, having already set up military bases in the Baltic states.

Dieses am 14. Dezember 1939 an der finnisch-schwedischen Grenze aufgenommene Foto dokumentiert das Lagerleben der Finnen, die vor der Roten Armee fliehen. Diese ist am 30. November ohne Kriegserklärung in Finnland einmarschiert, nachdem die UdSSR zuvor bereits Militärbasen in den baltischen Staaten errichtet hatte.

Cette photo prise le 14 décembre 1939 à la frontière entre la Finlande et la Suède documente la vie dans les camps que mènent les Finlandais fuyant l'Armée rouge. Le 30 novembre, celle-ci a envahi la Finlande sans déclaration de guerre après l'installation par l'URSS de bases militaires dans les Etats baltes.

The Burns family pictured on a trek of more than 1000 miles (1600 kilometers) in 1946. After their grocery store in New Mexico went bust, they tried their luck in San Antonio, Texas. Here, economic prospects had been given a substantial fillip after the establishment of a military base in 1940.

Die Familie Burns begibt sich 1946 auf einen 1600 km langen Treck. Nachdem ihr Gemüseladen in New Mexico Konkurs anmelden mußte, versuchen sie im texanischen San Antonio ihr Glück. Hier nimmt die Wirtschaft seit 1940 mit dem Aufbau eines Militärstützpunktes einen kräftigen Aufschwung.

La famille Burns entreprend en 1946 un périple de 1600 kilomètres. Après la faillite de leur commerce de légumes dans l'Etat du Nouveau Mexique, ils tentent leur chance à San Antonio, au Texas. En effet, depuis 1940, avec la construction d'une base militaire, l'économie y connait un essor vigoureux.

These Polish refugees celebrated their first Thanksgiving in the United States while in transit in New York in 1949. Their baby had been born on the airplane over the Atlantic. The family were intending to proceed to Illinois the next month, where the father was going to work on a farm.

Das erste Erntedankfest in den USA erleben diese polnischen Kriegs-flüchtlinge 1949 auf der Durchreise in New York. Ihr Baby kam auf dem Flug über den Atlantik zur Welt. Im Dezember will die Familie nach Illinois ziehen, wo der Vater auf einer Farm arbeiten wird.

Ces réfugiés de guerre polonais assistent à leur premier Thanksgiving Day aux Etats-Unis en 1949, tandis qu'ils font halte à New York. Leur bébé est venu au monde durant la traversée en avion de l'Atlantique. En décembre, la famille va s'installer en Illinois, où le père doit travailler dans une ferme.

Taking a bubble bath before the eyes of the photographers in Los Angeles, actress Ann Blyth had won the title of "Miss Tinker's Dame 1949." The actual coronation was to take place that October at the congress of the National Association of Inventors.

Durch ihr Schaumbad vor den Augen der Fotografen in Los Angeles gewinnt die Schauspielerin Ann Blyth endgültig den Titel »Traumfrau der Tüftler 1949«. Die Gewinnerin des Titels wird im Oktober auf dem Kongreß der Nationalen Vereinigung der Erfinder gekrönt.

En se glissant dans ce « bain bouillonnant » sous le regard des photographes à Los Angeles, l'actrice Ann Blyth se qualifie définitivement pour l'élection de la « Femme idéale du bricoleur 1949 ». La lauréate sera couronnée en octobre lors du congrès de l'Association nationale des Inventeurs.

The German village of Baumholder in the Palatinate saw big changes after the establishment there of a base for NATO troop maneuvers in the 1950s. "Barns were transformed into more or less elegant bars, in which the Americans stationed locally amused themselves – in every respect." The writer of these lines thus cleverly avoided the word "brothel" – here a peek behind the scenes.

Das deutsche Dorf Baumholder in der Pfalz verändert sich in den fünfziger Jahren nach der Einrichtung eines NATO-Truppenübungsplatzes grundlegend: »Scheunen verwandeln sich in mehr oder weniger elegante Bars, in denen sich die dort stationierten Amerikaner amüsieren – in jeder Hinsicht.« Den Begriff Bordell umschreibt der Autor geschickt – hier ein Blick hinter die Kulissen.

Dans les années 50, le village allemand de Baumholder, dans le Palatinat, se métamorphose après l'aménagement d'un terrain de manœuvre des troupes de l'OTAN : « Des granges se transforment en bars plus ou moins élégants, où les Américains stationnés ici s'amusent – dans tous les sens du terme. » Par une périphrase, l'auteur contourne la notion de bordel – jetons ici un coup d'œil dans les coulisses.

This model attracted some attention at the International Trailer Exhibition in Chicago in February 1949. The upper story with its space for three bedrooms can be entirely lowered into the "ground floor" before taking to the road. This home is mobile, yet still equipped with all the comforts of a standard house.

Auf der internationalen Wohnwagenausstellung im Februar 1949 in Chicago erregt dieses neue Modell Aufsehen. Die obere Etage bietet drei Schlafzimmer und kann vollständig versenkt werden, bevor der Anhänger im Straßenverkehr auf Reisen geht. Diese Behausung ist mobil, bietet aber dennoch den Luxus eines Einfamilienhauses.

Ce nouveau modèle fait sensation lors de l'Exposition internationale de Caravanes, en février 1949 à Chicago. L'étage supérieur qui comporte trois chambres à coucher est intégralement escamotable avant le démarrage du véhicule. Cette maison est mobile, mais offre cependant le luxe d'un pavillon.

Home sweet home

One Berlin furniture store supplemented the window dressing for its latest collection with Prof. Käthe Kruse dolls and, on 13 October 1951, invited the press to come along. The craftswoman herself was present, seen here dusting down her creations for the photographers. There had been a worldwide demand for her dolls since the 1930s on account of their realistic appearance.

Ein Berliner Möbelhaus schmückt seine neue Kollektion im Schaufenster mit Käthe-Kruse-Puppen und lädt die Presse am 13. Oktober 1951 zum Fototermin. Anwesend ist auch die Kunsthandwerkerin Käthe Kruse und entstaubt für die Fotografen ihre Geschöpfe, die aufgrund ihrer Realitätsnähe seit den dreißiger Jahren weltweit begehrte Sammlerstücke sind.

Un marchand de meubles berlinois décore de poupées de Käthe Kruse la vitrine où est présentée sa nouvelle collection que la presse est invitée à découvrir le 13 octobre 1951. Käthe Kruse en personne dépoussière, pour les photographes, ses créatures qui sont, de par leur réalisme saisissant, des objets de collection très prisés dans le monde entier depuis les années 30.

An English news agency came up with this picture as a gesture of reconciliation in 1950 – an insight into the studies of "young German intellectuals." Egon had just finished his latest book, *Goethe for Fourth-Graders*, and was now working on an edition of letters written by famous people in their childhood and youth.

Eine englische Nachrichtenagentur gibt 1950 mit diesem Foto einen versöhnlichen Einblick in die Studierstuben »junger deutscher Intellektueller«. Egon hat gerade sein neuestes Buch, *Goethe für Viertkläßler*, abgeschlossen. Nun arbeitet er an einer Ausgabe, die Kinder- und Jugendbriefe Prominenter vorstellt.

En 1950, avec cette photo, une agence de presse anglaise jette un regard réconciliateur dans les cabinets de travail des « jeunes intellectuels allemands ». Egon vient juste de terminer son livre *Goethe pour les enfants de CM2*. Et il travaille désormais à une édition qui présente des lettres écrites par des personnalités dans leur enfance et leur jeunesse.

In 1947, Great Britain had granted independence to India, with dominion status within the Commonwealth. Britain's colonial past is, however, still reflected in this 1953 photograph. Indian fakirs had their emulators in English living rooms.

1947 gewährt Großbritannien der indischen Kolonie die Unabhängigkeit mit dem Status des Dominion im Commonwealth. Überreste britischer Kolonialgeschichte spiegeln sich allerdings in dieser Aufnahme aus dem Jahre 1953 wider. Indische Fakire finden Nachahmer in englischen Wohnzimmern.

En 1947, la Grande-Bretagne accorde l'indépendance à sa colonie indienne en tant que dominion dans le Commonwealth. Le souvenir de l'histoire coloniale britannique est évoqué cependant par ce cliché datant de 1953. Des fakirs indiens trouvent ici un imitateur dans un salon anglais.

This Swedish motel in Furuvik offered its guests more than just bed and board in June 1958. The nearby wildlife and leisure park was an incentive for guests to linger longer. However, the Swedes had always put their own individual interpretation on the American lifestyle.

Dieses schwedische Motel in Furuvik bietet seinen Gästen im Juni 1958 nicht nur Übernachtungsmöglichkeiten. Der nahegelegene Tier- und Vergnügungspark erhöht die Verweildauer der Gäste. Die amerikanische Lebensweise interpretieren die Schweden von jeher auf ihre eigene Art.

Ce motel suédois, à Furuvik, n'offre pas seulement à ses hôtes, en juin 1958, un logement pour la nuit. Le parc zoologique et d'attraction tout proche amène souvent les clients à prolonger leur séjour. Depuis toujours, les Suédois interprètent à leur manière le style de vie américain.

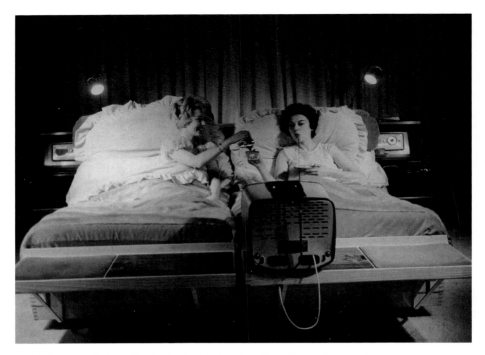

English bed-manufacturer Slumberland celebrated its 40th anniversary in 1959 with this luxury edition. For the sum of 2500 pounds sterling, the customer received not only electrically adjustable interior-sprung mattresses with built-in heating, but also a television, a radio, a telephone, a tea-making machine and a remote control for lights and curtains.

Die englische Bettenfirma Slumberland begeht 1959 mit dieser Luxusversion ihr 40jähriges Jubiläum. Für 2500 englische Pfund erhält der Kunde nicht nur elektrisch verstellbare Sprungfedermatratzen mit eingebauter Heizung, sondern auch einen Fernseher, ein Radio, ein Telefon, eine Teemaschine und eine Fernbedienung für Licht und Vorhänge.

En 1959, l'entreprise de literie anglaise Slumberland fête son 40ᵉ anniversaire avec cette version de luxe. Pour 2500 livres anglaises, le client n'achète pas seulement un sommier à ressorts réglable électriquement avec chauffage intégré, mais aussi un téléviseur, une radio, un téléphone, une théière électrique et une télécommande pour la lumière et les rideaux.

"To delight the hearts of housewives" in whose kitchens space was at a premium, a Californian firm developed this combination in 1953. It won 1st prize at a New York exhibition for multipurpose appliances.

»Um die Herzen der Hausfrauen zu erfreuen«, die nur über wenig Platz in ihrer Küche verfügen, entwickelt 1953 eine kalifornische Firma diese Gerätekombination und gewinnt den 1. Preis auf einer New Yorker Ausstellung für Mehrzweckgeräte.

« Pour réjouir les cœurs des ménagères », qui ne disposent que de peu de place dans leur cuisine, une société californienne invente en 1953 ce combiné universel et remporte le 1er prix lors d'une exposition newyorkaise d'appareils à usages multiples.

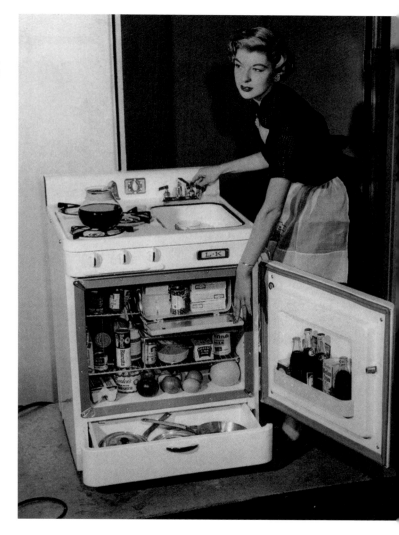

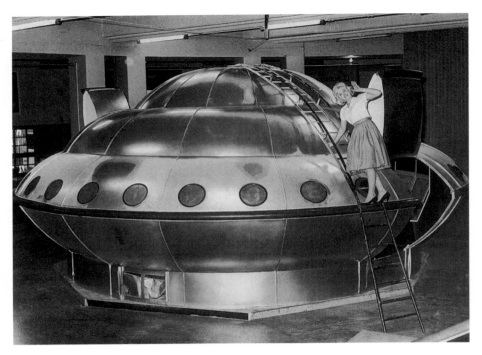

This space capsule or flying saucer attracted the attention of photographers on 2 May 1960 at a London Mechanical Handling Exhibition. It was reserved for foreign visitors, who were to be catered for in, and impressed by, this futuristic atmosphere.

Diese Raumkapsel oder fliegende Untertasse zieht am 2. Mai 1960 beim Pressetermin der Londoner Ausstellung für Mechanische Apparate die Objektive der Fotografen an. Sie ist für Gäste aus dem Ausland reserviert, die in dem futuristischen Ambiente bewirtet und beeindruckt werden sollen.

Le 2 mai 1960, cette capsule spatiale ou soucoupe volante attire les objectifs des photographes lors d'une conférence de presse à l'Exposition des Appareils Mécaniques à Londres. Elle est réservée aux visiteurs étrangers que l'on tient absolument à accueillir chaleureusement et à impressionner par cette ambiance futuriste.

The advice pages of English newspapers featured this picture in
1964, with the tip: "For the night of your party, the room can be full
of scented welcoming air by dabbing a little perfume on the tops of
electric light bulbs... But only a few drops should be used."

Auf den Ratgeberseiten englischer Zeitungen kursiert 1964 dieses
Foto mit dem entsprechenden Hinweis: »Am Abend Ihrer Feier kann
der Raum von einem einladenden Duft erfüllt sein, wenn Sie einige
Tropfen Parfüm auf die Spitze der Glühbirnen tupfen... Es sollten
aber nur wenige Tropfen verwendet werden.«

En 1964, cette photo est reproduite dans les pages de conseils des
journaux anglais avec le commentaire suivant : « Un soir de fête,
pour embaumer la pièce, posez quelques gouttes de ce parfum sur le
haut des ampoules électriques – mais, surtout, n'utilisez que
quelques gouttes. »

These Swedes are using their trailer in the summer of 1966 in order to get an impression of life behind the Iron Curtain, in East Germany. In view of the tense political situation and the Cold War, the caption provided by the socialist news agency must be treated with some skepticism: "Like this Swedish family, tourists from numerous countries spend their holidays at camping sites near the beautifully situated lakes of the GDR capital."

Diese Schweden nutzen ihren Wohnwagen im Sommer 1966, um im Osten Deutschlands hinter die Kulissen des Eisernen Vorhangs zu blicken. In Anbetracht der angespannten politischen Situation des Kalten Krieges ist der Bildkommentar der ostdeutschen Agentur jedoch in Zweifel zu ziehen: »Wie diese schwedische Familie verbringen Touristen aus zahlreichen Ländern ihre Ferien auf Campingplätzen in der Nähe wunderschön gelegener Seen der Hauptstadt der DDR.«

Durant l'été 1966, ces Suédois se rendent en caravane en Allemagne de l'Est pour jeter un coup d'œil de l'autre côté du Rideau de fer. Vu les tensions politiques dues à la Guerre froide, il faut mettre en doute le commentaire de la photo d'une agence est-allemande : « Telle cette famille suédoise, les touristes de nombreux pays passent leurs vacances sur des terrains de camping tout proches des lacs magnifiquement situés de la capitale de la RDA. »

Dr Feelgood

Gesunde Körper

Santé

The American press of the 1920s liked to drag out the words of a housewife who said: "Why do I need a bathtub? I can't drive a bathtub to town." Town was where the modern and emancipated American woman went to do her shopping, and the women's magazines told her what the latest trend dictated she should wear. There was no shortage of advice on the latest developments in cosmetics and bodycare.

These concerns were not reflected only in American newspapers and magazines. If one delves a little further, it will be seen that the concern was more than skin-deep. The advice pages of the Western press worked on their readers' new awareness of their own bodies, and men were not excluded. Cosmetics and medicine were lauded as bringers of happiness. The message was clear. Firstly, good looks and good health could be bought. Secondly, without some physical exercise, the goal was not attainable either by women or by men. The insight: healthy and attractive bodies are always an ideological item.

In der amerikanischen Presse der zwanziger Jahre wird gerne der Satz einer Hausfrau kolportiert: »Wozu brauche ich eine Badewanne, in einer Badewanne kann ich nicht in die Stadt fahren.« Dort geht die moderne und emanzipierte Amerikanerin einkaufen, und in den Frauenillustrierten wird ihr verraten, wie sie sich nach dem letzten Trend zu kleiden hat. Die Redaktionen sparen nicht mit Ratschlägen zu den neuesten Entwicklungen in der Kosmetik und Körperpflege.

Eifert man diesem nicht nur von amerikanischen Illustrierten und Zeitungen vorgezeichneten Bild nach, geht es dabei nicht nur um die Hülle des Menschen. Die westliche Presse arbeitet auf ihren Ratgeberseiten an einem neuen Körperbewußtsein ihrer Leserschaft, das auch die Männer als Zielgruppe nicht ausspart. Kosmetik und Medizin werden zu glückseligmachenden Mitteln hochstilisiert. Die Botschaft ist eindeutig. Erstens: Gutes Aussehen und Gesundheit kann man kaufen. Zweitens: Ganz ohne körperliche Bewegung werden Mann und Frau das Ziel jedoch nicht erreichen. Die Erkenntnis lautet: Gesunde und schöne Körper sind immer auch ein Stück Ideologie.

La presse américaine des années 20 se fait volontiers l'écho de la déclaration d'une ménagère : « A quoi bon posséder une baignoire ; ce n'est pas avec une baignoire que je peux aller en ville. » C'est là que l'Américaine moderne et émancipée va faire ses courses et, dans les journaux féminins qu'elle achète, on lui révèle comment s'habiller pour être à la dernière mode. Les rédactions multiplient les conseils d'utilisation des cosmétiques et des produits pour les soins corporels.

Il faut être à l'image de ce que les illustrés et journaux américains ne sont pas les seuls à propager. Toutefois l'aspect extérieur de l'homme moderne n'est qu'un aspect des choses. Sur ces pages conseils, la presse occidentale fait prendre conscience aux lecteurs – aux hommes aussi – de leur corps. Les cosmétiques et la médecine ont la capacité et les moyens de rendre heureux. Le message est clair. Premièrement : un physique agréable et une bonne santé peuvent s'acheter. Deuxièmement : ni l'homme ni la femme n'atteint cet objectif sans un minimum d'activité physique. Conclusion : des corps sains et beaux resteront toujours le reflet partiel d'une idéologie.

Was it the heat wave in the summer of 1947 in Baltimore, or was it the photographer, that persuaded children's nurse Virginia McCormick of St Agnes' Hospital to employ this unusual form of nursing care? In any case, the quadruplets are visibly unimpressed.

Ist es die Hitzewelle in Baltimore im Sommer 1947 oder der Fotograf, der die Kinderkrankenschwester Virginia McCormick im St.-Agnes-Hospital zu ungewöhnlichen Pflegemaßnahmen verleitet? Die Vierlinge lassen die Berieselung unbeteiligt über sich ergehen.

Est-ce la canicule régnant à Baltimore durant l'été 1947 ou le photographe qui incite l'infirmière en pédiatrie Virginia McCormick à prodiguer des soins inhabituels à l'hôpital St. Agnes ? Les quadruplés semblent totalement indifférents à l'aspersion.

Dr Feelgood 527

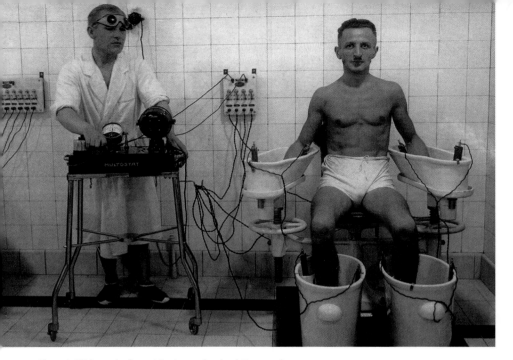

The establishment of municipal spas deprived Germany's health resorts and sanatoriums of their exclusivity. In the 1920s, a spa was opened in Berlin's Lunapark to supplement the existing wave pool. This patient is taking an "electric four-cell bath" to treat ailing joints.

Mit der Einrichtung von städtischen Kurbädern wird in Deutschland den Sanatorien und Heilkurorten die Exklusivität genommen. In den zwanziger Jahren wird im Berliner Lunapark in Ergänzung des Wellenbades ein Kurbad eröffnet. Dieser Patient nimmt ein »elektrisches Vierzellenbad« gegen Gelenkerkrankungen.

Avec la création des stations thermales municipales, les sanatoriums et lieux de cure perdent leur exclusivité en Allemagne. Dans les années 20, une station thermale est inaugurée au Lunapark de Berlin, en complément de la piscine à vagues artificielles. Ce patient prend un « bain électrique à quatre cellules » contre les maladies articulaires.

A "new method of slimming" was promised in the 1920s by this paraffin-wax bath. The middle-class women's movement in particular had promoted a new awareness of body and health since the turn of the century, reinforced by the publication of such books as *Körperkultur des Weibes* (Physical Culture for Women) in 1906.

Eine »neue Methode, um schlank zu werden« verspricht in den zwanziger Jahren der Hersteller dieses Paraffin-Bades. Vor allem die bürgerliche Frauenbewegung pflegt seit der Jahrhundertwende ein neues Gesundheits- und Körperbewußtsein, das durch Bücher wie *Körperkultur des Weibes* (1906) untermauert wird.

Dans les années 20, le bain de paraffine est présenté comme une « nouvelle méthode d'amaigrissement ». Le mouvement de libération de la femme, notamment, prône depuis le début du siècle une nouvelle approche de la santé et du corps qui est étayée par des livres comme *Körperkultur des Weibes* (La culture physique de la femme) en 1906.

In 1895, Wilhelm Röntgen discovered X-rays, known in German as Röntgen-rays. Though dangerous in their side effects due to radio-activity, they revolutionized and continually improved diagnostic procedures in medicine. Here a patient in London in the 1920s is having her mouth X-rayed.

Wilhelm Röntgen entdeckt 1895 die im deutschen Sprachraum nach ihm benannten Röntgenstrahlen. Die medizinische Diagnostik wird durch dieses radio-aktive, nicht ungefährliche Durchleuchtungsverfahren revolutioniert und ständig erweitert. Hier wird in den zwanziger Jahren in London der Mundraum einer Patientin geröntgt.

En 1895, Wilhelm Röntgen découvre les rayons X, qui portent d'ailleurs son nom, dans les pays de langue allemande. Ce procédé radiographique radioactif non sans risques révolutionne et améliore constamment le diagnostic médical. Ici, dans les années 20 à Londres, une patiente se fait radiographier la cavité buccale.

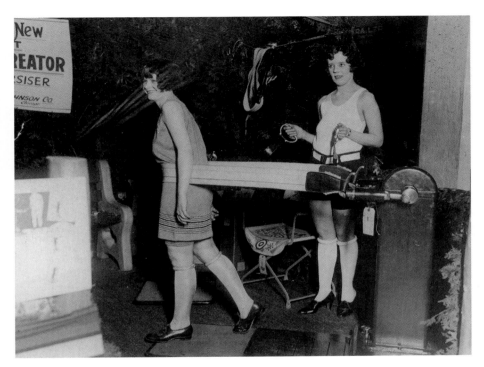

Weight loss without physical effort seems to be an evergreen topic in the advice columns of newspapers. On 12 May 1927, this "recreator" was introduced in Chicago. Mrs Montivedeo is seen trying to reduce her "tummy" while Mrs Smith is awaiting her turn.

Gewichtsabnahme ohne körperliches Training scheint ein ewiges Thema der Ratgeberseiten zu sein. Am 12. Mai 1927 wird dieser »Rekreator« in Chicago vorgestellt. Mrs Montivedeo versucht gerade, ihr »Geschwür« zu reduzieren, während Mrs Smith bereits auf ihren Durchgang wartet.

Perdre du poids sans faire d'exercice physique semble être un thème éternel des pages de conseils. Ce « récréateur » est présenté à Chicago le 12 mai 1927. Mme Montivedeo tente ici de perdre de l'embonpoint, tandis que Mme Smith attend déjà son tour.

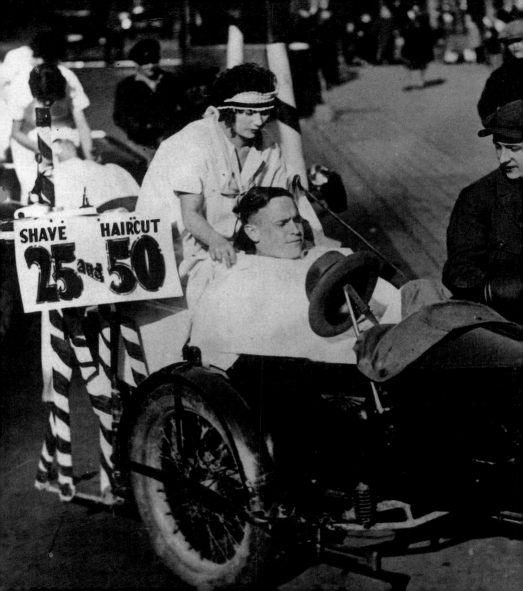

The barber's trade in New York discovered cosmetics for men in the 1920s. These two hair-dressers are offering a shave and a haircut on the street. If custom should slacken on this site, they can simply take their mobile salon elsewhere.

Das Friseurhandwerk in New York entdeckt in den zwanziger Jahren die Männerkosmetik. Diese beiden Friseurinnen bieten Rasur und Haarschnitt direkt auf der Straße an. Sollte der Kundenandrang an diesem Ort nachlassen, nehmen sie einfach mit ihrem fahrenden Salon einen fliegenden Wechsel vor.

Dans les années 20, à New York, les coiffeurs découvrent les cosmétiques pour hommes. Ces deux jeunes femmes proposent rasage et coupe de cheveux directement dans la rue. Si les clients viennent à faire défaut, il leur suffit de replier leur salon de coiffure ambulant et de s'installer ailleurs.

As long ago as 1846, American dentist William Thomas Morton had used ether as a general anesthetic. Technology had since improved to produce the local anesthetic. Around 1930, Viennese doctor Leopold Sofer demonstrated an inhalation technique which, he claimed, "would solve the problem of painless dentistry once and for all."

Bereits 1846 setzt der amerikanische Zahnarzt William Thomas Morton einen Patienten mit Äther unter Vollnarkose. Später wird die Technik bis hin zur örtlichen Betäubung verfeinert. Um 1930 stellt der Wiener Dr. Leopold Sofer ein Inhalationsverfahren vor, das »das Problem der schmerzlosen Zahnbehandlung endgültig« lösen soll.

Dès 1846, le dentiste américain William Thomas Morton utilise de l'éther pour pratiquer une anesthésie générale sur une patiente. Ce n'est que plus tard que cette technique sera améliorée et donnera naissance à l'anesthésie locale. Mais cela n'empêche pas le docteur viennois Leopold Sofer, vers 1930, de présenter un procédé d'inhalation censé être la solution « définitive pour un traitement dentaire sans douleur ».

During the Sino-Japanese war (1937–1945), Tokyo dentist Tadao Sera developed a mobile dentist's chair for the treatment of soldiers at the front. But this medical advance was unable to prevent Japan's defeat in 1945.

Während des Krieges zwischen Japan und China (1937–1945) entwickelt der Tokioter Zahnarzt Tadao Sera einen mobilen Behandlungsstuhl, mit dem er Soldaten an der Front verarzten möchte. Doch diese medizinische Fürsorge kann die Niederlage Japans 1945 nicht verhindern.

Pendant la guerre entre le Japon et la Chine (1937–1945), un dentiste originaire de Tokyo, Tadao Sera, met au point un fauteuil de traitement mobile pour les soldats au front. Pourtant, cette assistance médicale ne peut épargner au Japon la défaite de 1945.

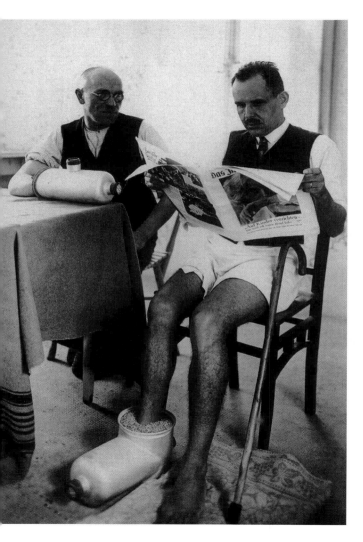

A popular treatment for muscle and joint pains in Germany in 1932 was the hot "partial sand bath." But the two gentlemen seem to be left cold by the headline in the newspaper one of them is reading. "No to children, just because I have a job?" From 1933 such questions would no longer be asked by the conformist Nazi press.

Gliederschmerzen werden 1932 in Deutschland gern mit heißen »Teilsandbädern« behandelt. Kalt hingegen läßt die Herren die Schlagzeile der Illustrierten, die einer der beiden liest: »Auf Kinder verzichten, nur weil ich einen Beruf habe?« In der gleichgeschalteten nationalsozialistischen Presse gibt es ab 1933 derartige Fragen nicht mehr.

En 1932, en Allemagne, on préconise des « bains de sable partiels » pour soigner des membres douloureux. Par contre, la manchette de cet illustré semble laisser de marbre ces deux patients : « Renoncer à avoir des enfants, simplement parce que j'exerce un métier ? » A partir de 1933, la presse mise au pas par les nazis ne posera plus de pareilles questions.

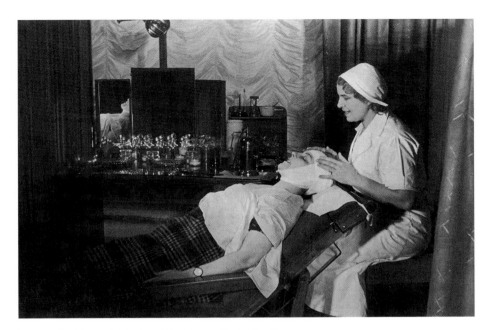

In 1937, a Soviet report introduced the Moscow "Institute of Cosmetics and Hygiene," at which the country's perfumes were tested. Western headlines meanwhile were reporting the "great purge" by which Stalin liquidated all his domestic political enemies between 1936 and 1938.

1937 wird in einer sowjetischen Meldung das »Institut für Kosmetik und Hygiene« in Moskau vorgestellt. Hier werden die Parfümerieprodukte des Landes getestet. Die Schlagzeilen der westlichen Zeitungen berichten jedoch über die »Große Säuberung«, mit der Stalin zwischen 1936 und 1938 alle innenpolitischen Gegner liquidiert.

En 1937, une publicité soviétique est consacrée à l'« Institut de cosmétique et d'hygiène » de Moscou. On teste ici les produits de parfumerie du pays. Mais les manchettes des journaux occidentaux s'intéressent davantage aux purges staliniennes qui se traduisent par l'élimination de tous les opposants au régime entre 1936 et 1938.

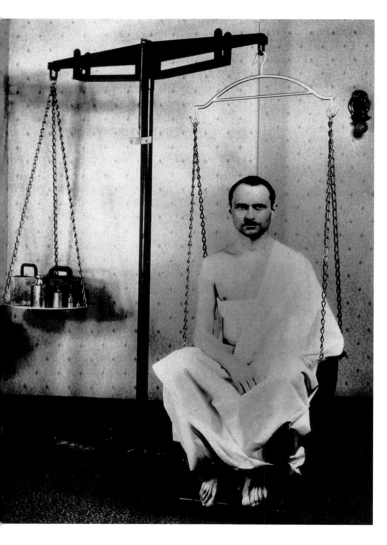

In many religions, fasting has a firm place as a means of giving the body an inner cleansing. In 1933, Alexander Bossiy, a Russian emigrant living in the United States, sought to prove the efficacy of the procedure. Under medical supervision, he fasted for 40 days, walking 10 miles (16 kilometers) each day.

In vielen Religionen ist das Fasten zur inneren Reinigung des Körpers rituell verankert. Den wissenschaftlichen Beweis, daß auf diese Weise das Organsystem entschlackt, will 1933 der russische US-Emigrant Alexander Bossiy antreten. Unter ärztlicher Betreuung fastet er 40 Tage und läuft dabei jeden Tag 16 km.

Le jeûne est un rituel de purification ancré dans de nombreuses religions. Alexander Bossiy, un Russe émigré aux Etats-Unis, veut, en 1933, prouver scientifiquement que l'organisme se purifie de cette façon. Suivi par des médecins, il jeûne durant 40 jours, tout en courant quotidiennement 16 kilomètres.

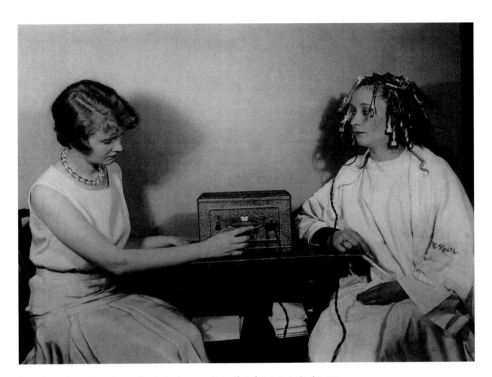

Ever since there have been illustrated magazines, they have run stories on innovations designed to help women win the beauty battle. This 1930s' permanent waving machine was praised as being smaller and lighter than other appliances, and above all for "eliminating the possibility of burning."

Seit es Illustrierte gibt, präsentieren sie Innovationen, die den Kampf um die Schönheit der Damen erleichtern sollen. Diese Dauerwellenmaschine der dreißiger Jahre wird gegenüber anderen Modellen als kleiner und leichter gepriesen, vor allem aber »eliminiert sie die Möglichkeit eines Brandes«.

Depuis que les illustrés existent, ils annoncent des innovations censées aider les femmes à être plus belles. Un exemple : cette machine à permanente des années 30, prisée pour sa taille et son poids réduits par rapport aux autres modèles, mais qui, surtout, « ne brûlent pas les cheveux. »

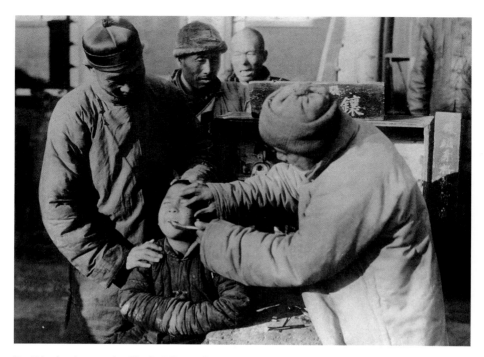

Dentistry has been a scientific discipline in the West only since the turn of the century. In the 1930s, the German press was making fun of Asians, because the Chinese, for example, practiced dentistry publicly in the street. "Still, the use of forceps is an advance; teeth used to be pulled by means of a string."

Die Zahnheilkunde als wissenschaftliche Disziplin gibt es im Westen erst seit der Jahrhundertwende. In den dreißiger Jahren mokiert sich die deutsche Presse über die Asiaten, weil beispielsweise die Chinesen auf offener Straße praktizieren: »Die Zange ist immerhin ein Fortschritt, früher wurden die Zähne mit Hilfe einer Schnur gezogen.«

L'odontologie n'existe à l'Ouest en tant que discipline scientifique que depuis le tournant du siècle. Dans les années 30, la presse allemande se moque des Asiatiques, parce que les Chinois, par exemple, pratiquent en pleine rue : « On dénote tout de même un progrès – l'apparition de la pince. Avant, les dents étaient arrachées à l'aide d'un fil. »

In the 1930s, a French surgeon developed a mobile operating theater, whose benefit was felt first and foremost by the ladies of Paris. Here he is seen practising cosmetic surgery in the patient's living room. The doctor stressed, however, that the equipment was equally useful for emergency surgery.

Ein französischer Chirurg entwickelt in den dreißiger Jahren einen mobilen »Operationssaal«, in dessen Genuß vor allem Pariserinnen kommen. Hier nimmt der Arzt im Wohnzimmer einer Patientin eine Schönheitsoperation vor. Er betont, daß das Instrumentarium auch in Notfällen dienlich sei.

Dans les années 30, un chirurgien français met au point une « salle d'opération » mobile, dont profitent avant tout les Parisiennes. Sur notre photo, le médecin pratique une opération de chirurgie esthétique dans la salle à manger de sa patiente. Il souligne toutefois que son invention est également efficace en cas d'interventions d'urgence.

A French newspaper reported in 1935 on the case of a Californian, George Bocklet, who was turning into a monkey. A doctor is seen here measuring his head, which had allegedly tripled in circumference. The report continued by saying that his arms had grown longer and his gait more bent, while he was also said to be growing a tail.

Eine französische Meldung von 1935 berichtet über den Kalifornier George Bocklet, der sich angeblich in einen Affen verwandelt. Der Arzt vermißt gerade seinen Kopf, der auf das Dreifache des ursprünglichen Umfangs angewachsen sein soll. Weiterhin wird berichtet, daß seine Arme sich verlängerten, sein Gang sich beuge und ihm ein Schwanz wachse.

Un communiqué français datant de 1935 relate l'histoire d'un Californien, George Bocklet, qui s'est soi-disant transformé en singe. Le médecin mesure ici sa tête, qui était, paraît-il, trois fois plus grande à l'origine. Le récit ajoute que ses bras se sont allongés, que son dos s'est courbé et qu'il lui est poussé une queue.

After its discovery in 1905, there was a veritable wave of euphoria about the possibilities of using radium in the treatment of malignant tumors. However, the disastrous results of irradiation suffered by doctors and medical staff led from the mid-1920s onward to wide-ranging safety measures, as seen in this London hospital.

Nach ihrer Entdeckung im Jahre 1905 setzt eine regelrechte Euphorie über die Radium-therapie zur Heilung bösartiger Geschwülste ein. Schwerwiegende radioaktive Verstrah-lungen von Ärzten und Personal führen ab Mitte der zwanziger Jahre zu umfangreichen Schutzbestimmungen, wie in diesem Londoner Krankenhaus.

Après sa découverte en 1905, la thérapie au radium pour soigner les tumeurs malignes déclenche une véritable euphorie. Au milieu des années 20, les irradia-tions radioactives qui ont fait des ravages parmi les médecins et le personnel ont incité à adopter de sévères normes de protection, comme dans cet hôpital londonien.

Dr Feelgood 543

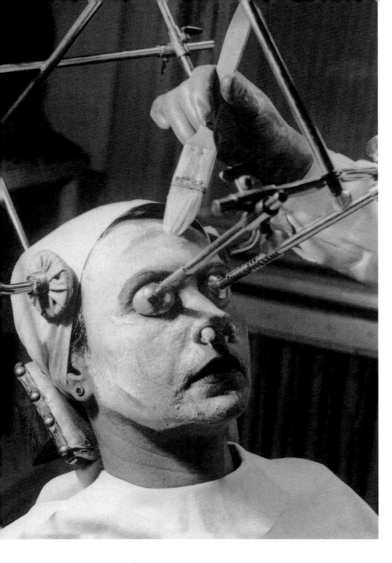

Particularly when they reach that certain age, ladies find freckles a problem. In the 1930s, a cosmetic surgeon in Budapest developed a substance designed to remove these results of exposure to the sun. The apparatus served to keep the patient still and protect the eyes.

Spätestens wenn Damen in die Jahre kommen, werden Sommersprossen zum Problem. In den dreißiger Jahren entwickelt ein kosmetischer Chirurg in Budapest eine Substanz, die den bräunlichen, sonnenbedingten Flecken den Kampf ansagt. Die Apparatur stellt die Patientin ruhig und schützt die Augen.

Au plus tard quand les femmes prennent de l'âge, les taches de rousseur deviennent un problème. Dans les années 30, un chirurgien esthétique met au point une substance qui déclare la guerre aux petites marques brunes provoquées par le soleil. L'équipement immobilise la patiente et protège les yeux.

At the turn of the century, Germany saw the establishment of "Institutes of Physical Culture," where one could practice "resistance gymnastics" using machines. This Berliner is pictured in a head-suspension apparatus in the 1930s. The accompanying caption reads "Hall of machines – corrector of our health."

Anfang des 20. Jahrhunderts entstehen in Deutschland Institute für Körperkultur, in denen »Widerstandsgymnastik« an Maschinen betrieben wird. Das Bild dieses Berliners aus den dreißiger Jahren, der die »Kopfschwebe« erprobt, trägt den Titel: »Eine Maschinenhalle – Korrektor unserer Gesundheit«.

Au début du XXᵉ siècle, en Allemagne apparaissent des instituts de culture physique, où l'on pratique une « gymnastique de résistance » en se servant d'appareils. Cette photo montre un Berlinois des années 30, qui s'essaie au « flottement de tête ». « Une salle des machines – un correcteur sanitaire », selon la légende.

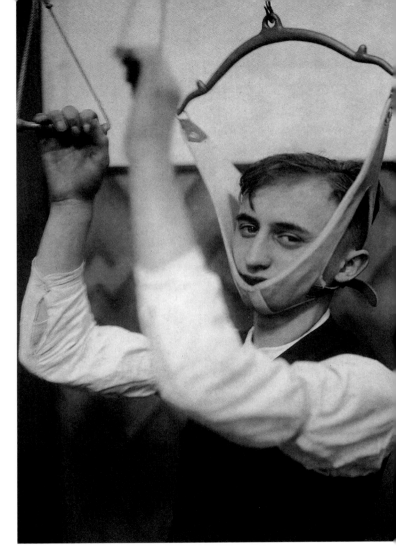

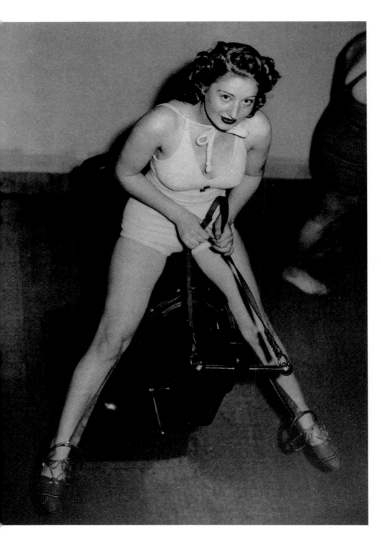

In the 1930s, luxury apartments near London's Marble Arch came complete with a sports and fitness club. Here a tenant is seen riding the "mechanical horse." Under the supervision of a retired army major, the tenants had the use of squash courts, billiard rooms, a swimming pool and an apparatus room for physical training.

Londoner Luxuswohnungen am Marble Arch bieten in den dreißiger Jahren einen Sport- und Fitneßclub. Hier reitet eine Mieterin das »mechanische Pferd«. Unter der Aufsicht eines ehemaligen Majors stehen den Mietern Squash-Hallen, Billardräume, ein Schwimmbecken und ein Geräteraum für die körperliche Ertüchtigung zur Verfügung.

Dans les années 30, un complexe résidentiel de Marble Arch, à Londres, se dote d'un club de sport et de musculation. Ici, une locataire chevauche un « cheval mécanique ». Sous la surveillance d'un ancien major, les locataires ont à leur disposition des salles de squash et de billard, une piscine et une salle d'agrès pour entretenir leur forme physique.

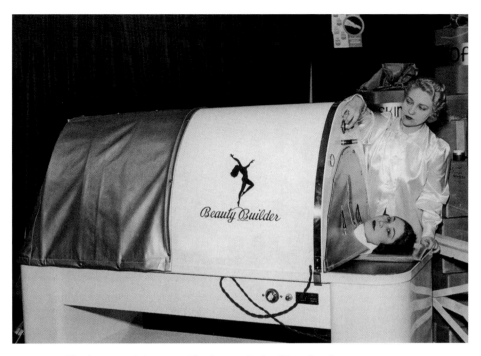

Unimpressed by the Women's Movement, business and advertising placed women in the "sweatbox", such as the "Beauty Builder" pictured here. In the inter-war years, the press published many images of the ideal woman, but these images had little in common with the real worlds of factory girls and housewives.

Unbeeindruckt von der Frauenbewegung nehmen Werbung und Industrie die Frauen in den »Schwitzkasten«, wie zum Beispiel in diesen »Beauty Builder«. Zwischen den beiden Weltkriegen werden in der Presse Idealbilder der Frau propagiert, die weit entfernt sind vom wirklichen Leben der Arbeiterinnen und Hausfrauen.

Indifférentes au mouvement féministe, l'industrie et la publicité donnent des bouffées de chaleur aux femmes, par exemple avec ce « Beauty Builder ». Entre les deux guerres mondiales, la presse diffuse des images de la femme idéale, sans aucun rapport avec la vie réelle des travailleuses et des ménagères.

This 1930s' Berliner is applying heat treatment to his rheumatic knee. Rheumatism was the fashionable complaint of the age – an International Rheumatism League was set up in Paris in 1928. Effective therapy only began with drugs such as cortisone, introduced in 1949.

Dieser Berliner therapiert in den dreißiger Jahren sein rheumatisches Knie mit Wärme. Rheuma gilt zu dieser Zeit als Volkskrankheit, so daß 1928 in Paris eine Internationale Rheumaliga gegründet wird. Eine wirkungsvolle Therapie versprechen jedoch erst Präparate wie Kortison (1949).

Dans les années 30, ce Berlinois rhumatisant soigne son genou à la chaleur. Les rhumatismes sont une maladie très répandue de cette époque, si bien que, dès 1928, la Ligue internationale des Rhumatisants est créée à Paris. Toutefois, seules des préparations comme la cortisone (1949) promettent de réelles chances de guérison.

These English children are being given sun-ray treatment, which was used primarily as a prophylactic and therapeutic measure against tuberculosis. The disease spreads as a result of malnutrition and inadequate hygiene. Its prevalence increased both in Europe and the USA after the First World War.

Diese englischen Kinder werden mit der Höhensonne bestrahlt, um der Tuberkulose vorzubeugen oder sie zu behandeln. Die Krankheit entfaltet sich durch Mangelernährung sowie unzureichende hygienische Verhältnisse und tritt nach dem Ersten Weltkrieg sowohl in Europa als auch in den USA verstärkt auf.

Ces enfants anglais subissent un traitement aux rayons ultraviolets à des fins de prévention ou de traitement de tuberculose. La maladie favorisée par un manque d'hygiène et par des carences alimentaires se propage de plus en plus aussi bien en Europe qu'aux Etats-Unis après la Première Guerre mondiale.

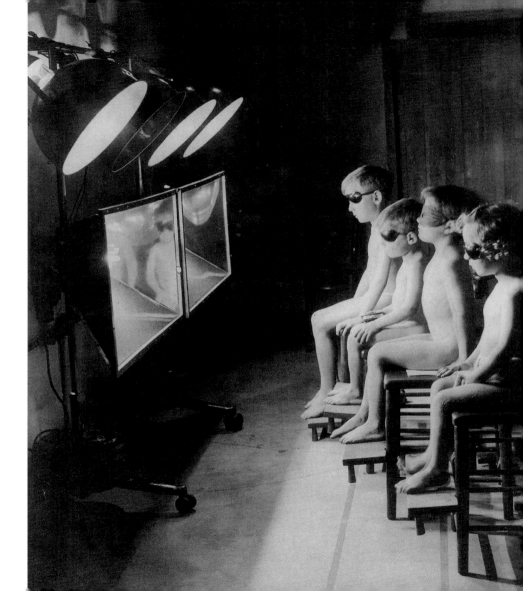

Swedish wrestler Olaf Svenson has his head measured with an anthropometer at the University of Pennsylvania in 1940. The theory of the evolution of human beings and human races took on its most perverted form between 1933 and 1945 in Germany in the National Socialist doctrine of the master race and sub-races.

Mit einem Anthropometer wird 1940 der Kopf des schwedischen Ringers Olaf Svenson an der Universität von Pennsylvania (USA) vermessen. Die Lehre von der Evolution des Menschen und der Menschenrassen findet von 1933 bis 1945 in Deutschland ihre pervertierteste Form in der nationalsozialistischen Rassenlehre vom Herrenmenschen und Untermenschen.

En 1940, un anthropomètre permet de mesurer la tête du lutteur suédois Olaf Svenson, à l'Université de Pennsylvanie (Etats-Unis). La théorie de l'évolution de l'homme et des races humaines trouve son expression la plus pervertie en Allemagne, de 1933 à 1945, dans la doctrine raciale national-socialiste du surhomme et du sous-homme.

During the 1930s in the Crimea, Soviet patients could be seen lying out in the sun encased in mud from the sea bed. Every Soviet citizen had free access to the centralized state health service, and conversely all working people had a duty to the state and to their collectives to preserve and improve their work potential.

In den dreißiger Jahren liegen auf der Insel Krim sowjetische Patienten in Seeschlammbädern in der Sonne. Jedem Sowjetbürger stehen kostenlos die Dienste des zentralisierten Gesundheitswesens zur Verfügung, denn die Werktätigen sind dem Kollektiv und dem Staat gegenüber verpflichtet, ihre Arbeitskraft zu erhalten und zu steigern.

Dans les années 30, sur la presqu'île de Crimée, des patients soviétiques prennent des bains de boue, allongés au soleil. Chaque citoyen soviétique est pris en charge gratuitement par les services de la santé publique centralisée, car la population active est tenue, vis-à-vis de la collectivité et de l'Etat, de préserver et d'accroître son potentiel de travail.

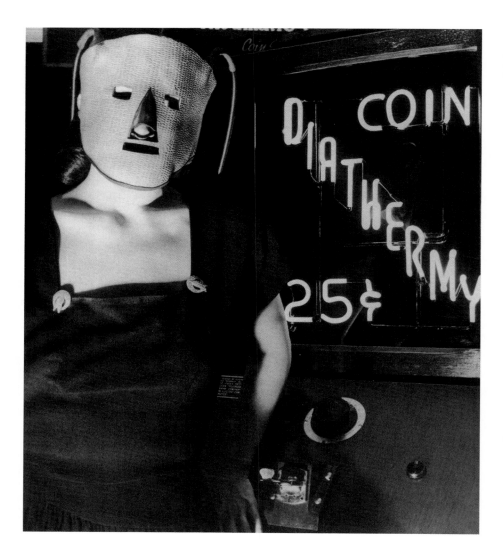

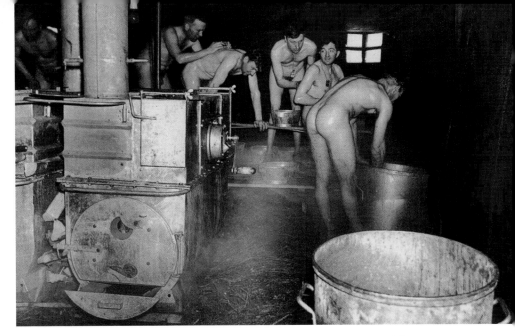

There was a plan to set up diathermy machines like this in public places in New York in September 1946. A commercial enterprise summed up in the slogan: "Treat yourself to a treatment while you're waiting for the train." The secret consists in the stimulation of the skin by electric currents.

Dieser Diathermie-Automat soll im September 1946 an öffentlichen Plätzen in New York aufgestellt werden. Die Geschäftsidee beschreibt der Slogan »Gönnen Sie sich eine Behandlung, während Sie auf den Zug warten.« Die Diathermie besteht in der Anregung der Haut durch elektrische Ströme.

On envisage d'installer cet automate diathermique dans des lieux publics à New York, en septembre 1946. Le slogan illustre cette idée commerciale : « Offrez-vous un traitement en attendant le train ». Le secret consiste à stimuler de la peau par des courants électriques.

The Swedish army enhances its defensive potential in the sauna. On 3 March 1941, the newspapers reported the introduction of a new field sauna. With a bath tent and two changing tents, it could serve 1500 soldiers daily. Only a neutral army could enjoy so much of the good life during the War.

Die schwedische Armee erhöht ihre Wehrkraft in der Sauna. Am 3. März 1941 wird eine neue Feldsauna vorgestellt. Täglich können 1500 Soldaten durch ein Badezelt und zwei Umkleidezelte geschleust werden. So viel Lebensart ist während des Kriegs nur einer neutralen Armee vergönnt.

L'Armée suédoise accroit sa résistance dans les saunas. Le 3 mars 1941, les journaux présentent un nouveau sauna de campagne. Tous les jours, 1500 soldats peuvent utiliser une tente et deux tentes vestiaires. Seule l'armée d'un pays neutre peut s'offrir un tel luxe pendant la guerre.

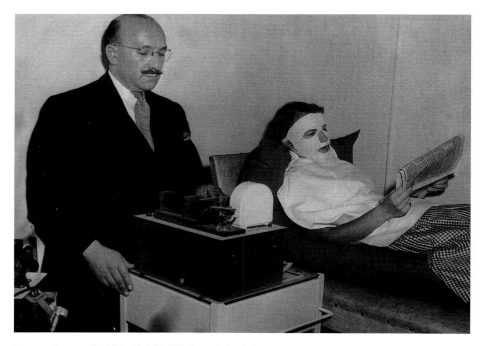

In 1949, pharmacologist Dr M. Désiré Piette and physiotherapist Henry Lewin turned their backs on science to open a beauty salon, the "Institut d'Esthétiques," in London's Berkeley Street. Mr Lewin is here seen demonstrating a device of his own construction to counter facial wrinkles.

1949 kehren der Pharmazeut Dr. M. Désiré Piette und der Physiotherapeut Henry Lewin der Wissenschaft den Rücken. Sie eröffnen in der Londoner Berkeley Street den Schönheitssalon »Institut d'Esthétique«. Mr Lewin demonstriert hier einen selbstgebauten Apparat, der Gesichtsfalten mindern soll.

En 1949, un pharmacien, le Dr M. Désiré Piette, et un physiothérapeute, Henry Lewin, tournent le dos à la science. Ils inaugurent sur la Berkeley Street, à Londres, le salon de beauté « Institut d'Esthétique ». M. Lewin fait ici la démonstration d'un appareil qu'il a créé lui-même et qui permet d'atténuer les rides du visage.

35,000 American beauticians met on 13 March 1940 for the International Beauty Show in New York. Miss Ann Drew attracted particular attention with this new electrical heating apparatus to make "milady's hair and skin look their best for Easter."

35 000 amerikanische Kosmetikerinnen treffen sich am 13. März 1940 in New York zur »Internationalen Schönheitsschau«. Für besonderes Aufsehen sorgt Miss Ann Drew, die dieses neue elektrische Heizgerät vorführt, das dem Zweck dient, »Miladys Frisur und Teint zu Ostern besonders gut aussehen zu lassen«.

35 000 esthéticiennes américaines se réunissent le 13 mars 1940 à New York à l'« Exposition internationale de la Beauté ». Miss Ann Drew fait sensation lorsqu'elle présente cet appareil de chauffage électrique d'un genre nouveau qui garantit à « Milady une coiffure et un teint particulièrement resplendissants pour Pâques ».

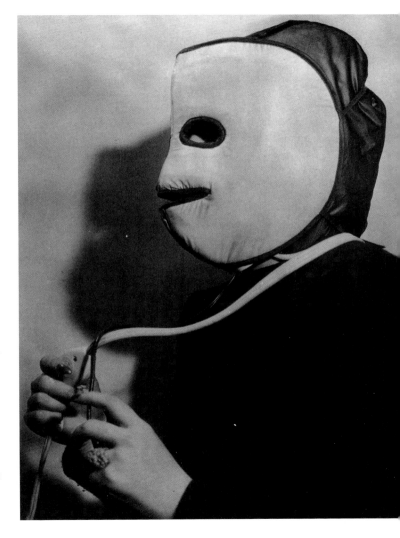

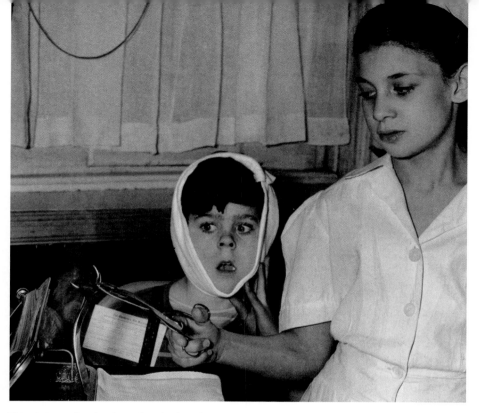

This photograph, taken in 1946 at the dental surgery run by the Children's Aid Society in New York's Lower East Side Center, could not have been better staged. The staff took care of the children of needy families from the neighborhood, thus softening some of the hardships of the American social security system.

Dieses Foto, 1946 in der zahnärztlichen Ambulanz einer Kinderhilfsorganisation im Lower East Side Center in New York aufgenommen, ist filmreif inszeniert. Das Personal versorgt die Kinder bedürftiger Familien aus dem Viertel und fängt damit Härten des amerikanischen Sozialsystems auf.

Cette photo, prise en 1946 dans le dispensaire de médecine dentaire d'une organisation d'aide à l'enfance du Lower East Side Center, repose sur une parfaite mise en scène. Le personnel s'occupe des enfants de familles défavorisées du quartier et compense ainsi les inégalités du système social américain.

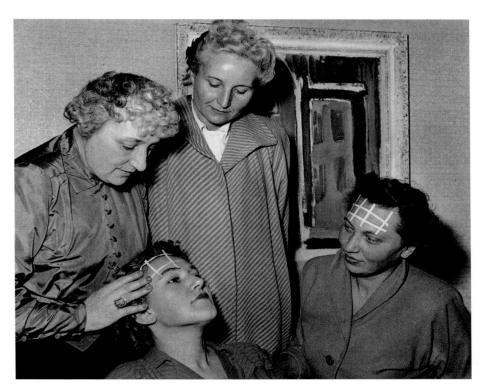

These Berlin housewives are receiving cosmetic instruction from France in 1952. At the foundation course run by a specialist from Paris, the ladies are learning all about make-up, French style. Here, Madame is seen revealing the secret of removing unwanted wrinkles from the brow.

Kosmetische Nachhilfe aus Frankreich erhalten 1952 diese Berliner Hausfrauen. Im Grundkurs der Expertin aus Paris erfahren die Damen alles über das Make-up im französischen Stil. Hier verrät Madame das Geheimnis, mit dem sie unerwünschte Stirnfalten beseitigt.

Ces ménagères berlinoises reçoivent des « cours de rattrapage » donnés par des Françaises en 1952. Dans un cours de base d'une spécialiste de Paris, ces dames apprennent à se maquiller à la française. Ici, Madame trahit le secret d'un front sans ride indésirable.

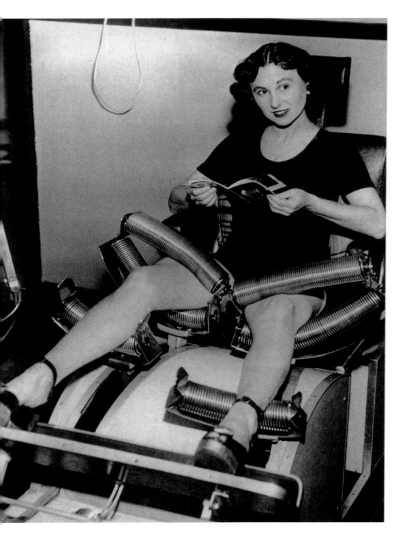

A photographer in 1952 claimed to have tracked down the most unusual job in the world in New York. Faye Suskind worked in the MacLevy Slenderizing Salon, where she tested the efficacy of its equipment. She regularly put on weight, in order to work it off again immediately.

Den ungewöhnlichsten Beruf der Welt will ein Fotograf 1952 in New York entdeckt haben. Faye Suskind arbeitet im MacLevy-Schlankheitssalon und testet dort den Wirkungsgrad des Maschinenparks. Sie nimmt regelmäßig zu, um sich die Pfunde umgehend wieder abzutrainieren.

Un photographe pense avoir découvert, à New York en 1952, le métier le plus curieux qui soit. Faye Suskind travaille dans le salon d'amaigrissement MacLevy et teste l'efficacité du parc à agrès. Elle grossit régulièrement pour, ensuite, se remettre immédiatement à l'exercice et se défaire de ses bourrelets.

A fine head of hair is a broad field of masculine vanity, on which charlatans and quacks have gambled since time immemorial. In the 1950s, this young American lady was not making any empty promises, however. "This brush polishes the bald pate and combs the hair at the sides."

Der Haarausfall des Mannes ist ein heikles Feld männlicher Eitelkeit, auf dem sich seit jeher Scharlatane und Pseudomediziner tummeln. In den fünfziger Jahren macht diese junge Amerikanerin ihren Kunden keine falschen Versprechungen: »Diese Bürste poliert die Glatze und kämmt das Seitenhaar.«

La perte des cheveux est, pour l'homme, un phénomène émouvant qui témoigne de la vanité masculine et auquel s'intéressent depuis toujours charlatans et autres pseudo-médecins. Dans les années 50, cette jeune Américaine ne fait pas de vaines promesses à son client : « Cette brosse polira votre calvitie et coiffera votre mèche latérale. »

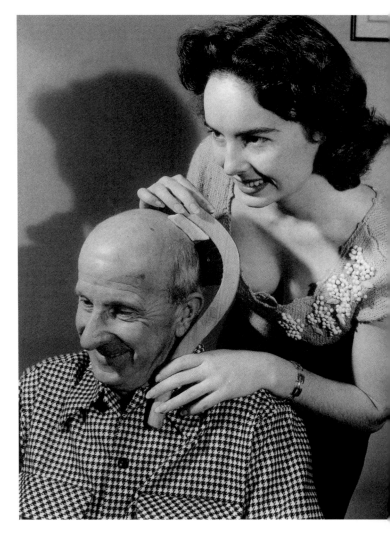

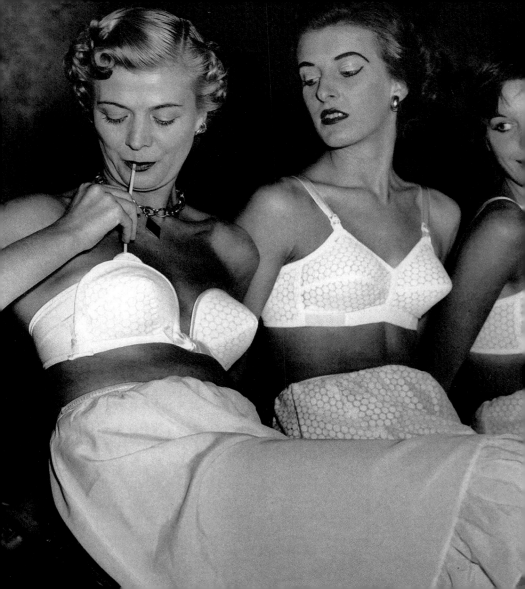

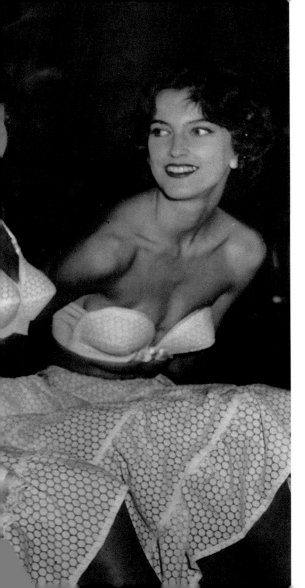

Models show off a miracle of bra
technology in London's Waldorf hotel
on 9 February 1952: the variable
air-cushion for perfect beauty.

Ein Wunder der »BH-Technik« präsen-
tieren Modelle im Londoner Waldorf-
Hotel am 9. Februar 1952: das variable
Luftpolster für die perfekte Schönheit.

Des mannequins présentent, à l'hôtel
Waldorf de Londres, le 9 février 1952,
toute la magie de la « technique du
soutien-gorge » : le coussin d'air
variable, garantie d'une beauté divine.

"Attention: women's page editors!" In this way, one agency sought to attract the attention of its clients for the Inventors' Fair to be held in Paris on 6 September 1952. Among the novelties devoted to feminine beauty from head to toe were the curling tongs (left) and the massage device for tired muscles or migraine (above). The press release enthused about "ingenious gadgets".

»Achtung: Redakteure der Frauen-Seiten...« In dieser Form buhlt eine Agentur um die Aufmerksamkeit ihrer Kunden für die Erfindermesse in Paris am 6. September 1952. Zu den Innovationen für die weibliche Schönheit von Kopf bis Fuß gehören die Lockenschere (links) und der Massageapparat gegen müde Muskeln oder Migräne (oben). Der Pressetext schwärmt von »genialen Geräten«.

« Attention : rédacteurs de rubriques féminines... » C'est ainsi qu'une agence brigue l'attention de ses clients lors de la Foire des Inventeurs de Paris, le 6 septembre 1952. Parmi les innovations permettant aux femmes d'être belles de la tête aux pieds figurent les ciseaux à boucles (à gauche) et l'appareil de massage contre les muscles fatigués ou contre la migraine (en haut). Le texte de presse fait l'éloge de ces « gadgets de génie ».

Keep fit

In sporting contests there are always winners and losers. This makes them highly interesting for local reporters who can fête the winner from next door. From the beginning of the 20th century, association football (soccer) became the number one sport in Europe. Sports were no longer the "games" of the privileged leisure class; local sports clubs were formed, and some countries saw the introduction, nationwide, of badges for sporting achievements. Not only did football, cycle racing and boxing provide broad sections of the population with an opportunity to take part in physically active pursuits themselves, but sporting events – and the reports thereof – also supplied the topics for a great deal of conversation. Newspapers and magazines devoted to nothing else soon appeared. Mass media like the press and the cinema must share much of the responsibility for the perversion of the pristine sporting spirit of the early years of the century. Mens sana in corpore sano – within a healthy body dwells a healthy mind. Yet even at an early stage, the six-day cycle races were more like circus acts within a sporting program. The 1936 Olympic Games in Germany degenerated into a display of propaganda for National Socialism. High-performance sport soon lost its innocence, and became the cat's paw of political and commercial interests.

Leibesübungen

Sportlicher Wettstreit ist Kampf, Sieg oder Niederlage. Dies macht ihn in höchstem Maße für die lokale Berichterstattung interessant, in der der Sieger von nebenan gefeiert wird. Fußball steigt zu Beginn des 20. Jahrhunderts zur Volkssportart in Europa auf. Freizeitsport ist nicht länger ein Privileg des Adels und des Bürgertums. Es bilden sich Ortsvereine, und nationale Verbände führen das Sportabzeichen ein. Fußballspiele, Radrennen und Boxkämpfe bieten breiten Schichten nicht nur die Möglichkeit, selbst aktiv zu werden, die Sportereignisse und die Berichterstattung darüber sorgen auch für jede Menge Gesprächsstoff. Bald schon entstehen Sport-Zeitungen und Illustrierte, die den Nachrichtenhunger der Sportfans exklusiv bedienen. Medien wie Presse und Film tragen maßgeblich dazu bei, daß im Verlauf des 20. Jahrhunderts der ursprüngliche Sportgeist pervertiert wird: "In einem gesunden Körper wohnt ein gesunder Geist". Bereits die frühen Sechs-Tage-Rennen sind eher Zirkusveranstaltungen mit einem sportlichen Rahmenprogramm. Die Olympischen Spiele 1936 in Deutschland degenerieren zu einer Propagandaschau des Nationalsozialismus. Der Spitzensport verliert schnell seine Unschuld und wird zum Spielball wirtschaftlicher und politischer Interessen.

La culture physique

La compétition sportive est synonyme de lutte, de victoire ou de défaite. Et c'est ce qui la rend intéressante au plus haut point pour les reportages locaux, qui célèbrent les vainqueurs que l'on connaît bien. Au début du xxe siècle, le football devient la discipline sportive la plus populaire d'Europe. Les sports de loisirs ne sont plus le privilège de la noblesse ou de la bourgeoisie. Des clubs sportifs se constituent et des fédérations nationales instaurent les premiers emblèmes sportifs. Les matches de football, courses cyclistes et combats de boxe ne motivent pas seulement de larges couches de la population à pratiquer elles-mêmes du sport. Par ailleurs, les événements sportifs et les reportages qui leur sont consacrés fournissent des motifs de discussions. Bientôt naissent des journaux et illustrés sportifs qui apaisent la faim d'informations des fanas du sport. Des médias comme la presse et la télévision contribuent à pervertir l'esprit sportif initial, au cours du xxe siècle : « Un esprit sain dans un corps sain ». Les courses des Six Jours, déjà, ressemblent davantage à des manifestations de cirque avec un programme d'animation sporive. Les Jeux Olympiques de 1936, en Allemagne, dégénèrent en propagande nazie. Le sport de haute compétition perd vite sa virginité et devient l'enjeu d'intérêts économiques et politiques.

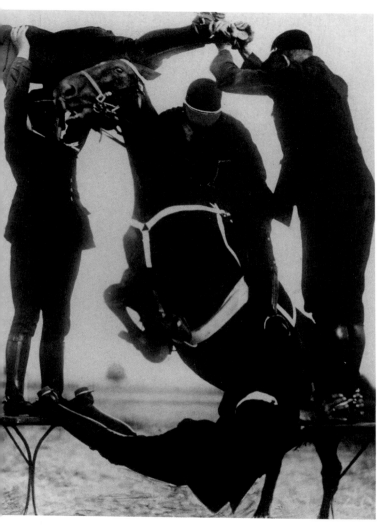

The concerned German author described this picture as "A leap through a human ring," and went on, "The desire for healthy sporting activity common to all classes has also given rise to excesses whose blatant and ridiculous exaggerations one can, without any qualms, describe as lunacy."

Besorgt kommentiert ein deutscher Autor 1929 diesen »Sprung durch eine menschliche Hürde«: »Der allen Schichten gemeinsame Wunsch nach gesunder sportlicher Betätigung hat auch Auswüchse hervorgebracht, die man infolge ihrer krassen, sinnlosen Übertreibungen getrost mit Wahnsinn bezeichnen kann.«

L'auteur allemand préoccupé commente ainsi ce cliché d'un « saut d'obstacle humain », datant de 1929 : « L'envie qu'a tout homme de faire du sport, activité au demeurant bénéfique à la santé, conduit parfois à des excès que l'on peut sans hésiter qualifier de folies en vertu de leur exagération manifeste et de leur inanité ».

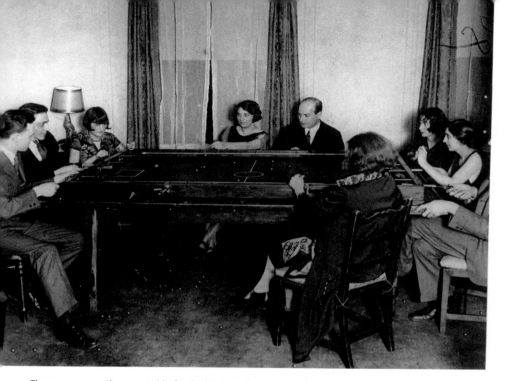

There were more than 500 table-football clubs in Europe, according to the report accompanying this picture, which dates from 1 April 1925. "The father of the game," Dr Hryntschak from Vienna, was currently in the USA to promote the game there. This photo was taken in the Austrian consulate in Chicago.

In Europa gibt es einer Meldung vom 1. April 1925 zufolge über 500 Tischfußballclubs. »Der Vater des Spiels«, Dr. Hryntschak aus Wien, befindet sich derzeit in den USA, um auch dort für dieses Freizeitvergnügen zu werben. Das Foto entsteht im österreichischen Konsulat in Chicago.

Selon une information du 1ᵉʳ avril 1925, il existe en Europe plus de 500 clubs de baby-foot. Le « père de ce jeu », le Dr Hryntschak de Vienne, se trouve actuellement aux Etats-Unis où il fait la promotion de cette activité de loisirs. La photo a été prise au consulat d'Autriche, à Chicago.

In the British Dominion of Canada, skiing was a growth sport in 1927. This picture was taken at Chateau de Fontenac in Quebec. At the international level, however, ice hockey was the sport in which the Canadians really excelled. They won the gold medal at the first winter Olympics, held in Chamonix in 1924.

Im britischen Dominion Kanada erfreut sich 1927 der Skisport wachsender Beliebtheit, wie hier in Chateau de Fontenac in der Provinz Quebec. International dominieren die Kanadier jedoch eher den Eishockeysport und siegen bei den ersten Olympischen Winterspielen 1924 in Chamonix.

Au Canada, dominion britannique, le ski est de plus en plus populaire en 1927, comme ici, au Château de Fontenac, dans la province du Québec. A l'échelon international, les Canadiens se distinguent toutefois en tant que joueurs de hockey, puisqu'ils remportent la médaille d'or aux premiers Jeux olympiques d'hiver en 1924 à Chamonix.

"Kati Bitter performing a particularly good leap." Pictured on the shores of a Berlin lake no later than 1925, this dancer demonstrates that "nudity" in sport and show business was already a matter of media interest – not least because bare flesh meant more readers.

»Kati Bitter bei der Ausführung eines besonders guten Sprunges«. Mit dieser Aufnahme, die vor 1925 an einem Berliner See entsteht, beweist diese Tänzerin, daß »Nacktheit« im Sport und im Showgeschäft bereits ein öffentliches Thema ist – wohl nicht zuletzt, weil nackte Haut die Auflagenzahlen steigert.

« Kati Bitter exécutant un saut particulièrement réussi ». Photographiée avant 1925 sur la rive d'un lac de Berlin, cette danseuse prouve que la « nudité » dans le sport et le show business fait déjà parler d'elle – sans aucun doute aussi parce que la peau nue fait s'envoler les tirages.

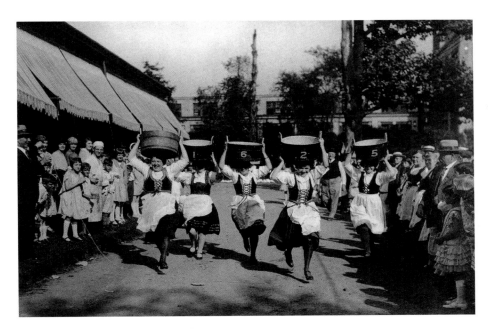

The American city of Philadelphia was the venue
for the Cannstatt Folk Festival held by German immi-
grants from Stuttgart – here in 1927 for the fifth time.
Back home, this was a fair with a long tradition, which
the emigrants continued in their new homeland.

Im amerikanischen Philadelphia feiern deutsche
Einwanderer aus Stuttgart 1927 zum fünften Mal
ihr alljährliches Cannstatter Volksfest. In der alten
Heimat ist dies ein Jahrmarkt mit langer Tradition,
die die Emigranten auch fernab von Deutschland
weiterpflegen.

En 1927, à Philadelphie (Etats-Unis) la fête bat son
plein. Des immigrants allemands originaires de
Stuttgart sont restés fidèles, pour la cinquième fois, à
la tradition et ont organisé la fête populaire qui les
réunissait tous les ans à Cannstatt, un quartier de leur
ville natale.

In 1929, a Berlin engineer named Loebner introduced to the public an "apparatus to register the times in sporting competitions." In practice, the invention had little success; times were still taken by stopwatch, and the winner was the first to breast the ribbon at the finishing line.

Der Berliner Konstrukteur Loebner stellt 1929 eine Apparatur »zur Registrierung der Zeit bei sportlichen Wettkämpfen« vor. In der Praxis kann sich die Erfindung jedoch nicht durchsetzen: Die Zeit wird noch immer per Stoppuhr gemessen, und am Einlauf wartet das Zielband auf die schnellsten Läufer.

En 1929, l'ingénieur berlinois Loebner présente un appareil « à enregistrer le temps lors de compétitions sportives ». On continue néanmoins de lui préférer le chronomètre et, à l'arrivée, c'est le vainqueur qui déchirera le ruban.

During the athletics meeting at London's White City Stadium on 7 August 1937, the favorite Barbara Burke from South Africa loses to British sprinter W. Jeffreys (center) in the women's 100 meters. Burke had been unlucky this season; a few days before, S. Walasiewicz from Poland had beaten her into second place in Berlin, and broken the world record in the process.

Beim Leichtathletikwettbewerb im Londoner Stadion White City unterliegt am 7. August 1937 die Favoritin Barbara Burke der Britin W. Jeffreys (Bildmitte) im 100-Meter-Lauf. Die Südafrikanerin Burke hat in dieser Saison Pech, denn wenige Tage zuvor war in Berlin die Polin Walasiewicz über 100 m einen Weltrekord gegen sie gelaufen.

Lors d'une course sur 100 mètres au stade de White City à Londres, le 7 août 1937, la favorite Barbara Burke est vaincue par la Britannique W. Jeffreys (au centre). La Sud-Africaine Burke n'a pas de chance cette saison-là, car, quelques jours auparavant, elle a été battue à Berlin par la Polonaise Walasiewicz qui a établi un record du monde du 100 mètres.

The advantages of jujitsu as a self-defense sport were demonstrated on 22 February 1933 by Miss Phyllis Boutell at the expense of "robber" Charles Cawkell. The excited spectators are members of the British Optical Association attending their annual dinner at London's Trocadero restaurant.

Die Vorteile von Jiu-Jitsu als Selbstverteidigungssport demonstriert am 22. Februar 1933 Miss Phyllis Boutell an dem »Angreifer« Charles Cawkell. Gespannt verfolgen die Mitglieder der Britischen Optiker-Gesellschaft auf ihrem Jahresbankett im Londoner Restaurant Trocadero das Geschehen.

Le 22 février 1933, Miss Phyllis Boutell montre les avantages du jiu-jitsu pour neutraliser son agresseur, rôle que tient Charles Cawkell. Réunis au restaurant londonien du Trocadero, pour leur banquet annuel, les membres de la Société d'optique britannique suivent avec intérêt l'issue du « combat ».

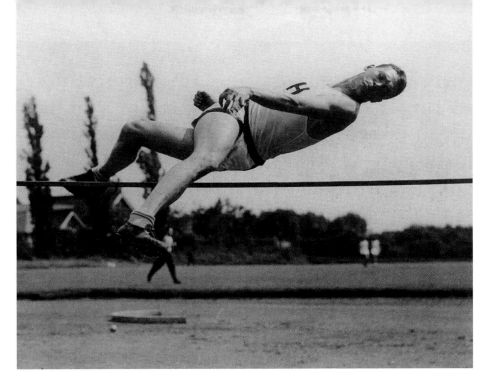

University sport as a means of encouraging young sportsmen and women was a particularly British and American phenomenon. On 18 July 1931, the combined Oxford and Cambridge track team met the combined team of Yale and Harvard. The picture shows a student training for the high jump.

Der Universitätssport stellt vor allem in Großbritannien und den USA eine Form der Sportförderung dar. Am 18. Juli 1931 tritt das gemeinsame Leicht-athletik-Team von Oxford und Cambridge gegen das Team von Yale und Harvard an. Das Bild zeigt einen Studenten beim Hochsprungtraining.

En Grande-Bretagne et aux Etats-Unis surtout, le sport universitaire est une forme de promotion des disciplines sportives. Le 18 juillet 1931, l'équipe d'athlétisme commun d'Oxford et de Cambridge va se mesurer à celle de Yale et de Harvard. La photo montre un étudiant s'entraînant au saut en hauteur.

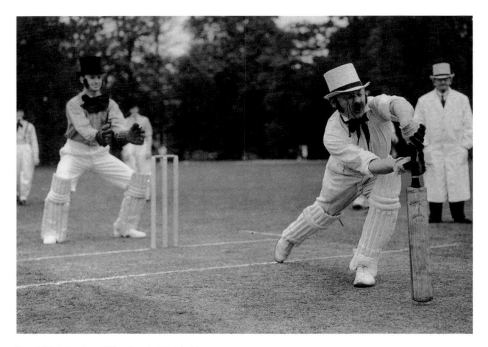

The British Foreign Office Sports Club held a
cricket match in period costume to mark its tenth
anniversary on 27 May 1939. The origins of this
English bat-and-ball game go back to the 13th
century.

Im Sportclub des britischen Außenministeriums
findet anläßlich des zehnjährigen Bestehens am
27. Mai 1939 ein Kricketspiel in historischer Klei-
dung statt. Die Anfänge des englischen Schlag-
ball-Spiels reichen bis ins 13. Jahrhundert zurück.

Le club sportif du Ministère des Affaires étran-
gères organise pour son dixième anniversaire,
le 27 mai 1939, un match de cricket en costumes
historiques. Ce sport anglais qui consiste à frapper
la balle de la batte remonte au XIIIᵉ siècle.

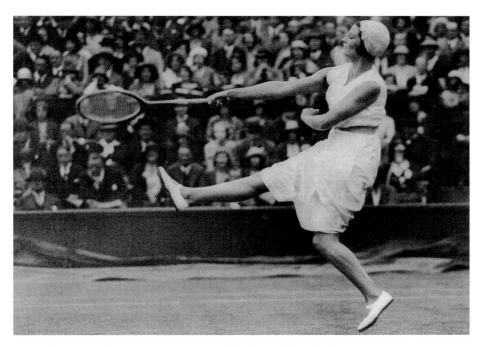

Wimbledon witnessed a tennis sensation in 1931. In the final of the Ladies' Singles, an all-German affair, Cilly Aussem beat Hilde Krahwinkel. The former four-times champion, Helen Wills, did not compete this year. The picture shows England's Joan Lycett; her opponent is Lili d'Alvarez from Spain.

Wimbledon erlebt 1931 eine Tennis-Sensation: Im deutsch-deutschen Einzelfinale der Damen schlägt Cilly Aussem Hilde Krahwinkel. Die viermalige Titelträgerin der Vorjahre, Helen Wills, hat jedoch nicht teilgenommen. Das Bild zeigt das Spiel der Engländerin Joan Lycett (im Bild) gegen die Spanierin Lili d'Alvarez.

Wimbledon est témoin d'une sensation en tennis, en 1931 : lors de la finale individuelle des dames, que disputent deux Allemandes, Cilly Aussem bat Hilde Krahwinkel. Quatre fois tenante du titre et victorieuse l'année précédente, Helen Wills, n'a cependant pas participé au tournoi. La photo représente le match de l'Anglaise Joan Lycett (photo) contre l'Espagnole Lili d'Alvarez.

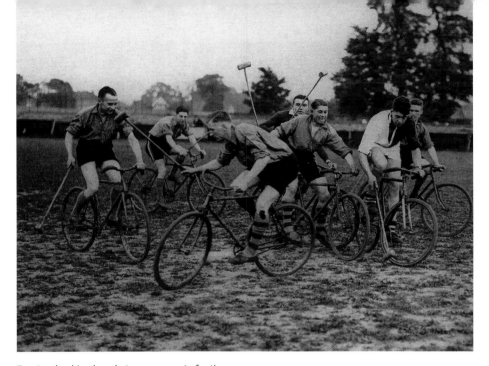

Two London bicycle-polo teams compete for the
ball in the semi-final of the 1935 city champion-
ships. The idea of popularizing this aristocratic
sport by substituting bicycles for horses found few
enthusiasts.

Zwei Londoner Radpolo-Mannschaften kämpfen
im Halbfinale der Stadtmeisterschaften 1935 um
den Ball. Die Idee, den Aristokratensport breiteren
Bevölkerungsschichten zugänglich zu machen und
das Pferd gegen ein Fahrrad auszutauschen, findet
nur wenige enthusiastische Anhänger.

Deux équipes londoniennes de vélo-polo se dispu-
tent la balle, lors de la demi-finale des champion-
nats municipaux de 1935. L'idée de démocratiser ce
sport d'aristocrates et de remplacer le cheval par
une bicyclette ne rencontre que peu d'adeptes.

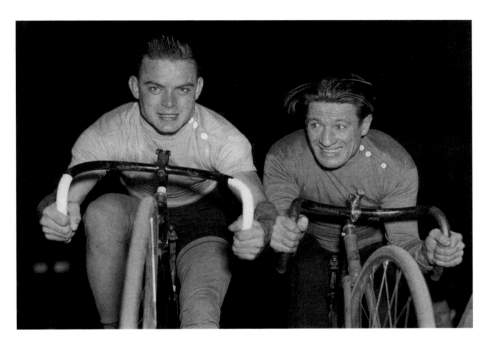

Russell Allen and Gerard Debaets formed a team for a six-day race in New York's Madison Square Garden in 1937. This indoor cycle marathon was thought up in America and reached Europe only in 1909.

Russell Allen und Gerard Debaets bilden 1937 ein Team für das Sechs-Tage-Rennen im New Yorker Madison Square Garden. Dieser Hallen-Radmarathon beruhte auf einer amerikanischen Idee und kam erst 1909 nach Europa.

En 1937, Russell Allen et Gerard Debaets font équipe pour la course des Six Jours au Madison Square Garden de New York. Les Américains ont été les premiers à organiser des marathons cyclistes en salle et les Européens ne les imite-ront qu'à partir de 1909.

Lorraine Graham in a preview of the World Rodeo Show in New York's Madison Square Garden on 31 October 1930. The 9-year-old stunt rider from Kansas had already defeated many a tough cowboy, winning a total of 12,000 dollars in the previous three years.

In Vorankündigung der World Rodeo Show im New Yorker Madison Square Garden wird am 31. Oktober 1930 Lorraine Graham vorgestellt. Die neunjährige Trickreiterin aus Kansas hat schon so manchen gestandenen Cowboy geschlagen und in den vergangenen drei Jahren 12 000 Dollar Preisgeld gewonnen.

Le 31 octobre 1930, Lorraine Graham fait une démonstration pour promouvoir le World Rodeo Show, au Madison Square Garden de New York. Originaire du Texas, la cavalière équilibriste de neuf ans, a déjà battu de nombreux cow-boys blanchis sous le harnais et a, au cours des trois dernières années, obtenu 12 000 dollars de récompense.

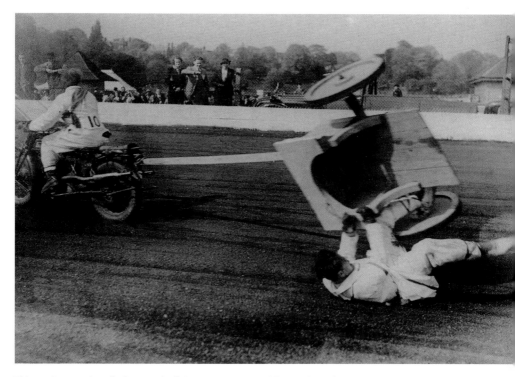

This modern version of a Roman chariot race was one event in a motorcycle rodeo held at London's Crystal Palace on 17 May 1937. Since the world's first car race in France in 1898, motor sport had developed at breakneck pace.

Diese Version moderner römischer Kampfwagen erproben am 17. Mai 1937 die Teilnehmer des Motorrad-Rodeos im Londoner Stadion Crystal Palace. Seit 1898 das erste Automobilrennen der Welt in Frankreich stattfand, hat sich der Motorsport rasant entwickelt.

Cette version moderne de la course de Ben Hur ne se termine pas comme l'escomptaient ces deux participants au rodéo motocycliste de Londres au stade Crystal Palace, le 17 mai 1937. La première course automobile du monde a eu lieu en France, en 1898. Depuis, les sports motorisés se sont développés à une vitesse époustouflante.

During the 1932 Olympic Games in Los Angeles, Chuhei Nambu from Japan failed to win the long jump, in which event he was the world-record holder at 7.98 meters. However, he drew strength from his defeat and went on to win the hop, step and jump at 15.72 meters.

Bei den Olympischen Spielen 1932 in Los Angeles verliert der Japaner Chuhei Nambu in der Disziplin Weitsprung, in der er mit 7,98 m den Weltrekord hält. Aus der Niederlage schöpft er jedoch Kraft und gewinnt die Goldmedaille in der Dreisprung-Konkurrenz mit 15,72 m.

Aux Jeux olympiques de 1932, à Los Angeles, le Japonais Chuhei Nambu, pourtant titulaire du record du monde de saut en longueur avec 7,98 mètres doit s'incliner devant ses concurrents. Cette défaite le motive cependant puisqu'il remporte la médaille d'or au triple saut (15,72 mètres).

On 10 May 1930, London newspapers introduced Steve McCall as a British boxing hopeful, but McCall failed to make the leap into the international ring.

Londoner Zeitungen stellen am 10. Mai 1930 Steve McCall als hoffnungsvolles Talent des britischen Boxsports vor. Der Sprung in die internationale Boxklasse bleibt McCall jedoch versagt.

Le 10 mai 1930, les journaux londoniens qualifient Steve McCall d'espoir de la boxe britannique. McCall ne parviendra cependant jamais à faire le bond dans la catégorie suprême de la boxe internationale.

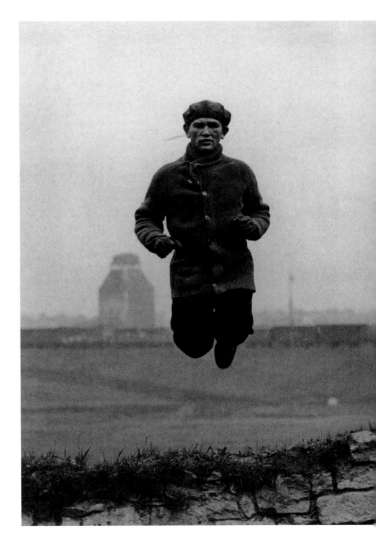

London's Wembley Stadium was the venue for the final of the Rugby League Cup Final on 5 May 1934. Press reports made much of the fact that King George V was indisposed and unfortunately unable to watch Hunslet's victory over Widnes.

Im Londoner Wembley-Stadion findet am 5. Mai 1934 das Meisterschaftsfinale der Rugbyliga statt. Die Zeitungsmeldung zu dieser Aufnahme betont, daß König Georg V. verhindert ist und leider nicht den Sieg des Teams aus Hunslet gegen Widnes verfolgen kann.

La finale du championnat de rugby est disputée à Londres, au stade de Wembley, le 5 mai 1934. Les journaux notent sous cette photo que le roi George V est empêché et ne peut malheureusement pas assister à la victoire de l'équipe de Hunslet contre Widnes.

The obstacle race in a sports day at Sudbury in London's north-western suburbs on 6 June 1931. The "runners" had to cover a two-kilometer course. This Sunday amusement represented a distraction from everyday cares; that same month, the papers reported 2,665,000 unemployed.

Die Hindernisläuferinnen beim Sportfest im englischen Sudbury (Middlesex) überwinden am 6. Juni 1931 einen 2 km langen Parcours. Das sonntägliche Vergnügen lenkt von den Alltagssorgen ab: In diesem Monat verkünden die Zeitungen die Zahl von 2 665 000 Arbeitslosen im Land.

Les participantes à la course d'obstacles lors de la fête des sports à Sudbury dans le comté anglais du Middlesex, le 6 juin 1931, doivent effectuer un parcours de 2 kilomètres. Ce petit plaisir dominical fait oublier les soucis de la vie quotidienne : ce mois-là, les journaux annoncent que le pays compte 2 665 000 chômeurs.

English bricklayers gather for their national championships in the town of Morecambe in Lancashire on 25 September 1933. They are pictured "working" under the critical eye of the local carnival queen, Miss Eva Withers. These public competitions served to enhance feelings of working-class self-respect.

Englische Maurer aus Morecambe in Lancashire versammeln sich am 25. September 1933 zu ihren nationalen Meisterschaften, die vor Ort stattfinden. Unter dem kritischen Auge von Miss Eva Withers, der einheimischen Festkönigin, wird »gearbeitet«. Die öffentlichen Berufs-gruppenwettkämpfe dienen der Steigerung des Selbstbewußtseins der Arbeiterklasse.

Des maçons anglais de Morecambe, dans le Lancashire, participent, le 25 septembre 1933, au championnat national organisé dans leur ville. Sous le regard critique de Miss Eva Withers, sacrée reine de la fête locale, ils travaillent d'arrache-pied. Les concours professionnels locaux ont pour but de grandir l'honneur des ouvriers.

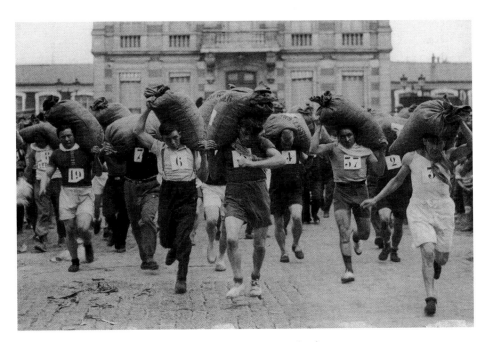

Competitive sport played an important part in the European workers'
movement in the 1920s and 1930s. Many trades started putting on
public competitions involving their specialties. Here, heavily-laden
Parisian coal porters are seen running two miles (three kilometers) for
pleasure one Sunday in May 1938.

Der Sport nimmt in der europäischen Arbeiterbewegung in den zwan-
ziger und dreißiger Jahren einen hohen Stellenwert ein. Viele Berufs-
gruppen beginnen, ihre beruflichen Fähigkeiten auch vor Publikum zu
messen. Hier laufen an einem Sonntag im Mai 1938 schwerbeladene
Pariser Kohlenmänner zu ihrem Vergnügen eine Distanz von 3 km.

Le sport devient prépondérant au sein du Mouvement ouvrier euro-
péen des années 20 et 30. De nombreuses catégories professionnelles
commencent à montrer aussi au grand public toute l'étendue de leurs
talents. Ici, un dimanche de mai 1938, des charbonniers parisiens,
lourdement chargés, participent pour leur plaisir à une course de
3 kilomètres.

Ever since photographs were first taken at the Scottish Highland Games in Aboyne, humorless readers have asked: "Is what the highlanders get up to at these lengthy festivals really sport?" They would have got no definitive answer from this shot of the 1930s games, either.

Seit es Fotos von den schottischen Highland Games in Aboyne gibt, stellen sich humorlose Zeitgenossen die Frage: »Ist es wirklich Sport, was die Hochländer auf diesem mehrtägigen Fest betreiben?« Auch diese Aufnahme aus dem Jahre 1930 gibt ihnen keine endgültige Antwort.

Depuis qu'il existe des photographies des Highland Games, à Aboyne, en Ecosse, nombreux sont ceux qui, dépourvu d'humour, se demandent : « Peut-on parler de sport à propos de ce que font les Highlanders lors de leurs fêtes de plusieurs jours ? » Cette photo de 1930 ne leur donne pas non plus de réponse définitive.

It was not until the 1920s and 1930s that the broad masses were able to indulge in fun at the seaside. But once they started, vacationers outdid each other in their attempts to find some way of overcoming the monotonous stretches between dips. These bathing beauties on California's Venice Beach are playing tightrope basketball.

Erst in den zwanziger und dreißiger Jahren beginnt die Freizeit am Meer, ein Vergnügen für die breite Masse zu werden. Gleichzeitig übertrumpfen sich die Badegäste gegenseitig in ihren Anstrengungen, die Langeweile zwischen den Badegängen zu überbrücken. Diese Badenixen am Strand von Venice Beach (Kalifornien) empfehlen »Basketball auf dem Seil«.

Il faut attendre les années 20 et 30 pour que les vacances au bord de la mer commencent à devenir un plaisir démocratique. Les baigneurs se surpassent pour ne pas s'ennuyer quand ils sortent de l'eau. Ces nageuses photographiées sur la plage de Venice Beach (Californie) se disputent, quant à elles, un « match de basket sur corde ».

This 1939 picture was captioned "Coming, sir!" The Annual Lyons' Sports Carnival at Sudbury was another opportunity for various trades and occupations to subject their skills to unusual stresses. Here we see a hurdle race for waitresses, complete with tray.

»Ich komme, Sir« – mit dieser launigen Überschrift grüßt das Bild aus dem Jahre 1939. Auch beim alljährlichen Sportfest in Sudbury messen Berufsgruppen ihre Kräfte, wie hier die Serviererinnen. Mit ausgefeilter Technik üben sie sich im Hürdenlauf mit Tablett.

« Tout de suite, Sir » – pense-t-on immédiatement à la vue de cet amusant cliché de 1939 : certaines catégories professionnelles participent à la fête sportive annuelle de Sudbury, comme ces serveuses de café. Grâce à une technique sophistiquée, elles font une course de haies, un plateau à la main.

Gymnasiums were not yet widespread in the 1930s. To help boost
the popularity of these institutions, two actresses from The Strand
Theatre are staging a keep-fit session for the benefit of the press
in the sports department of a London store.

Fitneßstudios sind in den dreißiger Jahren noch nicht sehr verbrei-
tet. Um deren Popularität zu steigern, legen diese beiden Schau-
spielerinnen des Theaters The Strand in der Sportabteilung eines
Londoner Kaufhauses vor Pressefotografen eine Trimmstunde ein.

Dans les années 30, les salles de musculation sont encore assez
rares. Pour en augmenter la popularité, ces deux actrices qui se
produisent au théâtre The Strand font, devant les journalistes, une
démonstration de culture physique au rayon des articles de sport
d'un grand magasin londonien.

In December 1939, a few weeks after the outbreak of the Second World War, the British Broadcasting Corporation started putting out an early-morning keep-fit program. From 7.30 a.m. on Mondays, Wednesdays and Fridays, men were encouraged – in the interests of the war effort and the health of the nation – to tone their muscles. The ladies had their turn on the other days.

Wenige Wochen nach Beginn des Zweiten Weltkriegs startet der britische Radiosender BBC im Dezember 1939 ein Frühsportprogramm. Zum Wohle der Volksgesundheit und zur Kriegsertüchtigung sind am Montag, Mittwoch und Freitag ab 7.30 Uhr die Männer dazu aufgefordert, sich zu stählen. An den übrigen Wochentagen wird Gymnastik für Frauen gesendet.

Quelques semaines après le début de la Seconde Guerre mondiale, l'émetteur de radio britannique BBC inaugure, en décembre 1939, un programme de sport matinal. Pour préserver leur santé et se préparer physiquement au combat, les hommes sont invités à faire de la culture physique le lundi, le mercredi et le vendredi à partir de 7 h 30. Les autres jours de la semaine sont réservés à la gymnastique féminine.

In England, the home of association football, the largely masculine clientele of a north London skating rink were provided with some amusement on 29 March 1934 by the ladies of two roller skate soccer teams. But for all the female artistry, soccer has remained largely a male domain throughout the 20th century.

In England, der Heimat des Fußballs, belustigen am 29. März 1934 die Damen zweier Rollschuhfußball-Teams die überwiegend männlichen Besucher einer Rollschuhbahn im Norden Londons. Doch trotz aller weiblichen Artistik ist und bleibt der Fußball im 20. Jahrhundert eine Domäne der Männer.

En Angleterre, la mère patrie du football, deux équipes féminines de football sur patins à roulettes distraient les visiteurs, essentiellement masculins, d'une patinoire du nord de Londres le 29 mars 1934. Mais, malgré les talents artistiques des joueuses, le football est et reste au xxᵉ siècle un sport réservé aux hommes.

T. Gasson (right), the inventor of the paravane, a device to sever mines from their moorings, is pictured continuing to train his gray matter at the advanced age of 80 by taking part in the International Chess Congress in the resort of Hastings on England's south coast. The onlooker and fellow thinker is three years younger.

T. Gasson (rechts), Erfinder eines Schneidegeräts zur Räumung von Minen, trainiert auch im hohen Alter von 80 Jahren noch seine grauen Zellen und nimmt im Dezember 1937 an einem internationalen Schachturnier im englischen Hastings teil. Sein Zuschauer und Mitdenker ist drei Jahre jünger.

Même à l'âge de 80 ans, T. Gasson (à droite), l'inventeur d'un appareil à découper les mines, fait travailler ses cellules grises et participe à un tournoi international d'échecs à Hastings, en Angleterre, en décembre 1937. Le spectateur, qui se creuse les méninges autant que lui, a tout juste trois ans de moins.

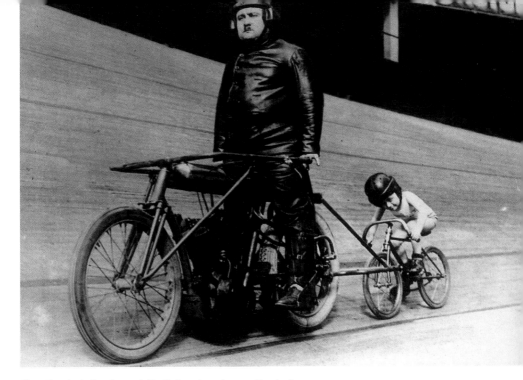

Since the start of cycle sport, the Italians have been enthusiastic followers. This 1930s' picture proves that even "bambini" were keen to try their hand at motor pacing, a discipline in which the so-called "stayer" rides behind a pace-setting motorcycle.

Die Italiener sind seit der Erfindung des Radsports wahre Enthusiasten dieser Sportart. Das Bild aus den dreißiger Jahren beweist, daß sich selbst »Bambini« in der Disziplin des Steherrennens versuchen. Es gilt, Runde um Runde hinter der Schrittmachermaschine herzufahren.

Depuis l'invention de la bicyclette, les Italiens sont de véritables fanatiques de ce sport. Cette photo des années 30 prouve que même les « bambini » s'essaient à la discipline de course derrière derny qui consiste à effectuer un tour après l'autre en suivant une motocyclette.

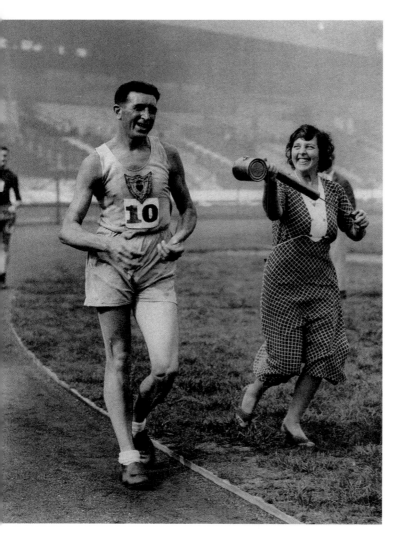

The World Walking Championships at London's White City Stadium in 1933 required the services of walkers' wives, too. Here we see Mr and Mrs Lloyd Johnson. At temperatures well above the average for September, Johnson's rival Tommy Green was seeking to break the world 50-mile record.

Die Weltmeisterschaften der Geher im Londoner White City Stadium 1933 verlangen auch den Ehefrauen höchsten Einsatz ab, wie die Gattin Lloyd Johnsons zeigt. Bei für September ungewöhnlich hohen Temperaturen versucht Johnsons Konkurrent Tommy Green, den Weltrekord über 80 km zu brechen.

Les championnats du monde des marcheurs de 1933, au Stade de White City à Londres, exigent aussi un engagement maximum de la part des femmes, comme ici l'épouse de Lloyd Johnson. A des températures inhabituellement élevées pour le mois de septembre, le concurrent de Johnson, Tommy Green, s'efforce de battre le record du monde sur 80 kilomètres.

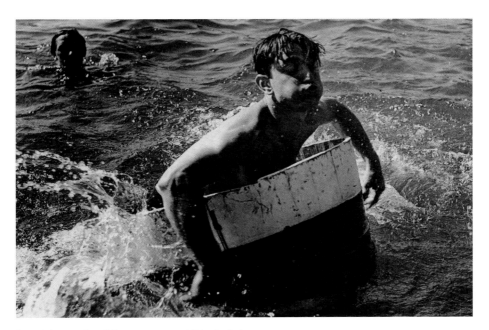

On 13 July 1941, Swedish newspapers published what must have seemed an idyllic picture with temperatures of 91° F (33° C) in the shade. The headlines in neutral Sweden, meanwhile, were more concerned with the advance of German troops into the Soviet Union, which they had invaded on 22 June without a declaration of war.

Am 13. Juli 1941 drucken schwedische Zeitungen diese Sommeridylle bei 33° C im Schatten. Die Schlagzeilen im neutralen Schweden verfolgen unterdessen den Vormarsch der deutschen Truppen gegen die Sowjet-union, der am 22. Juni ohne Kriegserklärung begann.

Le 13 juillet 1941, les journaux suédois reproduisent cette idylle estivale par 33° C à l'ombre. Les grands titres des journaux de ce pays neutre sont toutefois consacrés à l'offensive des troupes allemandes en Union soviétique, qui a commencé le 22 juin sans déclaration de guerre préalable.

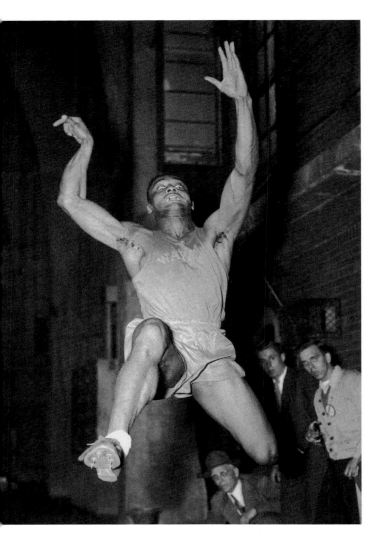

American long-jumper Lorenzo Wright prepares for the first postwar Olympic Games in London in 1948. In spite of all his training, he lost out to fellow-countryman Willie Steele, who took a 50-meter run-up for his 7.825-meter winning jump.

Der amerikanische Weitspringer Lorenzo Wright bereitet sich auf die ersten Olympischen Spiele nach Kriegsende 1948 in London vor. Trotz allen Trainings unterliegt er jedoch im olympischen Endkampf seinem Teamkollegen Willie Steele, der für seinen Siegessprung von 7,825 m einen 50 m langen Anlauf nimmt.

Le champion américain de saut en longueur, Lorenzo Wright, se prépare pour les premiers Jeux olympiques de l'après-guerre, en 1948 qui se tiennent à Londres. En dépit de tous ses efforts, il sera cependant battu en finale olympique par son coéquipier Willie Steele, qui, pour son bond victorieux de 7,825 mètres, a besoin de 50 mètres d'élan.

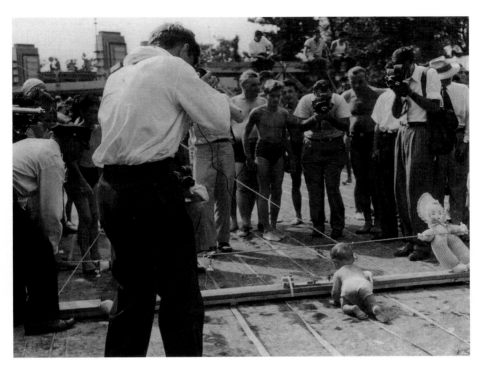

Palisades Park, New Jersey, staged the tenth annual baby-crawling race on 29 July 1948. The sponsor was the "National Institute for Diaper Services." The picture shows the winner, 14-month-old Donald Samuel, who has left all his rivals way behind.

Im Palisades Park (New Jersey) wird am 29. Juli 1948 bereits zum zehnten Mal das »Baby-Krabbel-Rennen« ausgetragen. Schirmherr der Veranstaltung ist das »Nationale Institut für Windelservice«. Das Bild zeigt den 14 Monate alten Sieger, Donald Samuel, der allen Gegnern davongekrabbelt ist.

Au Palisades Park, dans le New Jersey, on organise déjà, le 29 juillet 1948, la dixième « course de bébés à quatre pattes ». La manifestation est placée sous les auspices de l'« Institut national de services de couches ». La photo représente le vainqueur, Donald Samuel, 14 mois, qui a laissé derrière lui tous ses adversaires.

This "black-and-white" soccer match took place in the German city of Nuremberg in 1951. It is chimney sweeps versus bakers, and a bread-bin doubles up for the ball. "After numerous comical interruptions, the match ended in a decisive one-all draw."

Dieses »schwarz-weiße« Fußballspiel findet 1951 in Nürnberg statt. Die Auswahlmannschaften der Bäcker und der Schornsteinfeger haben den Ball gegen einen Brotkorb ausgetauscht: »Nach vielen lustigen Unterbrechungen endet das Spiel mit einem klaren 1:1.«

Ce match de football « noir et blanc » a lieu à Nuremberg en 1951. L'équipe des boulangers et celle des ramoneurs ont préféré au ballon une huche à pain : « Après de nombreux avatars tous plus amusants les uns que les autres, le match s'est terminé sur un nul sans équivoque 1:1. »

During the hungry war and postwar years, the food problem in Germany consisted in getting enough to eat; by the 1950s, overweight and physical fitness were back on the agenda, in this case both together: "(West) Berlin's fattest woman, Anni Ebert, is still very supple in spite of her 185 kilos (408 lbs)."

Während der Hungerjahre zu Kriegs- und Nachkriegszeiten ging es für die Bevölkerung in Deutschland um das nackte Überleben, doch in den fünfziger Jahren gewinnen Themen wie Übergewicht und Fitneß wieder an Bedeutung: »(West-)Berlins dickste Frau, Anni Ebert, ist trotz ihrer 370 Pfund Gewicht noch recht beweglich.«

Pendant la guerre et et les années d'après-guerre marquées par les privations, la population allemande s'efforçait de survivre. Mais, dans les années 50, l'obésité et l'exercice physique pour la combattre sont à nouveau d'actualité : « La femme la plus grosse de Berlin (Ouest), Anni Ebert, est encore relativement alerte malgré ses 185 kilos. »

In the north of Spain, the Basques and Catalans have spent the 20th century struggling for cultural and political autonomy. Under the dictatorship (1939–1975) of "Caudillo" General Franco, folk festivals, like this one in the 1950s, were the only chance of expressing regional self-identity.

Im Norden Spaniens kämpfen die Katalanen und Basken im 20. Jahrhundert für ihre kulturelle und politische Autonomie. Während der Diktatur des »Caudillo« Franco (1939–1975) bieten Volksfeste wie dieses in den fünfziger Jahren jedoch die einzige Möglichkeit, die regionale Eigenständigkeit in Bräuchen auszuleben.

Dans le nord de l'Espagne, Catalans et Basques luttent, au XXᵉ siècle, pour leur autonomie culturelle et politique. Sous la didacture du « Caudillo » Franco (1939–1975), les fêtes populaires comme celle-ci, sont cependant, dans les années 50, la seule possibilité de faire revivre la spécificité régionale par le biais de leurs coutumes.

American hopeful Hazel Barr in training for the 1952 Helsinki Summer Olympics. The water sports disciplines proved disastrous for the USA. Only the divers managed to put up a convincing performance.

Die amerikanische Hoffnungsträgerin Hazel Barr trainiert für die Olympischen Sommerspiele in Helsinki 1952. Die Kunst- und Turmspringer sind die einzigen US-Athleten, die bei den Schwimmwettbewerben überzeugen. Alle anderen Wasserdisziplinen enden in einem Desaster für das amerikanische Team.

Hazel Barr, sur qui se portent tous les espoirs des Etats-Unis, s'entraîne pour les Jeux olympiques d'été à Helsinki en 1952. Les plongeurs au tremplin et de haut vol sont les seuls athlètes américains performants lors des compétitions de natation. Toutes les autres disciplines aquatiques se terminent par un désastre pour l'équipe américaine.

Mrs Routledge (left) represented Cumberland in the National Amateur Bowls Championships at Wimbledon Common on 26 August 1965. With true English understatement, her opponent, Mrs Bruce from Durham, demonstrates her enthusiasm for a good shot.

Mrs Routledge (links) spielt am 26. August 1965 bei den Nationalen Amateur-Meisterschaften im Bowling im Park von Wimbledon für die Auswahl aus Cumberland. Ihre Gegnerin, Mrs Bruce aus Durham, zollt dem Wurf gemäß den Regeln des britischen Understatements Respekt.

Le 26 août 1965, aux championnats nationaux amateurs de bowling, dans le parc de Wimbledon, Mrs Routledge (à gauche) joue pour la sélection du Cumberland. Son adversaire, Mrs Bruce, qui joue à Durham, ne manque pas d'admirer ce jet sans se départir de son flegme.

The English photographer who came up with this shot in the 1960s saw it as a reflection of the "sweet and cheerful life" of the circus artiste. This particular artiste is Mimie Percival in training for her performance at the circus in Chessington Zoo.

Ein englischer Fotograf unterstreicht mit dieser Aufnahme aus den sechziger Jahren die Vorstellung vom »süßen und fröhlichen Artistenleben«. Der Schnappschuß zeigt Mimie Percival beim Training für ihren Auftritt im Zirkus des Zoos von Chessington.

Voilà l'idée que se fait un photographe anglais de la « douce et joyeuse vie d'artiste ». Cet instantané des années 60 montre Mimie Percival s'entraînant pour son numéro au cirque du zoo de Chessington.

Aliens

Fremdlinge

L'étrange

The press likes to play on the anxieties of its readers. As soon as aliens from distant exotic countries turn up in photographs, the papers stir up the fear of the unknown, the atavistic and the archaic. Anything "wild" is seen as symbolic of a primeval age which was believed to have been overcome, and, at the same time, a fascinating contrast to Western civilization. The press also looked to the future, however, with pictures from the world of machines, from factories and from research laboratories. Human beings appear here as no more than ant-like extraterrestrials, instilling fear at first into many contemporary readers. They transformed the future into an unpredictable quantity – or would have done, had it not been for the unshakable faith in progress, which acknowledged the developments as a law of nature. For a short moment, both species of alien shake the foundations of the humdrum and predictable world of the reader. It is the caption which tames the power of the pictures disparaging the foreign culture, while fatalistically genuflecting before the brave new world of progress. The arrogance displayed towards the "savage" and the awe in the face of the future confirm the reader's secure place in the here and now, and so the newspaper, once read, can be put to one side in peace and contentment.

Die Presse spielt gern mit den Ängsten ihrer Leser. Sobald Fremde aus exotischen Ländern in Fotografien auftauchen, rühren die Blätter an die Furcht der Leser vor dem Unbekannten, dem Atavistischen und Archaischen. Das »Wilde« ist das Symbol einer überwunden geglaubten Urzeit und zugleich das faszinierende Gegenbild zur westlichen Zivilisation. In die Zukunft blickt die Presse hingegen mit Bildern aus der Maschinenwelt, den Fabriken und Forschungslaboratorien. Menschen erscheinen hier nur als ameisengroße Außerirdische, die vielen Zeitgenossen auf den ersten Blick angst machen. Sie lassen die Zukunft zu einer unberechenbaren Größe werden – wäre da nicht der unerschütterliche Fortschrittsglaube, mit dem diese Entwicklung fast schon als Naturgesetz hingenommen wird. Beide Spezies Fremdlinge bringen für einen kurzen Moment die durchschnittliche und überschaubare Welt der Leser ins Wanken. Die Macht der Bilder wird aber durch den Text domestiziert, der auf der einen Seite einen überheblichen Blick auf fremde Kulturen wirft, auf der anderen Seite aber die schöne neue Welt fatalistisch anbetet. Die Arroganz gegenüber dem Wilden und die Ehrfurcht vor der Zukunft bestätigen den Leser in seinem Hier und Jetzt und lassen ihn letztendlich zufrieden die Zeitung beiseite legen.

La presse joue volontiers avec les émotions de ses lecteurs. Dès qu'ils reproduisent la photo d'étrangers de pays exotiques, les journaux inspirent de la peur aux lecteurs, celle qui s'empare d'eux face à l'inconnu, l'atavique et l'archaïque. Le « sauvage » est le symbole, de temps reculés, d'une époque préhistorique que l'on croyait révolue et, simultanément, l'antagonisme fascinant de la civilisation occidentale. La presse se tourne par contre vers l'avenir avec des clichés du « monde de machines », des usines et laboratoires de recherche. Ici, les hommes ne sont plus que des extraterrestres de la taille d'une fourmi qui, à première vue, suscitent la peur parmi beaucoup de leurs contemporains. L'avenir revêt une grandeur imprévisible. Dieu soit loué ! Il y a la foi inébranlable dans le progrès, qui permet de considérer ce développement comme une loi de la nature. Ces deux types d'étrangers ébranlent pour un bref instant le monde familier et transparent du lecteur. Mais, en dernier ressort, le texte canalise la puissance expressive des photos, ce texte qui, d'une part, jette un regard arrogant sur les cultures étrangères, mais, de l'autre, loue avec fatalisme le nouveau monde. L'arrogance envers l'étranger et la crainte de l'avenir confirment au lecteur qu'il est bien là où il est, l'incitent finalement à replier son journal avec un soupir de satisfaction.

Human beings as exhibits have exercised a particular fascination since time immemorial. On view here are heroes of the Second World War. At the Engineering and Marine Exhibition at London's Olympia on 27 August 1947, Jim Daly, a former Royal Navy frogman, is seen giving a vivid demonstration of diving skills.

Menschliche Lebewesen üben als Ausstellungsstücke von jeher einen besonderen Reiz auf das Publikum aus: Hier sieht man Helden des Zweiten Weltkriegs. Der ehemalige Froschmann der Königlichen Marine, Jim Daly, gibt am 27. August 1947 auf der Technik- und Marineausstellung im Londoner Olympia Anschauungsunterricht in Sachen Tauchen.

L'être humain en tant que pièce d'exposition a toujours exercé un attrait particulier sur le public : ici, on voit des héros de la Seconde Guerre mondiale. L'ancien homme-grenouille de la Marine royale, Jim Daly, fait une démonstration de plongée « in vitro », le 27 août 1947, à l'Exposition de la Technique et de la Marine, à l'Olympia de Londres.

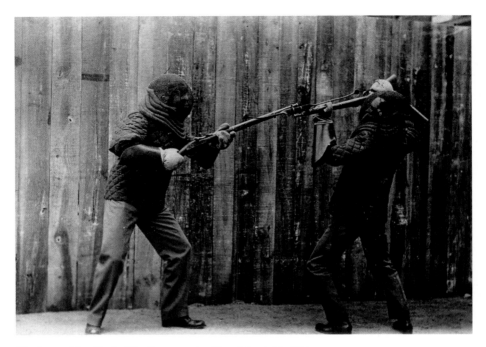

"Devils or soldiers?" asked the German sub-editor at the sight of this 1920s' picture, and then went on to explain. "American marines in protective gear at bayonet practice." The entry of the USA into the Great War in 1917 rapidly brought about a change in favor of the Franco-British entente.

»Teufel oder Soldaten?« fragt der deutsche Kommentar angesichts dieses Bildes aus den zwanziger Jahren und erklärt: »Amerikanische Seesoldaten in ihrer Schutzausrüstung bei Bajonettübungen«. Der Kriegseintritt der USA im Jahre 1917 brachte im Ersten Weltkrieg die Wende zugunsten der französisch-britischen Entente.

« Diables ou soldats ? », se demande le commentateur allemand de cette photo des années 20, avant d'expliquer : « Des membres de la marine américaine s'exercent au combat à la baïonnette en portant leur équipement de protection ». L'entrée en guerre des Etats-Unis, en 1917, fait définitivement pencher la balance en faveur de l'Entente franco-britannique.

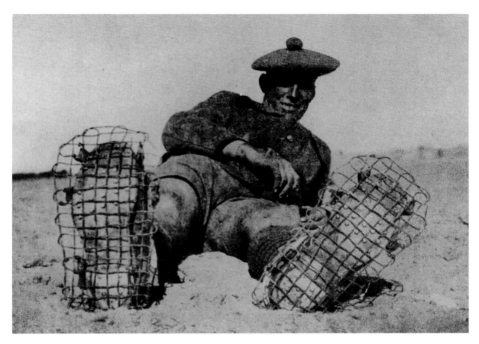

The steel-wire shoes worn by British soldiers in the Sinai desert stopped them sinking into the sand. Sappers constructed temporary wire-netting paths across the desert from 1914 on. Egypt, and thus the Sinai peninsula, became a British protectorate in that year, giving the United Kingdom control of the Suez Canal, which had been opened in 1869.

Die Stahldrahtschuhe des britischen Soldaten in der Wüste Sinai verhindern das Einsinken im Sand. Bausoldaten richten nach 1914 mit Maschendraht provisorische Wege durch die Wüste ein. Ägypten, und somit auch der Sinai, war seit 1914 britisches Protektorat, und das Vereinigte Königreich kontrollierte daher auch den 1869 eingeweihten Suezkanal.

Les chaussures à semelles en grillage métallique de ce soldat britannique l'empêchent de s'enfoncer dans le sable du désert du Sinaï. A partir de 1914, des soldats tracent à l'aide de grillage des voies de communication provisoires à travers le désert. L'Egypte, et donc aussi le Sinaï, était protectorat britannique depuis 1914 et ainsi le Royaume-Uni détenait le contrôle du canal de Suez inauguré en 1869.

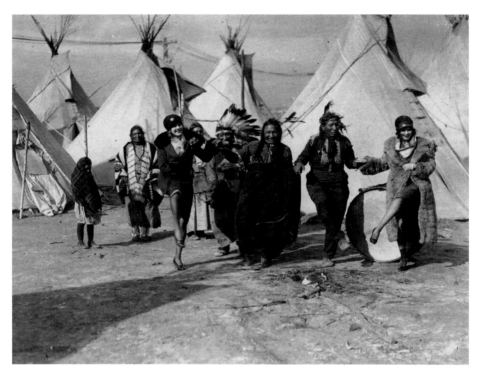

The Pow-Wow Centennial in Philadelphia in November 1926 also attracted two dancing girls from the world-famous Ziegfeld Follies chorus line, on hand to "teach the Indians the latest dance steps." The words of the caption leave no doubt as to who was supposed to learn from whom.

Das hundertjährige Jubiläum der Pow-Wow-Versammlung in Philadelphia zieht im November 1926 nicht nur Indianerstämme an. Auch zwei Tänzerinnen der weltberühmten Revue-Girls Ziegfeld Follies besuchen das Fest. Die Überschrift »Unterricht der Indianer in neuesten Tanzschritten« läßt keinen Zweifel daran, wer hier von wem zu lernen hat.

Le Centenaire de la réunion des Pow-Wow, à Philadelphie, en novembre 1926 : deux danseuses des Ziegfeld Follies, revue mondialement célèbre, assistent à la fête. La légende de cette photo « Cours de danse moderne donnés aux Indiens » nous indique clairement qui a besoin des cours.

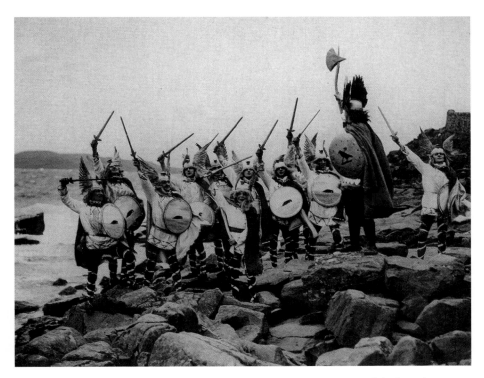

The Shetland Islands off the northern tip of Scotland are the scene every January of the festival of "Up Helly Aa." This picture, dating from the 1920s, shows the "Norsemen" in period costume before setting fire to a Viking ship off Lerwick pier. The festival is based on an ancient Nordic custom to celebrate the lengthening of the day and the return of light.

Auf den Shetlandinseln findet Ende Januar das alljährliche Festival »Up Helly Aa« statt. Auch diese Prozession in den zwanziger Jahren wird damit enden, daß Männer in historischen Kostümen an der Pier von Lerwick ein altes Wikingerschiff in Flammen aufgehen lassen. Nach altem nordischen Brauch feiern sie den Frühlingsanfang und die Rückkehr des Lichts.

Dans les îles des Shetland, on organise chaque année, à la fin du mois de janvier, le festival « Up Helly Aa ». Ce défilé des années 20 va aussi se terminer comme de coutume, à savoir ces « Normands » en costumes historiques vont incendier un vieux bateau viking à la jetée de Lerwick. Les jours s'allongent à nouveau et, selon une vieille tradition scandinave, ils fêtent le retour de la lumière.

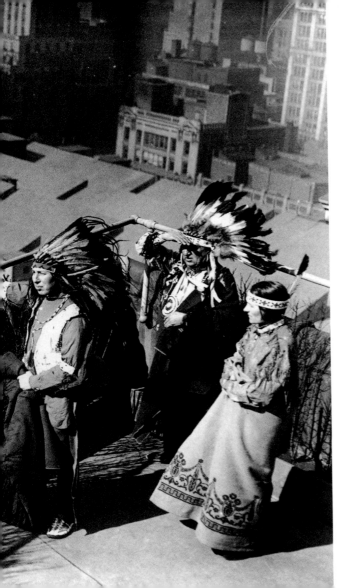

These two splendid gentlemen, pictured on 5 March 1926, are members of the Abeneki tribe, who originally sold Manhattan to the palefaces for the pitiful sum of $ 24.

5. März 1926. Diese beiden Ehrenmänner sind vom Stamm der Abenekis, der Manhattan ursprünglich für die klägliche Summe von 24 Dollar an die Bleichgesichter verkauft hat.

5 mars 1926. Ces deux chefs appartiennent à la tribu des Abenekis, qui, quelques siècles plus tôt, a vendu Manhattan aux visages pâles pour la dérisoire somme de 24 dollars.

Under the heading "The World in a Circus," an English newspaper reported on 19 December 1930 that "Mr Bertram Mills has returned from his continental tour with a trunk of thrills for his Olympia Circus program." The thrills included this Ugangi beauty from darkest Africa.

Die englische Meldung »Die Welt in einem Zirkus« vom 19. Dezember 1930 berichtet: »Mr Bertram Mills ist von seiner Tournee über den Kontinent mit einem Schrankkoffer voller Spannung für das Programm seines Olympia-Zirkus zurückgekehrt.« Auch diese Ugangi-Schönheit aus Schwarzafrika tritt auf.

Comme nous l'apprend le reportage anglais « Le monde dans un cirque » du 19 décembre 1930, « M. Bertram Mills est revenu de sa tournée à travers le continent avec une valise pleine de surprises qu'il a inscrites au programme de son prochain spectacle au cirque de l'Olympia ». Cette beauté Ugangi d'Afrique noire compte également parmi les artistes.

This photo, dating from the late 1920s, depicts an Indian hermaphrodite, a member of the Hindu Brahmin caste. Such people are regarded as the elect or the allies of the gods, for the god Shiva is also bisexual in nature. For outsiders, Hinduism is as many-layered as it is mysterious.

Dieses Foto aus den späten zwanziger Jahren zeigt einen indischen Hermaphroditen, der der Hindu-Kaste der Brahmanen angehört. Zwitter werden als Auserwählte oder Verbündete der Götter betrachtet; auch der Hindu-Gott Shiva ist bisexueller Natur. Der Hinduismus bleibt für Außenstehende ebenso vielschichtig wie geheimnisvoll.

Cette photo prise à la fin des années 20 montre un hermaphrodite indien appartenant à la caste hindoue des Brahmanes. Les hermaphrodites sont considérés comme des élus ou des alliés des dieux et la divinité hindoue Shiva est elle aussi bisexuelle. Pour les non-initiés, l'hindouisme est une religion aussi diversifiée que mystérieuse.

The lost property office at London's Waterloo Station provided one photographer in the 1920s with an unusual collection of finds and a well-disposed official, who was prepared to model a complete diving suit left behind on a train by a passenger. A stuffed alligator in the background had also escaped somebody's attention.

Im Fundbüro des Londoner Bahnhofs Waterloo trifft ein Fotograf in den zwanziger Jahren auf eine außergewöhnliche Sammlung an Fundstücken und einen gut aufgelegten Beamten. Letzterer steigt in einen Taucheranzug, den ein Bahngast vollständig im Zug zurückließ, den Hintergrund des Fotos bildet ein ausgestopfter Alligator.

Au bureau des objets trouvés de la gare de Waterloo, à Londres, un photographe des années 20 découvre un bric-à-brac extraordinaire d'objets en tout genre et un fonctionnaire facétieux. Celui-ci se glisse dans le costume de plongeur qu'un voyageur a oublié dans le trai ; à l'arrière-plan, un alligator empaillé.

While Mahatma Gandhi's struggle for Indian independence from Great Britain was constantly in the headlines, "curious" photographs provided a counter-balance on the inside pages. Here is one such, of a Hindu ascetic in the 1920s. "A penitent such as one comes across in India; this kind of torture is not very common."

Während Mahatma Gandhi seit 1919 durch seinen Kampf für die indische Unabhängigkeit von Großbritannien immer wieder in die Schlagzeilen gerät, werden diese Meldungen mit »kuriosen Photographien« im Unterhaltungsteil der Zeitungen konterkariert. Hier ein kurioses Foto eines hinduistischen Asketen aus den zwanziger Jahren: »... ein Büßer, wie man ihn bei den Indern finden kann; diese Art von Folter kommt nicht häufig vor«.

Alors que Mahatma Gandhi qui lutte pour obtenir de la Grande-Bretagne l'indépendance de l'Inde, ne cesse de faire les grands titres des journaux, depuis 1919, à la rubrique Divertissements, on découvre de « curieuses photographies » comme celle de cet ascète hindou des années 20 : « Un pénitent comme il y en a parfois chez les Indiens, mais ce genre de torture n'est pas fréquent ».

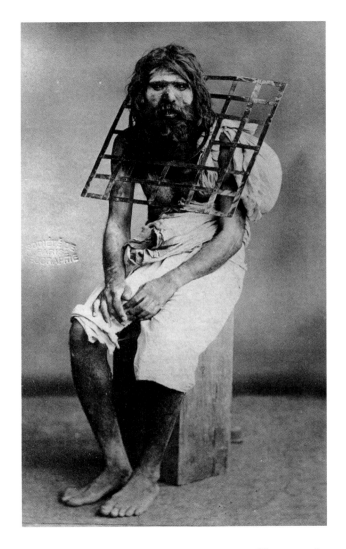

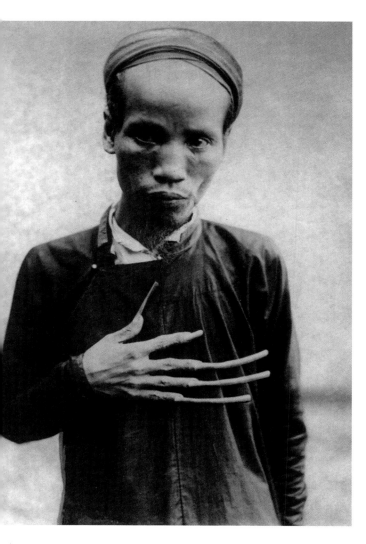

The caption to this 1920s' picture on the occasion of the Paris Colonial Exhibition says of this living exhibit: "An Annamese Longfinger, whose incredibly long fingernails are his great pride." In addition to Annam, the French colonial empire in south-east Asia also included Cambodia.

Anläßlich der Pariser Kolonialausstellung meint der Redakteur des Bildtextes aus den zwanziger Jahren über dieses lebende Exponat zu wissen: »Ein Langfinger aus Annam, dessen unglaublich lange Fingernägel sein ganzer Stolz sind.« Neben Annam umfaßte das französische Kolonialgebiet in Ostasien auch Kambodscha.

Cette photo d'un homme présenté pour l'Exposition coloniale, à Paris, dans les années 20, s'accompagne de la légende suivante : « Un Asiatique d'Annam, dont les ongles incroyablement longs sont toute la fierté ». Outre l'Annam, le Cambodge faisait partie des colonies françaises en Extrême-Orient.

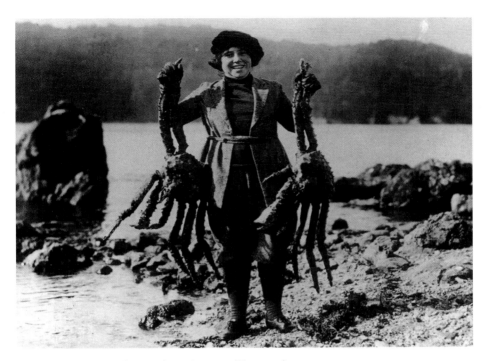

In typical hunting pose, this 1930s' American expedition member proudly displays two Alaska crabs she has caught on the islands in the Bering Sea. In comparison with ordinary crabs just a few centimeters long, these measuring 4–5 feet come across as monsters.

In typischer Jägerpose präsentiert in den dreißiger Jahren diese amerikanische Expeditionsteilnehmerin auf den Inseln der Bering-See zwei erlegte Alaska-Krebse. Diese nehmen sich gegenüber den gewöhnlichen Krebsen, die nur wenige Zentimeter messen, wie Untiere aus.

Posant fièrement comme un chasseur, cette exploratrice américaine des années 30 exhibe deux écrevisses de l'Alaska qu'elle a capturés dans les îles de la mer de Béring. Comparés aux autres écrevisses conventionnels qui ne mesurent que quelques centimètres, ceux-ci font figure de monstres.

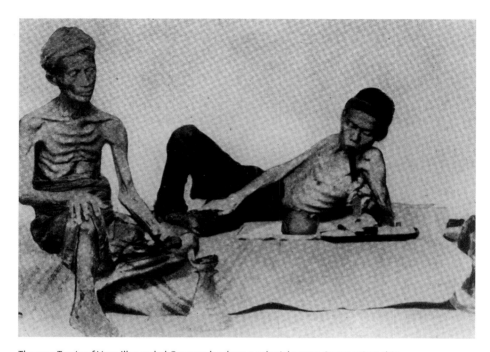

The 1919 Treaty of Versailles ended Germany's role as a colonial power. Seen against this background, the criticism of the German sub-editor comes across in a different light: "English greed has made the vice of opium-smoking endemic not only in China, but in India too. Here, even babies are pacified with opium pills, so that their mothers can work for starvation wages in English factories."

Der Friedensvertrag von Versailles beendet 1919 Deutschlands Rolle als Kolonialmacht. Vor diesem Hintergrund erscheint die Kritik des deutschen Redakteurs in einem anderen Licht: »Englische Gewinnsucht hat das Laster des Opiumrauchens nicht nur in China, sondern auch in Indien heimisch gemacht. Hier werden sogar die Säuglinge mit Opiumpillen zur Ruhe gebracht, damit ihre Mütter in englischen Fabriken für Hungerlöhne arbeiten können.«

Le Traité de Versailles impose à l'Allemagne l'abandon de ses colonies en 1919. C'est dans ce contexte qu'il faut replacer la critique du rédacteur allemand : « L'âpreté au gain des Anglais a favorisé le développement des fumeries d'opium, un fléau en Chine, mais aussi en Inde. Dans ce pays, on calme même les nourrissons avec des comprimés d'opium afin que leurs mères puissent travailler pour un salaire de misère dans les usines des Anglais ».

On 6 June 1929, German newspapers explained to their readers how pilots had to be equipped for high-flying "...with generously fur-lined flying coat and fur shoes to protect them from the immense cold. The oxygen apparatus enables him to breathe, while the fur-lined goggles protect his eyes from the cold and the glare."

Am 6. Juni 1929 erklären deutsche Zeitungen ihren Lesern, wie Piloten für einen Höhenflug ausgerüstet sein müssen – mit einer »mit starkem Pelz gefütterten Fliegerausrüstung und Pelzschuhen, welche ihn vor der ungeheuren Kälte schützen. Der Sauerstoffapparat ermöglicht ihm die Atmung, die mit Pelz gefütterten Brillen schützen vor Kälte und grellem Licht.«

Le 6 juin 1929, les journaux allemands expliquent à leurs lecteurs comment doivent s'équiper les pilotes pour voler à haute altitude – « une combinaison doublée d'une épaisse fourrure et des chaussures en fourrure qui les protègent du froid très vif. L'appareil à oxygène leur permet de respirer et les lunettes fourrées les protègent du froid et de la lumière éblouissante ».

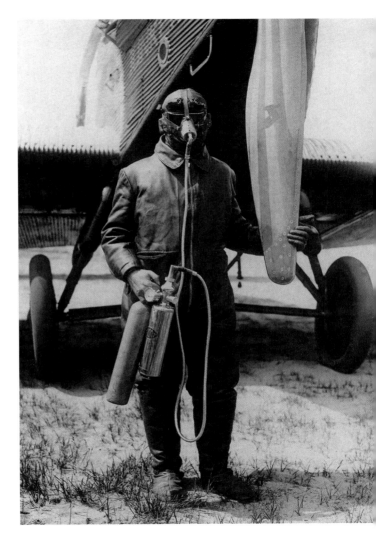

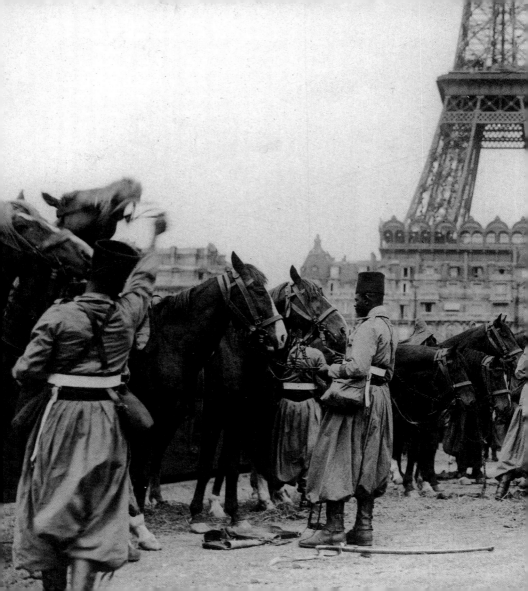

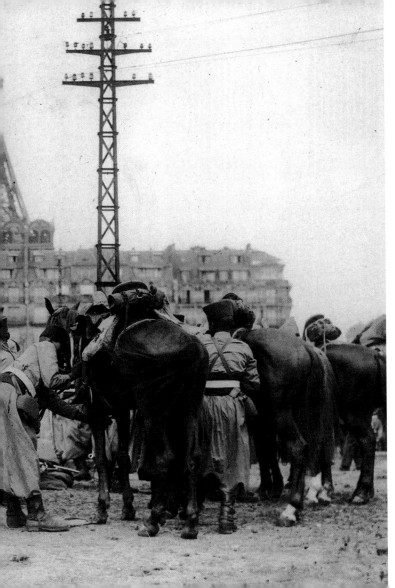

The Sultan of Morocco's household cavalry arrive in Paris in the 1920s. On 14 July, France summoned the rulers of its colonies to Paris. Morocco had been a French protectorate since 1912, but from 1930 there was increased resistance to the colonial masters.

Die Reitergarde des Sultans von Marokko kommt in den zwanziger Jahren in Paris an. Am 14. Juli ruft Frankreich auch die Regenten seiner Kolonien in die Hauptstadt. Marokko ist seit 1912 französisches Protektorat, ab 1930 verstärkt sich jedoch der Widerstand gegen die Kolonialherren.

Dans les années 20, la garde montée du sultan du Maroc arrive à Paris. Le 14 juillet, la Grande Nation fait aussi venir dans la capitale ceux qui administrent ses colonies. Depuis 1912, le Maroc est protectorat français, mais, à partir de 1930, la résistance au régime colonial s'accentue.

The "Gallery of Phenomena" in the Lunapark in Paris acquired a new live exhibit in the early 1930s. The promoter hoped that the German Adriana, the "bearded lady", would attract the crowds.

Die »Galerie der Phänomene« im Pariser Lunapark hat Anfang der dreißiger Jahre ein neues lebendes Exponat für sich gewinnen können: Der Veranstalter hofft, daß die Deutsche Adriana, die »Frau mit Bart«, viele Schaulustige anziehen wird.

La « Galerie des phénomènes », au Lunapark de Paris, au début des années 30, compte une nouvelle attraction : l'organisateur espère que l'Allemande Adriana, la « femme à barbe », attirera d'innombrables visiteurs.

"The revelation of the true identity of Mr Burtt has caused amazement at Tisbury, Wiltshire, where he has lived as a woman for 29 years." This item in an English local newspaper was passed on to agencies on 26 March 1930, with the additional information that Burtt's employer valued his services as the perfect maidservant.

»Die Enthüllung der wahren Identität des Mr Burtt hat in Tisbury (Wiltshire) Erstaunen ausgelöst, wo er 29 Jahre lang als Frau gelebt hat.« Diese englische Lokalnachricht geht am 26. März 1930 an die Agenturen, mit der zusätzlichen Information, daß Burtts Arbeitgeber ihn als ideales Dienstmädchen schätzt.

« La divulgation de la véritable identité de Mr Burtt a déclenché une vague de stupeur à Tisbury, dans le Wiltshire, où il a vécu pendant 29 ans en tant que femme. » Le 26 mars 1930, la presse locale anglaise envoie cette information aux agences en précisant que l'employeur de Burtt l'appréciait comme servante, rôle dans lequel il excellait.

This worker in an American steel foundry during the 1930s is pictured using a sand-blaster for cleaning operations. The German sub-editor captioned the photograph "A monster of technology" and went on: "For his own protection, he wears a helmet similar to that worn by divers. A tube supplies him with a constant fresh-air supply."

Dieser Arbeiter einer amerikanischen Stahlgießerei benutzt in den dreißiger Jahren für Reinigungsarbeiten ein Sandstrahlgebläse. Der deutsche Redakteur betitelt das Bild mit »Ein Ungeheuer der Technik«: »Um dabei geschützt zu sein, trägt er einen Helm, ähnlich den Taucherkappen. Durch eine Rohrleitung wird ihm ständig frische Luft zugeführt.«

Dans les années 30, cet ouvrier d'une aciérie américaine utilise une sableuse pour des opérations de nettoyage. Le rédacteur allemand intitule ce cliché : « Un monstre de la technique » : « Pour bien se protéger, il porte un casque, similaire à celui d'un plongeur. Un tuyau en caoutchouc lui fournit en permanence de l'air frais. »

In 1929, an underwater expedition placed a mobile research station on the seabed off the Bahamas. The expedition photographer on this occasion was accompanied by his wife and child; one of the divers is entertaining the baby.

Auf den Bahamas hat 1929 eine Unterwasserexpedition eine mobile Forschungsstation auf den Meeresboden herabgelassen. Der Expeditionsfotograf wird hier von Frau und Kind begleitet, und einer der Taucher »unterhält« das Baby.

Aux Bahamas, en 1929, une expédition sous-marine a placé sur le fond de la mer une station mobile de recherche. Le photographe de l'expédition s'est fait accompagner par sa femme et son enfant ; ici, l'un des plongeurs « divertit » le bébé.

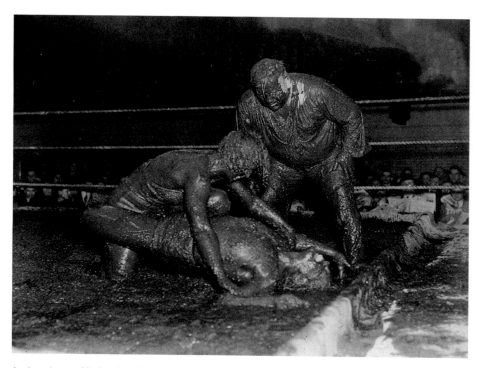

An American public hardened by the rigors of the Depression wanted rough sports in the 1930s. This "spectatoritis" led to the sort of excesses documented by this photograph: ladies' mud-wrestling. Even so, prejudice against women participating in any kind of leisure sport was only gradually breaking down.

Ein durch die Wirtschaftskrise abgehärtetes amerikanisches Publikum verlangt in den dreißiger Jahren nach rauhen Sportarten. Diese »Spectatoritis« führt mitunter auch zu Auswüchsen, die dieses Foto dokumentiert: Schlammringen für Damen. Die Vorurteile gegen im Freizeitsport aktive Frauen geraten allerdings erst langsam ins Wanken.

Un public américain endurci par la crise économique exige, dans les années 30, des disciplines sportives plus rudes. Cette « spectatorite » conduit aussi à des excès, comme le montre cette photo : combat de dames dans la boue. Les préjugés contre les femmes qui pratiquent des sports d'agrément ne disparaissent toutefois que très lentement.

"Crawl" was the name given to this swimming aid demonstrated at a Paris swimming pool on the evening of 12 May 1937. The photographer succeeded in taking a promising picture at the press preview.

»Crawl« nennt sich diese Schwimmhilfe, die am Abend des 12. Mai 1937 in einem Pariser Schwimmbad vorgestellt wird. Dem Fotografen gelingt beim Pressetermin ein vielversprechendes Foto.

« Crawl » est le nom de cet accessoire de natation, présenté le soir du 12 mai 1937 dans une piscine parisienne. Lors de la présentation à la presse, le photographe réussit à faire une photo très prometteuse.

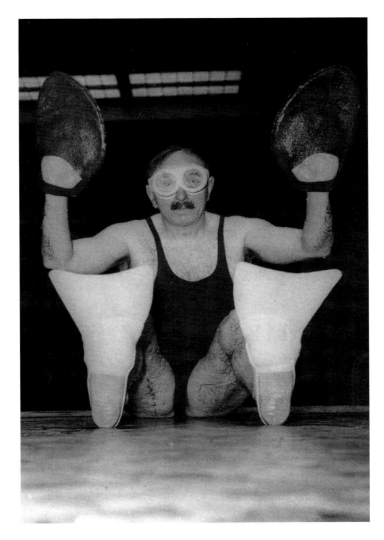

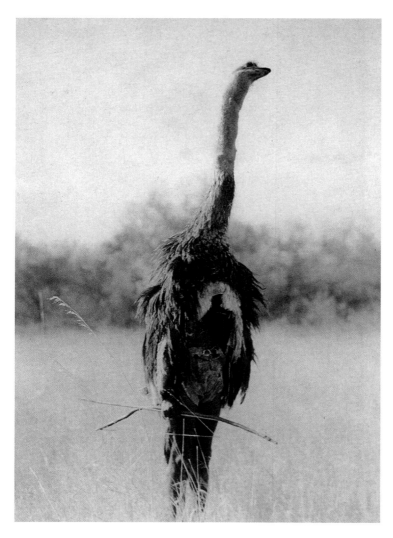

Kalahari desert in southern Africa, March 1930. The bushmen camouflage themselves with the plumage, neck and head of an ostrich in order to approach their quarry without attracting attention. The prey is then dispatched with bow and arrow.

Kalahari-Wüste im Süden Afrikas, März 1930. Die Buschmänner tarnen sich mit dem Gefieder und dem Kopf eines Straußes, um sich den Tieren unauffällig nähern zu können. Die Beute wird dann mit Pfeil und Bogen erlegt.

Désert du Kalahari, dans le sud de l'Afrique, en mars 1930. Les autochtones utilisent les plumes et la tête d'une autruche pour tromper ces animaux et se rapprocher d'eux sans les effrayer. Ils abattent alors leur proie avec un arc et une flèche.

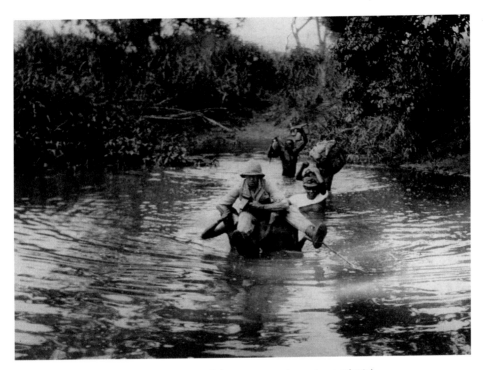

This picture was released by an agency on 10 February 1930 and reports on colonial behavior not only in the British protectorate of Uganda, but throughout Africa. "Colonel Furlong keeping his feet dry in Uganda. Many streams and rivers on the expedition were forced in this manner."

Dieses Bild wird am 10. Februar 1930 von einer Agentur zur Veröffentlichung frei-gegeben und berichtet über koloniales Verhalten nicht nur im britischen Protektorat Uganda, sondern in ganz Afrika: »Colonel Furlong hält in Uganda seine Füße trocken. – Viele Ströme und Flüsse wurden auf der Expedition in dieser Manier bezwungen.«

Le 10 février 1930, une agence de presse autorise la publication de cette photo illustrant le comportement des colons non seulement dans le protectorat britannique de l'Ouganda, mais aussi dans toute l'Afrique : « Le colonel Furlong garde les pieds au sec en Ouganda. – Beaucoup de fleuves et rivières sont franchis de cette manière au cours de l'expédition. »

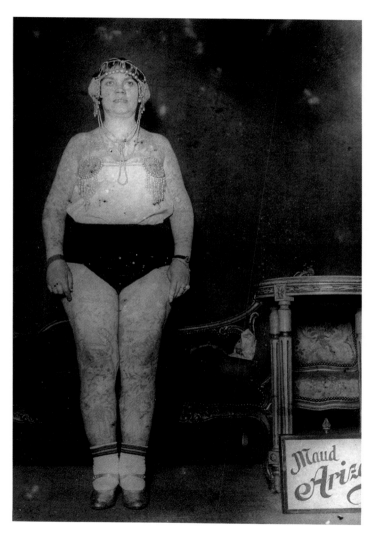

A "Gallery of Strange Phenomena" in Paris specialized in just that. This lady, tattooed from head to toe, appeared under the name of "Maud Arizon."

Eine »Galerie der wundersamen Erscheinungen« in Paris hat sich auf bizarre Phänomene spezialisiert. Diese von Kopf bis Fuß tätowierte Dame tritt unter dem Namen Maud Arizon auf.

Une « Galerie des phénomènes étonnants », à Paris, s'est spécialisée dans la présentation de bizarreries. Cette femme tatouée de la tête aux pieds se produit sous le surnom de Maud Arizon.

On 21 July 1932, a photographer espied a so-called "crocodile woman" at a fair in Paris. "Her skin is rough like a lizard's, and grayish in color."

Auf einem Jahrmarkt in Paris entdeckt ein Fotograf am 21. Juli 1932 eine sogenannte »Krokodilfrau«: »Ihre Haut ist rauh wie die einer Echse und von gräulicher Farbe.«

A une fête foraine parisienne, un photographe découvre, le 21 juillet 1932, une « femme-crocodile » : « Sa peau de couleur grisâtre est râpeuse comme celle de l'animal. »

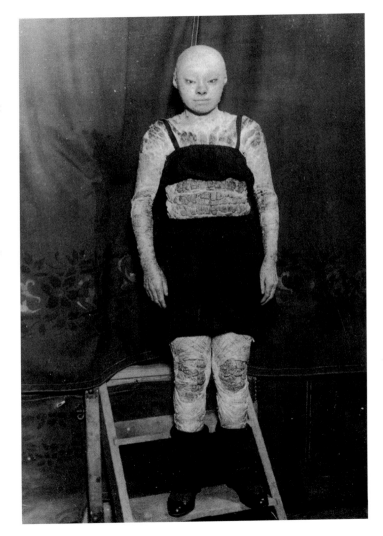

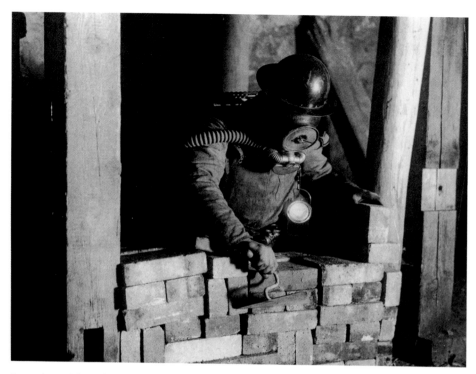

A 1930s' report from the Mining Academy in the town of Freiberg in Saxony included this picture of a student practising walling up a gallery to create a firebreak in the event of a gas escape.

Aus einer Reportage über die deutsche Bergakademie Freiberg stammt dieses Bild aus den dreißiger Jahren. Ein Student übt für den Notfall das Mauern eines Branddammes im vergasten Schacht.

Cette photo des années 30 est tirée d'un reportage sur l'Académie allemande des mines de Freiberg. Un étudiant-mineur apprend à édifier un mur anti-feu dans une galerie envahie par les gaz.

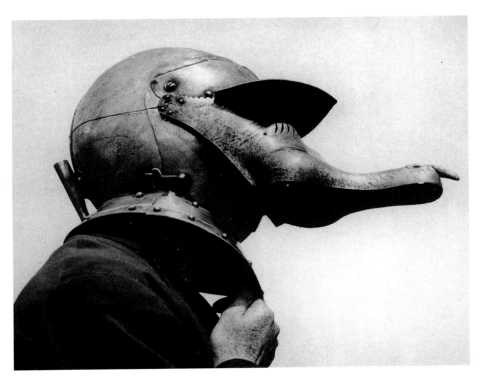

In the 1930s, a Mr Rex from England added this development to the Knight's helmet. The beak-like shape not only looks futuristic, but protects the bearer in close combat.

In den dreißiger Jahren entwickelt Mr Rex aus England den Ritterhelm weiter. Die Schnabelform läßt den Kopfschutz nicht nur futuristischer aussehen, sie schützt den Träger auch im Nahkampf.

Dans les années 30, un Anglais, M. Rex, perfectionne le heaume de chevalier du Moyen Age. La protubérance en forme de bec d'oiseau ne donne pas seulement un aspect plus futuriste à ce casque, elle protège aussi celui qui le porte dans les combats au corps à corps.

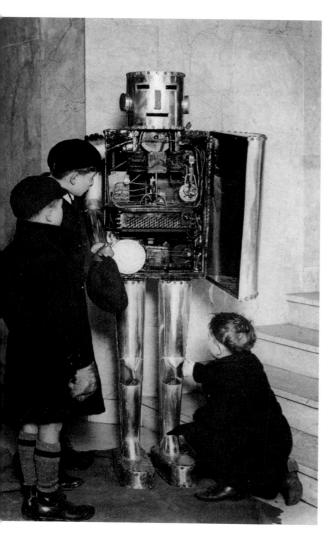

The original 1930s caption, it must be said, reflects the writer's faith in progress rather than in reality: "This steel man is near enough to accuracy to explain the physiology of the human frame."

Beim Original-Bildtext aus den dreißiger Jahren ist der Fortschrittsglaube des Reporters der Vater des formulierten Gedankens: »Der Stahlmann ist nahe genug an der Wirklichkeit gebaut, um die Physiologie des menschlichen Körpers zu erläutern.«

La légende originale de la photo, des années 30, montre que le reporter croit au progrès : « L'homme d'acier est suffisamment proche de la réalité pour expliquer la physiologie du corps humain. »

The title "Two pygmy friends of the discoverer" continues the prejudice that Europeans had "discovered" Africa in the previous two centuries and ignores the fact that Africans had been the first people to settle southern Europe and central Asia.

Die Bildüberschrift »Zwei Pygmäen-Freunde des Entdeckers« schreibt in den dreißiger Jahren das Vorurteil fort, daß die Europäer Afrika in den zwei vorangegangenen Jahrhunderten entdeckten und verschweigt, daß lange vorher die Afrikaner als erste Menschen Südeuropa und Zentralasien besiedelten.

Le titre « Deux amis pygmées de l'explorateur » fait perdurer, dans les années 30, le préjugé selon lequel les Européens ont découvert l'Afrique au cours des deux siècles précédents, ignorant le fait que les Africains ont été les premiers à peupler l'Europe méridionale et l'Asie centrale.

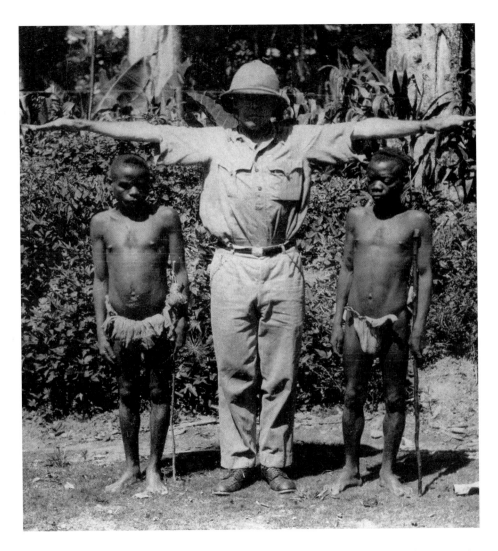

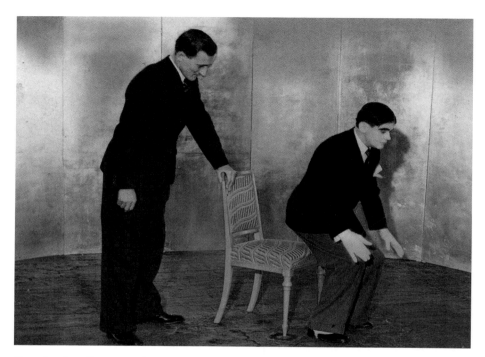

"Rupert walks, talks – saying things like 'Good morning' and 'How are you?' – smokes a cigarette, starts and drives a car, lifts his hat." This astonishingly lifelike robot was displayed by Albert Creuziger from Germany at London's Savoy Hotel on 12 January 1938. Rupert was a one-off.

»Rupert geht, spricht – er sagt Dinge wie ›Guten Morgen‹ oder ›Wie geht's?‹ –, raucht eine Zigarette, startet ein Auto und fährt damit, zieht seinen Hut.« Seinen erstaunlichen Menschen-Roboter stellt der Deutsche Albert Creuziger am 12. Januar 1938 im Londoner Savoy-Hotel vor. Rupert ist ein Unikat.

« Rupert marche, parle – il dit ‹ Bonjour › ou ‹ Comment ça va ? › – fume une cigarette, fait démarrer une voiture et la conduit ou ôte son chapeau. » L'Allemand Albert Creuziger présente son robot étonnamment humain, le 12 janvier 1938, à l'Hôtel Savoy de Londres. Rupert est unique au monde.

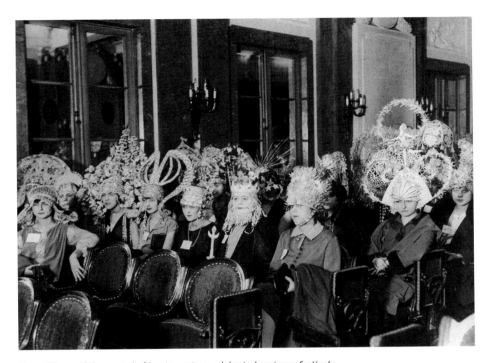

The milliners of the capital of haute couture celebrated costume festivals throughout the city on St Catherine's Day. During the 1930s, one Parisian newspaper held a competition: "Every midinette from the age of 25 upward is summoned to draw attention to her status with particularly bizarre headgear."

Die Hutmacherinnen der Hauptstadt der Haute Couture feiern am St.-Katharinentag überall in der Stadt Kostümfeste. In den dreißiger Jahren schreibt eine Pariser Zeitung einen Wettbewerb aus: Alle Midinetten ab 25 Jahre sind dazu aufgerufen, mit besonders bizarren Hutkreationen auf ihren Status aufmerksam zu machen.

Le jour de la Sainte-Catherine, les chapelières de la capitale de la haute-couture organisent dans toute la ville des fêtes costumées. Dans les années 30, un journal de Paris lance un concours : toutes les midinettes de plus de 25 ans sont invitées à promouvoir leur profession en créant des chapeaux d'une grande originalité.

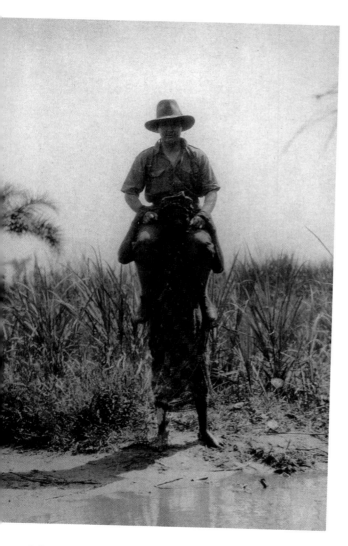

The caption to this photograph, published on 27 July 1930, reads: "The human element enters the native taxi service." T. F. Bramley, the Transport Officer of the Chicago Field Museum's Africa Expedition, is pictured preparing to cross a river on the shoulders of a Nigerian.

Die Überschrift vom 27. Juli 1930 zu dieser Abbildung lautet: »Der Taxi-Dienst der Eingeborenen erhält eine menschliche Komponente.« T. F. Bramley, der Transport-Offizier der Afrika-Expedition des Chicago Field Museum, durchquert auf den Schultern eines Nigerianers einen Fluß.

Selon la légende de cette illustration du 27 juillet 1930, « le service de taxi assuré par les autochtones a une dimension humaine. » L'officier T. F. Bramley, qui participe à l'expédition en Afrique du Chicago Field Museum, traverse un fleuve à gué sur les épaules d'un Nigérian.

"Passers-by in Leicester Square were surprised to
spy Zulu warriors in the back of a cab." Under the
direction of Bertha Slosberg, African artists were
rehearsing for a performance in London's West End
in the spring of 1937.

»Die Passanten am Leicester Square waren überrascht,
Zulu-Krieger im Fond eines Taxis zu erblicken.« Unter
der Regie von Bertha Slosberg proben im Frühjahr
1937 afrikanische Künstler im Londoner West End für
eine Aufführung.

« Les passants de Leicester Square ont été surpris de
découvrir des guerriers zoulous sur la banquette
arrière d'un taxi. » Sous la régie de Bertha Slosberg,
au printemps 1937, des artistes africains répètent dans
le West End londonien en vue d'une représentation.

Following the outbreak of the Second World War, precautions against gas warfare were evident throughout Europe. Officially the use of gas in war had been banned by the 1925 Geneva Protocol, but who was going to put his trust in a mere piece of paper? Not these English rugby players in 1939, at any rate.

Seit dem Ausbruch des Zweiten Weltkriegs sind überall in Europa Gasschutzübungen zu beobachten. Offiziell ist der Einsatz von Kampfgasen seit der Genfer Konvention von 1925 zwar verboten, doch wer will im Ernstfall einem Papier trauen? Diese englischen Rugbyspieler im Jahre 1939 in Leeds jedenfalls nicht.

Depuis le déclenchement de la Seconde Guerre mondiale, des exercices de protection contre les gaz sont organisés dans toute l'Europe. L'utilisation de gaz de combat est officiellement interdite depuis la Convention de Genève de 1925 ; mais, au moment fatidique, qui oserait se fier à un vulgaire bout de papier, aussi officiel fût-il ? En tout cas, pas ces rugbymen anglais, en 1939, à Leeds.

On 21 April 1939, the Third Reich attempted to lull the German people into a sense of security with a demonstration of technical innovations. "Alongside the adult gas mask, Germany has also developed gas-protection equipment for children. This is a gas-proof protective bag for babies."

Das Dritte Reich versucht am 21. April 1939, die Deutschen mit einer Demonstration technischer Innovationen in Sicherheit zu wiegen: »Neben der Vollgasmaske sind in Deutschland auch Gasschutzgeräte für Kinder entwickelt worden. Hier zeigen wir den gassicheren Schutzbeutel für Säuglinge.«

Le 21 avril 1939, le Troisième Reich cherche à rassurer les Allemands par une démonstration d'innovations techniques : « Outre le masque à gaz intégral, l'Allemagne a aussi mis au point des appareils de protection contre les gaz pour les enfants. Ici, une gaine de protection étanche au gaz pour les nourrissons. »

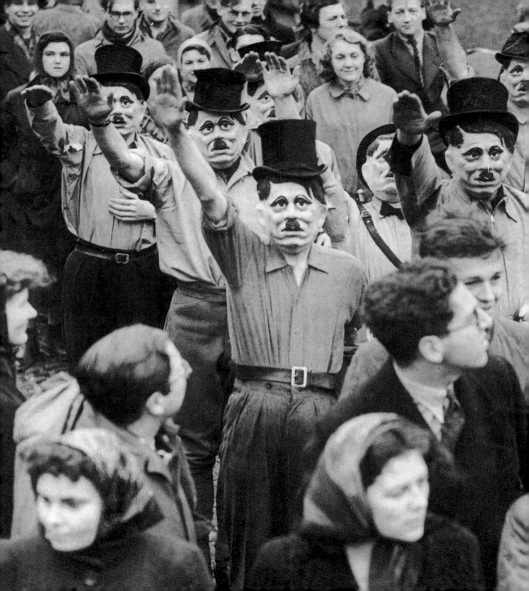

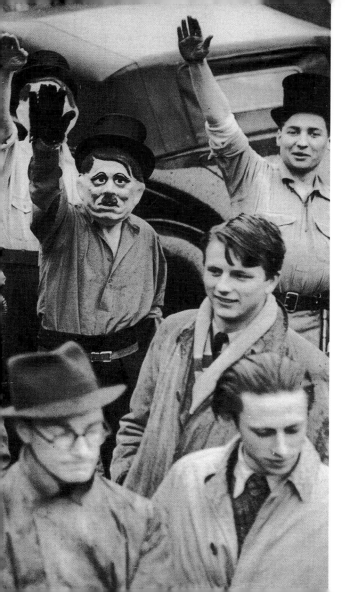

An anti-Chamberlain demonstration in Oxford on 25 February 1939. The largely student demonstrators, some of them wearing Chamberlain, Hitler, Mussolini and Franco masks, were attacking British foreign policy for coming up with no effective means of halting the advance of fascism in Europe. The picture depicts the Hitler group.

Eine Anti-Chamberlain-Kundgebung findet am 25. Februar 1939 in Oxford statt. Die überwiegend studentischen Demonstranten, zum Teil mit Chamberlain-, Mussolini-, Hitler- und Franco-Masken, greifen die britische Außenpolitik an, die gegen den Vormarsch des Faschismus in Europa kein probates Mittel findet. Im Bild ist die Hitler-Fraktion zu sehen.

Une manifestation contre Chamberlain est organisée à Oxford le 25 février 1939. Les manifestants, presque tous des étudiants, qui portent des masques de Chamberlain, Mussolini, Hitler et Franco, fustigent la politique étrangère britannique qui ne parvient pas à stopper la montée du fascisme en Europe. Sur la photo, la fraction « hitlérienne ».

This experiment in the wind tunnel at the American Navy base
in Philadelphia simulates the stresses to which a pilot would be
exposed in the event of an emergency bailout. The photos, dating
from 8 April 1949, document the condition of the subject before
the experiment to the distortions caused by an airflow of 325 mph
(524 kph).

Dieses Experiment im Windkanal des amerikanischen Marinestütz-
punkts in Philadelphia simuliert die Belastung eines Piloten, der den
Notfallschirm oder Schleudersitz eines Flugzeugs betätigen muß.
Die Aufnahmen vom 8. April 1949 dokumentieren den Zustand des
Probanden vor dem Versuch bis hin zu den Verzerrungen unter
Einwirkung eines Luftstroms von 524 km/h.

Cette expérience dans la soufflerie de la base navale américaine
de Philadelphie simule les épreuves subies par un pilote qui doit
actionner le parachute de secours ou le siège éjectable d'un avion.
Les photos prises le 8 avril 1949 montrent la déformation des traits
du visage du cobaye humain depuis le début de l'essai et les
distorsions subies sous l'action d'un courant d'air de 524 km/h.

Beneath the caption "Science studies the common cold," the English newspapers in 1947 passed on a call for volunteers by Harvard Hospital in Salisbury. They would be injected with the cold virus, and then be examined. The picture shows an infected experimental subject in protective covering.

Unter der Überschrift »Wissenschaft untersucht die normale Erkältung« verbreiten 1947 die englischen Zeitungen einen Aufruf. Das Harvard-Krankenhaus in Salisbury sucht Freiwillige, die sich mit dem Grippevirus infizieren und dann untersuchen lassen. Das Bild zeigt eine infizierte Testperson in einer Schutzhülle.

Sous le titre « La science analyse la grippe normale », les journaux anglais diffusent un appel en 1947. L'hôpital de Harvard, à Salisbury, recherche des volontaires prêts à se faire inoculer la grippe et à être examinés ensuite. La photo représente un candidat inoculé dans une combinaison de protection.

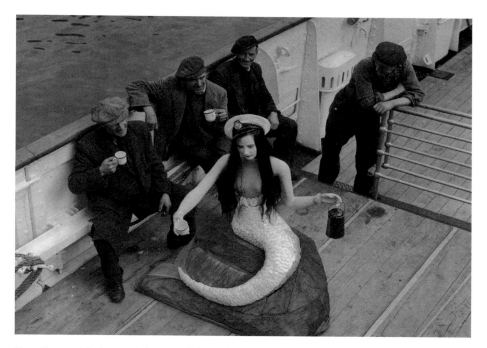

These Liverpool dockers are being served the tea for their tea break by window dummy "Mirabel the Mermaid" in 1957. As a rule, the figure adorned the displays of British ship's chandlers and shipping lines. The photo was taken as she was being transported to a shop window in Belfast.

Diese Liverpooler Dockarbeiter lassen sich 1957 von der Schaufensterpuppe »Mirabel, die Meerjungfrau« den Pausentee servieren. Die Figur schmückt normalerweise die Auslagen britischer Schiffsausstatter und Schiffahrtsgesellschaften. Das Foto entsteht während des Transports: Ihre nächste Station wird ein Schaufenster in Belfast sein.

En 1957, ces dockers du port de Liverpool se font servir leur thé de cinq heures par le mannequin de vitrine « Mirabel, la sirène ». L'objet orne normalement les devantures de shipchandlers et de compagnies de navigation britanniques. La photo a été prise pendant son transport : la prochaine étape sera la vitrine d'un magasin de Belfast.

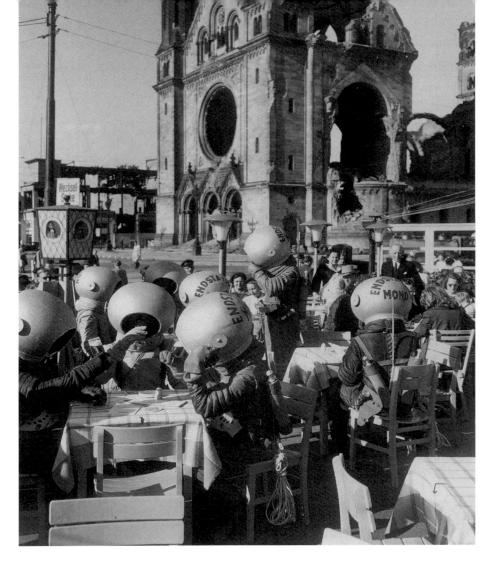

While some of Berlin's streets, with their bomb craters, still resembled moonscapes in the 1950s, these "men from the moon" were merely publicizing a film in the western sectors of the city. Here, the photographer has surprised the extra-terrestrials at a street café.

Während einige Straßenzüge Berlins noch Kraterlandschaften gleichen, laufen diese »Mondmänner« in den fünfziger Jahren für den Film *Endstation Mond* im Westteil der Stadt Reklame. Der Fotograf überrascht die »Außerirdischen« in einem Straßencafé.

Alors que certains quartiers de Berlin, dans les années 50, ressemblent encore à des champs de ruines constellés de cratères, ces « martiens » font de la réclame, dans le secteur occidental de la ville, pour le film *Terminus lune*. Le photographe surprend les « extraterrestres » à la terrasse d'un café.

Problems arose on 5 September 1947 during the filming of *The Black Arrow*. An actor playing a knight in armor refused to don the complete suit because the heat wave made it intolerably hot inside. The situation was resolved by an improvized air-conditioning system which allowed him to cool down during breaks in filming.

Bei den Dreharbeiten zu *Der Schwarze Pfeil* ergeben sich am 5. September 1947 Probleme: Der Ritterdarsteller sieht sich aufgrund einer Hitzewelle nicht mehr imstande, die Rüstung zu tragen. Abhilfe schafft ein provisorisches Lüftungssystem, das ihm in den Drehpausen Kühlung verschafft.

Sur tournage de *La flèche noire*, le 5 septembre 1947, des problèmes se posent : en raison de la canicule, un chevalier ne peut pas porter toute son armure. Un système de ventilation provisoire y remédie et lui permet de se rafraîchir durant les pauses.

The English sub-editor was reminded of "ghosts at work" by this 1955 picture of pharmaceutical workers making antibiotics in Kent. Previously, these drugs had been imported from America.

An »Gespenster bei der Arbeit« erinnern 1955 einen englischen Redakteur diese Arbeiter der pharmazeutischen Industrie bei der Herstellung von Antibiotika in der Grafschaft Kent. Bisher wurden diese aus den USA importiert.

En voyant ces ouvriers de l'industrie pharmaceutique fabriquer des antibiotiques dans le Kent, en 1955, le rédacteur anglais pense à des « fantômes au travail ». Jusqu'ici, on importait ces produits des Etats-Unis.

Englishman Ted Evans, 9 feet (2.74 meters) tall, boarded the *Queen Mary* on 21 March 1952. He was preparing to launch his circus career upon arrival in the USA.

Der 2,74 m große Engländer Ted Evans geht am 21. März 1952 an Bord der *Queen Mary,* um nach der Atlantiküberquerung in den USA eine Zirkuskarriere zu beginnen.

L'Anglais Ted Evans, qui mesure 2,74 mètres, monte à bord du *Queen Mary,* le 21 mars 1952, pour entamer une carrière de saltimbanque aux Etats-Unis.

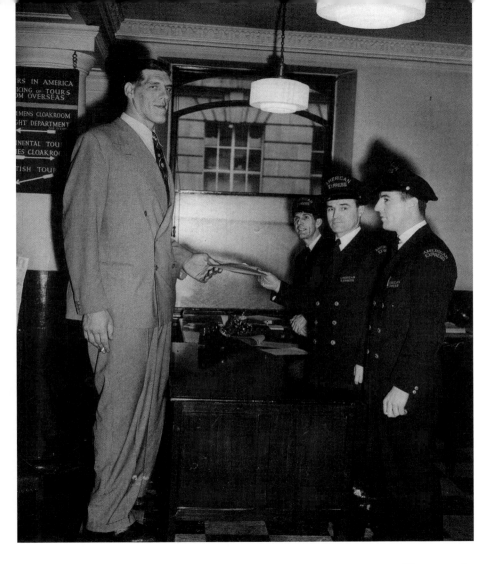

This Paris restaurant, opened in 1952, "in which everyone takes part," holds theme parties. Here, the dark chapters of French colonial history are being caricatured. The subject was politically provocative, because it was colonial policy in Indo-China and north Africa which brought down the Fourth Republic (1946–1958).

Dieses 1952 eröffnete Pariser Restaurant, »in dem jeder mitmacht«, bietet Themenfeste und karikiert die dunklen Kapitel der französischen Kolonialgeschichte. Dieses Thema ist politisch brisant, denn an ihrer Kolonialpolitik in Indochina und Nordafrika zerbricht die Vierte Republik (1946–1958).

Ce restaurant parisien inauguré en 1952 « où chacun met la main à la pâte » organise des fêtes à thème et caricature le sombre chapitre de la colonisation française. Un thème délicat car l'instabilité ministérielle de la Quatrième République (1946–1958) est précisément aggravé par les problèmes de décolonisation en Indochine et en Afrique du Nord.

This 1958 Soviet photograph shows the Kremlin's vision of manned lunar exploration. However, in 1969 it was the Americans Armstrong and Aldrin who in fact were the first to set foot on the moon.

Das sowjetische Foto von 1958 zeigt die Kreml-Vision der bemannten Mondfahrt. 1969 betreten jedoch die Amerikaner Armstrong und Aldrin als erste Menschen den Mond.

Cette photo soviétique de 1958 représente la vision du Kremlin de l'homme dans l'espace. En 1969, ce sont cependant les Américains Armstrong et Aldrin qui seront les premiers à mettre le pied sur la lune.

These knights were out and about in London in 1954 urging more chivalry on the road.

Für mehr Aufmerksamkeit im Londoner Straßenverkehr werben 1954 diese beiden Ritter.

A Londres, en 1954, ces deux chevaliers plaident à leur façon en faveur d'une plus grande vigilance de la part de tous les conducteurs de véhicules.

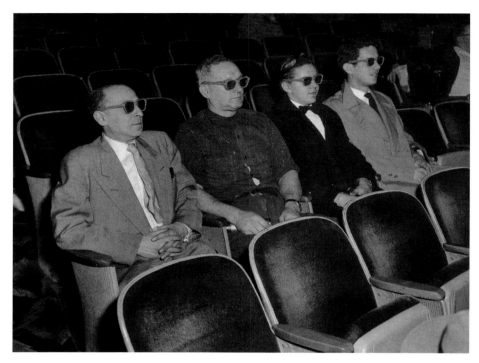

On 10 March 1953, new cinema projection techniques were demonstrated in New York. Special glasses allowed movie-goers to experience a 3-D effect. This was one of the ways in which the film industry was trying to make the cinema more attractive, in order to face up to competition from its new rival, television.

Am 10. März 1953 werden in New York neue Projektionsverfahren für das Kino vorgestellt. Spezialbrillen suggerieren dem Betrachter ein dreidimensionales Bild. Die Filmindustrie in Hollywood versucht auf diese Weise, das Kino attraktiver zu gestalten, um gegen den neuen Konkurrenten, das Fernsehen, bestehen zu können.

Le 10 mars 1953, un nouveau procédé de projection pour le cinéma est présenté à New York. Des lunettes spéciales donnent à ces spectateurs l'illusion d'une image en trois dimensions. L'industrie cinématographique de Hollywood essaie ainsi de rendre le cinéma plus attrayant pour contrer son nouveau concurrent, la télévision.

The civilian use of nuclear power meant a broader range of protective clothing and safety measures for those working in contaminated areas. This PVC suit from 1958 is entered through the door.

Mit der zivilen Nutzung der Atomspaltung erweitert sich das Angebot an Sicherheitskleidung und -technik für die Arbeit in kontaminierten Räumen. Dieser PVC-Anzug von 1958 wird durch die Tür bestiegen.

Avec l'utilisation civile de la fission nucléaire, l'offre d'équipements et de techniques de sécurité conçus pour ceux qui travaillent dans les pièces contaminées se multiplie. On entre par la porte dans cette combinaison en matière plastique, conçue en 1958.

While father Berggren, wearing a radiation-proof combat outfit, does his stint as a Swedish army reservist in 1959, his family relax in the sun on the beach.

Während Vater Berggren 1959 seinen Reservedienst in der schwedischen Armee in einem atomwaffensicheren Kampfanzug leistet, nimmt seine Familie ein Sonnenbad am Strand.

Tandis que le père accomplit son service de réserve dans l'armée suédoise en portant une combinaison de combat antinucléaire, en 1959, sa famille prend un bain de soleil sur la plage.

In 1951, a West German agency asked: "Is this some new device for splitting the atom?" English journalists by contrast thought it was a telescope of unusual focal length which would allow an "intimate glimpse" behind the Iron Curtain.

Eine westdeutsche Agentur fragt 1951: »Gibt es ein neues Atomzertrümmerungsgerät?« Die englischen Kollegen meinen, daß es sich um ein Teleskop mit besonderer Brennweite handelt, das einen »intimen Blick« hinter den Eisernen Vorhang erlaubt.

En 1951, une agence de presse ouest-allemande s'interroge : « Est-ce un nouvel appareil de destruction atomique ? » Ses collègues anglais sont d'avis qu'il s'agit plutôt d'un téléscope à focale particulièrement grande permettant de jeter un « regard intime » pour voir ce qui se passe de l'autre côté du Rideau de fer.

God bless you

Gott segne Dich

Que Dieu te bénisse

The press is without doubt an inappropriate place to look for answers to the ultimate questions of Mankind. But people in search of God and deities attract photographers nonetheless, because they provide deep feelings of grief, awe, bliss and ecstasy.
In addition to encounters with exotic religions, cults and eccentrics are also always worth a mention. Press articles confirm the mass of readers in the industrial countries in their code of moral values. Western reporting relished sensational pictures, and the captions – more or less openly – called out "God bless you" to those of different faith.

Die Presse ist sicher nicht der richtige Ort, um die letzten Fragen der Menschheit zu beantworten. Doch Menschen auf der Suche nach Gott und Gottheiten ziehen die Fotografen an, denn sie liefern der Presse große Gefühle wie Trauer, Ehrfurcht, Glück und Ekstase.
Neben Begegnungen mit fernen Religionen sind auch Sektierer und Spinner immer eine Meldung wert. Die Presseartikel bestätigen die Lesermasse der Industrienationen in ihrem sittlich-moralischen Wertekodex. Die westliche Berichterstattung ergötzt sich an sensationellen Bildern, und die Texte rufen Andersgläubigen mehr oder weniger unverhohlen zu:
»Gott segne Dich«.

La presse n'est assurément pas l'endroit approprié pour répondre aux ultimes questions que se pose l'humanité. Mais les hommes à la recherche de Dieu et de divinités attirent les photographes, car ils livrent à la presse grands sentiments, tristesse, profond respect, bonheur et extase.
Outre les religions lointaines donc inconnues, les sectaires et les loufoques méritent qu'on parle d'eux. Les articles de presse confirment à la grande masse des pays industrialisés la justesse de leur code de valeurs spirituelles et morales. Les reportages occidentaux se délectent des clichés sensationnels et les textes proclament de façon plus ou moins franche aux adeptes d'autres religions : « Dieu te bénisse ! ».

Concentration, meditation and trance allow ascetics to tolerate great physical pain. At an illusionists' meeting in Paris on 15 March 1957, a Hindu named Abarha had himself nailed to a cross before an audience. In 20th century India, Christian cross symbolism is strictly rejected by orthodox Hindus. Reformers such as Gandhi, by contrast, paid tribute: "Jesus's sacrificial death is an example to us all."

Asketen ertragen mittels Konzentration, Meditation und Trance große körperliche Schmerzen. Auf einem Illusionistentreffen in Paris läßt sich am 15. März 1957 der Hindu Abarha vor Publikum an ein Kreuz nageln. Im Indien des 20. Jahrhunderts trifft die christliche Kreuzessymbolik bei orthodoxen Hindus auf strikte Ablehnung. Reformer wie Gandhi hingegen zollen Respekt: »Jesu Opfertod ist Vorbild und Beispiel für uns.«

Concentration, méditation et transe permettent aux ascètes de supporter de grandes douleurs physiques. Lors d'une rencontre d'illusionnistes, à Paris, le 15 mars 1957, l'hindou Abarha se fait crucifier en public. Dans l'Inde du xxᵉ siècle, le symbole chrétien de la croix est refusé catégoriquement par les hindous orthodoxes. Des réformateurs comme Gandhi, par contre, lui rendent hommage : « Le sacrifice de Jésus est un exemple pour nous. »

Rushwa, a member of the Shona tribe, played the lead role in a 1930s' film which told a love story set in the British colony of Rhodesia. Here she is seen withstanding an ordeal by poison, to which she had been condemned by a council of elders for adultery.

Rushwa vom Stamme der Schona spielt die Hauptrolle in einem Film der dreißiger Jahre, der eine Liebesgeschichte aus der britischen Kolonie Rhodesien erzählt. Hier besteht sie die Giftprobe, zu der sie vom Ältestenrat wegen Ehebruchs verurteilt wird.

Rushwa, de la tribu des Shonas, joue le rôle principal dans un film des années 30 qui relate une histoire d'amour dans la colonie britannique de Rhodésie. Ici, elle résiste à l'épreuve du poison auquel elle a été condamnée par le conseil des anciens pour avoir commis un adultère.

French "dramatic artist" Audrie Cahuzac danced her interpretation of the Fall of Man for a Parisian photographer in the 1920s. The sight of her prelapsarian nakedness is obscured by her long hair, thus giving free rein to the beholder's imagination.

Die französische »dramatische Künstlerin« Audrie Cahuzac tanzt in den zwanziger Jahren für einen Pariser Fotografen ihre Interpretation des Sündenfalls. Den Blick auf ihre paradiesische Nacktheit verwehren die langen Haare – der Phantasie der Leser sind somit keine Grenzen gesetzt.

L'« artiste dramaturgique » Audrie Cahuzac danse dans les années 20, pour un photographe parisien, son interprétation du péché originel. Sa longue chevelure soustrait au regard son corps nu comme celui d'Eve – rien ne peut ainsi brider l'imagination des lecteurs.

Hinduism bestows on Indian fakirs a superhuman strength to withstand tortures without injury. No one can convert to this faith; one is born into it. Rose Schaeffer, however, is here seen proving that she has succeeded in acquiring the mental techniques of the fakirs. "The lady in the picture has just shown New Yorkers that the art of the fakir is not so difficult as generally assumed. The picture was taken on Longacre Square and shows Rose on a bed of nails, while her brother Willie hammers an anvil on her breast. The picture on the right shows that the massage was not only to her benefit."

Der Hinduismus verleiht indischen Fakiren übermenschliche Kraft und die Fähigkeit, Qualen unbeschadet zu überstehen. Zu diesem Glauben kann niemand übertreten, man wird als Hindu geboren. Rose Schaeffer beweist jedoch, daß sie sich die mentalen Techniken der Fakire aneignen konnte: »Die Dame auf dem Bild hat den New Yorkern gezeigt, daß die Fakirkunst nicht so schwierig ist, wie man gemeinhin annimmt. Das Bild ist auf dem Longacre Square aufge-

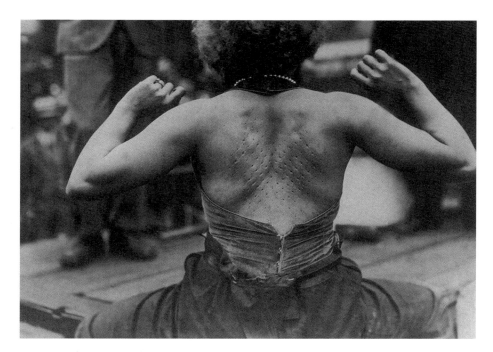

nommen und zeigt Rose auf einem Nagelbett liegend, während ihr Bruder Willie auf einen Amboß schlägt, der auf ihrer Brust steht. Das rechte Bild zeigt, daß die Massage nicht nur zu ihrem Nutzen war.«

L'hindouisme confère aux fakirs indiens le pouvoir de ne pas ressentir la souffrance. Aucun homme ne peut embrasser cette religion, on naît hindou. Rose Schaeffer prouve que les techniques mentales des fakirs s'apprennent : « La dame sur la photo a montré aux New Yorkais que l'art du fakir n'est pas aussi difficile qu'on le croit généralement. La photo a été prise au Longacre Square et représente Rose allongé sur des clous pendant que son frère Willie frappe une enclume placée sur son thorax. La photo de droite montre que le massage n'a pas été seulement un bienfait. »

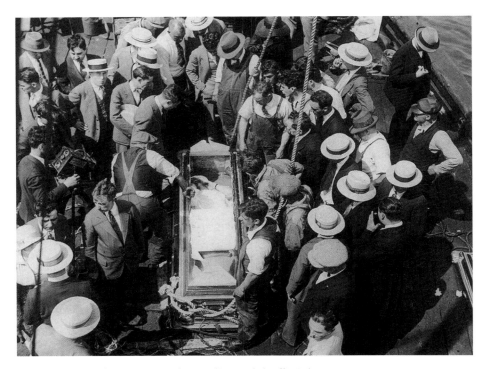

On 7 August 1926, after 21 minutes submerged in a sealed coffin, Rahman Bey from Egypt was brought to the surface of the Hudson River once more. By this time, American Erich Weiss, alias Houdini, had long been attracting attention with his feats of being buried alive.

Nach 21 Minuten unter Wasser in einem versiegelten Sarg wird am 7. August 1926 der Ägypter Rahman Bey aus dem Hudson River wieder ans Tageslicht geholt. Der Amerikaner Houdini alias Erich Weiss hat zu diesem Zeitpunkt schon längst mit seinen »lebendigen Begräbnissen« für Aufsehen gesorgt.

Après 21 minutes passées sous l'eau dans un cercueil plombé, le 7 août 1926, l'Égyptien Rahman Bey est ramené à la surface de l'Hudson River. A cette époque, l'Américain Houdini, alias Erich Weiss, a depuis longtemps déjà défrayé la chronique pour s'être « enterré vivant ».

On 20 January 1927, Hamid Bey had himself buried alive for three hours in Walter Shannon's front garden in Elizabeth, New Jersey. According to Bey, "in catalepsy, the tongue is inverted and breath cut off, and as long as the apparently lifeless body is not disturbed, it will stay in that condition. By raising the body to an upright position, the tongue resumes its normal position, and the person regains consciousness."

Im Vorgarten Walter Shannons in Elizabeth im Bundesstaat New Jersey läßt sich Hamid Bey am 20. Januar 1927 für drei Stunden lebendig begraben. Bey erklärt hierzu: »Während der Katalepsie stülpt sich die Zunge um und die Atmung wird abgeschnitten. Solange der scheinbar leblose Körper nicht bewegt wird, verbleibt er in dieser Verfassung. Wird er wieder aufgerichtet, nimmt die Zunge ihre normale Position ein, und die Person kommt zu sich.«

Le 20 janvier 1927, Hamid Bey se fait enterrer vivant pendant trois heures dans le jardinet de Walter Shannon, à Elizabeth, dans l'État du New Jersey. Bey déclare à ce sujet : «Durant la catalepsie, on retourne sa langue, ce qui interrompt la respiration si le corps apparemment sans vie n'est pas déplacé. Dès que le corps est redressé, la langue reprend sa position habituelle et la personne retrouve ses esprits.»

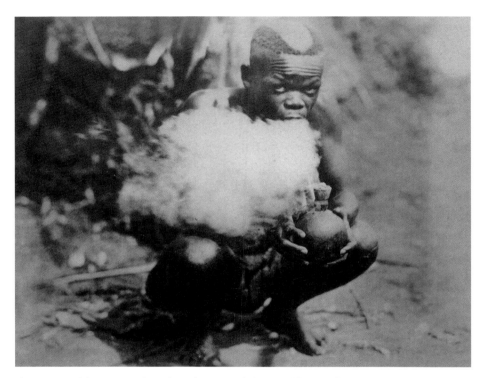

The pygmies of the equatorial rain forest have provided material for speculation ever since the first journeys of exploration in the region. This 1920s' photo shows a pygmy priest performing a cultic rite. Exceptionally for a people of hunters and gatherers, they believe in one supreme god.

Die Pygmäen des äquatorialen Regenwaldes haben seit den ersten Entdeckungsreisen in diese Region Anlaß zu Spekulationen gegeben. Dieses Foto aus den zwanziger Jahren zeigt einen Pygmäen-Priester bei einer Kulthandlung. Im Gegensatz zu anderen Jäger- und Sammlerkulturen glauben die Pygmäen nur an einen Gott.

Depuis les premiers voyages des explorateurs dans la forêt équatoriale, les pygmées n'ont cessé de fournir matière à spéculation. Cette photo datant des années 20 montre un prêtre pygmée lors d'un acte rituel. Ce peuple qui se nourrit de la cueillette et de la chasse ne croit qu'à une seule divinité supérieure et constitue à ce point de vue une exception.

On 16 January 1920, the 18th Amendment to the U.S. Constitution came into force, prohibiting the sale and consumption of alcohol; the details were regulated by an Act of Congress known as the Volstead Act. For the benefit of photographers, Representative John Hill from Maryland demonstrates his rejection of the attempt to "dry out the entire United States."

Am 16. Januar 1920 tritt der 18. Zusatzartikel zur amerikanischen Verfassung in Kraft, und ein gesondertes Gesetz, der Volstead Act, erläutert im Detail das allgemeine Alkoholverbot. Der Abgeordnete John Hill aus Maryland demonstriert dem Fotografen seine Ablehnung des Versuchs, »die gesamten Vereinigten Staaten trockenzulegen«.

Le 16 janvier 1920 entre en vigueur le 18ᵉ article additionnel de la Constitution américaine et une loi particulière, le Volstead Act, explique en détail la prohibition générale de l'alcool. Le député John Hill, du Maryland, fait, à l'intention du photographe, la démonstration de son opposition à cette tentative «de mettre à sec la totalité des Etats-Unis».

Englishwomen who had served as medical ancillary staff during the First World War are pictured giving up their valuable free time. In view of the growing number of road accidents, they acted as voluntary first-aid workers for traffic victims, such as here on the road between Sturry and Sarre in Kent.

Ehemalige englische Sanitätshelferinnen, die im Ersten Weltkrieg dienten, opfern ihre kostbare Freizeit: In Anbetracht der steigenden Zahl von Verkehrs-unfällen versorgen sie die Opfer ehrenamtlich, wie hier auf der Straße zwischen Sturry und Sarre in der Grafschaft Kent.

D'anciennes infirmières anglaises, qui ont soigné des blessés durant la Première Guerre mondiale, sacrifient leur précieux temps libre. Compte tenu de l'augmentation inexorable du nombre d'accidents de la circulation, elles aident bénévolement les victimes de la route, comme ici, entre Sturry et Sarre, dans le Kent.

During the 1920s, Baptist preacher Aimée McPherson baptized her followers in the River Jordan in Palestine. In the USA, the cult preacher had achieved popularity through her own radio station. Baptists seek to live according to the precepts of the earliest Christian congregations. A particular feature of their practice is adult baptism.

Die Baptisten-Predigerin Aimée McPherson tauft in den zwanziger Jahren ihre Anhänger im Jordan in Palästina. In den USA ist »die Sektenpredigerin« durch ihren eigenen Radiosender populär geworden. Baptisten leben nach dem Modell der christlichen Urgemeinde, und ein besonderes Merkmal dieser Freikirche ist die Erwachsenentaufe.

Dans les années 20, la prédicatrice baptiste Aimée McPherson baptise ses adeptes dans le Jourdain, en Palestine. Aux Etats-Unis, « la prédicatrice de la secte » est devenue populaire grâce à sa propre chaîne de radio. Les baptistes vivent en s'inspirant de la communauté chrétienne originelle, et une caractéristique particulière de cette Eglise libre est le baptême des adultes.

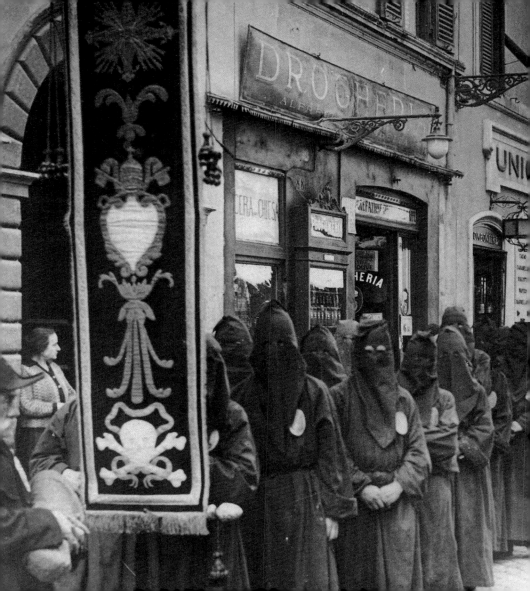

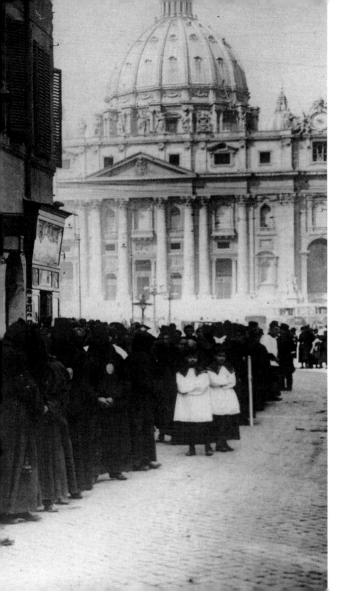

When the late Pope Pius X's sister died in Rome in the mid-1920s, her coffin was escorted to the Church of the Holy Spirit by the brothers of the Buona Morte Order. By requiring would-be priests to take an oath denouncing Modernism, Pius X (1903–1914) rekindled hostilities between the church and secular society; the anti-democratic tendencies of his approach were to have considerable influence on Vatican policy well into the 1950s.

Mitte der zwanziger Jahre verstirbt die Schwester von Papst Pius X. in Rom und erhält von den Brüdern des Ordens Buona Morte das letzte Geleit zur Heiliggeistkirche. Pius X. (1903–1914) nahm 1910 mit dem Anti-Modernisten-Eid den Kulturkampf wieder auf, der in seinen antidemokratischen Tendenzen die Politik des Vatikans bis in die fünfziger Jahre weitgehend bestimmen sollte.

Au milieu des années 20, la sœur du pape Pie X décède à Rome et les frères de l'ordre Buona Morte accompagnent sa dépouille mortelle jusqu'à l'Eglise du Saint-Esprit. Pie X (pontificat 1903–1914) a fait revivre, en 1910, par sa condamnation du modernisme, la lutte culturelle qui, dans ses tendances antidémocratiques, allait dicter la presque totalité de la politique du Vatican jusque dans les années 50.

God bless you 673

150 water diviners or "dowsers" on an excursion to a cave village in Haute-Isle in 1933. The international participants in a French Radiaesthesis Congress, for example the lady in the picture, are testing their abilities in practice. This followed after a few days' theoretical discussion of sensitivity to pendulum and divining rod.

150 Wünschelrutengänger machen 1933 einen Ausflug in ein Höhlendorf in Haute-Isle. Die internationalen Teilnehmer des französischen Kongresses für Radiästhesie erproben, wie die Dame im Bild, ihre Fähigkeiten in der Praxis. In den Tagen davor haben sie bereits die Strahlenfühligkeit mit Pendel und Rute theoretisch erörtert.

150 sourciers font, en 1933, une excursion au village rupestre de Haute-Isle. Les participants internationaux à un congrès français de radiesthésie, comme la dame sur la photo, testent leurs aptitudes pratiques. Au cours des premiers jours, la réceptivité aux radiations a été expliquée en théorie avec un pendule ou une baguette.

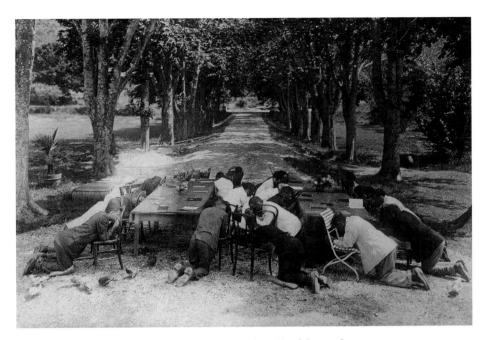

In the 1930s, Swiss cult leader Dr Alexandre Freytag gathered his followers from all over Europe and the United States around him in the Provence region of southern France. At the "Nouvelle Terre" colony, the cult turned its back on "modern society" and went back to nature. The photo shows "Monsieur Freytag's pupils at their evening benediction, adopting a profoundly humble demeanor for their prayer of thanksgiving."

Seine Jünger aus ganz Europa und den USA schart in den dreißiger Jahren der Schweizer Sektierer Dr Alexandre Freytag in der Provence um sich. In der Kolonie »Nouvelle Terre« kehrt die Sekte der modernen Gesellschaft den Rücken und findet zurück zur Natur. Das Foto zeigt »das Abendgebet der Schüler von Herrn Freytag, die während des Dankgebetes eine Haltung größter Demut einnehmen.«

Dans les années 30, le docteur suisse Alexandre Freytag regroupe autour de lui, en Provence, ses adeptes de l'Europe entière et des Etats-Unis. Dans la colonie appelée « Nouvelle Terre », la secte tourne le dos à la société moderne et prône le retour à la nature. La photo représent « la prière du soir des adeptes de Monsieur Freytag, qui, pendant la prière d'action de grâces, prennent une attitude de très grande soumission. »

"And new life blossoms on the ruins. The skull serves as a home for the young brood." This lyrical attempt by the sub-editor of an upmarket illustrated magazine gives an insight into the mood of Germany's middle class, which as the backbone of the Kaiser's Empire had had to share responsibility for the "ruins" of the First World War. The middle classes observed developments during Germany's first democratic era with a mixture of aloofness and hatred.

»Und neues Leben blüht auf den Ruinen. Der Totenschädel dient der jungen Brut als Heim.« Dieser lyrische Versuch des Redakteurs einer bürgerlichen Illustrierten gibt Einblick in die Stimmung des deutschen Bürgertums, das als politisch tragende Schicht des Kaiserreichs die »Ruinen« des Ersten Weltkriegs mitzuverantworten hatte. Die Entwicklung der ersten deutschen Demokratie verfolgt das Bürgertum distanziert bis haßerfüllt.

«Et une vie nouvelle naît des ruines. Le crâne sert de nid à ces oisillons.» Cette envolée lyrique d'un rédacteur d'un illustré libéral montre l'état d'esprit de la bourgeoisie allemande, qui, en tant que l'une des forces politiques les plus importantes du Reich allemand, était, en une bonne partie, responsable des ravages de la Première Guerre mondiale. Cependant, elle observe avec distance, voire haine, les balbutiements de la première démocratie allemande.

God bless you

"A poltergeist." In the late 1920s, the case of Elenore Zugun was taken up by a scholarly Berlin illustrated magazine, because "in recent years the courts and the police have repeatedly had to concern themselves with the specter of telekinesis." She had been visited by a poltergeist in her Romanian home village since she was 12, and in 1925 had been confined to an institution. A Viennese scientist had her released, and introduced her to the scientific community. Using film as a documentary aid (right), parapsychologists thought they were getting somewhere. "The developed film (left) confirmed the observation that during the experiment a scratch, a weal and a set of toothmarks had appeared on the layer of make-up without any apparent external cause."

»Ein Poltergeist«. Eine Berliner Wissenschaftsillustrierte nimmt sich Ende der zwanziger Jahre des Falles Elenore Zugun an, denn »Gericht und Polizei haben sich in den letzten Jahren wiederholt mit telekinetischem Spuk befassen müssen«. In ihrem rumänischen Dorf ist sie bereits im Alter von 12 Jahren als Poltergeist bekannt und wird 1925 in eine Anstalt eingewiesen. Ein Wiener Wissenschaftler befreit Elenore und führt sie der Wissenschaft zu. Mit Hilfe von dokumentarischen Filmaufnahmen (rechts) meinen nun Parapsychologen, sich dem Phänomen nähern zu können: »Der entwickelte Film (links) bestätigt die Beobachtung, daß während der Kontrolle je ein Kratzer, ein Striemen und ein Gebißabdruck ohne irgendwelche erkennbare Einwirkung von außen her die Schminkschicht verletzten.«

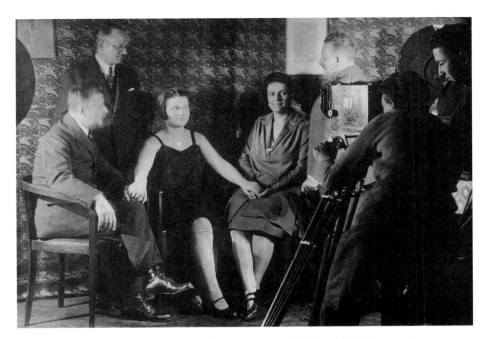

« Une possédée du démon ». A la fin des années 20, une revue scientifique de Berlin se penche sur le cas d'Elenore Zugun, car ces dernières années, « tribunaux et police ont dû examiner à diverses reprises, des phénomènes de télékinésie ». Dans son village de Roumanie, on la disait déjà possédée du démon alors qu'elle n'avait que 12 ans et elle fut internée en 1925. Un scientifique viennois obtient la libération d'Elenore et la confie à la science. A l'appui du documentaire de films (photo de droite), les parapsychologues croient maintenant pouvoir mieux comprendre le phénomène : « Le film développé (photo de gauche) confirme ce qui a été observé, à savoir qu'un coup de griffe, des rainures et une trace de morsure ont abîmé sa couche de maquillage – sans aucune action visible reconnaissable de l'extérieur. »

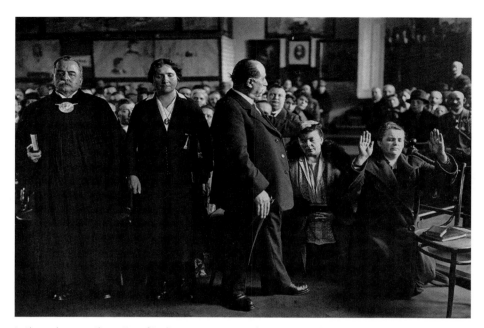

In the early 1930s, the notice of Berlin newspapers was drawn to Joseph Weissenberg. "A bricklayer, he had founded a very strange sect in Trebbin near Berlin, and within a short time had found 120,000 adherents. Many claimed that they had been cured of serious ailments after he had laid hands on them. He said that Europe was facing dreadful disasters in the month of May."

Anfang der dreißiger Jahre werden Berliner Zeitungen auf Josef Weissenberg aufmerksam: »Der Maurer hat in Trebbin bei Berlin eine höchst eigenartige Sekte gegründet, die in kurzer Zeit 120 000 Anhänger gefunden hat. Viele behaupten, von ihm durch Handauflegen von schweren Leiden geheilt worden zu sein. Wie er sagt, stehen Europa für den Monat Mai noch die schrecklichsten Katastrophen bevor.«

Au début des années 30, les journaux berlinois commencent à s'intéresser à Josef Weissenberg : « A Trebbin, près de Berlin, le maçon a fondé une secte vraiment étrange, qui, en un très bref laps de temps, compte 120 000 adeptes. Beaucoup prétendent qu'il les a soulagés de leurs maux par l'imposition des mains. Comme il le dit lui-même, l'Europe sera encore le théâtre des plus horribles catastrophes au mois de mai. »

This photo accompanied an article headlined "Wonderland of Dreams" in a Berlin newspaper. The painter, Mrs Abé, is, by her own account, practicing "dream art." "On waking, she then begins, in a state of trance, to put her dream to paper."

Den Artikel »Wunderland der Träume« illustriert in einer Berliner Zeitung dieses Foto. Die Malerin, die sich »Frau Abé« nennt, betreibt nach eigener Aussage »Traumkunst«: »Nach dem Erwachen beginnt sie, in einem Trancezustand ihren Traum zu Papier zu bringen.«

Cette photo illustre, dans un journal berlinois, l'article intitulé « Le merveilleux pays des songes ». Selon ses dires, l'artiste peintre « Madame Abé » pratique « l'art du rêve » : « Une fois éveillée, elle commence, en transe, à coucher sur le papier le rêve qu'elle vient de faire. »

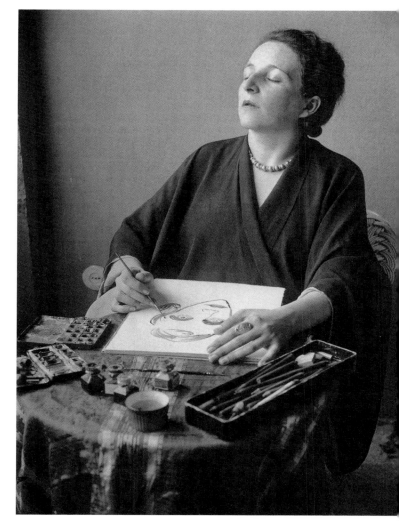

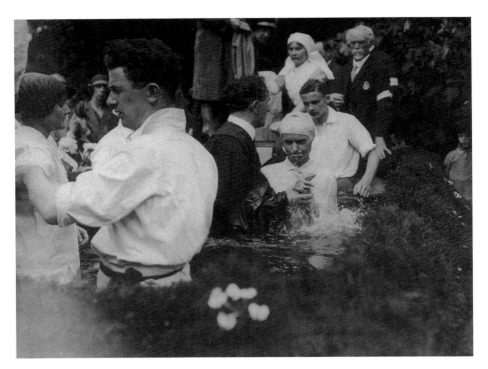

Principal Jeffreys, the founder and pastor of the Baptist "Elim Four-Square Gospel Alliance" in London, baptizing new members in 1935. The Baptists were an offshoot of English Puritanism, but only really developed in 19th-century America, from where the movement spread back to Europe.

Principal Jeffreys, Gründer und Priester der baptistischen »Elim Four-Square Gospel Alliance« in London, tauft 1935 neue Mitglieder. Die freikirchliche Bewegung der Baptisten entwickelt sich aus dem englischen Puritanismus, entfaltet sich aber erst im 19. Jahrhundert in den USA. Von dort aus wirkt die Sekte wieder in Richtung Europa.

Principal Jeffreys, fondateur et prêtre de l'« Elim Four-Square Gospel Alliance » baptiste, à Londres, baptise de nouveaux membres en 1935. Le mouvement de l'Eglise libre des baptistes est l'émanation du puritanisme anglais, mais c'est aux Etats-Unis qu'il se propage tout d'abord, au XIX⁰ siècle. Puis, de là, la secte réapparaît en Europe.

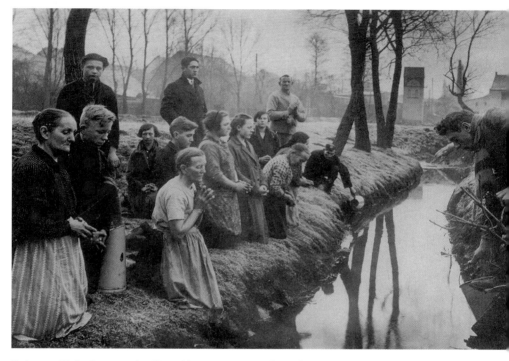

Easter provided a German sub-editor with an occasion, on 28 March 1930, to remind readers of the German enclaves in Poland. "Each celebrates Easter in its own way. In Upper Silesia, washing in the brook after devotional prayer is an old Good Friday custom." Upper Silesia had been part of Poland since 1919.

Das Osterfest bietet einem deutschen Redakteur am 28. März 1930 einen Anlaß, an die deutsche Enklave in Polen zu erinnern: »Jeder feiert Ostern auf seine Weise! In Oberschlesien ist das Bachwaschen, nach dem andächtig gebetet wird, ein alter Karfreitagsbrauch.« Oberschlesien gehört seit 1919 zum polnischen Staatsgebiet.

Pour un rédacteur allemand, la fête de Pâques, le 28 mars 1930, est l'occasion de rappeler qu'il existe une enclave allemande en Pologne : « Chacun fête Pâques à sa manière ! En Haute-Silésie, les ablutions dans le ruisseau, suivies d'une prière, est une vieille coutume du Vendredi saint. » La Haute-Silésie fait partie du territoire polonais depuis 1919.

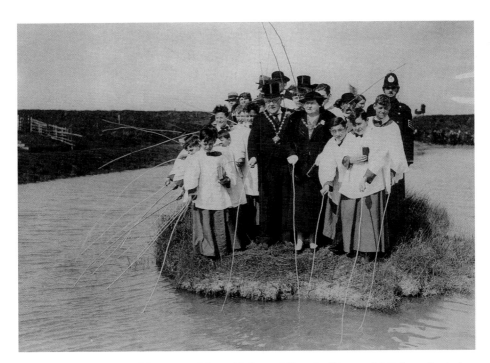

On 1 April 1935, the mayor of the east English seaside town of Margate, Alderman F. L. Pettman (center), was able to implement his expansionist fantasies with the help of the local press. As an April Fool's Day joke, they simply annexed the neighboring boroughs. The custom of "beating the bounds" is an otherwise perfectly normal ritual marking municipal boundaries. Here, the beaters are seen with their rods on "Plum Pudding Island." Their action had no long-term consequences.

Am 1. April 1935 verwirklicht der Bürgermeister des ostenglischen Küstenorts Margate, Alderman F. L. Pettman (Mitte), mit Hilfe der lokalen Presse seine Expansionsgelüste: Als Aprilscherz werden kurzerhand die Nachbarorte eingemeindet. Der Brauch des »Beating the bounds« – ein rituelles Abschreiten der Stadtgrenzen – bleibt in diesem auf der »Plumpudding-Insel« inszenierten Fall jedoch folgenlos.

Le 1er avril 1935, Alderman F. L. Pettman (au centre), maire de Margate, petite localité du littoral est de l'Angleterre, concrétise avec l'aide de la presse locale ses visées expansionnistes : son poisson d'avril consiste à annexer sans prévenir les localités voisines. La coutume du « beating the bounds », qui veut que soit longées rituellement les délimitations de la ville, restera cependant sans conséquence avec cette mise en scène sur l'« île plumpudding ».

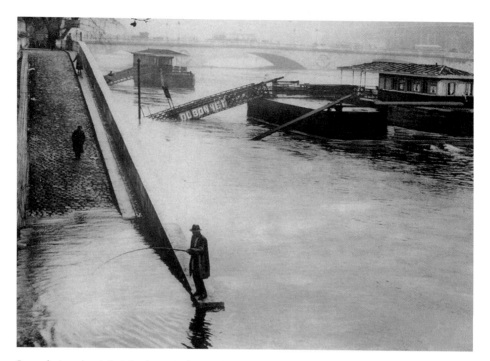

Europe's rivers burst their banks again during the 1930s, and this Parisian angler had an opportunity to demonstrate his equanimity on the Seine. The reports coming out of China on 26 July 1935 by contrast were apocalyptic: 200,000 people had been swept to their deaths by the floodwaters of the Yangtse and the Hoangho.

Europas Flüsse treten in den dreißiger Jahren wieder einmal über die Ufer, aber dieser Pariser Angler an der Seine demonstriert fatalistische Gelassenheit. Apokalyptische Meldungen kommen hingegen am 26. Juli 1935 aus China: Der Jangtse und der Hoangho reißen mit ihren Fluten 200 000 Menschen in den Tod.

Dans les années 30, les fleuves d'Europe sortent une fois de plus de leur lit, néanmoins ce pêcheur à la ligne parisien, en bord de Seine, ne se départit pas de son calme qui tient du fatalisme. Des informations apocalyptiques arrivent par contre de Chine, le 26 juillet 1935 : le Yang-tseu-kiang et le Hoang-ho emportent dans leurs flots 200 000 victimes impuissantes.

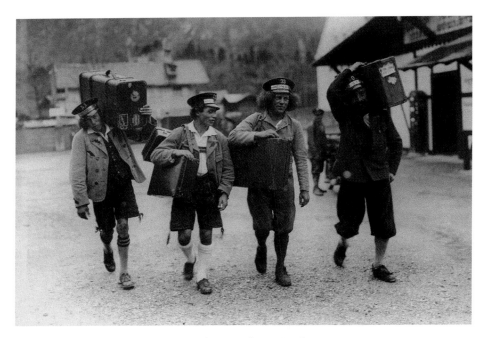

The south German town of Oberammergau has staged a Passion Play every ten years since 1634. During the Great Plague of 1633, the townspeople took an oath to this effect. The numerous amateur performers earn their living by normal means between productions. The hairstyle of these porters in 1934 is a fair indication, however, that another production was imminent.

Im deutschen Oberammergau finden seit 1634 alle zehn Jahre Passionsspiele statt: Während der großen Pest von 1633 legten die Einwohner ein entsprechendes Gelübde ab. Die unzähligen Laiendarsteller gehen in der Zwischenzeit bürgerlichen Berufen nach. Die Frisuren der Dienstmänner von 1934 deuten jedoch darauf hin, daß die nächste Aufführung bevorsteht.

Depuis 1634, la ville allemande d'Oberammergau organise tous les dix ans les Jeux de la Passion : durant la grande peste de 1633, les habitants avaient pris cet engagement solennel au cas où ils survivraient à l'épidémie. Entre-temps, les innombrables protagonistes profanes exercent des métiers courants. Mais les coiffures des porteurs de bagages de 1934 indiquent que la prochaine représentation va bientôt avoir lieu.

"Santa Claus", born in a song composed by German poet Hoffmann von Fallersleben in 1835, underwent a curious professionalization in 1930s' America. "Every year a whole army of Santa Claus' is recruited, who have to attend a veritable Santa Claus college."

Der »Weihnachtsmann«, vom deutschen Dichter Hoffmann von Fallersleben 1835 mit einem Lied aus der Taufe gehoben, wird in den dreißiger Jahren in Amerika auf bemerkenswerte Weise professionalisiert: »So wird alljährlich eine ganze Armee von Weihnachtsmännern aufgebracht, die regelrecht in die Schule der Weihnachtsmänner gehen müssen.«

Le « père Noël », porté sur les fonts baptismaux dans une chanson du poète allemand Hoffmann von Fallersleben, en 1835, suit un stage de formation professionnelle dans l'Amérique des années 30. « Tous les ans, on lève une véritable armée de pères Noël qui sont formés dans une école correspondante. »

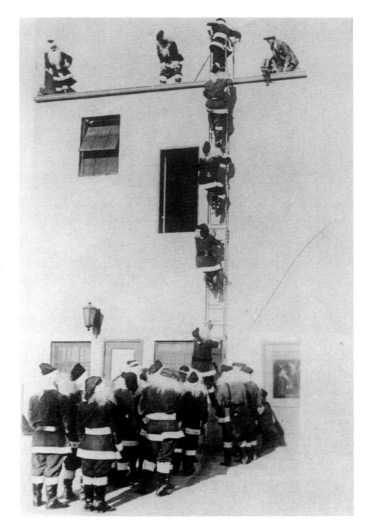

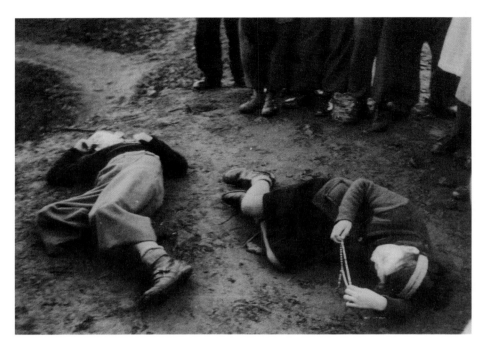

The cult of the Virgin Mary as a feature of popular Roman Catholicism was boosted by apparitions such as one reported from the Luxembourg village of Kayl in the 1930s. The sub-editor summarized as follows: "A large crowd has already assembled at the site of the miracle. Here we see two of the three children, Jean Denter and Emilie Winandy, in a trance."

Der volkstümliche Marienkult der Katholiken wird durch Marienerscheinungen wie diese in den dreißiger Jahren in der Nähe des luxemburgischen Dorfes Kayl getragen. Der Redakteur faßt das Ereignis kurz zusammen: »Schon kommt eine Menschenmenge an dem Ort des Wunders zusammen. Hier sehen wir zwei der drei Kinder, Jean Denter und Emilie Winandy, in Trance.«

Le culte de Marie, très populaire parmi les catholiques, s'appuie sur des apparitions de la Vierge, comme ici dans les années 30, à proximité du village luxembourgeois de Kayl. Le rédacteur résume cet événement en ces termes : « Une foule de gens se réunit déjà sur le lieu du miracle. Ici, nous voyons deux des trois enfants, Jean Denter et Emilie Winandy, en transe. »

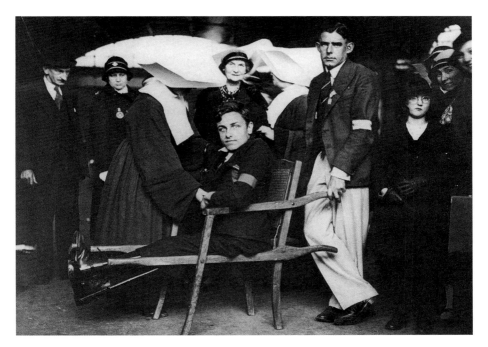

Since the mid-19th century, countless millions have made the pilgrimage to Lourdes at the foot of the French Pyrenees, where the Virgin was reported to have appeared in a grotto. On 28 May 1935, a group of 700 Roman Catholic pilgrims set out from London. Among them were 130 sick people who were all hoping that a miracle at this sanctified place would release them from their sufferings.

Seit Mitte des 19. Jahrhunderts pilgern Abermillionen zum Ort der Marienerscheinungen in Lourdes am Fuße der französischen Pyrenäen. Am 28. Mai 1935 startet eine Gruppe von 700 katholischen Pilgern aus London. Unter ihnen befinden sich 130 Kranke, die alle auf das Wunder hoffen, an diesem heiliggesprochenen Ort von ihren körperlichen Gebrechen erlöst zu werden.

Depuis le milieu du XIXᵉ siècle, des millions de fidèles se rendent en pèlerinage à la grotte dédiée à la Vierge Marie, à Lourdes, au pied des Pyrénées françaises. Le 28 mai 1935, un groupe de 700 pèlerins catholiques quitte Londres. Parmi eux se trouvent 130 malades qui, tous, espèrent que se réalisera LE miracle qui, en ce lieu saint, les délivrera de leur handicap physique.

A series of photos taken in Germany in the 1930s reveals this "beheading of a man" for the trick it is. The text provides a detailed description. Beheading has its roots in West African cultural history. Human beings were ritually sacrificed to the King of Dahomey right up to the start of the present century. Furthermore beheading is the ultimate sacrifice to the gods in order to end long periods of drought.

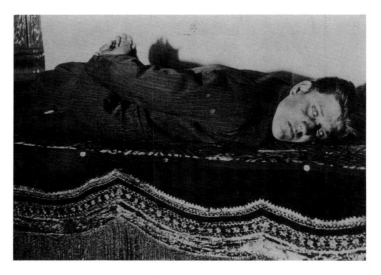

Die deutsche Fotoserie aus den dreißiger Jahren entlarvt diese "Enthauptung eines Menschen" als Trick. Der Text liefert eine genaue Beschreibung. Kulturhistorische Wurzeln hat die Enthauptung in Westafrika. Bis Anfang des 20. Jahrhunderts werden dem König von Dahomey Menschen zeremoniell geopfert. Zudem ist die Enthauptung das letzte Opfer an die Götter, um lange Dürreperioden zu beenden.

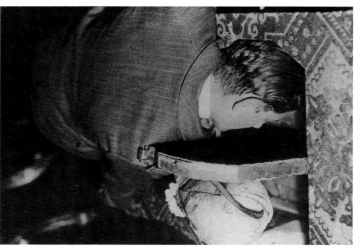

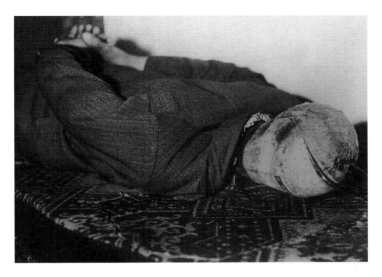

La série de photos allemande des années 30 démasque l'énigme de ce numéro de magie appelé « La décollation d'un être humain ». Le texte en donne une description exacte. Sur le plan historique, la décapitation a ses origines en Afrique de l'Ouest. Jusqu'au début du xxᵉ siècle, des victimes humaines étaient sacrifiées cérémoniellement en l'honneur du roi du Dahomey. De surcroît, la décapitation est l'ultime sacrifice que l'on puisse faire aux dieux pour mettre un terme à de longues périodes de sécheresse.

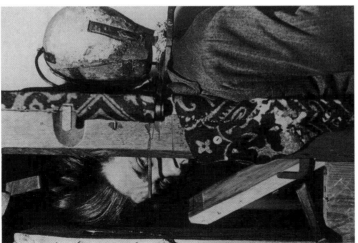

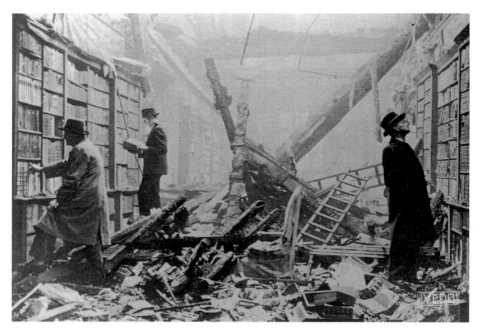

An Italian sub-editor got worked up about this British agency photo from November 1940. "That London is subject to the brave fire of German and Italian bombers is true, as is the representation of the effects of the bombing. But one should not believe in the authenticity of the phlegmatic attitude displayed by the three English students who seek their required books amidst the ruins of the Kensington Military Library." The Italians, in fact, were only marginally involved in the bombing raids on Britain.

Ein italienischer Redakteur empört sich über dieses britische Agenturbild im November 1940: »Daß London unter dem tapferen Feuer der italienischen und deutschen Bomber liegt, ist ebenso wahr, wie die Wirkung der Bombardierungen authentisch ist, aber man sollte nicht an die Gelassenheit der drei englischen Studenten glauben, die trotz des Einsturzes der Militärbibliothek von Kensington nach dem gewünschten Band suchen.« Am Bombardement Englands sind die Italiener nur peripher beteiligt.

Un rédacteur italien exprime sa fureur à la vue de cette photo d'une agence de presse britannique de novembre 1940 en ces termes : « Londres est exposée au feu courageux des bombardiers italiens et allemands. Ceci est authentique comme l'est aussi l'impact des bombardements ; mais le flegme affiché par les trois étudiants anglais qui, nonobstant l'effondrement de la bibliothèque militaire de Kensington, continuent de rechercher l'ouvrage dont ils ont besoin, est un leurre » Les Italiens ne participent cependant qu'accessoirement aux bombardements de l'Angleterre.

This young Briton appealed to the sympathy of Londoners in 1947 by writing a placard: "Wanted – Urgently – a strong rope to hang myself. Alternatively, unfurnished accommodation for my wife, unborn child and myself." The caption writer's comment: "It's difficult to believe..."

Dieser junge Brite appelliert 1947 während der Nachkriegskrise an das Mitgefühl der Londoner und malt ein Plakat: »Gesucht – dringendst – ein starkes Seil, um mich zu erhängen, oder: ein unmöbliertes Zimmer für meine Frau, mein ungeborenes Kind und mich.« Den englischen Redakteur überzeugt der Auftritt nicht: »Es ist schwer zu glauben ...«

En 1947, durant la crise de l'après-guerre, ce jeune Britannique, qui en appelle au cœur des Londoniens, a écrit sur la pancarte : « Recherche – d'urgence – une corde solide pour me pendre ou, sinon, une chambre non meublée pour ma femme, mon enfant à naître et moi-même. » Une démarche qui ne convainc pas le rédacteur anglais : « C'est difficile à croire ... »

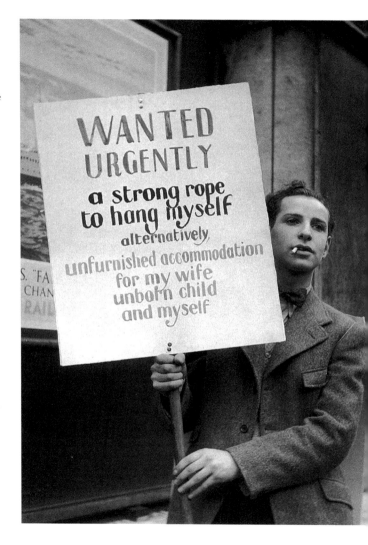

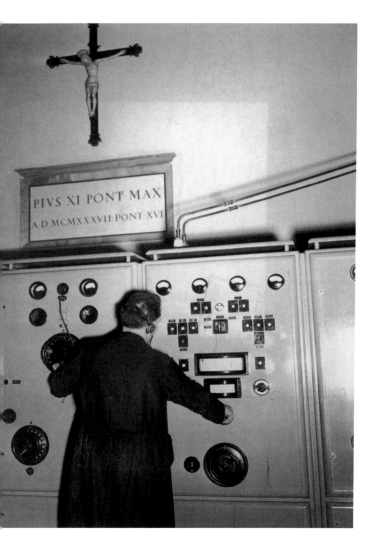

Papal employees had extended the range of Vatican Radio, which from 1949 broadcast the Christmas messages delivered by Pope Pius XII across the Iron Curtain too, to the Eastern half of divided Europe. But the Pope clearly felt the universal mission of the Church to be of secondary importance, and neglected it in favor of the West.

Päpstliche Bedienstete haben die Reichweite des Senders Radio Vatikan ausgebaut und übertragen ab 1949 die Weihnachtsbotschaften von Pius XII. nun auch über den Eisernen Vorhang in den Osten des politisch geteilten Europas. Pius' politische Präferenzen liegen eindeutig in der westlichen Welt, der universelle Auftrag der Kirche ist für ihn zweitrangig.

Le personnel au service du pape a augmenté la portée de l'émetteur de Radio Vatican et, à partir de 1949, transmet aussi le message de Noël de Pie XII au-delà du Rideau de fer, dans l'est d'une Europe politiquement divisée. Etant donné ses préférences pour l'Occident, Pie XII juge secondaire la mission universelle de l'Eglise en faveur du monde occidental.

Venta, a self-appointed Messiah from London, ran his sect as a family business together with his wife Ruth. She is pictured coping with the secretarial work in the office in St James' Street in 1951.

Venta, selbsternannter Messias aus London, und seine Frau Ruth führen ihre Sekte als Familienbetrieb. Im Büro in der St. James's Street erledigt 1951 die Ehefrau alle anfallenden Sekretariatsarbeiten.

Venta, un Londonien qui s'est lui-même érigé en messie, gère une entreprise familiale avec sa femme Ruth. Dans son bureau de St. James's Street, son épouse s'occupe, en 1951, de tous les travaux de secrétariat.

American insurance companies set up dispensing machines at airport terminals in the 1940s. The passenger had to decide how much his life was worth: 5000 or 25,000 dollars?

Amerikanische Versicherungsgesellschaften stellen in den vierziger Jahren Automaten in den Schalterhallen der Flughäfen auf. Der Fluggast hat nun die Wahl: Wieviel ist ihm sein Leben wert? 5000 oder 25 000 Dollar?

Dans les années 40, des compagnies d'assurances américaines mettent en place des appareils automatiques dans les salles de guichets des aéroports. Le voyageur a maintenant le choix : à combien estime-t-il sa vie ? 5000 ou 25 000 dollars ?

Marital war in Manhattan in 1949. After millionaire Robert Lord had evicted his wife, she reconquered the luxury apartment and fortified it.

Scheidungskrieg in Manhattan im Jahre 1949. Nachdem der Millionär Robert Lord seine Frau vor die Tür gesetzt hat, erobert sie das Luxus-appartement zurück und baut es zur Festung aus.

La guerre du divorce à Manhattan en 1949. Après avoir été expulsé par son mari, le million-naire Robert Lord, son épouse a repris posses-sion du luxueux domicile conjugal, qu'elle a trans-formé en une citadelle.

698 God bless you

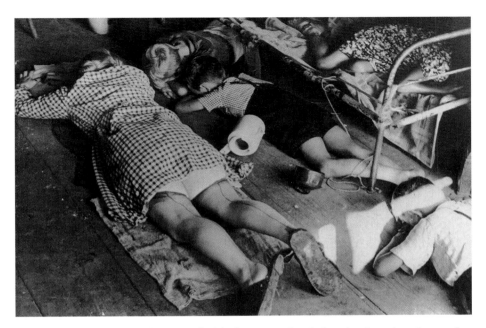

These pictures, from 17 September 1948, tell of the "most sensational crime story in postwar Germany." Adolf Pakatzki, a refugee from Poland, turned his close family circle into a religious cult in Bookholzberg. Together with his wife (left) he preached a fanatical doctrine which envisioned the sacrifice of their two 6-year-old sons "in order to protect the world from otherwise certain destruction by the Holy Ghost." The police intervened, and found the cult members, who had tied their children to bedposts.

Von der »sensationellsten Kriminalgeschichte im Nachkriegsdeutschland« erzählen diese Aufnahmen vom 17. September 1948. Adolf Pakatzki, ein Flüchtling aus Polen, bildet aus seinem engsten Familienkreis eine Sekte in Bookholzberg. Gemeinsam mit seiner Frau (links) predigt er seine fanatische Lehre, die das Opfer ihrer beiden sechs Jahre alten Söhne vorsieht, »um die Welt vor der ansonsten unvermeidlichen Zerstörung durch den Heiligen Geist zu beschützen«. Die Polizei greift ein und findet die Sektenmitglieder, die ihre Kinder an Bettpfosten gebunden haben.

Ces photos, du 17 septembre 1948, relatent « l'histoire criminelle la plus sensationnelle de l'Allemagne de l'après-guerre ». Adolf Pakatzki, un réfugié polonais, crée avec les membres les plus proches de sa famille une secte à Bookholzberg. Avec sa femme (à gauche), il prêche sa doctrine fanatique qui prévoit le sacrifice de leurs deux fils de six ans « afin de prévenir le monde d'une destruction sinon irrémédiable par le Saint-Esprit ». La police intervient et découvre les membres de la secte, qui ont ligoté leurs enfants au pied du lit.

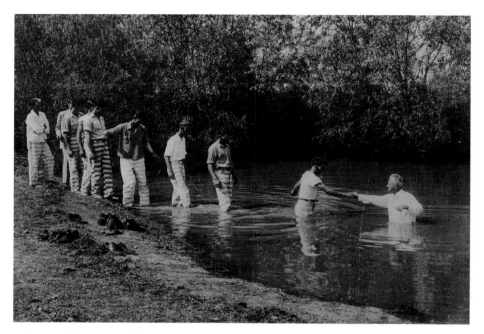

Dr D. A. McCall, secretary of the Mississippi Baptist Convention Board, baptizes convicts on a prison farm near Parchman on 18 August 1946. Baptists and Methodists are among the leading protestant free churches in the United States. Both are characterized by missionary zeal and social commitment.

Dr D. A. McCall, Sekretär des »Mississippi Baptist Convention Board«, tauft am 18. August 1946 Zuchthäusler einer Gefängnisfarm in der Nähe von Parchman. Baptisten und Methodisten gehören zu den bedeutendsten protestantisch beeinflußten Freikirchen der USA. Beide zeichnen sich durch eifrige Missionsarbeit und soziales Engagement aus.

Le 18 août 1946, le Dr D. A. McCall, secrétaire de la « Mississippi Baptist Convention Board », baptise des détenus internés dans une ferme à proximité de Parchman. Les baptistes et les méthodistes figurent parmi les Eglises libres à influence protestante qui ont le plus de crédit aux Etats-Unis. Ces deux Eglises se distinguent par leur missionnariat zélé et leur engagement social.

Heavy snowfall inspired these two members of the Iceberg Athletic Club to dive into the deep snow-drifts off Coney Island on 29 December 1947. But this was just a warming-up exercise for their ritual form of asceticism – a regular swim in the icy waters of the Atlantic.

Starker Schneefall inspiriert am 29. Dezember 1947 diese beiden Mitglieder des Iceberg Athletic Club zum Sprung in die hohen Schneewehen vor Coney Island. Dies ist jedoch nur der außerge-wöhnliche Auftakt für ihre Form der rituellen Askese – ein Bad im eisigen Wasser des Atlantik.

Le 29 décembre 1947, de fortes chutes de neige incitent ces deux membres de l'Iceberg Athletic Club à se lancer dans les tourbillons de neige de Coney Island. Il ne s'agit, en fait, que d'un exercice d'échauf-fement avant de plonger dans les eaux glacées de l'Atlantique – le prélude à leur ascèse habituelle.

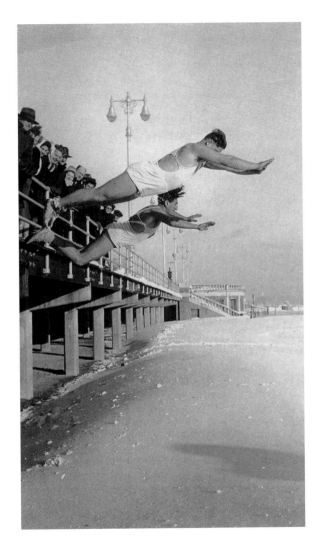

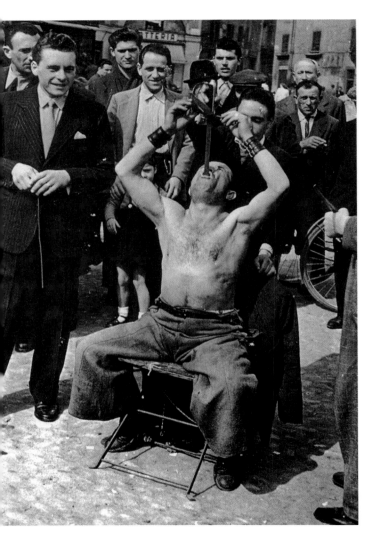

The Sabbath was no reason for this sword-eater to take a rest in spring 1947. After all, the people of Turin were out of doors on their way to church, providing a good opportunity for the showman to persuade them to part with a few lire.

An einem Sonntag im Frühling 1947 läßt der Schwertschlucker seine Arbeit nicht ruhen: Der Kirchgang lockt die Turiner aus ihren Häusern. Eine günstige Gelegenheit für den Magier, den Schaulustigen Lire zu entlocken.

Ce dimanche du printemps 1947, l'avaleur de sabres ne respecte pas le repos dominical : les Turinois vont à l'église et le magicien en profite pour obtenir quelques lires des curieux.

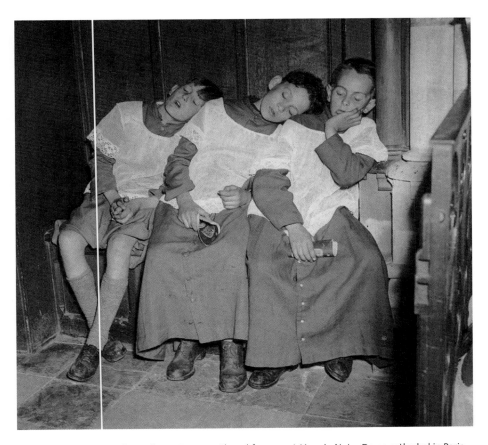

Thousands of choirboys from all over France gathered for a great Mass in Notre Dame cathedral in Paris on 21 April 1948. This trio were not up to all the excitement.

Tausende von Chorknaben aus ganz Frankreich versammeln sich am 21. April 1948 zur großen Kommunionsmesse in Paris Dieses Trio hat in der Kathedrale ein Nickerchen eingelegt.

Des milliers de petits chanteurs de chœurs de toute la France se réunissent pour la grande messe de communion à Notre Dame de Paris, le 21 avril 1948. Le photographe découvre ce trio qui fait un petit somme.

This series on the theme of "Sleepwalker stops the traffic" was sold by an agency on 17 February 1948 as "exclusive amateur photos from Los Angeles." "Clad in a long white robe, Anna Bogdanoff paid no heed to the speeding traffic. This unusual sequence of pictures follows her progress into the arms of two police-men. When they finally steered the lady into the police car, she awakened and started screaming for her husband and her two babies who were safe at home still sleeping." The hard contours of the touched-up photos were rather lessened due to the quality of newspaper print in the 1940s. One question, however, remains unanswered: "Why was the whole Family Bogdanoff asleep in broad daylight?"

Diese Fotomontage zum Thema »Schlafwandlerin stoppt den Verkehr« verkauft eine Agentur am 17. Februar 1948 als »exklusive Amateurfotos« aus Los Angeles: »In ein langes, weißes Gewand gekleidet schenkte Anna Bogdanoff dem vorbeirauschenden Verkehr keinerlei Beachtung. Diese ungewöhnliche Bildsequenz folgt ihrem Weg bis in die Arme zweier Polizeibeamter. Als sie die Dame schließlich in den Streifenwagen lenkten, erwachte sie und begann, nach ihrem Ehemann und ihren zwei kleinen Kindern zu schreien, die sich im sicheren Heim befanden und noch immer schliefen.« Die harten Konturen der Retusche werden zwar durch den schlechten Zeitungsdruck der vierziger Jahre verwischt worden sein, doch bleibt die Frage offen: Warum schläft die gesamte Familie Bogdanoff am hellichten Tag?

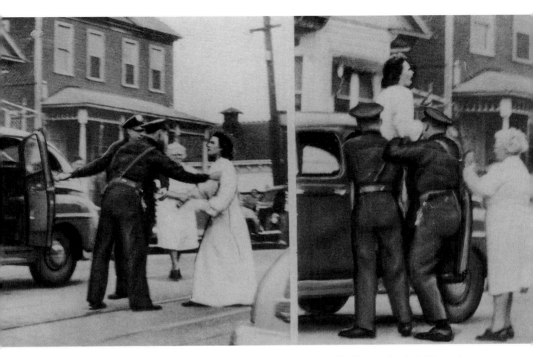

Une agence de presse vend, le 17 février 1948, ce photomontage intitulé « Une noctambule bloque la circulation » en prétendant qu'il s'agit de « photos exclusives d'amateur » de Los Angeles : « Vêtue d'une longue toge blanche, Anna Bogdanoff n'accorde pas la moindre attention à la circulation. Cette séquence imagée inhabituelle la montre au moment où deux agents de police la dirigent vers le fourgon. Celle-ci se réveille alors et se met à réclamer son époux et ses deux petits enfants, qui en toute sécurité à la maison, dorment profondément. » La mauvaise qualité d'impression des journaux des années 40 a, certes, rendu flous les contours des retouches, mais on peut tout de même se demander : pourquoi toute la famille Bogdanoff dort-elle comme par hasard en plein jour ?

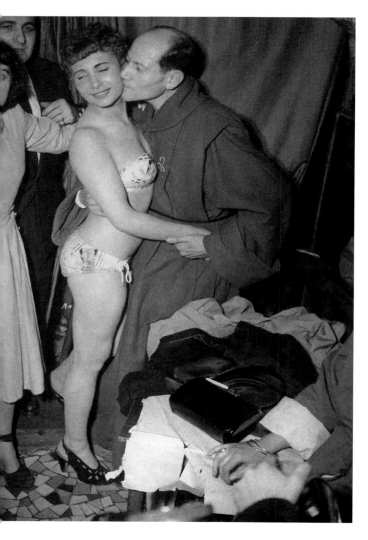

Robert France called himself the "priest of love." The core teaching of his faith was that the world could only be saved by love. He arranged a photo opportunity together with the "priestess of love," Lisa Merville, on the steps of the Courts of Justice in Paris, in order to publicize his suit against a daily newspaper which he accused of libeling him and his religion of love.

Robert France bezeichnet sich als »Priester der Liebe«, und der Kernsatz seiner Lehre ist, daß die Welt nur durch die Liebe gerettet werden kann. Hier tritt er gemeinsam mit der »Priesterin der Liebe«, Lise Merville, auf den Stufen des Pariser Gerichtshofs vor die Pressefotografen, um auf seinen Prozeß gegen eine Tageszeitung aufmerksam zu machen. Diese soll ihn und seine Religion der Liebe verleumdet haben.

Robert France s'est surnommé lui-même le « prêtre de l'amour » et selon le précepte majeur de sa doctrine, seul l'amour peut sauver le monde. Ici, il se présente aux photographes de presse avec la « prêtresse de l'amour », Lise Merville, sur les marches du Tribunal de Paris pour assister au procès qu'il a intenté à un quotidien. Il reproche à ce dernier de l'avoir diffamé, lui et sa religion de l'amour.

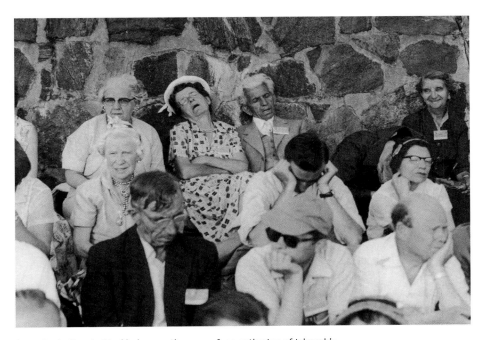

A sports stadium in Stockholm was the venue for a gathering of Jehovah's Witnesses from all over Europe on 17 August 1955 for the opening of their annual convention of "the message of the triumphant kingdom." "Tired from the long journey and maybe also from the unexpected heat in Stockholm, many of the Witnesses were nodding off on the seats" reads the empathetic caption.

In einem Sportstadion in Stockholm versammeln sich am 17. August 1955 Zeugen Jehovas aus ganz Europa, um zur Eröffnung ihres Jahreskonvents »der Botschaft des triumphierenden Reiches« zu lauschen. »Müde von der langen Reise und vielleicht auch von der unerwarteten Hitze in Stockholm schlummern viele der Zeugen auf den Rängen«, lautet die emphatische Bildunterschrift.

Le 17 août 1955, des témoins de Jéhovah venus de toute l'Europe se sont réunis dans un stade de Stockholm pour inaugurer leur convention annuelle et entendre «le message du Royaume triomphant». «Fatigués par le long voyage et, peut-être aussi, par une chaleur inhabituelle pour Stockholm, beaucoup des témoins se sont assoupis dans les gradins du stade», comme le souligne la légende de la photo.

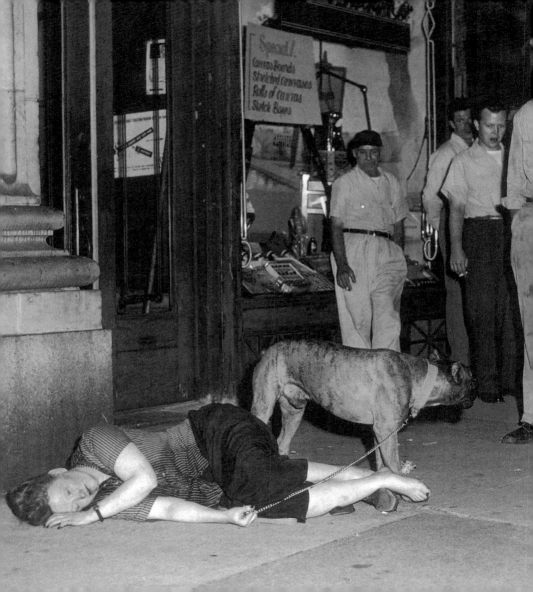

Sympathy for a New York animal lover was aroused by this story on 3 August 1953. "Growls of 70-pound boxer held cops at bay for 40 minutes and kept ambulance attendants from aiding his mistress, Eula Page, 38, who had collapsed on the sidewalk on West 68th Street. Cops finally distracted the dog and revived the woman."

Mitleid mit dieser New Yorker Tierfreundin weckt am 3. August 1953 folgende Geschichte: »Das Knurren eines 70 Pfund schweren Boxers hielt Polizisten 40 Minuten lang in Schach und hinderte Sanitäter daran, seinem Frauchen, Eula Page, 38 Jahre, Hilfe zu leisten, die auf dem Gehsteig der 68. Straße zusammengebrochen war. Beamte lenkten schließlich den Hund ab und brachten die Frau wieder auf die Beine.«

Le 3 août 1953, l'histoire émouvante de cette New-Yorkaise amie des animaux : « Pendant 40 minutes, les grognements d'un boxer de 35 kilos ont maintenu les agents de police en échec et empêché les infirmiers de ranimer sa maîtresse, Eula Page, 38 ans, qui s'était effondrée sur le trottoir de la 68ᵉ Rue. Des agents ont finalement détourné l'attention du chien et l'on a pu faire revenir à elle la femme. »

God bless you

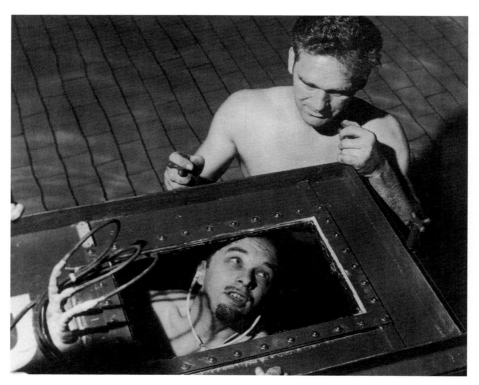

A London newspaper came up with an infelicitous comparison in 1958. "Recently the United States atomic submarine broke the record for staying submerged for 60 days. Yesterday at the West Ham swimming bath the 'amazing Randi' broke his record by staying underwater in a steel coffin for two hours."

Mit einem unseligen Vergleich stellt 1958 eine Londoner Lokalzeitung fest: »Kürzlich brach das amerikanische Atom-U-Boot den Rekord im Dauertauchen von 60 Tagen. Und gestern brach der ›erstaunliche Randi‹ im Schwimmbad von West Ham seinen eigenen Rekord, indem er in einem Stahlsarg zwei Stunden lang unter Wasser blieb.«

Comparaison déplacée dans un journal local londonien qui constate en 1958 que « Tout récemment, un sous-marin nucléaire américain a battu le record du monde de plongée de 60 jours. Et, hier, l'‹ étonnant Randi ›, à la piscine de West Ham, a battu son propre record en restant pendant deux heures sous l'eau dans un coffre d'acier. »

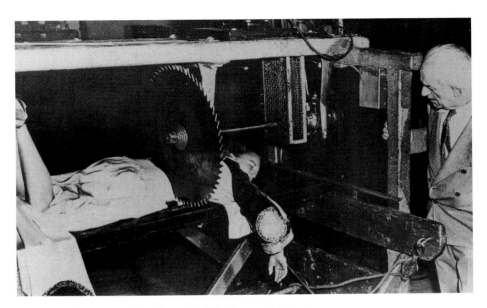

Reporter Barbara East would go through hell-fire for a good story, or even have herself sawn in half, as on 27 June 1951. What began as an interview with Blackstone the magician ended with her on the table. "Clad in the regal robes which are part of the hair-raising stunt, Miss East is pictured as the 36-inch lumber saw slashes through her body."

Für einen guten Bericht geht die Reporterin Barbara East sogar durchs Feuer oder läßt sich, wie hier am 27. Juni 1951, zersägen. Was als Interview mit dem Magier Blackstone begann, endet für sie auf dem Sägetisch: »Gekleidet in die königlichen Gewänder, die Teil dieses haarsträubenden Kunststücks sind, zeigt das Bild, wie eine Kreissäge mit über 90 cm Durchmesser Miss Easts Körper aufschlitzt und zertrennt.«

Pour un bon reportage, la journaliste Barbara East n'hésite même pas à franchir le feu ou, comme ici, à se faire couper par une scie, le 27 juin 1951. Ce qui a commencé comme une interview de Blackstone, le magicien, se termine pour elle sur la table à scier : « Portant des vêtements royaux qui font partie de la performance à donner la chair de poule, une scie circulaire de plus de 90 centimètres de diamètre coupe et sépare le corps de Miss East. »

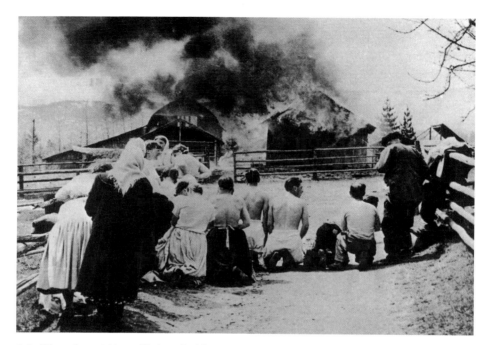

Cut off from the outside world, the radical "Sons of Freedom" cult lived in the woods of British Columbia in Canada. Strict vegetarians, they rejected all modern technology, and refused to accept either compulsory schooling or military service. They expressed their contempt for worldly things by sacrificing their homes, clothes and money to the flames from time to time. When however they set fire to a few schools in the vicinity of their colony in 1954, they were prosecuted. But even in the presence of Justice, they followed their principle: "If I disagree with you, my only method of lodging a protest is to take off my clothes."

Abgeschieden von der Außenwelt lebt die radikale Sekte »Söhne der Freiheit« in den Wäldern British Columbias in Kanada. Die strikten Vegetarier lehnen jede moderne Technik ab und verweigern die Schulpflicht und den Kriegsdienst. Indem sie von Zeit zu Zeit ihre Häuser, Kleidung und ihr Geld den Flammen opfern, drücken sie ihre Verachtung für weltliche Dinge aus. Als sie jedoch 1954 einige Schulen in der Umgebung ihrer Kolonie in Brand stecken, werden sie vor Gericht gestellt. Aber auch vor den Schranken der Justiz gehorchen sie ihrem Grundsatz »Wenn ich Dir nicht zustimme, dann besteht mein einziger Weg, Protest zu zeigen, darin, meine Kleidung abzulegen.«

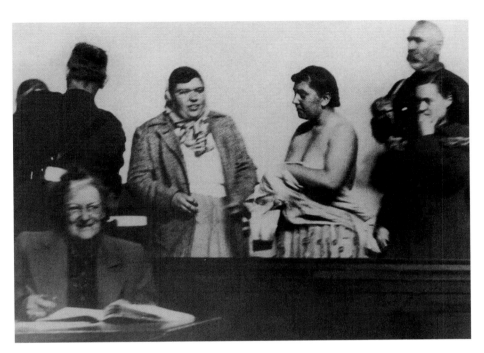

Coupée du monde extérieur, la secte radicale des « Fils de la liberté » vit dans les forêts de British Columbia, au Canada. Végétariens invétérés, ces membres rejettent toute technique moderne et refusent la scolarité obligatoire et le service militaire. En sacrifiant aux flammes, de temps à autre, leurs maisons, leurs vêtements et leur argent, ils expriment leur mépris des biens de ce bas monde. Lorsque, en 1954, ils incendient cependant quelques écoles du voisinage de leur colonie, ils sont traînés devant les tribunaux. Mais, même devant les représentants de la justice, ils restent fidèles à leurs principes : « Si je ne suis pas d'accord avec toi, le seul moyen de protester consiste à me débarrasser de mes vêtements. »

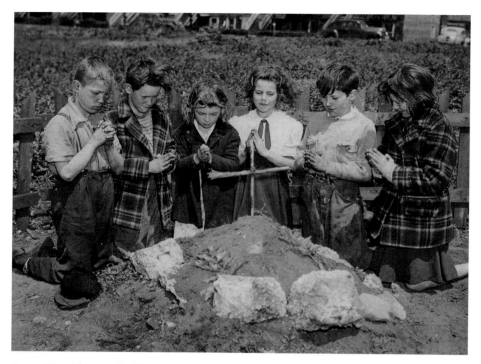

Some of the children at this "funeral service" in Chicago can hardly keep a straight face in 1948, when posed by a photographer around the grave of "their old friend." "They dig a grave and say a prayer over a dog killed by a hit-and-run driver."

Einige Kinder dieser »Trauergemeinde« in Chicago im Jahre 1948 können sich kaum halten vor Lachen, als der Fotograf sie um das Grab »ihres alten Freundes« gruppiert. Der Bildkommentar verrät: »Sie heben ein Grab aus und sprechen ein Gebet für einen Hund, der von einem flüchtigen Fahrer getötet wurde.«

Ces enfants en deuil, à Chicago, ont le plus grand mal à retenir leur fou-rire lorsque le photographe les fait se regrouper autour de la tombe de « leur vieil ami ». La légende de la photo nous fournit l'explication : « Après avoir creusé une tombe, ils récitent en commun une prière pour un chien tué par un automobiliste qui a pris la fuite. »

This Swedish girl fell into a trance at a Marana'ta meeting in the early 1960s. This charismatic Christian revivalist movement had split off from the Pentecostalists in Scandinavia in 1958.

Dieses schwedische Mädchen fällt Anfang der sechziger Jahre auf einer Marana'ta-Zusammenkunft in Trance. Die charismatische christliche Erweckungsbewegung hat sich in Skandinavien 1958 von der Pfingstbewegung abgespalten.

Au début des années 60, cette petite Suédoise tombe en transe lors d'une grand messe des Marana'ta. Ce mouvement charismatique du Réveil chrétien s'est dissocié, en 1958, du mouvement pentecôtiste en Scandinavie.

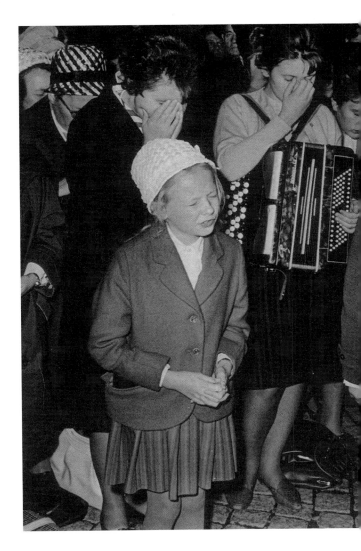

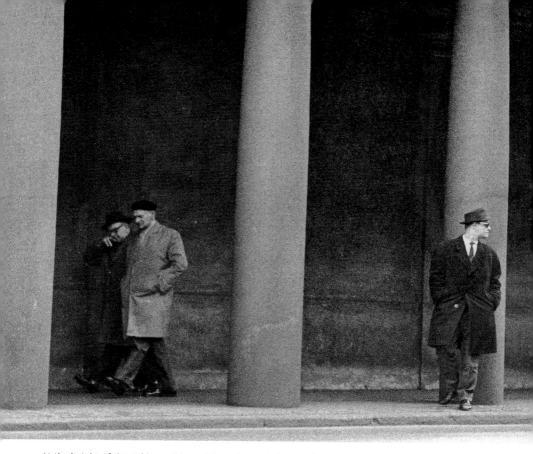

At the height of the Cold war, Edmond Khayat, 40, a Lebanese from Copenhagen, forged a 14-point plan for world peace in 1961. Before presenting it to the United Nations in New York he carried a 16-foot long (5-meter) cross with the inscription "Humanity" in English and Arabic through the capitals of Europe. He is pictured here in Copenhagen in November 1961. Nowhere did he arouse so much notice as in Berlin, where he was stopped at the sector boundary even before the Wall was built.

Auf dem Höhepunkt des Kalten Krieges schmiedet der Libanese Edmond Khayat (40) aus Kopenhagen 1961 einen 14-Punkte-Plan für den Weltfrieden. Bevor er diesen den Vereinten Nationen in New York präsentiert, trägt er ein 5 m langes Kreuz mit der Aufschrift »Humanität« in englischer und arabischer

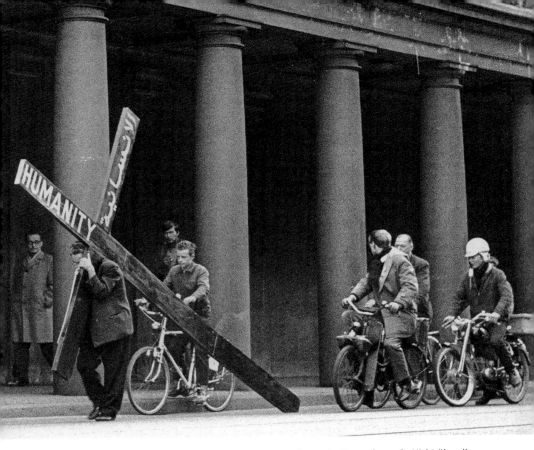

Sprache durch europäische Metropolen, so wie hier in Kopenhagen im November 1961. Nicht überall erregt Khayat so großes Aufsehen wie in Berlin: Noch vor dem Mauerbau im August wird er an der Sektorengrenze Ost gestoppt.

A l'apogée de la Guerre froide, le Libanais Edmond Khayat (40 ans), de Copenhague, élabore, en 1961, un plan en 14 points pour rétablir la paix mondiale. Avant de le présenter aux Nations Unies, à New York, il traverse les métropoles européennes, ici Copenhague en novembre 1961, en portant une croix de 5 mètres de long avec l'inscription « humanité » en anglais et en arabe. Khayat n'attire pas toujours l'attention comme ici à Berlin : avant la construction du Mur, en août, il est stoppé à la frontière du secteur oriental.

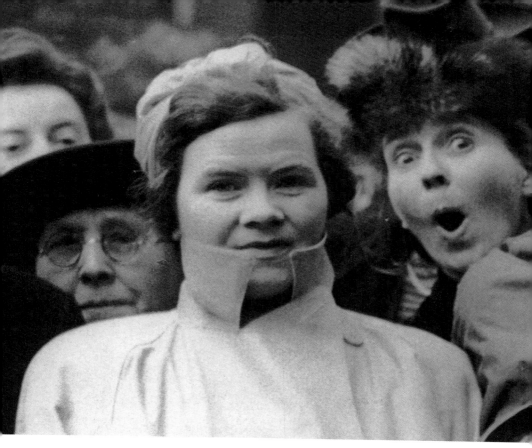

Final curtain

These London women outside
Westminster Abbey are hoping
some of the glitter would rub
off on to them. On 19 December
1945, the first postwar wedding

Schlußvorhang

Diese Londoner Frauen vor
Westminster Abbey versuchen
am 19. Dezember 1945 ein wenig
von dem Glanz zu erhaschen,
den die 1500 Gäste der ersten

Le rideau tombe

Ces Londoniennes font la haie
devant l'Abbaye de Westminster,
le 19 décembre 1945, pour aper-
cevoir les 1500 invités entrant
dans la véritable église pour

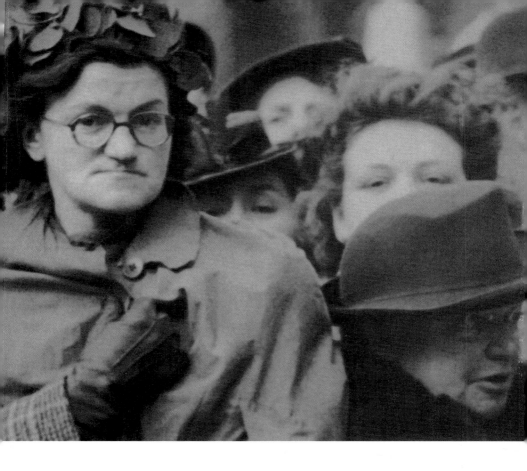

in the ancient church took place in the presence of 1500 guests. Two years before her friend Princess Elizabeth, 21-year-old Marjorie "Mollie" Wyndham-Quin was entering holy wedlock.

Nachkriegshochzeit in der ehrwürdigen Kirche verströmen. Zwei Jahre vor ihrer Freundin Prinzessin Elizabeth tritt Marjorie »Mollie« Wyndham-Quin im Alter von 21 Jahren vor den Altar.

assister à la célébration du premier mariage mondain de l'après-guerre. Deux ans avant son amie, la princesse Elizabeth, Marjorie « Mollie » Wyndham-Quin se marie religieusement à l'âge de 21 ans.

All good things must come to an end. Behind-the-scenes assistance was provided by: Tove Kleiven and Birgitta Werner, who held my hand (metaphorically) in the archives of SVT Bild, Stockholm, and elsewhere – many thanks for pleasant hours spent together after work, with a special greeting also to Göran Aneer; Ludwig Könemann and Peter Feierabend, who conveyed the project to me over numerous plates of sild; Dr Volker Guckel, who cast his eagle's eye, as always, over the text; Dr Dirk Levsen, who at some points said "No"; Sally Bald and her "Coaching Cologne" team, who at a decisive moment formed the *Curious Moments* crisis management committee over beer and wine, and acted as midwives for the organization of the flood of pictures; Oliver Hessmann and Thomas Lindner, who saw to the success of the graphics; Regine Möllenbeck, who translated French captions at all possible and impossible times of the day and night; the Christoph&Friends& DAS FOTOARCHIV agency, without whose support such projects as these are not feasible; my parents Dr Hans-Gert and Brigitte Neubauer, who equipped me with more than just this bloodcurdling laugh; and finally and first and foremost Regina Berkowitz and Nora Neubauer, who time and again made me laugh when all seemed lost.

Jeder Spaß hat auch ein Ende. Hinter den Kulissen haben mitgewirkt: Tove Kleiven und Birgitta Werner, die mir nicht nur im Archiv von SVT Bild/ Stockholm mit Rat und Tat zur Seite standen, vielen Dank für die schönen Stunden nach der Arbeit, ein besonderer Gruß auch an Göran Aneer; Ludwig Könemann und Peter Feierabend, die mir über mehreren Tellern Sild das Projekt übertragen haben; Dr. Volker Guckel, der wie immer sein Adlerauge über die Texte schweifen ließ; Dr. Dirk Levsen, der irgendwann »Nein« sagte; Sally Bald und ihrem Team »Coaching Cologne«, die im entscheidenden Moment bei Bier und Wein einen Krisenstab *Curious Moments* bildeten und Starthilfe für die Gliederung der Bilderflut gaben; Oliver Hessmann und Thomas Lindner, die grafisch alles gut werden ließen; Regine Möllenbeck, die zu allen möglichen und unmöglichen Tageszeiten französische Bildlegenden übersetzte; der Agentur Christoph & Friends & DAS FOTOARCHIV, ohne deren Unterstützung solche Projekte nicht durchzuführen sind; meinen Eltern Dr. Hans-Gert und Brigitte Neubauer, die mir nicht nur dieses markerschütternde Lachen mit auf den Weg gegeben haben; zuletzt und allererst Regina Berkowitz und Nora Neubauer, die mich immer wieder zum Lachen ermuntert haben, auch wenn gar nichts mehr ging.

Toute plaisanterie a une fin. De nombreux acteurs ont œuvré en coulisse : Tove Kleiven et Birgitta Werner, qui ne se sont pas contentés de m'aider et de me conseiller aux Archives photographiques de la SVT Bild/Stockholm, merci beaucoup pour les heures inoubliables après le travail ; un salut particulier aussi à Göran Aneer ; à Ludwig Könemann et Peter Feierabend, qui m'ont confié le projet après plusieurs assiettes de « sild » ; à Volker Guckel, qui, comme toujours, a scruté les textes de son œil d'aigle ; à Dirk Levsen, qui, à un moment ou à un autre, a dit « Non » ; à Sally Bald et son équipe du « Coaching Cologne », qui, au moment décisif, autour de quelques verres de bière et de vin, ont constitué une cellule de crise « Curious Moments » et nous ont donné un coup de pouce pour canaliser le raz-de-marée de clichés ; à Oliver Hessmann et Thomas Lindner, à qui l'on doit le remarquable graphisme ; à Regine Möllenbeck et Jean-Luc Lesouëf, qui, à (presque) toutes les heures du jour et de la nuit, ont traduit en français les légendes ; à l'agence Christoph & Friends & DAS FOTOARCHIV, sans l'aide de laquelle il serait impensable de mener de tels projets à bien ; à mes parents, Hans-Gert et Brigitte Neubauer, auxquels je ne dois pas seulement ce rire qui fait trembler toute ma carcasse ; et, enfin et surtout, à Regina Berkowitz et Nora Neubauer, qui ont toujours réussi à me faire sourire, même lorsque rien n'allait comme je le voulais.

Hendrik Neubauer

Notes

1 Franz Kafka. Aufzeichnungen aus dem Jahre 1914. In: *Tagebücher 1910–1923.* Frankfurt a. M., 1983. S. 305

2 siehe: Pierre Schaeffer und Gilles Feyel. *Fotografie und Medien. Die Veränderungen der illustrierten Presse.* S. 359-369. In: Michel Frizot (Hrsg.). *Die Neue Geschichte der Fotografie.* Köln, 1998. S. 363ff

3 siehe: Hendrik Neubauer. *Black Star. 60 years of photojournalism.* Köln, 1997. S. 9ff

4 John C. Merril, Carter R. Bryan und Marvin Alisky. *The Foreign Press.* Louisiana, 1964. S. 6

5 A. J. Ezickson. Selling your pictures to newspapers and syndicates. In: *Complete book of press photography.* National Press Photographers Association, Inc. New York, 1950. page 83f.

6 Gisèle Freund. *Photographie und Gesellschaft.* Erstausgabe: Paris, 1936. Frankfurt a. M., 1974. S. 119.

7 Joseph Costa. *Pictures with story telling impact.* In: *Complete book of press photography.* National Press Photographers Association, Inc. New York, 1950. S. 21ff.

8 E. K. Butler. *Picture collection and distribution in Post-War Europe.* In: *Complete book of press photography.* National Press Photographers Association, Inc. New York, 1950. S. 65ff.

9 Gespräch mit Werner Ebeler. In: Sigrid Schneider (Hrsg.). *Bildberichte. Aus dem Ruhrgebiet der Nachkriegszeit.* Essen, 1995. S. 230ff.

10 ebenda

11 Susan Sontag. *Heroismus des Sehens.* In: Dieselbe. *Über Fotografie.* Frankfurt a. M., 1980. S. 84.

12 Lutz Röhrich. Vorwort. In: Bengt af Klingberg. *Die Ratte in der Pizza. Und andere moderne Sagen und Großstadtmythen.* Kiel, 1990. S. 7.

13 zitiert nach: Bengt af Klingberg. *Die Ratte in der Pizza.* S. 111

14 ebenda, S. 111f

15 Joseph Roth. *Dem Anschein nach.* In: *Das Neue Tagebuch.* Paris, 1938. S. 16

16 ebenda

17 ebenda

18 Heidrun Friese. *Bilder der Geschichte.* In: Jörn Rüsen und Klaus E. Müller (Hrsg.). *Historische Sinnbildung. Problemstellungen, Zeitkonzepte, Wahrnehmungshorizonte, Darstellungsstrategien.* Reinbek bei Hamburg, 1997. S. 344